仁：设计的善意　　REN:GOOD DESIGN

# 首届北京国际设计三年展
# THE FIRST BEIJING INTERNATIONAL DESIGN TRIENNIAL

2011_
09.28_10.17

首届北京国际设计三年展筹备办公室　编

中国建筑工业出版社

| | |
|---|---|
| **主办单位** | **Hosted by** |
| 中华人民共和国教育部 | Ministry of Education of the People's Republic of China |
| 中华人民共和国文化部 | Ministry of Culture of the People's Republic of China |
| 中国文学艺术界联合会 | China Federation of Literary and Art Circles |
| 北京市人民政府 | People's Government of Beijing Municipality |
| | |
| **承办单位** | **Organized by** |
| 清华大学 | Tsinghua University |
| 北京歌华文化发展集团 | Beijing Gehua Cultural Development Group |
| 北京工业设计促进中心 | Beijing Industrial Design Center |
| | |
| **展览时间** | **Exhibition Period** |
| 2011年9月28日–10月17日 | Sep.28, 2011 - Oct.17, 2011 |
| | |
| **展览地点** | **Exhibition Venue** |
| 中国国家博物馆 | National Museum of China |

## 主承办机构

**主办单位：**

中华人民共和国教育部
中华人民共和国文化部
中国文学艺术界联合会
北京市人民政府

**承办单位：**

清华大学
北京歌华文化发展集团
北京工业设计促进中心

## 组委会成员

**名誉主席：**

刘　淇　中央政治局委员、北京市委书记

**主　席：**

袁贵仁　教育部部长
蔡　武　文化部部长
赵　实　中国文联党组书记
郭金龙　北京市市长

**副主席：**

郝　平　教育部副部长
赵少华　文化部副部长
冯　远　中国文联副主席
鲁　炜　北京市副市长，北京市委常委、宣传部部长

**执行主席：**

鲁　炜　北京市副市长，北京市委常委、宣传部部长

**秘书长：**

刘宝利　教育部国际合作与交流司副司长
董俊新　文化部外联局局长
黄文娟　中国文联国际联络部主任

**执行秘书长：**

侯玉兰　北京市政府副秘书长

**副秘书长：**

谢维和　清华大学副校长
闫傲霜　北京市科委主任
张　淼　北京市委宣传部副部长

**委　员：**

陈履生　中国国家博物馆副馆长
孔建华　北京市委宣传部文化产业改革发展办公室副主任
朱世龙　北京市科学技术委员会副主任
李润华　北京市公安局副局长
吴素芳　北京市财政局副局长
吴亚梅　北京市市政市容管理委员会副主任
关　宇　北京市文化局副局长
向　萍　北京市政府外事办公室副巡视员
邱月玲　北京海关副关长
王洪存　北京市政府口岸办公室副主任
王　惠　北京市政府新闻办公室主任
苏仁先　北京广播电视台副台长
朴学东　东城区政府副区长
郭怀刚　西城区政府副区长
张春秀　朝阳区政府副区长
刘长利　海淀区政府副区长
赵　萌　清华大学美术学院副院长
王建琪　北京歌华文化发展集团董事长
陈冬亮　北京工业设计促进中心主任

### 组委会办公室成员

**主　任：**
张　淼　　北京市委宣传部副部长

**常务副主任：**
郑曙旸　　清华大学美术学院常务副院长
李丹阳　　北京歌华文化发展集团总经理
宋慰祖　　北京工业设计促进中心副主任

**副主任：**
杭　间　　清华大学美术学院副院长
杨冬江　　清华大学美术学院环境艺术系副主任
曾　辉　　北京歌华文化创意产业中心主任
孙　群　　北京歌华科意公司总经理
王果儿　　北京工业设计促进中心总监

### 组委会成员单位

教育部国际合作与交流司
文化部外联局
中国文联国际联络部
中国国家博物馆
北京市委宣传部
北京市政府办公厅
北京市科学技术委员会
北京市公安局
北京市财政局
北京市市政市容管理委员会
北京市政府口岸办公室
北京市旅游发展委员会
北京市文化局
北京市政府外事办公室
北京海关
北京市政府新闻办公室
北京广播电视台
北京市东城区人民政府
北京市西城区人民政府
北京市朝阳区人民政府
北京市海淀区人民政府
清华大学
北京歌华文化发展集团
北京工业设计促进中心

## Host and Organizer

**Host:**
Ministry of Education of the People's Republic of China
Ministry of Culture of the People's Republic of China
China Federation of Literary and Art Circles
People's Government of Beijing Municipality

**Organizer:**
Tsinghua University
Beijing Gehua Cultural Development Group
Beijing Industrial Design Center

## Leaders of the Organizing Committee

**Honorary President:**
Liu Qi / Member of the Political Bureau of the CPC Central Committee, Secretary of Beijing Municipal CPC Committee

**President:**
Yuan Guiren / Minister of Education of the PRC
Cai Wu / Minister of Culture of the PRC
Zhao Shi / Secretary of Party Leadership Group of China Federation of Literary and Art Circles
Guo Jinlong / Mayor of Beijing

**Vice President:**
Hao Ping / Vice Minister of Education of the PRC
Zhao Shaohua / Vice Minister of Culture of the PRC
Feng Yuan / Vice President of China Federation of Literary and Art Circles
Lu Wei / Standing Member, Director of the Publicity Department of the CPC Beijing Municipal Committee, Vice Mayor of Beijing

**Executive President:**
Lu Wei / Standing Member, Director of the Publicity Department of the CPC Beijing Municipal Committee, Vice Mayor of Beijing

**Secretary-General:**
Liu Baoli / Deputy Director of Department of International Cooperation and Communication of Ministry of Education of P.R.C
Dong Junxin / Director-General of the Bureau for External Cultural Relations of Ministry of Culture of P.R.C
Huang Wenjuan / Director of International Liaison Department of China Federation of Literary and Art Circles

**Executive Secretary-General:**
Hou Yulan   Deputy Secretary-General of Beijing Municipal Government

**Deputy Secretary-General:**
Xie Weihe / Vice President of Tsinghua University
Yan Aoshuang / Director of Beijing Science and Technology Committee
Zhang Miao / Deputy Director of the Publicity Department of the CPC Beijing Municipal Committee

**Committee Member:**
Chen Lvsheng / Vice director of the National Museum of China
Kong Jianhua / Vice director of the Culture Industry Reform and Promotion Office, Publicity Department of the CPC Beijing Municipal Committee
Zhu Shilong / Vice director of the Beijing Municipal Commission of Science and Technology
Li Runhua / Vice director of the Beijing Municipal Bureau of Public Security
Wu Sufang / Vice director of the Beijing Municipal Bureau of Finance
Wu Yamei / Vice director of the Beijing Municipal Commission of City Administration
Guan Yu / Vice director of the Beijing Municipal Bureau of Culture
Xiang Ping / Vice counsel of the Foreign Affairs Office of the People's Government of Beijing Municipality
Qiu Yueling / Deputy Chief of the Beijing Customs District People's Republic of China
Wang Hongcun / Vice director of the Beijing Municipal Government Port Office

Wang Hui  Director of the Beijing Municipal Government Information Office
Su Renxian / Vice director of the Beijing Radio and Television Station
Piao Xuedong / Deputy District Chief of the Beijing Dongcheng District People's Government
Guo Huaigang / Deputy District Chief of the Beijing Xicheng District People's Government
Zhang Chunxiu / Deputy District Chief of the Beijing Chaoyang District People's Government
Liu Changli / Deputy District Chief of the Beijing Haidian District People's Government
Zhao Meng / Deputy Dean of the Academy of Arts and Design of Tsinghua University
Wang Jianqi / Chairman of the Beijing Gehua Cultural Development Group
Chen Dongliang / Chief of the Beijing Industrial Design Center

## Members of the Office of Organizing Committee

### Director:
Zhang Miao / Deputy Director of the Publicity Department of the CPC Beijing Municipal Committee

### Standing Deputy Director:
Zheng Shuyang / Standing Deputy Dean of the Academy of Arts and Design of Tsinghua University
Li Danyang / General Manager of the Beijing Ge Hua Cultural Development Group
Song Weizu / Deputy Director of the Beijing Industrial Design Center

### Deputy Director:
Hang Jian / Deputy Dean of the Academy of Arts and Design of Tsinghua University
Yang Dongjiang / Deputy Director of the Environment and Art Department of Academy of Arts and Design of Tsinghua University
Zeng Hui / Director of the Creative Industry Center of Beijing Ge Hua Cultural Development Group
Sun Qun / Manager of the Beijing Gehua Keyi Company
Wang Guo'er / Director of the Beijing Industrial Design Center

## Units of the Organizing Committee

Department of International Cooperation and Communication of Ministry of Education of P.R.C

Bureau for External Cultural Relations of Ministry of Culture of P.R.C

International Liaison Department of China Federation of Literary and Art Circles

National Museum of China

Publicity Department of the CPC Beijing Municipal Committee

General Office of the People's Government of Beijing Municipality

Beijing Municipal Commission of Science and Technology

Beijing Municipal Bureau of Public Security

Beijing Municipal Bureau of Finance

Beijing Municipal Commission of City Administration

Beijing Municipal Government Port Office

Beijing Tourism Development Committee

Beijing Municipal Bureau of Culture

Foreign Affairs Office of the People's Government of Beijing Municipality

Beijing Customs District People's Republic of China

Beijing Municipal Government Information Office

Beijing Radio and Television Station

Beijing Dongcheng District People's Government

Beijing Xicheng District People's Government

Beijing Chaoyang District People's Government

Beijing Haidian District People's Government

Tsinghua University

Beijing Ge Hua Cultural Development Group

Beijing Industrial Design Center

2011北京国际设计周暨首届北京国际设计三年展即将隆重开幕，我谨代表中国教育部，向活动的成功举办致以热烈祝贺！

设计，作为当今全球经济创新的首要话题，是思想与创新的展现，是精品与品牌的先导，是完美和成功的阶梯，与经济社会、文化生活、自然景观相互交融。北京国际设计周暨北京国际设计三年展，作为高规格的国际设计大展，集中体现设计艺术与国际化水平，是全球设计界交流合作的重要平台，是设计师展现睿智和才华，推介精品的重要舞台。本次活动的举办，关系到中国创新经济的发展，关系到北京建设创意城市的宏伟事业，更关系到中国设计教育事业的长远发展，对以展览促进设计前沿研究与设计实践接轨，对全球设计界和谐共处，创新提高，具有重要意义。

衷心希望本次活动充分展示当代国际设计的最高水平，充分展示中国作为全球最大的发展中国家，其设计产业蕴藏的美好发展前景，助推中国设计行业又好又快地发展。预祝本次活动取得圆满成功！

袁贵仁
中华人民共和国教育部部长

On the occasion of the approaching of the 2011 Beijing Design Week and the First Beijing International Design Triennial, I would like to extend, on behalf of the Ministry of Education of the People's Republic of China, heart-felt congratulations on the opening of this grand event.

As the hottest topic in global economic innovation today, design is the manifestation of ideas and innovations, the guide to quality goods and brands, and the ladder to perfection and success, interacting with economy and society, cultural life and natural landscape. As the world-class design exhibition, the Beijing Design Week and the Beijing International Design Triennial present the international design works of the highest quality and will become an important platform for the global design community to carry out international exchange and cooperation as well as an important stage on which designers can show their design wisdom and talents and introduce their elaborate works. This grand event is of relevance to the development of China's innovation economy, to the great cause of constructing Beijing into a creative city, and to the long-term development of China's design education, and is of significance in facilitating the combination of design frontier research and design practice and in enabling all members of the global design community to work together in harmony to continuously improve design quality.

I sincerely hope this grand event will fully demonstrate the highest level of contemporary international design as well as the promising development prospects of the design industry of China, the largest developing country in the world, and boost the rapid and sound development of China's design industry. And finally, I wish this grand event a great success.

Yuan Guiren
Minister of Education of the People's Republic of China

2011北京国际设计周暨首届北京国际设计三年展即将开幕，我谨代表中华人民共和国文化部表示热烈的祝贺。

文化是设计的内核，设计是文化的体现，也是文化的浓缩和见证。设计是一种文化的沟通，反映着每个时代的文化精神，同时又在不断创造着新的文化。

2011北京国际设计周暨首届北京国际设计三年展是一场设计的盛会，文化的盛会！不仅让中国设计界和公众能够借鉴欣赏当今世界设计领域最璀璨的成果，还将为中国设计文化与世界设计文化提供一个交流、对话的平台。我相信，这一活动的举办必将促进中国在设计领域的发展与进步，同时对于北京申请成为"世界设计之都"也将产生积极的推动作用。

预祝2011北京国际设计周暨首届北京国际设计三年展圆满成功！

On the occasion of the upcoming of the 2011 Beijing Design Week and the First Beijing International Design Triennial, I would like to extend, on behalf of the Ministry of Culture of the People's Republic of China, heart-felt congratulations on the opening of this grand event.

Culture is the inner core of design, and design is both the manifestation of culture and the enrichment and reflection of culture. As a form of cultural communication, design has a dynamic interactive relationship with culture: it reflects the cultural spirit of each era and constantly creates new cultures.

The 2011 Beijing Design Week and the First Beijing International Design Triennial are both a grand deign event and a grand cultural event. This grand event will not only enable Chinese design community and the general public to enjoy and learn the most inspirational contemporary design works in the world, but will also offer a platform for the exchange and dialogue between Chinese design culture and world design culture. I firmly believe this grand event will play a very positive role in promoting the progress and advancement of Chinese design sector and in advancing the great cause of constructing Beijing into a "design capital in the world".

I wish the 2011 Beijing Design Week and the Beijing International Design Triennial a great success.

中华人民共和国文化部部长

Cai Wu
Minister of Culture of the People's Republic of China

与纯艺术不同,设计必须落实到物质生活和社会生产的层面才能具有实质意义。真正具有领先性和创造性的设计,不能被短暂的商业利益所左右;而真正有前途的产业和经济发展,恰好离不开这些不为暂时的功利所左右的创造。

在这个意义上,首届北京国际设计三年展兼具产业性与学术性,以作品的质量和创意为最终评判的依据,并以此为基础,对设计的创造力、设计的善意等问题进行了全面的、富于学术意味的探讨,从而具有了一种难能可贵的品质和高瞻远瞩的眼光,并跻身于国际上优秀的设计双年展和三年展之列。

我相信,展览开幕后,无论是专业界人士,还是普通百姓,当他们漫步在这些琳琅满目的作品中,一定会留下十分深刻的印象。我相信,2011北京国际设计周暨首届北京国际设计三年展将积极推动中外文化交流与合作!

预祝2011北京国际设计周暨首届北京国际设计三年展圆满成功!

Unlike pure art, design must be rooted in the material life and social production to fulfill its meaningful role in the life. Really original and creative designers will not be swayed by the short-lived commercial interest; and really promising industries and economic development will rely on these creations beyond short-sighted utilitarianism.

In this sense, the first Beijing International Design Triennial (BIDT) is both industry-oriented and academic-oriented. BIDT takes the quality and creativity of design works as the basis for final judgment, and on this basis, conducts thorough academic investigations into such topics as the creativity and the moral dimension of design. Thanks to its valuable quality and forward-looking perspectives, BIDT has been among the top international design biennial/triennial exhibitions.

I firmly believe that after the opening of BIDT, these fantastic design works created by the first-rate designers across the world will leave a very deep impression on both design professionals and the general public. I also firmly believe that the 2011 Beijing Design Week and the First Beijing International Design Triennial will actively promote the Sino-foreign cultural exchange and cooperation.

I wish the 2011 Beijing Design Week and the First Beijing International Design Triennial a great success.

中国文学艺术界联合会党组书记

Zhao Shi
Party Committee Secretary of China Federation of Literary and Art Circles

北京作为中国首都，是全国的政治中心、文化中心，也是一座历史悠久的世界著名古都，拥有丰富的文化、科技、教育和人才资源，设计产业发展要素齐全、优势明显。改革开放以来，首都经济社会持续快速发展，设计行业欣欣向荣，产业规模日益扩大，政策、制度、市场环境不断完善。特别是成功举办奥运会，极大地提升了城市的国际影响力和吸引力，为建设设计之都奠定了重要基础。

设计是人类智慧的结晶，在推动创新，促进发展方式转变，改善人们生活，应对全球挑战等方面发挥着越来越重要的作用。由教育部、文化部、中国文联和北京市政府联合主办，清华大学、北京歌华文化发展集团、北京工业设计促进中心共同承办的2011北京国际设计周暨首届北京国际设计三年展，有利于汇聚国际创新创意思想，加强国内外设计界的交流合作，普及设计理念知识，推动设计产业发展，对于把北京建设成为世界一流的设计之都、时尚之都和具有重大国际影响力的文化中心，具有十分重要的意义。

值此2011北京国际设计周暨首届北京国际设计三年展开幕之际，我谨代表北京市政府，诚挚欢迎国内外设计界朋友相聚北京，共享机遇，放飞梦想，增进友谊。真诚希望本次活动的举办能够有力促进国内外设计界的深入交流与广泛合作！

预祝2011北京国际设计周暨首届北京国际设计三年展圆满成功！

北京市市长

Beijing, capital city of China, is the nation's political and cultural centre as well as a primary platform for international communications. With its global reputation of spectacular history, Beijing has ample cultural, technological, educational, and human resources. Well supported by these factors, Beijing has a particular advantage for design industry to develop. Since the nation's open-door reform, the city's economy and social development has moved to a fast and sustainable track. At present, Beijing's design sector prospers with the size of the industry expanding day by day and improvement in terms of policies, institutions and market conditions. In particular, the success of Olympic Game in 2008 significantly boosted Beijing's attraction and influence to the world, which has laid an essential foundation in making a great city of designation.

Design is the crystallization of human wisdom, which plays an increasingly important role in promoting innovation, improving people's life and coping with challenges during the process of globalization. Hosted by the Ministry of Education, the Ministry of Culture, China Federation of Literary and Arts Circles and the Municipal Government of Beijing, and executed by Tsinghua University, Beijing Gehua Cultural and Development Group, Beijing Industrial Design Center, the 2011 Beijing Design Week & the First Beijing International Design Triennial, will benefit Beijing by attracting international creative and innovative thoughts, strengthening communications and cooperations between domestic and international designers, popularizing the knowledge of design, promoting the design industry. It also has great significance in building Beijing a world class city of design, a world class city of fashion and a cultural centre with strong global influence.

At the launching moment of 2011 Beijing Design Week & the First Beijing International Design Triennial, on behalf of the Municipal Government of Beijing, I would like to give my sincere welcome to designers and friends from China and the world gathering in Beijing. I hope you will enjoy the opportunities that Beijing provides, enable your dreams and enhance our friendship in Beijing. I truly expect this event will effectively promote understanding and cooperation between local and global designers.

Wish *2011 Beijing Design Week & the First Beijing International Design Triennial a great success!*

Guo Jinlong
Mayor of Beijing

# 序

进入21世纪以来，创新成为促进社会经济发展的主要力量。加强文化传承创新，对增强国家的软实力和促进人类文明的进步发展，有着十分重要的意义。为推动创意产业的发展、促进文化传承创新，清华大学首倡了亚洲最大规模的国际设计三年展，由教育部、文化部、中国文联和北京市政府共同主办，清华大学等单位承办。在北京市政府的建议和支持下，首届国际设计三年展与2011年北京国际设计周联合举办。这必将对建设首都"设计之都"和带动全国创意产业的发展，发挥积极作用。

清华大学刚刚度过百年华诞。百年清华，人文日新。多年来，清华大学美术学院坚持艺术设计为生活服务的优良传统，促进科学与艺术的结合，取得了可喜的成绩。在全国高校一级学科评估中，清华大学名列艺术学整体水平第一位。相信这次在国家博物馆举办的国际设计三年展和国际设计周系列活动，也必将对促进清华美院不断提高设计水平、推动学科发展，起到鞭策作用。

国际设计三年展的策展，从前年夏天在清华大学美术学院启动，历时两年有余，既经历了曲折艰辛，也积累了宝贵经验。展览以"仁：设计的善意"为主题，采用国际通行的"三年展"模式和"策展人"制度，可以说有一个较高的学术起点。由于筹备组工作人员废寝忘食、夜以继日的辛勤努力，更由于众多设计大师和国内外广大艺术设计工作者热情参与、大力支持，这次展览无论从规模还是质量上看，都达到了一流水准。

毋庸讳言，与欧美等设计发达国家相比，我国的设计产业还存在很多差距。这一展览面向全球征集当代最优秀的设计作品，除了希望它们发挥榜样和示范作用外，也是为了给中国设计界提供一个同台竞技的舞台和机会，一方面鼓励大胆创新，另一方面也有利于寻找差距、迎头赶上。展览期间举办的设计论坛、设计之旅等丰富多彩的活动，更将促进中外设计工作者之间的深入交流。

万事开头难。衷心希望这项展览能坚持举办下去，成为中国现代设计发展史上高水平、有影响的设计大展，对中国设计产业发展和中外文化交流合作，产生更加深远的影响。

清华大学校长
2011年8月25日

# PREFACE

In the 21st century, innovation has become the primary driving force for the social and economic development. Enhancing cultural inheritance and innovation is of great significance to the enhancement of the nation's soft power as well as to the advancement of human civilization. To promote the development of the creative industry and advance the cultural inheritance and innovation, Tsinghua University initially proposed the Beijing International Design Triennial (BIDT), the largest design exhibition in the Asia, which is co-sponsored by the Ministry of Education, the Ministry of Culture, the China Federation of Literacy and Art Circles and the People's Government of Beijing Municipality and co-organized by Tsinghua University and other institutions. With advice and support of the People's Government of Beijing Municipality, the 1st Beijing International Design Triennial and the 2011 Beijing Design Week (BJDW) will be jointly held. This will inevitably play an active role in constructing Beijing into the Design Capital and in promoting the development of Chinese creative industry.

Recently Tsinghua University celebrated its 100th Anniversary. As a university with a hundred-year history, Tsinghua has pioneered in the innovative humanities education and research. Over years, Tsinghua University's Academy of Arts & Design carries forward the fine tradition of design for life and promotes the combination of science and art and thus has accomplished the outstanding results. According to the official evaluation on the first-rank disciplines of Chinese universities, Tsinghua University ranks the first place in arts education by the overall performance. I firmly believe that the BIDT held in the National Museum of China and the other events of BJDW will play a positive role in encouraging Tsinghua University's Academy of Arts & Design to continue its efforts in improving design quality and advancing discipline development.

The planning of the BIDT was initiated by Tsinghua University's Academy of Arts & Design in the summer of 2009 and lasted for more than two years. During the course of planning, many challenges have been overcome and the valuable experience has been accumulated. The BIDT is themed on "Ren: Good Design" and adopts the international prevailing practice of triennial exhibition and the curator system, making itself a high-profile international design event. Thanks to the diligent work of all members of the preparation team for the BIDT and the active participation and substantial support of a great number of international and domestic design masters and designers, the BIDT has reached the world-class level in terms of both scale and quality.

Needless to say, there is still a considerable development gap between the Chinese design industry and that of the Western countries. The BIDT solicits the most excellent contemporary design works from the global design community, aiming at displaying the model design works for Chinese designers to learn and providing the Chinese design community with a platform and opportunity to catch up with and compete with their foreign counterparts by making bold innovations. The various events held during the BIDT such as design forum and design journey will further facilitate the in-depth communication and dialogue between Chinese and foreign designers.

Each beginning is difficult. I sincerely hope that the BIDT will be held uninterruptedly and become the high level and high impact design exhibition in Chinese modem design development history, playing the further role in promoting the development of Chinese design industry and the Sino-foreign cultural exchanges and cooperation.

Gu Binglin
President of Tsinghua University
August 25, 2011

# 前言

北京国际设计三年展的正式启动始于2009年，其目标是想成为中国迄今为止最高规格的国际设计大展。经过努力，该项目得到了教育部、文化部、中国文联、北京市政府的认可并成为三年展主办单位，同时还得到了北京歌华文化发展集团和北京工业设计促进中心的大力支持。

经过三年展筹备组紧张而卓有成效的工作，以及各承办方的密切配合，在确定了展览主题、展览场地、展览组织形式以及高度国际化的策划人团队，并经多方论证选定了来自世界各地的当代顶尖设计作品后，终于在2011年国庆节前夕迎来了首届北京国际设计三年展的隆重开幕。

作为北京国际设计周的重点活动，北京国际设计三年展将努力办成目前中国乃至亚洲地区最具学术价值、最具前瞻性、最高端的综合性设计大展，其展览总主题"仁：设计的善意"蕴含着深刻而广博的意义。"仁"在中国传统文化中代表着关爱他人、关爱民众，在设计产业中，"好设计"完美地体现出"仁"的精神，优秀的设计能够使大多数民众受益，从中折射出现代设计在人文精神层面的仁爱与关怀。

本届展览由五个分主题展组成，并由五组中外策展人团队共同策划。五个分主题分别是：创意联结，知"竹"，理智设计情感，混合现实，可能的世界。"创意联结"单元旨在通过对国际顶尖设计产品的广泛选择和比较，突出强调设计师与代表高新技术的制造业的关联，以及他们与手工艺传统的关联。"知'竹'"单元关注中国、亚洲乃至世界范围内的竹设计，强调了源远流长的竹文化和竹工艺与当代设计的对接。"理智设计情感"单元希望通过中外设计师的优秀作品，让观众体悟设计中理智与情感交融的境界，同时感受东西方文化和而不同的意蕴。"混合现实"单元试图展现世界一流设计师如何在经济全球化时代多元文化并存发展的局面中，运用他们的设计智慧去解决生活中的现实问题。"可能的世界"则通过科幻小说式的设计实验，对新技术和人类的未来进行了大胆的探索。

以上五个分主题展，汇集了当下中外最顶尖的设计师和最优秀的当代设计作品，共有超过30个国家的近500名设计师参展，展品总数达2000余件，其规模、规格和质量均达到了国际一流水平，这对于进一步推动中国创意产业和设计事业向前发展具有举足轻重的意义。

借此机会，祝愿精彩纷呈的2011北京国际设计周以及在中国国家博物馆举办的首届北京国际设计三年展，带给大家更多更广泛的设计体验、艺术享受、精神思考和思想启迪。

中国文联副主席、清华大学美术学院名誉院长

2011年8月25日

# INTRODUCTION

The planning of the Beijing International Design Triennial (BIDT) was initiated in 2009, with the aim of creating a top-level international design exhibition hosted in China. Through the efforts of the planning team, this project has been recognized and co-sponsored by the Ministry of Education, the Ministry of Culture, the China Federation of Literary and Art Circles and the People's Government of Beijing Municipality, and received the substantial support from Beijing Gehua Cultural Development Group and Beijing Industrial Design Center.
Thanks to the efficient and effective work of the preparation team for the BIDT over the past years and the close cooperation of the co-organizers, the BIDT will present its magnificent debut in the eve of 2011 National Day after the exhibition theme, venue, organization form and international curator teams are defined and established, and a wide range of the best contemporary design works created by the designers across the world are selected.
As the key event of the Beijing Design Week, the BIDT aims to create the most academic, the most forward-looking and the most high-level comprehensive design exhibition in China or even in Asia. The general theme of the BIDT, "Ren: Good Design", contains deep and profound meanings. In Chinese traditional culture, "Ren" means showing concern and love to others and people. In the design industry, the concept of "Good Design" perfectly reflects the spirit of "Ren" in that the excellent design can always benefit the majority of people. The humanistic concerns and the moral dimension of the modern design are highlighted in the BIDT.

The 1st BIDT consists of five sub-theme exhibitions organized by five teams of Chinese and foreign curators. The five sub-themes are "Creative Junctions", "Rethinking Bamboo", "Reason Design Emotion", "Good Guys", and "What If". The Creative Junctions Exhibition aims to highlight the value of the work of a selected group of international designers that through testing, comparison and transformation underscores the importance of their relationship with the manufacturer, who activate moments of technological innovation and application of industrial know-how, together with the skills of craftsmanship passed down over time. The Rethinking Bamboo Exhibition pays close attention to the bamboo design in China, Asia and the whole world and highlights the connection between the contemporary design and the time-honored traditional bamboo culture and bamboo craftsmanship. The Reason Design Emotion Exhibition aims to make the viewers comprehend the blending of reason and emotion in the design and experience the harmony of difference and sameness of oriental and western cultures by viewing the excellent design works of Chinese and foreign designers. The Good Guys Exhibition presents the efforts of the leading global designers to offer the innovative solutions to the problems of the daily life in the context of economic globalization and multiculturalism by exploiting their design wisdom. The What If Exhibition presents the designers' bold explorations into new technologies and the future of mankind by their science fiction-like experiential design projects.
These five sub-theme exhibitions gather together the most reputed Chinese and foreign designers and the most excellent contemporary design works: About 500 designers from over 30 countries are present at the exhibitions and over 2000 design works are displayed. The BIDT has reached the world-class level in terms of both scale and quality, and provided the substantial impetus to the further development of Chinese creative industry and design undertakings.
Finally, I hope that the wonderful 2011 Beijing Design Week and the 1st Beijing International Design Triennial held in the National Museum of China will provide the general public with more extensive design experience, artistic enjoyment, spiritual thinking and intellectual illumination.

Feng Yuan
Vice President of China Federation of Literary and Art Circles and Honorary Dean of Academy of Arts & Design, Tsinghua University
August 25, 2011

# 目录 CONTENT

006 组织机构 ORGANIZATION

014 序 PREFACE

016 前言 INTRODUCTION

020 "仁：设计的善意"主题释义 "REN: GOOD DESIGN" INTERPRETATION OF THE EXHIBITION THEME

025 1. 创意联结 1. CREATIVE JUNCTIONS

177 2. 知"竹" 2. RETHINKING BAMBOO

241 3. 理智设计情感 3. REASON DESIGN EMOTION

371 4. 混合现实 4. GOOD GUYS

447 5. 可能的世界 5. WHAT IF

524 首届北京国际设计三年展大事记 CHRONICLE OF EVENTS OF THE FIRST BEIJING INTERNATIONAL DESIGN TRIENNIAL

528 索引 INDEX

532 后记 EPILOGUE

# "仁：设计的善意"主题释义

在中国第一次做如此大规模的设计三年展，对我们，对整个中国的设计界，都是一个难得的机遇，这是在场的历史。策划小组筹划主题时心中自然会有很多想法，但反复考虑后，觉得不适宜做宏大的题目，而希望是冷静和有提醒性的。

"设计"这个词在汉语里包含的意思不一定都是好的，它常常与"计谋"联系在一起，是一种主体被动情况下他者的单向度给予。当然，对于发展的中国来说，现阶段发展设计是必须的选择，尤其当它把人类科技新成果转换为人的使用、产生服务价值的时候。但是，问题是创造发明可以遵循科学伦理和技术伦理，如果在科学技术和设计之间加了消费者，设计的立场就会产生变化，将科学技术转换成消费者可用的东西，这里面没有绝对的无功利原则，一定会有市场、商业和利益的推动，所以设计师常常被资本控制，于是设计和使用设计者就成了"被设计"。当然，消费者自身有选择权，为了使这样一个"选择权"更有力量，理性的社会价值要对此有提醒，目的是为了使设计更符合人类的生存和发展，所以选择了"善意"这个词，善意体现了平等、商量和交流。

在《设计的民主精神》这篇文章里，我借用普通的民主概念来谈设计民主的三个层次，体制的，消费者的，设计师的。在这三者的关系之中，善意是一种态度还是一种道德？我想应该不是道德问题，道德有很强的受时间限制的价值色彩，而设计没有非常强烈的形而上内容，它的价值呈现是通过人的使用、通过生活的经验来慢慢培养和体会的。所以在设计中，善意更多是一种角度、一种建议、一种可供选择的方式，并通过它们来调和各种关系，包括使消费者不要陷入某种疯狂拜物境地中，清楚自己真正需要什么；从设计师的角度来说，设计民主提醒设计师永远只是服务，而不是一个创世的英雄。而设计体制之所以在中国还未健全，根源在于中国人对民主价值的认识不足，设计在中国不受重视，我们没有真正去体会设计对于改善民生是多么重要。

许多人好奇展览主题的英文翻译。"仁"在英文里有很多对应的词汇，为何最后选择不译，而以汉语拼音代替？而"设计的善意"，为何被译为"Good Design"，也就是"好的设计"？这个"好"和"善"应该怎么理解？二者是等同的吗？当"好"被解说为"好用"、"适合"等意义时，"好"与"善"发生了重合，但是，在不同文化中，"好"和"善"的意义会出现漂移。

我们的考虑是，"仁"和"善意"有共同之处，我们做的是一个"在中国"而不是在罗马、巴黎或纽约的国际设计展，因此想通过这个音译提醒国际设计师把最好的东西拿到中国来，希望通过"仁"的拼音的翻译，给他们一个"在中国"的提醒。"设计的善意"的翻译，我们征求了中外友人的意见。"Good"这个词十分常见，但也多义，与设计结合后语境就更丰富了，选择"Good Design"，一个最普通、最容易记住的、含义宽泛的词，这样，设计师呼应我们展览的时候，可以有充分的选择性和宽广的边界，可以更国际化。但当时也有疑问，因为"Good"这个词含义太宽泛，和"Design"结合后带来了不确定性，体现在价值观上，"好"

的原则在西方，常常让人联想到进化论的法则，跟东方的"善意"有相当的距离。但考虑到国际展还是要让外国人容易接受，而且近十年来，西方"好设计"观念也在变化中，包括"环保"、"可持续"或者"交互"都慢慢接近东方的意思，也接近"善意"这个词的立意。我们通过一段带有阐述性的策展文字，让外国设计师清楚这个"Good Design"有中国的角度。

我们认为，单讲"创意"，不是好设计的最高标准。创意常常与商业产生更多的联系，就更大的人生意义来说，创意不是本质，而是外在的东西。因此，在设计进步过程中，那些推动生活的新的方式和产生新的生活意义的伟大设计，离不开创造，但不是单纯的"创意"。

设计要处理的一个核心问题是人与物的问题。在人和物的关系中，人是主体，物不论能起到多大作用，都不能代替人。但人是主体，该主到怎么样一个程度？设计在这里是矛盾的。一方面，设计永远要解决现实问题，但也需要前瞻性。如何把握？这是个太大的命题。当代设计，我们只能尽可能好地来解决受地球环境制约下的人类生存和生活问题，让生活、能源、环境能够回到朴素、节制、环境和生物链友好的关系中，不要让地球上的东西消耗得太快，不要使人类对于幸福的追求太过于贪婪，而能永续经营。这些，都是"善意"的延伸内容之一。

这些问题不是靠设计能独立解决的。我们这个展览，或许只能解决一些"小"设计问题，"中"设计可能会涉及一些观念和体制，但像物理学家霍金说的"大"设计，我们还是无能为力。

杭 间

清华大学美术学院副院长

2011年8月26日

# "REN: GOOD DESIGN"
# INTERPRETATION OF THE EXHIBITION THEME

Such a large-scale triennial design exhibition in China is a rare opportunity for us and for the whole design community of China, and this is the history of the present. While planning the theme, the planning team has a lot of ideas. But after much consideration, it is felt that calm and remindful theme rather than grand theme is more suitable.

The word "design" in Chinese is not necessarily means good. It is always linked with "plot", which is a unilateral delivery while the subject is in a passive situation. Without doubt, for the developing China, the development design at present stage is the only choice, especially when it transfers human scientific achievements into the application and production service values. However, the problem is that invention can follow the scientific ethics and technical ethics, but if consumers are existed between science & technology and design, the position of design will be changed. There is no absolute utilitarian principle while transferring science & technology into objects which can be used by consumers, and this will certainly be pushed by market, business and interests. Therefore, designers will always be controlled by capital, and so the design and its user becomes "being designed". Of course, consumers themselves have the right to choose. To make such "right to choose" more powerful, the rational social values have to remind this. The purpose is to make the design more suitable for the survival and development of human. Therefore, the word "good" has been selected to reflect the equality, consultation and communication.

In the article "Democracy Sprit of Design", I take use of the common concept of democracy to discuss the three levels of design democracy: design system, consumer and designer. In the relationships among these three levels, is "goodness" an attitude or a moral? I think it's not a moral issue. Because moral has a strong value meaning restrained by time, while design does not have a very strong metaphysical content. Its value is slowly cultivated and understood through usage and life experience. Therefore in the design, "goodness" is an angle, a suggestion, and an alternative way. It can be used to reconcile various relationships, including preventing consumers from falling into some kind of crazy situation in fetish, and helping them to realize what they really want. From the designer's point of view, design democracy reminds the designer to give service rather than a creative hero. The reasons why design system is not perfect in China are the lack of understanding of democratic values by Chinese people, and the neglecting of design in China, and the lack of real experience for the great importance of design in improving the people's livelihood.

Many people are curious of the English translation of the theme of the exhibition. "Ren" has many translations in English, but why the final choice is not translated, and replace with the Chinese Pinyin. Why the "Shan Yi of Design" (roughly to be translated as good will of design) is translated to "Good Design"? How to understand this "Good" and "Shan"? Are they equivalent? When "Good" is explained as "convenient to use", "suitable", and other meanings, it coincides with "Shan". However, the meanings of "Good" and "Shan" are shifting in different cultures.

Our consideration is "Ren" and "Good" have meaning in common. What we do is an international design exhibition in China rather in Rome, Paris or New York. Therefore, we want to remind international designers to bring the best things to China through this transliteration. We hope to remind them "in China" through the translation of "Ren" in Pinyin. We sought the views of Chinese and Foreign friends for the translation of "Good Design". The word "Good" is very common in use and has many meanings. The context will be enriched after it being used together with design. By selecting the most common, the easiest to remember and the ambiguous word-"Good Design", when designers act in cooperate with our exhibition, they will have more selectivity and wider border, and it will make out exhibition more international. However, there were questions because the meaning of "Good" is too broad. When used together with "design", it will bring uncertainty. Reflected in values, the "Good" principle in the West is often associated with the law of evolution, which is quite different with the "Shan Yi" in the East. However, to make the international exhibition to be easily accepted by foreigners, we still use "Good Design". Moreover, over the past decade, the concept of "good design" in the West is changing, including the "Environmental protection", "sustainable" or "interactive", which are all slowly approaching to the meaning in the East and also close to the conception of

"Shan Yi". Through a paragraph declarative curatorial text, we will help foreign designers to be aware of the Chinese point of view of "Good Design".

We believe that only focusing "creativity" is not the highest standard of good design. Creativity always has more relation with business. On the greater meaning of life, creativity is not essential but the external factor. Therefore, in the progress of design, those new ways of promoting living and great designs generating new meanings of life can not be realized without creation, but not simply relying on "creativity".

One of the core issues which must be dealt with by designs is the problem between people and things. Among the relations between mankind and things, mankind is the subject, and things can not take the place of mankind no matter how much role they can play. However, as the subject, how far can we go? This is contradiction in design. On the one hand, design is always used to solve practical problems, but prospective is also required. How to balance it? This is a so large topic. In contemporary design, we can only try our best to solve the issues of human survival and living problems under the constrains of the earth's environment, try to make life, energy and environment back into the simple and modest friendly relations with environment and biological chain, try to reduce the consumption rate of things on earth, try to avoid the greedy in the pursuit of happiness, and maintain the sustainability. These are all the extension of "Good" or "Shan".

These problems can not be solved by design independently. Our exhibition may only solve some of the "small" design problems, "medium" design may involve a number of concepts and systems, but for the Grand Design mentioned by physicist Stephen Hawking, we can do nothing right now.

Hang Jian
Vice Dean of Academy of Arts & Design, Tsinghua University
August 26, 2011

# 1.

## 创意联结
## CREATIVE JUNCTIONS

| 策展人 | Curators |
|---|---|
| 吉达·博亚迪（意大利） | Gilda Bojardi (Italy) |
| 杨冬江（中国） | Yang Dongjiang (China) |

吉达·博亚迪(意大利)
杨冬江(中国)

**Gilda Bojardi**(Italy)
**Yang Dongjiang**(China)

## 单元主题阐释

"仁：设计的善意"是一种设计乒乓，其中，创意的联结是指，由不同的地域和不同生产条件的交叠所产生的故事总和。在对生产能力和项目质量的追求中，这种联结在东西方之间、不同文化之间已表现得越来越普遍。

"创意联结"旨在通过对国际顶尖设计产品的广泛选择和比较，突出强调设计师与代表高新技术的制造业的关联，以及他们与手工艺传统的关联。

展览所选择的展品既是国际化又是地域性的，也即是glocal（全球本地化）的，既体现了特定国家或地区的设计特色，同时又定位于全球市场。

当今时代的设计，呈现出复杂多元的局面。其中，传统和语言、工业制造和手工艺全都混杂在一起：在此图景中，历史中形成的作品或者成为可资借鉴的经典，或者成为影响当代设计研究的记忆。

本展览的主题，以一种复杂的展陈形式呈现在观众面前，参观流线突出了设计方案与成品之间的关系，20个由标准产品和限量版产品所组成的令人震撼的装置，突出了手工艺和工业技术之间的关联；这一参观流线考虑到设计与沟通之间的关系，力图促成国际设计中不同创意来源之间的真实相遇。

本展览由五个部分组成：
1. 创意 < > 技艺
2. 设计师 < > 协作
3. 传统 < > 科技
4. 代际 < > 感性
5. 东方 < > 西方

## Interpretation of the Sub-theme

Ren: Good Design is a kind of design Ping-Pong, a Creative Junction in which the face-off between different geographical and productive realities generates a story composed of many stories, in pursuit of productive capacity and project quality that become more and more widespread, in the synergy between Occident and Orient, between different cultures and civilizations.

Creative Junctions aims to highlight the value of the work of a selected group of international designers that through testing, comparison and transformation underscores the importance of their relationship with the manufacturer, who activate moments of technological innovation and application of industrial know-how, together with the skills of craftsmanship passed down over time.

The idea of the exhibition is to propose a selection of objects and products as global + local = glocal artifacts that represent the specific characteristics of the design of a country or a place, while addressing a global market.

Design in the contemporary world becomes a complex, multilinear scenario in which traditions and languages, industrial production processes and crafts skills all blend: a landscape of forms and figures that are passed down in history as established models of reference, or as memories that guide contemporary research in design.

The themes of the exhibition, the complex scenario it will present to visitors will take the form of an itinerary that emphasizes the relationship between project and realization also through 20 striking installations made with standard products or precious limited editions, shedding light on manual skills and technological know-how; a path that observes the relationship between design and its communication: a true encounter among different resources of creativity in international design.

The exhibition is organized in 5 sections:
1. CREATIVITY < > KNOW-HOW
2. DESIGNER < > COORDINATION
3. TRADITION < > TECHNOLOGY
4. GENERATIONS < > SENSIBILITY
5. ORIENT < > OCCIDENT

# 吉达·博亚迪

意大利《INTERNI》、《GCASA》杂志主编,
米兰设计周主策划人

吉达·博亚迪,生于意大利皮亚琴察,在米兰居住和工作。自1994年开始担任《INTERNI》杂志的主编,这是一本关于室内和当代设计的月刊,同时负责该杂志的一系列子刊(Interni/Panorama, Interni Guides, Interni International King Size)。她同时还负责一系列相关展览活动的创意和协调,以此增进设计师与企业之间的合作,探讨二者在其中扮演的角色,并搭建起专业人士与普通公众之间的沟通平台。她于2010年开始兼任《GCasa》杂志(月刊)的主编。

鉴于她在设计文化的国际推广方面所做的卓越贡献,法国文化部于2006年授予她法国艺术及文学军官勋章,米兰市政府于2007年授予她Ambrogino金质奖章,以表彰她于1990年创办并推动米兰沙龙外围展(FuoriSalone of Milan)——世界上第一个、同时也是最重要的设计周——的功勋。

# Gilda Bojardi

Editor of INTERNI / GCASA,
Chief Planner of the Milan Design Week

Gilda Bojardi, born in Piacenza (Italy), lives and works in Milan. Since 1994 she has been the Editor of INTERNI, a monthly magazine of interiors and contemporary design, and of its system of publications (Interni/Panorama, Interni Guides, Interni International King Size). Her activities with INTERNI also include the creation and coordination of events and exhibitions, organized to encourage contact between designers and manufacturers, in an exploration of their mutual roles, and an interface between these professionals and the general public. Since 2010 she is also the Editor of the monthly magazine GCasa.

For her efforts to promote international awareness of design culture, she has received many awards and honors, including: Officer des Arts et des Lettres, French Ministry of Culture (2006); the Ambrogino d'Oro, City of Milan (2007) for the invention and development of the FuoriSalone of Milan, the first and most important Design Week in the world, founded in 1990.

# 杨冬江

中国室内装饰协会设计委员会秘书长，中国陈设艺术委员会副主任，清华大学美术学院环境艺术设计系副主任

杨冬江，1971年生于哈尔滨，1993年毕业于中央工艺美术学院环境艺术设计系，获学士学位；2006年毕业于中央美术学院建筑学院，获博士学位。现任清华大学美术学院环境艺术设计系副主任、副教授、硕士研究生导师，清华大学美术学院装饰材料应用与信息研究所所长；中国室内装饰协会设计委员会秘书长；中国陈设艺术委员会副主任。

曾参加第五届圣保罗国际建筑双年展（中国国家馆）、中国国际建筑双年展、艺术与科学国际作品展等重要的国际性展览。先后担任第七届和第八届中国国际室内设计双年展总策展人以及2009国际金属艺术展策展人。作为总策划、总导演与中央电视台合作，拍摄完成大型系列片《为中国而设计——境外建筑师与中国当代建筑》（共18集），该片于2008年奥运会期间在中央电视台播出后，引发了全社会对中国当代建筑设计的广泛关注；2010年，与中央电视台合作完成大型系列片《为世博而设计》（共10集），该片已成为记录上海世博会优秀建筑从创意到建造全过程的重要文献。

设计作品分别获得第九届全国美术作品展览金奖（合作）、首届全国室内设计大展金奖、第三届全国室内设计大展银奖、第五届中国室内设计双年展金奖和银奖、中国美术家协会/首届全国环境艺术设计大展银奖和优秀奖、第二届全国环境艺术设计优秀论文奖、第七届中国室内设计双年展铜奖、第八届中国室内设计双年展金奖，2008年分别被授予中国室内设计成就奖以及全国杰出中青年室内建筑师称号、2010年获得全国有成就的资深室内建筑师称号，入选中国教育部"新世纪优秀人才支持计划"。

# Yang Dongjiang

Secretary-general of the Committee on Design, China National Interior Decoration Association
Associate Director of the Art Display & Decoration Committee of China,
Vice Director of the Environmental Art Design Department, Academy of Arts & Design, Tsinghua University

Yang Dongjiang, born 1971 in Harbin, graduated from the Environmental Art Design department, the Central Academy of Arts and Crafts in 1993 with bachelor's degree; in 2006, he graduated from the School of Architecture, Central Academy of Fine Arts with doctor's degree. He is associate professor, current vice dean of the Environmental Art Design Department, the Academy of Arts & Design, Tsinghua University; director of the Research Institute of Application and Information of Decorative Materials, Academy of Arts & Design, Tsinghua University; secretary-general of the Committee on Design, China National Interior Decoration Association; associate director of the Art Display & Decoration Committee of China.

He attended the Fifth International Architecture and Design Biannual Exhibition of Sao Paulo(China Pavilion), Architectural Biennial Beijing and The Art & Science International Exhibition. He was the chief curator of the Seventh and Eighth China International Interior Design Biennale. He served as the curator of the 2009 International Metal Art Exhibition. He worked as the chief curator and chief director of the maxi-series "Design for China—Foreign Architects and Contemporary Chinese Architecture"(18 episodes) in collaboration with CCTV(China Central Television). The maxi-series was broadcasted in CCTV during the 2008 Olympic Games, which attracted the whole society's attention to contemporary Chinese architecture design. In 2010, he cooperated with CCTV for the maxi-series "Design for China—Expo Building"(10 episodes), which has become an important document to record the building process from idea to manufacture process of the outstanding Expo building in Shanghai.

He is the winner of many prestigious awards, inclusive of the gold award of the Ninth National Art Exhibition(collaboration), gold award of the First National Interior Design Exhibition, silver award of the Third National Interior Design Exhibition, gold award and silver award of the fifth China Interior Design Biennial, silver award and outstanding award of the Chinese Artists Association/the First National Environmental Art and Design Exhibition, the Second National Environmental Art Design Excellent Papers Award, bronze award of the Seventh China Interior Design Biennial, gold award of the Eighth China Interior Design Biennial, 2008 China Interior Design Artistic Achievement Award. In 2008, he got the title "National Outstanding Young and Middle-aged Architect". And he was selected by the "New Century Excellent Talents in University" program from the Ministry of Education, P. R. China.

# 创意联结

吉达·博亚迪 / 杨冬江

作为首届北京国际设计三年展的主题,"仁:设计的善意"在中国的语言和文化中有着复杂的含义。"仁"事实上有各种不同的含义,如仁慈、以人道的方式相互对待、爱以及美德;"仁"字由"人"和"二"两个字组成,即突显了这样一层意思:人从来都不是单独存在的,而总是处在与他人的关系之中。因此,这一主题强调了人际关系以及思想交流对于设计的价值。

这一哲学同样贯彻在"创意联结"展览单元中,这一展览将在中国国家博物馆中央大厅中举办——中国国家博物馆位于北京市天安门广场东侧,最近采用德国GMP建筑事务所的方案修葺一新。为了与"仁"这一概念保持理论上的一致,本展览提供了不同的创意现实之间一系列具有实质意义的碰撞,通过东方与西方这两大文化、文明体之间的交融汇合,通过在国际范围内遴选设计师,选择他们设计的、已投入生产并以三维方式呈现的作品——这些作品就像是"设计的世界语",体现了对品质有着共同追求的不同思想("仁")和语言之间的沟通与交流——由此向观众讲述了一个由众多子故事组成的、不断追求更高生产和设计品质的故事。

本展览通过验证、比较和转化,力图显示来自不同文化背景的设计师的天才创造力,尤其强调"设计师—企业"这一关联对于促进技术革新、工业生产与历史悠久的手工技能相结合所具有的重要意义。

我们认识到,东西方之间的古老纽带,反映了文化交流的巨大潜力,体现了人、作品和产品之间持续不断的"反弹"效应。19世纪末以来流行于欧洲,后来又流行于中国的乒乓球运动,正是这一效应的最佳象征。

乒乓球那不间断的、快速的双向运动,以一种直接的方式,成为表述本展览意义的令人信服的隐喻,这一隐喻强调了两种不同设计文化之间的相遇和交流。

本展览所选择的展品既是国际化又是地域性的,也即是glocal(全球global + 地域local)的,既体现了特定国家或地区的设计特色,同时又定位于全球市场。

"创意联结"意味着"相遇"和"比较";这个创意的交叉系统,突出了每件设计作品的"示范价值"以及设计背后的思想。

当代国际设计,呈现出复杂多元的局面。其中,不同传统和不同语言、工业制造和手工艺全都混杂在一起。历史中流传下来的丰富多样的形式,或者成为可供学习的永恒经典(如同中国艺术史所做出的榜样),或者成为一种可供追溯的记忆。

假如我们能时常回顾过去,那么我们就能更好地理解现在和将来,对于设计史,这同时意味着回望大师。借助影像、物品以及经典陈设,现代设计的先驱也被及时呈现在本展览中。

我们选择了一部分具有代表性的设计师和建筑师,其人及其作品也同时出现在电影中:他们的生活、设计方法、工作思路、创意和研究将以片段的形式展现在观众面前。正是他们造就了今日国际设计界充满活力、多元并存的局面,而这正是本展览的着眼点所在。大量经典图像,包括珍稀电影胶片,记录了国际设计各个充满创造力的侧面。

来自24个国家150余位设计师的近700余件展品,连同本展览的主题,以一种复杂的展陈形式呈现在观众面前,参观流线突出了设计方案与成品之间的关系,20个由标准产品和限量版产品所组成的令人震撼的装置,突出了手工艺和工业技术之间的关联;这一参观流线考虑到设计与沟通之间的关系,力图促成国际设计中不同创意来源之间的真实相遇。

# Creative Junctions

Gilda Bojardi / Yang Dongjiang

"REN: Good Design" is the title of the 1st Beijing International Design Triennial, in the complex sense this term possesses in Chinese language and culture. "Ren", in fact, takes on many different meanings (benevolence, mutual humanity, love and virtue); the character is composed of the root "man", in the left part, and the sign for "two" on the right, underscoring the idea that man is never alone, but always seen in relation to other human beings. Therefore the title points to the value of human relations and exchange of ideas, in this case on the theme of design.

This philosophy of reference is also seen in the exhibition "Creative Junctions", located in the large central space of the prestigious National Museum of China, in the east of Beijing Tiananmen Square, recently renovated with a project by the studio GMP – Von Gerkan, Marg and Partners Architects. In keeping with the theoretical accent on the concept of "REN", the show offers a series of effective encounters between different creative realities capable of outlining a story composed of many stories, in pursuit of an increasingly widespread productive and design quality, through the synergetic encounter of Occident and Orient, of two cultures and civilizations, offered by an international selection of designers who propose works, all now in production, capable of representation in three-dimensional form, like a sort of 'design Esperanto', reflecting the relationship and the exchange of ideas (REN) and languages that share the same desire for quality.

The Exhibition sets out to underline the wealth of talent of designers from different cultures and backgrounds, through processes of verification, comparison and transformation, with special focus on the importance of the designer-business relationship to bring out moments of technological innovation and industrial know-how along with crafts skills passed down over time.

Ancient ties between East and West are revealed, the expression of a great potential of culture and exchange; a sort of ongoing 'bounce' effect between people, works, products. The popular game of Ping Pong, widespread in China and Europe since the end of the 1800s, is a good representation of this in a symbolic form.

The continuing, rapid two-directional movement becomes a convincing metaphor to describe the meaning of the exhibition in an immediate way, with its focus on the encounter of two different design cultures.

The idea is to propose a selection of objects and products as glocal articles (global + local), to represent the capacity of an object to conserve the specific characteristics of the design of a country or a place, while also being able to approach the global market.

Creative Junctions means 'encounter, comparison'; a system of creative crossings which underline the 'guiding value' of every design piece as the idea that lies behind the project.

International design in the contemporary world, then, is a complex, multilinear scenario in which traditions and languages, industrial production processes and crafts skills mingle and mix. A panorama of forms and figures passed down by history as immutable models of reference, as we are taught by the history of Chinese art, or as memories to which to make reference.

Our present and our near future seem to be more comprehensible if we look at the past. For design history this also means looking at the great masters, the pioneers of modern design, included in the exhibition thanks to films, objects, iconic furnishings that are still very timely today.

The work and the personality of designers/architects is also presented in films: a slice of life, of design approach and working knowledge, creativity and research of selected protagonists who form the present lively and versatile international design scene to which the exhibition refers. Rich iconographic material, including exceptional footage that documents international design in all its various creative phases.

The themes of the exhibition, the complex scenario it will present to visitors (around 700 exhibits, more than 150 designers of 24 nationalities), will take the form of an itinerary that emphasizes the relationship between project and realization also through 20 striking installations made with standard products or precious limited editions, shedding light on manual skills and technological know-how; a path that observes the relationship between design and its communication: a true encounter among different resources of creativity in international design.

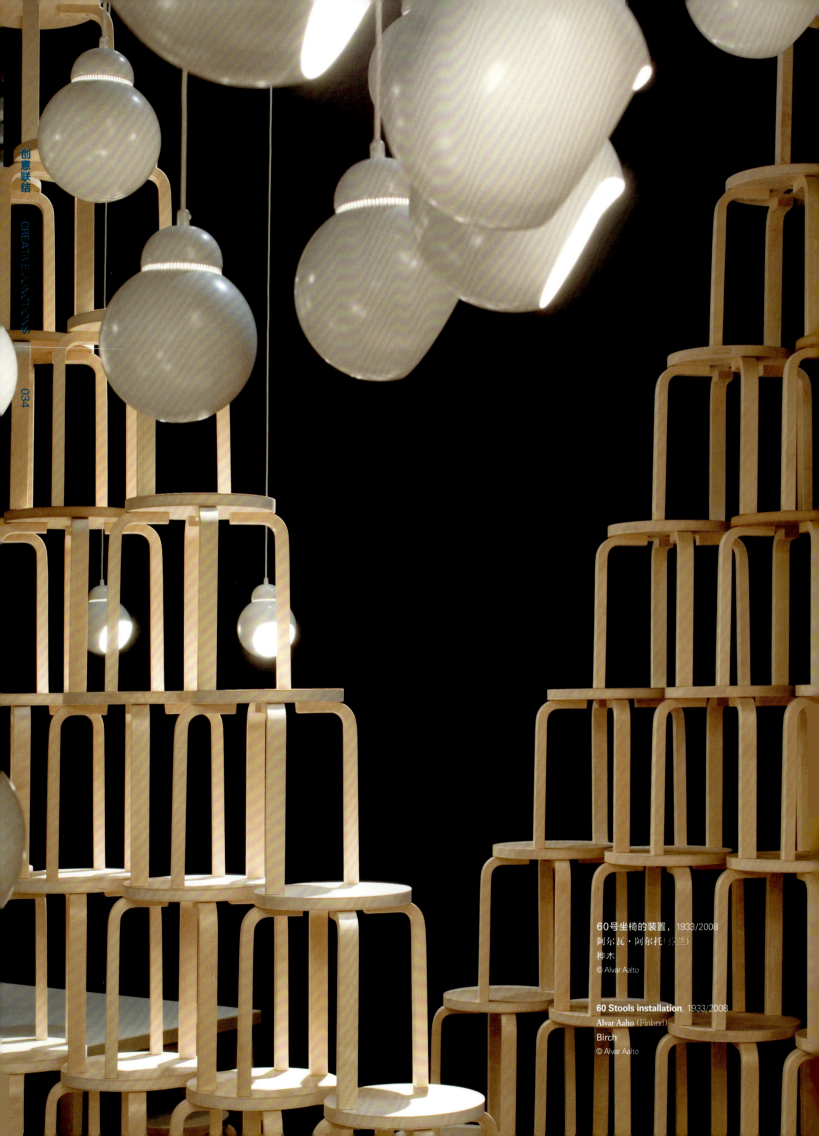

60号坐椅的装置，1933/2008
阿尔瓦·阿尔托（芬兰）
桦木
© Alvar Aalto

**60 Stools installation**, 1933/2008
Alvar Aalto (Finland)
Birch
© Alvar Aalto

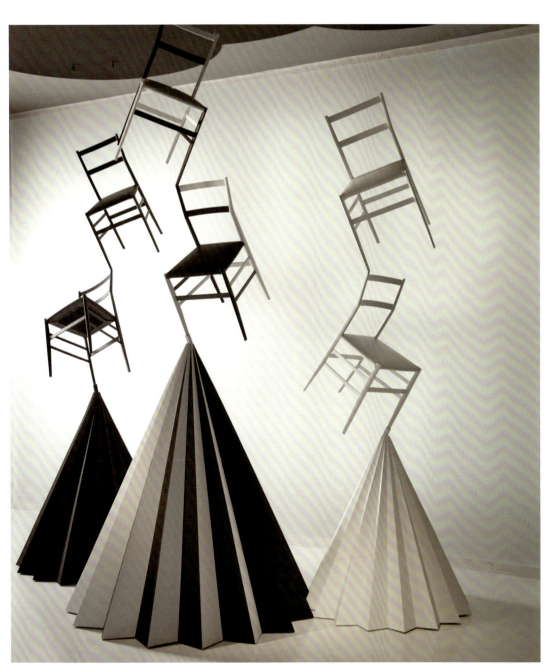

**699超轻椅**，1957，2010再版
吉奥·庞蒂（意大利）
型号1：白蜡木，印度竹藤
型号2：白蜡木，埠奈椅面
© Gio Ponti

**699 Superleggera**, 1957 re-edition 2010
Gio Ponti (Italy)
Version 1- Ash-wood, indian cane
Version 2-Ash-wood, pad
© Gio Ponti

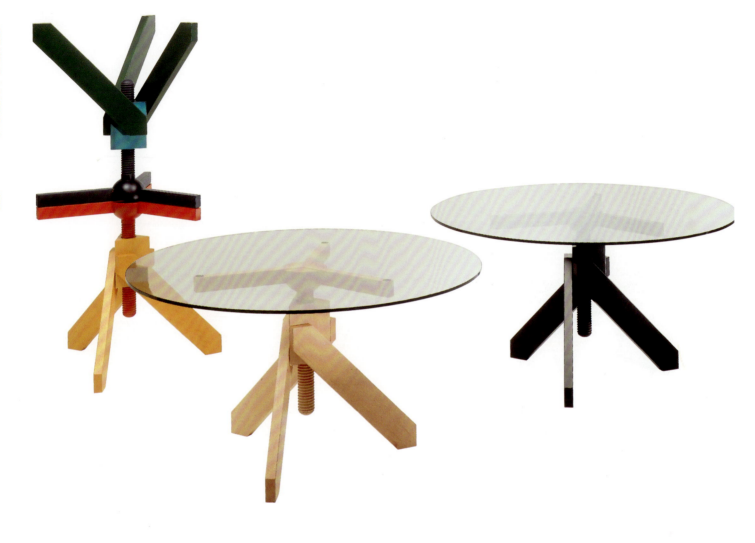

**螺丝钉茶几**，1987
维克·马吉斯特莱蒂(意大利)
12mm厚抛光平板玻璃
© Vico Magistretti

**Vidun**, 1987
**Vico Magistretti** (Italy)
Top in 12 mm thick tempered plate-glass, with polished edges. Three-legged base in beech
© Vico Magistretti

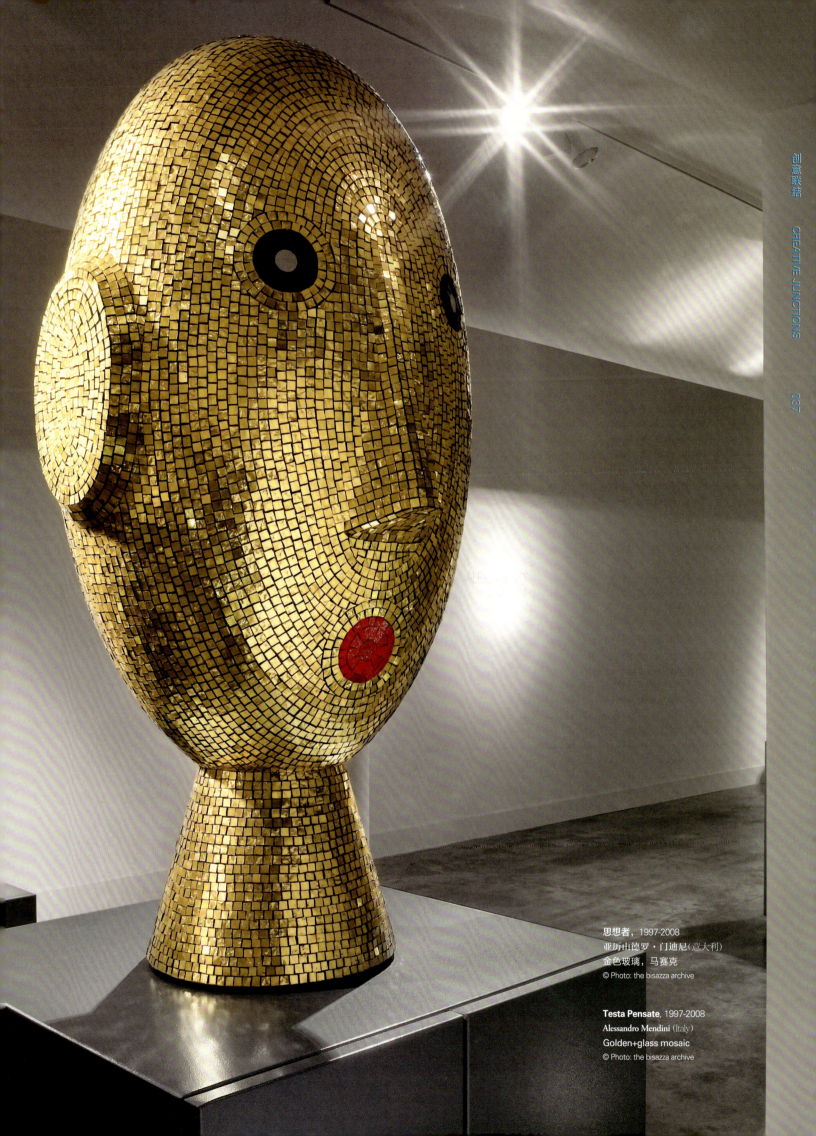

思想者，1997-2008
亚历山德罗·门迪尼（意大利）
金色玻璃，马赛克
© Photo: the bisazza archive

**Testa Pensate**, 1997-2008
Alessandro Mendini (Italy)
Golden+glass mosaic
© Photo: the bisazza archive

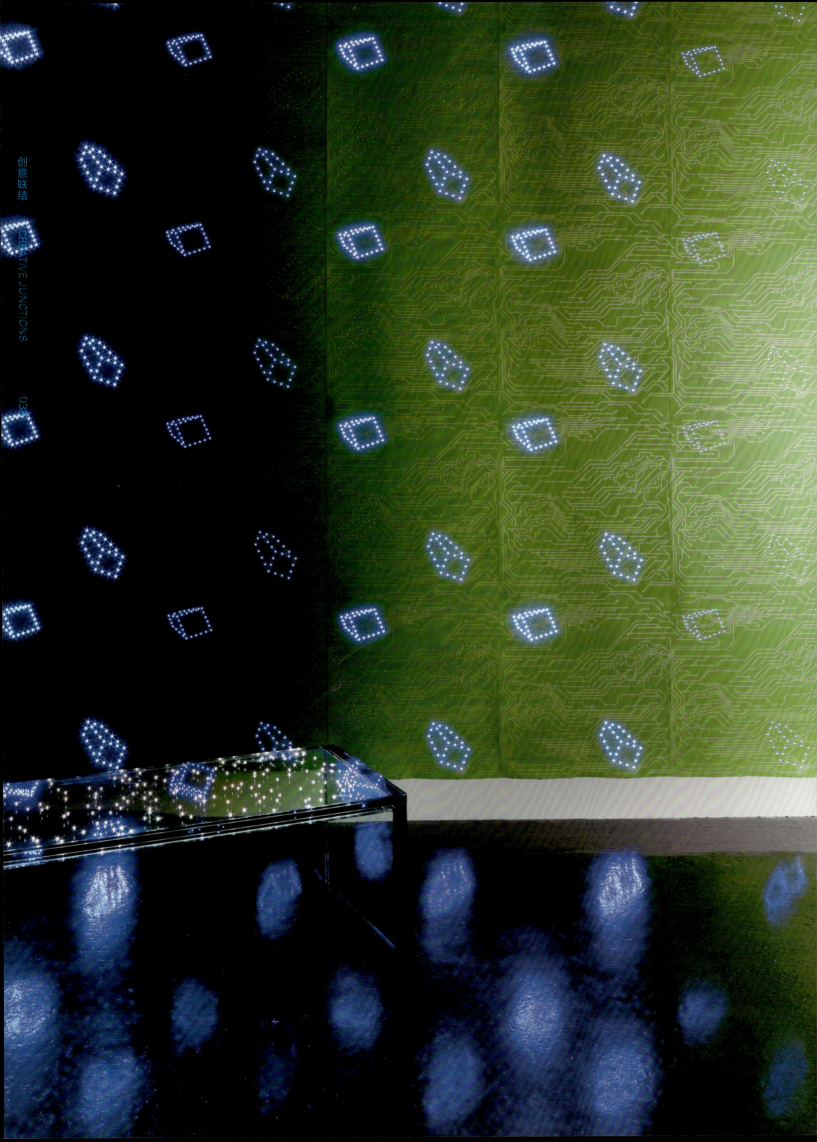

**LED长凳**，2003
因格·毛赫尔（德国）
玻璃，LED，电子设备
© Ingo Maurer

**LED Bench**, 2003
Ingo Maurer (Germany)
Glass, LEDs, electronics
© Ingo Maurer

**LED墙纸**，2011
因格·毛赫尔（德国）
LED，电子设备
© Ingo Maurer

**LED Wallpaper**, 2011
Ingo Maurer (Germany)
LEDs, electronics
© Ingo Maurer

一号坐椅（装置），2003
康斯坦丁·格里克（德国）
聚酯喷涂电镀铝
© Konstantin Grcic

**Chair_One (Installation)**, 2003
Konstantin Grcic (Germany)
Anodized aluminium, painted in polyester powder
© Konstantin Grcic

**ARC** 弧形环保桌，2010
福斯特建筑事务所（英国）
桌脚：水泥粘合剂与有机纤维合成的新材料；桌面：超轻磨砂钢化玻璃
© Molteni&C

**ARC**, 2010
Foster+Partners (UK)
Base: an innovative material composed by cement and organic fibre; tops: tempered glass, in extra light finish
© Molteni&C

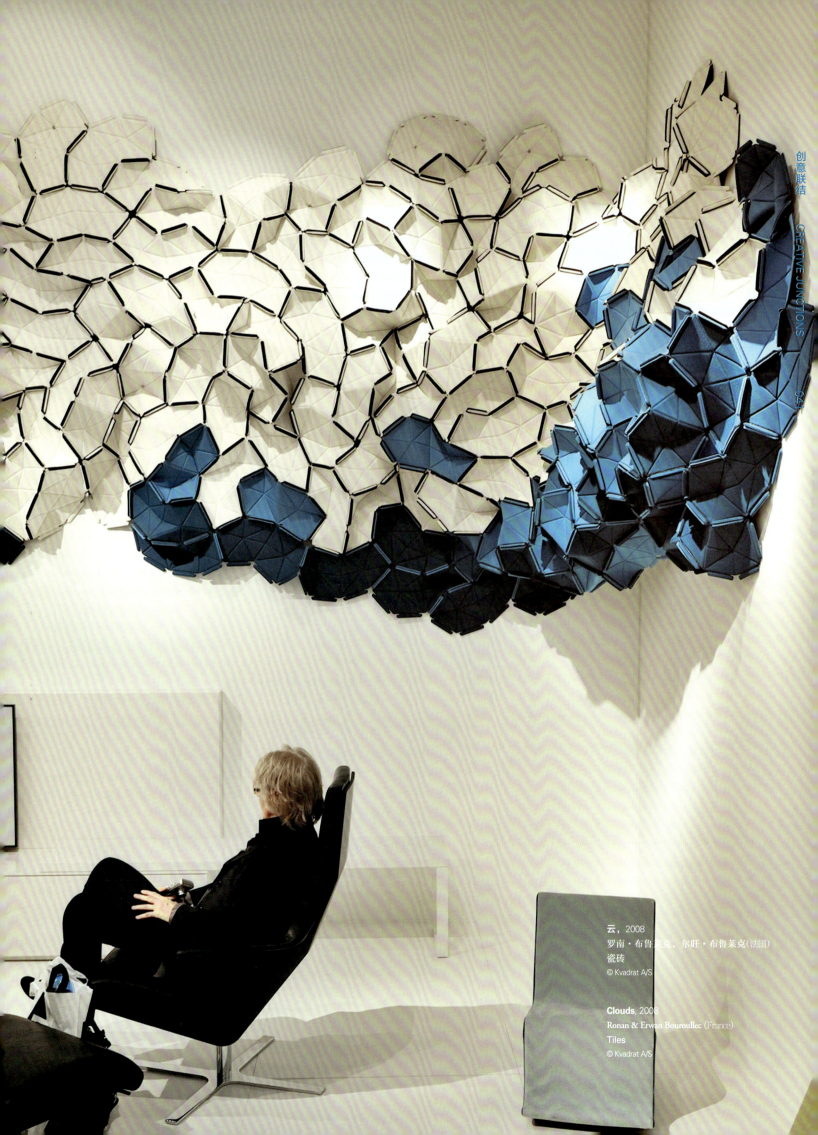

云，2008
罗南·布鲁克，尔旺·布鲁莱克(法国)
瓷砖
© Kvadrat A/S

**Clouds**, 2008
Ronan & Erwan Bouroullec (France)
Tiles
© Kvadrat A/S

**Do-Lo-Rez 地毯**，2007/2009
让·阿瑞得（英国/以色列）
100%新西兰羊毛
© Photo: Albert Font

**Do-Lo-Rez 沙发**，2007
让·阿瑞得（英国/以色列）
木，泡沫塑料
© Ron Arad

**Do-Lo-Rez Carpet**，2007/2009
Ron Arad (UK / Israel)
100% Wool (New Zealand)
© Photo: Albert Font

**Do-Lo-Rez Sofa**，2007
Ron Arad (UK / Israel)
Wood, foam modules
© Ron Arad

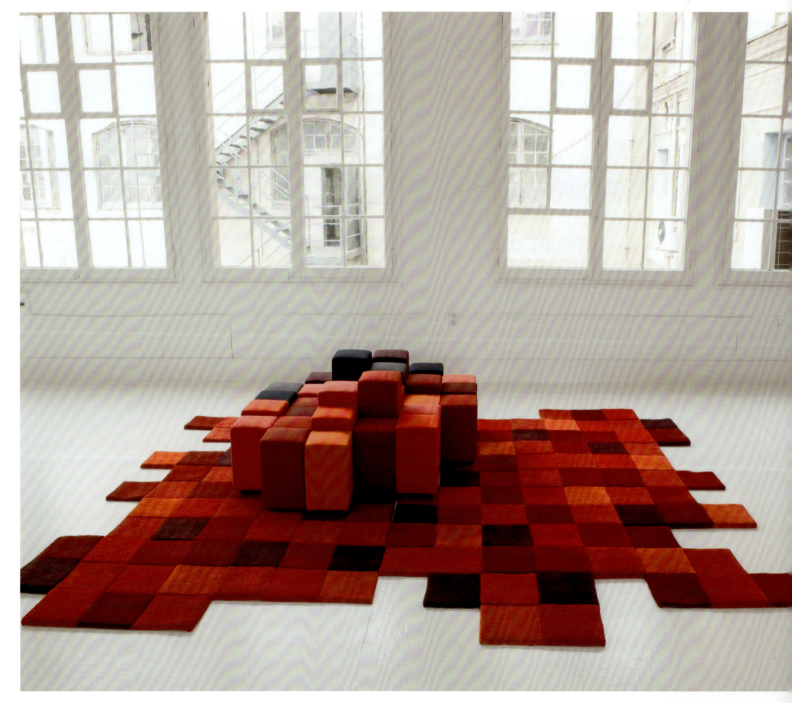

"路易斯魂灵"扶手椅，2002
菲利浦·斯塔克(法国)
聚碳酸酯
© KARTELL

**Louis Ghost**, 2002
**Philippe Starck** (France)
Polycarbonate
© KARTELL

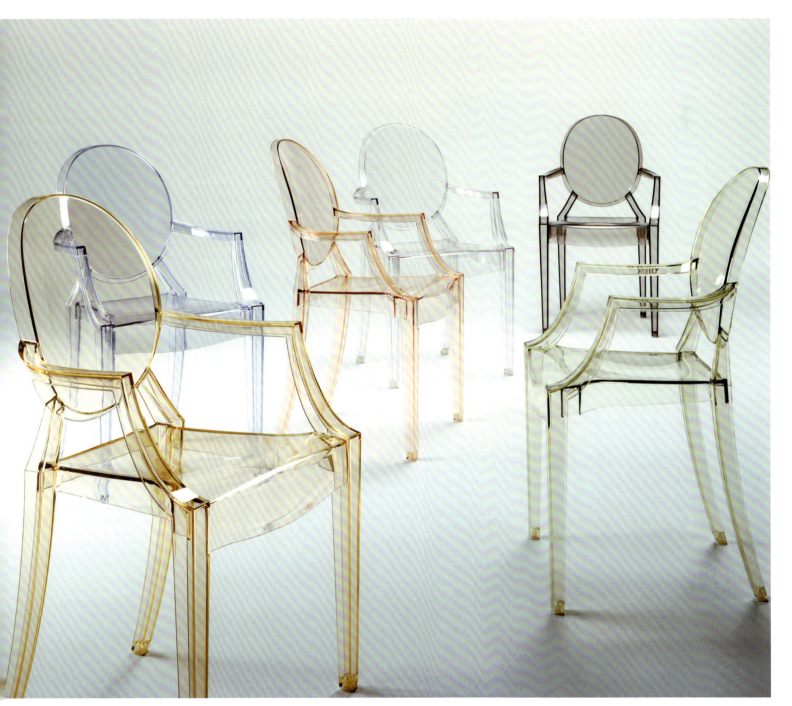

雪花椅，2007
奥多尔多·费奥拉万提(意大利)
聚丙烯
© Odoardo Fioravanti

**Snow**, 2007
**Odoardo Fioravanti** (Italy)
**Polypropylene**
© Odoardo Fioravanti

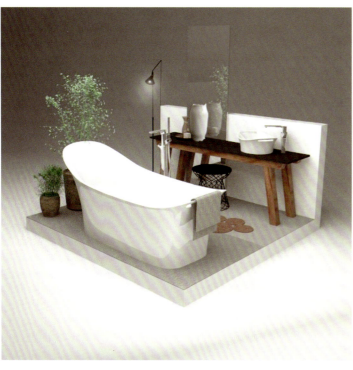

浴室氛围，2008
帕特里夏·乌古拉（西班牙）
多种材料
© Patricia Urquiola

**Bathroom Ambience**, 2008
Patricia Urquiola (Spain)
Various materials
© Patricia Urquiola

水之梦，2005
帕特里夏·乌古拉（西班牙）
多种材料
© Patricia Urquiola

**Waterdream**, 2005
Patricia Urquiola (Spain)
Various materials
© Patricia Urquiola

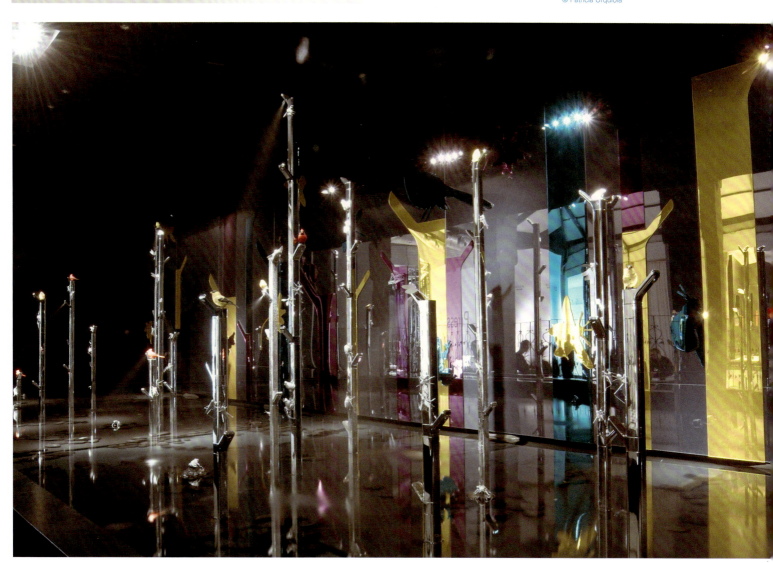

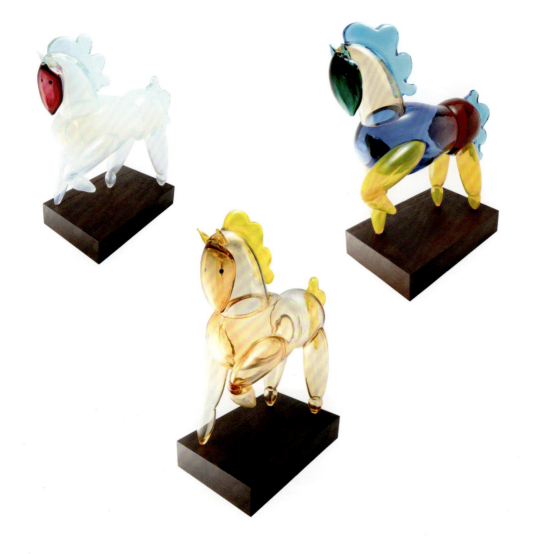

威尼尼之马，2008
亚历山德罗·门迪尼（意大利）
玻璃
© Alessandro Mendini

**Il Cavallo di Venini**, 2008
**Alessandro Mendini** (Italy)
Glass
© Alessandro Mendini

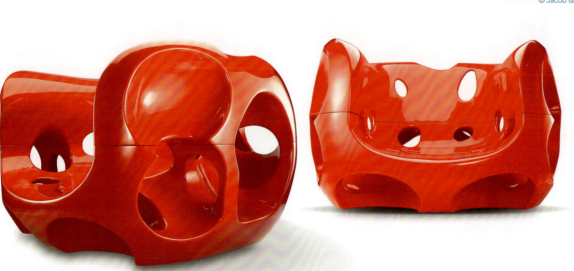

IT沙发，2004
贾柯柏+麦克法兰建筑事务所（法国）
抛光聚酯
© Jacob & MacFarlane

**IT**, 2004
**Jacob & MacFarlane** (France)
Polished polyester
© Jacob & MacFarlane

**Darwish**沙发，1999
威廉·萨瓦亚（黎巴嫩）
抛光铸铜
© William Sawaya

**Darwish**, 1999
William Sawaya (Lebanon)
Polished cast bronze
© William Sawaya

贝拉椅，2002
威廉·萨瓦亚（黎巴嫩）
半透明聚碳酸酯
© William Sawaya

**Bella Rifatta**, 2002
William Sawaya (Lebanon)
Translucid polycarbonate
© William Sawaya

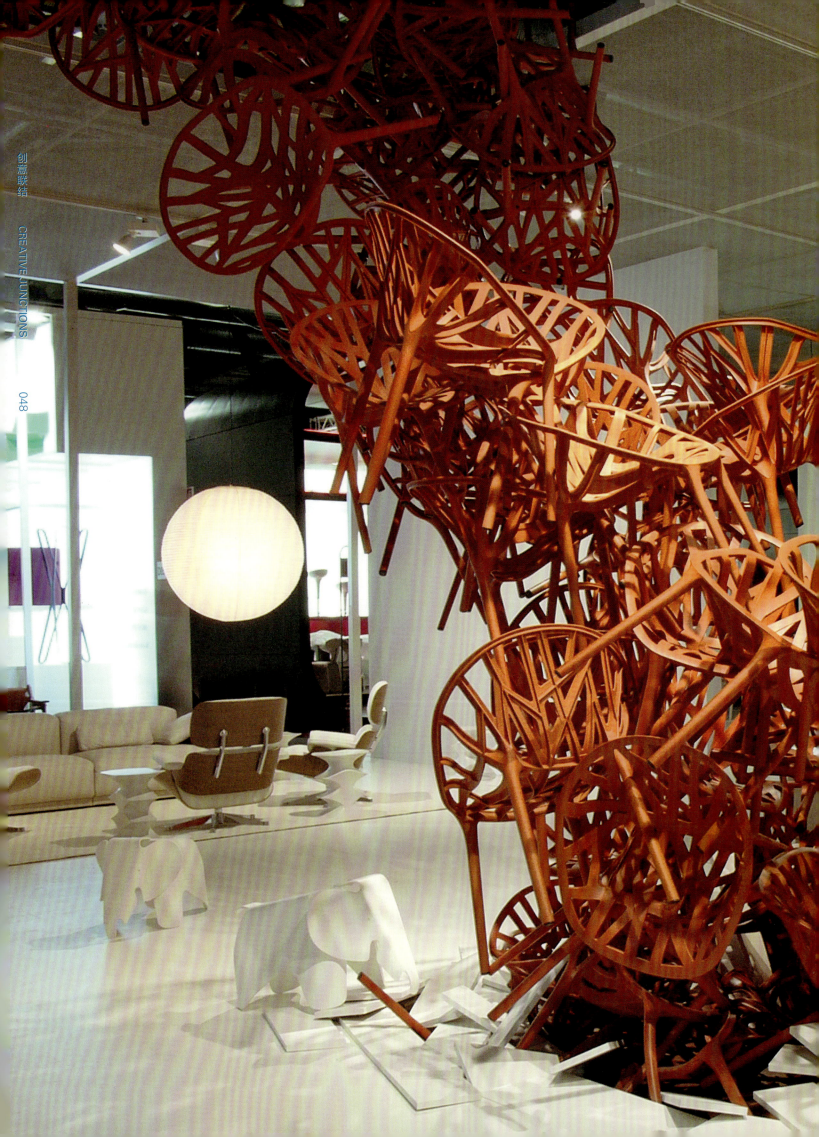

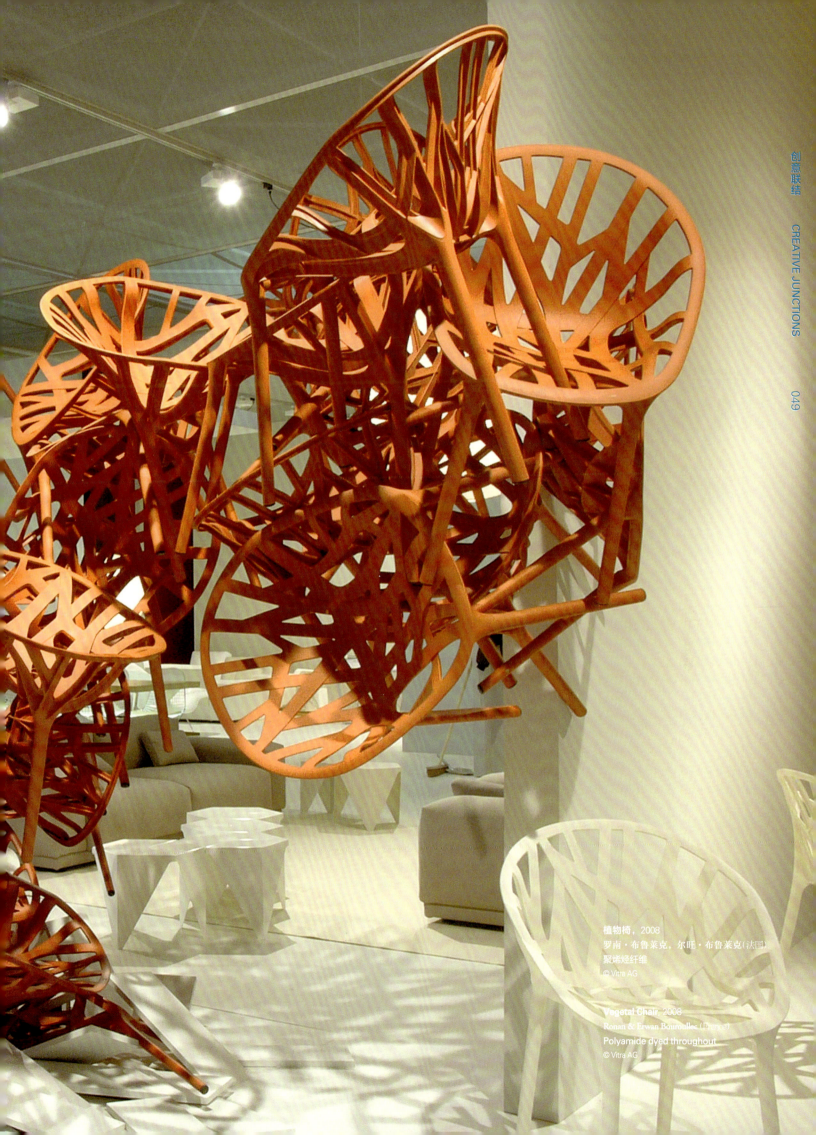

植物椅，2008
罗南·布鲁莱克，尔旺·布鲁莱克（法国）
聚酰胺纤维
© Vitra AG

Vegetal Chair, 2008
Ronan & Erwan Bouroullec (France)
Polyamide dyed throughout
© Vitra AG

MYTO椅，2008
康斯坦丁·格里克（德国）
巴斯夫塑料
© Konstantin Grcic

**MYTO**, 2008
**Konstantin Grcic** (Germany)
Plastic BASF
© Konstantin Grcic

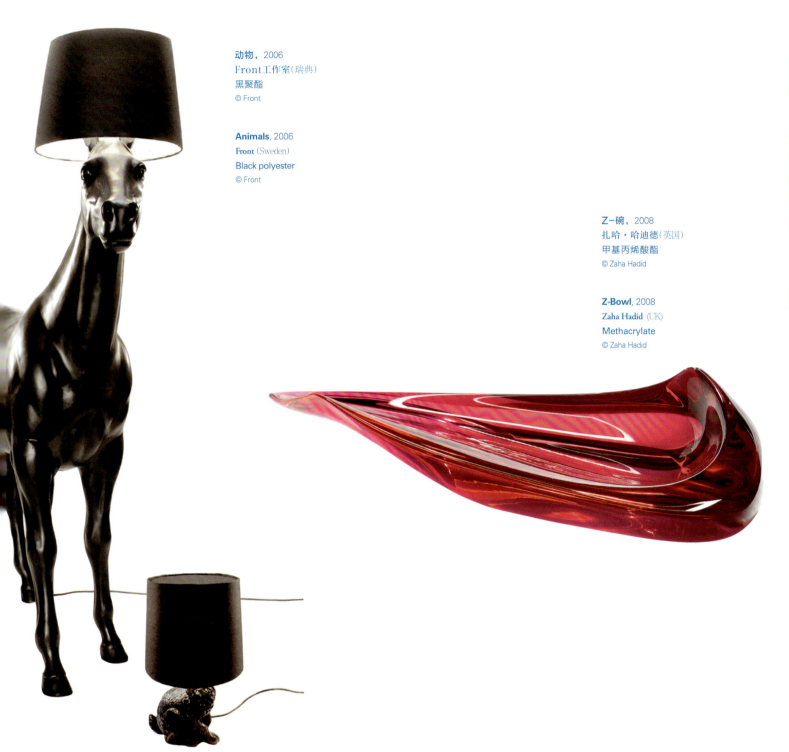

动物，2006
Front工作室（瑞典）
黑聚酯
© Front

**Animals**, 2006
Front (Sweden)
Black polyester
© Front

Z-碗，2008
扎哈·哈迪德（英国）
甲基丙烯酸酯
© Zaha Hadid

**Z-Bowl**, 2008
Zaha Hadid (UK)
Methacrylate
© Zaha Hadid

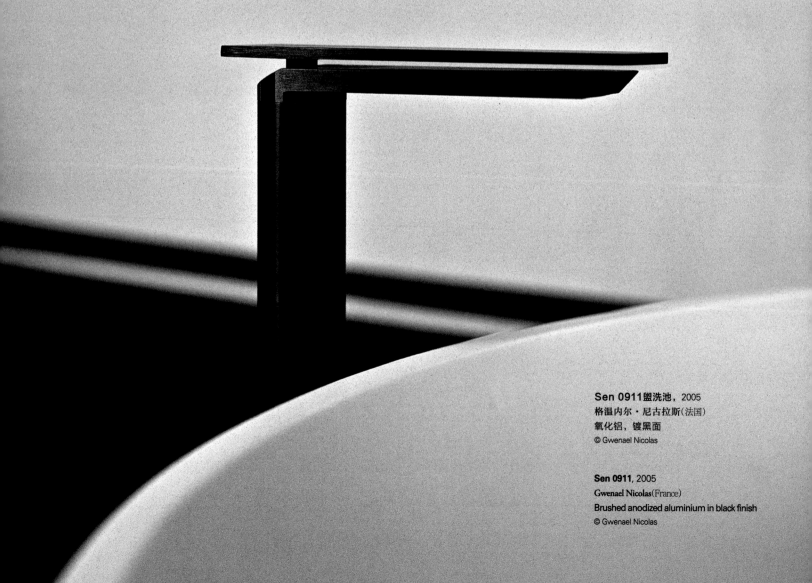

**Sen 0911盥洗池**,2005
格温内尔·尼古拉斯(法国)
氧化铝,镀黑面
© Gwenael Nicolas

**Sen 0911**, 2005
Gwenael Nicolas(France)
Brushed anodized aluminium in black finish
© Gwenael Nicolas

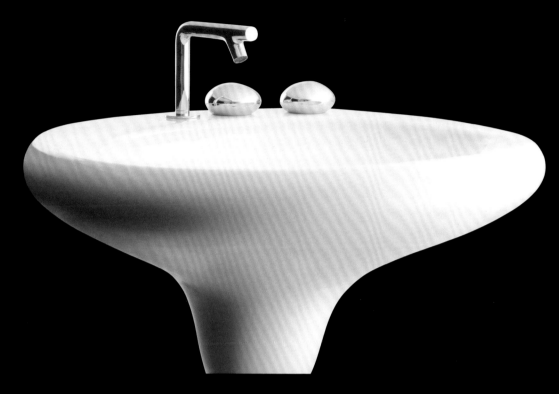

"伊斯坦布尔"盥洗池，2006
罗斯·拉古路夫(英国)
玻璃瓷
© Ross Lovegrove

Istanbul, 2006
Ross Lovegrove (UK)
Vitreous china
© Ross Lovegrove

"伊斯坦布尔"水龙头，2006
罗斯·拉古路夫(英国)
玻璃瓷
© Ross Lovegrove

Istanbul, 2006
Ross Lovegrove (UK)
Vitreous china
© Ross Lovegrove

"伊斯坦布尔"水龙头，2006
罗斯·拉古路夫(英国)
镀铬黄铜
© Ross Lovegrove

Istanbul, 2006
Ross Lovegrove (UK)
Brassware with chrome coating
© Ross Lovegrove

AF/21水龙头，2010
深泽直人(日本)
高氧化氮镀层，铬化黄铜
© ABOUTWATER

AF/21, 2010
Naoto Fukasawa (Japan)
HI-NOX finish, chrome polished brass
© ABOUTWATER

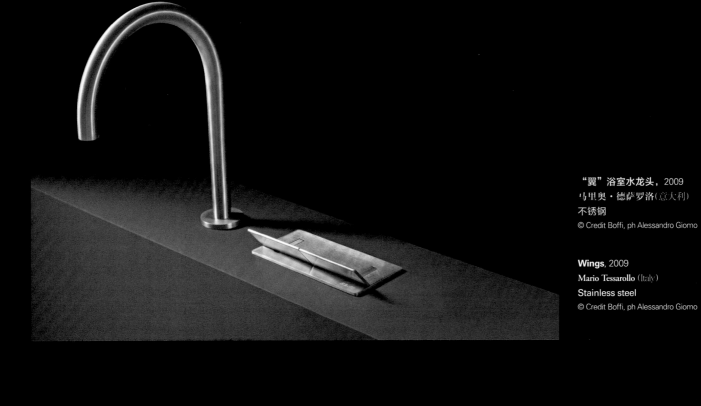

"翼"浴室水龙头,2009
马里奥·德萨罗洛(意大利)
不锈钢
© Credit Boffi, ph Alessandro Giomo

**Wings**, 2009
Mario Tessarollo (Italy)
**Stainless steel**
© Credit Boffi, ph Alessandro Giomo

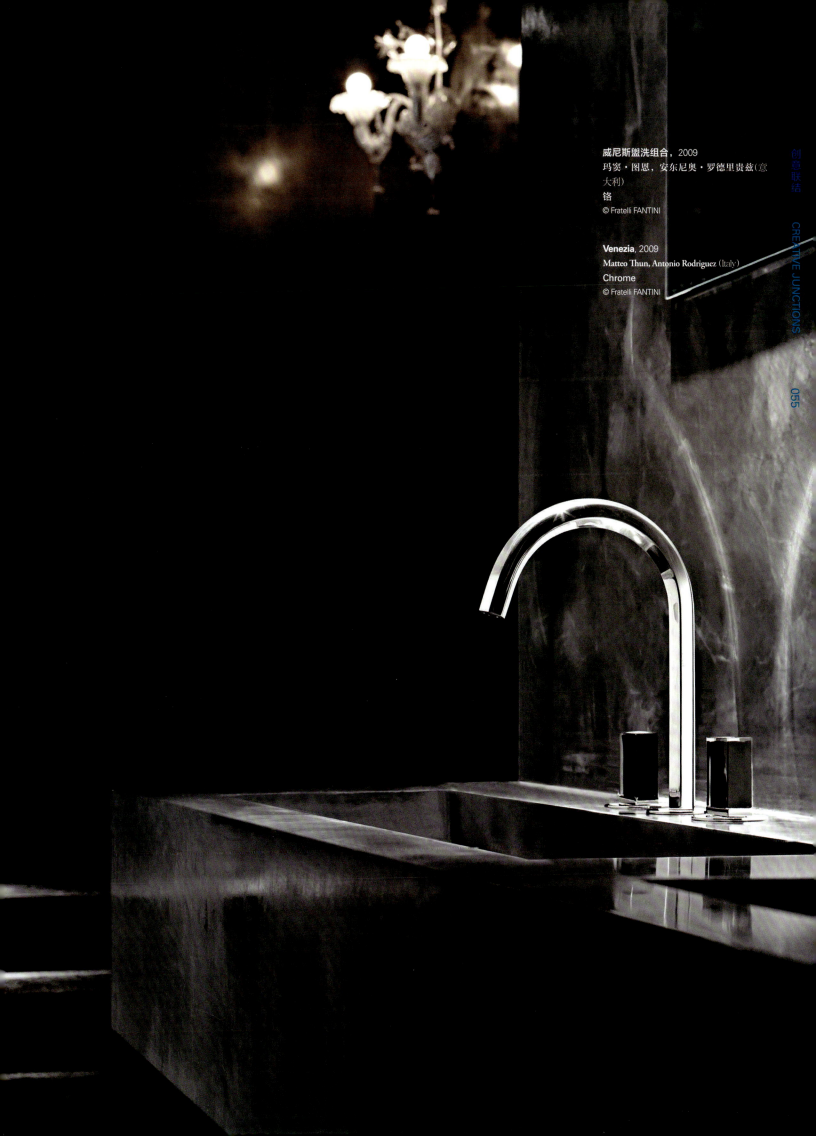

威尼斯盥洗组合，2009
玛窦·图恩，安东尼奥·罗德里贵兹（意大利）
铬
© Fratelli FANTINI

**Venezia**, 2009
Matteo Thun, Antonio Rodriguez (Italy)
Chrome
© Fratelli FANTINI

生活:"祝福"柜椅组,2010
尼帕·多施,乔纳森·莱维(英国)
混凝土,玻璃,陶瓷
© Nipa Doshi&Jonathan Levien

**Living: Ananda**, 2010
Nipa Doshi, Jonathan Levien (UK)
Concrete, glass, ceramic
© Nipa Doshi&Jonathan Levien

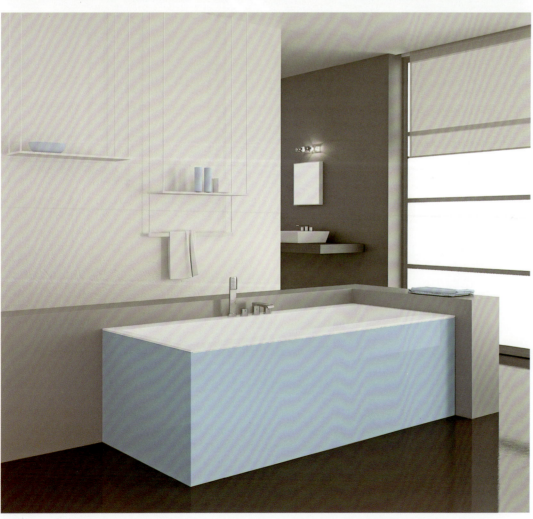

"纸"浴缸,2010
乔瓦娜·塔洛奇(意大利)
Duralight材料
© Giovanna Talocci

**Paper**, 2010
Giovanna Talocci (Italy)
Duralight
© Giovanna Talocci

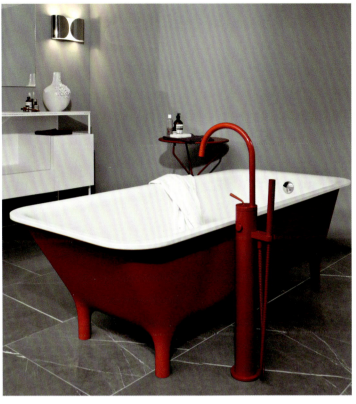

ISY洗浴组合，2001
玛窦·图恩，安东尼奥·罗德里格斯(意大利)
黄铜
© Matteo Thun & Antonio Rodriguez

**ISY**, 2001
Matteo Thun, Antonio Rodriguez (Italy)
Brass
© Matteo Thun & Antonio Rodriguez

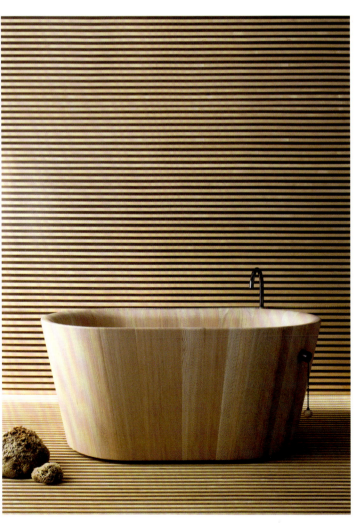

日式木桶浴缸，2009
玛窦·图恩，安东尼奥·罗德里格斯
(意大利)
落叶松木
© Thun Matteo & Antonio Rodriguez

**Ofurò**, 2009
Matteo Thun, Antonio Rodriguez (Italy)
Larch Wood
© Matteo Thun & Antonio Rodriguez

茶具，咖啡具，2003
让·努维尔(法国)
银，热塑树脂
© Photo: ph. Carlo Lavatori

**Tea & Coffee Towers**, 2003
Jean Nouvel (France)
Silver, temoplastic resin
© Photo: ph. Carlo Lavatori

茶具，咖啡具，2003
马西米拉诺·福克萨斯，多里安娜·奥·曼德莱利，奥莱里安·巴布里(意大利)
银，瓷
© Photo: ph. Carlo Lavatori

**Tea & Coffee Towers**, 2003
Massimiliano Fuksas, Doriana O. Mandrelli, Aurélien Barbry (Italy)
Silver, porcelain
© Photo: ph. Carlo Lavatori

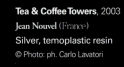
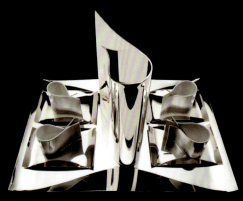

茶具，咖啡具，2003
大卫·奇普菲尔德(英国)
银，陶瓷，热塑树脂
© Photo: ph. Carlo Lavatori

**Tea & Coffee Towers**, 2003
David Chipperfield (UK)
Silver, ceramic, temoplastic resin
© Photo: ph. Carlo Lavatori

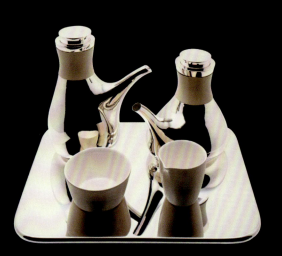

k2橱柜，2006
诺伯特·万根(德国)
不锈钢
© Photo: ph Duilio Bitetto

**k2**, 2006
Norbert Wangen (Germany)
Stainless steel
© Photo: ph Duilio Bitetto

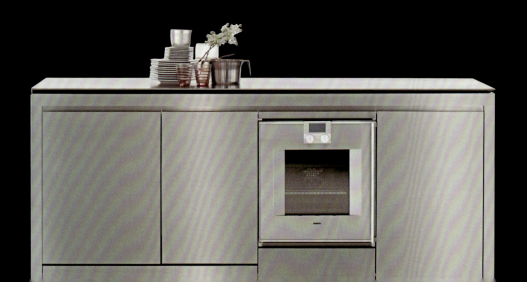

"士美菲"灯，2009
贾斯伯·莫里森（英国）
铝，聚碳酸酯
© Jasper Morrison

**Smithfield**, 2009
Jasper Morrison (UK)
Aluminum, polycarbonate
© Jasper Morrison

"特大汤勺"浴缸，2005
贝纳蒂尼公司（意大利）
Cristalplant©热塑性聚合物
© Benedini Associati

**Spoon XL**, 2005
Benedini Associati (Italy)
Cristalplant
© Benedini Associati

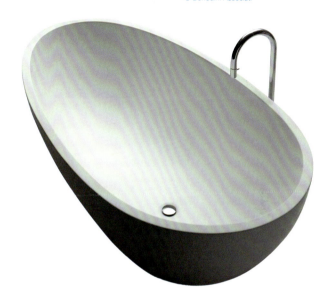

**Liquida厨房**，2010
斯蒂凡诺·乔凡诺尼，伊莉莎·葛甘（意大利）
木，硬质PET
© Stefano Giovannoni & Gargan Elisa

**Liquida**, 2010
Stefano Giovannoni, Gargan Elisa (Italy)
Wood, hard PET
© Stefano Giovannoni & Gargan Elisa

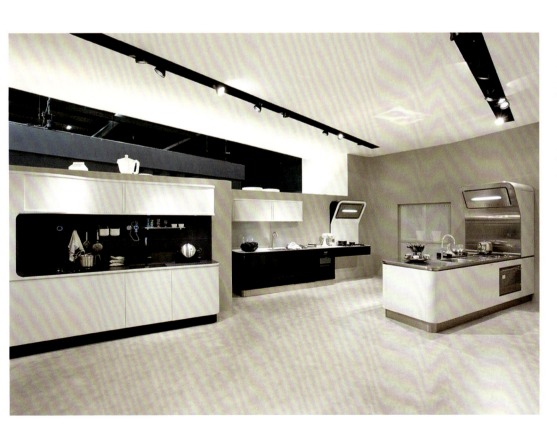

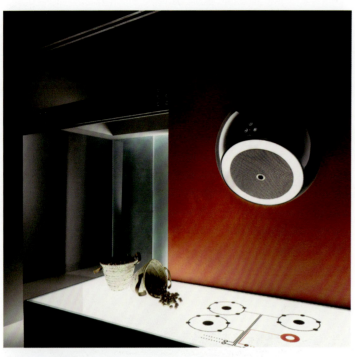

"气泡"抽油烟机，2010
斯蒂凡诺·乔凡诺尼（意大利）
尼龙
© Stefano Giovannoni

**Bubble**, 2010
Stefano Giovannoni (Italy)
Technopolymer (nylonht)
© Stefano Giovannoni

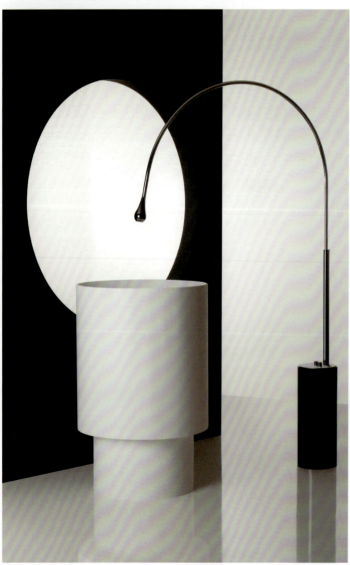

Goccia落地台盆，2010
普洛斯贝罗·拉苏洛（意大利）
镀铬黄铜，砂岩底座
© Gessi

**Goccia floor standing washbasin**, 2010
Prospero Rasulo (Italy)
Chromed brass with base in Gres
© Gessi

"裂缝"花瓶，2005/2010
扎哈·哈迪德（英国）
18/10不锈钢，PVD
© Alessi

**Crevasse**, 2005/2010
Zaha Hadid (UK)
18/10 stainless steel, PVD
© Alessi

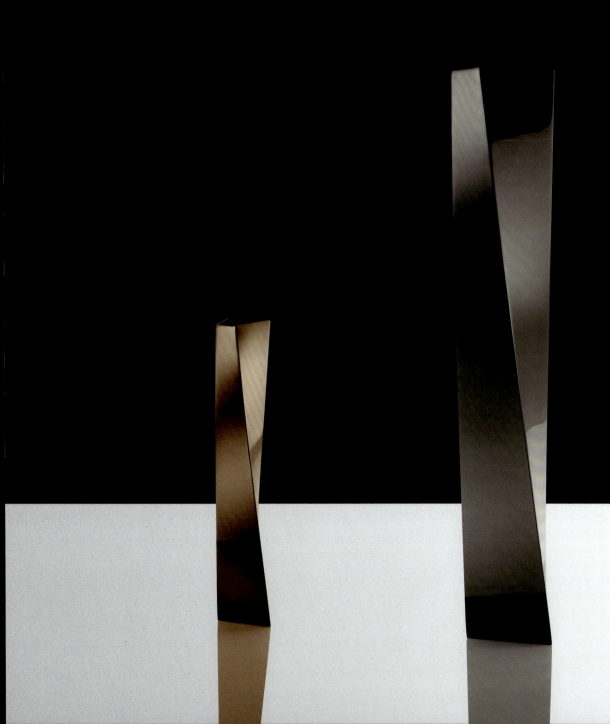

波浪饰面，2010
帕特里克·诺尔盖(法国)
粗陶薄板
© Patrick Norguet

**Slimtech Waves**, 2010
Patrick Norguet (France)
Laminated stoneware UGL
© Patrick Norguet

**D.R.Y瓷砖**，2011
文森特·凡·杜森(比利时)
粗陶瓷
© Vincent Van Duysen

**D.R.Y**, 2011
Vincent Van Duysen (Belgium)
Porcellain stoneware
© Vincent Van Duysen

春天，2009
托德·布谢尔(荷兰)
瓷砖
© Tord Boontje

**Primavera**, 2009
Tord Boontje (Netherlands)
Ceramic tiles
© Tord Boontje

弗纳塞蒂娜，2010
巴拿巴·弗纳塞蒂(意大利)
瓷砖
© Riediting Fornasetti Barnaba

**Fornasettiana**, 2010
Barnaba Fornasetti (Italy)
Ceramic Tiles
© Riediting Fornasetti Barnaba

建筑，2011
卡萨格兰德·帕达纳公司(意大利)
瓷，粗陶
© Casalgrande Padana

**Architecture**, 2011
Casalgrande Padana S.P.A. (Italy)
Porcelain, stoneware
© Casalgrande Padana

鸢尾花，2009
马塞尔·万德斯(荷兰)
瓷砖
© Marce Wanders

**Iris**, 2009
Marcel Wanders (Netherlands)
Ceramic tiles
© Marce Wanders

Slimtech Mauk Spina饰面，2009
迭戈·格兰迪(意大利)
粗陶薄板
© Diego Grandi

**Slimtech Mauk Spina**, 2009
Diego Grandi (Italy)
Laminated stoneware UGL
© Diego Grandi

科尔杜索城市地图3D仿铜瓷砖，2007
迭戈·格兰迪(意大利)
整块粗陶
© Diego Grandi

**City Cordusio Bronze 3D**, 2007
Diego Grandi (Italy)
Full-body stoneware UGL
© Diego Grandi

**Diamante R20 BOA**,2010
5+1AA工作室(意大利)
粗陶瓷
© 5+1 AA

**Diamante R20 BOA**, 2010
**5+1 AA** (Italy)
Porcelain stoneware
© 5+1 AA

**SOHO瓷砖**,2008
玛拉兹中心(意大利)
粗陶瓷
© Centro Stile Marazzi

**SOHO**, 2008
**Centro Stile Marazzi** (Italy)
Porcelain stoneware
© Centro Stile Marazzi

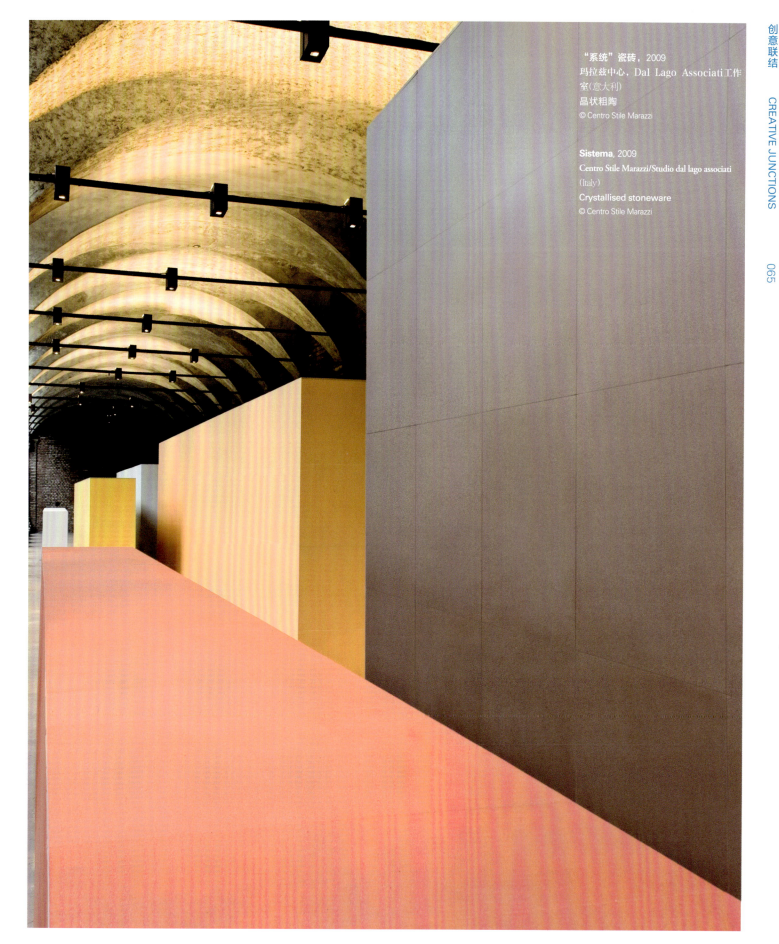

"系统"瓷砖,2009
玛拉兹中心,Dal Lago Associati工作室(意大利)
晶状粗陶
© Centro Stile Marazzi

**Sistema**, 2009
Centro Stile Marazzi/Studio dal lago associati (Italy)
Crystallised stoneware
© Centro Stile Marazzi

**Tam Tam**盥洗池，2010
斯特法诺·乔万诺尼（意大利）
陶瓷
© Laufen

**Tam Tam**, 2010
Stefano Giovannoni (Italy)
Ceramic
© Laufen

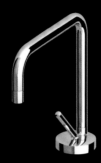
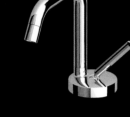

**ISY水龙头，2001**
玛窦·图恩，安东尼奥·罗德里格斯(意大利)
黄铜
© Matteo Thun & Antonio Rodriguez

**ISY水龙头，2001**
玛窦·图恩，安东尼奥·罗德里格斯(意大利)
黄铜
© Matteo Thun & Antonio Rodriguez

**ISY水龙头，2001**
玛窦·图恩，安东尼奥·罗德里格斯(意大利)
黄铜
© Matteo Thun & Antonio Rodriguez

**ISY水龙头，2001**
玛窦·图恩，安东尼奥·罗德里格斯(意大利)
黄铜
© Matteo Thun & Antonio Rodriguez

**ISY**, 2001
Matteo Thun, Antonio Rodriguez (Italy)
Brass
© Matteo Thun & Antonio Rodriguez

**ISY**, 2001
Matteo Thun, Antonio Rodriguez (Italy)
Brass
© Matteo Thun & Antonio Rodriguez

**ISY**, 2001
Matteo Thun, Antonio Rodriguez (Italy)
Brass
© Matteo Thun & Antonio Rodriguez

**ISY**, 2001
Matteo Thun, Antonio Rodriguez (Italy)
Brass
© Matteo Thun & Antonio Rodriguez

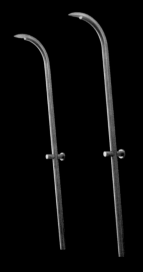
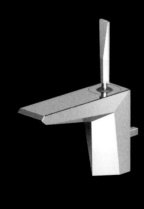
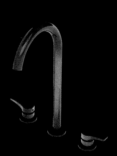
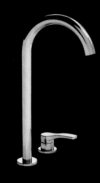

**"眼镜蛇"调温喷头，2001**
阿德里·哈斯布罗克(荷兰)
不锈钢
© Adri Hazebroek

**WOSH水龙头，2007**
威廉·萨瓦亚(黎巴嫩)
黄铜
© William Sawaya

**Flaap AF/23盥洗组合，2010**
皮耶罗·里梭尼(意大利)
镀黑面
© ABOUTWATER

**Flaap AL/23水龙头，2010**
皮耶罗·里梭尼(意大利)
铬化黄铜
© ABOUTWATER

**Cobra**, 2001
Adri Hazebroek (Netherlands)
Stainless Steel
© Adri Hazebroek

**WOSH**, 2007
William Sawaya (Lebanon)
Brass
© William Sawaya

**Flaap AL/23**, 2010
Piero Lissoni (Italy)
Black Finish
© ABOUTWATER

**Flaap AL/23**, 2010
Piero Lissoni (Italy)
Chrome polished brass
© ABOUTWATER

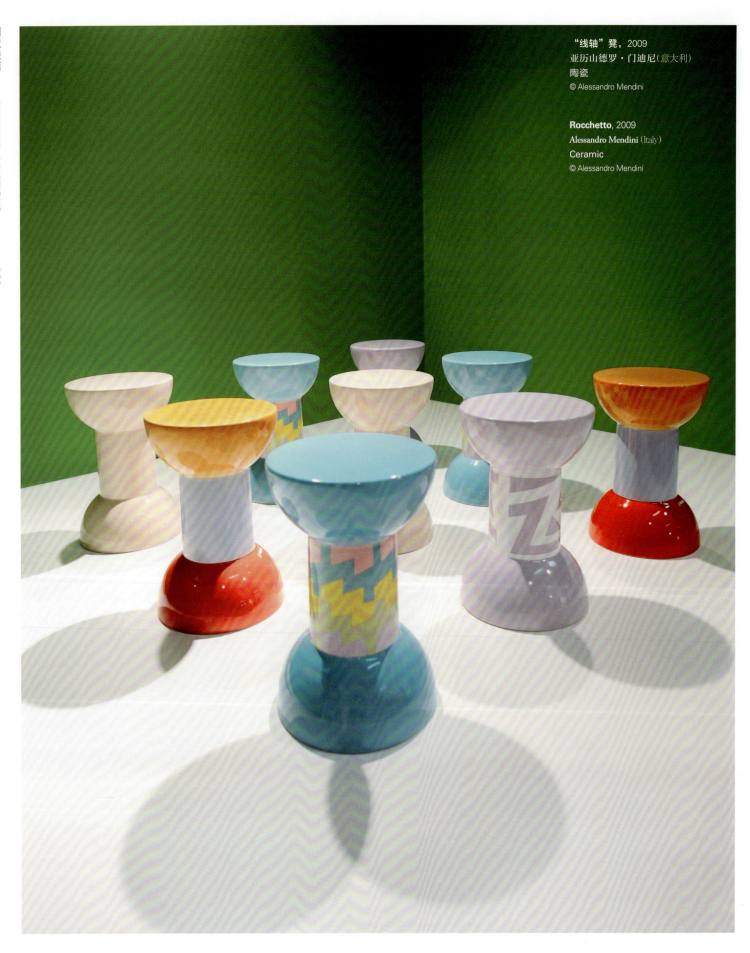

"线轴"凳，2009
亚历山德罗·门迪尼（意大利）
陶瓷
© Alessandro Mendini

**Rocchetto**, 2009
Alessandro Mendini (Italy)
Ceramic
© Alessandro Mendini

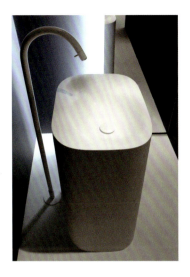

**Nivis**盟洗池，2011
安德莱·摩根特（意大利）
热塑性聚合物
© Andrea Morgante

**Nivis**, 2011
Andrea Morgante (Italy)
Cristalplant
© Andrea Morgante

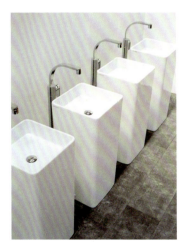

单人盟洗池，2004
朱利奥·卡佩里尼（意大利）
陶瓷
© CeramicaFlaminia S.P.A.

**Monowash**, 2004
Giulio Cappellini (Italy)
Ceramic
© CeramicaFlaminia S.P.A.

"单一"水龙头，2002
卢多维卡·帕洛姆巴，罗伯托·帕洛姆巴，塞尔吉奥·莫里（意大利）
镀铬黄铜
© Ludovica Palomba and Roberto with Sergio Mori

**One**, 2002
Ludovica & Roberto Palomba with Sergio Mori (Italy)
Chromed brass
© Ludovica Palomba and Roberto with Sergio Mori

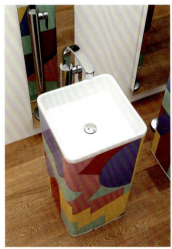

单人AZ盟洗池，2009
亚历山德罗·门迪尼（意大利）
陶瓷
© Alessandro Mendini

**Monowash AZ**, 2009
Alessandro Mendini (Italy)
Ceramic
© Alessandro Mendini

**FS3**淋浴龙头，2009
Vola设计研发工作室（丹麦）
铬
© Vola Research & Development Studio

**FS3**, 2009
Vola Research & Development Studio (Denmark)
Chrome
© Vola Research & Development Studio

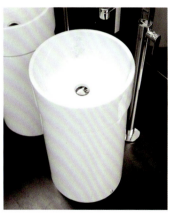

双子柱盟洗池，1996
卢多维卡·帕洛姆巴，罗伯托·帕洛姆巴，塞尔吉奥·莫里（意大利）
陶瓷
© Ludovica & Roberto Palomba with Sergio Mori

**Twin Column**, 1996
Ludovica & Roberto Palomba with Sergio Mori (Italy)
Ceramic
© Ludovica & Roberto Palomba with Sergio Mori

印花卡拉拉大理石，2011
马乌里齐奥·加兰特，塔尔·兰克曼(意大利/以色列)
无氟易变形聚氨酯，塑料，弹性面料
© Photo: ezio manciucca

**Tattoo carrara marble**, 2011
Maurizio Galante & Tal Lancman (Italy / Israel)
CFC-free flexible polyurethane, with internal anatomical rigid structure and plastic base. Original photographic image printed on the bi-elastic technical-fabric cover.
© Photo: ezio manciucca

印花仿古大理石，2011
马乌里齐奥·加兰特，塔尔·兰克曼(意大利/以色列)
无氟易变形聚氨酯，塑料，弹性面料
© Photo: Ezio Manciucca

**Tattoo grande antico marble**, 2011
Maurizio Galante & Tal Lancman (Italy / Israel)
CFC-free flexible polyurethane, with internal anatomical rigid structure and plastic base. Original photographic image printed on the bi-elastic technical-fabric cover
© Photo: Ezio Manciucca

印花波尔塔桑塔大理石，2011
马乌里齐奥·加兰特，塔尔·兰克曼(意大利/以色列)
无氟易变形聚氨酯，塑料，弹性面料
© Photo: ezio manciucca

**Tattoo portasanta marble**, 2011
Maurizio Galante & Tal Lancman (Italy / Israel)
CFC-free flexible polyurethane, with internal anatomical rigid structure and plastic base. Original photographic image printed on the bi-elastic technical-fabric cover
© Photo: ezio manciucca

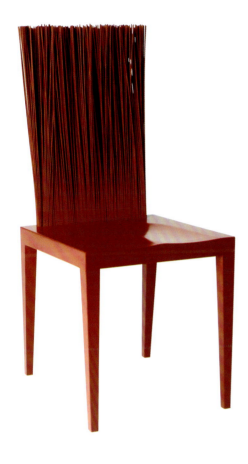

詹妮特椅，2005
费尔南多·坎帕纳，翁贝托·坎帕纳（巴西）
聚亚安酯，金属，PVC 材料
© Edra

**Jenette**, 2005
Fernando & Humberto Campana (Brazil)
Rigid structural polyurethane, metal, rigid PVC
© Edra

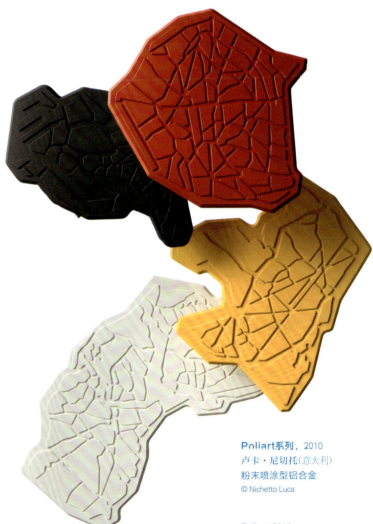

**Poliart系列**，2010
卢卡·尼切托（意大利）
粉末喷涂型铝合金
© Nichetto Luca

**Poliart**, 2010
Luca Nichetto (Italy)
Powder coated aluminium
© Nichetto Luca

"巴加蒂先生"椅，2006
弗朗索瓦·阿臧宝（法国）
薄金属板，聚氨基甲酸乙酯泡沫
© François Azambourg

**Mr Bugatti - chair**, 2006
François Azambourg (France)
Thin metal plate, polyurethanic foam
© François Azambourg

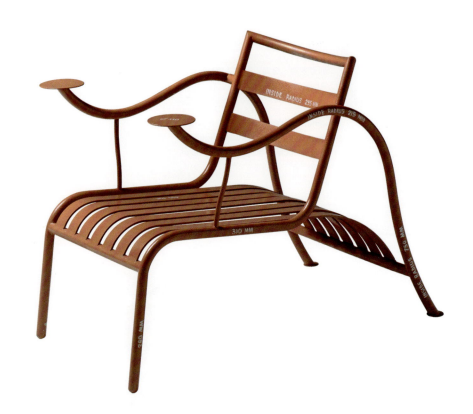

思想者安乐椅，1998
贾斯伯·莫里森（英国）
上漆金属
© Jasper Morrison

**Thinking Man's Chair**, 1998
Jasper Morrison (UK)
Varnished metal
© Jasper Morrison

Bong角桌，2004
朱利奥·卡佩里尼（意大利）
玻璃纤维
© Giulio Cappellini

**Bong**, 2004
Giulio Cappellini (Italy)
Fiberglass
© Giulio Cappellini

MT1扶手椅，2005
让·阿瑞得（英国/以色列）
聚乙烯
© Ron Arad

**MT1**, 2005
Ron Arad (UK / Israel)
Polyethylene
© Ron Arad

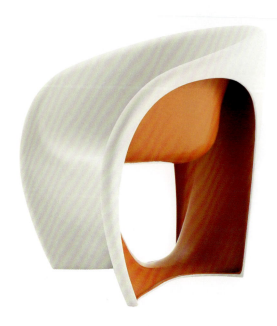

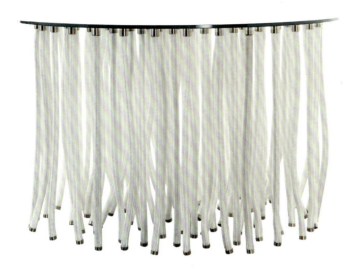

**Org低角桌**, 2001
法比奥·诺文布雷(意大利)
玻璃，钢，聚丙烯绳
© Fabio Novembre

**Org low**, 2001
Fabio Novembre (Italy)
Glass, steel, polypropylene rope
© Fabio Novembre

**孔雀椅**, 2009
德罗尔·本舍齐特(以色列)
金属，毛毡
© Dror Benshetrit

**Peacock**, 2009
Dror Benshetrit (Israel)
Metal, sheets of felt
© Dror Benshetrit

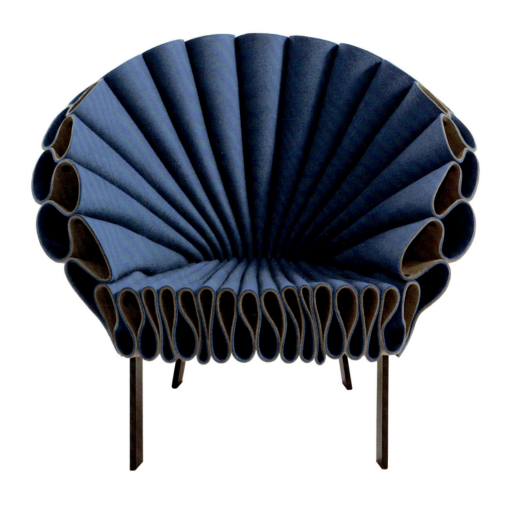

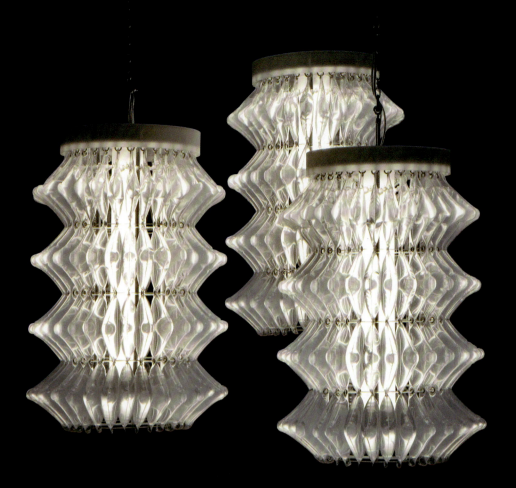

"达那厄"灯，2008
玛乌里齐奥·加兰特，塔尔·兰克曼（意大利）
PVC材料
© Photo: ph Duilio Bitetto

**Danae**, 2008
Maurizio Galante, Tal Lancman (Italy)
PVC
© Photo: ph Duilio Bitetto

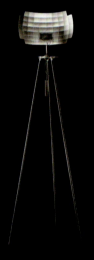

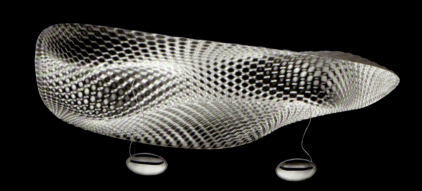

雷达落地灯，2011
囚格·毛赫尔（德国）
金属，铝，塑料，电子元件
© Ingo Maurer

**Radarrr**, 2011
**Ingo Maurer** (Germany)
Metal, aluminum, plastic, electronics
© Ingo Maurer

宇宙天使吊顶灯，2009
罗斯·拉古路夫（英国）
热塑性材料，压铸铝，乳色有机玻璃
© Artemide

**Cosmic Angel soffitto**, 2009
Ross Lovegrove (UK)
Thermoplastic material, die-cast aluminium, opal methacrylate
© Artemide

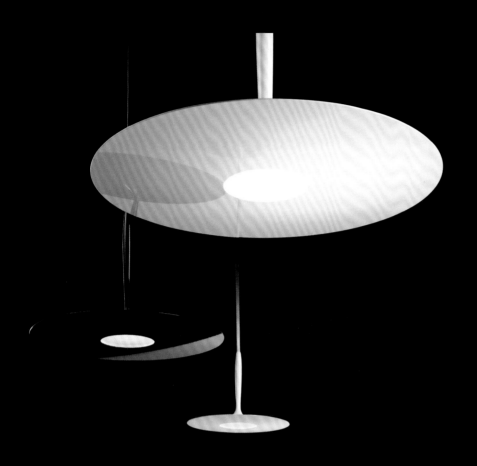

细颈瓶形灯，2011
Targetti公司研发部(意大利)
铝，聚甲基丙烯酸甲酯
© Targetti

**Decanter**, 2011
Targetti R&D Dept. (Italy)
Aluminium, PMMA
© Targetti

Genesy落地灯，2009
扎哈·哈迪德(英国)
注塑成型聚氨酯泡沫塑料
© Artemide

**Genesy**, 2009
Zaha Hadid (UK)
Injection-moulded foam polyurethane
© Artemide

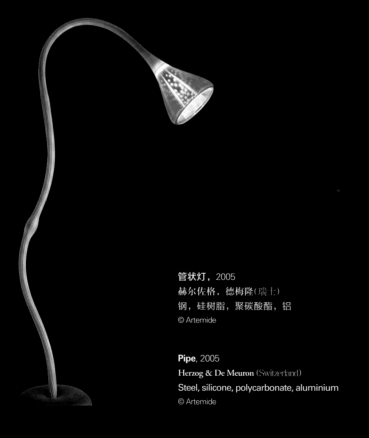

管状灯，2005
赫尔佐格，德梅隆(瑞士)
钢，硅树脂，聚碳酸酯，铝
© Artemide

**Pipe**, 2005
Herzog & De Meuron (Switzerland)
Steel, silicone, polycarbonate, aluminium
© Artemide

格子花呢长椅，2011
Raw Edges设计工作室／谢伊·阿克雷，雅艾尔·莫（以色列）
上漆木材
© Dilmos

**Plaid bench**, 2011
Raw Edges / Shay Alkalay and Yael Mer (Israel)
Painted wood
© Dilmos

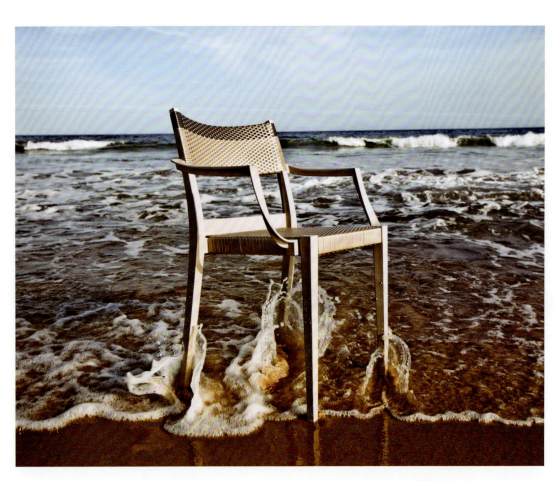

玩乐扶手椅，2010
菲利浦·斯塔克，欧仁妮·桂勒（法国）
合成纤维，聚丙烯纤维，玻璃框架
© Dedon

**PLAY Armchair**, 2010
Philippe Starck, Eugenie Quitllet (France)
Synthetic fiber, polypropylene fiber, glass frame
© Dedon

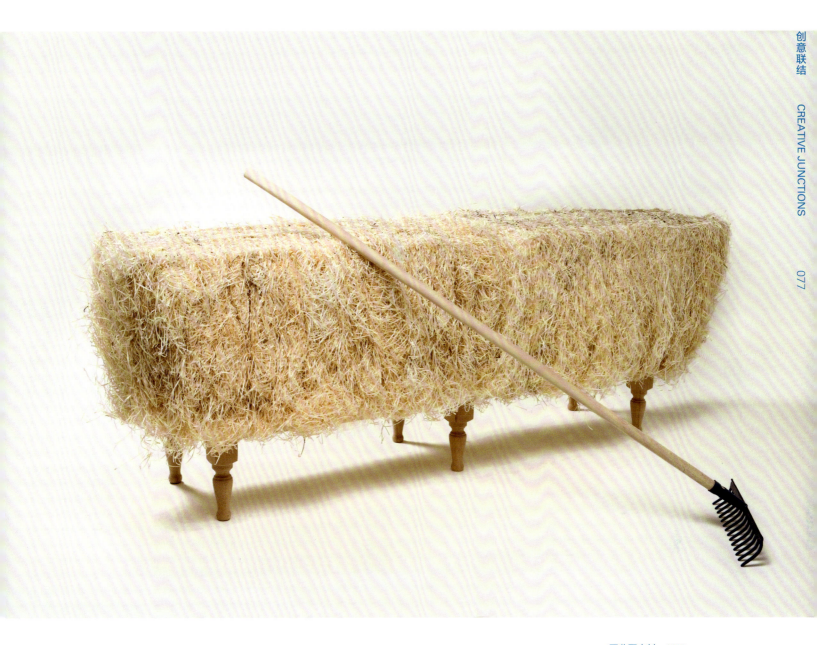

百分百木材，2008
山姆·巴让，法布里卡·本·卡贝利(法国)
木，干草
© Fabrica

**100% Wood**, 2008
Sam Baron & Fabrica Ben Cabelli (France)
Wood, dry hay
© Fabrica

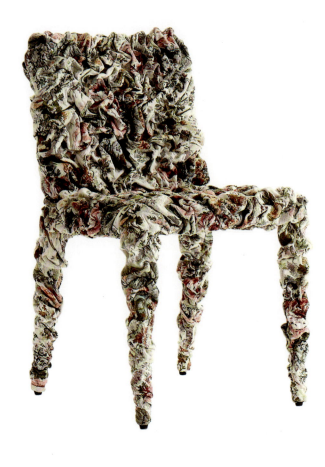

**Sharpei椅**,2008
马西米里奥诺·阿达米(意大利)
木,面料
© Massimiliano Adami

**Sharpei**, 2008
Massimiliano Adami (Italy)
Wood, fabric
© Massimiliano Adami

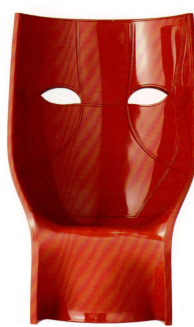

**尼姆椅**,2010
法比奥·诺文布雷(意大利)
聚乙烯
© Fabio Novembre

**NEMO**, 2010
Fabio Novembre (Italy)
Polyethylene
© Fabio Novembre

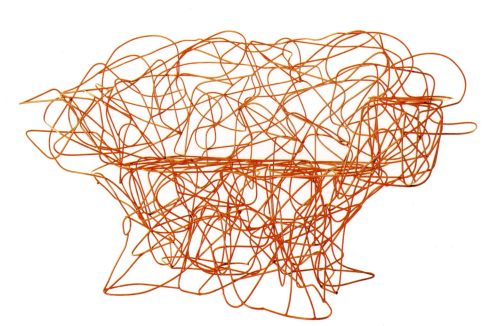

**科拉罗椅**,2004
费尔南多·坎帕纳,翁贝托·坎帕纳(巴西)
不锈钢丝
© Fernand Campana and Humberto

**Corallo**, 2004
Fernando & Humberto Campana (Brazil)
Stainless steel wire
© Fernand Campana and Humberto

碎片1号，2006
克劳迪奥·西尔伟斯特林(意大利)
粗陶瓷
© Claudio Silvestrin

**I FRAMMENTI**, 2006
Claudio Silvestrin (Italy)
Porcellain stoneware
© Claudio Silvestrin

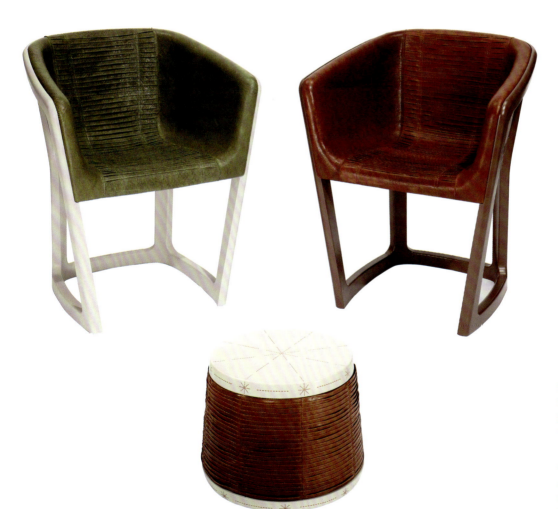

百年桌椅 – Trussardi我设计，1966
迈克尔·扬(英国)
塑料，皮革
© Michael Young

**100 Chair and Table - Trussardi MY Design**, 1966
Michael Young (UK)
Plastic, leather
© Michael Young

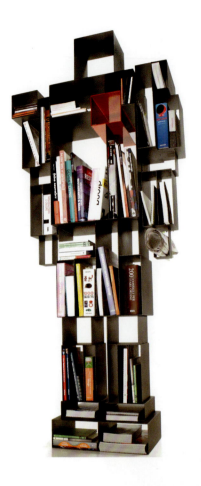

机器人书架，2011
法比奥·诺文布雷（意大利）
上漆金属
© Fabio Novembre

**Robox**, 2011
Fabio Novembre (Italy)
Painted Metal
© Fabio Novembre

眼钟，2008
麦隽永（中国香港）
ABS
© Mike mak design

**Eyeclock**, 2008
Mike Mak (Hong Kong, China)
ABS
© Mike mak design

"孔雀"户外椅，2011
帕特里夏·乌古拉（西班牙）
铝管，塑料编织
©Patricia Urquiola

**Pavo real outdoor**, 2011
Patricia Urquiola (Spain)
Tubular aluminium, braided plastic
©Patricia Urquiola

**Per Par Pum桌,** 2009
马克·萨德勒(法国/奥地利)
上漆金属
© Marc Sadler

**Per Par Pum**, 2009
Marc Sadler (France/Austria)
Metal lacquered
© Marc Sadler

"森林"书架, 2011
Nendo公司(日本)
砾岩，实木
© Nendo

**Forest,** 2011
Nendo(Japan)
Conglomerate and solid wood
© Nendo

一号坐椅, 2003
康斯坦丁·格里克(德国)
铝
© Konstantin Grcic

**Chair_One**, 2003
Konstantin Grcic (Germany)
Aluminium
© Konstantin Grcic

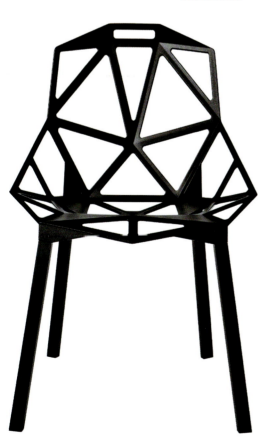

穿墙灯1X，2010
让·杰拉德(以色列)
铝，聚碳酸酯
© Ron Gilad

**WALL PIERCING 1X**, 2010
Ron Gilad (Israel)
Aluminum, Polycarbonate
© Ron Gilad

"卡巴娜"储物柜，2010
费尔南多·坎帕纳，翁贝托·坎帕纳(巴西)
金属，防火酒椰纤维
© Edra

**Cabana**, 2010
Fernando & Humberto Campana (Brazil)
Metal, fire-proofed raffia
© Edra

Flap周年庆纪念版沙发，2010
弗兰切斯科·宾法莱(意大利)
上漆镀铬钢，聚亚安酯，莱卡布，生态毛皮
© Edra

**Flap Anniversary Edition**, 2010
Francesco Binfaré (Italy)
Brushed chrome-plated steel, polyurethane, Lycra, ecological fur
© Edra

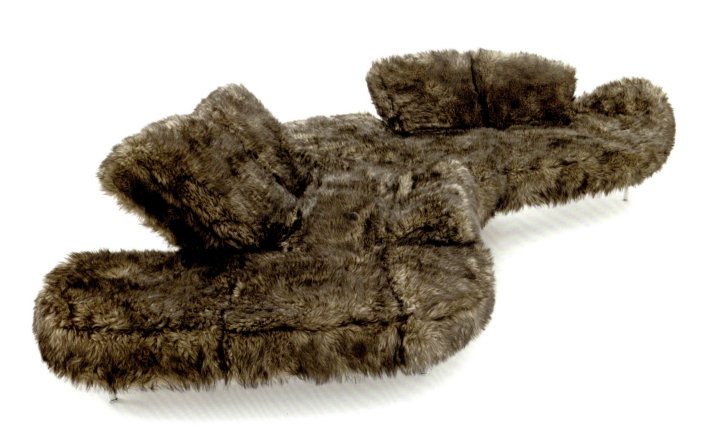

大钢琴床系列，2007
马里奥·贝里尼（意大利）
多种材料
© Mario Bellini

**Grandpiano Bed**, 2007
Mario Bellini (Italy)
Various materials
© Mario Bellini

斯薇拉胡桃木床系列，2011
奥多尔多·费奥拉万提（意大利）
多种材料
© Odoardo Fioravanti

**Sveva bed walnut canaletto**, 2011
Odoardo Fioravanti (Italy)
Various materials
© Odoardo Fioravanti

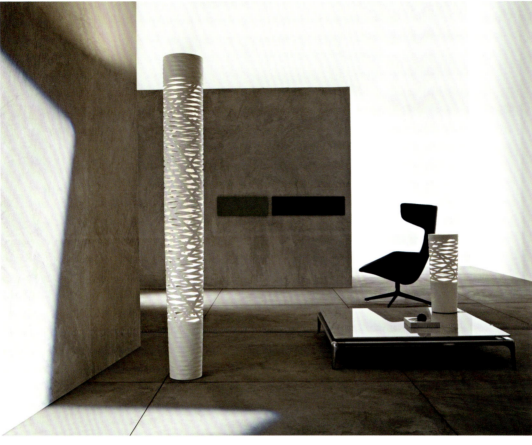

"编织"地灯，2008
马克·萨德勒（法国/奥地利）
合成材料，基础漆玻璃纤维
© Photo: Massimo Gardone

**Tress**, 2008
Marc Sadler (France/Austria)
Compound material, lacquered glass fibre base
© Photo: Massimo Gardone

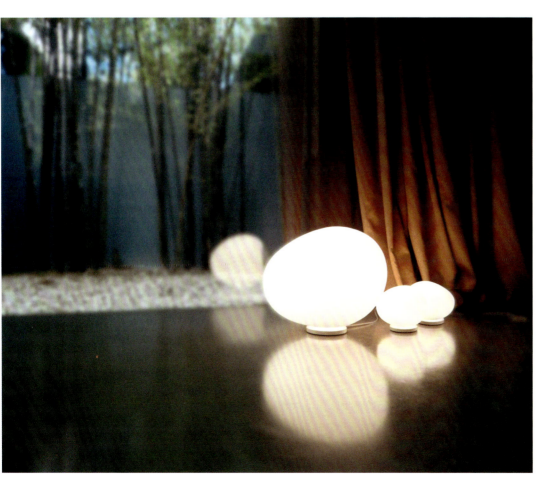

格雷格地灯，2007
卢多维卡·帕罗姆巴，罗伯托·帕罗姆巴（意大利）
玻璃，金属
© Photo: Massimo Gardone

**Gregg**, 2007
Ludovica Palomba & Roberto Palomba (Italy)
Glass, metal
© Photo: Massimo Gardone

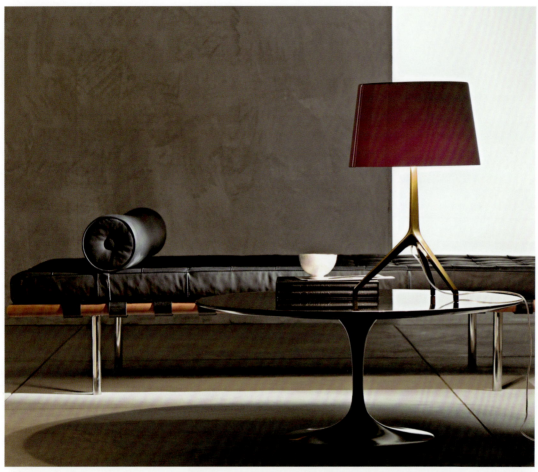

卢米埃尔特大号台灯，2009
鲁道夫·多多尼（意大利）
玻璃，铝
© Massimo Gardone for Foscarini

**Lumiere XXL**, 2009
Rodolfo Dordoni (Italy)
Glass, aluminium
© Massimo Gardone for Foscarini

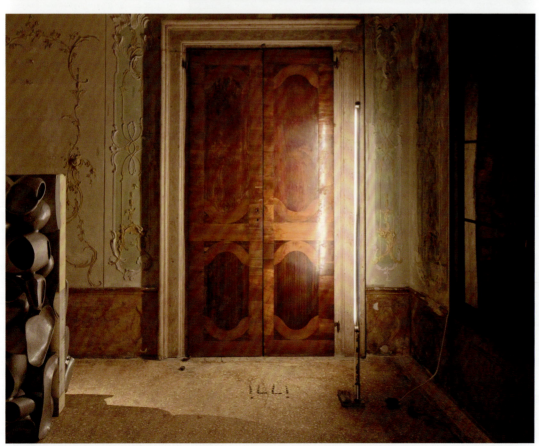

魔杖，2003
马里奥·纳尼（意大利）
玻璃，不锈钢
© Mario Nanni

**Bacchetta magica**, 2003
Mario Nanni (Italy)
Glass, stainless steel
© Mario Nanni

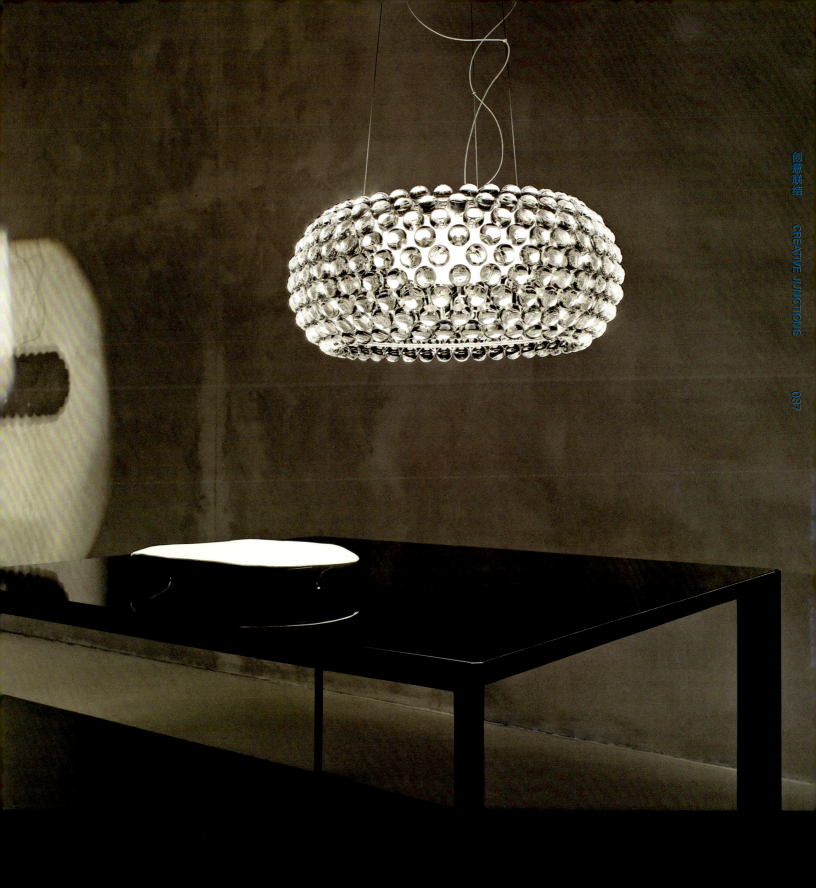

**Caboche悬挂灯,** 2005
帕特里夏·乌古拉(西班牙)
有机玻璃,吹制玻璃,铬合金
© Photo: by Massimo Gardone

**Caboche,** 2005
Patricia Urquiola (Spain)
Polymethyl methacrylate, blown glass, chrome metal
© Photo: by Massimo Gardone

炖锅，2011
鲁道夫·多多尼（意大利）
Wonderplus 18/10不锈钢
© Rodolfo Dordoni

**Casserole**, 2011
Rodolfo Dordoni (Italy)
Wonderplus 18/10 stainlesssteel
© Rodolfo Dordoni

蛋糕盘，2011
鲁道夫·多多尼（意大利）
抛光不锈钢，铜，玻璃
© Rodolfo Dordoni

**Lid/cake stand**, 2011
Rodolfo Dordoni (Italy)
Polished stainless steel, copper, glass
© Rodolfo Dordoni

"塔津/灯"盛食器，2011
鲁道夫·多多尼（意大利）
玻璃
© Rodolfo Dordoni

**Tajine / Lantern**, 2011
Rodolfo Dordoni (Italy)
Glass
© Rodolfo Dordoni

托盘，2011
鲁道夫·多多尼（意大利）
Wonderplus 18/10不锈钢
© Rodolfo Dordoni

**Tray**, 2011
Rodolfo Dordoni (Italy)
Wonderplus 18/10 stainlesssteel
© Rodolfo Dordoni

把手，2011
鲁道夫·多多尼（意大利）
黑表面18/10不锈钢
© Rodolfo Dordoni

**Handle**, 2011
Rodolfo Dordoni (Italy)
Black finished 18/10 stainless steel
© Rodolfo Dordoni

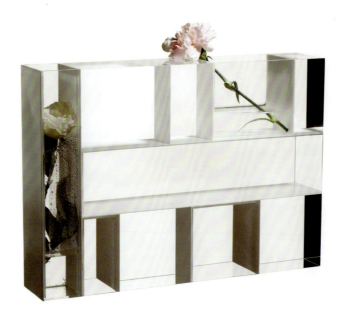

毕达哥拉斯花瓶2号，2005
安德里亚·布兰兹（意大利）
树脂玻璃
© Andrea Branzi

**Pitagora mod.2**, 2005
Andrea Branzi (Italy)
Plexiglas
© Andrea Branzi

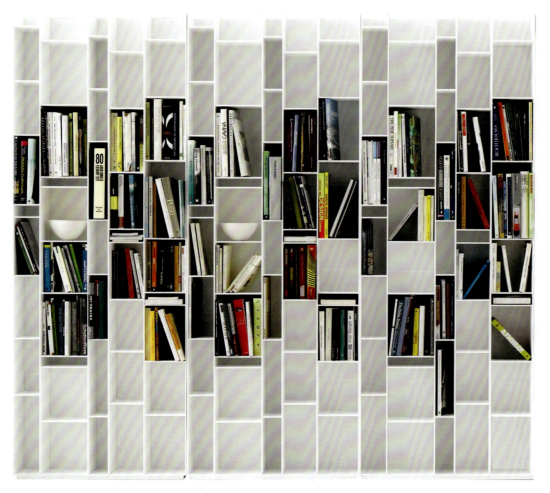

"随机"书架，2005
爱娃·帕斯特，迈克尔·哥德马赫（德国）
中密度木板
© Eva Paster

**Random**, 2005
Eva Paster, Michael Geldmacher (Germany)
Medium-density wood fibreboards
© Eva Paster

佩斯系列：Fare花瓶，2010
盖塔诺·佩瑟（意大利）
树脂，织物
© courtesy of Meritalia

**Le Edizioni del Pesce: Fare**, 2010
Gaetano Pesce (Italy)
Resin and fabric
© courtesy of Meritalia

"阿波罗尼奥"灯，2010
波列克·斯伯克（捷克）
黄铜，钢，玻璃
© Borek Sipek

**Apollonio**, 2010
Borek Sipek (Czech)
Brass, steel, glass
© Borek Sipek

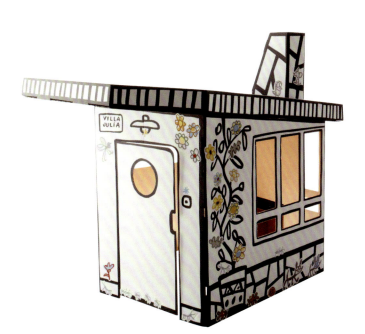

Me Too: "朱丽叶别墅"，2009
哈维尔·马里斯卡尔（西班牙）
纸板，贴纸
© Javier Mariscal

**Me Too: Villa Julia**, 2009
Javier Mariscal (Spain)
Carton, stickers for personalization
© Javier Mariscal

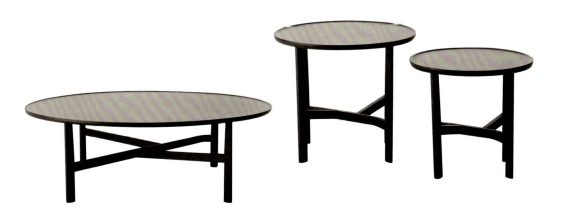

Quake桌，2008
艾瑞克·莱维（以色列）
黑核桃木
© Molteni&C

**Quake**, 2008
Arik Levy (Israel)
American walnut
© Molteni&C

"新浪潮"躺椅，2005
克里斯托夫·皮耶（法国）
热塑性塑料
© Pillet Christophe

**Nouvelle vague chaise longue**, 2005
Christophe Pillet (France)
Thermoplastic
© Pillet Christophe

温布尔登椅，2010
皮耶罗·里梭尼（意大利）
铬钢，Coach皮革
© Matteograssi

**Wimbledon**, 2010
Piero Lissoni (Italy)
Chromed steel, coach hide
© Matteograssi

"皮"扶手椅，2007
让·努维尔（法国）
铝，皮革，泡沫橡胶
© Molteni&C

**Skin Armchair**, 2007
Jean Nouvel (France)
Aluminium, leather, foam rubber
© Molteni&C

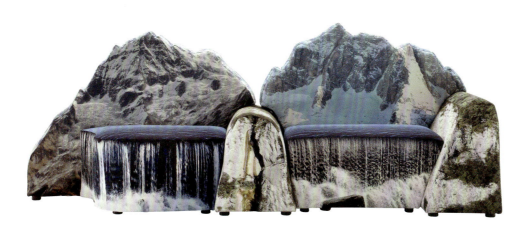

"山岳"沙发,2009
盖塔诺·佩瑟(意大利)
木,金属,聚氨酯,棉布
© Meritalia

**Montanara**, 2009
Gaetano Pesce (Italy)
Structure in wood and metal, fiberfill and polyurethane padding, cotton fabric
© Meritalia

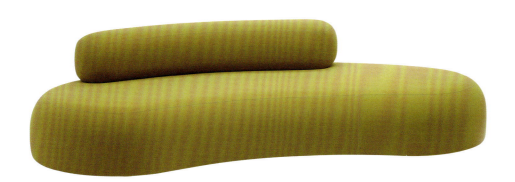

泡泡摇滚,2005
皮耶罗·里梭尼(意大利)
木,聚氨酯泡沫,织物
© Piero Lissoni

**Bubble Rock**, 2005
Piero Lissoni (Italy)
Wood, polyurethane foam, fabric
© Piero Lissoni

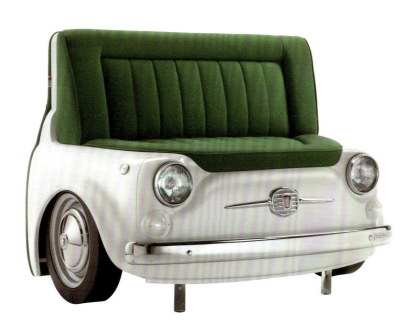

菲亚特500设计系列:"全景"沙发,2011
拉普·埃尔康,梅里塔里亚(意大利)
钢,聚氨酯,织物
© Meritalia

**Fiat 500 Design Collection: Panorama**, 2011
Lapo Elkann and Meritalia (Italy)
Steel, polyurethane, fabric
© Meritalia

佩斯系列：鬼灯，2010
盖塔诺·佩思（意大利）
树脂
© Meritalia

**Le Edizioni del Pesce: Ghost Lamp**, 2010
Gaetano Pesce (Italy)
Resin
© Meritalia

佩斯系列：大惊喜1号，2010
盖塔诺·佩思（意大利）
硬树脂
© Meritalia

**Le Edizioni del Pesce: Big Surprise 1**, 2010
Gaetano Pesce (Italy)
Hard resin
© Meritalia

**Via Lattea沙发**，2007
马里奥·贝里尼（意大利）
聚丙烯，气垫，LED灯
© Meritalia

**Via Lattea**, 2007
Mario Bellini (Italy)
Polypropylene, cushions, LED lights
© Meritalia

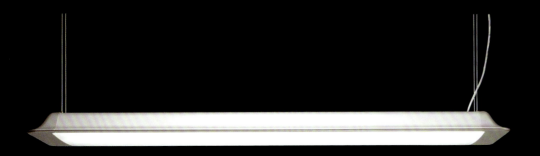

Lens悬挂灯，2010
马西莫·约莎·基尼（意大利）
铝，甲基丙烯酸酯
© Photo: Amendolagine & Barracchia

**Lens**, 2010
Massimo Iosa Ghini (Italy)
Aluminium, methacrylate
© Photo: Amendolagine & Barracchia

眼镜蛇灯，2006
让·阿瑞得（英国/以色列）
铝
© Photo: Amendolagine e Barracchia

**PizzaKobra**, 2006
Ron Arad (UK / Israel)
Aluminium
© Photo: Amendolagine e Barracchia

"图表"书柜，2011
安德里亚·布兰兹（意大利）
钢，玻璃，天然木材
© Andrea Branzi

**Diagrammi**, 2011
Andrea Branzi (Italy)
Steel, glass, natural wood
© Andrea Branzi

图腾 G 300 柜，2010
文森特·凡·杜森（比利时）
木
© Pastoe

**Totem G 300**, 2010
Vincent Van Duysen (Belgium)
Wood
© Pastoe

**Hati椅**,2009
皮耶罗·里梭尼(意大利)
木
© Piero Lissoni

**Hati**, 2009
Piero Lissoni (Italy)
Wood
© Piero Lissoni

**"摩登化石"衣柜**,2004
马西米里奥诺·阿达米(意大利)
塑料,木
© Photo: Carlo Furgeri Gilbert

**FOSSILE MODERNO armadio**, 2004
Massimiliano Adami (Italy)
Plastic and wood objects
© Photo: Carlo Furgeri Gilbert

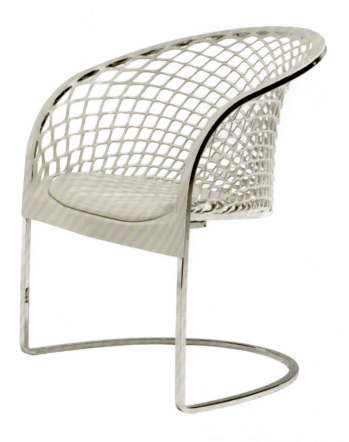

**Aretè椅,** 2007
弗兰克·波利(意大利)
镀铬钢,泡沫塑料,Coach皮革
© Photo: Beppe Raso

**Aretè,** 2007
Franco Poli (Italy)
Chrome plated steel frame, polyuerthane foam, Coach hide covered
© Photo: Beppe Raso

**Antibodi椅,** 2005
帕特里夏·乌古拉(西班牙)
钢,织物,皮革
© Patricia Urquiola

**Antibodi,** 2005
Patricia Urquiola (Spain)
Steel ,fabric,leather
© Patricia Urquiola

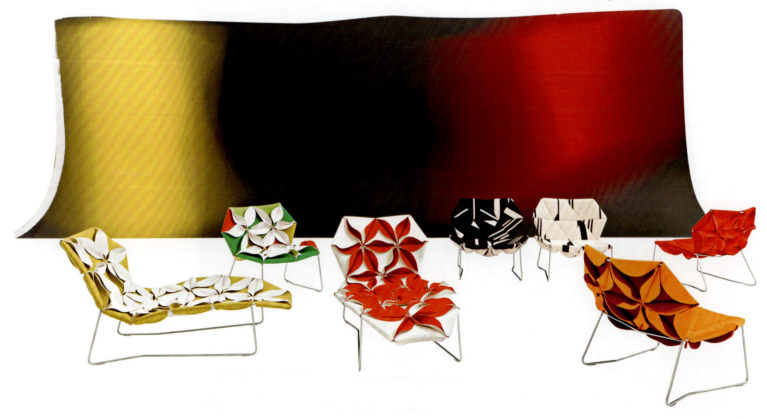

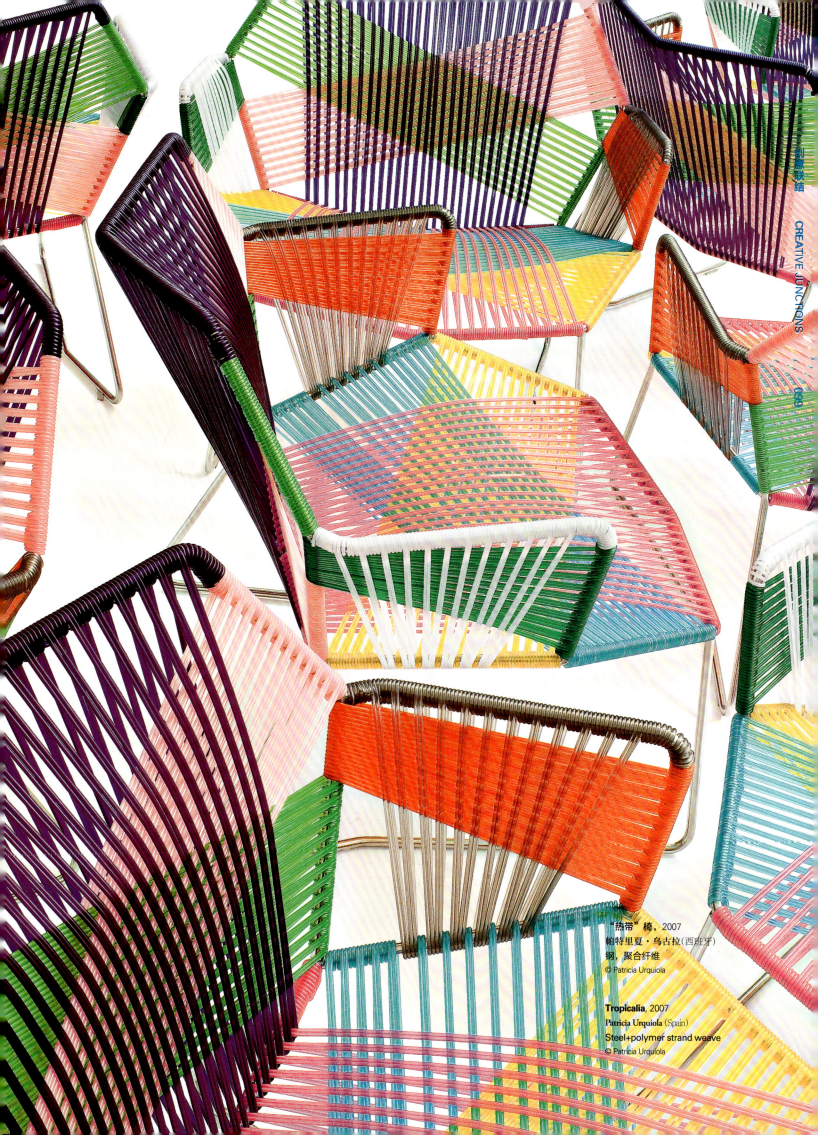

"热带"椅, 2007
帕特里夏·乌古拉(西班牙)
钢,聚合纤维
© Patricia Urquiola

**Tropicalia**, 2007
Patricia Urquiola (Spain)
Steel+polymer strand weave
© Patricia Urquiola

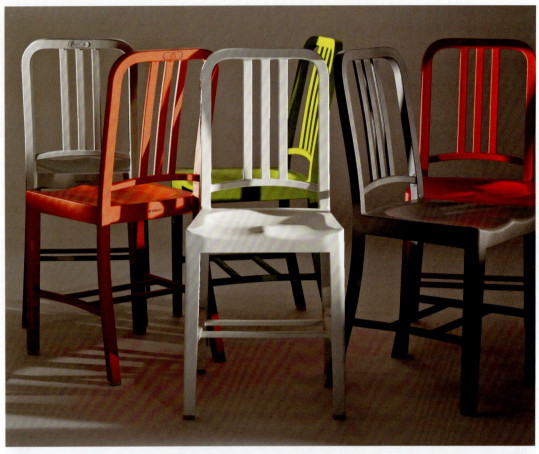

**111 "海军"椅**,2006
Emeco公司/可口可乐公司(美国)
111个回收的塑料瓶
© Design Republic

**111 Navy Chair**, 2006
Emeco / Coca-Cola (USA)
Recycled PET plastic
© Design Republic

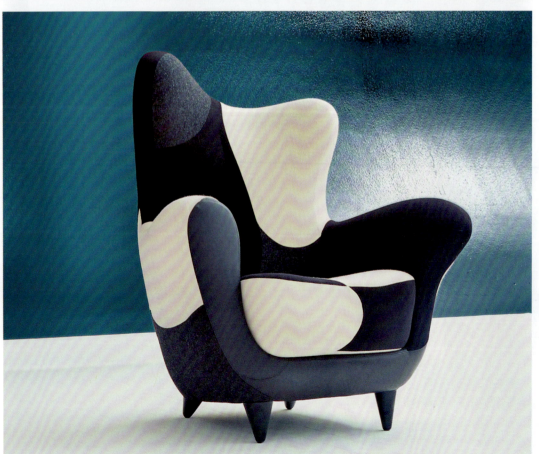

**亚历山德拉椅**,1994
哈维尔·马里斯卡尔(西班牙)
泡沫塑料,钢,皮革,面料
© Javier Mariscal

**Alessandra**, 1994
Javier Mariscal (Spain)
Foam, steel, leather, fabric
© Javier Mariscal

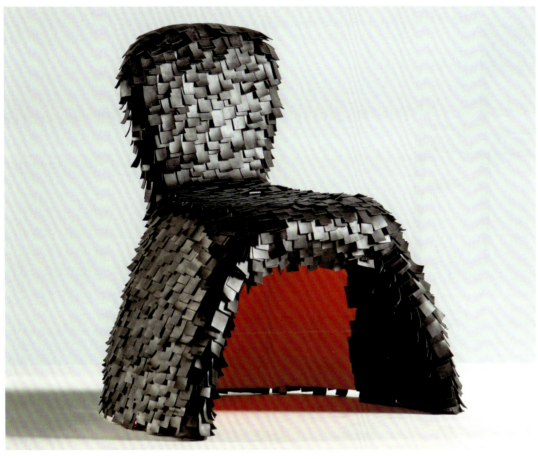

"女巫"椅,2004
托德·布谢尔(荷兰)
木,皮革
© Tord Boontje

**Witch Chair**, 2004
**Tord Boontje** (Netherlands)
Wood, leather
© Tord Boontje

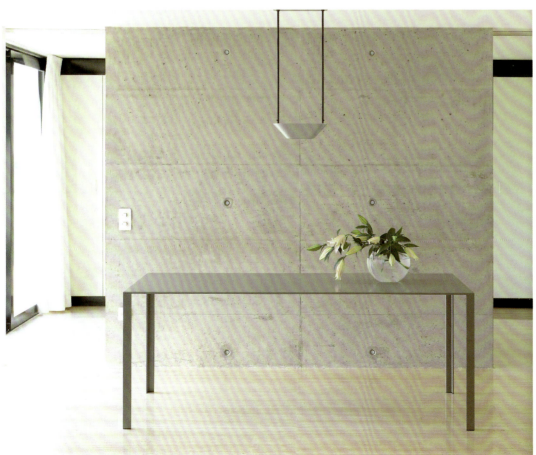

极简茶几,1994
让·努维尔(法国)
金属
© Molteni&C

**Less**, 1994
**Jean Nouvel** (France)
Metal
© Molteni&C

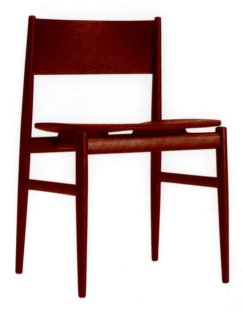

**Neve椅**，2010
皮耶罗·里梭尼（意大利）
白蜡木
© Piero Lissoni

**Neve**, 2010
Piero Lissoni (Italy)
Ash
© Piero Lissoni

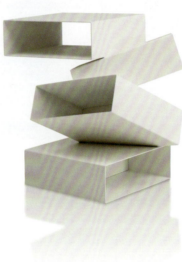

**"平衡箱"桌子**，2010
Front工作室／安娜·林格伦，索菲亚·拉格维斯，夏洛特·凡·德·兰肯（瑞典）
可折叠金属薄片
© Front

**Balancing boxes**, 2010
Front / Anna Lindgren, Sofia Lagerkvist, Charlotte von der Lancken (Sweden)
Folded metal sheet
© Front

**伍德斯托克**，2010
让-马里·马索德（法国）
木
© Jean-Marie Massaud

**Woodstock**, 2010
Jean-Marie Massaud (France)
Wood
© Jean-Marie Massaud

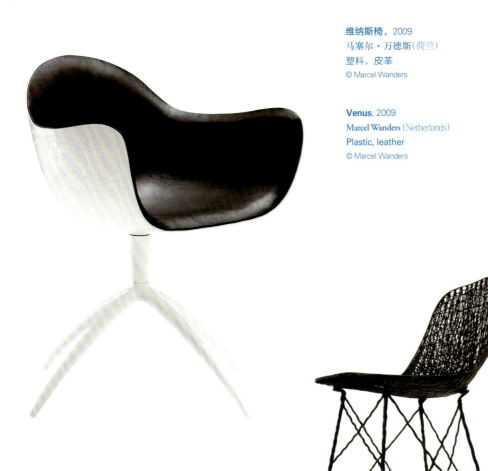

维纳斯椅，2009
马塞尔·万德斯(荷兰)
塑料，皮革
© Marcel Wanders

**Venus**, 2009
Marcel Wanders (Netherlands)
Plastic, leather
© Marcel Wanders

碳椅，2004
贝特扬·波特(荷兰)
环氧树脂，碳纤维
© Design Republic

**Carbon Chair**, 2004
Bertjan Pot (Netherlands)
Epoxy and carbon fibre
© Design Republic

Kennedee沙发，2006
让-马里·马索德(法国)
榉木，胶合板，聚氨酯泡沫，涤纶，扶手，弹性带，炮铜
© Jean-Marie Massaud

**Kennedee**, 2006
Jean-Marie Massaud (France)
Beech wood, plywood, polyurethane foam, dacron, armrests, elastic belts, gunmetal
© Jean-Marie Massaud

"没有不带刺的意大利"书架，2011
亚历山德罗·门迪尼(意大利)
聚苯乙烯，聚氨酯
© Photo: Amendolagine & Barracchia

**Non c'è Italia senza spine**, 2011
Alessandro Mendini (Italy)
Polystyrene, polyurethane
© Photo: Amendolagine & Barracchia

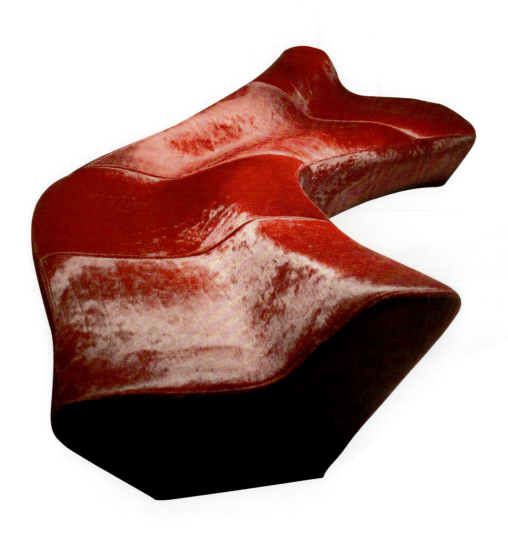

Z形"冰碛"沙发，2000
扎哈·哈迪德(英国)
防火泡沫塑料，小种马皮革
© Zaha Hadid

**Z.Scape Moraine**, 2000
Zaha Hadid (UK)
Fireproof foam covered, pony fantasy leather
© Zaha Hadid

"电线架"椅，1992
汤姆·迪克森(英国)
钢丝
© Tom Dixon

**Pylon chair**, 1992
Tom Dixon (UK)
Steel wire
© Tom Dixon

"火山"咖啡桌，2006
葆拉·娜万(意大利)
聚氨酯，哑光漆
© Paola Navone

**Vulcano**, 2006
Paola Navone (Italy)
Polyurethane, matt lacquered
© Paola Navone

创意联结 CREATIVE JUNCTIONS 105

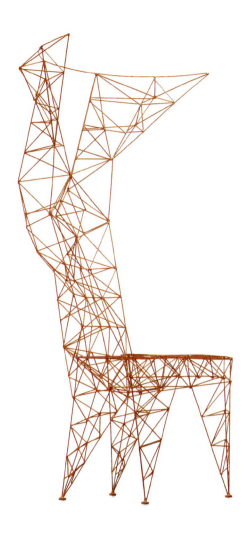

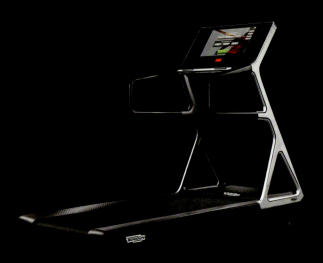

私人跑步机，2009
安东尼·奇特里奥，全阮（意大利／越南）
钢，橡胶，玻璃
© Antonio Citterio Toan Nguyen

**Run personal**, 2009
Antonio Citterio, Toan Nguyen (Italy / Vietnam)
Steel, rubber, glass
© Antonio Citterio Toan Nguyen

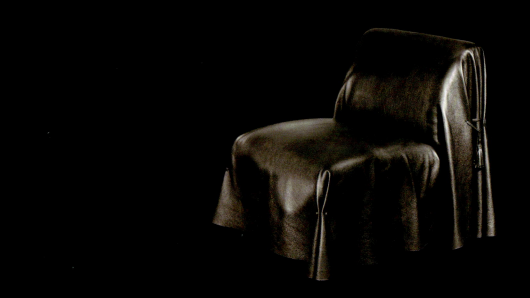

Tunica椅，2008
意大利俱乐部之屋（意大利）
木，皮革
© Club House Italia

**Tunica chair**, 2008
Club House Italia (Italy)
Wood, draped leather
© Club House Italia

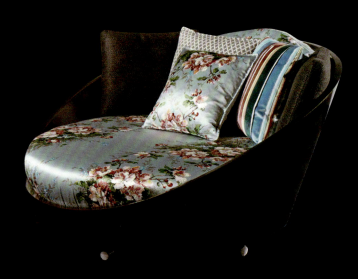

Arco双人沙发，2008
意大利俱乐部之屋（意大利）
木框架，坐垫，靠垫，金属椅脚
© Club House Italia

**Arco love-seat**, 2008
Club House Italia (Italy)
Frame: Wood stained black ancient effect or veneered walnut. Paded seat, Back: cushions and cushion, Feet: Metal chromed.
© Club House Italia

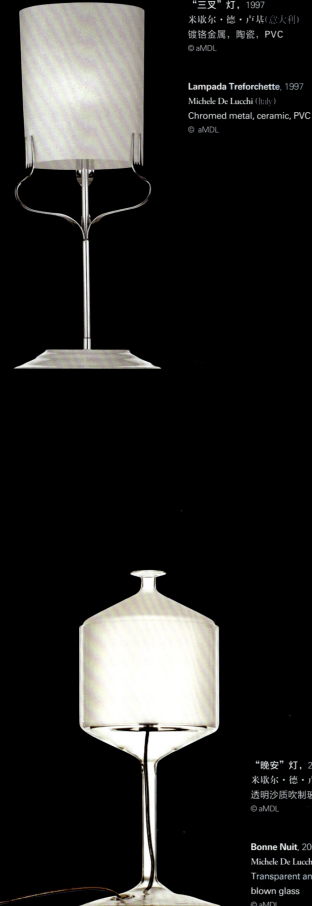

"三叉"灯，1997
米歇尔·德·卢基（意大利）
镀铬金属，陶瓷，PVC
© aMDL

**Lampada Treforchette**, 1997
Michele De Lucchi (Italy)
Chromed metal, ceramic, PVC
© aMDL

OJ灯，2010
奥利·詹森（丹麦）
钢
© Louis Poulsen

**OJ**, 2010
Ole Jensen (Denmark)
Steel
© Louis Poulsen

"玛丽亚"灯，1997
克劳迪奥·拉·维奥拉（意大利）
不锈钢
© Claudio La viola

**Maria**, 1997
Claudio La Viola (Italy)
Stainless steel
© Claudio La viola

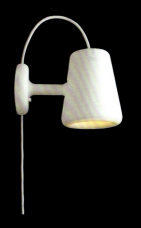

"晚安"灯，2009
米歇尔·德·卢基（意大利）
透明沙质吹制玻璃
© aMDL

**Bonne Nuit**, 2009
Michele De Lucchi (Italy)
Transparent and sanded borosilicate
blown glass
© aMDL

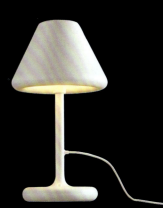

世博自行车，2010
刘传凯（中国台湾）
钢，铝合金，木
© Carl Liu

**EXPO BIKE**, 2010
**Carl Liu** (Taiwan, China)
Steel, aluminu malloy, wood
© Carl Liu

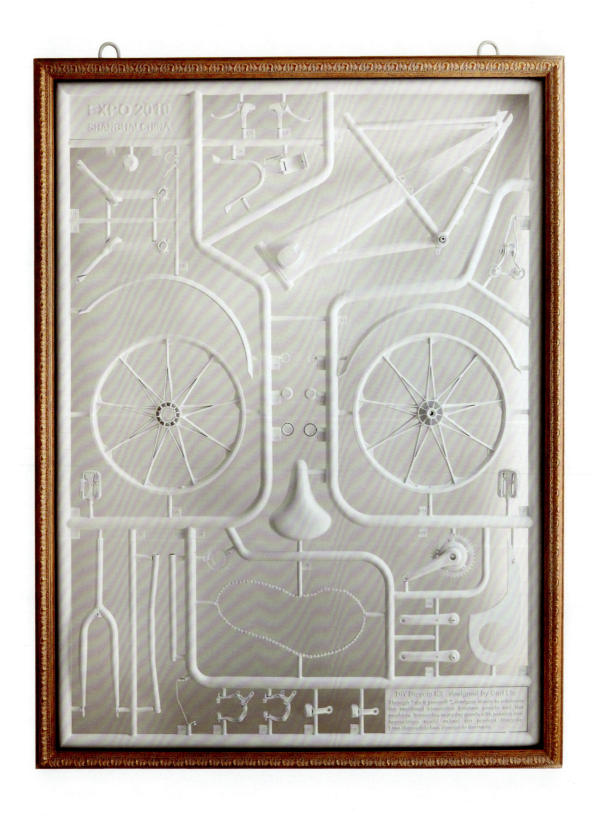

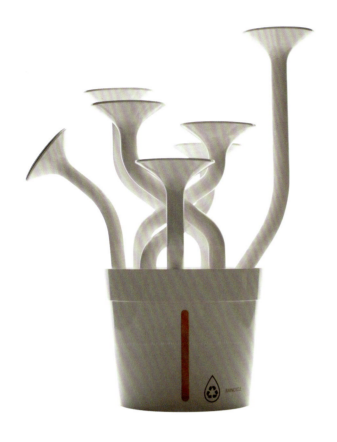

花·洒，2009
刘传凯(中国台湾)
塑料
© Carl Liu

**Planto**, 2009
Carl Liu (Taiwan, China)
Plastic
© Carl Liu

积云，2009
刘传凯(中国台湾)
塑料
© Carl Liu

**Cumulus**, 2009
Carl Liu (Taiwan, China)
Plastic
© Carl Liu

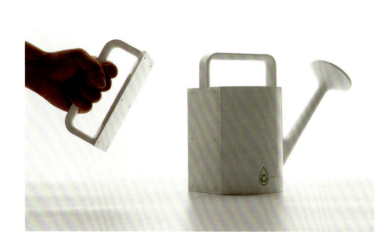
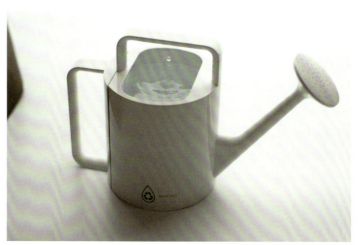

组歌，2009
孙嘉英，陆永庆(中国)
银，珍珠，钻石
© Sun Jiaying

**Songs**, 2009
Sun Jiaying, Lu Yongqing (China)
Silver, pearls, diamonds
© Sun Jiaying

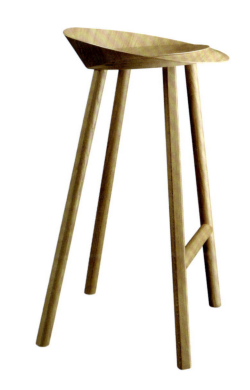

上海微风，2009
刘传凯(中国台湾)
乌木
© Carl Liu

ST 10牛仔高脚凳，2010
斯蒂芬·迪茨(德国)
天然橡木板
© Design Republic

**City Breeze-Shanghai,** 2009
Carl Liu (Taiwan, China)
Ebony
© Carl Liu

**ST 10 Jean,** 2010
Stefan Diez (Germany)
Natural oak veneer
© Design Republic

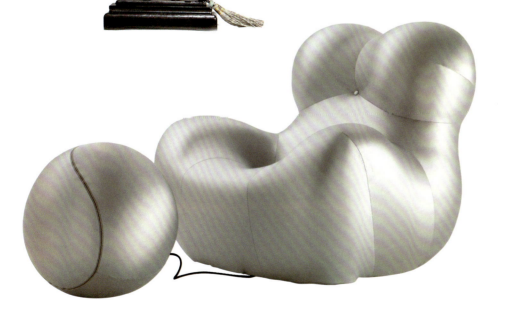

"上"系列2000银色特别版，2009
盖塔诺·佩瑟(意大利)
柔性冷弯成型聚氨酯泡沫塑料，银丝弹力面料
© Gaetano Pesce

**Up 2000 Silver Special Edition,** 2009
Gaetano Pesce (Italy)
Flexible cold shaped polyurethane foam, silver stretch fabric
© Gaetano Pesce

花园系列：柠檬树，2005
米歇尔·德·卢基（意大利）
粗金属激光切割
© aMDL

**The Garden: Lemon Tree**, 2005
Michele De Lucchi (Italy)
Protected raw metal laser cut
© aMDL

花园系列：玫瑰，2005
米歇尔·德·卢基（意大利）
粗金属激光切割
© aMDL

**The Garden: Rose Tree**, 2005
Michele De Lucchi (Italy)
Protected raw metal laser cut
© aMDL

花园系列：棕榈树，2005
米歇尔·德·卢基（意大利）
粗金属激光切割
© aMDL

**The Garden: Palm Tree**, 2005
Michele De Lucchi (Italy)
Protected Raw Metal Laser Cut
© aMDL

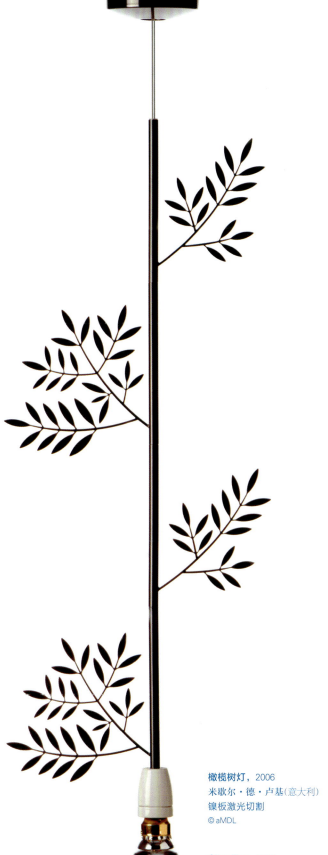

蜻蜓灯，2006
米歇尔·德·卢基（意大利）
镍板激光切割
© aMDL

**Dragonfly Fauna**, 2006
Michele De Lucchi (Italy)
Nickel plating metal laser cut
© aMDL

橄榄树灯，2006
米歇尔·德·卢基（意大利）
镍板激光切割
© aMDL

**Olive Flora**, 2006
Michele De Lucchi (Italy)
Nickel plating metal laser cut
© aMDL

镂空花纹椅，2010
艾瑞克·莱维（以色列）
金属
© Arik Levy

**Pattern**, 2010
Arik Levy (Israel)
Metal
© Arik Levy

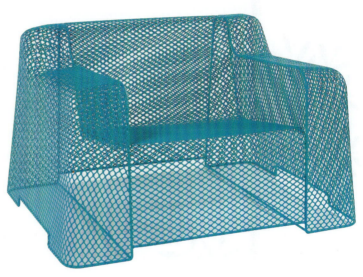

常青藤扶手椅，2008
葆拉·娜万（意大利）
金属
© Paola Navone

**Ivy**, 2008
Paola Navone (Italy)
Metal
© Paola Navone

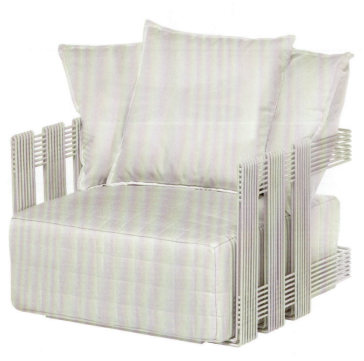

**Intrecci**扶手椅，2009
卡洛·科伦坡（意大利）
金属
© Carlo Colombo

**Poltrona intrecci**, 2009
Carlo Colombo (Italy)
Metal
© Carlo Colombo

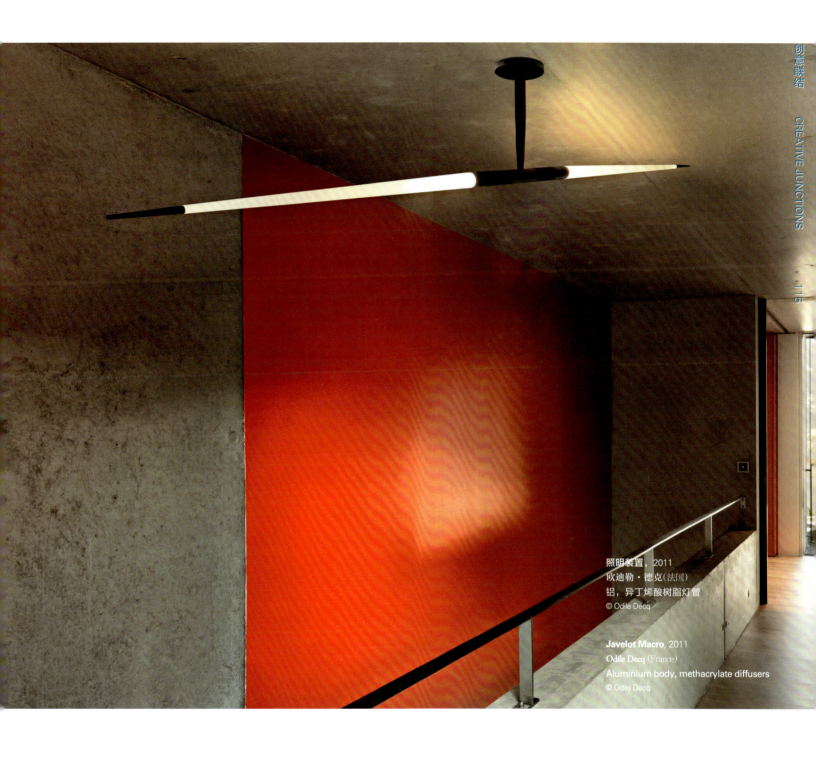

照明装置，2011
欧迪勒·德克(法国)
铝，异丁烯酸树脂灯管
© Odile Decq

**Javelot Macro**, 2011
**Odile Decq** (France)
Aluminium body, methacrylate diffusers
© Odile Decq

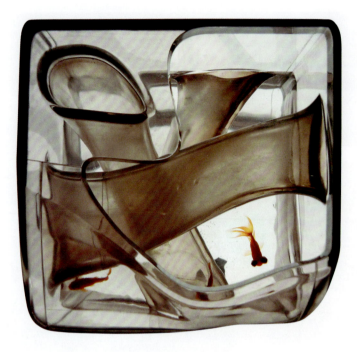

**鱼缸**，2004
马岩松（中国）
亚克力
© Fang Zhenning

**Fish Tank**, 2004
Ma Yansong (China)
Acrylic
© Fang Zhenning

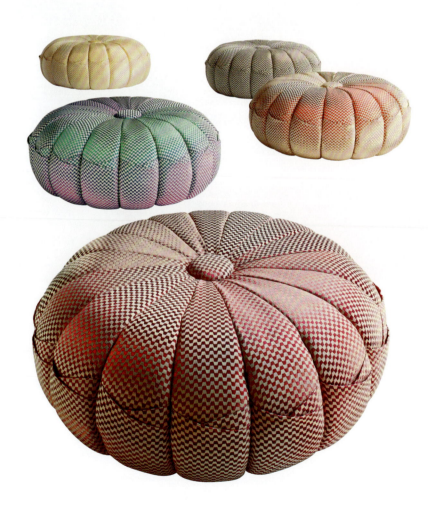

**Puntaspillone凳**，2010
米索尼家庭工作室（意大利）
木，泡沫塑料
© MissoniHome Studio

**Puntaspillone**, 2010
Missoni Home Studio (Italy)
Wooden support covered with foam
© MissoniHome Studio

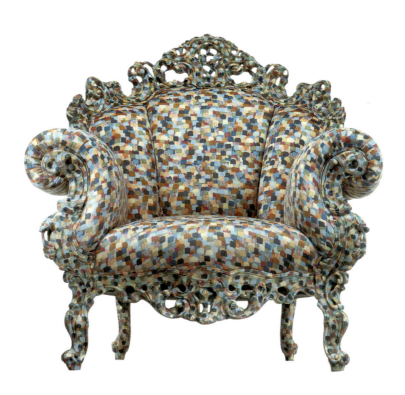

普鲁斯特椅，1978
亚历山德罗·门迪尼（意大利）
木，织物
© Alessandro Mendini

**Proust**, 1978
Alessandro Mendini (Italy)
Wood and fabric
© Alessandro Mendini

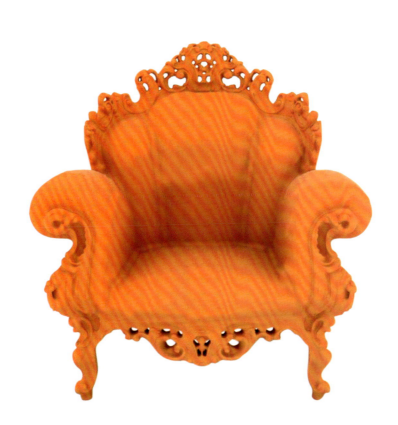

神圣普鲁斯特椅，2011
亚历山德罗·门迪尼（意大利）
聚乙烯
© Alessandro Mendini

**Magis Proust**, 2011
Alessandro Mendini (Italy)
Armchair in rotational-moulded polyethylene
© Alessandro Mendini

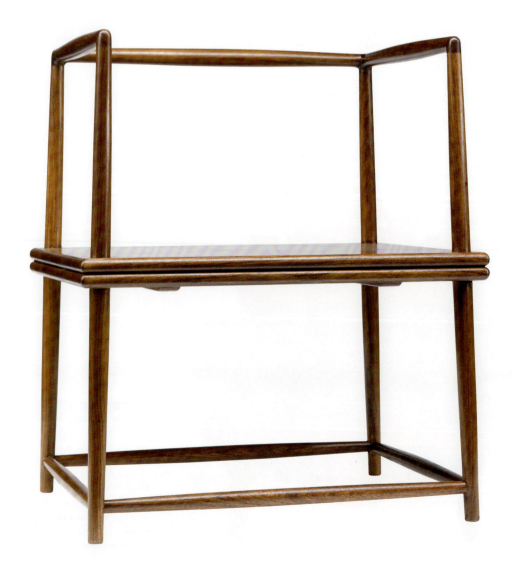

端椅，2011
刘铁军（中国）
硬木
© Photo: Liu Tiejun

**Proper Chair**, 2011
Liu Tiejun (China)
Hard wood
© Photo: Liu Tiejun

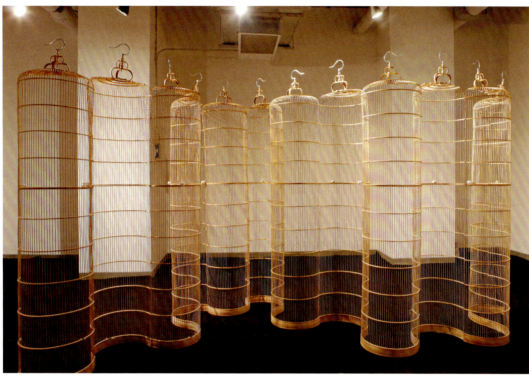

开笼，2010
刘峰（中国台湾）
竹
© Photo: Nathan liu

**The open cage**, 2010
**Nathan liu** (Taiwan, China)
Bamboo
© Photo: Nathan liu

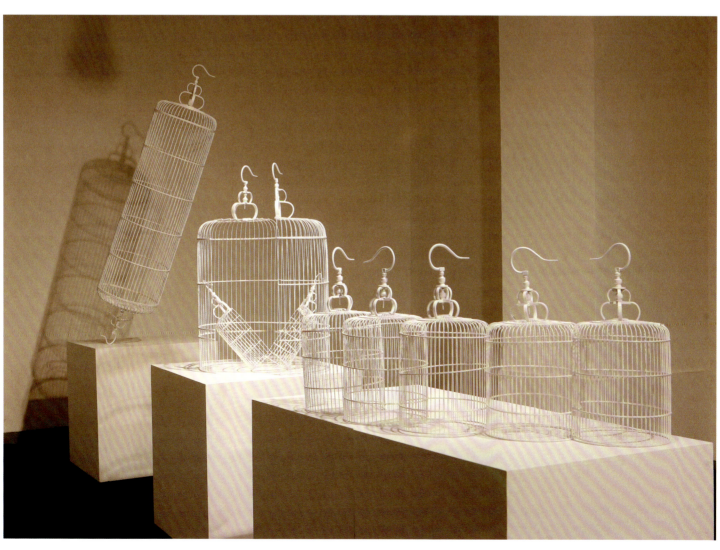

黑线系列－椅，2010  
Nendo公司／佐藤大(日本)  
钢  
© Nendo

**Thin black lines colletcion (chair)**, 2010  
Nendo / Oki Sato (Japan)  
Steel  
© Nendo

黑线系列－花瓶，2010  
Nendo公司／佐藤大(日本)  
钢  
© Nendo

**Thin black lines colletcion (vase)**, 2010  
Nendo / Oki Sato (Japan)  
Steel  
© Nendo

黑线系列－桌，2010  
Nendo公司／佐藤大(日本)  
钢  
© Nendo

**Thin black lines colletcion (table)**, 2010  
Nendo / Oki Sato (Japan)  
Steel  
© Nendo

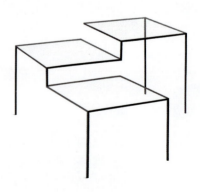

黑线系列－桌，2010  
Nendo公司／佐藤大(日本)  
钢  
© Nendo

**Thin black lines colletcion (table)**, 2010  
Nendo / Oki Sato (Japan)  
Steel  
© Nendo

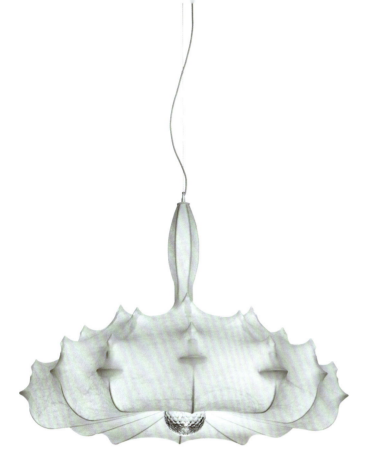

齐柏林灯2号，2005
马塞尔·万德斯（荷兰）
蚕丝，钢，水晶
© Marcel Wanders

**Zeppelin 2**, 2005
Marcel Wanders (Netherlands)
Cocoon, steel, crystal
© Marcel Wanders

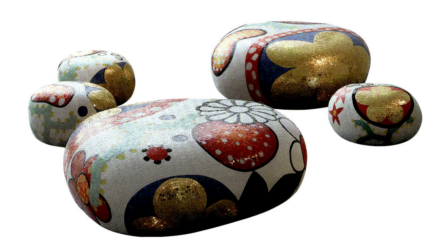

咖啡桌，2004
马塞尔·万德斯（荷兰）
玻璃马赛克，金瓷砖
© Photo: Ottavio Tomasini

**Coffee Table**, 2004
Marcel Wanders (Netherlands)
Glass mosaic + single tiles in gold
© Photo: Ottavio Tomasini

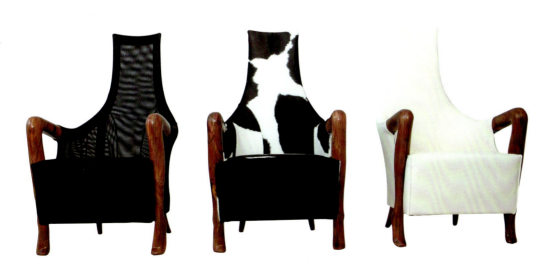

休闲椅—意识与潜意识，2011
于历战（中国）
木，皮革，织物
© Yu Lizhan

**Recliners—consciousness and subconsciousness**, 2011
Yu Lizhan (China)
Wood, leather, cobweb
© Yu Lizhan

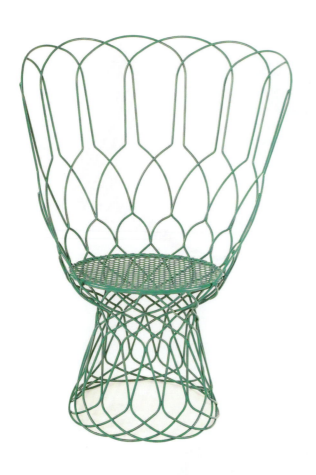

**Re-trouvé 扶手椅**, 2009
帕特里夏·乌古拉(西班牙)
金属
© Patricia Urquiola

**Re-trouvé**, 2009
Patricia Urquiola (Spain)
Metal
© Patricia Urquiola

**卡洛斯扶手椅**, 1997
安东尼·奇特里奥(意大利)
钢,聚氨酯泡沫塑料,美利奴羊毛皮料
© Antonio Citterio

**Armchair Kalos**, 1997
Antonio Citterio (Italy)
Steel and steel profiles, flexible cold shaped polyurethane foam, Merinos suede
© Antonio Citterio

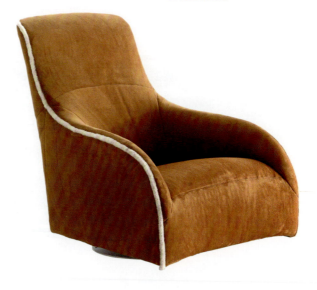

**"圣经"书架**, 2008
安东尼·奇特里奥(意大利)
实木,橡木,钢铁,铝,塑料
© Antonio Citterio

**Biblia**, 2008
Antonio Citterio (Italy)
solid wood, oak finishing, steel, aluminium, plastic
© Antonio Citterio

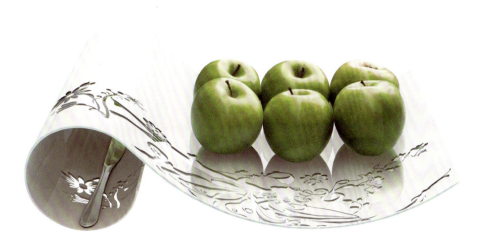

童话，2011
贾立，刘孜(中国)
金属
© Photo : Woopin

**Tale**, 2011
Jia Li, Liu Zi (China)
Metal
© Photo : Woopin

述说，2008
李薇(中国)
亚克力，丝
© Li Wei

**Narrate**, 2008
Li Wei (China)
Alcrylic, Silk
© Li Wei

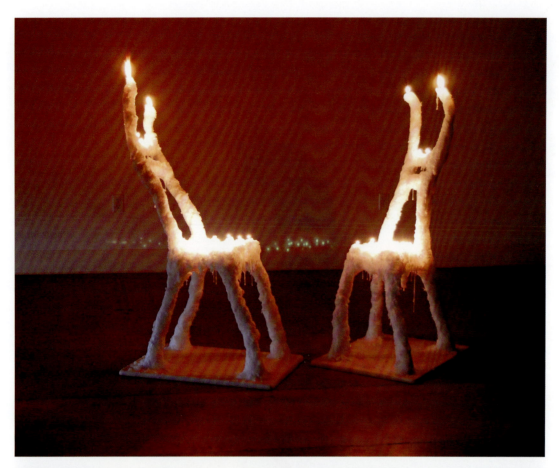

燃烧椅，2010
周洪涛（中国）
蜡烛
© Zhou Hongtao

**Burniture**, 2010
Zhou Hongtao (China)
Wax
© Zhou Hongtao

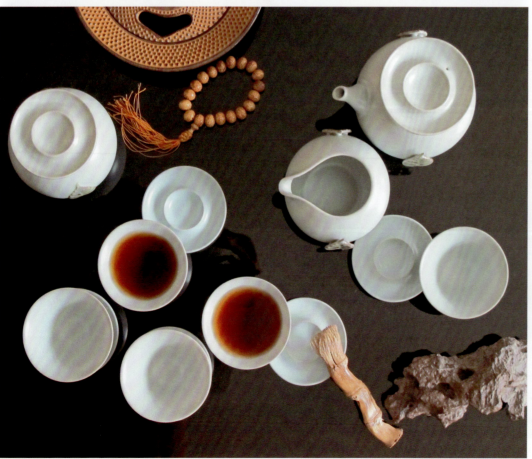

"菩提清心"茶具，2009
李泓（中国）
陶瓷
© Li Hong

**Bodhi-tea set**, 2009
Li Hong (China)
Ceramic
© Li Hong

M桌，1969
安杰洛·曼加洛蒂（意大利）
卡拉拉白色大理石
© Angelo Mangiarotti

**M Table**, 1969
Angelo Mangiarotti (Italy)
White Carrara marble
© Angelo Mangiarotti

"裙衬"椅，2008
帕特里夏·乌古拉（西班牙）
铜绳（底座），天然纤维绳（椅）
© Patricia Urquiola

**Crinoline**, 2008
Patricia Urquiola (Spain)
Base with bronze rope interlacing, seat with natural rope interlacing
© Patricia Urquiola

少女沙发07，1972
安东尼·奇特里奥（意大利）
钢，聚氨酯泡沫，织物或皮革
© Antonio Citterio

**Sofa Le Bambole 07**, 1972
Antonio Citterio (Italy)
Tubolar steel and steel profiles, flexible cold shaped polyurethane foam, fabric or leather
© Antonio Citterio

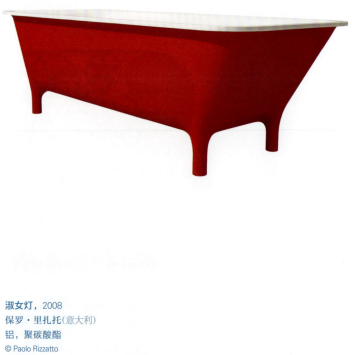

变形浴缸，2010
罗伯托·帕罗姆巴，卢多维卡·帕罗姆巴（意大利）
Cristalplant©热塑性聚合物
© Ludovica + Roberto Palomba

**Morphing**, 2010
Ludovica + Roberto Palomba (Italy)
Cristalplant
© Ludovica + Roberto Palomba

淑女灯，2008
保罗·里扎托（意大利）
铝，聚碳酸酯
© Paolo Rizzatto

**Lady Costanza**, 2008
Paolo Rizzatto (Italy)
Aluminium stem, polycarbonate
© Paolo Rizzatto

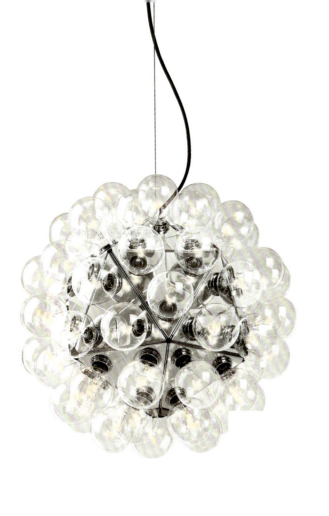

蒲公英88 S1/S2，1988
阿切莱·卡斯蒂里奥尼(意大利)
铝
© Achille Castiglioni

**Taraxacum 88 S1, S2**, 1988
Achille Castiglioni (Italy)
Aluminum
© Achille Castiglioni

豆袋沙发，1968
皮耶罗·加蒂，切萨里·帕奥里尼，弗朗哥·狄奥多罗(意大利)
聚乙脂，织物，皮革
© Zanotta

**Sacco**, 1968
Piero Gatti, Cesare Paolini, Franco Teodoro (Italy)
Polystrene, Fabric, Leather
© Zanotta

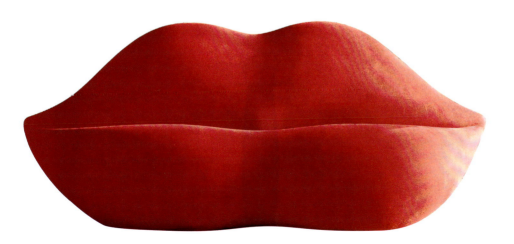

唇形沙发，1970
65工作室(意大利)
聚氨酯，弹性面料
© Studio 65

**Bocca**, 1970
Studio 65 (Italy)
Cold foamed polyurethane differentiated load bearing. Upholstery in elastic washable fabric
© Studio 65

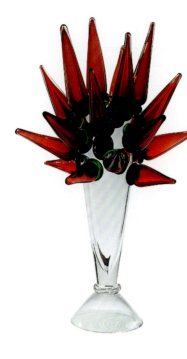

玛利亚·皮亚，2001
波列克·斯伯克（捷克）
玻璃
© Borek Sipek

**Maria Pia**, 2001
**Borek Sipek** (Czech)
Glass
© Borek Sipek

奥尔加，2001
波列克·斯伯克（捷克）
玻璃
© Borek Sipek

**Olga**, 2001
**Borek Sipek** (Czech)
Glass
© Borek Sipek

皮埃尔花瓶，1998
波列克·斯伯克（捷克）
玻璃
© Borek Sipek

**Pierre**, 1998
**Borek Sipek** (Czech)
Glass
© Borek Sipek

塞里尼1号，1995
波列克·斯伯克（捷克）
玻璃，瓷
© Borek Sipek

**CELINE I**, 1995
**Borek Sipek** (Czech)
Glass, porcelain
© Borek Sipek

哦！花瓶，2005
菲利浦·斯塔克（法国）
透明水晶，黑水晶
© Philippe Starck

**Oups! Vase**, 2005
Philippe Starck, (France)
Clear & black crystal
© Philippe Starck

"森林之王"花瓶，2010
马塞尔·万德斯（荷兰）
透明水晶，黄金座
© Marcel Wanders

**Roi de la forêt**, 2010
Marcel Wanders (Netherlands)
Clear crystal & golden base
© Marcel Wanders

"醉森林"细颈瓶，2010
马塞尔·万德斯（荷兰）
透明水晶，红水晶
© Marcel Wanders

**Ivresse des bois**, 2010
Marcel Wanders (Netherlands)
Clear & red crystal
© Marcel Wanders

Darkside系列：火烛灯，2011
菲利浦·斯塔克（法国）
透明水晶
© Philippe Starck

**Darkside: Our Fire**, 2011
Philippe Starck (France)
Clear crystal
© Philippe Starck

复制的"力量",2010
何洁(中国)
丝网印刷
© He Jie

**"Power" of Reproduction**, 2010
He Jie (China)
Screen print
© He Jie

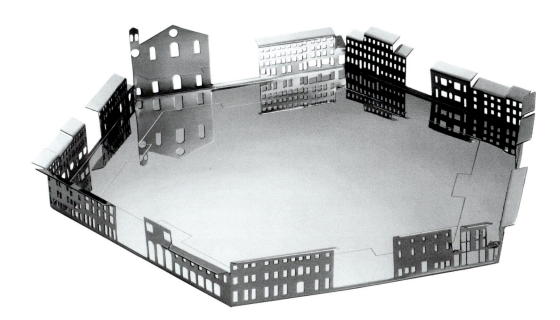

**100广场系列摆饰：帕尔马洛广场**，2008
法比奥·诺文布雷(意大利)
镀银铜
© Fabio Novembre

**100 PIAZZE - PALMANOVA**, 2008
Fabio Novembre (Italy)
Silver plated brass
© Fabio Novembre

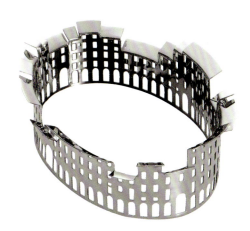

**100广场系列摆饰：卢卡广场**，2008
法比奥·诺文布雷(意大利)
镀银铜
© Fabio Novembre

**100 PIAZZE - LUCCA**, 2008
Fabio Novembre (Italy)
Silver plated brass
© Fabio Novembre

**100广场系列摆饰：米兰广场**，2008
法比奥·诺文布雷(意大利)
镀银铜
© Fabio Novembre

**100 PIAZZE - MILANO**, 2008
Fabio Novembre (Italy)
Silver plated brass
© Fabio Novembre

Wink椅,1980
喜多俊之(日本)
钢,聚酯,涤纶填充物,织物或皮革
© Kita Toshiyuki - Cassina I Contemporanei Collection

**Wink**, 1980
**Toshiyuki Kita** (Japan)
Steel, CFC-free polyurethane foam, polyester, fabric/leather
© Kita Toshiyuki - Cassina I Contemporanei Collection

Maralunga沙发,1973
维克·玛吉斯特莱蒂(意大利)
钢,塑料,涤纶填充物,聚酯
© Vico Magistretti - Cassina I Contemporanei Collection

**Maralunga**, 1973
**Vico Magistretti** (Italy)
Lacquered steel, plastic material, CFC-free polyurethane foam, polyester
© Vico Magistretti - Cassina I Contemporanei Collection

"乔"手套沙发，1970
纳森·德·巴斯，多纳托·德·乌日比诺，保罗·洛马齐（意大利）
钢，聚氨酯泡沫，皮革
© Poltronova

**Joe**, 1970
Jonathan De Pas, Donato D'Urbino, Paolo Lomazzi (Italy)
Steel, polyurethane foam, leather
© Poltronova

鬼椅，1987
契尼·波尔里（意大利）
玻璃
© Cini Boeri

**Ghost**, 1987
Cini Boeri (Italy)
Glass
© Cini Boeri

安德森轻便沙发，2010
鲁道夫·多多尼（意大利）
木，金属，织物
© Minotti

**Andersen Slim**, 2010
Rodolfo Dordoni (Italy)
Wood, metal, fabric
© Minotti

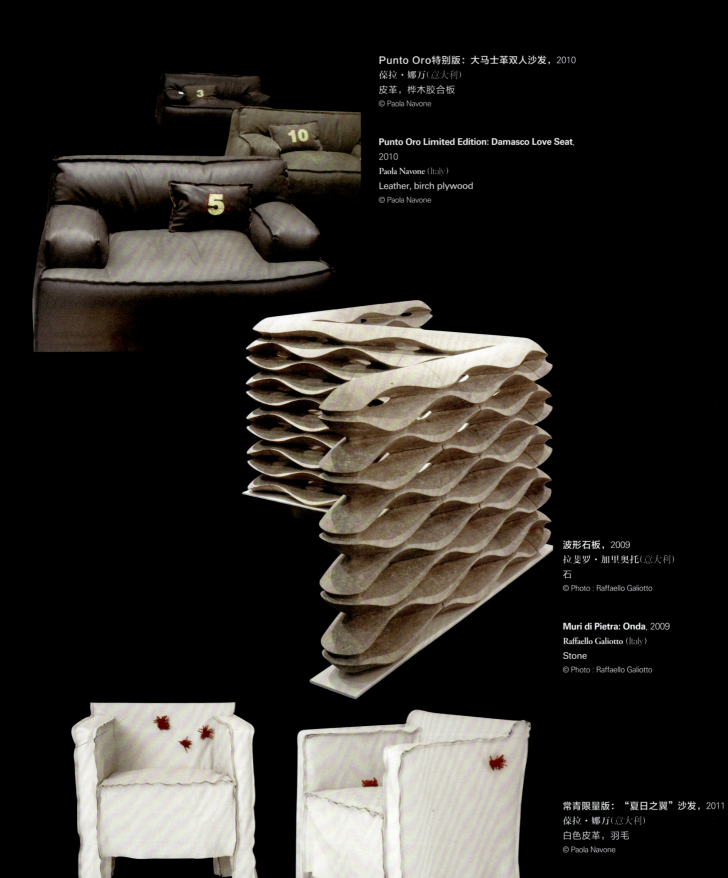

**Punto Oro特别版：大马士革双人沙发**，2010
葆拉·娜万（意大利）
皮革，桦木胶合板
© Paola Navone

**Punto Oro Limited Edition: Damasco Love Seat**, 2010
Paola Navone (Italy)
Leather, birch plywood
© Paola Navone

波形石板，2009
拉斐罗·加里奥托（意大利）
石
© Photo : Raffaello Galiotto

**Muri di Pietra: Onda**, 2009
Raffaello Galiotto (Italy)
Stone
© Photo : Raffaello Galiotto

常青限量版："夏日之翼"沙发，2011
葆拉·娜万（意大利）
白色皮革，羽毛
© Paola Navone

**Evergreen Limited Edition: Summer Arms Raccomodage**, 2011
Paola Navone (Italy)
Leather Plume Blanc
© Paola Navone

AEO椅，1973
保罗·德加尼罗（意大利）
上漆钢，塑料，涤纶填充物，聚酯
© Paolo Deganell

**AEO**, 1973
Paolo Deganello (Italy)
Lacquered steel, plastic material, CFC-free polyurethane foam, polyester
© Paolo Deganello

草叶花瓶1号，2011
安德里亚·布兰兹（意大利）
树脂玻璃
© Andrea Branzi

**Erbe mod.1**, 2011
Andrea Branzi (Italy)
Plexiglas
© Andrea Branzi

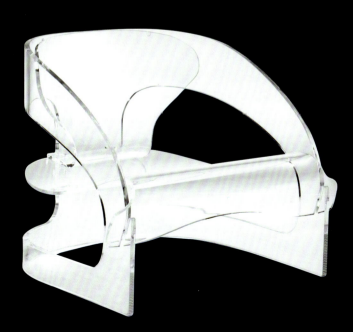

4801号扶手椅新版，2011
乔·科伦波（意大利）
透明热塑性塑料
© KARTELL

**POLTRONA 4801 - new version**, 2011
Joe Colombo (Italy)
Thermoplastic technopolymer
© KARTELL

葫芦系列，2008
张永和(中国)
多种材质
© JIA Inc.

**Hulu Tableware series**, 2008
Chang Yung Ho (China)
Various materials
© JIA Inc.

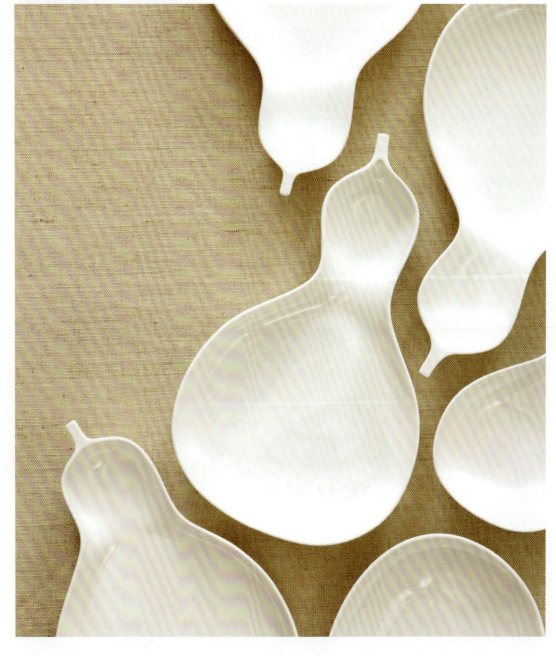

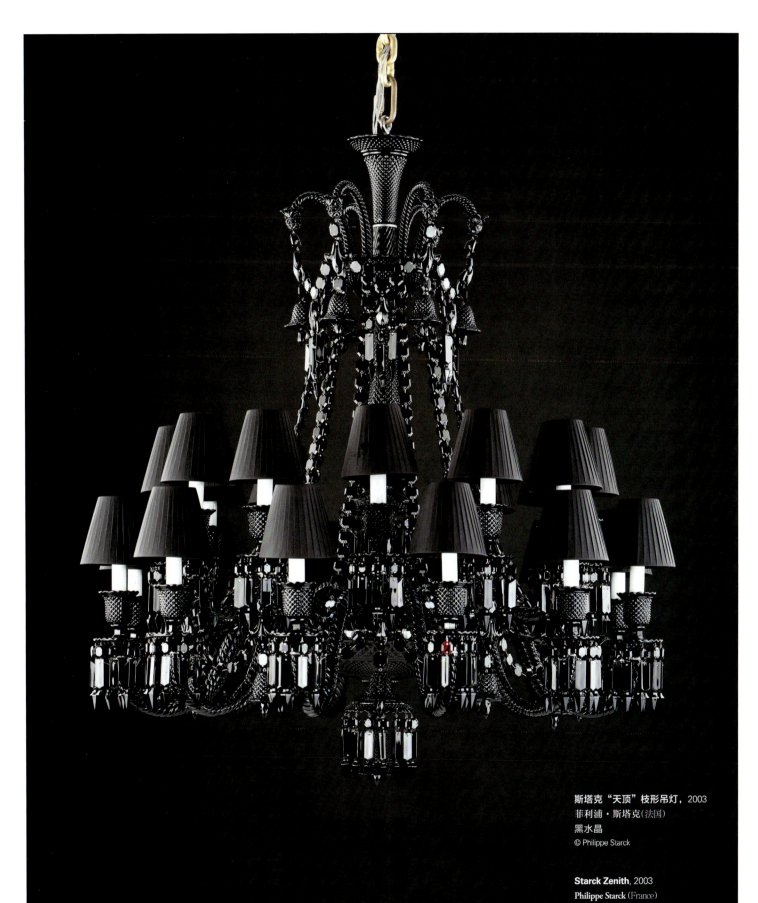

斯塔克"天顶"枝形吊灯，2003
菲利浦·斯塔克(法国)
黑水晶
© Philippe Starck

**Starck Zenith**, 2003
**Philippe Starck** (France)
**Black crystal**
© Philippe Starck

佩吉勺，2008
葆拉·朗格尼，马拉斯·吉安卢卡(意大利)
镀银黄铜
© Paola Longoni & Marras Gianluca

**Peggy Spoon**, 2008
Paola Longoni, Marras Gianluca (Italy)
Brass silvered
© Paola Longoni & Marras Gianluca

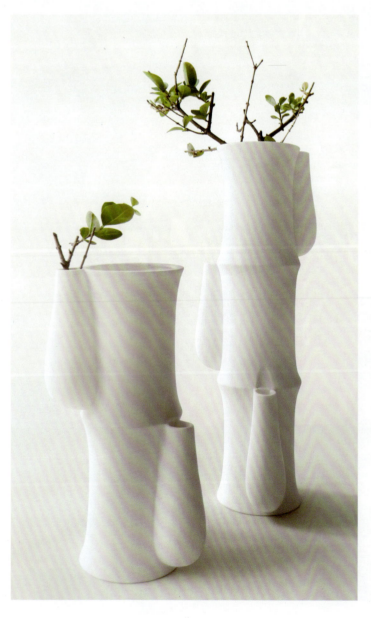

竹节花瓶Ⅰ，2010
吴其华（吴为），刘轶楠(中国)
骨瓷
© LITOU Creative&Design Center

**Bamboo Vase** Ⅰ, 2010
Wu Qihua & Liu Yinan (China)
Bone China
© LITOU Creative&Design Center

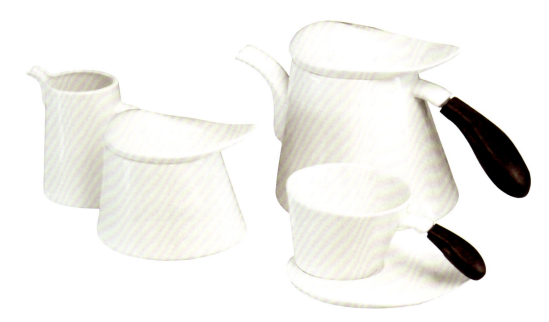

"风"咖啡具，2011
李泓，刘文伟(中国)
陶瓷
© Li Hong & Liu Wenwei

**Wind-Coffee Set**, 2011
Li Hong, Liu Wenwei (China)
Ceramic
© Li Hong & Liu Wenwei

草坪椅子，1971
乔治·切里提，皮埃特罗·德罗西，里卡多·罗索(意大利)
聚氨酯泡沫塑料，Guflac涂料
© Ceretti / Derossi / Rosso - Gufram

**Pratone**, 1971
Giorgio Ceretti, Pietro Derossi And Riccardo Rosso (Italy)
Cold polyurethane foam, Guflac paint
© Ceretti / Derossi / Rosso - Gufram

警惕白色污染，2009
王鹏，任蕊(中国)
印刷品
© Wang Peng

**Alert white pollution**, 2009
Wang Peng, Ren Rui (China)
Print
© Wang Peng

水滴壶杯组，2008
叶宇轩(中国台湾)
骨质瓷
© Yehidea Home Design

**Water-Drop Tea Set**, 2008
Yeh Yu –Hsuan (Taiwan, China)
**Bone China**
© Yehidea Home Design

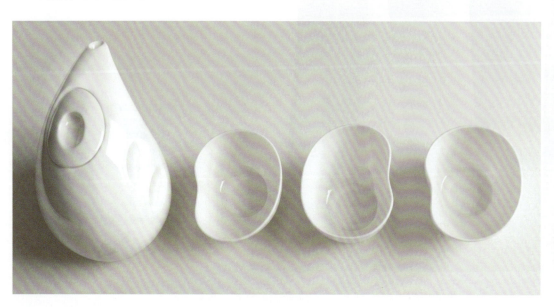 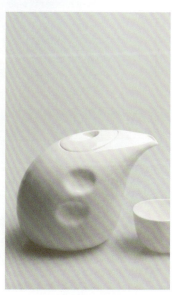

调料瓶，2008
郭锡恩，胡如珊(美国)
骨瓷
© Neri&Hu

**1/3 Salt & Peppers**, 2008
Lyndon Neri, Rossana Hu (USA)
Bone China
© Neri&Hu

2:1比例漆器 —— 超大碟子，2008
郭锡恩，胡如珊(美国)
中密度板，树脂，漆器
© Neri&Hu

**Lacquer Scale 2:1—oversized dish**, 2008
Lyndon Neri, Rossana Hu (USA)
Mdf, resin, lacquer
© Neri&Hu

2:1比例漆器 —— 超大托盘，2008
郭锡恩，胡如珊(美国)
中密度板，树脂，漆器
© Neri&Hu

**Lacquer Scale 2:1—oversized tray**, 2008
Lyndon Neri, Rossana Hu (USA)
Mdf, resin, lacquer
© Neri&Hu

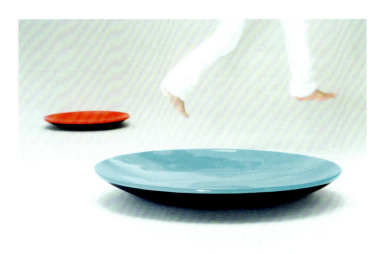
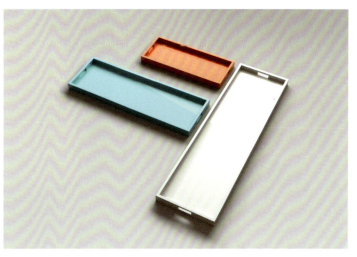

逸：青花玲珑吊灯组合，2009
吴凌之(中国)
陶瓷
© Vivian Wu

**Flying-Blue and white celling lamps**, 2009
**Vivian Wu** (China)
Ceramic
© Vivian Wu

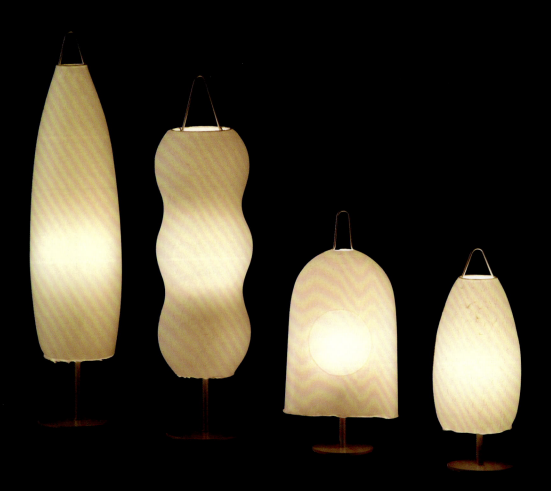

**Toh** 小号和中号落地灯/Tsuki落地灯/San落地灯，2005
喜多俊之(日本)
和纸，钢
© Photo: Luigi Sciuccati

**Toh stand-S / M, Tsuki stand, San stand,** 2005
**Toshiyuki Kita** (Japan)
WASHI paper, Steel
© Photo: Luigi Sciuccati

糖果灯，2011
亚米·海因(西班牙)
白瓷，水晶
铜色瓷，水晶
铂金瓷，水晶
© Jaime Hayon

**Candy Light**, 2011
**Jaime Hayon** (Spain)
White Ceramic, Cristal
Copper Ceramic, Cristal
Platinum Ceramic, Cristal
© Jaime Hayon

"福克兰"灯，1964
布鲁诺·穆纳里(意大利)
铝结构，弹性面料
© Bruno Munari

**Falkland**, 1964
**Bruno Munari** (Italy)
Struttura in alluminio, diffusore in maglia elastica
© Bruno Munari

灯泡，2009
易春友，谭雪娇(中国)
竹子
© Photo : Nature home design studio

**Bulb**, 2009
**BBKen, Corri** (China)
Bamboo
© Photo : Nature home design studio

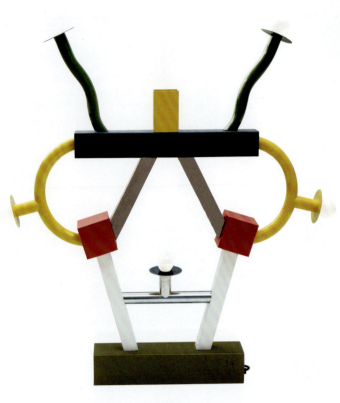

**Ashoka灯**，1981
埃托·索特萨斯（意大利）
上漆金属
© Memphis

**Ashoka**, 1981
Ettore Sottsass (Italy)
Lacquered metal
© Memphis

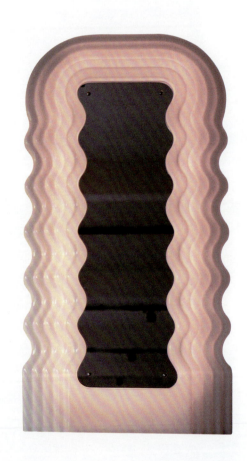

"超级草莓"镜，1970
埃托·索特萨斯（意大利）
乳白色塑料，霓虹灯，镜子
© Poltronova

**Ultra Fragola**, 1970
Ettore Sottsass (Italy)
Opaline plastic, neon light, mirrorr
© Poltronova

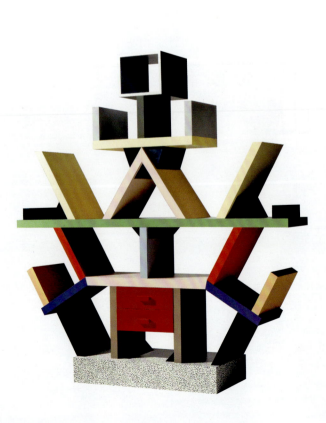

卡尔顿书架，1981
埃托·索特萨斯（意大利）
磨砂塑料层压板
© Memphis

**CARLTON**, 1981
Ettore Sottsass (Italy)
Laminato plastico
© Memphis

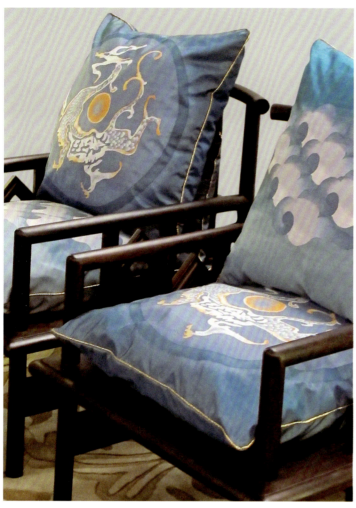

对话，2011
郑曙旸，田青(中国)
木材，毛，棉，麻，丝
© Zheng Shuyang & Tian Qing

**Dialogue**, 2011
**Zheng Shuyang, Tian Qing** (China)
Wood, wool, cotton, gunny, silk
© Zheng Shuyang & Tian Qing

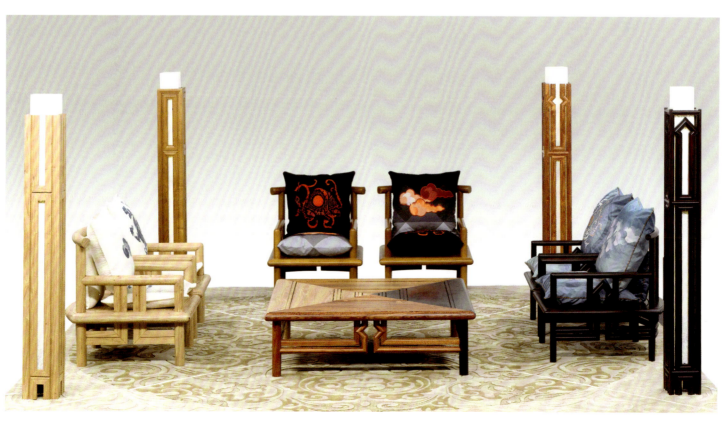

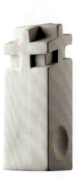

向菲利浦·罗森塔尔致敬（国际象棋限量版），2003
玛切洛·莫兰蒂尼（罗森塔尔创意中心）
（意大利）
瓷，树脂玻璃，木
© Marcello Morandini

**Hommage to Philip Rosenthal**, 2003
Marcello Morandini (Rosenthal Creative Center)
(Italy)
Porcelain, plexiglas, wood
© Marcello Morandini

"钱币"椅，2010
朱小杰(中国)
钢，海豹皮
© Zhu Xiaojie

**Coin Chair**, 2010
Zhu Xiaojie (China)
Steel, Seal fur
© Zhu Xiaojie

**ABC单人沙发**，1998
安东尼·奇特里奥(意大利)
金属，聚氨酯，皮革或织物
© Antonio Citterio

**Poltroncina A.B.C.**, 1998
Antonio Citterio (Italy)
Metal, polyurethane, leather/fabric
© Antonio Citterio

"道路"沙发，2010
鲁道夫·多多尼(意大利)
柚木，面料
© Rodolfo Dordoni

**Road**, 2010
Rodolfo Dordoni (Italy)
Teak, fabric
© Rodolfo Dordoni

甲骨文字绘，2010
陈楠(中国)
金属薄铝板（用于印刷制版的1mm厚铝板）
© Chen Nan

**Graphic Inscriptions on Oracle Bones**, 2010
Chen Nan (China)
Thin aluminium panel (1mm aluminium panel for printing works)
© Chen Nan

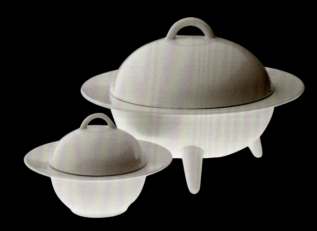

**Arita Nanakura盖碗，** 2002
喜多俊之(日本)
瓷
© Photo: Luigi Sciuccati

**Arita Nanakura Bowl With Cover**, 2002
Toshiyuki Kita (Japan)
Porcellana
© Photo: Luigi Sciuccati

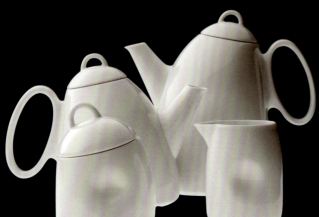

**Arita Nanakura，** 2002
喜多俊之(日本)
瓷
© Photo: Luigi Sciuccati

**Arita Nanakura**, 2002
Toshiyuki Kita (Japan)
Porcellana
© Photo: Luigi Sciuccati

曲苑风荷——2004作品1号，2004
邵帆（中国）
亚克力，老榆木
© Shao Fan

**Lotus: work No.1 of year 2004**, 2004
Shao Fan (China)
Acrylic, old elm
© Shao Fan

光艺术系列：刺激物，2000
阿提里奥·托诺(意大利)
蜂蜡，树脂玻璃，氙气灯
© Targetti Foundation

**Light Art Collection: Stimolazione materica**, 2000
Attilio Tono (Italy)
Bee wax, plexiglass, xenon lamps
© Targetti Foundation

厚薄折，2009
张永和(中国)
富美家 色丽石（CE01）
© Formica

**Thick and Thin Paper Folding**, 2009
Chang Yung Ho (China)
Formica surell (CE01)
© Formica

大汉风尚系列，2010
周尚仪(中国)
不锈钢，木
© Zhou Shangyi

**Expression of Han Dynasty-plate**, 2010
Zhou Shangyi (China)
Stainless steel, wood
© Zhou Shangyi

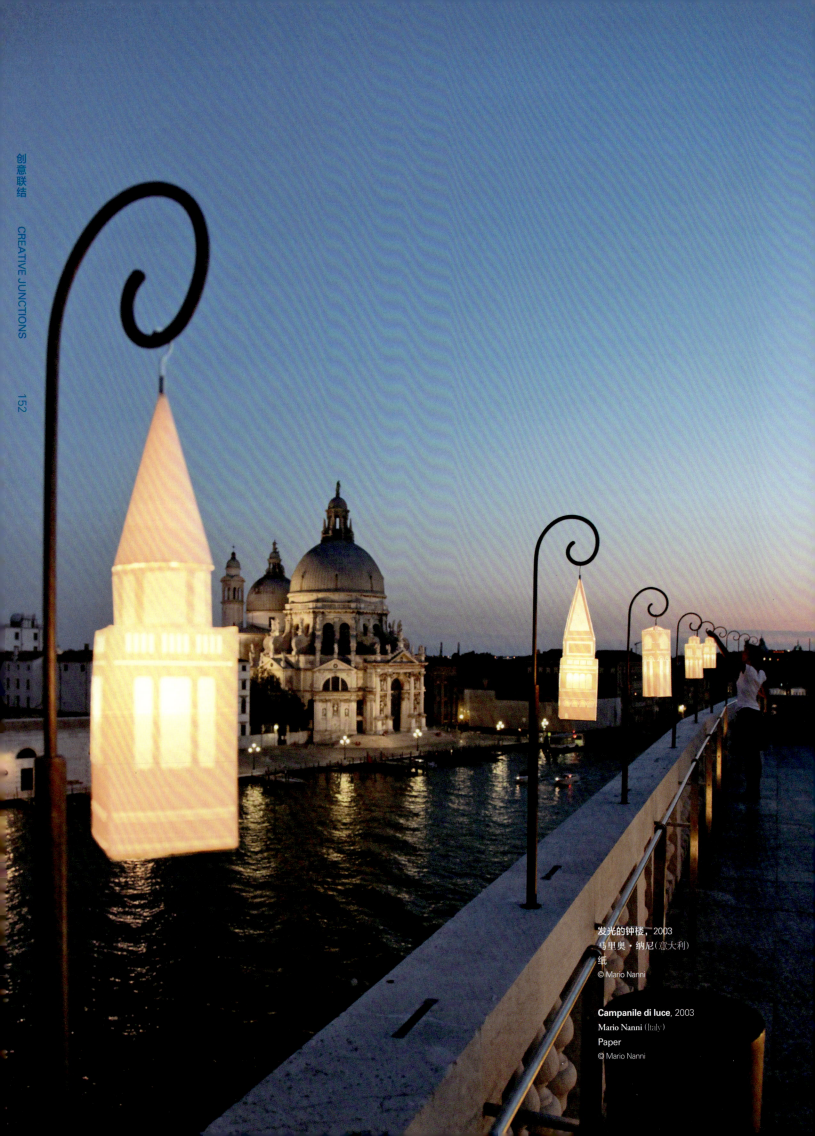

**Campanile di luce**, 2003
Mario Nanni (Italy)
Paper
© Mario Nanni

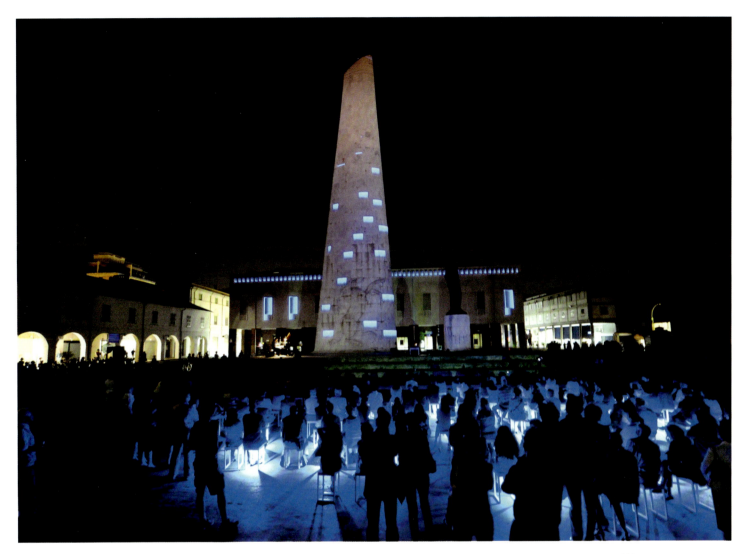

**Sga Bello** 地灯，2003
马里奥·纳尼（意大利）
木
© Mario Nanni

**Sga bello**, 2003
Mario Nanni (Italy)
Wood
© Mario Nanni

休闲椅，1948
查尔斯和蕾·伊姆斯夫妇(美国)
玻璃纤维，铬，橡木
© Vitra Collections AG

**La Chaise**, 1948
Charles & Ray Eames (USA)
Bonded fibreglass shells, chromed rod base, oak cruciform foot
© Vitra Collections AG

鱼盘，1957
罗贝托·桑博奈(意大利)
不锈钢
© Roberto Sambonet

**Fish Dish**, 1957
Roberto Sambonet (Italy)
Stainless steel
© Roberto Sambonet

充气椅，1967
纳森·德·巴斯，多纳托·德·乌日比诺，保罗·洛马齐(意大利)
透明PVC材料
© Jonathan De Pas, Paolo D'Urbino, Donato Lomazzi

**Blow**, 1967
Jonathan De Pas, Donato D'Urbino, Paolo Lomazzi (Italy)
Transparent PVC
© Jonathan De Pas, Paolo D'Urbino, Donato Lomazzi

**Tatino,** 1997
巴莱里·安利柯,桑塔其阿莱·丹尼斯
(意大利)
聚氨酯,织物
© Photo: ezio manciucca

**Tatino**, 1997
Baleri Enrico& Santachiara Denis (Italy)
Flexible polyurethane, internal anatomical
rigid structure. bi-elastic fabric in place
© Photo: ezio manciucca

**Tato,** 1995
桑塔其阿莱·丹尼斯(意大利)
聚氨酯,织物
© Photo: ezio manciucca

**Tato**, 1995
Santachiara Denis (Italy)
Flexible polyurethane, internal anatomical
slits bi-elastic fabric place
© Photo: ezio manciucca

**Tatone,** 1997
巴莱里·安利柯,桑塔其阿莱·丹尼斯
(意大利)
聚氨酯,织物
© Photo: ezio manciucca

**Tatone**, 1997
Baleri Enrico & Santachiara Denis (Italy)
Flexible polyurethane,cold-processed
anatomical rigid structure. Two lateral slits
bi-elastic fabric place
© Photo: ezio manciucca

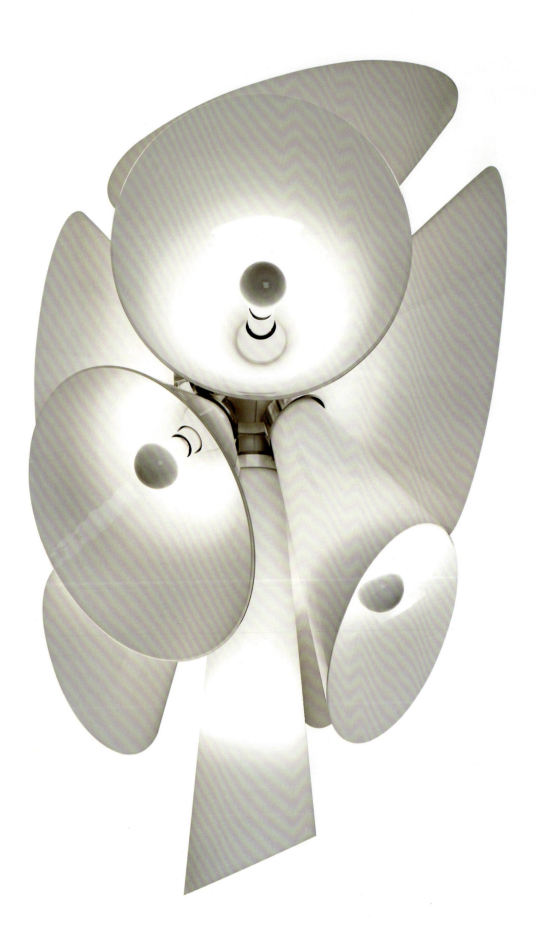

星云，2007
乔瑞斯·拉曼（荷兰）
铝，玻璃
© Joris Laarman

**Nebula**, 2007
**Joris Laarman** (Netherlands)
Aluminum, glass
© Joris Laarman

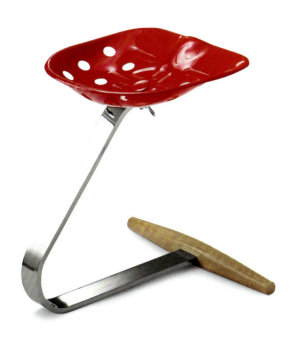

**Mezzadro**凳，1957
阿切莱·卡斯蒂里奥尼，皮埃尔·贾科莫·卡斯蒂里奥尼（意大利）
钢，木
© Achille Castiglioni & Pier Giacomo Castiglioni

**Mezzadro**, 1957
Achille Castiglioni & Pier Giacomo Castiglioni
(Italy)
Steel, Wood
© Achille Castiglioni & Pier Giacomo Castiglioni

水滴瓶，2010
肖 勇（中国）
玻璃
© Xiao Yong

**Drop**, 2010
Xiao Yong (China)
Glass
© Xiao Yong

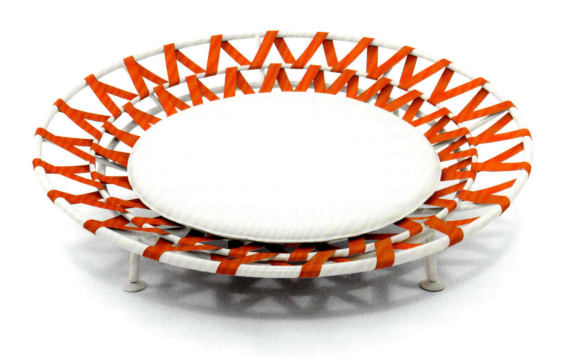

红巢椅，2009
西维亚·苏阿尔迪，阿克苏·赛斯格
（意大利）
上漆钢架铝管，缎带，坐垫
© Silvia Suardi & Aksu Sezgin

**Framura Nido**, 2009
Silvia Suardi, Aksu Sezgin (Italy)
Tubular aluminium structure with internal steel reinforce, painted with powder paint. Woven with polyester ribbon. Central cushion
© Silvia Suardi & Aksu Sezgin

铁杵成针，2011
贾伟(中国)
石材
© LKK Design

**Stone to Needle**, 2011
David Jia (China)
Stone
© LKK Design

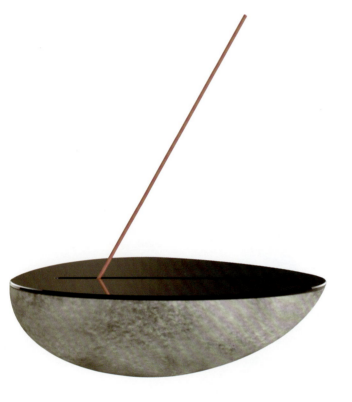

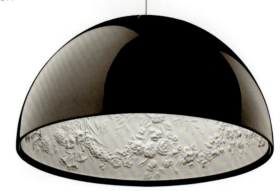

天空花园灯S2，2007
马寒尔·万德斯(荷兰)
石膏，玻璃，不锈钢
© Marcel Wanders

**SKYGARDEN S2**, 2007
Marcel Wanders (Netherlands)
Plaster, glass, stainless steel
© Marcel Wanders

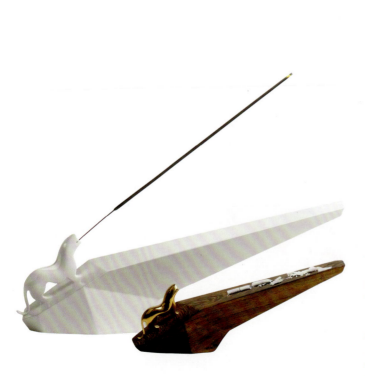

上山虎，2009
贾伟(中国)
陶瓷，鸡翅木，镀金
© LKK Design

**SHANG-TIGER: Incense Tray**, 2009
David Jia (China)
Ceramics, Chicken wing wood, gold
© LKK Design

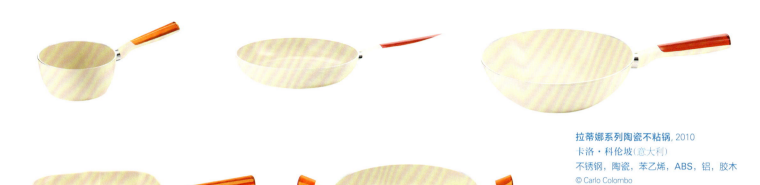

**拉蒂娜系列陶瓷不粘锅**, 2010
卡洛·科伦坡(意大利)
不锈钢，陶瓷，苯乙烯，ABS，铝，胶木
© Carlo Colombo

**Latina series ceramic coating pot**, 2010
Carlo Colombo (Italy)
Stainless Steel, Ceramic coating, San, ABS, Aluminium, Bakelite
© Carlo Colombo

**网络**，2008
马帝·古克斯(西班牙)
亚麻，棉，人造棉，聚酯
© Marti Guixé

**XARXA**, 2008
Marti Guixé (Spain)
Flax, cotton, staple ragon, polyester
© Marti Guixé

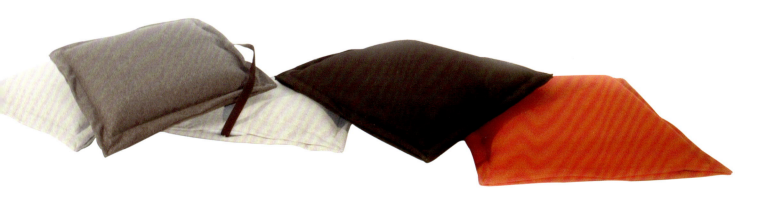

伊甸园刀叉组合，2009—2010
马塞尔·万德斯（法国）
昆庭银
© Christofle

**Jardin D'Eden**, 2009 - 2010
Marcel Wanders (France)
Christofle Silver
© Christofle

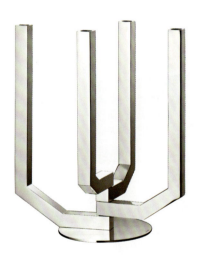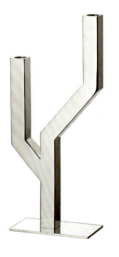

树枝烛台，2010
欧若·伊图（法国）
昆庭银
© Christofle

**Arborescene**, 2010
Ora-Ïto (France)
Christofle Silver
© Christofle

金色扎染风景花瓶，2008
帕特里夏·乌古拉（罗森塔尔创意中心）（西班牙）
瓷
© Patricia Urquiola

**Landscape Shibori Gold**, 2008
Patricia Urquiola (Rosenthal Creative Center) (Spain)
Porcelain
© Patricia Urquiola

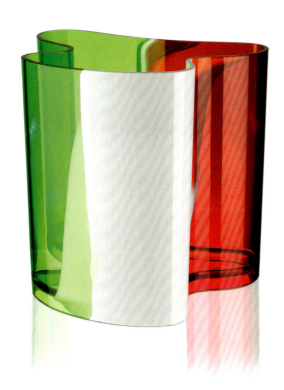

"伊索拉"杂志筐，2011
安杰莱蒂，鲁扎(意大利)
苯乙烯有机玻璃
© Angeletti&Ruzza

**Isola magazine holder**, 2011
Angeletti&Ruzza (Italy)
SAN PMMA
© Angeletti&Ruzza

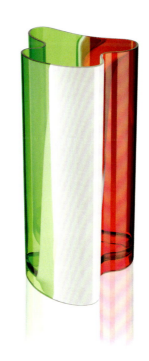

"浮云"雨伞筐，2011
安杰莱蒂，鲁扎(意大利)
苯乙烯有机玻璃
© Angeletti&Ruzza

**Nuvola umbrella holder**, 2011
Angeletti&Ruzza (Italy)
SAN PMMA
© Angeletti&Ruzza

"叶子"茶壶，2010
安德里亚·布兰兹(意大利)
陶瓷
© Andrea Branzi

**Teapot Foglia**, 2010
Andrea Branzi (Italy)
Ceramic
© Andrea Branzi

"幻想"双色碗，2008
卢卡·尼切托(意大利)
苯乙烯
© Luca Nichetto

**Mirage two-tone bowls**, 2008
Luca Nichetto (Italy)
SAN
© Luca Nichetto

**Gocce**
双色刀叉组，2011
安杰莱蒂，鲁扎(意大利)
苯乙烯有机玻璃
© Angeletti&Ruzza

**Gocce**
**Two-tone cutlery set**, 2011
Angeletti&Ruzza (Italy)
SAN PMMA
© Angeletti&Ruzza

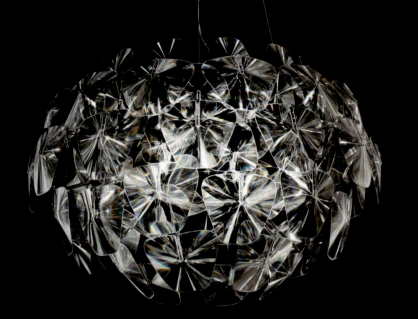

希望之灯，2009
弗朗西斯科·戈麦斯·帕斯，保罗·里扎托(阿根廷)
不锈钢，聚碳酸酯，棱透镜
© Francisco Gomez Paz & Paolo Rizzatto

**Hope**, 2009
Francisco Gomez Paz/ Paolo Rizzatto (Argentina)
Stainless steel frame, polycarbonate arms and prismatic lenses
© Francisco Gomez Paz & Paolo Rizzatto

"大地"浴缸，2006
深泽直人(日本)
热塑性聚合物
© credit Boffi, ph Duilio Bitetto

**Terra**, 2006
Naoto Fukasawa (Japan)
Cristalplant
© credit Boffi, ph Duilio Bitetto

**HOOO灯**，2010
菲利浦·斯塔克，珍妮·霍尔泽 (法国/美国)
铝，水晶玻璃
© Philippe Starck

**HOOO**, 2010
Philippe Starck, Jenny Holzer (France/USA)
Aluminum, blown cast crystal glass

卡门落地灯，2011
赫克托·赛拉诺(西班牙)
金属
© FontanaArte

**Carmen Terra**, 2011
Hector Sérrano (Spain)
Metal
© FontanaArte

Pirellone灯，1967
吉奥·庞蒂(意大利)
金属，玻璃
© FontanaArte

**Pirellone**, 1967
Gio Ponti (Italy)
Metal and glass
© FontanaArte

卡门台灯，2011
赫克托·赛拉诺(西班牙)
金属
© FontanaArte

**Carmen Tavolo**, 2011
Hector Sérrano (Spain)
Metal
© FontanaArte

"马戏团"地毯，2010
费尔南多·坎帕纳，翁贝托·坎帕纳
（巴西）
麻，布偶
© Polifemo Fotografia

**Circus**, 2010
Fernando & Humberto Campana (Brazil)
Hemp and rag dolls
© Polifemo Fotografia

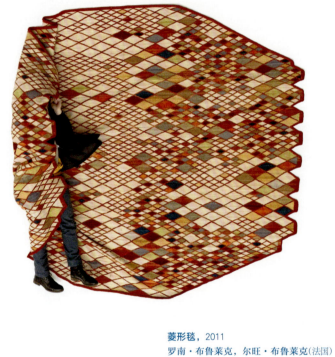

菱形毯，2011
罗南·布鲁莱克，尔旺·布鲁莱克(法国)
100%阿富汗羊毛
© Photo: Albert Font & Studio Ronan & Erwan Bouroullec

**Losanges**, 2011
Ronan & Erwan Bouroullec (France)
100% Wool (Afganistan)
© Photo: Albert Font & Studio Ronan & Erwan Bouroullec

"花海"地毯，2006
托德·布谢尔(荷兰)
100%染色羊毛毡
© Photo: Albert Font

**Little field of flowers**, 2006
Tord Boontje (Netherlands)
Dyed felt 100%Wool
© Photo: Albert Font

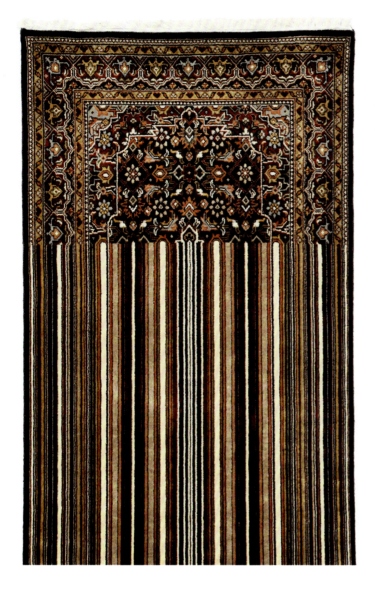

戏说传统，2009
理查德·胡腾（荷兰）
羊毛
© I+I

**Playing with tradition**, 2009
Richard Hutten (Netherlands)
WOOL
© I+I

"进化"橱柜，2009
费鲁齐奥·拉维阿尼（意大利）
抛光黄铜，橡木
© Ferruccio Laviani

**EVOLUTION cabinet**, 2009
Ferruccio Laviani (Italy)
Burnished brass, solid oak wood
© Ferruccio Laviani

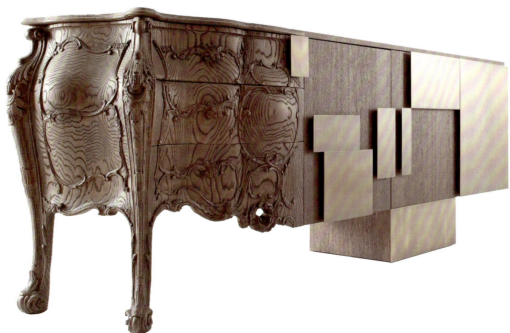

"记忆"沙发，2009
吉冈德仁(日本)
环保铝织物
© Tokujin Yoshioka

**Memory**, 2009
Tokujin Yoshioka (Japan)
Recycled aluminium fabric
© Tokujin Yoshioka

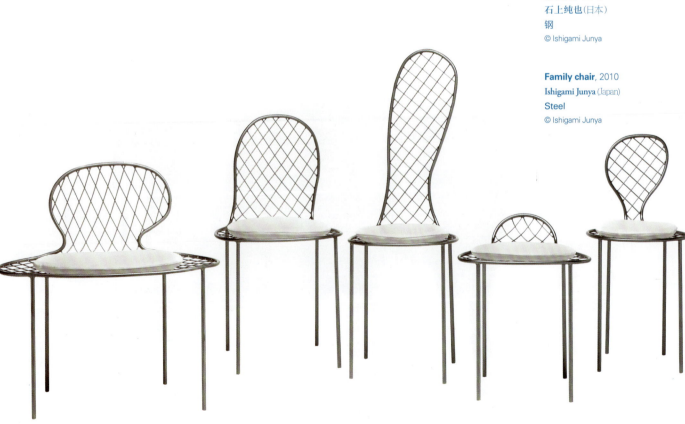

家庭椅，2010
石上纯也(日本)
钢
© Ishigami Junya

**Family chair**, 2010
Ishigami Junya (Japan)
Steel
© Ishigami Junya

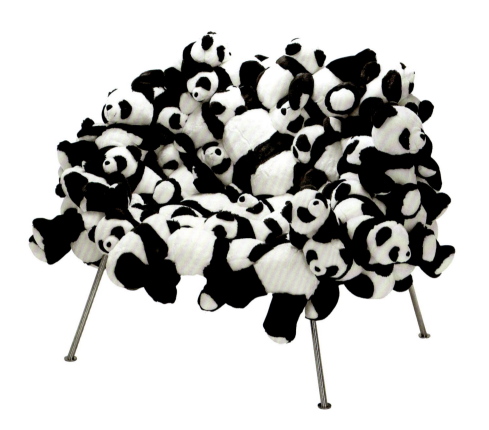

熊猫椅，2006
费尔南多·坎帕纳，翁贝托·坎帕纳
(巴西)
不锈钢，熊猫玩具
© Fernando Campana & Humberto Campana

**Banquete Chair with Pandas**, 2006
Fernando & Humberto Campana (Brazil)
Stainless steel, stuffed panda toys
© Fernando Campana & Humberto Campana

"娱乐时间"扶手椅，2006
亚米·海因(西班牙)
聚乙烯，皮革
© Design Republic

**Show time Armchair**, 2006
Jaime Hayon (Spain)
Polyethylene, leather
© Design Republic

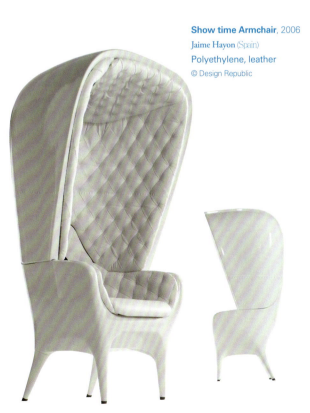

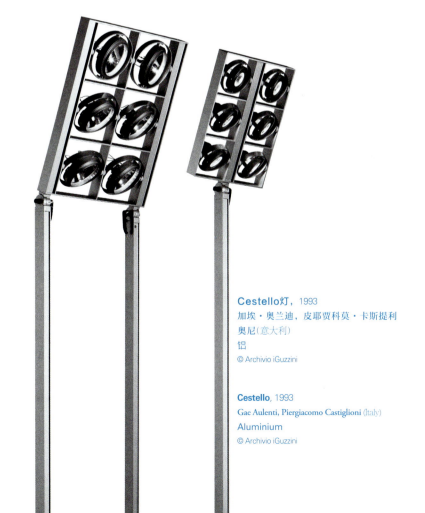

Cestello灯，1993
加埃·奥兰迪，皮耶贾科莫·卡斯提利奥尼(意大利)
铝
© Archivio iGuzzini

**Cestello**, 1993
Gae Aulenti, Piergiacomo Castiglioni (Italy)
Aluminium
© Archivio iGuzzini

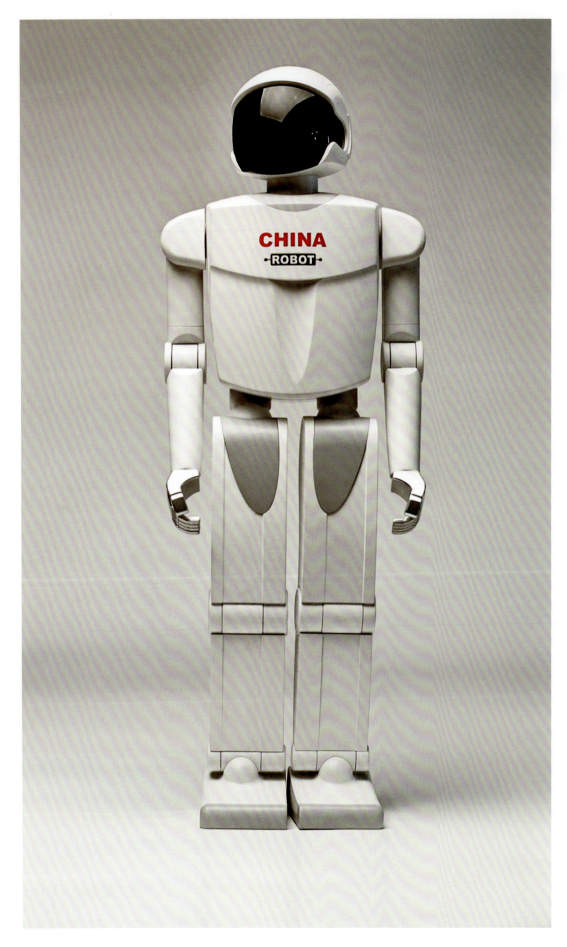

智能机器人，2010
张雷，刘凯威(中国)
金属，工程塑料
© Photo : Zhang lei

**Intelligent Robot**, 2010
Zhang Lei, Liu Kaiwei (China)
Metal, engineering plastic
© Photo : Zhang lei

隐形家具系列：长凳，2010
吉冈德仁(日本)
聚碳酸酯
© KARTELL S.P.A.

**The Invisibles Collection:Bench**, 2010
Tokujin Yoshioka (Japan)
Polycarbonate
© KARTELL S.P.A.

隐形家具系列：大扶手椅，2010
吉冈德仁(日本)
聚碳酸酯
© KARTELL S.P.A.

**The Invisibles Collection:Big armchair**, 2010
Tokujin Yoshioka (Japan)
Polycarbonate
© KARTELL S.P.A.

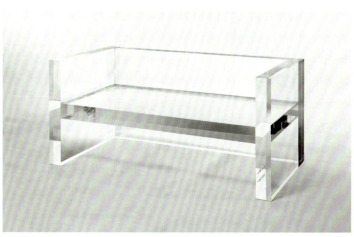

隐形家具系列：沙发，2010
吉冈德仁(日本)
聚碳酸酯
© KARTELL S.P.A.

**The Invisibles Collection: Sofa**, 2010
Tokujin Yoshioka (Japan)
Polycarbonate
© KARTELL S.P.A.

殇，2010
高一强(中国)
尼龙
© Photo :Gao Yiqiang

**Memory**, 2010
Gao Yiqiang (China)
Polyamide
© Photo :Gao Yiqiang

荷盘，2009
朱锫，吴桐(中国)
玻璃，水晶
© Swarovski

**Lotus Plate**, 2009
Zhu Pei, Wu Tong (China)
Glass and Crystal
© Swarovski

生物芯片扫描仪，2008
赵超(中国)
Abs塑料，金属，复合材质
© Zhao Chao

**Bio chip instrument Design: Luxscan HT microarray Scanner**, 2008
Zhao Chao (China)
ABS plastic, metal, and multi-material
© Zhao Chao

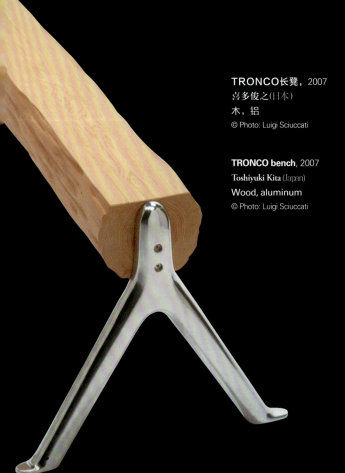

**TRONCO**长凳，2007
喜多俊之(日本)
木，铝
© Photo: Luigi Sciuccati

**TRONCO bench**, 2007
Toshiyuki Kita (Japan)
Wood, aluminum
© Photo: Luigi Sciuccati

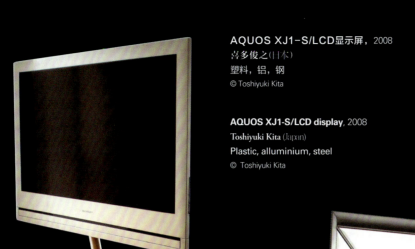

**AQUOS XJ1-S/LCD显示屏**，2008
喜多俊之(日本)
塑料，铝，钢
© Toshiyuki Kita

**AQUOS XJ1-S/LCD display**, 2008
Toshiyuki Kita (Japan)
Plastic, alluminium, steel
© Toshiyuki Kita

奥斯蒙，2005
皮埃特罗·德罗西(意大利)
铝，镜子
© Pietro Derossi

**Osmond**, 2005
Pietro Derossi (Italy)
Aluminium, mirror
© Pietro Derossi

+/− 桌，2011
谢一鸣(中国香港)
塑料，木，金属
© PEGA D&E

**+/− desk**, 2011
Zaru Xie (Hong Kong, China)
Plastic, Wood, Metal
© PEGA D&E

**11度**,2010
孙云(中国)
橡木
© Photo: Wood House Studio

**Angle of 11 degree**, 2010
Sun Yun (China)
Oak
© Photo: Wood House Studio

**之形架**,2011
Nendo公司(日本)
漆木
© Nendo

**Zigzag**, 2011
Nendo (Japan)
Lacquered wood
© Nendo

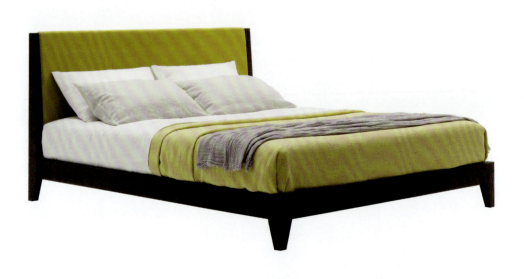

**Java床**,2009
曾士生(马来西亚/新加坡)
木,聚氨酯泡沫塑料,织物/皮革/生态皮革
© Chan Soo

**Java**, 2009
**Chan Soo** (Malaysia /Singapore)
Wood, polyurethane foam, fabric/leather/eco leather
© Chan Soo

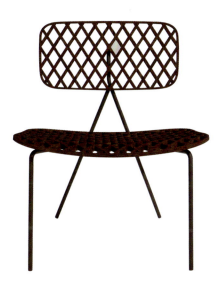

人系列椅子，2011
郭锡恩，胡如珊（美国）
橡木，喷漆钢管
© Neri&Hu

**Ren**, 2011
Lyndon Neri, Rossana Hu (USA)
Solid oak and tubular steel with powder coating
© Neri&Hu

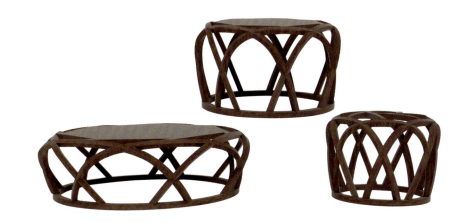

网系列凳子，2011
郭锡恩，胡如珊（美国）
橡木
© Neri&Hu

**Wang**, 2011
Lyndon Neri, Rossana Hu (USA)
Solid oak
© Neri&Hu

无线，2010
郭锡恩，胡如珊（美国）
施华洛世奇水晶，不锈钢，有色玻璃
© Neri&Hu

**Un-Wired**, 2010
Lyndon Neri, Rossana Hu (USA)
Stainless steel, swarovski crystal, colored glass
© Neri&Hu

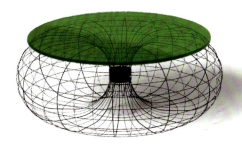
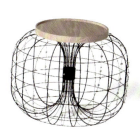

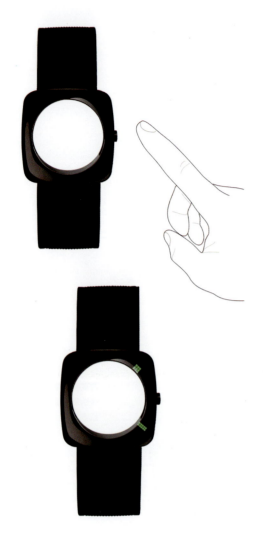

风暴之眼，2009
钱轶冉(中国)
塑料
© Photo: Qian Yiran

**Eye of The Storm**, 2009
Qian Yiran (China)
Plastic
© Photo: Qian Yiran

安藤艺术玻璃系列，2011
安藤忠雄(日本)
玻璃
© Ando Tadao

**Artglass Collection: Ando**, 2011
Ando Tadao (Japan)
Glass
© Ando Tadao

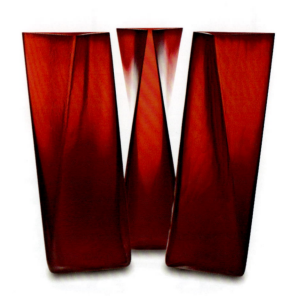

水纹系列，2005
谢东(中国)
骨瓷
© Xie Dong Studio

**The Series of Flowing Water**, 2005
Xie Dong (China)
Bone China
© Xie Dong Studio

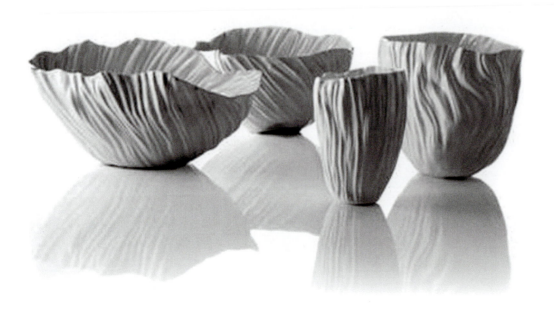

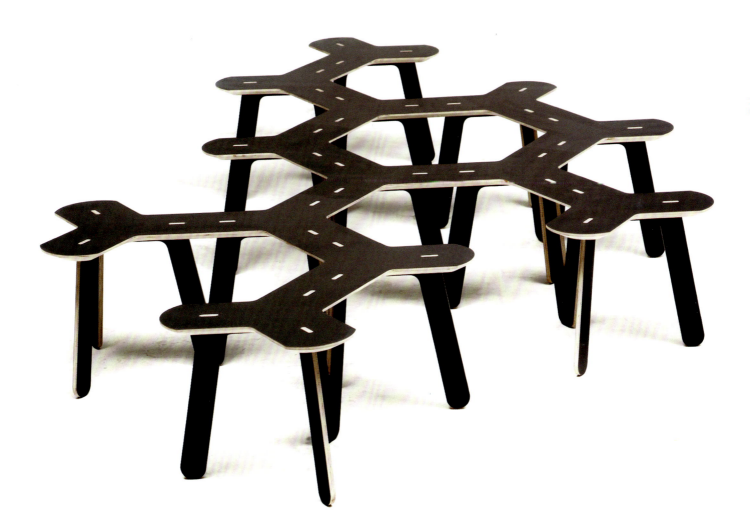

团契7，2010
孙云(中国)
多层板
© Photo: Wood House Studio

**Fellowship Groups7**, 2010
Sun Yun (China)
Multi-layer boards
© Photo: Wood House Studio

# 2.

## 知"竹"
## RETHINKING BAMBOO

| 策展人 | Curators |
|---|---|
| 刘小康（中国香港） | **Freeman Lau** (Hong Kong, China) |
| 杭间（中国） | **Hang Jian** (China) |

**刘小康**(中国香港)
**杭间**(中国)

**Freeman Lau** (Hong Kong, China)
**Hang Jian** (China)

## 单元主题阐释

谚语有谓："知足常乐"。"竹"的普通话发音与"足"相近，其实，知"竹"也是快乐的。竹子确实可以满足人类生活众多方面的需要。

竹子在西方植物学的角度被定性为木质草科，从中国人的角度看则"不刚不柔，非草非木"，与草木皆不同。全世界的竹子种类共有1250多种，其中约有100多种可用于商业开发。《康熙字典》中，竹字部首字共968字，其中竹器物字共495字；《辞海》中，常用竹器物字共223字，可见竹子用途之广泛。

本次展览有两大策划焦点：首先探讨竹子象征的文化精神及其在生活里的应用；进而立足亚洲，借鉴西方。作为一次世界性的竹子考察及最具前瞻性的竹设计展览，本展览将关注中国、亚洲乃至全世界的竹设计，分为五个部分呈现：
1. 意：文化之竹（引子）
2. 艺：工艺之竹
3. 器：日用之竹
4. 境：建筑之竹
5. 悟：创新之竹

本展览邀请来自欧美及亚洲共66位设计师及参展机构，展出逾150件竹设计作品、珍贵图片及装置。展览以"竹生活"为概念，并从文化、现代设计及科技提升的角度对其进行探索，其中包含了对竹传统的应用、欣赏，以及现代设计从中得到的启发。

现时世界流行的LOHAS (Lifestyle of Health and Sustainability)，是一种生活方式，又可说是慢生活；将来，又会否有一种"竹生活"呢？

## Interpretation of the Sub-theme

As the saying goes, "to achieve a state of contentment (zhi zu) is to truly know one's own happiness". The pronunciation of "Bamboo" (zhu) in Mandarin sounds like "enough" (zu). Indeed, a better understanding of this ubiquitous plant brings its own rewards. Bamboo can indeed bring fulfillment to the many needs in human life.

In Western botanical studies, bamboo is classified as a Poaceae, a member of the true grass family. However, from a Chinese perspective, it is 'neither hard nor soft neither grass nor wood'. It is different from both. There are around 1,250 varieties of bamboo found in different parts of the world, with more than a hundred suitable for commercial development purposes. In "Kang Xi Dictionary", there are a total of 968 Chinese characters with "bamboo" as a radical and 495 of these characters denote a bamboo utensil; and in "Ci Hai", a dictionary especially for combinations of single Chinese characters, 223 entries of commonly-used bamboo utensils are found. The large amount of Chinese words relating to bamboo indicates its wide-ranging applications.

"Rethinking Bamboo" is curated with two questions in mind: What are bamboo's cultural and pragmatic significances? And what can we learn from the use of bamboo in Western designs? This current exhibition features a worldwide research and study on bamboo and the most forward-thinking bamboo design, showcasing works from all over the world under five themes:
1. Metaphor – Bamboo in Chinese Culture (Prologue)
2. Craftsmanship – Bamboo Craftsmanship
3. Utensils – Bamboo in Daily Life
4. Space – Bamboo and Architecture
5. Rethinking – Bamboo Innovation

We have invited 66 designers and participating organisations from Asia, Europe and the United States in exhibiting over 150 precious pieces of bamboo design works, images and installations. The exhibition takes "bamboo life" as a concept and explores it through cultural, modern design and technological advancement perspectives which include applications and appreciation of and inspiration from traditional bamboo craftsmanship.

Today, LOHAS (Lifestyle of Health and Sustainability), a new way of living also is regarded as slow living is gaining its popularity. Would we see in the future, the emergence of a 'Bamboo Life'?

## 刘小康

香港设计中心董事会副主席，香港设计总会秘书长，
香港当代文化中心董事，香港理工大学院士

刘小康，1958年生于香港，毕业于香港理工学院（香港理工大学前身），并于1982年在新思域设计制作任设计师，1985年出任主任设计师。1988年，刘小康应靳埭强先生之邀请，合力成立"靳埭强设计有限公司"，于1996年更名为"靳与刘设计顾问"，现为公司合伙人。

从1984年起，刘小康获香港及海外之奖项超过三百项，其中包括：1989年德国莱比锡最佳书籍设计银奖、香港设计师协会双年展金奖及苹果大奖、1993年东京字体协会铜奖及纽约水银奖金奖、1997年韩国第三届国际海报三年展全场大奖、1995年路易·卡地亚卓越成就奖、1997年以设计师身份获颁香港艺术家年奖及全港十大杰出青年、1998年Porsche Design 创意动力大奖、2000年莫斯科Golden Bee奖、新加坡设计奖、台北国际海报双年展全场大奖、日本滋贺县长滨市海报比赛长滨市长奖及2001年香港理工大学校友会联会颁发之"杰出理大校友"奖等。

刘小康于2001年应邀参与北京申奥海报设计比赛，以首名获选并印制成官方宣传品，这幅海报于同年荣获芬兰拉赫蒂第十三届国际海报双年展之最佳体育海报奖。2003年，由韩国的当代实验性设计协会举办的亚太地区海报三年展为刘小康带来另一奖项。2004年，他为屈臣氏蒸馏水设计的水瓶，荣获"瓶装水世界"全球设计大奖。在该项水瓶设计中，刘小康成功结合艺术、文化、设计和商业元素，在提升品牌市场占有率的同时，也促进了本土文化的发扬。2006年，刘小康凭此获香港传艺中心颁发大中华杰出设计大奖。2008年，他在设计上的成就得到肯定，荣获第三届中国国际设计艺术观摩展终身设计艺术成就奖。2010年，刘小康获中国美术学院艺术设计研究院颁予年度成就奖。2011年，获颁香港理工大学院士名衔。

刘小康对设计的贡献并不限于其个人之创作。自1990年代起，刘小康积极投入于设计的公共服务，如担当香港设计师协会主席及发起"设计与香港委员会"。其中，"设计与香港委员会"之重点研究，反映香港具有相当人口从事设计行业，并标志着设计行业发展的潜力。借着相关研究，香港政府对设计业界从业员的尊重大大提升。

刘小康现担任多间非盈利设计机构的领导职位，包括香港设计中心董事局副主席、香港设计总会秘书长及国际设计管理学会的顾问。刘小康于2006年获香港特别行政区政府颁授的铜紫荆星章，以此肯定其在国际舞台上为提升香港设计形象所付出的努力。

## Freeman Lau

Vice Chairman of the Board of Directors of Hong Kong Design Centre,
Secretary General of the Hong Kong Federation of Design Associations,
Director of Hong Kong Institute of Contemporary Culture,
University Fellow, The Hong Kong Polytechnic University

Born in 1958 in Hong Kong, Freeman Lau was graduated from the Hong Kong Polytechnic, now the Hong Kong Polytechnic University, which is highly reputed for design. He started his career at SS Design & Production and became the Art Director in 1985. In 1988, he joined Kan Tai-keung Design & Associates Ltd and became the Partner of "Kan & Lau Design Consultants" ever since 1996.

Freeman has won over 300 design awards since 1984, which prove his international success. To name a few, these awards include Silver Award in International Book Design Exhibition, Leipzig Germany (1989); Bronze Award in Typodirectionim Tokyo (1993); Outstanding Graphic Designer – the Louis Cartier Award of Excellence (1995); Porsche Design 'Creative Energy' Award (1998); Golden Bee Awards, Moscow (2000); Singapore Design Award (2000); The Mayor of Nagahama Prize, Japan Poster Grandprix (2000); First Prize in poster design competition of "Beijing's Bid for the 2008 Olympic Games" (2001); Best Sport Poster, Lahti Poster Biennale, Finland (2001) and etc. His remarkable achievement is fully recognized by the society while he was awarded Ten Outstanding Young Persons (1997) and Outstanding PolyU Alumni Awards (2001).

In 2004, Freeman achieved another milestone by designing the Watson's Water Bottle, which was later awarded the international "Bottlewaterworld Design Awards" (2004) and Outstanding Greater China Design Awards, Hong Kong Communication Art Centre (2006). He has created a model of symbiosis among art, culture, design and business acumen, which significantly increased the brand's share of market. It is also regarded as a contribution to the local cultural movement while creative talents from different sectors were invited to design iconic labels for the bottle. Many local citizens got to know these talents through daily products. His contribution to design is appreciated and awarded Lifelong Design and Art Achievement Award in the 3rd (Jiajun) International Exhibition of Design and Art in China (2008), Achievement Award, Art Design Institute of China Academy of Art (2010) and University Fellow, The Hong Kong Polytechnic University (2011).

Freeman's contribution to the society is not limited to his own designs. He devoted himself to many public services such as being the chairman of Hong Kong Design Association (HKDA) and co-founding "Design: Hong Kong" in the 1990s. The major research report by "Design: Hong Kong" has statistically proved the huge labor force of design sectors in Hong Kong and marked the potentials of Hong Kong Design industry. It is not too much to claim that design practitioners have gained greater respect from the government after the release of the report.

Currently, Freeman is the Vice-Chairman of the Board of Directors of Hong Kong Design Centre. Their annual event, Business of Design Week (BoDW), is regarded as one of the most successful ones in Asia. Freeman's contribution in enhancing the identity of Hong Kong design is recognized by the Hong Kong government and was eventually awarded the Bronze Bauhinia Star in 2006.

## 杭间

艺术史学家、清华大学美术学院副院长、教授、
中国美术家协会理事、理论委员会副主任

杭间，1961年生于浙江义乌，从事中国古代物质文化史、现当代设计理论和中国现代艺术史研究。1994-1999年任《装饰》杂志主编，2000-2004年任清华大学美术学院艺术史论系主任，2003-2005年任汕头大学长江艺术与设计学院副院长，2005-2006年任美国康内尔大学城市与规划学院高级访问学者。2008年至今，任清华大学美术学院副院长。

主要策划的展览有：中国现代绘画展（1995年，德国）；学院化状态六人展（1998年）；中国现代手工艺学院展（2004年）；岁寒三友：两岸三地中国传统图形与现代设计作品展（2006年）；"包豪斯道路：历史、遗泽、世界和中国"文献展（2010年）；设计新青年：中国内地六所设计学院学生作品展（2010年）；手艺的新美学——中国现代手工艺术家提名展（2010年）等。

曾获高等学校科学研究（人文社会科学）优秀成果奖，第十届北京哲学社会科学优秀成果一等奖，第七届北京市哲学社会科学优秀成果二等奖，中国艺术研究院学术著作奖。

出版著作：《新具象艺术》，吉林美术出版社，1999年；《中国工艺美学史》，人民美术出版社，2007年；《原乡—设计》，重庆大学出版社，2009年；《设计道——中国设计的基本问题》，重庆大学出版社，2009年；《中国传统工艺》，五洲传播出版社，2010年；《手艺的思想》，山东画报出版社，2001年。主编《中国著名设计师学术访谈丛书》、《中国古代物质文化经典图说丛书》等。

## Hang Jian

Vice-dean of the Academy of Arts & Design, Tsinghua University, Art History Professor, Director of the Chinese Artists Association, Associate Director of the Theoretical Council of Chinese Artists Association

Hang Jian, born in 1961, focused on the research of the history of material culture in ancient China, modern and contemporary design theory, modern Chinese art history. 1994-1999, he served as the editor in chief of Zhuangshi magazine, Tsinghua University; 2000-2004, he was appointed the head of the Department of Art History, Academy of Arts & Design, Tsinghua University; 2003-2005, he was the associate dean of the Cheung Kong School of Art and Design, Shantou University; 2005-2006, he was the senior visiting scholar of the City and Regional Planning program, Cornell University, U.S.A.

He curated many exhibitions such as Modern Chinese Painting Exhibition(Germany, 1995), Institutionalized--Six Artist's Works Exhibition(1998), College Fair of Chinese Modern Arts and Crafts(2004), Three Friends of the Scholar: Traditional Graphics and Modern Design Work from mainland, Taiwan, Hongkong and Macao(2006), Documentary Exhibition of "Path of the Bauhaus: Its History, Legacy, World and China" (2010),"Design of the New Youth: Students Work Exhibition from Six Design Schools in Mainland China "(2010) , "New Aesthetics of the Craftsmanship—Modern Chinese Craftsman Nomination Exhibition" (2010) , etc.

He has been awarded Scientific Research Award for Outstanding Achievements in Humanities and Social Sciences, Academic Publication Award from the Chinese National Academy of Arts, Young College Teacher Award from China's Ministry of Education, the first prize of the Tenth Beijing Philosophy and Social Science Award, and the second prize of the Seventh Beijing Philosophy and Social Science Achievement Award.

He published many works such as *Nouveau Realisme*, Jilin Fine Arts Press, 1999; *History of Chinese Craft Aesthetics*, People's Fine Arts Publishing House, 2007; *Hometown • Design*, Chongqing University Press, 2009; *Way of Design—Essential Problem of Chinese Design*, Chongqing University Press, 2009; *Traditional Chinese Craftsmanship*, China Intercontinental Press, 2010; *Thinking about Craftsmanship*, Shandong Pictorial Publishing House, 2001. He also edited *Series Interview of Famous Chinese Designer*, *Collection of the Illustrated Handbook of Material Culture in Ancient China*, etc.

# 知"竹"

刘小康

## 前言

竹子在中国人及至亚洲人的设计角度里,是从文化层次及生活情感出发,以竹喻人。相对地,西方视竹为一种环保简约的物料,反映一种回归大自然的生活态度。彼此出发点有异,形成有趣的对话,比较双方的竹设计,当可求同存异,找到竹子的今日意义。此次展览有两大策划焦点:首先探讨竹子象征的文化精神及其在生活里的应用;进而立足亚洲,借鉴西方。

## 一、意

竹子在中国文化的象征意义,迥异于在西方人认知及应用中的地位,体现出古人对"天人合一"的追求,贯穿在人格、情操和生活态度里,象征着一种气节,一种雅,一种境界。正如宋代包恢在《竹轩记》里说:"竹之中虚,我之心也;竹之外直,我之行也;竹之节刚,我之介也;竹之干峻拔,我之高也;竹之根深固,我之本也;竹之色常青,枝叶常秀,我之文也。"

在中国文人画里,竹子更是非常重要的题材。宋代的文同以墨代色,画出竹子的脱俗、写意、写心中的情怀;元代的李衎以观竹为生活情趣,所画出的《竹谱》成为至今写竹不二的章法;清代郑板桥爱竹、敬竹、画竹,以"一竹一兰一石,有节有香有骨"为君子的象征,并以之自况……又如明代王守仁在《君子亭记》中写道:"君子之道四焉:中虚而静,通而有间,有君子之德;外节而直,贯四时而柯叶无所改,有君子之操,应蛰而出,遇伏而隐,雨雪晦明,无所不宜,清风时至,风止籁静。"

故此,此次展览的首要部分——意,以文人名士画竹的意境来展现竹子蕴含的柔而不屈的特性:"挺直而有节、难折而柔顺、常青而不凋……",代表传统中国文人精神。

## 二、艺

在展览的第二部分——艺,从传统竹艺看竹子在亚洲日常文化中的千年渊源。所谓"知足常乐",而"竹"与"足"之音相近,所以民间器物常以竹子为吉祥图案,寓意生活富足。而不同地区的工艺变化,也令竹子在中国人生活中的涵义更加丰富。

竹广泛分布于热带和亚热带地区,在西方植物学里被归类为大型木质草本植物,其四处扩展和多鞭的根系能抓紧泥土,有助防止水土流失。然而中国人的分类却有所不同。晋代的戴凯之在《竹谱》里说:"不刚不柔,非草非木;小异空实,大同节目;内实外泽",很形象地道出了竹子与草木皆不同的特质。

全世界的竹子共有1250多种,其中约有100多种具备商业潜质,包括可用于建材的木质竹,如毛竹、慈竹,而可用于器物制造的则有孟宗竹、桂竹和紫竹等。《康熙字典》中,竹字部首字共968字,其中竹器物字共495字;《辞海》中,常用竹器物字共223字,可见竹用途之广泛。竹的每一部分都有用处:竹笋、竹笙可吃,竹叶可编器皿,竹茎可作建材。它们一般生长在气候湿润的山区,也适应非农耕地和森林边缘。因其木质茎干生长迅速,可年年砍伐更新,加上取材灵活、应用广泛,为家具制造及建筑板材料的理想材料。

看看亚洲地图,从中国岭南地区到云南西双版纳、四川成都、浙江温州,以及中国台湾南投县的竹山镇,再延伸至越南、缅甸、印度特里普拉邦、东南亚的泰国清迈地区及印度尼西亚爪哇西部,均是产竹盛地。因此,这些地区历来都是全球竹工艺品、竹家具制造及竹建材业最为兴盛的地区,有关技术也最好。例如,中国香港继承了岭南地区的竹棚工艺传统,在现代建筑中仍然广泛使用竹材料。而越南民俗博物馆则收藏了不同部族使用的竹篮子,当地居民以之上山采摘、背到市集就地一搁即可摆卖,尽显生活智慧。

如今,欧洲设计的竹家具生产地来源主要是越南、缅甸及中国的浙江地区;中国台湾则以本土工艺为主,配合设计师的创意,开发可量产的当代竹设计产品,相对其他地区发展更为成熟及有系统。反观较少受设计界注意的印度及东南亚地区如泰国,近年来小开始有新一代的设计师深入竹乡如印度特里普拉邦的山克拉(Sankhla)地区,与当地种竹的农民及传统竹艺师合作,研发出具有当地传统特色的新颖竹家具设计。印度人利用传统的扎作方法,却摆脱了旧有形式,造出具欧洲风格的精品家具。而泰国则以传统的风筝竹扎作方法取代惯常的扎作或者编织制法家具,旧法新用,带来新的启发。

## 三、器

竹制品在生活中的角色,也反映各国民众的生活方式。印度年轻设计师桑伽如(Sandeep Sangaru)从印度人的生活特点及城市发展的状况出发,设计自己的作品。他以三角形竹构件的力学设

计为原点，组合变化出轻巧、稳固而善用空间的竹家具，既有简约主义的美学味道，又蕴含印度传统竹工艺实用优点。

在泰国，许多家族世代以制风筝为业；但随着现代城市发展的步伐，竹制风筝正被淘汰，而近年来许多以竹家具营销为生的厂家代理，也因订单的减少而停止生意，情况一如中国南方原本盛极一时的竹扎工艺的式微。成长于竹制风筝家族、读设计的克拉克特（Karakot Aromdee），对祖业兴趣浓厚，亦想贡献当地小区，适时地灵活改变思维，硕士毕业后开始将爷爷传授的竹扎风筝传统手艺加上自己的工业设计训练背景，揉合成当代竹灯饰设计，旋即闯出名堂，广受欧洲设计界认同，为泰国的传统竹工艺找到了新的发展方向。

"器"的部分还会探讨设计与科技的配合，看设计师如何运用竹，而科技又怎样提取出竹的优点。若说到中国的竹设计，中国竹乡四川成都的竹凳便是佼佼者。做竹凳的方法，从传统的手工艺，发展成现代技术，其中两款竹凳，到今天仍广泛使用。在成都少城及罗城，竹凳随着城里人饮茶、看戏曲的生活习俗而传承不衰，这在陈锦先生的《川人茶事》里有非常生动的记载。成都的竹凳使用，可说是十分独特的现象。它承载着的不只是坐者的身体重量，还有社区的习俗和邻里间的关系。竹凳是成都人生活的一部分，不仅经济实用，而且长时间使用后会滋润出一种难以取替、别具魅力的光泽。

中国台湾的当代设计发展也值得注意。在当地政府大力推动及投资下，当地的工艺师及设计师共同开发新品牌，为世界所瞩目，而其中一项设计，用的正是新兴的材料——竹。中国台湾工艺研究发展中心研发了yii品牌以及"自慢活"系列，设计切合人们生活需要及品位要求的构想，美观、实用，而且呈现了浓厚的台湾本土竹工艺特色，在海外渐获认同。

中国台湾的竹从中国内地移植而来，但因生长的气候完全不同，形成了南投县竹山镇独有的孟宗竹。其特殊的韧度与内地的品种不一样，因此制成品的质感也不同。例如中国台湾竹山镇的竹工艺师林群涵先生，就利用孟宗竹及桂竹独特的温润质感，研究出"保青"技术，可将竹器皿如茶壶、茶杯、筷子的原生青绿色在室内环境下保留达七年。

同时，著名中国台湾设计师石大宇先生，十多年来一直致力研究"竹条"设计概念。他现时正探究讲求四平八稳的桌子结构，如何与竹条弹性与韧性的特征完美结合。他于2011年研制出新的竹桌子，巧妙地转化竹条的弹性为刚性。桌脚的主体由三片竹条构成，各自以120度的角度相交，每隔一段间距再以竹制套件扣紧巩固桌脚主体，增加结构强度，由此使竹条的刚性成为可能。竹条以本真的姿态表现竹材长纤维的特性，而竹制加固套件则像竹节一样给予支撑，两者的关系正是竹子原生结构的再现。还有陈仁毅先生设计的"咏竹系列"家具，以经风历雨的陈年玫瑰紫檀竹，作为硬木家具的表面饰材，善用竹的温润质感。

日本设计师在这方面也有很多探索，如美国旧金山亚洲文化博物馆哥臣收藏（lloyd Cotsen Collection）中的日本传统竹花器，其工艺展现的已是纯艺术表现的抽象性及美感。当然亦有当代建筑师及设计师研究竹家具设计的可能性，如雅万那卡（Yamanaka Group）专为本次展览而设计的蘑菇凳，也是以竹的韧性及承托力为重点而设计的。此外，日本京都大学的松重和美教授研制的、以竹编成车身的电动车Bamgoo，既轻巧又凉快、美观，让人耳目一新。

欧洲人与亚洲人的竹设计很不同。亚洲人与竹子的关系比较密切，也有祖传的传统技术和本土习俗，使竹子不单单是一种建材物料，还包含了多重象征意义。相反，对于欧洲设计师，竹子代表的是一种新的生活态度，是一种环保概念和回归大自然的实践。东西方看竹的起点也许不同，但今天是殊途同归，都希望把竹子的象征意义，无论是来自传统文化的深厚积淀还是现代的创造，都融入到当代设计中，以表达一种新的生活态度。

当然，据学者吉连（Gillian Walkling）在《竹古董家具》（Antique Bamboo Furniture,1979）中的记载，早在18世纪中期，已有中国竹制古董家具外销的风潮，但当时的热情源自对中国的猎奇多于美学欣赏或文化了解的渴求。反观现时的欧洲竹设计，荷兰设计师受到东南亚地区如缅甸、越南竹工艺的启发，结合了欧洲当代设计美学观点及趣味，进行东西文化交流，研发出新的视角及品牌。例如自2006至2007年，由马尔科（Marco Groenen）及学者柏布罗（Pablo van der Lugt）合作成立的"竹实验室"（Bamboo Labs），在商界及学院的支持下，推行竹产品研发计划"荷兰设计遇上竹子"（Dutch Design Meets Bamboo），结合学术研究、科技实验及实践量产，研发当代竹家具设计的可能性及品牌开发。其中，艾德·范·恩格仑（Ed van Engelen）及斯蒂恩·凡·韦科姆（Stijn van Woerkom）以竹子剖面，保存竹子结构的轮廓，制成屏风图案及桌子。这种纵向破开，以竹节示人的设计，为中国几千年来罕见，构成一件相当特别的作品。

此外，"器"也重点介绍竹子在交通工具方面的运用。除了前面提及的日本竹制电动车外，在世界知名的单车之城哥本哈根，拜奥米加（Biomega）公司就采用了英国著名设计师洛斯（Ross Lovegrove）的竹制单车架为其新品牌代表作；荷兰设计师卡特·艾高塔（Karta Agotob）也以环保回收的概念设计出以竹作车架的单车；竹单车设计在菲律宾原本早已流行，卡华欣科技（Kawayan Tech）公司设计的竹单车系列，不仅包括爬山、市区代步和电动单车等型号，还有以俗称"人面竹"的独特竹节设计了"艺术单车"的骨干，以及专供儿童使用的小型车；欧洲则有瑞典著名的汽车厂"云速"（Rinspeed Inc.），由法兰克（Frank M. Rinderknecht）操刀，设计出以竹纤维、竹材为汽车

内笼装潢的休闲车，于2011年三月正式登场。

由此可见，竹设计已建立环保、舒适又时尚的形象，已成为当代设计的一项重要元素，象征着一种全新的生活态度。

### 四、境

从竹子与建筑的关系，也可观察人类的生活态度及智慧。中式竹建筑是大量民间智慧的累积，如形制始于公元前250年（秦昭王）、横跨四川成都都江堰的竹索桥——安澜桥，以竹为绳、木桩为墩，承托巨大门索，上铺木板以通行人。以竹索为桥之主体结构，承传上千年之久，还有竹亭、河上的小竹楼房，都是巧妙地利用竹的特性而建的。在南方，中国香港亦有沿袭两千多年、岭南文化里最完整鲜活的传统竹棚技艺，其主要应用在两方面：现代建造工程及演变自汉唐时期的"棚阁"搭建技巧临时戏棚。

东南亚地区及中国岭南地区，因地处沿海及海运要道，所产竹子以质地坚硬的毛竹为主；加上潮湿的气候、频密的洪水及风灾等环境因素，促成了这些地区应用竹子于居住的传统。这些地区保留了传承自原始时代的干栏式建筑传统，随各地的地方文化及历史因素，各自发展出独特的规范及形制。自2000年始，香港建筑师严迅奇及林伟而将竹棚艺术带出海外，并借着结合当代建筑设计以及艺术装置，在国际间引起热切的兴趣和关注。

不同于中国香港，印度尼西亚爪哇西部至今仍保留了半固定竹屋的建筑传统面貌。不只是屋子的外部结构，内内外外，连墙壁、家居用品、床铺等，均是以竹织成或制造的。这些传统半永固竹建筑，包括住宅、酒店、小区中心和学校，据印度尼西亚研究组织普斯达喀尔（Pustaka Rumahkebun）提供的资料，寿命可达27年之久，比中国的戏棚更进一步，耐久而与现代建筑方法兼容，为世界首创，更可能是竹建筑发展的新方向。

其实，一些传统的扎竹方法早已有改进，例如由用竹篾到胶篾再到胶索带，已是设计上的几度进展。中国香港的传统竹棚工业是由公司储存一批竹，重用一段时间后才替换，环保、经济而有效率。以竹子的强度和生长速度计算，若广泛取代木材作为建材，成本不及十分之一。现时所见灾区的临时建筑不敷应用，若存有竹材，在灾害发生时便能马上运到灾区，在一两天搭内建起小区中心、医疗站和传讯中心等，以解燃眉之急。

建于印度尼西亚巴厘岛、世界知名的绿色学校村（Green School Village），不但实现竹建筑设计的可能，其教育意义及对下一代的启发，更为重要。而以竹建筑作为关注环境及绿色生活的象征，呈现未来生活态度的具体实践，已经蔚为风潮，从竹建酒店如泰国的六感酒店（Six Senses Hotel）的流行可见一斑。

而以竹为建筑板材方面，用竹代替木板来做水泥砖模是其中一种行之有效而不被注意的技术。现时竹压板技术已大量使用在地板生产方面，更开始应用在墙壁方面。最新的技术已发展至将竹纤维抽出来，加入合成材料，造成非常规的建材。比较创新的方法，可见于日本建筑师隈研吾（Kengo Kuma）于2002年在北京八达岭"长城下的公社"计划里，尝试将竹子内部穿上钢筋、注入水泥，使其成为建筑物的支撑梁柱，虽然当时并不成功，后来却在日本造出来了。

制成地板材料及家具、器具的板材的技术在中国台湾已发展得很成熟：小至一支笔、桌面用具，大至家私，甚至在电子产品上的应用，如计算机键盘，都一应俱全。虽然中国台湾的板材技术并未大规模应用到建筑空间里，但中国内地则因为高速开发房地产而将这种技术广泛应用在板材上，其以量发展的方向看来是独有的。例如浙江杭州的永裕竹业股份有限公司（YoYu Bamboo Joint-Stock Co.Ltd）及其姊妹公司杭州合骏竹文化创意有限公司（Hangzhou Hotry Bamboo Culture & Creativity Co.Ltd）分别以量产竹地板、办公室家具及厨具等成为国内外最大的竹产品供货商。

当然，中国内地将竹用于办公室家具等用途是好的开始，但还停留在作为生产材料的层面，在设计层面上，精致程度却未及中国台湾、印度等地区，未曾真正利用竹的特性，深入地探讨竹的当代设计发展。

### 五、悟

最后，未来生活中竹子将有更广阔、抽象的应用方式，值得提出探讨。竹子除可变成合成材料外，其摄取物如竹纤维可用于制造衣物、毛巾和地毯等；历史悠久的英国品牌刚古纸，于2011年推出含50%竹纤维的"竹造纸"，用于计算机打印效果理想，打破了之前粗糙、不适合印刷的局限。此外，竹炭除了可吸收异味，清新空气，其远红外线辐射也有益人体，因此竹纤维内衣、保健产品愈趋普及。

超出造型，直接对人体有好处的新产品，未来还大有尝试空间。例如日本的在野浴品设计公司（Uchino Bath Designs）的方形蜂巢孔状竹炭块，抽象的外观设计使其应用走向时尚。还有中国台湾研制的竹盐、竹醋液、竹牙膏、竹芯茶、竹炭食品及饮料等——竹变成了生活的另一种可能性。

### 结语

竹子，一如前述中国文人欣赏其内涵的情意结，在当代设计的过程中，不只是创作材料，更应是对世界环境关注的责任感及生活态度的启发，以及文化传承的载体。从文化、现代设计、科技的提升角度去探讨竹传统，包含了对其应用、欣赏和从中寻求启迪与之相通的竹设计将是未来生活一种重要的形式，现时世界流行的LOHAS（Lifestyle of Health and Sustainability，又称慢生活），将来又会否有一种"知竹（知足）生活"呢？

# Rethinking Bamboo

Freeman Lau

### Introduction
From a Western perspective, bamboo is an environmentally friendly and natural material, pointing to an organic way of life. The East, on the contrary, emphasises its cultural and sentimental values as a metaphor for personhood. These contrasting approaches form the basis of an interesting dialogue. Through comparing bamboo designs from the East and the West and henceforth reaching a consensus of the two, the exhibition aims to investigate the role and significance of bamboo in contemporary society. 'Rethinking Bamboo' is curated with two questions in mind: What are bamboo's cultural and pragmatic significances? And what can we learn from the use of bamboo in Western designs?

### The Metaphor – Bamboo of Culture
The cultural significance of bamboo to the Chinese differs from a Western perspective on both symbolic and pragmatic levels. For the Chinese, bamboo is an embodiment of cultural ideals. It is the harmony between man and nature that is to be realized through moral integrity, grace and virtue, which are in turn observed in Bamboo. As Bao Hui (Song Dynasty, 960-1270) said in Zhu Xuan Ji ("Notes on the Bamboo Veranda"): The hollow bamboo is my humility; the straight bamboo is my conduct; The bamboo's strength is my courage; the bamboo's height is my will; The bamboo's deep roots are my foundation; the evergreen bamboo is my words.

Bamboo is also often the subject matter in Chinese literati paintings. Wen Tong of Song Dynasty used black ink instead of colours to depict bamboo, revealing his modesty through simplicity. Li Heng of Yuan Dynasty (1271-1368) took pleasure in bamboo-seeing. His work, Zhu Pu ("the bamboo score") is regarded till today as the reference to bamboo-drawing techniques. Zheng Banqiao of Qing Dynasty (1644-1911) loved, respect and drew bamboo. His quote "one bamboo, one orchid, one rock; has integrity, has charm, has courage" expresses the qualities these plants possess as a metaphor for qualities gentlemen should pursue, such as integrity and moral courage. Exactly as Wang Shouren of Ming Dynasty said in Jun Zi Ting Ji ("Notes on the Bamboo Pavilion which represents a Gentleman"):

The way to be a gentleman includes four parts:
A gentleman's virtue is to be generous at heart and peaceful in mind, he is to be always upright and constant. It awakens in spring and provides shade in summer. Able to withstand both rain and snow, both darkness and light. Once the breeze has passed, silence remains.

Along this vein, the first section of our exhibition, "Metaphor - Bamboo of Culture (Prologue)", Chinese literati paintings on bamboo were used to demonstrate both the tenderness and firmness in the character of bamboo. "The stem, tall and straight, represents honour; the hollow interior represents modesty; it is soft yet resilient, and is evergreen." This is the spirit of our literati.

### Craftsmanship – Bamboo of Handicraft
This section, we go on to investigate, through traditional bamboo handicrafts, the millennia-old kinship between bamboo and the Chinese people, as well as Asians at large. As the saying goes, "to achieve a state of contentment (zhi zu) is to truly know one's own happiness". In Mandarin the pronunciation of "bamboo" (zhu) is similar to "sufficiency" (zu); bamboo is thus often used on utensils as an auspicious symbol which denotes a life full of wealth and satisfaction. Variety in craftsmanship in different regions further enriches the meaning of bamboo in the life of Chinese people.

The plant is widely distributed in tropical and subtropical zones and is classified as a large-sized xyloid poaceae in Western botany. Typical of poaceae, bamboo's rhizome system retains soil effectively and helps prevent soil erosion. Yet the Chinese hold a different view regarding classification. Dai Kaizhi of the Jin Dynasty (165-420) wrote in Zhu Pu (The Companion to Bamboo): "neither hard nor soft, neither grass nor wood. Some are not hollow, but all have nodes"; "strong structure with a sleek appearance," are vivid descriptions that show the difference in the nature of bamboo and grasses or trees.

Of the 1,250 or so varieties of bamboo, more than a hundred are suitable for commercial use. Phyllostachys (Mao bamboo) and Neosinocalamus are ideal construction materials, while Mao Bamboo, Makino Bamboo and Phyllostachys nigra can be manufactured into utensils. The wide application of bamboo in China is also evident in the large amount of Chinese words relating to bamboo. In "Kang Xi Dictionary", there are a total of 968 Chinese characters with "bamboo" as a radical, 495 of these characters denote a bamboo utensil. In "Ci Hai", a dictionary specifically compiled for the combination of singular Chinese characters, 223 entries of commonly-used bamboo utensils are found.

Every part of bamboo has its use: bamboo shoots and bamboo fungi are edible, household containers are often woven from bamboo leaves, while bamboo culm is regularly used for construction. Bamboo is well adapted to moist, mountainous terrains, non-agricultural land or at the peripheries of forests. As its xyloid culm grows rapidly, bamboo regenerates every year. Versatile, adaptable, fast-growing, it is the ideal

raw material for furniture making and construction.

Bamboo is found all across Asia. In China, it spreads from Lingnan area, Xishuangbanna of Yunan Province, Chengdu of Sichuan Province and Wenzhou of Zhejiang Province of China. It is also found in Zhushan of Nantou Province of China Taiwan, Vietnam and Myanmar, spanning over Tripura in India, Chiang Mai in Thailand and West Java, Indonesia. Unsurprisingly, bamboo is used widely to make handicrafts, furniture and construction materials, compared to the rest of the world. China Hong Kong inherited the Lingnan legacy of bamboo scaffolding and it is still extensively used in modern construction. Another example is the bamboo baskets used by various tribes that are exhibited at the Vietnam Museum of Ethnology. The very same bamboo basket is used for both fruit picking in the mountains and display at markets, demonstrating a clever use of the material, which is in turn embedded in the local way of life.

Currently, most raw materials for European bamboo furniture come from Vietnam, Burma and Zhejiang region in China. On the other hand, China Taiwan focuses mainly on the development of local handicrafts, incorporating creativity from designers and exploring the possibilities of mass producing contemporary bamboo design, which is a more mature and systematic approach to this new business.

In areas largely overlooked by the international design industry such as India and Thailand, a new generation of designers is joining the trade of bamboo design. Through working with local bamboo growers and traditional bamboo handicrafters from areas like Sankhla of India Tripura, these Asian designers create new furniture pieces with rich local flavours. Indian designers apply the traditional binding technique into a more European style of contemporary bamboo furniture making. Similarly, Thai designers make modern furniture with their traditional kite binding skills, updating tradition to a modern context.

### Utensils - Bamboo of Daily Use
The way bamboo products are used reflects the way of living of in various cultures.

One of the major challenges to traditional bamboo culture is modernization. In Thailand, the bamboo industry faces similar challenges from modernisation. Traditional family kite-making businesses are having a hard time surviving amidst rapid urban development. In recent years, bamboo furniture factories are also closing down due to shrinkage of the market, which is comparable to the decline of bamboo binding industry in southern China. Brought up in a kite-making family, Karakot Aromdee combines traditional techniques with modern industrial know-how in designing contemporary lighting. His works soon gain recognition in the European design circle and opened up an exciting direction for traditional bamboo design in Thailand.

On the other hand, the young Indian designer Sangaru Sandeep interprets the influences of urban development and as result combines modern aesthetics with the practicality of traditional Indian bamboo craftsmanship. He created light, sturdy and space-saving bamboo furniture from triangular bamboo components, subtly preserving the essence of traditional Indian craft.

In the two Chinese cities, Shaocheng and Luocheng in Chengdu, known as the "home of bamboo", bamboo chairs are seen everywhere even in the age of rapid urbanisation. With the tea-drinking and opera-watching culture in the city, the particular kind of bamboo chairs has become an indispensible part of everyday life, which is vividly depicted in About Sichuan People and Tea by Chen Jin. Not only are bamboo chairs inexpensive and sturdy, they acquire a charming sheen with use, symbolising the legacy and solidarity of a community.

This section also investigates the marriage of design and technology, looking at how designers manipulate bamboo in their works and the role of technology in extracting the essences of bamboo.

Sponsored and brought forward by the government, one of latest research projects of the China Taiwan Craft Research and Development Institute focuses on bamboo as a new material. Recently launched brand "yii" and a product line "New Lifestyle" combines traditional bamboo craft with contemporary design. The products are practical, handsome and most importantly, infused with China Taiwanese craftsmanship.

Bamboo in China Taiwan was imported from Mainland China. Nevertheless, Phyllostachys edulis (Moso bamboo, named "Meng Zong" Bamboo in Taiwan) in the Zhushan Town of Nantou Province has acquired the unique characteristics in the local climate. Its flexibility is different and the finish products have a special quality and texture to them. 'Evergreen' treatment, developed by Master Lin Qun-han, enables bamboo utensils to retain its natural green colour for seven years in indoor environments.

Mr. Jeff Shi Dayu, an internationally-acclaimed designer from China Taiwan, has devoted more than a decade to the creative possibilities of bamboo strips. Mr. Shi launched a new bamboo table in 2011 – an ingenious design which transforms the elasticity of bamboo strips into firm support. Each leg of the table is constructed with three pieces of bamboo strips, crossing each other at an angle of 120°. At regular intervals, bamboo locks are added to reinforce the structure, attaining to the hardness of bamboo. Bamboo strips represent the strength of bamboo fibre in their original form, while the bamboo locks provide structural support as in nodes. It is indeed an ingenuous imitation of natural. On the other hand, Mr. Jerry J.I. Chen's (Chunzai, Shanghai) "Ode to Bamboo" series uses a piece of aged Rose Sandalwood bamboo as surface material on a hardwood furniture, fully utilising the pleasant, warm texture of bamboo.

Japanese designers have also made substantial progress in the field. The traditional Japanese flower baskets of The Iloyd Cotsen Collection at the Asian Art Museum in San Francisco transcend materiality into abstraction, achieving the aesthetics of fine art. Contemporary architects and designers are also part of the movement in exploring the possibilities of bamboo furniture design. One example is the "Mushroom Stool" specially designed by the Yamanaka Group for this

exhibition, which plays with the flexibility and load-bearing capacity of the material. Professor Matsushige Kazumi from the Venture Business Laboratory, Kyoto University of Japan has developed an electric vehicle "Bamboo" with a bamboo-woven exterior. It is thus a lightweight, cool and pleasant design product bringing a fresh and new concept to users.

According to Antique Bamboo Furniture (1979) written by Gillian Walkling, the export wave of antique Chinese bamboo furniture dates back to as early as the mid-18th century. At that time, people became passionate about Chinese antiques because of exoticism more than any genuine aesthetic or cultural interests. In recent years, among their European counterparts, Dutch bamboo design deserves more attention. They are often inspired by bamboo designs in Southeast Asian countries such as Burma and Vietnam. These renowned designers assimilate European contemporary aesthetics in their creative process and are nurturing new brands and new perspectives. For example, in 2006 and 2007, with the help of the commercial sector and institutions, Bamboo Labs, co-founded by Marco Groenen and researcher Pablo van der Lugt launched a bamboo product development project named "Dutch Design Meets Bamboo". Integrating academic research, technological expertise and mass production, the project explores the possibilities for brand-building in contemporary bamboo furniture design. Ed van Engelen and Stijn van Woerkom of Bamboo Labs made use of the cross-section of bamboo in making patterns for room-dividers and tables where the inner structure of bamboo is revealed. Using vertically fractured bamboo, with the bare nodes facing outwards, a design that is rarely envisaged throughout the long history of China, is still regarded as a truly special piece.

Yet another focus of this section is the use of bamboo in transportation. Besides the Japanese electric vehicle mentioned above, bamboo is also used in transportation in Copenhagen, a city famous for its cycling-friendliness. The Biomega Philosophy Company adopted the design by the well-known English designer Ross Lovegrove and produced bicycles with bamboo frames, which became the signature piece of the brand. Dutch designer Karta Agotob sees his bamboo bicycle as a statement on recycling and environmental protection. As a matter of fact, bamboo bicycles have been used in the Philippines for a long time. The Kawayantech company has its own bamboo bicycle series, which includes mountain bikes, urban bikes and electrical bikes. They even made use of Phyllostachys aurea, which has a very special node pattern, in their "Art Bike" series. Kids will be happy to see their small bamboo bicycle made especially for them. Another European vehicle model which have recently joint the trend is Rinspeed Inc. designed by Frank M. Rinderknecht. It has a bamboo fibre and bamboo wood interior and was officially launched in March 2011.

To conclude, bamboo designs are environmentally friendly, comfortable and at the same time fashionable. They symbolise a brand-new lifestyle and have become an important element in contemporary design.

Space – Bamboo of Architecture
We will now look into human mentality and wisdom as reflected in bamboo and architecture.

One of the gems of pre-modern bamboo architecture can be found in Sichuan, China. An ancient bamboo bridge by the name of An-lan Bridge across Dujiangyan of Chengdu was built in circa. BC 250 (the time of Emperor Zhao, Qin Dynasty). It consists of ropes woven from bamboo and wooden stakes for its foundation, on top wooden boards were placed for the passage of people. Elsewhere, bamboo pagodas and bamboo houses built on rivers also utilise the characteristics of bamboo cleverly. The traditional skill of bamboo scaffolding is preserved in China Hong Kong – a most lively and complete part of the Lingnan culture dating back more than 2000 years. Bamboo scaffolding in Hong Kong is applied in modern construction and building bamboo-shed theatres, which evolved from the "peng ge" structure found in the Han and Tang Dynasties.

In Southeastern Asia, due to local factors such as humid climate, frequent floods and typhoons, the application of bamboo has become both tradition and the norm. These regions have inherited the building method of stilt houses, a method which can be dated back to primeval times. These are just a few examples of how cultural, historical and environmental factors lead to the unique uses of the same resource. Such cultural variety is celebrated by Hong Kong architects Rocco Yim and William Lim, who brought bamboo scaffolding into international architecture arena from year 2000 receiving high acclaims.

Different from the situation in China Hong Kong, in West Java, Indonesia, bamboo structures are not only temporary. The outer structure of the house as well as the furniture, bedding and utensils are all made of bamboo. This form of architecture is used in residences, hotels, community centres and schools. According to a research by Pustaka Rumahkebun, this kind of semi-permanent constructions can last for up to 27 years. The Indonesian bamboo architecture tradition is a step ahead of Chinese bamboo-shed theatres – with its durability and compatibility with modern construction techniques. It is possibly a new direction of bamboo architecture that is not yet explored elsewhere. In fact, the development of "traditional" bamboo-binding techniques in no way stagnant. Over the years there have been technological advancements for example the use of bamboo strips, plastic strips to zip ties.

Moreover, bamboo architecture has an edge over conventional systems in many aspects. Bamboos used in scaffolding in China Hong Kong are stored and reused, only to be replaced when worn out. It is an environmentally friendly, economical and efficient system. Bamboo grows much faster than trees. Taking into account the growth time and strength, replacing wood with bamboo as a standard construction material could lower the cost by more than 90%. In fact the use of bamboo in concrete templates making is well-developed albeit less well-known. Also, bamboo platen pressing plates are now commonly used in the production of flooring and the technique is also applied to wall paneling. It is now technologically possible to extract bamboo fibre which can be mixed with composite materials to produce highly

standardised construction materials. In 2002, Japanese architect Kengo Kuma experimented with a radical way of working with bamboo. As part of the "Commune by the Great Wall" project, he inserted steel bars into the hollow of the culms of the plant and filled them with concrete, making them into structural pillars. Despite initial failure, he succeeded later in Japan. In cases of emergency, bamboo temporary shelters can be erected quickly and efficiently in disaster areas.

The world-famous Green School Village built in Bali of Indonesia, the significance bamboo is not only a construction material, it also educates and inspires the next generation to pursuit a more organic lifestyle. A recent trend in hotel building with bamboo such as the Six Senses Hotel in Thailand reveals that bamboo architecture is increasingly seen as a symbol of eco-friendliness.

The techniques for the production of bamboo boards for flooring and manufacturing of utensils and household items have been developed very well in China Taiwan. Bamboo production is a very mature method and products are numerous and varied: items as small as pens, stationeries, and to larger pieces like furniture and even application in digital products such as keyboards of calculators. While the technique of platen flat pressing is not yet a common practice in Taiwan, it is widely used in Mainland China due to the rapid development of real estate. The largest suppliers of bamboo furnishing materials in China are YoYu Bamboo Joint Stock Co. Ltd stationed in Hangzhou of Zhejiang and its sister company Hangzhou Hotry Bamboo Culture & Creativity Co. Ltd.

The extensive application of bamboo design in office furniture is no doubt a great start. However, in China bamboo is still merely a construction material. When it comes to design concept and product quality, it is still to catch up with Taiwan and India. All in all, the full potential of bamboo as a material is yet to be realised.

### Rethinking - Bamboo of Creativity
Having showcased the impressive cultural background and endless possibilities of bamboo, we shall conclude by considering the potential of the material in a more extensive and abstract fashion. One example is bamboo extract.

Bamboo extract is very useful in manufacturing fabric items such as garments, towels and rugs. Conqueror, the well-established British paper-making brand, launched a new series containing 50% bamboo fibre this year. The result of the application in printing calculators was a huge success. It has overcome the material's inherent roughness and thus the limitation of printing on bamboo fibre.

In its incinerated form, bamboo works well as an air freshener to absorb unpleasant smells. This is but one of its many functions. Far infrared emitted from bamboo charcoal is also beneficial to the human body, and as a result bamboo health products and bamboo extract undergarments are becoming more and more popular. Uchino Bath Designs from Japan takes bamboo charcoal and transforms it into a square block made up of honeycomb-shaped tube; the abstract shape even adds a touch of chic to its uses. In China Taiwan, a wide range of bamboo-based products such as salt, vinegar, toothpaste, tea and food and drinks are available; it has become an alternative way of living today. In the future, besides using bamboo as a material in its original form, it will come as no surprise that there are more innovative products made from bamboo in extracted form.

### Conclusion
Bamboo, aforementioned, has historically been an object of emotional attachment and cultural symbolism to Chinese scholars. In the process of contemporary design, it has become much more than a raw material. It is associated with a sense of responsibility towards the environment, an inspired attitude to life and also a symbol of cultural legacy. Hence, it is necessary to rethink bamboo from a cultural, modern design and technological perspectives, both in terms of appreciation and application. Most likely, bamboo culture is an important mode of living in the future. Today, LOHAS (Lifestyle of Health and Sustainability) is increasingly popular; in the near future, why not a "contented (Zu) bamboo (Zhu)" lifestyle?

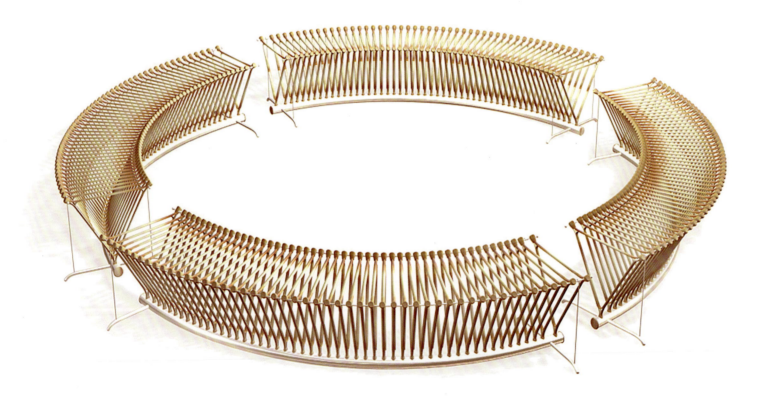

**Truss Me长凳,** 2011
桑迪普·桑伽如(印度)
竹
© Sangaru Design Objects Pvt. Ltd.

**Truss Me Bench**, 2011
Sandeep Sangaru (India)
Bamboo
© Sangaru Design Objects Pvt. Ltd.

**Truss Me 拐杖**,2011
桑迪普·桑伽如(印度)
竹
© Sangaru Design Objects Pvt. Ltd.

**Truss Me Crutch**, 2011
Sandeep Sangaru (India)
Bamboo
© Sangaru Design Objects Pvt. Ltd.

**Truss Me 组件凳**,2011
桑迪普·桑伽如(印度)
竹
© Sangaru Design Objects Pvt. Ltd.

**Truss Me Module-Stool**, 2011
Sandeep Sangaru (India)
Bamboo
© Sangaru Design Objects Pvt. Ltd.

**Truss Me模件2**,2011
桑迪普·桑伽如(印度)
竹
© Sangaru Design Objects Pvt. Ltd.

**Truss Me Module two**, 2011
Sandeep Sangaru (India)
Bamboo
© Sangaru Design Objects Pvt. Ltd.

**Truss Me四面体**,2011
桑迪普·桑伽如(印度)
竹
© Sangaru Design Objects Pvt. Ltd.

**Truss Me Tetra**, 2011
Sandeep Sangaru (India)
Bamboo
© Sangaru Design Objects Pvt. Ltd.

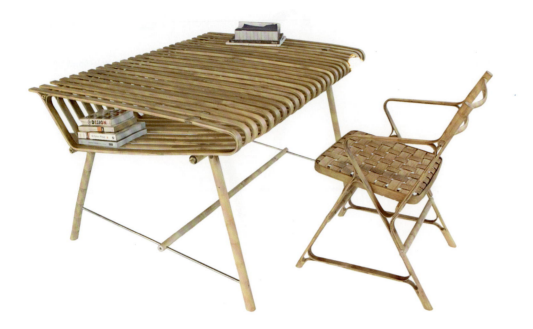

书桌，2011
桑迪普·桑伽如(印度)
竹
© Sangaru Design Objects Pvt. Ltd.

**Study Table**, 2011
Sandeep Sangaru (India)
Bamboo
© Sangaru Design Objects Pvt. Ltd.

Ottoman，2011
桑迪普·桑伽如(印度)
竹
© Sangaru Design Objects Pvt. Ltd.

**Ottoman**, 2011
Sandeep Sangaru (India)
Bamboo
© Sangaru Design Objects Pvt. Ltd.

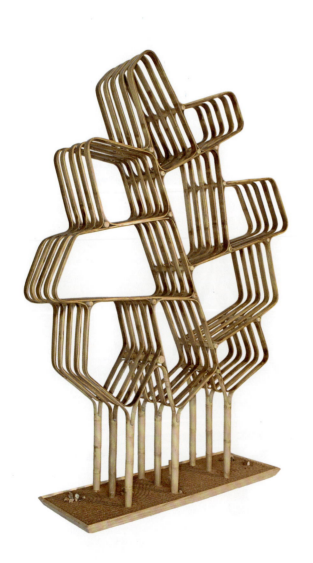

树形书架，2011
桑迪普·桑伽如(印度)
竹
© Sangaru Design Objects Pvt. Ltd.

**Tree-shape Book Shelf**, 2011
Sandeep Sangaru (India)
Bamboo
© Sangaru Design Objects Pvt. Ltd.

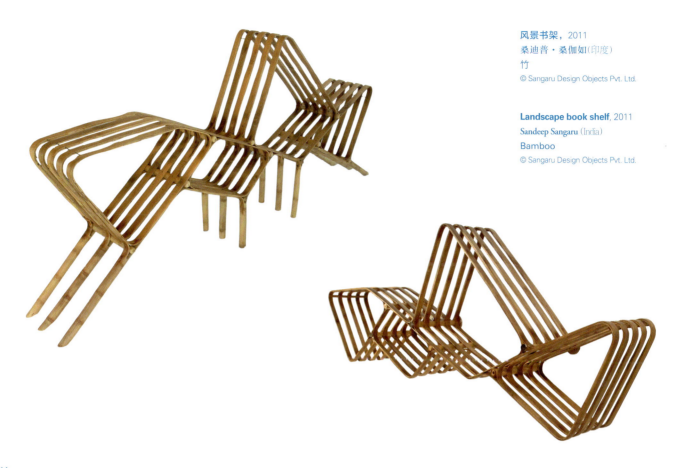

风景书架，2011
桑迪普·桑伽如（印度）
竹
© Sangaru Design Objects Pvt. Ltd.

**Landscape book shelf**, 2011
Sandeep Sangaru (India)
Bamboo
© Sangaru Design Objects Pvt. Ltd.

灯，2011
桑迪普·桑伽如（印度）
竹
© Sangaru Design Objects Pvt. Ltd.

**Lamp**, 2011
Sandeep Sangaru (India)
Bamboo
© Sangaru Design Objects Pvt. Ltd.

翅形沙发，2011
桑迪普·桑伽如（印度）
竹
© Sangaru Design Objects Pvt. Ltd.

**Wing Sofa**, 2011
Sandeep Sangaru (India)
Bamboo
© Sangaru Design Objects Pvt. Ltd.

"B"椅，2011
桑迪普·桑伽如（印度）
竹
© Sangaru Design Objects Pvt. Ltd.

**"B" Chair**, 2011
**Sandeep Sangaru**（India）
**Bamboo**
© Sangaru Design Objects Pvt. Ltd.

"A"椅，2011
桑迪普·桑伽如（印度）
竹
© Sangaru Design Objects Pvt. Ltd.

**"A" Chair**, 2011
**Sandeep Sangaru**（India）
**Bamboo**
© Sangaru Design Objects Pvt. Ltd.

沙发，2011
桑迪普·桑伽如（印度）
竹
© Sangaru Design Objects Pvt. Ltd.

**Sofa**, 2011
**Sandeep Sangaru**（India）
**Bamboo**
© Sangaru Design Objects Pvt. Ltd.

方竹桌，2006
斯蒂恩·凡·韦科姆（荷兰）
竹，环氧基树脂
© Stijn van Woerkom

**Square Bamboo Table**, 2006
Stijn van Woerkom (Netherlands)
Bamboo, epoxy
© Stijn van Woerkom

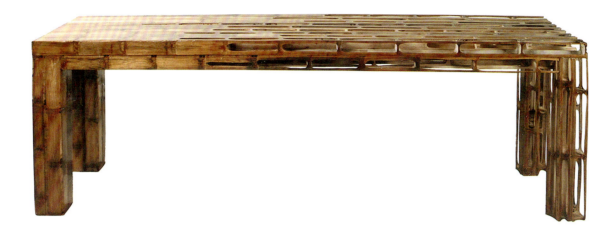

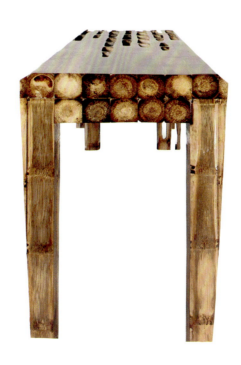

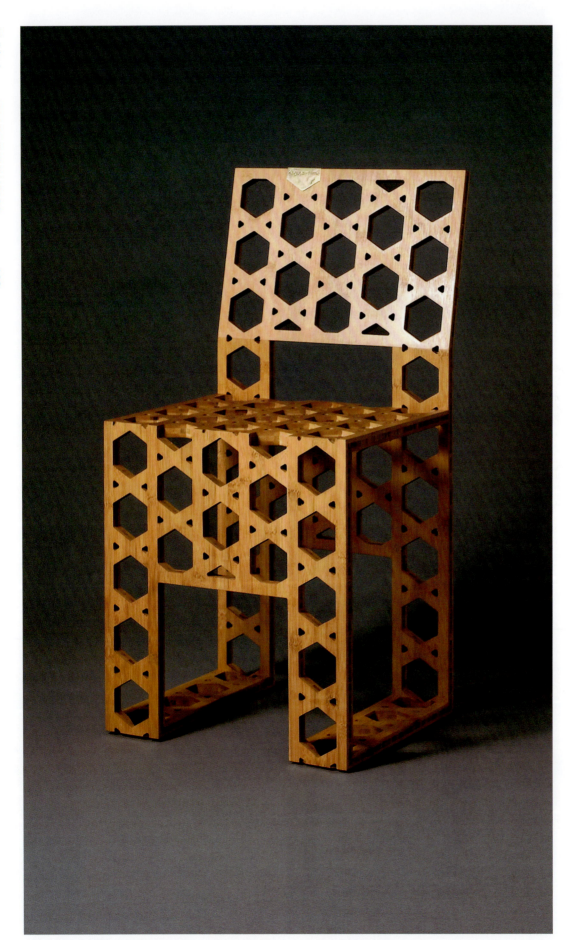

**Kaguya-Hime竹椅**, 2007
洛特·凡·拉顿(荷兰)
竹
© Lotte van Laatum

**Kaguya-Hime Bamboo Chair**, 2007
Lotte van Laatum (Netherlands)
Bamboo
© Lotte van Laatum

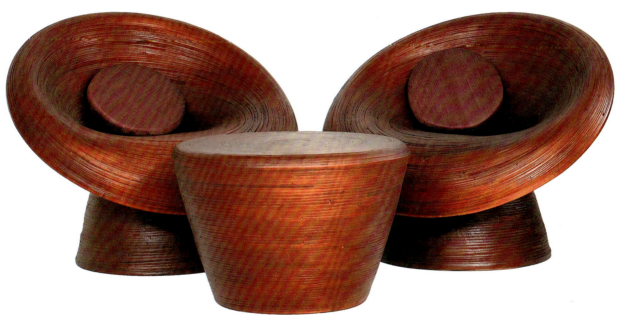

农斋椅, 2004
杰瑞德·胡克(美国)
竹
© Huke Jared

**Nung Chair**, 2004
Jared Huke (USA)
Bamboo
© Huke Jared

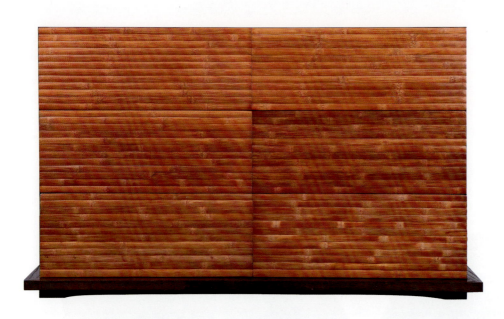

"咏竹"六抽双排柜，2008
春在（上海）家具贸易有限公司（中国）
竹，木
© Chun Zai Inc.

**Double-row Cabinet with 6 Drawers**, 2008
Chun Zai Furniture Design ( Shanghai ) (China)
Bamboo ,Wood
© Chun Zai Inc.

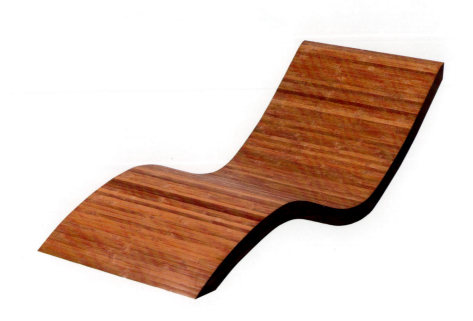

"咏竹"躺椅，2008
春在（上海）家具贸易有限公司（中国）
竹，木
© Chun Zai Inc.

**Lounge Chair**, 2008
Chun Zai Furniture Design ( Shanghai ) (China)
Bamboo, Wood
© Chun Zai Inc.

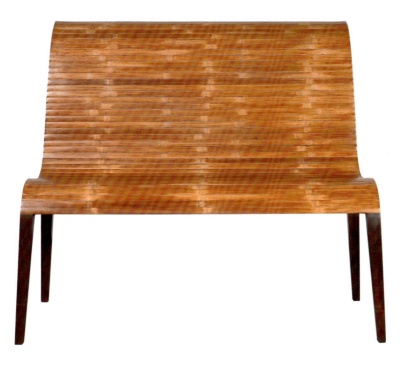

"咏竹"双人单背椅，2008
春在（上海）家具贸易有限公司(中国)
竹
© Chun Zai Inc.

**Single-back Double Chair,** 2008
Chun Zai Furniture Design ( Shanghai ) (China)
Bamboo, Wood
© Chun Zai Inc.

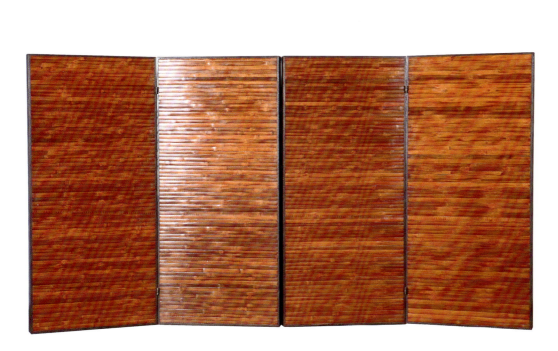

"咏竹"双面屏风，2008
春在（上海）家具贸易有限公司(中国)
竹，木
©Chun Zai Inc.

**Double-sided Screen**, 2008
Chun Zai Furniture Design ( Shanghai ) (China)
Bamboo, wood
©Chun Zai Inc.

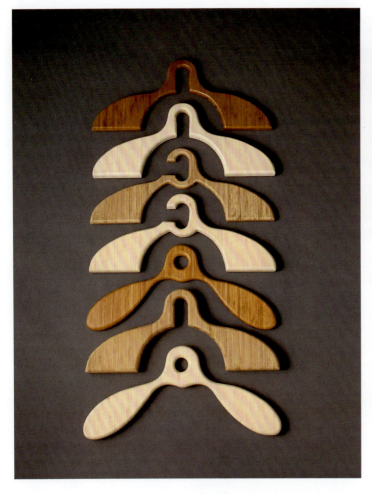
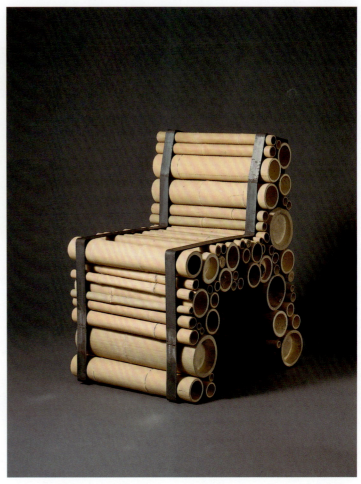

竹衣架，2008
Yksi设计团队／莱昂内·库佩，爱德华·斯韦普，谢斯·霍尔肯斯(荷兰)
竹，铁
© Yksi Design

**Yksi Bamboo Hangers**, 2008
Yksi Design / Leonne Cuppen, Eduard Sweep, Kees Heurkens (Netherlands)
Bamboo and steel
© Yksi Design

竹椅，2007
Yksi设计团队／莱昂内·库佩，爱德华·斯韦普，谢斯·霍尔肯斯(荷兰)
竹，铁
© Yksi Design

**Yksi Bamboo Chair**, 2007
Yksi Design / Leonne Cuppen, Eduard Sweep, Kees Heurkens (Netherlands)
Bamboo and steel
© Yksi Design

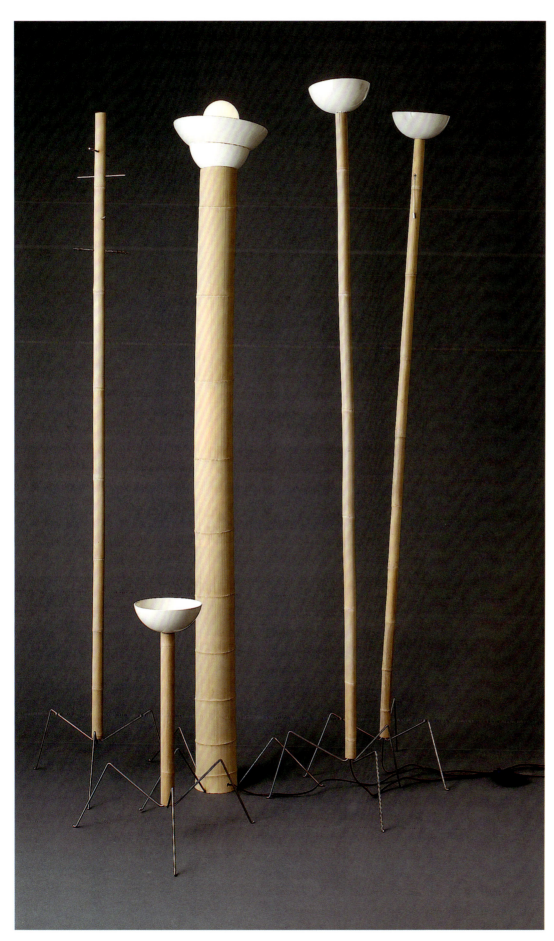

竹灯，2007
Yksi设计团队／莱昂内·库佩，爱德华·斯韦普，谢斯·霍尔肯斯（荷兰）
竹
© Yksi Design

**Yksi Bamboo Lamp**, 2007
Yksi Design / Leonne Cuppen, Eduard Sweep, Kees Heurkens (Netherlands)
Bamboo
© Yksi Design

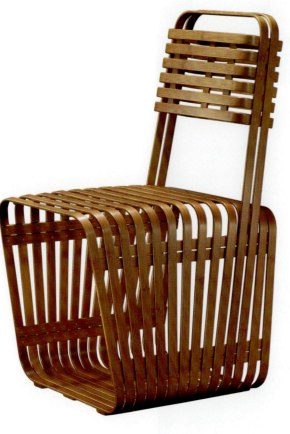

椅"君子",2009
石大宇(中国台湾)
竹
© Dragonfly Design Center

**Chair Jun Zi**, 2009
**Jeff Dah-Yue Shi** (Taiwan, Chian)
Bamboo
© Dragonfly Design Center

"苹果"手机保护壳,1980
竹采艺品有限公司（林群涵)(中国台湾)
竹
© Brilliant Bamboo Craft Co.Ltd.

**iPhone Case**, 1980
**Brilliant Bamboo Craft Co.Ltd.(Lin Chunhan)**
(Taiwan, China)
Bamboo
© Brilliant Bamboo Craft Co.Ltd

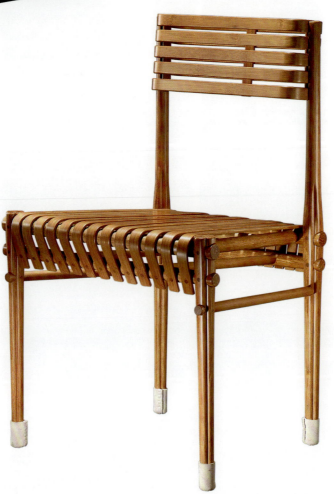

"琴剑"椅,2009
石大宇(中国台湾)
竹
© Dragonfly Design Center

**Chair Qin Jian**, 2009
**Jeff Dah-Yue Shi** (Taiwan, China)
Bamboo
© Dragonfly Design Center

**中式方桌**，2011
石大宇（中国台湾）
竹
© Dragonfly Design Center

**Chinese Square Table**, 2011
**Jeff Dah-Yue Shi** (Taiwan, China)
Bamboo
© Dragonfly Design Center

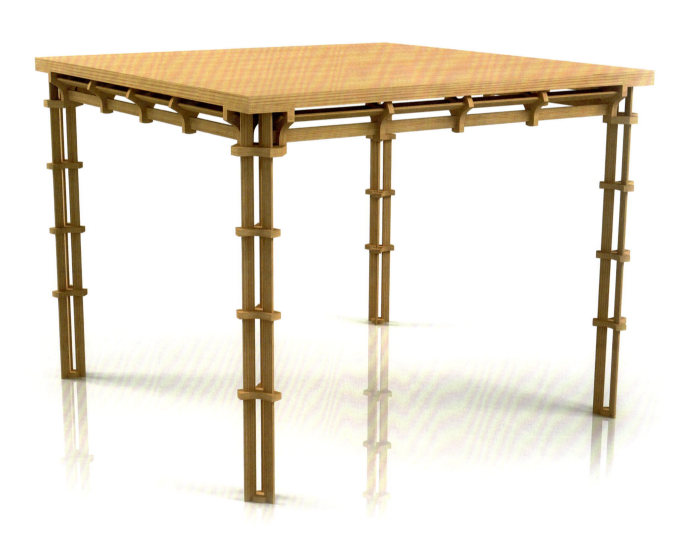

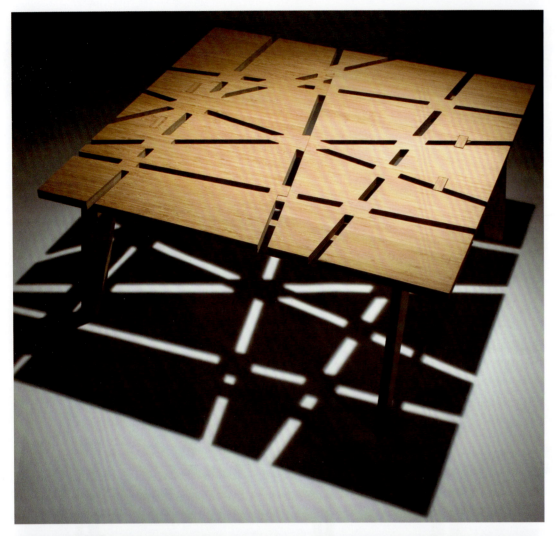

街道桌，2009
维尼休斯·里贝罗·利马（美国）
竹，夹板
© Vinicius Rebello Lima

**Street Table**, 2009
Vinicius Rebello Lima (USA)
Bamboo, plywood
© Vinicius Rebello Lima

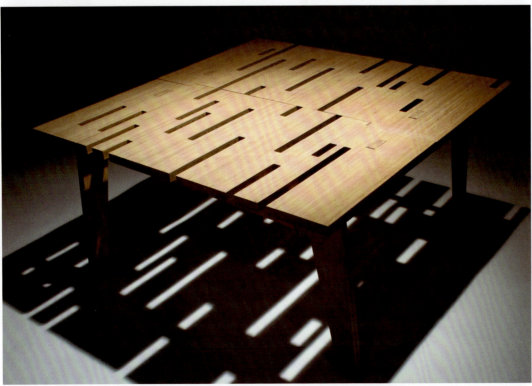

广场桌，2009
维尼休斯·里贝罗·利马（美国）
竹，夹板
© Vinicius Rebello Lima

**Plaza Table**, 2009
Vinicius Rebello Lima (USA)
Bamboo, plywood
© Vinicius Rebello Lima

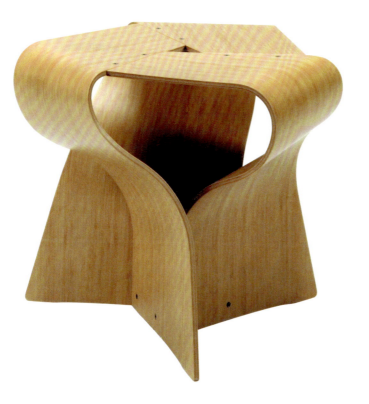

蘑菇凳（S-7297）
原始设计：1961／竹制版本：2011
Yamanaka设计团队／山中康广，山中阿美子，曽原厚之助（日本）
外部：竹子，内部：山毛榉
© Yamanaka Group

**Mushroom Stool (S-7297)**
Original Design:1961 / Bamboo Version: 2011
Yamanaka Group (Yasuhiro Yamanaka, Amiko Yamanaka, Kounosuke Sohara) (Japan)
Outsides : Bamboo, Insides : beech
© Yamanaka Group

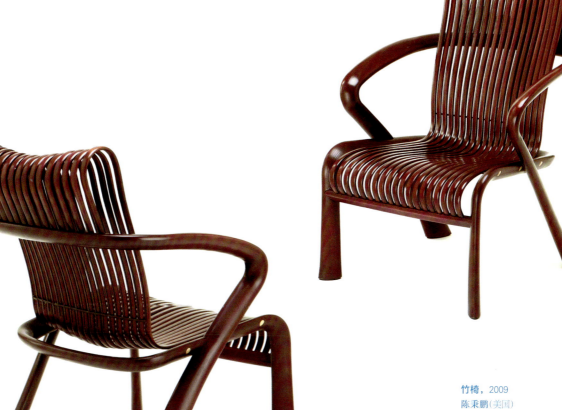

竹椅，2009
陈秉鹏（美国）
竹
© Chan Eric

**Bamboo Chair**, 2009
Chan Eric (USA)
Bamboo
© Chan Eric

转管桌灯，2011
Tek-sià设计工作室（设计师：林桓民，林文柄/设计顾问：王文雄）（中国台湾）
竹，电子元件
© Tek-sià design studio

**Demise Bamboo Table Lamp**, 2011
Tek-sià design studio(Designer: Camo Lin,Lin Wun-Bing/ Design Adviser: Wang Wen-Hsiung)
(Taiwan, China)
Bamboo, electric component
© Tek-sià design studio

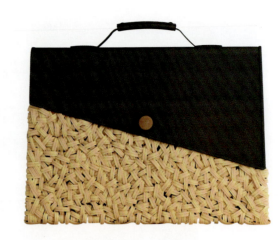

竹编公事包，2010
Tek-sià设计工作室（设计师：林桓民，林文柄/设计顾问：王文雄）（中国台湾）
竹，皮革
© Tek-sià design studio

**The Balance**, 2010
Tek-sià design studio (Designer: Camo Lin,Lin Wun-Bing/ Design Adviser: Wang Wen-Hsiung)
(Taiwan, China)
Bamboo, leather
© Tek-sià design studio

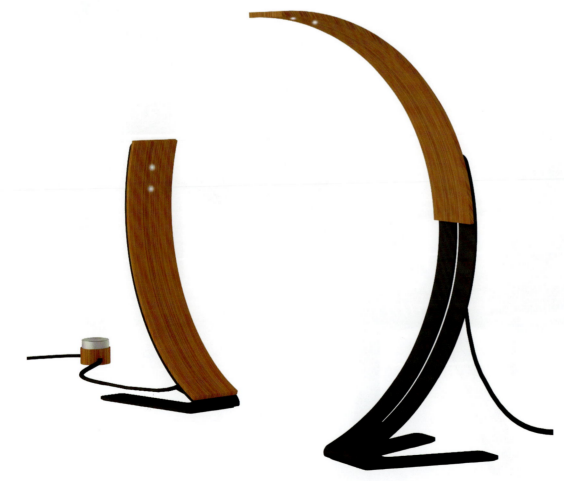

曲，2010
Tek-sià设计工作室（设计师：林桓民，林文柄/设计顾问：王文雄）（中国台湾）
竹，钢
© Tek-sià design studio

**BendBoo**, 2010
Tek-sià design studio(Designer: Camo Lin,Lin Wun-Bing/ Design Adviser: Wang Wen-Hsiung)
(Taiwan, China)
Bamboo, steel
© Tek-sià design studio

兽角，2010
Tek-sià设计工作室（设计师：林桓民，林文柄／设计顾问：王文雄）(中国台湾)
竹，电子元件
© Tek-sià design studio

**Specimen**, 2010
Tek-sià design studio(Designer: Camo Lin, Lin Wun-Bing/ Design Adviser: Wang Wen-Hsiung)
(Taiwan, China)
Bamboo, electric component
© Tek-sià design studio

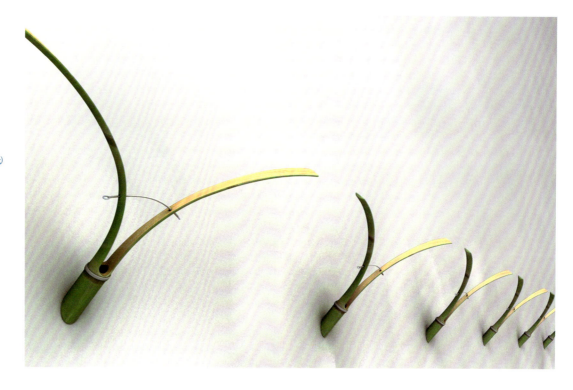

竹拖鞋，2010
Tek-sià设计工作室（设计师：林桓民，林文柄／设计顾问：王文雄）(中国台湾)
竹，皮革及橡胶
© Tek-sià design studio

**Bamboo Slipper**, 2010
Tek-sià design studio(Designer: Camo Lin, Lin Wun-Bing/ Design Adviser: Wang Wen-Hsiung)
(Taiwan, China)
Bamboo, leather and rubber
© Tek-sià design studio

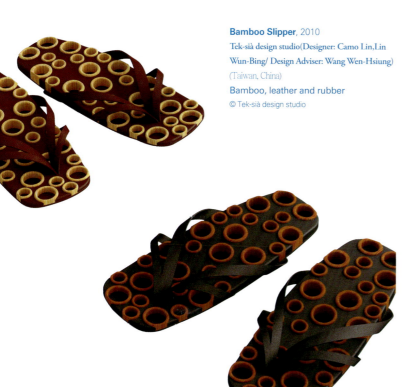

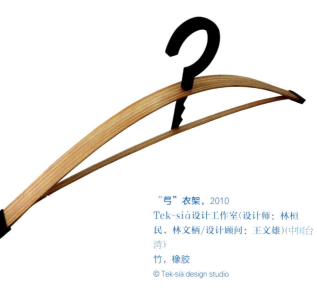

"弓"衣架，2010
Tek-sià设计工作室(设计师：林桓民，林文柄／设计顾问：王文雄)(中国台湾)
竹，橡胶
© Tek-sià design studio

**Bow Hanger**, 2010
Tek-sià design studio(Designer: Camo Lin, Lin Wun-Bing/ Design Adviser: Wang Wen-Hsiung)
(Taiwan, China)
Bamboo, rubber
© Tek-sià design studio

竹编茶罐，1998
竹采艺品有限公司（林群涵）(中国台湾)
竹
© Photo : Brilliant Bamboo Craft Co.,Ltd.

**Bamboo Tea Container**, 1998
Brilliant Bamboo Craft Co.,Ltd.(Lin Chun Han)
(Taiwan, China)
Bamboo
© Photo : Brilliant Bamboo Craft Co.,Ltd.

马克杯，1985
竹采艺品有限公司（林群涵）(中国台湾)
竹
© Photo : Brilliant Bamboo Craft Co.,Ltd.

**Bamboo Mug**, 1985
Brilliant Bamboo Craft Co.,Ltd.(Lin Chun Han)
(Taiwan, China)
Bamboo
© Photo : Brilliant Bamboo Craft Co.,Ltd.

竹制茶壶，1980
竹采艺品有限公司（林群涵）(中国台湾)
竹
© Photo : Brilliant Bamboo Craft Co.,Ltd.

**Bamboo Teapot**, 1980
Brilliant Bamboo Craft Co.,Ltd.(Lin Chun Han)
(Taiwan, China)
Bamboo
© Photo : Brilliant Bamboo Craft Co.,Ltd.

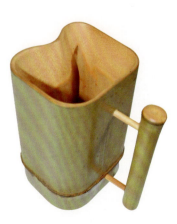

竹制茶杯，1980
竹采艺品有限公司（林群涵）(中国台湾)
竹
© Photo : Brilliant Bamboo Craft Co.,Ltd.

**Bamboo Teacup**, 1980
Brilliant Bamboo Craft Co.,Ltd.(Lin Chun Han)
(Taiwan, China)
Bamboo
© Photo : Brilliant Bamboo Craft Co.,Ltd.

竹制茶杯，1990
竹采艺品有限公司（林群涵）(中国台湾)
竹
© Photo : Brilliant Bamboo Craft Co.,Ltd.

**Bamboo Teacup**, 1990
Brilliant Bamboo Craft Co.,Ltd.(Lin Chun Han)
(Taiwan, China)
Bamboo
© Photo : Brilliant Bamboo Craft Co.,Ltd.

方竹花器（黑色有裂纹），1988
竹采艺品有限公司（林群涵）(中国台湾)
竹
© Photo : Brilliant Bamboo Craft Co.,Ltd.

**Bamboo Tea Container**, 1988
Brilliant Bamboo Craft Co.,Ltd.(Lin Chun Han)
(Taiwan, China)
Bamboo
© Photo : Brilliant Bamboo Craft Co.,Ltd.

环保休闲竹水杯，2010
杭州合骏竹文化创意有限公司(中国)
竹，玻璃
© Photo : Hangzhou Hotry Bamboo Culture & Creativity Co., Ltd

**Eco-Leisure Bamboo Water Bottle**, 2010
Hangzhou Hotry Bamboo Culture & Creativity Co., Ltd (China)
Bamboo, glass
© Photo : Hangzhou Hotry Bamboo Culture & Creativity Co., Ltd

笔记本，1980
竹采艺品有限公司（林群涵）(中国台湾)
竹
© Photo : Brilliant Bamboo Craft Co.,Ltd.

**Notepad**, 1980
Brilliant Bamboo Craft Co.,Ltd.(Lin Chun Han)
(Taiwan, China)
Bamboo
© Photo : Brilliant Bamboo Craft Co.,Ltd.

竹板材，2010
互若亚股份有限公司(中国台湾)
竹纤维
© Photo : Flora

**Bamboo Plate**, 2010
Flora (Taiwan, China)
Bamboo fibre
© Photo : Flora

竹纸，2010
康戴里贸易（上海）有限公司(中国香港)
© Photo : Antalis(Shanghai)Trading Co.,Ltd

**Bamboo paper**, 2010
Antalis(Shanghai)Trading Co.,Ltd
(Hong Kong, China)
© Photo : Antalis(Shanghai)Trading Co.,Ltd

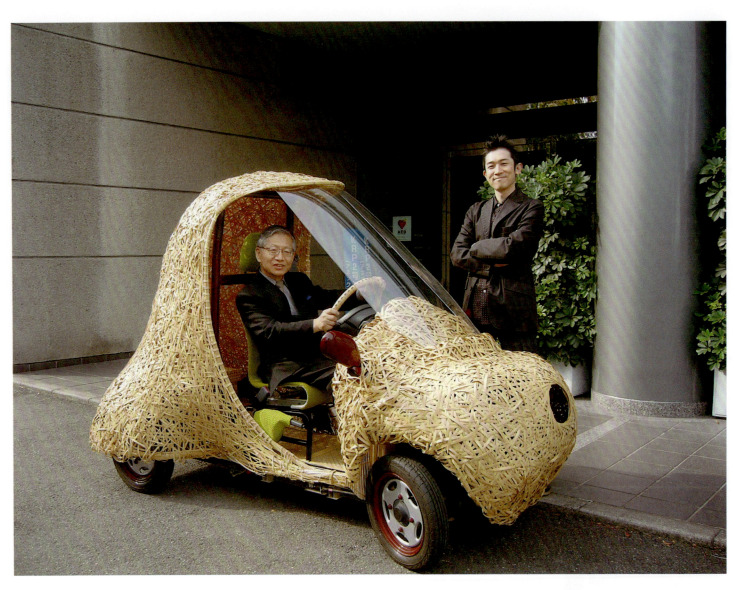

竹身电动车,2008
京都大学(松重和美教授)(日本)
竹
© Kyoto University

**Bamboo EV (Electric Vehicle)**, 2008
Kyoto University (Prof. Matsushige Kazumi) (Japan)
Bamboo
© Kyoto University

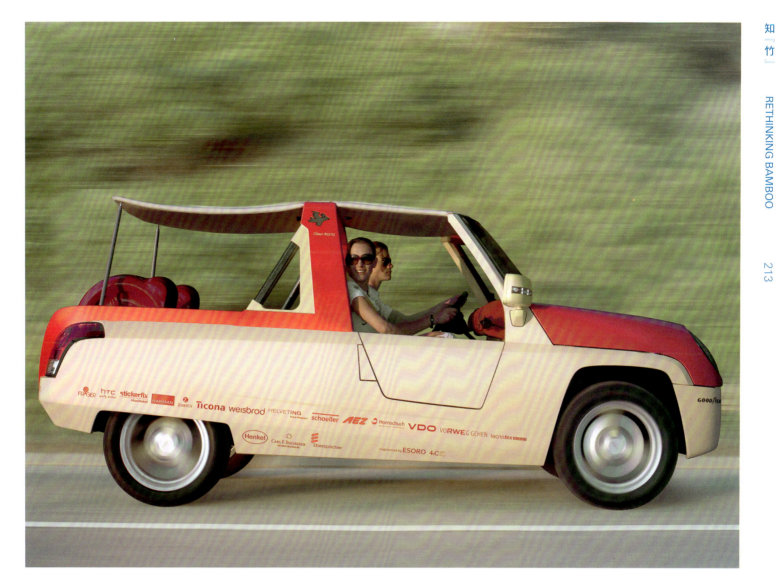

竹电动车，2011
林斯比得公司（弗兰克·M·林德克奈希特）（瑞士）
竹
© Photo : Rinspeed Inc

**Rinspeed bamboo concept car (woven bamboo interior tissue)**, 2011
Rinspeed Inc (Frank M.Rinderknecht) (Switzerland)
Bamboo
© Photo : Rinspeed Inc

 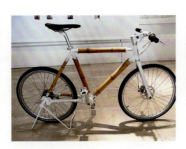 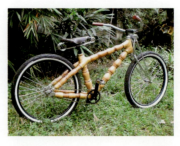 

竹制儿童推行自行车，2010
KawayanTech（埃里克·卡迪兹）（菲律宾）
竹
© KawayanTech

**Kids Bamboo Push Bikes**, 2010
KawayanTech(Eric Cadiz) (Philippines)
Bamboo
© KawayanTech

Rio自行车，2009
洛斯·拉古路夫（英国）
竹
© Ross Lovegrove

**Rio Bike**, 2009
Ross Lovegrove (UK)
Bamboo
© Ross Lovegrove

佛肚竹自行车，2010
KawayanTech（陈·英格尔伯特）（菲律宾）
竹
© KawayanTech

**Buddhas Belly Bamboo Bike**, 2010
KawayanTech(Chan Englebert) (Philippines)
Bamboo
© KawayanTech

竹自行车把手，2010
KawayanTech（陈·英格尔伯特）（菲律宾）
竹
© KawayanTech

**Bamboo Bike Handlebar**, 2010
KawayanTech(Chan Englebert) (Philippines)
Bamboo
© KawayanTech

竹自行车，2009
Biomega Philosophy 公司（洛斯·拉古路夫）（英国）
竹
© Photo: Biomega Philosophy

**Bamboo Bike**, 2009
Biomega Philosophy (Ross Lovegrove) (UK)
Bamboo
© Photo: Biomega Philosophy

竹制自行车，2010
卡特·艾高塔（荷兰）
竹
© Photo: Karta Agotob

**Bamboo Bikes**, 2010
Karta Agotob (Netherlands)
Bamboo
© Photo: Karta Agotob

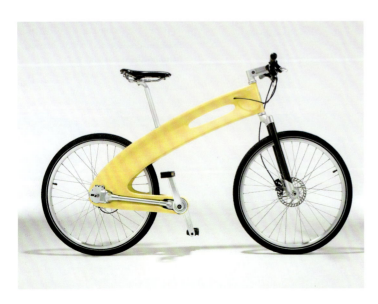 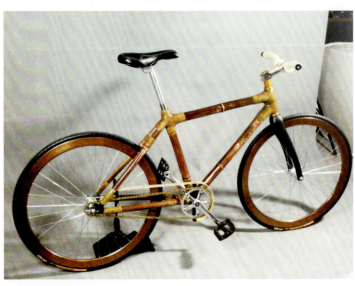

公事包，2006
邱锦缎（中国台湾）
竹

**Briefcase**, 2006
Chiu Chin Tuan (Taiwan, China)
Bamboo

布莱利伞，2009
布莱利／宋·巴米兰（美国）
竹、有机棉、可降解PVC
© BRELLI

**BRELLI Umbrella**, 2009
Brelli(Zonsius Pamelan) (USA)
Bamboo, organic cotton, biodegradable PVC
© BRELLI

笼，2008
米莫提卡·米可拉公司（西班牙）
竹
© Mimótica Micola S.L

**LA CAGE**, 2008
Mimótica Micola (Spain)
Bamboo
© Mimótica Micola S.L

"爆竹"装饰大碗，2010
蓝钟香港有限公司（坎帕纳兄弟）（中国香港）
竹，木
© Bluebell HK Ltd

**"Blow Up" Bam.Centrepiece Bowl**, 2010
**Bluebell HK Ltd (Campana Fratelli)** (Hong Kong, China)
Bamboo, wood
© Bluebell HK Ltd

"爆竹"竹桌，2010
蓝钟香港有限公司（坎帕纳兄弟）（中国香港）
竹，木，玻璃
© Bluebell HK Ltd

**"Blow Up" Bamboo Table**, 2010
**Bluebell HK Ltd (Campana Fratelli)** (Hong Kong, China)
Bamboo, wood and glass
© Bluebell HK Ltd

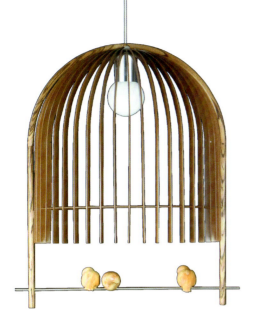

鸟笼灯，2008
朱小杰(中国)
竹
© Zhu Xiaojie

**Cage Swage Lamp**, 2008
Zhu Xiaojie (China)
Bamboo
© Zhu Xiaojie

手电筒，2009
竹采艺品有限公司（林群涵）(中国台湾)
竹
© Brilliant Bamboo Craft Co.Ltd.

**Electronic Hand Torch**, 2009
Brilliant Bamboo Craft Co.Ltd.(Lin Chunhan)
(Taiwan, China)
Bamboo
© Brilliant Bamboo Craft Co.Ltd

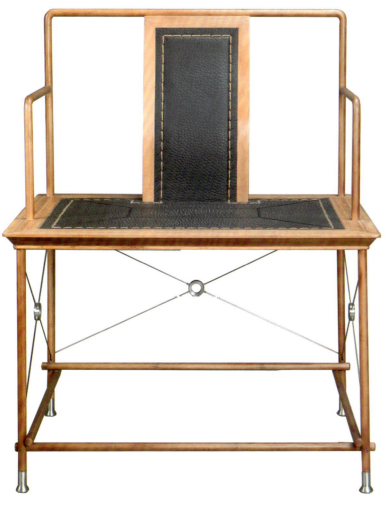

玫瑰椅，2009
朱小杰(中国)
竹，不锈钢
© Zhu Xiaojie

**Rose Chair**, 2009
Zhu Xiaojie (China)
Bamboo, stainless steel
© Zhu Xiaojie

竹椅，2008
马腾·巴普蒂斯特（荷兰）
竹
© Maarten Baptist

**Bamboo Chair**, 2008
**Maarten Baptist** (Netherlands)
Bamboo
© Maarten Baptist

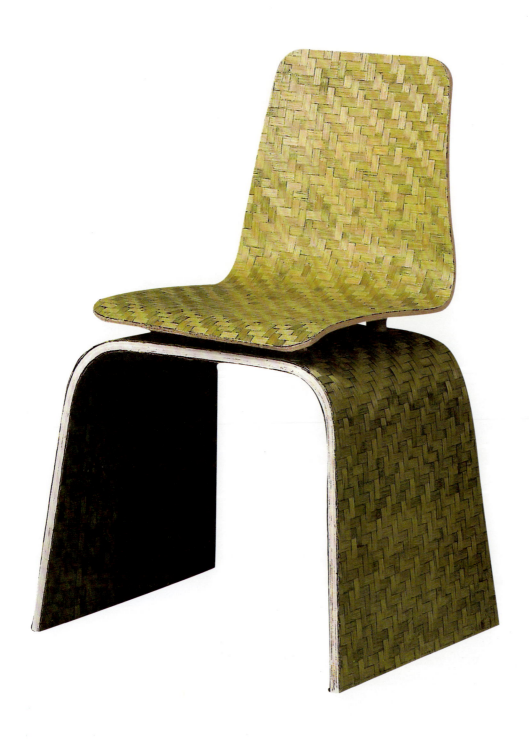

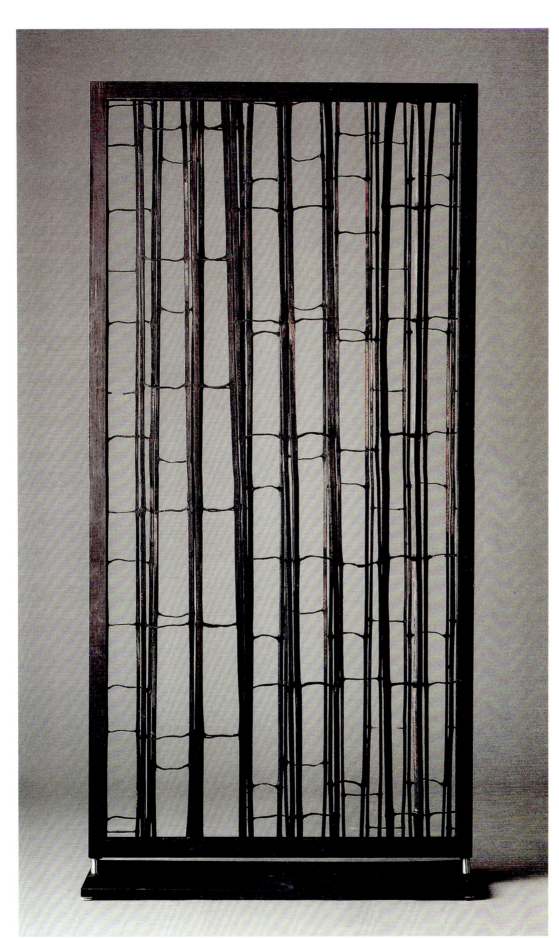

竹屏风，2007
艾德·范·恩格仑(荷兰)
竹片
© Haans Lifestyle

**Sliced room divider**, 2007
**Ed van Engelen** (Netherlands)
Sliced Bamboo
© Haans Lifestyle

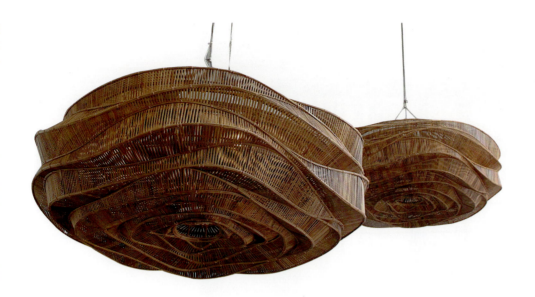

"玫瑰系列"吊灯，2011
可拉寇特·阿旺迪(泰国)
竹
© Korakat Aromdee

**"ROSE SERIES" Hanging Lamp**, 2011
Korakat Aromdee (Thailand)
Bamboo
© Korakat Aromdee

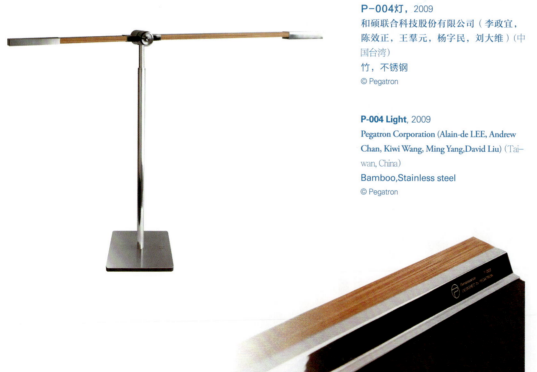

P-004灯，2009
和硕联合科技股份有限公司（李政宜，陈效正，王羣元，杨宇民，刘大维）(中国台湾)
竹，不锈钢
© Pegatron

**P-004 Light**, 2009
Pegatron Corporation (Alain-de LEE, Andrew Chan, Kiwi Wang, Ming Yang, David Liu) (Taiwan, China)
Bamboo, Stainless steel
© Pegatron

桌垫，2009
和硕联合科技股份有限公司（李政宜，陈效正，王羣元，杨宇民，刘大维）(中国台湾)
竹，不锈钢
© Photo : Pegatron Corporation

**P-003 Tablemat**, 2009
Pegatron Corporation (Alain-de LEE, Andrew Chan, Kiwi Wang, Ming Yang, David Liu) (Taiwan, China)
Bamboo, Stainless steel
© Photo : Pegatron Corporation

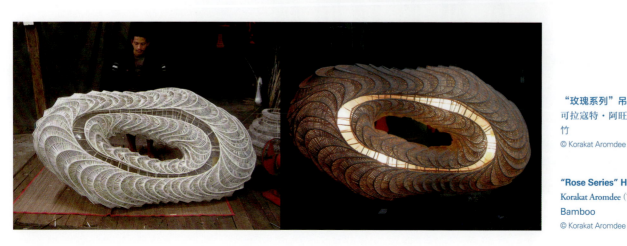

"玫瑰系列"吊灯，2011
可拉寇特·阿旺迪(泰国)
竹
© Korakat Aromdee

**"Rose Series" Hanging Lamp**, 2011
Korakat Aromdee (Thailand)
Bamboo
© Korakat Aromdee

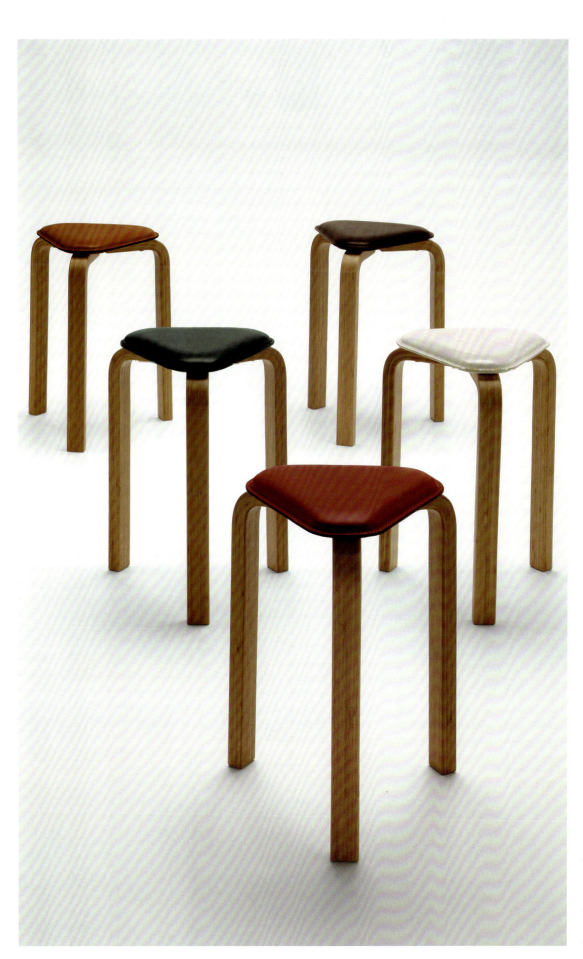

**Hagi stool**, 2010
**Toshiyuki Kita** (Japan)
Bamboo, leather
© Toshiyuki Kita

男用竹篮，1996收藏
越南民族博物馆（越南）
竹
© Vietnam Museum of Ethnology

**Man's basket**, collected in 1996
Vietnam Museum of Ethnology (Vietnam)
Bamboo
© Vietnam Museum of Ethnology

男用肩篮，1996收藏
越南民族博物馆（越南）
竹
© Vietnam Museum of Ethnology

**Man's Shoulder Basket**, collected in 1996
Vietnam Museum of Ethnology (Vietnam)
Bamboo
© Vietnam Museum of Ethnology

肩篮，1996收藏
越南民族博物馆（越南）
竹
© Vietnam Museum of Ethnology

**Shoulder Basket**, collected in 1996
Vietnam Museum of Ethnology (Vietnam)
Bamboo
© Vietnam Museum of Ethnology

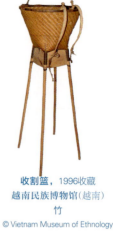

收割篮，1996收藏
越南民族博物馆（越南）
竹
© Vietnam Museum of Ethnology

**Harvesting basket**, collected in 1996
Vietnam Museum of Ethnology (Vietnam)
Bamboo
© Vietnam Museum of Ethnology

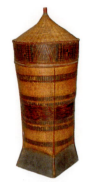

有盖衣篮，1998收藏
越南民族博物馆（越南）
竹
© Vietnam Museum of Ethnology

**Basket for clothes with a lid**, collected in 1998
Vietnam Museum of Ethnology (Vietnam)
Bamboo
© Vietnam Museum of Ethnology

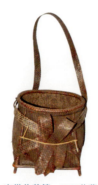

束带收获篮，2002收藏
越南民族博物馆（越南）
竹
© Vietnam Museum of Ethnology

**Belted harvesting basket**, collected in 2002
Vietnam Museum of Ethnology (Vietnam)
Bamboo
© Vietnam Museum of Ethnology

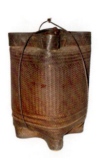

衣篮，1998收藏
越南民族博物馆（越南）
竹
© Vietnam Museum of Ethnology

**Basket for clothes**, collected in 1998
Vietnam Museum of Ethnology (Vietnam)
Bamboo
© Vietnam Museum of Ethnology

米饭篮，2004收藏
越南民族博物馆（越南）
竹
© Vietnam Museum of Ethnology

**Basket for cooked rice**, collected in 2004
Vietnam Museum of Ethnology (Vietnam)
Bamboo
© Vietnam Museum of Ethnology

前额篮（枷锁在颈背），1994收藏
越南人类博物馆（越南）
竹
© Vietnam Museum of Ethnology

**Basket with a yoke at the nape**, collected in 1994
Vietnam Museum of Ethnology (Vietnam)
Bamboo
© Vietnam Museum of Ethnology

肩篮，1996收藏
越南民族博物馆（越南）
竹
© Vietnam Museum of Ethnology

**Shoulder basket**, collected in 1996
Vietnam Museum of Ethnology (Vietnam)
Bamboo
© Vietnam Museum of Ethnology

前额篮（枷锁在颈背），1996收藏
越南人类博物馆（越南）
竹
© Vietnam Museum of Ethnology

**Basket with a yoke at the nape**, collected in 1996
Vietnam Museum of Ethnology (Vietnam)
Bamboo
© Vietnam Museum of Ethnology

欧式宝宝毛巾，2010
赏竹雅商贸有限公司（中国）
竹纤维
© Photo : Enjoy Bamboo Home

**European Baby Towel**, 2010
Enjoy Bamboo Home (China)
Bamboo fiber
© Photo : Enjoy Bamboo Home

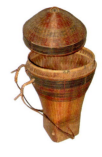

肩篮，1996收藏
越南民族博物馆（越南）
竹
© Vietnam Museum of Ethnology

**Shoulder basket**, collected in1996
Vietnam Museum of Ethnology (Vietnam)
Bamboo
© Vietnam Museum of Ethnology

肩篮，1996收藏
越南民族博物馆（越南）
竹
© Vietnam Museum of Ethnology

**Shoulder basket**, collected in1996
Vietnam Museum of Ethnology (Vietnam)
Bamboo
© Vietnam Museum of Ethnology

肩篮，1996收藏
越南民族博物馆（越南）
竹
© Vietnam Museum of Ethnology

**Shoulder basket**, collected in1996
Vietnam Museum of Ethnology (Vietnam)
Bamboo
© Vietnam Museum of Ethnology

衣篮，1997收藏
越南民族博物馆（越南）
竹
© Vietnam Museum of Ethnology

**Basket for clothes**, collected in1997
Vietnam Museum of Ethnology (Vietnam)
Bamboo
© Vietnam Museum of Ethnology

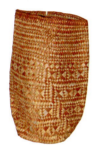
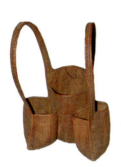
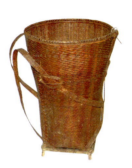
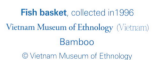

米饭篮，2004收藏
越南民族博物馆（越南）
竹
© Vietnam Museum of Ethnology

**Basket for cooked rice**, collected in2004
Vietnam Museum of Ethnology (Vietnam)
Bamboo
© Vietnam Museum of Ethnology

男用肩篮，2006收藏
越南民族博物馆（越南）
竹
© Vietnam Museum of Ethnology

**Man shoulder basket**, collected in2006
Vietnam Museum of Ethnology (Vietnam)
Bamboo
© Vietnam Museum of Ethnology

肩篮，1996收藏
越南民族博物馆（越南）
竹
© Vietnam Museum of Ethnology

**Shoulder basket**, collected in1996
Vietnam Museum of Ethnology (Vietnam)
Bamboo
© Vietnam Museum of Ethnology

鱼篮，1996收藏
越南民族博物馆（越南）
竹
© Vietnam Museum of Ethnology

**Fish basket**, collected in1996
Vietnam Museum of Ethnology (Vietnam)
Bamboo
© Vietnam Museum of Ethnology

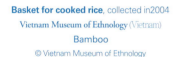
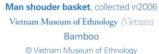
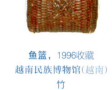

西班牙彩虹方巾，2010
赏竹雅商贸有限公司（中国）
竹纤维
© Photo : Enjoy Bamboo Home

**Spanish Rainbow Towel**, 2010
Enjoy Bamboo Home (China)
Bamboo fiber
© Photo : Enjoy Bamboo Home

神奇压缩毛巾，2010
赏竹雅商贸有限公司（中国）
竹纤维
© Photo : Enjoy Bamboo Home

**Compressed Towel**, 2010
Enjoy Bamboo Home (China)
Bamboo fiber
© Photo : Enjoy Bamboo Home

高尔夫宝宝方巾，2010
赏竹雅商贸有限公司（中国）
竹纤维
© Photo : Enjoy Bamboo Home

**Golf Baby Towel**, 2010
Enjoy Bamboo Home (China)
Bamboo fiber
© Photo : Enjoy Bamboo Home

竹毯，2011
Faux（路易斯·帕帕克里斯顿）（中国香港）
竹
© Faux

**Bamboo Carpet Rugs**, 2011
Faux(Louis Papachristou) (Hong Kong, China)
Bamboo
© Faux

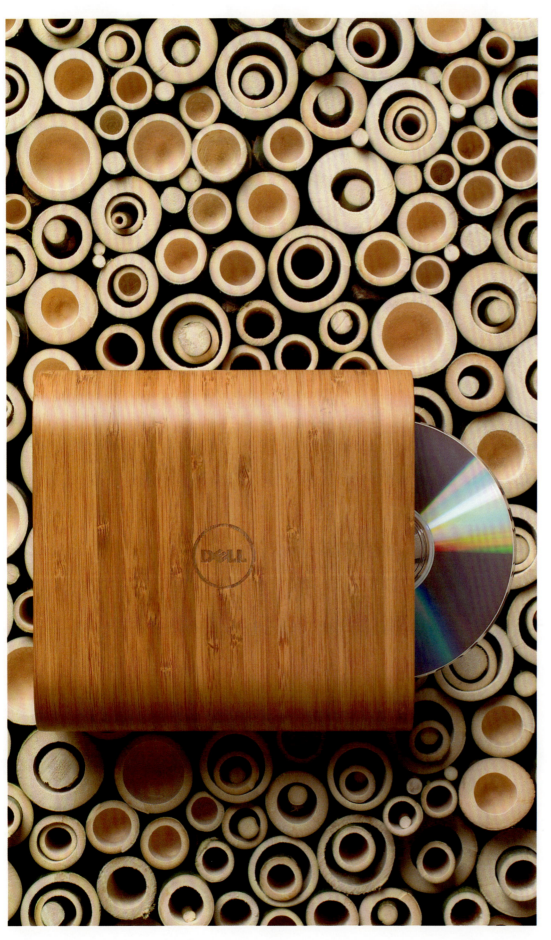

戴尔电脑外壳，2008
New Deal Design（伽迪·阿米特）（美国）
竹，金属，塑料
© Dell Inc

**DELL Computer Shell**, 2008
New Deal Design (Gadi Amit) (USA)
Bamboo, metal, plastic
© Dell Inc

竹方块
日本内野公司（日本）
竹
© Uchino Co., Ltd.

**Chikuno Cube**
Uchino Co., Ltd. (Japan)
Bamboo
© Uchino Co., Ltd.

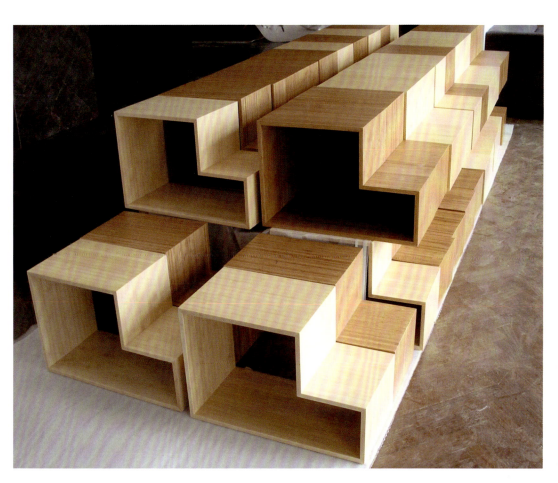

竹墙纸
浙江永裕竹业股份有限公司（中国）
竹
© YoYu

**Bamboo Veneer**
Zhejiang YoYu Bamboo Joint-Stock Co. Ltd (China)
Bamboo
© YoYu

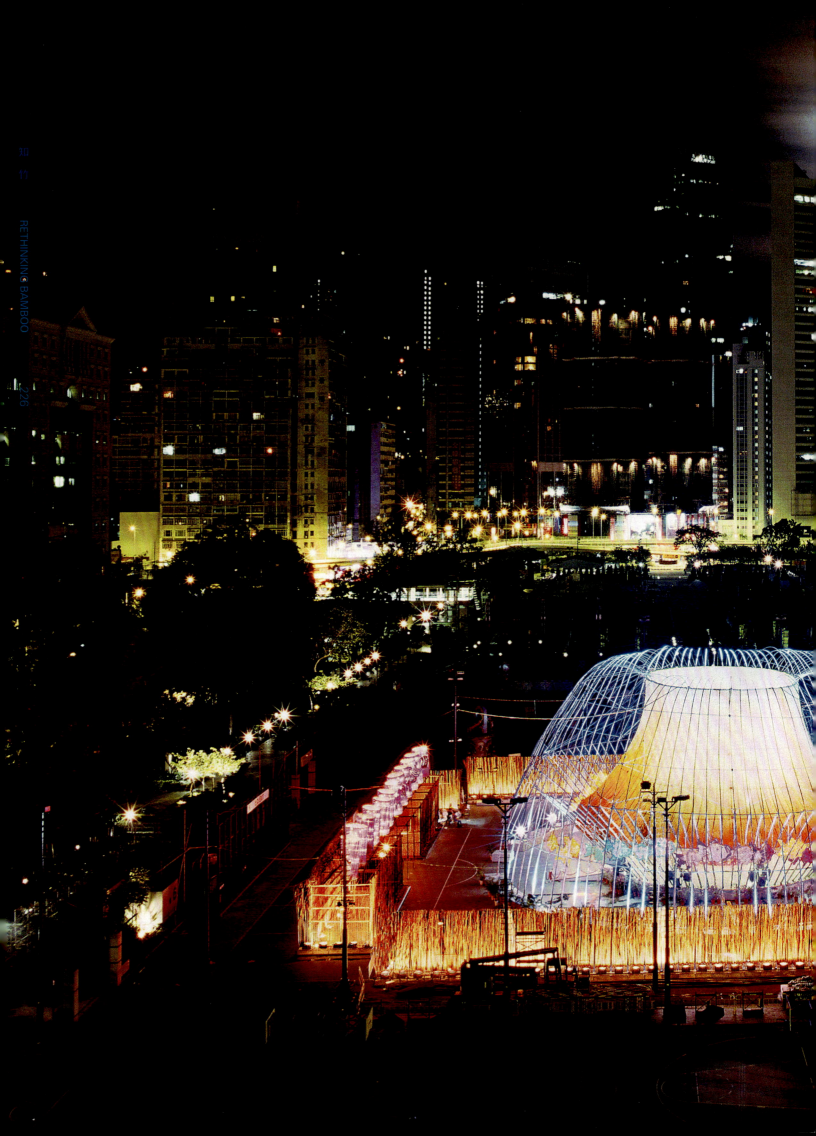

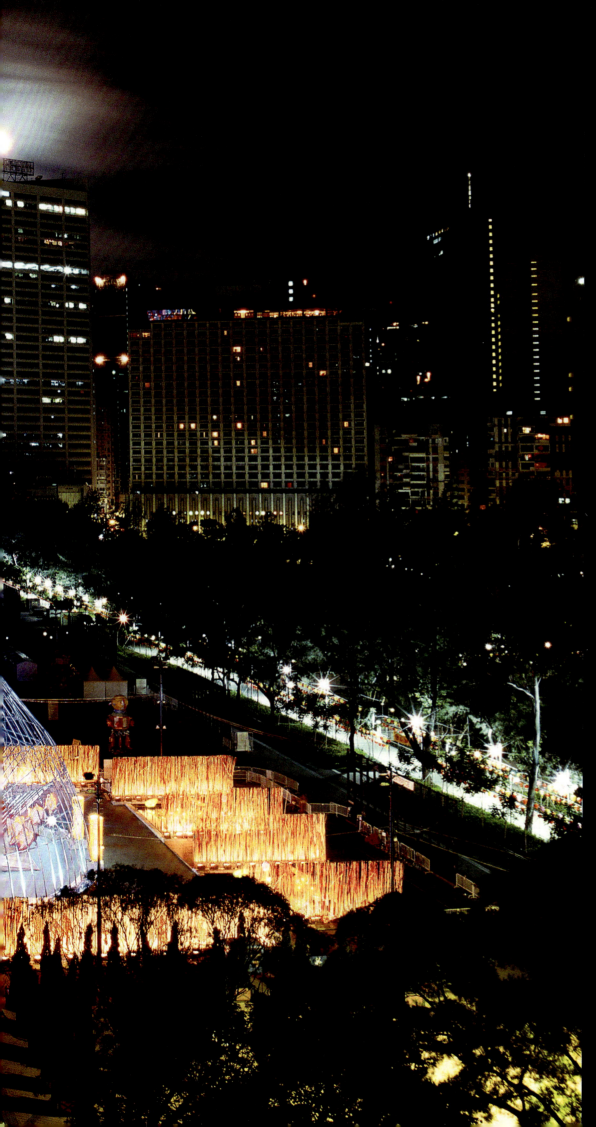

彩灯大观园（模型），2003
思联建筑设计有限公司／林伟而（中国香港）
竹，木，卡板，玻璃
© CL3 Architects Limited

**Lantern Wonderland (model)**, 2003
**CL3 Architects Limited / Lim William**
(Hong Kong, China)
Bamboo, wood, cardboard, glasses
© CL3 Architects Limited

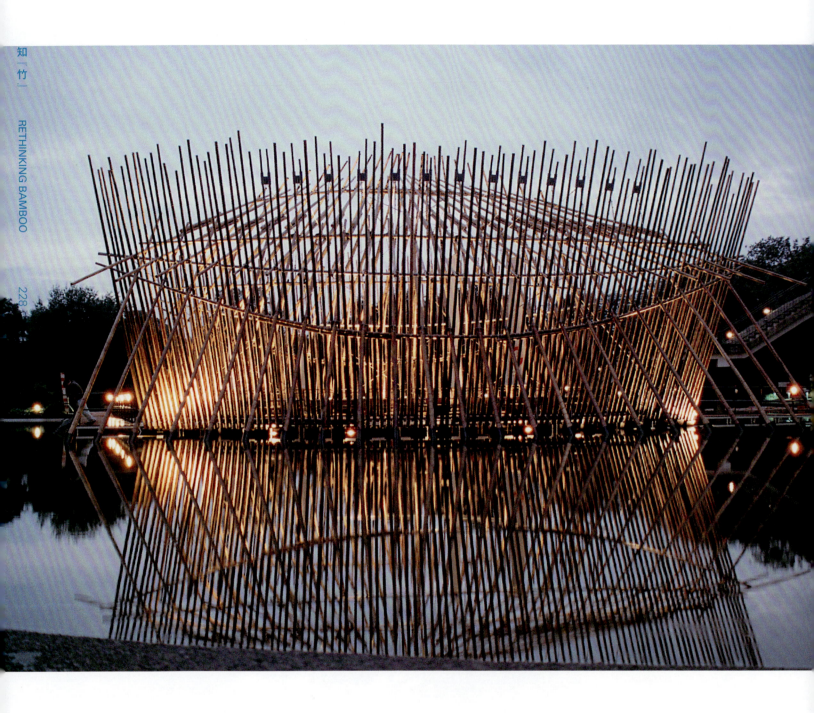

柏林文化节／竹亭，1999
许李严建筑师事务有限公司／严迅奇
(中国香港)
竹
© Rocco Design Architects Ltd.

**The Bamboo Pavilion, Festival of Vision-Hong Kong in Berlin**, 1999
Rocco Design Architects Ltd. / Yim Rocco
(Hong Kong, China)
**Bamboo**
© Rocco Design Architects Ltd.

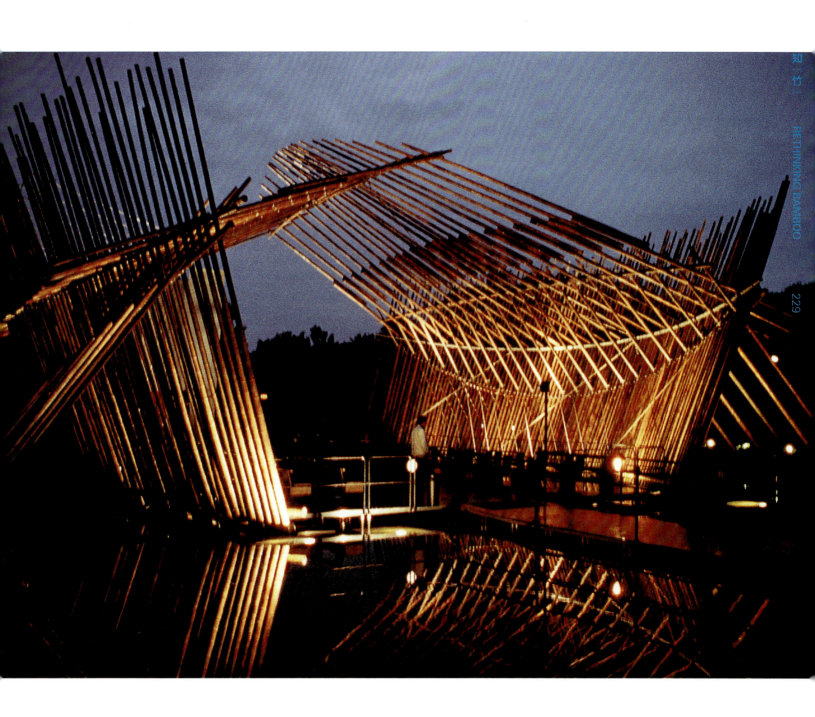

柏林文化节 / 竹亭，1999
许李严建筑师事务有限公司／严迅奇
(中国香港)
竹
© Rocco Design Architects Ltd.

**The Bamboo Pavilion, Festival of Vision-Hong Kong in Berlin**, 1999
Rocco Design Architects Ltd. / Yim Rocco
(Hong Kong, China)
Bamboo
© Rocco Design Architects Ltd.

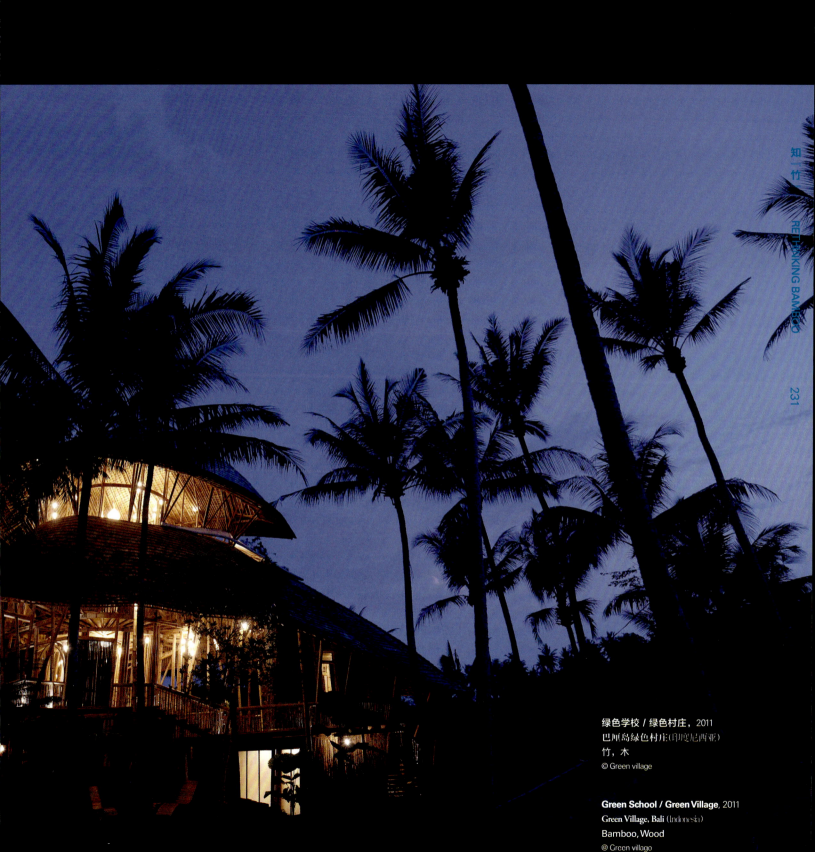

绿色学校 / 绿色村庄，2011
巴厘岛绿色村庄（印度尼西亚）
竹，木
© Green village

**Green School / Green Village**, 2011
Green Village, Bali (Indonesia)
Bamboo, Wood
© Green village

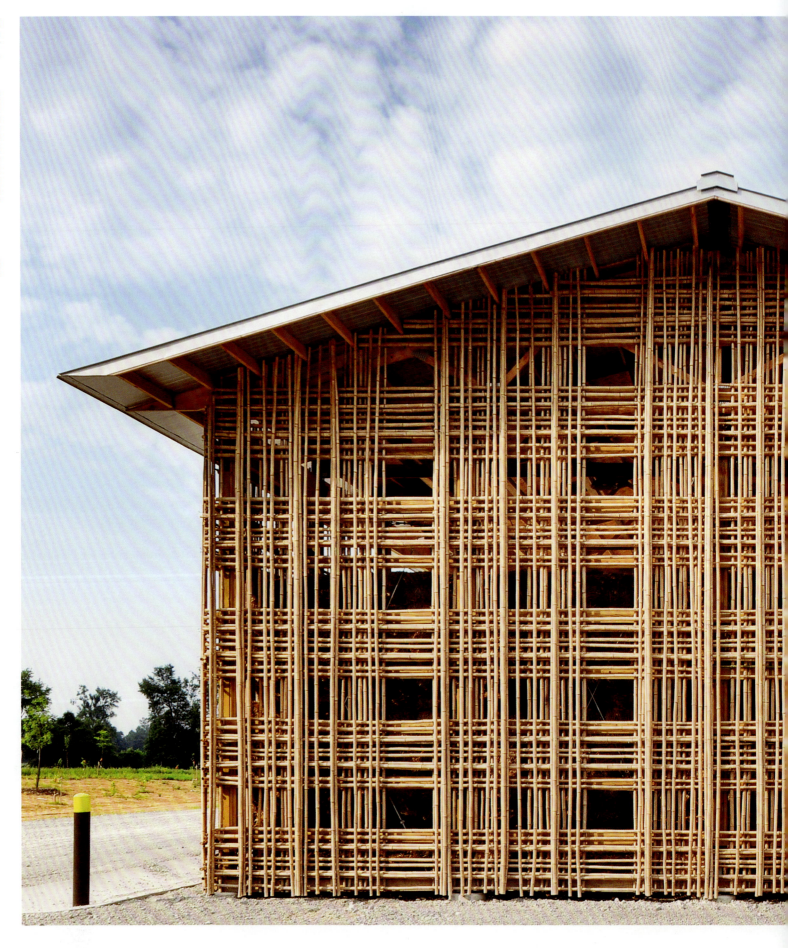

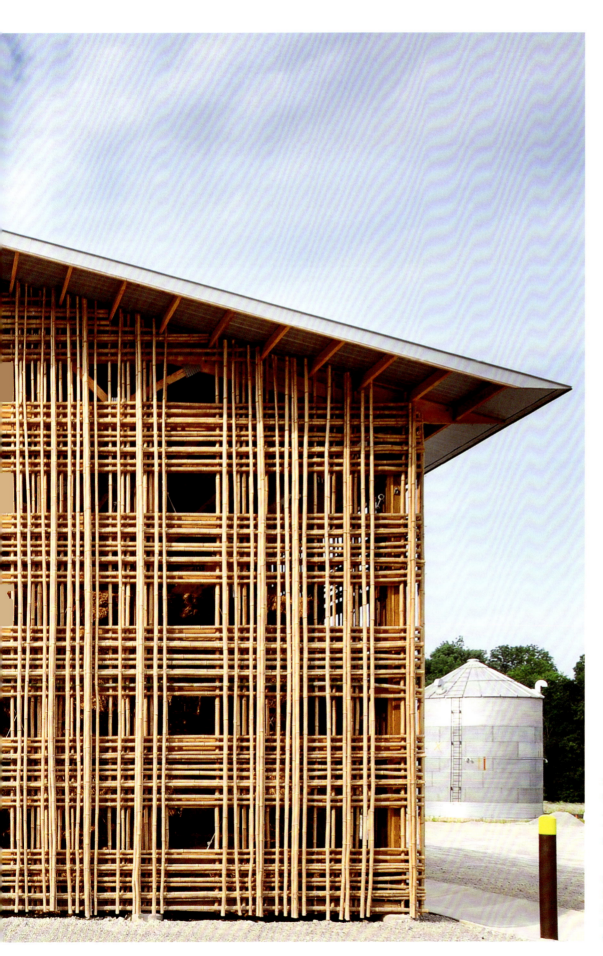

**石匠坊农场**，2009
德里昂和普利莫建筑工作室（罗伯特·德里昂，罗斯·普利莫）(美国)
竹，木
© De Leon & Primmer Architecture Workshop

**Mason Lane Farm**, 2009
De Leon & Primmer Architecture Workshop(Jr Roberto de Leon, M. Ross Primmer) (USA)
Bamboo, wood
© De Leon & Primmer Architecture Workshop

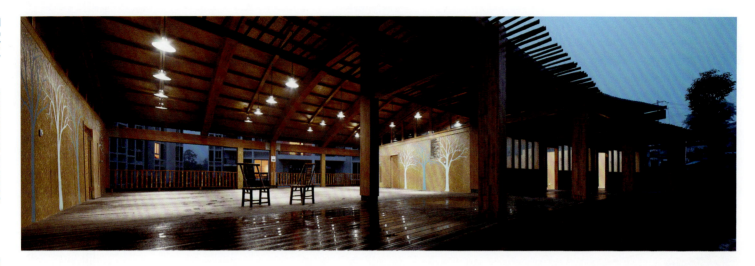

**毕马威安康社区中心,** 2010

奥华尔顾问有限公司（郝琳博士，罗健中）（中国香港）

应用节能环保设计和本地区可更新素材，包括预制的产自本地乡镇企业和永续林区的复合竹结构、竹外围护板和内外竹地板、零污染的农业秸秆材保温墙体、再生集成木材双层保温窗等建筑材料。

© The Oval Partnership Ltd

**KPMG-CCTF community centre,** 2010

Oval Partnership Ltd.(Dr. Lin Hao, Chris Law) (Hong Kong, China)

Locally sourced materials, renewable resources - such as a full reconstituted bamboo post & beam structure prefabricated from local factory and sourced from local sustainable forest, pollution free agricultural straw fibre panel for wall and roof system, bamboo cladding and floor finish.

© The Oval Partnership Ltd

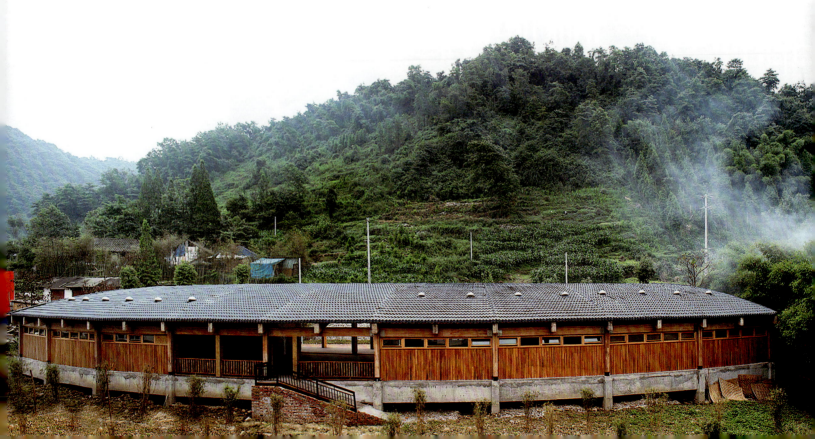

竹管桌灯/壁灯/天花板灯，2011
石大宇(中国台湾)
竹
© Dragonfly Design Center

**Lamp (wall, Dah-Yue table, ceiling)**, 2011
Dah-Yue Jeff Shi (Taiwan, China)
**Bamboo**
© Dragonfly Design Center

竹光屋（装置），2011
石大宇(中国台湾)
竹
© Dragonfly Design Center

**Bamboo Device**, 2011
Dah-Yue Jeff Shi (Taiwan, China)
**Bamboo**
© Dragonfly Design Center

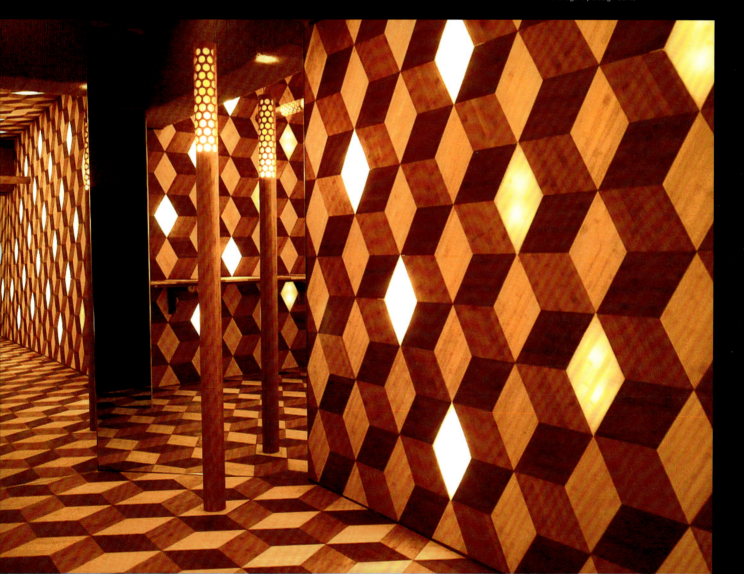

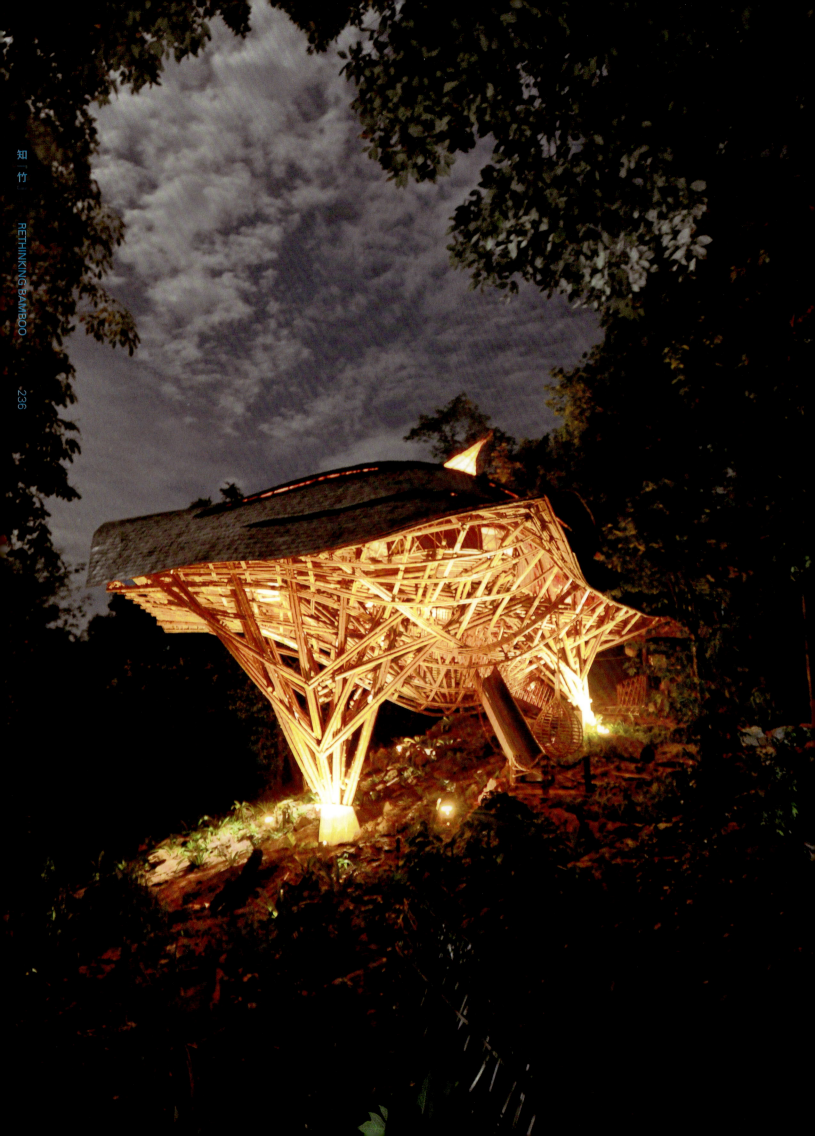

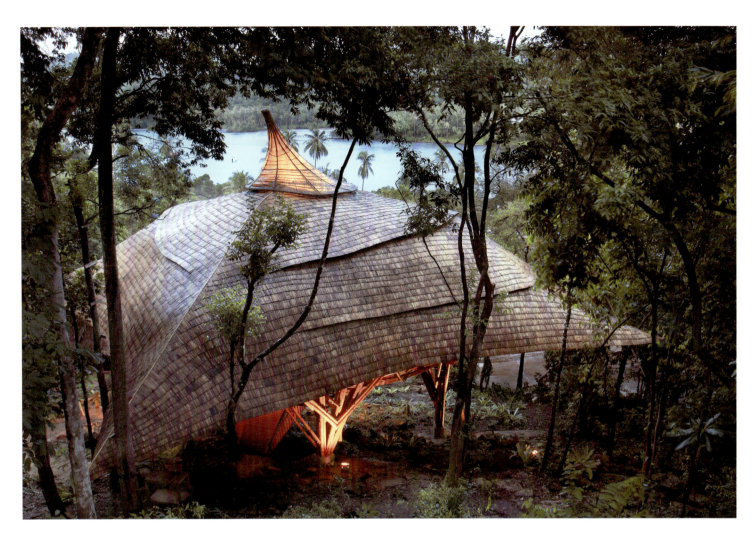

六感酒店，2006 — 2007
鲍里斯·齐泽尔，马蒂尔·拉姆斯（泰国）
竹
© 24h-architecture

**Six Sense Hotel**, 2006 – 2007
Boris Zeisser, Maartje Lammers (Thailand)
Bamboo
© 24h-architecture

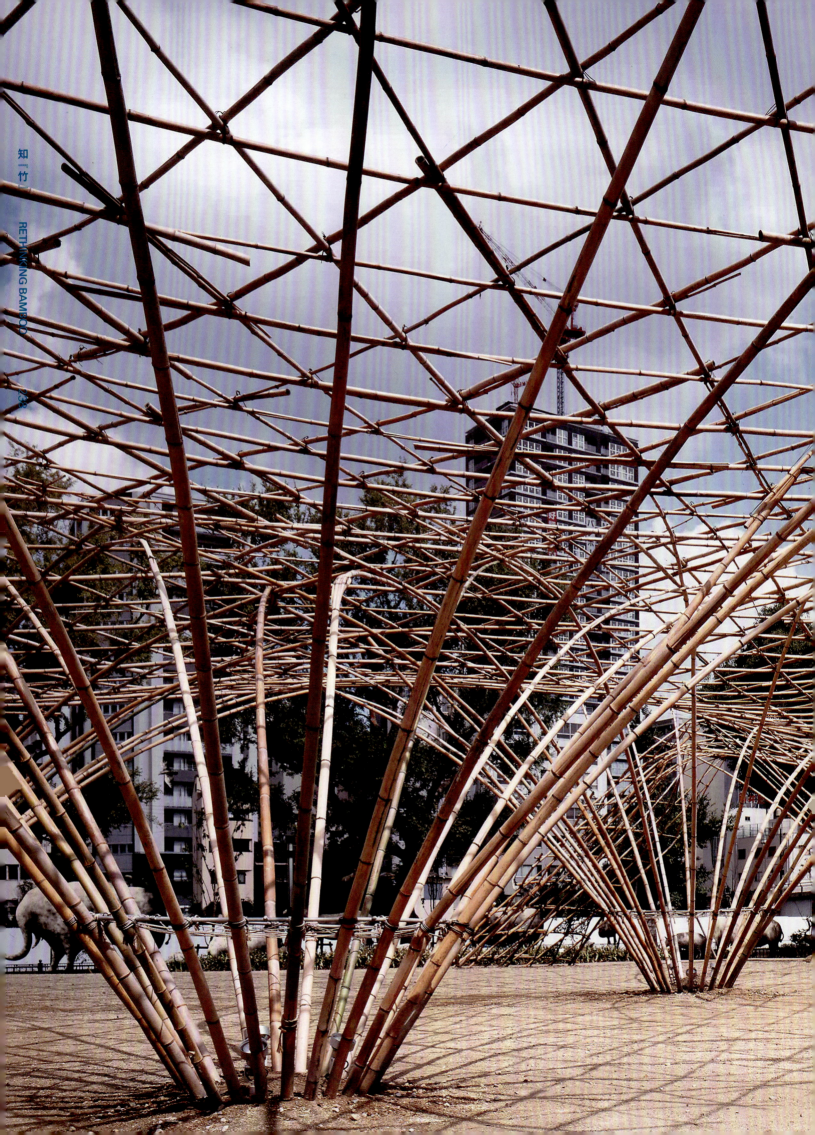

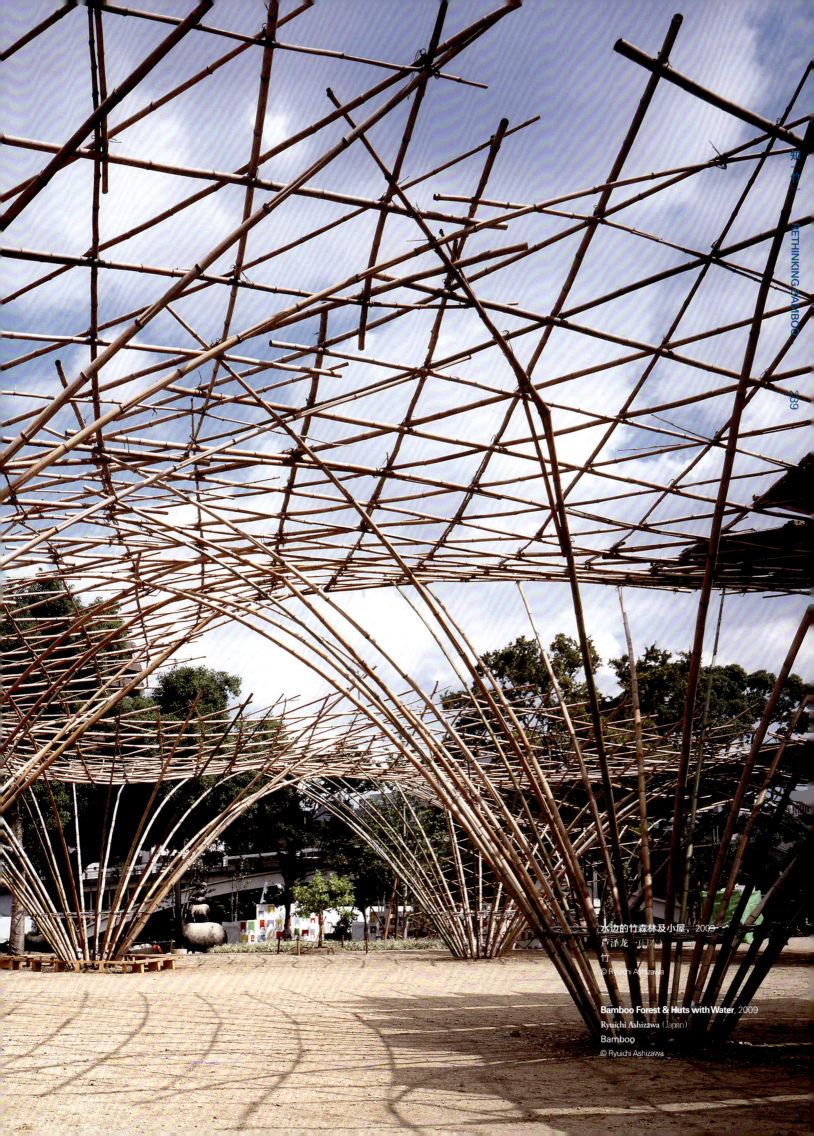

水边的竹森林及小屋,2009
芦泽龙一(日本)
竹
© Ryuichi Ashizawa

**Bamboo Forest & Huts with Water**, 2009
Ryuichi Ashizawa (Japan)
Bamboo
© Ryuichi Ashizawa

# 3.

## 理智设计情感
## REASON DESIGN EMOTION

| 策展人 | Curators |
|---|---|
| 本杰明·卢瓦约特（法国） | Benjamin Loyauté (France) |
| 方晓风（中国） | Fang Xiaofeng (China) |

本杰明·卢瓦约特(法国)
方晓风(中国)

**Benjamin Loyauté** (France)
**Fang Xiaofeng** (China)

## 单元主题阐释

"好设计"总是在理智与情感之间寻找最佳平衡。理智的设计,偏重物或产品的使用价值;情感的设计,偏重物或产品的象征(想象)价值。不同文化背景会导致对这二者的不同偏重,有时理智压倒情感,有时情感压倒理智。每个设计师都以自己的方式设计和理解使用价值和象征价值之间的平衡。设计师在设计中创造、引入和重组他认为好而且正确的平衡。

凭借这一富于原创性的展览,我们打算向世界揭示:好设计来自设计师思维中的最佳平衡,并体现了设计师从自身的文化背景出发对设计的独特思考。这是一个事关智慧的问题。我们特地创造出一个新词汇REASEMOTION(理智+情感),以体现形式和功能的交融互渗,并探索二者间的理想平衡。这一词语组合人人都能理解。此二者相辅相成,缺一不可,构成了你中有我、我中有你的关系。

本展览将按以下七个部分组织展品,由此讲述一个由七个主题组成的故事:
平静
快乐
冷峻
幽默
庆典
自由
空

## Interpretation of the Sub-theme

The good balance between the two words Reason and Emotion reveals a good design, but according to the different cultures and countries the symbolic (imaginary) value are more important ( in object or products ) than the use value and vice versa. Each designer has his own way of designing and understanding the relationship between the symbolic value of an object and its use value. The designer invents, includes and organizes in his design the right balance he thinks is good.

With this original exhibition, we propose to reveal to the world that good design is a good balance from the brain of the designer and a way of thinking the design according to the culture where he is from. It is a wisdom question. The new word we created -REASEMOTION- (reason+emotion) is merging to form and function and to find the ideal in the balance in between. Items understandable by all. They are complementary. The one cannot exist without the other. Each of them carries within it the germ of the other.

The exhibits will be organized in 7 parts, so thus telling a story in 7 themes:
CALM
DELIGHT
COOL
HUMOR
CELEBRATION
FREEDOM
EMPTINESS

# 本杰明·卢瓦约特

独立策展人,作家,制片人,
设计批评家和设计史家,博物馆顾问和展陈设计师

本杰明·卢瓦约特,1979年生于法国,毕业于艺术学院艺术史系。他定期为索邦大学等国内外大学授课。作为研究20世纪装饰艺术和设计的专家,他是一位作家、设计史家、策展人、博物馆顾问、艺术指导和展陈设计师。他在设计史和文化管理方面获得了资质认证。

2006年,他在巴黎创办了Loya-B工作室,导演纪录片《设计师的宇宙——设计师生活探微》,该片对16位知名设计师进行了采访,开创了这方面的先河。2007年,他参与策划在巴黎大皇宫举办的"设计对抗设计"展览,负责其中的当代部分,并从事相关研究。2010年,他应邀担任法国圣泰田国际设计双年展策展人,在2500余平方米的空间中完成了单元展"预言"。2011年初,他邀请马蒂诺·甘佩尔对著名建筑师勒·科布西耶在法国费尔米尼建的教堂进行投资,并完成了"理性的对话"展览的概念方案。

作为多产的作家,他最近出版了《后设计》。2001—2005年间,担任《艺术知识》杂志的设计评论家,发表多篇关于设计的文章。此后,他为其他出版物和期刊写作,如《建筑文摘》等。他还撰写了《皮尔·卡丹的演化》,2006年由弗拉马里翁出版社出版。他在2008年撰写了文章《老派的回归》。2010年,他开始对"理智情感"这一新概念进行研究。此外,他还是博物馆和艺术品经营的顾问,业务遍及全球。

# Benjamin Loyauté

Independent Curator, Author, Film Producer,
Design Critic, Design Historian, Museum Adviser and Scenographer

Benjamin Loyauté was born in France in 1979, and graduated in the History of Art from the Institute of Art. He lectures regularly at many universities in France, such as the Sorbonne, and abroad as well. Specialist of 20th century decorative arts and design, he is an author, design historian, curator, museum adviser, artistic director and scenographer. He is certified in the history of design and cultural management.

He founded his agency Loya-b in 2006 and directed the film "Designer's universe, a private visit in their own world", the first film documentary on 16 famous contemporary designers. In 2007, he co-curated the exhibition "Design contre Design" held at the Grand Palais in Paris, in charge of the contemporary section and research. In 2010, he was chosen as a curator of the International Design Biennial in St. Etienne in France and curated the exhibition "Prédiction" in a space of over 2,500 square meters. In early 2011, he invited Martino Gamper to invest in famous architect Le Corbusier's Church at Firminy (France) and conceptualized the exhibition "Rational Conversation".

An author of numerous essays, he recently published "After Design". Between 2001 and 2005, he was a design critic for the journal "Connaissance des Arts", in which he published several articles about design. Since then he has written for other publications and journals such as Architectural Digest. Benjamin Loyauté also wrote "Pierre Cardin Evolution," published by Flammarion in 2006 and the essay "Old is Back" in 2008. In 2010 he began working on a new concept called Reasemotion. He is also a consultant for museums and businesses worldwide.

## 方晓风

建筑师,《装饰》杂志主编,
清华大学美术学院环境艺术设计系副教授

1969年生于上海,1992年毕业于清华大学建筑学院,获建筑学学士学位;1992—1997年任职于上海中建建筑设计院;2002年于清华大学建筑学院获工学博士学位;2002年至今,任教于清华大学美术学院;2007年至今,任职于《装饰》杂志。

专业方向为建筑历史与理论,除教学和编辑工作之外,经常撰写建筑评论,策划相关活动。作为国内唯一的艺术设计类核心期刊的主编,他十分关注中国设计各个领域的现状和发展,多次组织全国性的设计与教育论坛,注重对当代中国设计的问题进行探讨,尤为关注设计伦理的理论研究。

曾参与中央电视台《为中国而设计——境外设计二十年》和《为中国而设计——世博建筑》两部大型纪录片的策划。2008年为纪念《装饰》创刊50周年,策划了"装饰·中国路——新中国设计文献展",引起广泛关注。2009年策划的"艺之维新——清华大学美术学院邀请展"着重展现了中国设计传统中的文人文化。

2003年,以"杭州雷峰塔(新塔)"获教育部优秀勘察设计建筑设计一等奖;2004年,以"杭州雷峰塔(新塔)"获建设部部级优秀勘察设计二等奖;2007年,其著作《建筑风语》获评"中国最美的书";2008年,获清华大学2007年度"学术新人奖";2008年,策划"装饰·中国路——新中国设计文献展";2009年,策划"艺之维新——清华大学美术学院邀请展"。

## Fang Xiaofeng

Architect, Chief Editor of Zhuangshi Journal,
Associate Professor at the Environmental Art Design Department, Academy of Arts & Design, Tsinghua University

Born 1969 in Shanghai, and graduated from Tsinghua University in 1992, received Bachelor of Architecture. From 1992 to 1997, he worked at Shanghai Zhongjian Architectural Design Insititute Co., Ltd; he received his Ph.D at School of Architecture, Tsinghua University in 2002. Since 2002, he has been teaching at the Academy of Arts and Design, Tsinghua University; since 2007, he has been working in the Zhuangshi magazine.

Fang Xiaofeng's major is architecture history and theory. In addition to teaching and editorial work, he often writes architectural review while planning related activities. As the editor in chief of the only art and design core journal in mainland China, he is very concerned about the current situation of Chinese design and its development in various fields. He organized many national design and education forums, paying attention to contemporary Chinese design issue especially theoretical research about design ethics.

He has taken part in the curatorial work of "Design for China—Twenty Years of Foreign Design" and "Design for China—Expo Building", two full-length documentary for CCTV. In 2008, he worked as the curator of "Zhuangshi · China's Road—New Chinese Design Document" during the 50th anniversary of Zhuangshi, which attracted broad attention. In 2009, he was the curator of "Art Renovation—The Academy of Arts & Design, Tsinghua University Invitation Exhibition". The exhibition mainly reflected literati culture in Chinese design tradition.

2003, his project "Lei Fung Pagoda(new pagoda)" in Hangzhou won the first prize of the Best Engineering Design Architectural Design from the Ministry of Education;2004, "Lei Fung Pagoda(new pagoda)" in Hangzhou won the second prize of the ministerial level Best Engineering Design from the Ministry of Construction;2007, Thoughts on Architecture was honored as "China's Most Beautiful Book";2008, curator of the exhibition "Zhuangshi · China's Road—New Chinese Design Document"; 2008, won 2007 "Young Scholar of Distinction" award from Tsinghua University; 2009, curator of the "Art Renovation—The Academy of Arts & Design, Tsinghua University Invitation Exhibition".

# 理智设计情感

本杰明·卢瓦约特

在一个设计对象之中,我们能够体会到一种基于两种价值观的语言。其一是,与理智相联的使用价值;其二是,作为情感的结果的象征价值。这两种价值往往是共通的,而且对其所作的阐释也存在自发性重叠。功能价值和象征价值不能分离,两者的共通性是协调的源泉之一。借此可建立理智设计情感理念,理智设计情感展览凸显这一演绎原则,其抽象性与哲学性恰同数学与理性。根据该原则,一个设计对象在相当大的范围内具有此两种价值。理智设计情感理念形成了一个兼具一般与个别的设计。相较于中国的阴阳两极,其协调理念堪称完美。每个设计师都能够根据需要、文化、个人的理解、社会文化的起源、独具特色的国家的固有条件,决定平衡的诸项参数。恰如阴阳两极,理智与情感是思想的两种互补元素。一方无法脱离另一方而存在。此处以互补形式存在的二元性,催生出一个新的探索领域,揭示了在设计中理智承载着情感的因子,反之亦然。理智与情感构成了我们所说的设计之气。借由创作与理念,以及围绕一极和同一目标的思索与内省,就可达到此两者之间的协调。

当前盛行的独特而又普遍的设计构想提出了一个反对设计流派、设计类型、设计概念的主导理论,设计原则要与之调和以求一致。理智设计情感理念旨在证明,一个设计概念的物质性结果和语义学结果影响人们进行内省的方式以及个人之于国家的方式。设计的真正意旨是掌握如何去观察,如何去体认每次创作的功能价值和象征价值,同时不至于忽视,最终是由个体赋予其不同属性。如某人在一个设计对象中发现的理性因素压倒感性因素,另一人则从中体会出感性因素压倒理性因素。不存在任何规则。设计的普遍性仅通过其特殊性以及观察到此种普遍性的个人而存在。某个词语语义的统一性或整个世界的一体化,仅可经由汇集诸多特殊性与不同本体特性来实现。如此方可决定如何设计;它允许受众融入现实并随之演变,唤醒并号令世界,正如它允许人们从中拥有梦想或逃离。

社会影响通常是发挥创造力进而创造出作品或设计对象的条件,设计领域中的创作行为也要遵循此种社会影响。某个创作行为的物质化承载着外部影响的符号,最常见的是将之作为设计师对所生活的世界和社会的需要所做出的的回应。设计师同样必须应对我们社会的要求以解决日常问题,亦必是已知现实的媒介和催生因素,预见未来的创作者。因此,设计师必须按照特定标准感知其设计对象。社会的阐释能够与设计师希望达到的效应同时产生,但是,反过来,存在着从属于设计师自身预见到的效果的邻近反应。在此情形下,自由意志主导我们感知某个物体或某个设计对象的方式。在此种阐释的起点上,设计师完全与之疏离。正由于此,在盖然性、创作活动与内省的空间之中,理智设计情感理念开始盛传。这个领域无需在意占支配地位的观点,能够容纳众多可能性。我们每个人处理设计对象并使之融入自身的方式激发我们作出各种判断。通过观察我们赋予周围事务或对象的理论(理智)与实效(情感),理智设计情感理念允许我们匹配这些判断。

理智设计情感展览揭开了通常被遗忘或被诋毁的因素——情感,正如它同样重视逻辑或理性的广泛应用。理智与情感的二元体验起源于对协调的探求——我们每个人的主要原则。本次展览提供了对我们所熟悉的七种体验的七个阶段的反思。

冷静的情感是出发点,它允许不发生各类活动,周围环境缓慢达到静止不变的状态。这个阶段的设计对象孕育着具有艺术色彩的冷峻与神秘智慧的元素,通向存在之物的平和状态。冷静境界依赖基于经验的内省以及对理性的体悟。在知足常乐性情的影响下,我们接触的各类物件可用于平息我们焦躁不安的行为。

布鲁莱克兄弟(Bouroullec brothers)的作品"光屋"阐明了激发批判性反思的顿悟。火炬灯照亮了创作者的电脑与键盘,如同烛光映照的手稿与鹅毛笔。玻璃球体安装在金属臂上,实现了量身打造的精微平衡,稳固性能较佳,但却脆弱易碎。圣人有言曰:"君子求诸己。"康斯坦丁·格里克(Konstantin Grcic)作品"苏丹椅"让身心俱可安卧于无声的大理石上休息。精湛工艺愈发凸显出它的线条与设计,将心灵带进对皮埃尔·莱格雷(Pierre Legrain)设计的极简非洲座椅的记忆之中。冷静造就出精湛、静谧、专注。43号椅采用43块竹板条,遵照古老工艺精心镌刻而成,赋予其生命的神奇品质与神圣特征。Nendo公司和设计师佐藤大在其黑线系列作品中探索金属线条与距离的寂寥和纯洁。"1360mm坐椅"内蕴中立与公平。纯粹的线条,恒定的间距,流畅优美的结构,缔造出一个精湛座椅,使人几乎感觉不到它的存在。独具慧眼的建筑师托拉弗(Torafu)利用剪纸创作的Airvases,明晰而又舒缓的诗意,掩映于明亮色彩之中。

快乐是一种受制于时间而又令人愉悦的强烈自发情感。平静之

后，本次展览导引我们进一步体悟即时欲望及其平息。通过占有某个对象或产品得以满足，产生一种短暂的、难以持久的人为幸福感。我们所谓的"设计作品"是高效市场营销战略作用下商业广告宣传的结果。因此，我们看到了经重新改造后被反复利用的各种形式与功能。随着愉快感的消散，设计而成的某个作品必须适应社会的不同期望，具体取决于社会成员的行为习惯、性别、兴趣范围、社会文化背景。设计的某个作品必须能够弥补所缺失的东西，产生短暂的幸福感，刺激相关的各种感官。此种情形下，必须研究其用途与符号。表面上服务于消费至上主义的各种设计对象或设计作品，必须具有较短的使用期限，以期形成短缺进而创造出新的需求。

这就是我们称道的有计划废止。适当命名的"快餐式"设计是被认同的诸多组成元素之一。过度的消费至上主义造成了对消费、享乐、慰藉产生的幸福感的依赖。它是一种满足感，该满足感根据逐渐发展起来的模式和需要所确定的标准进行研究、衡量。该阶段使我们能够理解我们的社会及其演化。

克里斯多佛·马歇（Christophe Machet）及其作品"载货自行车"以一种创造性方式回应消费至上主义的需要。设计新锐的自行车前后均安有巨大的车篮，适应我们对空间的需要。双轮设计缩小车轮和骑车人所用空间，留出更多的空间增加车篮的载重量，进而满足消费至上主义的需要。设计简约有效，是一款便捷的交通工具，能够达到消费至上主义者对舒适度的要求。设计师默罕默德·格采特里克（Mehmet Gozetlik）名为"最大市场的极简效应"的包装设计质疑我们摆脱对消费至上主义及其表现形式的依赖的能力。修改一盒巧克力糖果的图形设计，就是试图矫正某个失去其仪度的消费者的行为举止。默罕默德·格采特里克洞察了我们对广泛普及的消费产品外在表象的顺从。他还质疑取决于其实际形象演化的某种流行产品的稳固形象与有限认同之间的真实差异。某个广泛普及的形象的转变会刺激受众的感官，并对革新形象的观念提出疑问。史蒂芬·科勒（Steffen Kehrle）潜心研究身边事物，颇为讽刺地抛弃了他采用耐用金属创作的一次性餐具系列。WASARA公司利用可回收纸材制造出能够重复回收的一次性餐具，成为此款"快餐式"设计的伦理缺陷。类似于跨国市场营销服务力图夺取或抄袭的事物；如今，消费至上主义与道德考量已成为进行设计时必须兼顾的因素。

疏离或冷峻较少注意情感。按照事先定义的各种条件，过程的表达、机械式执行以及再现性被奉为此处的使用价值。它承载着对主宰感的深刻理解。制约因素是设计中的疏离。然而，它并非完全缺乏情感或象征意义。表面上具有敌意的特征仅可由将之视为敌对的个人察觉到。设计可利用含蓄和冷静进行美学渲染，同时引起一种伴随疏离的情感。这种对立面的融合表明，理智同样能够产生情感。如果形式与功能不可避免地在本次展示的这个阶段中加以运用，则表明，在其外部功能之下，每件创作均可蕴藏一个自省的意念以及对某一对象的个人理解。判断的价值仅可经由观察并使用该对象的个人发挥作用。参观路径上陈列的家具品质内敛、形式简约，使得每个人均可从展出的各类物件中确定自身的冷静程度。在个人理解的范围内，象征价值隐藏于功能价值的核心之中。

建筑师坂茂（Shigeru Ban）采用木材和可回收塑料制成的十构件组合座椅具有防水功能。其技术特征使之能够在室内外摆放。Artek公司采用L-型建筑构件制造，可根据个人需要进行组装。设计师斯蒂芬·迪茨（Stefan Diez）设计并由Wilkhahn公司制造的名为"底盘"的无底座椅原型，其整体构造通透可见，设计师采用先进的汽车制造技术。工业设计体现的理性，有时会因机械的卓越表现产生出情感因素，这在不加修饰的方框体设计中表现得淋漓尽致。

需要吸引注意力的幽默绝非自发形成，而是蕴含于讲述方式之中，并且取决于采用它的个人。具有幽默感的设计师能够叙述发生在我们社会中的故事，但其品位有高低之分，表达方式也存在谦逊与粗野之别。幽默具有某种救场作用——保持了良好的社交氛围。其文学属性能够激起情感，进而通向理智。通过幽默可对现实世界的方方面面进行冷嘲热讽。社交圈通过幽默维持其稳定，可使思想逃离现实或将之根植于现实。因此，本次展览的参观路径，让我们专注于掩盖住理性的色彩与形式的连续冲击。

盖塔诺·佩瑟（Gaetano Pesce）将其Senza Fine坐椅的创意起源表述为，超越游客理解能力的理性方法，若游客仅仅询问自己这款座椅是否柔软舒适以及其设计是否借鉴了盛满通心粉的餐盘。马塞尔·万德斯（Marcel Wanders）创作的"泡泡椅"讲述了回收矿泉水瓶——污染生态系统，各地海滩上随处可见的那些塑料瓶的故事，该问题因为我们社会的忽视而陷于无法解决的境地。马塞尔·万德斯设计的塑料泡泡椅重量不足一千克，幽默与意图的宣示共存，戏谑与批判交融。他通过诙谐的语言彰显出生态保护的重要性。艾奥娜·沃特琳（Ionna Vautrin）借由形似前照灯的作品比尼克射灯讲述她的创作起源，以她童年时期居住的阿摩尔滨海地区布列塔尼的一个村庄命名。灯光令人欣慰，宛如一个缩微的前照灯。

在设计层面上，庆典是注意力的中心。它是利用新的叙事手法、符号和发现来构建一个未来的条件。它形成了凝聚力，指引我们迈向一个共同的宿命。它构成了本次展览提供的路径的最普遍阶段。整体而言，拥有重要经历、共有理想、共同梦想的这个阶段，最受社会关注。我们发现了创新、探索、现象的发生以及各自的替代选择。采用了最新技术、最新程式与研究结果、最新探索方法以及最新思考形式。庆典建立了两条轴线，一条指向对热情的发掘，另一条指向赞美与纪念。他们同样是互补的——如欲向未来前行，就不能忽视往昔。了解它是一种方式，目的是为了

能够忘却，若有意如此或需要如此。记忆是新意与进步的不可或缺的组成部分，同时是宣称理智的情感的组成部分，也是控制情感的理智的组成部分。设计中，庆典的成功会激起竞争精神。它唤起人们的善意，进行沟通并分享知识，最终激励他人。

远见、首创精神、创造力是体悟庆典的关键词语。通过科学与想象的结合，无层次的前瞻性设计同样借用了本次庆典环节的各种技法。由人的欲望驱使，始终向前行进。

马克·纽森（Marc Newson）作品"人体喷气机"原型的创作灵感可能源于行动或科幻电影。该作品的材料赋予其超越现实的力量。偶然情况下，公民社会或军队就会采用这个独创设计。精心设计的紧凑构造使之无疑就是伊卡洛斯的完美梦想。它赋予人们独自翱翔蓝天的能力，而在过去只有超人具备这样的能力。今天，梦想就能有条件地实现，正如泽维尔·克拉拉蒙特（Xavier Claramunt）的作品"银河度假村"让您体验如横越太平洋诸岛般地完成穿越时空的旅行。梦想购票预订穿越时空的旅行似乎近在咫尺，即使真正未来的图景完全取决于拥有金钱的多寡。塞缪尔·威尔金森（Samuel Wilkinson）协同哈格（Hulger）将精湛工艺与先进技术融入一盏灯之中。棕色玻璃外壳，如果LED灯逐渐取代普通灯泡，内装Plumen 01的灯盏就能与之抗衡。其经济性与耐久性毫不逊色于LED灯，但它唤醒了人们对格里特·里特维尔德（Gerrit Rietveld）吊灯的尘封记忆。Vessel系列灯具通过这种方式构想出灯盏、桌台、悬挂物件，其间摇曳着灯丝隐藏于彩色玻璃外壳之内的灯盏，只需保持能够使之发光的电力。托马斯·勒博塞（Thomas Lebecel）探索Fablabs创作与创新的范围，Fablabs是由发明家与信息专家以及设计师与科学家组成的社会合作组织，成员在一个实验室中共同工作，开发独立创作所需的各种工具供成员共享使用。其作品"三维扫描仪"具有使用树脂材料复制完全相同的物件的潜力。这种复制体验使得我们能够构思并推测各种技术设想，服务于医疗领域；举例来说，个性化假肢器官以及不可思议的器官复制。

在设计与架构层面上，自由观念会激发出与自主原则相对立的自愿行为。工业设计本质上受到构造与创作规则的制约。在诸多设计师之中，有人将此主导原则抽象化，进而确立自己的创作规则作为替代。其他人则在这些制约之中体悟到适应的必要。这种适应体现在其行动的完成之中。从中觉察到发明创造能力的形成过程。对一种理论性制约因素或理论方法的原则的熟习，适合于情感强度为理智所支配的内省范围。在此情形下，制约因素可视为孕育想象力的温床。它是优化创作过程的一种方式，所具有的唯一目标仅在于满足可行性条件。设计师面对自由的态度可分为两个方面：首要目标是坚持最初的创作意图或方案，次要目标是将创意转化为现实，亦即借助机器使之变为作品。本次展示的这个阶段表明，设计师与建筑师如何定义接近于艺术姿态的新行为状态，以及如何展现其创作行为的多面性。在设计层面上，恰如力学与数学，制约因素是重视各种层次的条件，具体则决定于每位设计师。

形式幻想工作室（Studio Formafantasma）的"专制"系列作品，展现了利用手工技艺和天然材料，而非新材料，创作而成的设计的面貌。安德里亚·奇马卡奇（Andrea Trimarchi）和西蒙·法热辛（Simone Farresin）提出了一个设计，要求就设计理念的一体化以及模式与创作的普适性，有权自行确定其替代选择。他们的作品唤起了自发抗拒的潜力，并揭示出狂傲自负的新魅力。个人能够在探求革新以及提高理性与实践能力的过程中，学会去顺应外部世界。Raw Edges 设计工作室创作的"剪裁的木材"系列座凳的独特设计风格，是延续纯粹创意的痕迹的座椅与掺杂了制约因素与技术创新的原创设计及加工改造，此两者之间冲突的视觉范例。艺术家兼建筑师安德列斯·安格利达克斯（Andreas Angelidakis）的作品"云屋"中描绘了一个适于居住的云状寓所，充分展示了该作品的象征价值。阿曼达·莱维特（Amande Leveté）与安尼施·卡普尔（Anish Kapoor）共同完成的"那不勒斯地铁站"首先是一件艺术品，其次才是一座地铁站。功能价值与象征价值在完美和谐中共存。它是建筑师兼设计师阿曼达·莱维特自由意志的选择。她赋予了设计一词本该蕴涵的意旨——自由与演变的可能。这件佳作的力量揭示出特殊字词的复杂性，维持了它永不止息的运动、变化。作品使她能够潜心于字词的语义学研究。

在西方文化中，"空"与"无"并存。"空"规定出一个不具任何内容的对象。它被视为一个阴性空间。花瓶在没有插花时是空的，而水瓶在没有盛水时是空的。相比之下，在中国文化中，"空"则呈阳性，它就是充实。它使我们认识到这样一个事实，即一个空花瓶总能被充实，具有无限性。"空"意味着存在后续事物及连续性的可能；"空"是包容各种可能性的空间。它呈阳性，着眼于未来。理性路径与感性路径的最终阶段尝试着去理解这种"空"。隈研吾（Kengo Kuma）先生为雷丁村创作的"六号立方体"力图通过一个反光的"空"去映射、留存游客们的身影。我们必须去观察，从而学会如何观察我们自己。沿着这条路径铺设的梦想之石创造出此种可能。借着张载推崇的太虚，有形之物终归于无形。它复苏了人的心灵与感官，伴其在平衡之旅上前行。光与影的设计，连同塞尔万·雅克（Sylvain Jacques）创作的声音效果以及克里斯汀·奥斯特古成莱奥（Christian Astuguevielle）构思的芬芳气息，吉沃丹实验室使我们预见到设计对未来的征服。无形之物创造出的这个巨石，使得游客有可能去体验各类感觉能力，调动起全部感官，同时激发大脑的各种官能（嗅觉、触觉、听觉、视觉）。唤起各类感觉的石块和道路使得每个人均能体验到理智设计情感理念。设计处在认知心理学的门边，现在，轮到我们开启并引领它。

诚挚感谢所有的参展者、无私奉献的匿名收藏家以及所有工作人员，没有他们的热心帮助，就没有本展览。

# REASON DESIGN EMOTION

Benjamin Loyauté

In an object of design, we can apprehend a language that is built around two values. One is the value of use, linked to reason; the other is its symbolic value, the result of emotion. These two values are constantly interconnected and their interpretation is as autonomous as overlapping. The functional value and the symbolic value cannot be separated - their connectivity acts as a source of balance. It allows for the establishment of the concept of Reasemotion; the exhibition Reason Design Emotion highlights this deductive principle that is just as mathematic and rational as it is abstract and philosophical. The established principle stipulates that an object of design possesses within it these two values in fairly large spectrums. The concept of Reasemotion leads to a design that is at once universal and specific. It is considered ideal for its concept of balance close to that of the Chinese yin and yang. Every designer can determine the parameters of the equilibrium in terms of irrevocable conditions related to needs, culture, understanding, socio-cultural origins, and the country of each individual. Just as with yin and yang, reason and emotion are two complementary elements of thought. One cannot exist without the other. The duality, here in form of complementariness, brings into existence a field of exploration revealing that in design, the reason carries within it the germ of emotion, and vice versa. The reason and the emotion constitute what we can call the qi of design. Their balance is attained through creation and conception, through thought and reflection revolving around one sole and same objective.

The individual and global vision of design that thrives today presents a domination of theory that opposes genres, types and ideas, while the principle of design is to assemble and reconcile them. The concept Reasemotion intends to demonstrate that the physical and semantic result of a design idea affects the way in which people, their reflections, and their countries base themselves. The true intention of design is to know how to observe and to recognize the functional and symbolic value in each creation without ever forgetting that it is up to the individual to make the attributions. When one finds more reason than emotion in an object, the other finds more emotion than reason. There are no rules. The universality of design exists only through its particularities and those who observe them. The globalization of a word or a world can happen only through the coming together of its individualities and different identities. Design can then be determined; it allows the user to enter into and evolve within reality, to awaken and order the world just as it allows one to dream in it and escape from it.

The act of creation in the realm of design is subject to sociological influences that often operate as conditions for creativity and the production of products known as design objects. The materialization of an act of creativity carries signs of exterior influences, most often identifiable as a designer's response to the needs of the world and of the society in which he lives. He must also respond to the demands of our society to resolve daily problems and must also be a catalyst and incubator of the given reality, an initiator that anticipates the future. He therefore must conceive of his object in terms of specific criteria. Society's interpretation can be concurrent with the effects that the designer wishes to produce, but there may in turn be adjacent reactions that subordinate the impact anticipated by the designer himself. In this case, free will guides the way in which we perceive a product or an object. The designer may be at the origin of this interpretation just as he may be entirely distant from it. It is here, in this space of contingency, activity and reflection that the concept of Reasemotion thrives. This zone ignores the hegemonic point of view and harbors a multitude of potentialities. The way in which each and every one of us approaches a design object and makes it our own provokes a profusion of judgments. The concept of Reasemotion allows us to match these judgments by observing the theory (reason) and the effect (emotion) that we ascribe to the products or objects that surround us.

The exhibition Reason Design Emotion brings to light what is often forgotten or libeled, the emotion, as it also highlights the favored demonstration of logic, or reason. The binary experience of reason and emotion springs from a common sense exploration of balance, the ruling axiom determined by each of us. This exhibition offers introspection in seven stages of seven experiences familiar to us all.

Calm emotion is a point of departure, it shelters an absence of activity in which the atmosphere is slowed to the point of immobility. The objects of this stage have inoculated artistic seeds of sober and subtle wisdom that lead to a peaceful state of being. The calm predicament rests on a reflection grounded on experience and an understanding of reason. In this disposition for which "less is more" is a constant, the objects that we come into contact with serve as remedies for our restless behavior.

The "LightHouse" by the Bouroullec brothers illustrates this enlightened wisdom that induces critical reflection. It's the torch

that lights up the writer's computer and keyboard just as the candle lighted their manuscripts and feather pens. Its glass globe is placed on a metal arm only by sophisticated and calculated balance that is just as stable as it is fragile. According to Confucius, "experience is a candle that lights up only he who holds it." The "Sultan chair" by Konstantin Grcic enables the rest of the body and mind on silent marble. The technical prowess in execution highlights its line and design, bringing to mind African memories of minimalist chairs by Pierre Legrain and the articulated African chairs of the Senoufo keepers. Calmness enables precision, silence and concentration. The Chair 43 that is composed of 43 slats of bamboo is chiseled with unparalleled precision. It brings to life both the magical and sacred qualities and also the methods and precision of the artisan composer's ancestral gestures. Nendo and Oki Sato explore the silence and purity of metal lines and gaps in their Black Lines Series. The 13600mm chair praises neutrality and impartiality. Pure lines at regular intervals of melodic sound compose a chair just as minute as imperceptible. It spreads on its own a lucid and calming poetry that the Airvases in cut paper, done by the ingenious architects Torafu, harbor in their lightness.

Delight is a lively, spontaneous, and pleasant emotion that is limited by time. After calm, the path of the exhibition leads us into the spur of immediate desire and its assuaging. The satisfaction from possessing an object or product procures a temporary and artificial happiness that is not sustainable. The "design product" as we call it is the outcome of the commercial agenda with efficient marketing strategies. Here we find forms and functions that are constantly being reinvented or recycled. As the pleasure is fleeting, a product that is designed must respond to the expectations of a society studied according to the behavior of its individuals, according to their sex, their country, and their socio-cultural background. A product of "design" must make up for something missing and procure temporary happiness and stimulate the related senses. The use and the symbol in this case are studied. Every object or product of design that is ostensibly linked to consumerism must have a short life span in order to create the lack and the need.

This is what we call planned obsolescence. The appropriately named Fast design is one of the identified components. Consumerism in excess provokes an addiction to the well being of consumerism, enjoyment and consolation. It's a kind of satisfaction that is studied and quasi-fabricated according to criterion established by cultivated modes and needs. This stage allows us to apprehend our society and its evolution.

Christophe Machet and his Camioncyclette respond in a creative way to needs of consumerism. His contemporary velocipede with structured baskets adapt to the needs of places in which we are dependent. These two wheels facilitate the refueling and supplying of an excess of products that testify to our needs of consumerism and accumulation. Simple and efficient, it enables an easy transport and meets the demands for consumerist comfort.

The packaging proposals of Mehmet Gozetlik named Minimalist Effect in Maximalist Market question our capacity to own up to our dependence on consumerism and its representations. To modify the graphic design of a pack of chocolate candy is an attempt to modify the behavior of a consumer who loses his bearings. Mehmet Gozetlik plays with our submissiveness to the image of a widespread consumer product. He also questions the true disparity between the fixed image of a popular product according to the real evolution of images and definite identities. The transformation of a widespread image creates excitement and questions the idea of renewal. Steffen Kehrle studies the gadget and ironically denaturalizes the system of disposable cutlery that he creates in durable metal. WASARA has created disposable tableware out of recyclable paper, capable of continual resuscitation, inserting the ethic bug in this Fast design. This is similar to what multinational marketing services try to capture and plagiarize; consumerism and ethics today are new obsessions of the good conscience of design.

Distance, or cool, gives little attention to emotion. The value of use here is consecrated by the expression of process, mechanical execution and reproducibility, tied to predefined terms. It carries the DNA of mastery. The constraint is the distance in design. And yet, it is not utterly lacking in sense or symbolism. The seemingly hostile character contained within it is seen as so only by he who determines it as hostile. Design can be aesthetically rendered with reserve and coldness and simultaneously provoke an emotion related to this distance. It is this association in antithesis that demonstrates that reason can produce emotion. If the form and function inevitably bring out the use in this stage of the exhibition, it is to demonstrate that each creation can conceal an introspective idea and individual appreciation of an object behind its outward function. The value of judgment comes into play only through he who beholds the object and uses it. The quality often closed, austere and insensitive of furniture placed in this part of the path allows each individual to determine his own level of detachment from the objects presented. It is a zone of individual appreciation where the symbolic value is hidden in the heart of the functional value.

The chair from the 10-Unit System by architect Shigeru Ban in wood and recycled plastic is water-resistant. Its technical characteristics allow it to be placed indoors and outdoors. Fabricated by Artek, it is made by architectured elements in an L shape that call for individual and mechanical assembly. The process of fabrication is visible in the prototype of the chair Chassis, edited by Wilkhahn and designed by Stefan Diez, who uses the advanced technologies of automobile production. The industrial reason at times procures emotions that are connected to the prowess of machinery and robotics, which is perceptible in the details of unveiled matrixes.

Humor, which needs to attract attention, is never spontaneous but instead narrative and decided by he who handles it. The designer

who has the sense of it can tell stories that manifest in our society with good or bad taste, modesty or insolence. Humor has a saving quality – it preserves good social health. Its literary properties provoke emotion and lead to reason. Those who use it come into touch with the ironic, cynical, candid, caustic, parodic, and unusual aspects of reality. Society stabilizes itself through humor and enables the mind to escape from reality as well as anchor itself in it. The path of the exhibition therefore leads our gazes to a joyous bombardment of colors and forms that camouflage reason.

Gaetano Pesce expresses the creative origin of his sofa Senza Fine that echoes other intellectual approaches beyond what the visitor can understand when the visitor asks himself simply whether or not the chair is soft or solid and if it makes reference to a plate of colored spaghetti. The Sparkling chair by Marcel Wanders tells the story of the recycling of a plastic bottle of mineral water, the same one that pollutes our ecosystem and is found on beaches all over our globe, stranded by the negligence of our society. In Marcel Wanders' plastic chair that weights less than a kilogram coexists humor and declaration of intent, jokes and criticism. He takes on ecological needs through a humoristic language. Ionna Vautrin tells the story of her origins through her lamp Binic in the form of a headlight, named after a village in Bretagne in the region of the Armor Coast where the designer spent her childhood. Her lamp is reassuring like a miniature bright character.

Celebration is, in design, at the center of attention. It is the condition for constructing a future around new narratives, signs and discoveries. It builds cohesion and guides us toward a shared destiny. It constitutes the most universal stage of the path offered in the exhibition. Society as a whole is concerned by this stage that holds important events, communal ambitions and common dreams. Here we find innovation, exploration, the emergence of phenomena and their own alternatives. It brings to date all of the new technologies, new programs and research, new inquiries and new debates. Celebration builds two axes, one pointed towards the enthusiasm of discovery, the other pointed to praise and commemoration. They are also complementary- one cannot ignore the past if he wishes to head toward the future. Knowing it is a means of being able to forget it, if there is a will or a need for it. Memory is an integral part of newness and advancement. It is at once the part of emotion that proclaims reason and the part of reason that regulates emotion. The triumph of celebration in design spurs the spirit of competition. It arouses the good will to communicate and share the knowledge in order to boost others.

Foresight, initiative and invention are words relating to the mastery of celebration. The prospective and discursive design also borrows routes of this celebration by uniting science and illusions. This is driven by man's desire to always go further.

The prototype of Body Jet by Marc Newson could come straight out of propositions for action or science fiction films. The material of this work awards it a power over reality. Incidentally, civil society or the army could attach themselves to it. It is a reasonable dream of Icarus because it is studied and precise. It gives to man the ability to fly alone. Yesterday, this ability was given to individual superheroes. Today the dream becomes something that is conditionally realized, just like the Galactic Suite Space Resort by Xavier Claramunt that offers the experience of a time in space just as a journey to an island in the Pacific would be offered. The dream of taking a ticket and making a reservation seems possible even if the image of the real future is only momentary. Samuel Wilkinson, in collaboration with Hulger, unites artisanship and technology in a lamp. The glass is blown, and if LED replaces the mythical light bulb little by little, the new Plumen 01 that this lamp contains resists it. Economical and durable as LED, it revives the memory of the light bulb that exhibits its filaments in the ceiling lamps of Gerrit Rietveld. Vessel series in this way envisages lamps and tables and suspensions, in which the bulb, with filaments concealed behind tinted glass, need only the electricity fairy to become visible. Thomas Lebécel explores the scope of creation and innovation of Fablabs, social cooperatives workshop composed of inventors and informaticians, designers and scientists who work in a laboratory to produce tools of autonomous creation that can be auto-produced and shared. It is his 3D scanner that has the potential to reproduce an identical object in resin. This experience of replication allows one to envision and calculate a number of technical hypotheses to serve the medical domain, for example the creation of personalized prosthetic devices and the unimaginable reproduction of organs.

The notion of liberty in design and in architecture motivates voluntary behavior that confronts the principle of autonomy. Industrial design is essentially constrained by rules of construction and production. Among designers, some make abstractions of this domination and initiate their own rules of creation as alternatives. Others discern within these constraints the redeeming necessity of adaptation. This acclimation resounds in the accomplishment of their actions. They see in it a generator of inventiveness. The habituation of principles of one theoretical constraint or technique equips zones of reflection where the intensity of emotion is ruled by reason. In this case, the constraint can be perceived as an incubator of imagination. It's a way of optimizing a process of creation with the one goal of satisfying the conditions of feasibility. The attitude of designers in the face of liberty has two sides. The first aims to conserve the original intent or plan and the second aims to manufacture the idea, that is to say, make it permeable and disciplinable when it comes to the machine. This stage of the exhibition demonstrates how designers and architects define new behaviors that near artistic gestures and how they declare the versatility of their creative acts. The constraint is, in design as in mechanics and mathematics, a condition to respect on many levels, and determined by each designer.

Autarchy project by Studio Formafantasma offers the face of a design that harks back to artisanal techniques and within which

new materials have surrendered to natural materials. Andrea Trimarchi and Simone Farresin propose a design that demands the right to an alternative to the globalization of concepts and the universality of modes and productions. Their creations evoke the potential of autonomous resistance and announce the new power of self-sufficiency. One can detect the resilience of a world in search of reformation and intellectual and practical betterment. The juxtaposition of the Tailored Stool and the TWB Stool by Raw Edges Studio is a visual example of the confrontation between a chair that conserved that traces of a pure idea and its original design and its industrial adaptation that is crossbred with constraint and technological innovation. Andreas Angelidakis, artist and architect, dreams of a habitable cloud in his Cloud House in which he grants his project the full intelligence of its symbolic value. The project Naples Subway Traiano by Amande Levete in collaboration with artist Anish Kapoor is at once a work of art and a subway station. The functional and symbolic values coexist here in perfect harmony. It is the choice of free will, that of Amanda Levete, this architect and designer. She gives back to design what belongs to the word itself - the potential for liberty and evolution. The force of this project reveals the complexity of one word and perpetuates its eternal movement. It gives her the authorization to an onomasiological study of the word.

In Western culture, emptiness coexists with nothingness. Emptiness defines an object that is devoid of content. It is perceived as a negative space. The vase is devoid of flowers when it is empty and the pitcher is devoid of water when it is empty. In Chinese culture, emptiness is active, it is fullness. It makes us realize that an empty vase can always be filled, to infinity. Emptiness would be the possibility of what follows, of continuity; emptiness is the space that harbors possibilities. It is positive and it is oriented toward the future. The last stage of the path of reason and of emotion attempts to comprehend this emptiness. The work Cube # 6 for Raiding by Kengo Kuma seeks to provoke and to capture the shadows of visitors through a luminous emptiness. One must see in order to know how to see oneself. The dream stone that accompanies the path sets this potential free. It enables the visible to become invisible with this "supreme emptiness" ( tàixū 太虚 ) consecrated by Chang Tsai. It revitalizes the mind and senses of man and accompanies him on the journey of balance. The design of the light, the sound created in collaboration with Sylvain Jacques, and the fragrance conceived with Christian Astuguevielle and the Givaudan Laboratory allow us to anticipate the future conquests of design. The creation of this giant stone of impalpable substance gives the visitors the possibility to experience all of the sensations and to engage all of their organs of perception. The faculties (smell, touch, hearing, vision) of their cerebrum are also stimulated. The stone and the path that revitalize the senses enable everyone to live the experience of Reasemotion. Design is at the door of cognitive psychology. It is now our turn to allow it in and guide it.

We express our deep gratitude to all the designers who participated in our exhibition and also to Alessi, Amanda Levete Architects, Artek, Artemide, Ascète, Black Milk Agency, Cappellini, ClassiCon, Decode, Domestic, Doro, Dyson, EADS Innovation Works UK, Edouard François Architects, Eno, Galerie Fat, Flos, Foscarini, Galerie Gosserez, Galactic Suite, Galerie Ymer & Malta, Givaudan, Heatherwick Studio, Industrial Facility, Jawbone, Kvadrat, Le Laboratoire, LaCie, Lladro, Ligne Roset, Luccon Concrete, Magis, Marc Newson Ltd, MateriO, .MGX by Materialise, Marsotto, Mattiazzi, Meritalia, Moooi, Moroso, Moustache, Next Level Galerie, Norman Foster + Partners, Philips Design, Phillips de Pury & Company, Plank, Porzellan Manufaktur Nymphenburg, Raiding Foundation, Royal VKB, Thonet, Thorsten van Elten, Saasz, Sèvres - Cité de la Céramique, Sham Conseil, Skitsch, Specimen Editions, Tokyo Eat, Triode Design, Wasara Co Ltd, Wilkhahn, Wogg, XO Design, YikeBike, and Zaha Hadid Architects.

To private collectors who wish to remain anonymous and all those who helped this exhibition.

And also many thanks to Agence Loya-b, Thibault Guittet, Alexandra Jaffré, Julie Lafortune, Isabel McWilliams, Alix de Moulins, Sébastien Sans, Olivia de Smedt, Guan Yunjia, Chen Anying, Li Minmin, Wang Chenya, and the co-curator Fang Xiaofeng.

Without their help, the exhibition won't be possible.

理智情感——平静，2011
弗雷德里克·塔舍尔（法国）
© Photo: Frederic Tacer

**Reasemotion—CALM**, 2011
Frederic Tacer (France)
© Photo: Frederic Tacer

THE SOUND OF RAIN FALLING INTO A WATER

(raindrop raindrop raindrop...)

加热器，2011
5.5设计工作室(法国)
量子玻璃加热片，上漆木板底座，树枝，
上漆钢管
© Photo: Saazs

**Heat**, 2011
5.5 designers (France)
Heating glass panel by Quantum Glass,
Lacquered wood base, natural tree branch,
lacquered steel tube
© Photo: Saazs

高脚花冠杯，2010
安德里亚·布兰兹(意大利)
无釉瓷
© Photo Sèvres, Cité de la Céramique

**Corolle pied haut**, 2010
Andrea Branzi (Italy)
Piece of non-glazed porcelain, called
"biscuit de porcelaine"
© Photo Sèvres, Cité de la Céramique

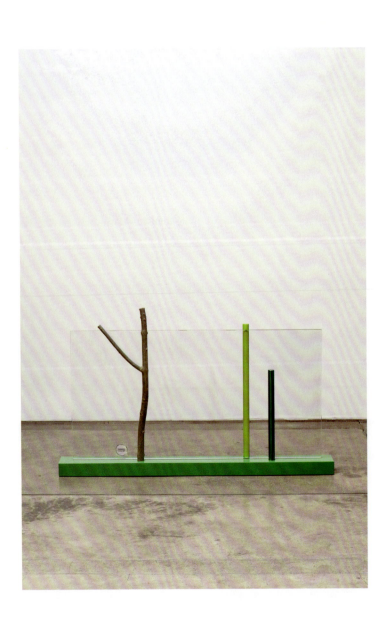

加热器，2011
5.5设计工作室(法国)
量子玻璃加热片，上漆木板底座，树枝，
上漆钢管

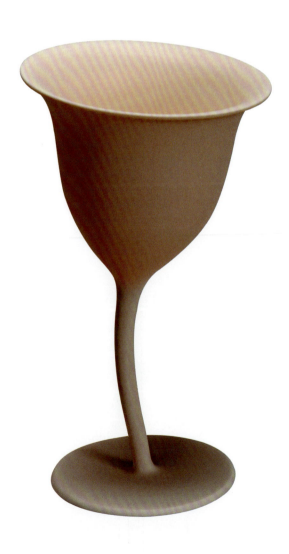

高脚花冠杯，2010
安德里亚·布兰兹(意大利)
无釉瓷

微型生活世界,2010
本杰明·格兰多戈(法国)
大理石
© Photo: Bernard Maltaverne

**Small Living Land**, 2010
Benjamin Graindorge (France)
Carrare Marble
© Photo: Bernard Maltaverne

甜蜜地平线,2010
本杰明·格兰多戈(法国)
大理石
© Photo: Bernard Maltaverne

**Sweet Horizon**, 2010
Benjamin Graindorge (France)
Carrare Marble
© Photo: Bernard Maltaverne

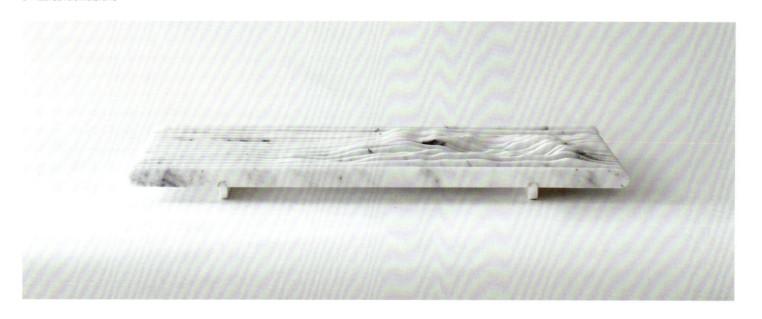

彩灯，2010
丹尼尔·瑞巴克（挪威）
上漆铝盘，浸渍式玻璃
© Photo: Ligne Roset

**Color lamp**, 2010
Daniel Rybakken (Norway)
Lacquered aluminium disc / impregnated glass
© Photo: Ligne Roset

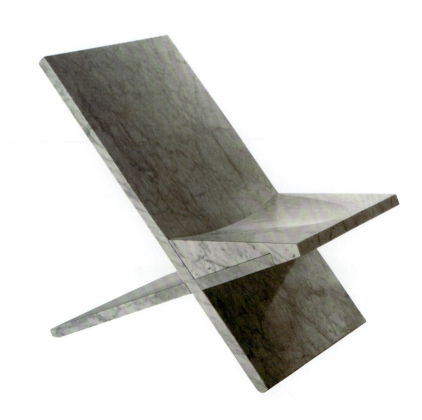

苏丹椅，2010
康斯坦丁·格里克（德国）
白色卡拉拉大理石，衬边抛光
© Photo: Marsotto Edizioni

**Sultan chair**, 2010
Konstantin Grcic (Germany)
White Carrara Marble, matt polished finish
© Photo: Marsotto Edizioni

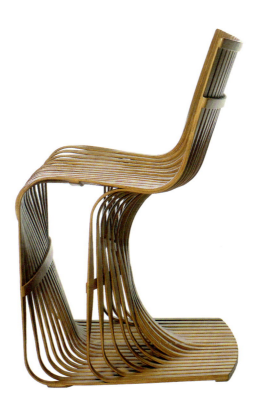

**43号椅**，2008
康斯坦丁·格里克，陈考明
中国台湾工艺研究所与台湾创意设计中心合作项目（德国/中国）
竹板条
© Photo: Skitsch

**43 Chair**, 2008
Konstantin Grcic, Chen Kao-Ming
Collaborative project organized by NTCRI and TDC (Germany / China)
Bamboo slats
© Photo: Skitsch

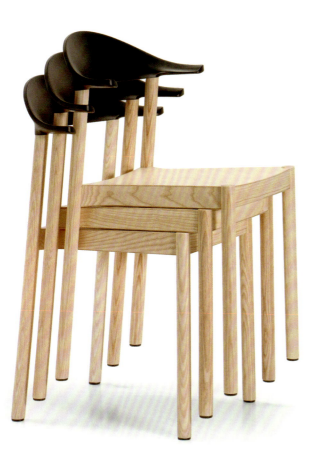

**蒙萨椅**，2010
康斯坦丁·格里克（德国）
木材，漆，聚丙烯树脂
© Photo: Plank Collezioni SRL

**Monza Chair**, 2010
Konstantin Grcic (Germany)
Wood and laquer, polypropylene
© Photo: Plank Collezioni SRL

书签灯, 2010
莱奥纳尔·卡迪德 (法国)
野生樱桃木材, LED
© Photo: Leonard Kadid

**Bookmark Lamp**, 2010
**Léonard Kadid** (France)
Wild cherry wood, LED
© Photo: Leonard Kadid

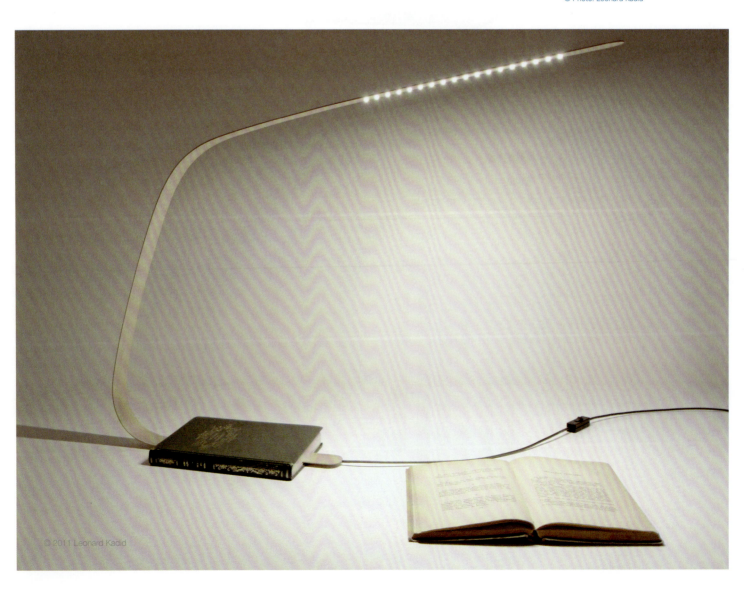

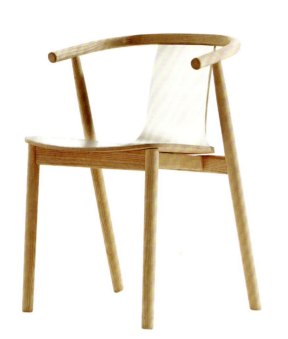

**Bac扶手椅**, 2009
贾斯珀·莫里森（英国）
木材
© Photo: Cappellini

**Bac Armchair**, 2009
Jasper Morrison (UK)
Wood
© Photo: Cappellini

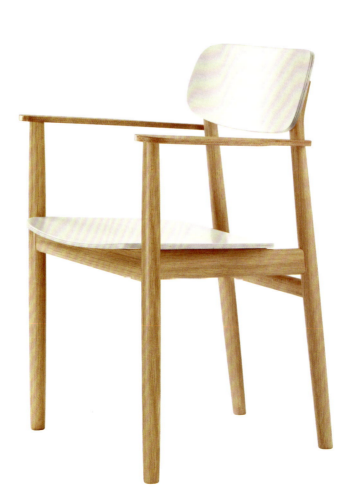

**130号椅子**, 2000
深泽直人（日本）
木材
© Photo: Thonet

**Chair 130**, 2000
Naoto Fukasawa (Japan)
Wood
© Photo: Thonet

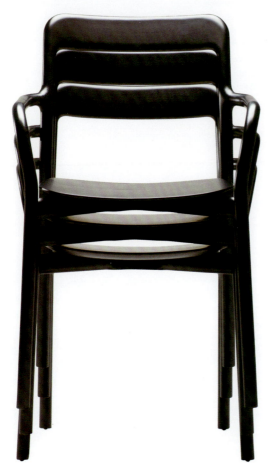

**Branca椅，** 2010
山姆·赫奇特（英国）
实木
© Photo: Industrial Facility

**Branca Chair,** 2010
Sam Hecht (UK)
Solid wood
© Photo: Industrial Facility

**黑线系列-3800mm碗，** 2010
Nendo公司（日本）
钢
© Photo: Phillips de Pury & Company

**3800mm-bowl, Thin Black Lines Series,** 2010
Nendo (Japan)
Steel
© Photo: Phillips de Pury & Company

黑线系列—13600mm座椅，2010
Nendo公司(日本)
钢
© Photo: Phillips de Pury & Company

**13600mm-chair, Thin Black Lines Series**, 2010
Nendo (Japan)
Steel
© Photo: Phillips de Pury & Company

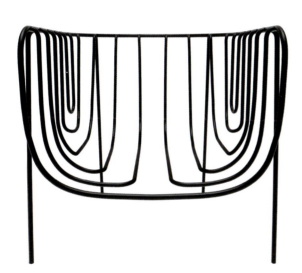

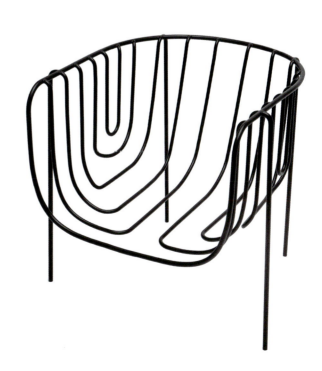

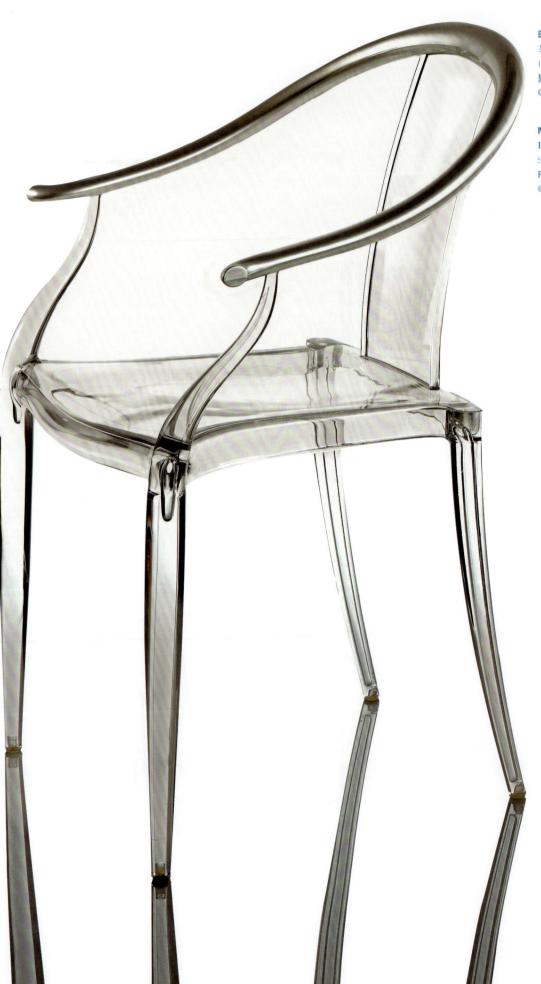

明式椅，2008
菲利普·斯塔克，欧金尼·凯特莱特
（法国／西班牙）
聚碳酸酯，银漆
© Photo: XO design edition

**Mi ming armchair**, 2008
Philippe Starck & Eugeni Quitllet (France/Spain)
Polycarbonate, fushou lacquered in silver
© Photo: XO design edition

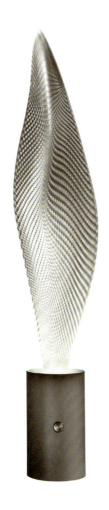

宇宙叶,2009
洛斯·拉古路夫(英国)
带纹理的透明甲基丙烯酸酯,上漆金属发光元件
© Photo: Artemide

**Cosmic Leaf Tavolo**, 2009
Ross Lovegrove (UK)
Body lamp-diffuser in transparent methacrylate with texture, brushed metal lighting unit
© Photo: Artemide

Pane椅,2003—2006
吉冈德仁(日本)
录像 3分,8分26秒
© Tokulin Yoshioka

**Pane Chair**, 2003-2006
Tokujin Yoshioka (Japan)
Video 3'00minutes, 8'26 minutes
© Tokulin Yoshioka

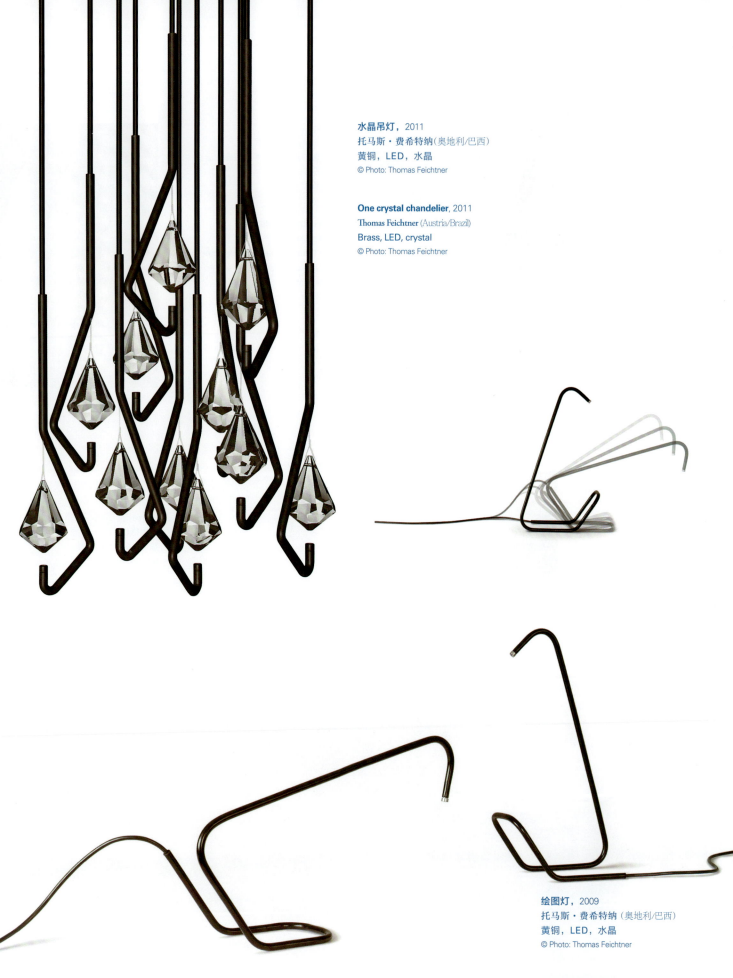

水晶吊灯，2011
托马斯·费希特纳（奥地利/巴西）
黄铜，LED，水晶
© Photo: Thomas Feichtner

**One crystal chandelier**, 2011
Thomas Feichtner (Austria/Brazil)
Brass, LED, crystal
© Photo: Thomas Feichtner

绘图灯，2009
托马斯·费希特纳（奥地利/巴西）
黄铜，LED，水晶
© Photo: Thomas Feichtner

**Drawing lamp**, 2009
Thomas Feichtner (Austria/Brazil)
Brass, LED, crystal
© Photo: Thomas Feichtner

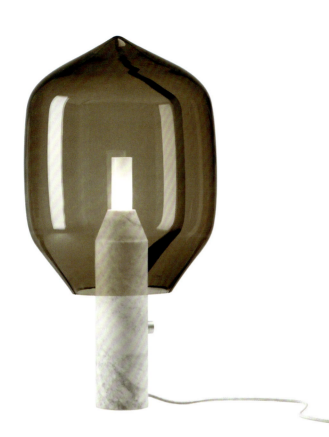

光屋，2010
罗南·布鲁莱克，尔旺·布鲁莱克（法国）
威尼尼吹制玻璃罩，亚光大理石底座，阳极氧化铝灯架，调光开关
© Photo: Established and Sons

**Light House**, 2010
Ronan & Erwan Bouroullec (France)
Mouth blown Venini glass shade, matt marble base, anodised aluminium arch and dimmer switch
© Photo: Established and Sons

珍珠灯，2011
皮埃尔·法夫雷斯，艾玛纽勒·杜蓬特（法国）
玻璃，金属，棉花
© Photo: Specimen Editions and Triode

**Pearl**, 2011
Pierre Favresse & Emmanuelle Dupont (France)
Glass, metal, cotton
© Photo: Specimen Editions and Triode

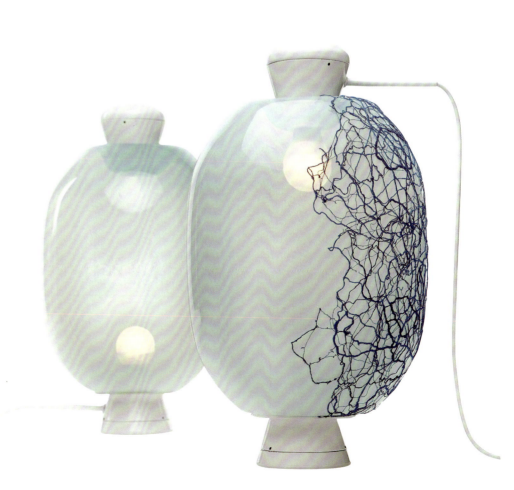

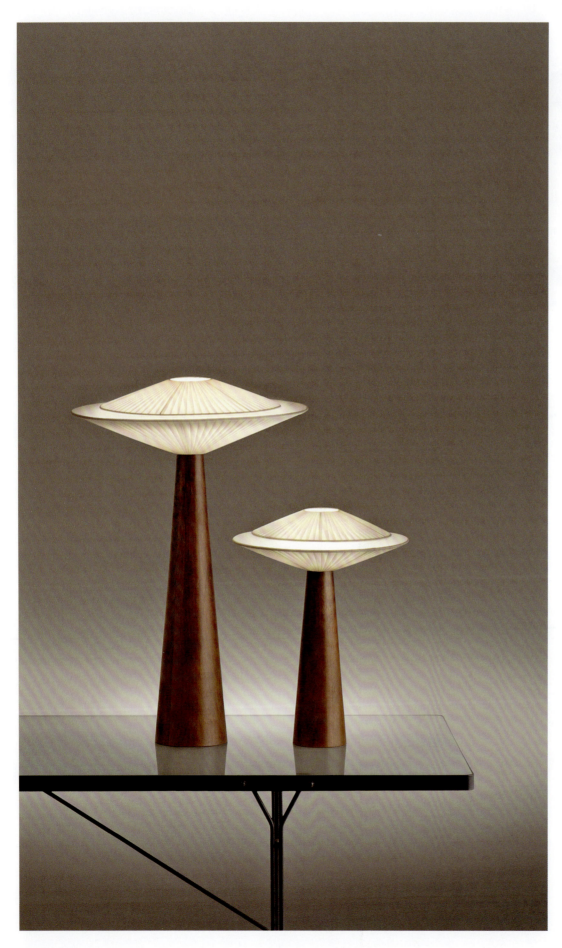

木架布艺台灯，2009
周佚(中国)
胡桃木，布
© Photo: Zhou Yi

**Fabric lamp on wooden stand**, 2009
Zhou Yi (China)
Walnut, fabric
© Photo: Zhou Yi

空气花瓶,2010
Torafu建筑事务所(日本)
塑料
© Photo: Fuminari Yoshitsugu

**Air Vases**, 2010
Torafu architects (Japan)
Plastic
© Photo: Fuminari Yoshitsugu

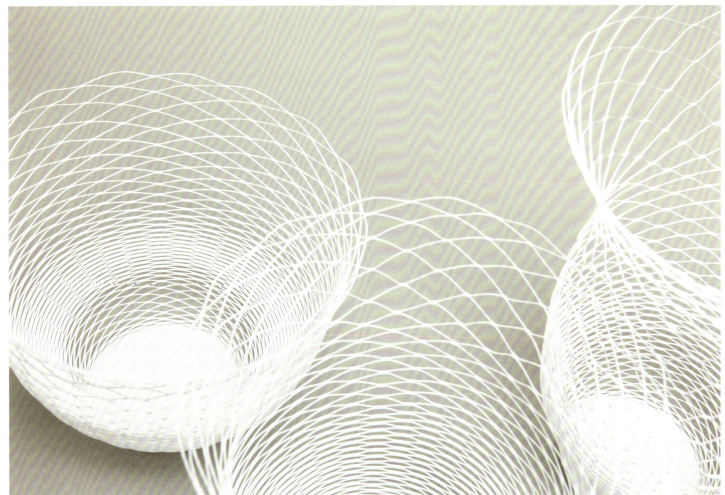

理智情感——快乐，2011
弗雷德里克·塔舍尔（法国）
© Photo: Frederic Tacer

**Reasemotion-DELIGHT**, 2011
**Frederic Tacer** (France)
© Photo: Frederic Tacer

PLEASE
FOLD ME GENTLY
AND
LET'S...

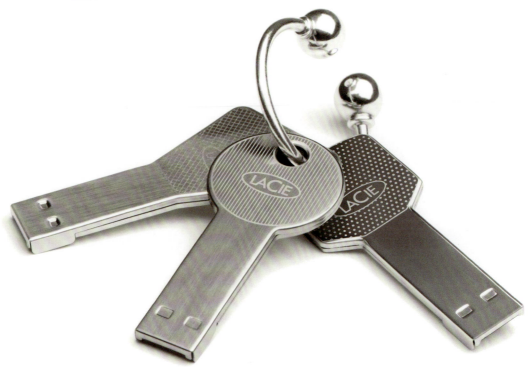

钥匙u盘，2009
5.5设计工作室（法国）
锌铝镁铜
© Photo: LaCie

**LaCie iamakey**, 2009
5.5 designers (France)
ZAMAK (Zinc Aluminium Magnesium ans copper)
© Photo: LaCie

载货自行车，2010
克里斯多佛·马歇(法国)
钢材，粉末涂层
© Photo: Christophe Machet

**Camioncyclette**, 2010
Christophe Machet (France)
Steel and powder-coated
© Photo: Christophe Machet

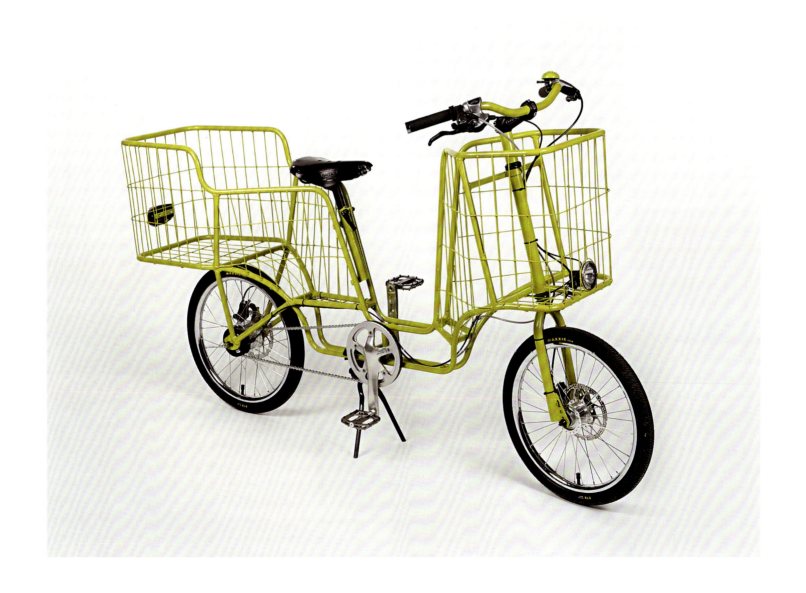

Doro HandlePlus 334gsm老人手机，2008
人体工学设计工作室／杨·普拉恩(瑞典)
Plastic Consumer电子移动电话
© Photo: Doro

**Doro HandlePlus 334gsm**, 2008
Ergonomidesign, Jan Puranen (Sweden)
Plastic Consumer electronics mobile phone
© Photo: Doro

最大市场极简效应，2011
默罕默德·格采特里克(土耳其)
印刷品
© Photo: Mehmet Gözetlik - Antrepo

**Minimalist Effect in Maximalist Market**, 2011
Mehmet Gözetlik (Turkey)
Print
© Photo: Mehmet Gözetlik - Antrepo

苹果图标替代方案，2011
默罕默德·格采特里克(土耳其)
印刷品
© Photo: Mehmet Gözetlik - Antrepo

**Alternate Apple Icons**, 2011
Mehmet Gözetlik (Turkey)
Prints
© Photo: Mehmet Gözetlik - Antrepo

莱斯斯塔克移动硬盘，2010
菲利浦·斯塔克（法国）
铝
© Photo: LaCie

**LaCie Starck Desktop Hard Drive**, 2010
Philippe Starck (France)
Aluminium
© Photo: LaCie

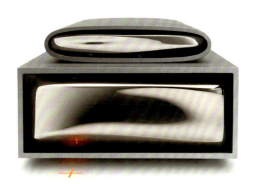

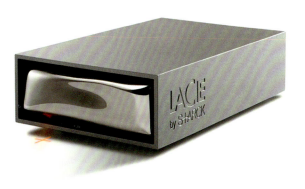

科技型腕表，2009
石振宇 (中国)
316L不锈钢，蓝宝石
© Photo: A-ONE Innovative Design Research Center

**Wristwatch**, 2009
Shi Zhenyu (China)
316 L stainless steel, sapphires
© Photo: A-ONE Innovative Design Research Center

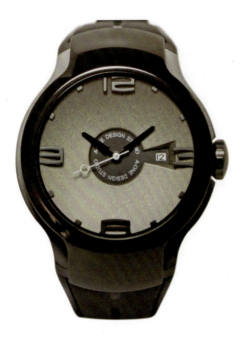
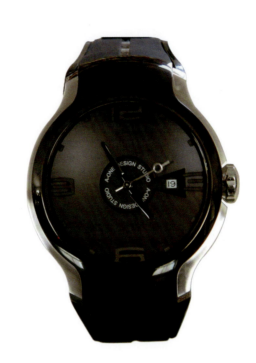
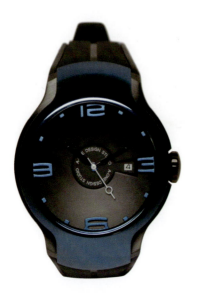

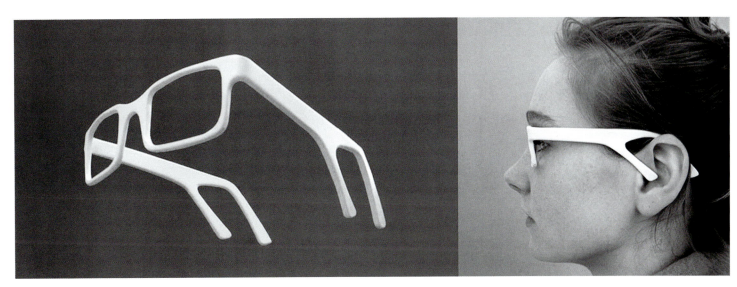

环绕音效眼镜，2005
山姆·赫奇特（英国）
英国皇家聋人协会与贺妮瑞塔·汤普森委托设计
丙烯酸甲酯塑料，电子制品
© Photo: Industrial Facility, London

**Surround Sound Eyewear**, 2005
Sam Hecht (UK)
Design Commissioned by the RNID, UK
and Henrietta Thompson
**Methacrylate plastic with electronics**
© Photo: Industrial Facility, London

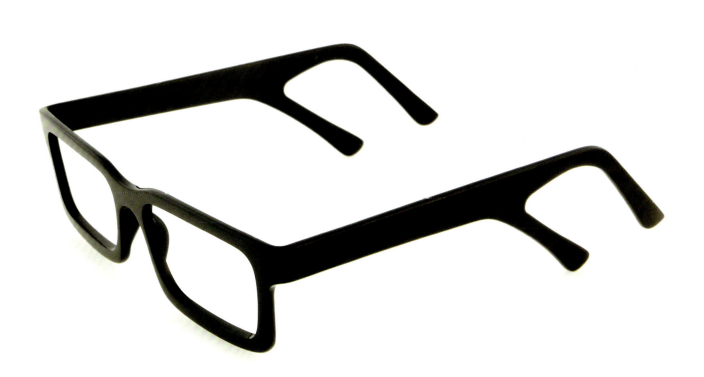

救生包系列，2005
史蒂芬·科勒，罗伯特·吕夫（奥地利）
不锈钢，PVD 涂层
© Photo: Steffen Kehrle

**Survival Kit Serie**, 2005
Steffen Kehrle & Robert Rüf (Austria)
Stainless steel, PVD coated
© Photo: Steffen Kehrle

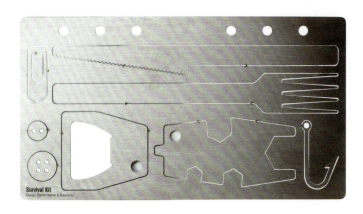

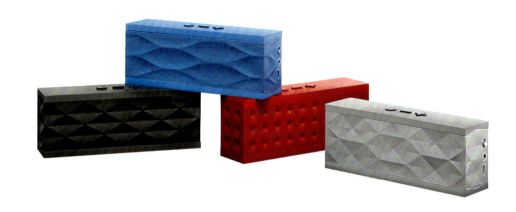

**Jambox音箱**, 2010
伊夫斯·贝哈(瑞士)
钢，塑料
© Photo: Jawbone Editions

**Jambox**, 2010
Yves Béhar (Switzerland)
Steel, plastic
© Photo: Jawbone Editions

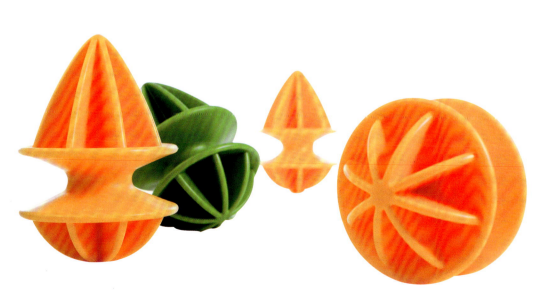

"枳橙"榨汁器, 2008
昆汀·德·考斯特(比利时)
聚丙烯
© Photo: Royal VKB

**Citrange**, 2008
Quentin de Coster (Belgium)
Polypropylene
© Photo: Royal VKB

绝对伏特加双瓶装，2008
杨明洁（中国）
塑料
© Photo: Jamy Yang

**Absolut Pears Dual Package**, 2008
**Jamy Yang** (China)
Plastics
© Photo: Jamy Yang

一次性餐具套装，2008
绪方慎一郎／Wasara（日本）
100％非树木再生原材料（甘蔗纤维，竹，草浆）
© Photo: WASARA

**Tableware full line**, 2008
Shinichiro Ogata / Wasara (Japan)
100% tree-free renewable material (Mixed pulp of Bagasse, bamboo, and reed)
© Photo: WASARA

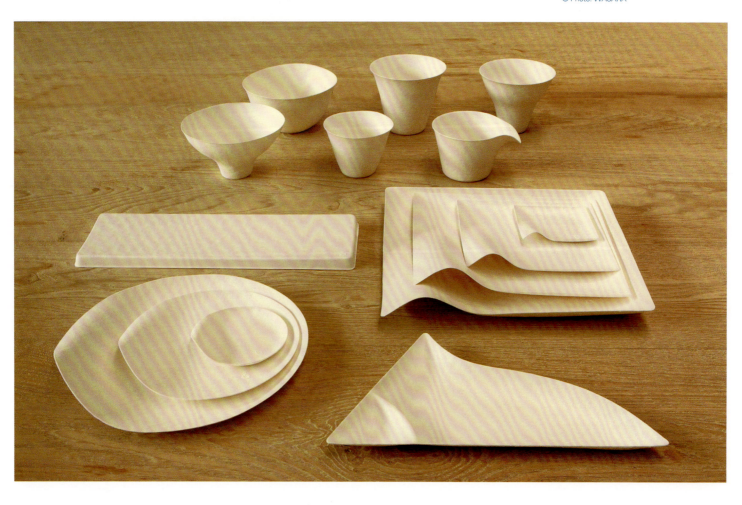

巧克力U盘，2008
叶宇轩（中国台湾）
硅胶
© Photo: Yehidea Home Design Co.Ltd

**Chocolate USB Disk**, 2008
Yeh Yu –hsuan (Taiwan, China)
Silicone
© Photo: Yehidea Home Design Co.Ltd

理智设计情感　REASON DESIGN EMOTION　285

理智情感——冷峻，2011
弗雷德里克·塔舍尔（法国）
© Photo: Frederic Tacer

**Reasemotion-COOL**, 2011
**Frederic Tacer** (France)
© Photo: Frederic Tacer

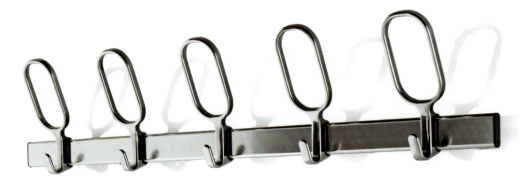

"电线上的小鸟"，2005
爱德华·巴伯，杰·奥斯格毕（英国）
电镀锡箔，锡箔冲模磨光或聚酯粉末涂层
© Photo: Magis

**Birds on a wire**, 2005
Edward Barber & Jay Osgerby (UK)
Anodized aluminium, polished die-cast aluminium or painted in polyester powder
© Photo: Magis

**TAB T形灯**，2007
爱德华·巴伯，杰·奥斯格毕（英国）
铝，瓷
© Photo: Flos

**TAB T lamp**, 2007
Edward Barber & Jay Osgerby (UK)
Aluminium, porcelain
© Photo: Flos

**52号储物柜**，2010
克里斯多夫·马尚（瑞士）
半透明的丙烯醛基
© Photo: Wogg

**Storage 52**, 2010
Christophe Marchand (Switzerland)
Cryl translucent
© Photo: Wogg

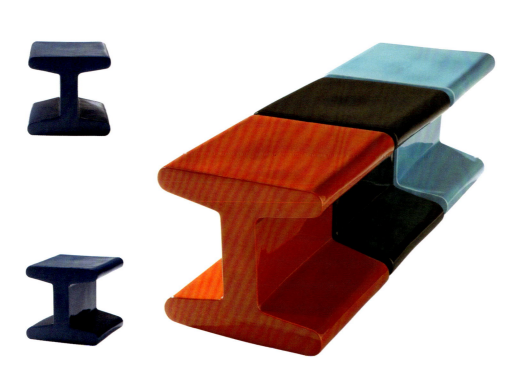

**IPN凳**，2002
弗朗索瓦·班查德（法国）
珐琅彩陶
© Photo: Ligne Roset

**IPN**, 2002
François Bauchet (France)
Enamelled earthenware
© Photo: Ligne Roset

黛安娜A桌，2002
康斯坦丁·格里克（德国）
金属板
© Photo: ClassiCon

**Diana Table A**, 2002
Konstantin Grcic (Germany)
Sheet metal
© Photo: ClassiCon

360系列桌子，2009
康斯坦丁·格里克（德国）
聚氨酯，钢管
© Photo: Magis

360系列柜子，2009
康斯坦丁·格里克（德国）
聚氨酯，钢管
© Photo: Magis

**Desk Serie 360**, 2009
Konstantin Grcic (Germany)
Polyurethane and steel tube
© Photo: Magis

**Container Serie 360**, 2009
Konstantin Grcic (Germany)
Polyurethane and steel tube
© Photo: Magis

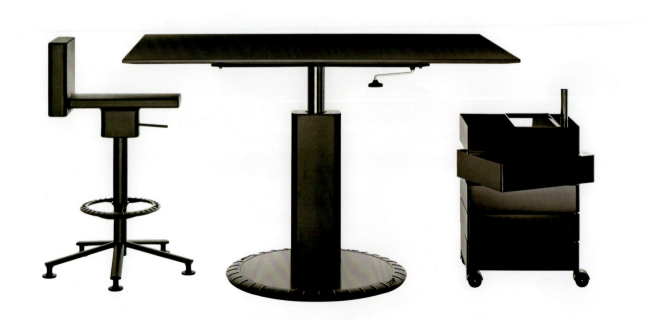

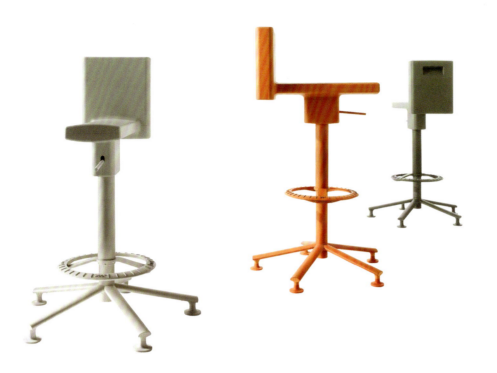

**360系列凳子**,2009
康斯坦丁·格里克(德国)
聚氨酯,钢管
© Photo: Magis

**Stool Serie 360**, 2009
**Konstantin Grcic** (Germany)
Polyurethane and steel tube
© Photo: Magis

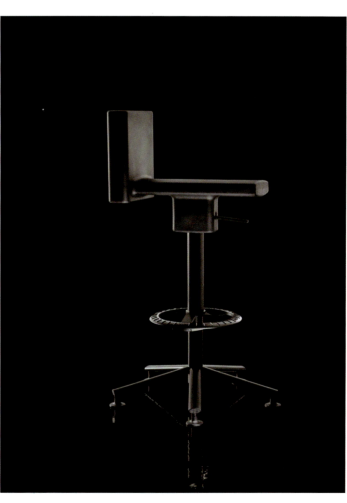

**Rad桌模块**，2010
菲利浦·玛洛因（加拿大）
铝管，不锈钢接头，黑色中密度纤维板
© Photo: NextLevel

**Rad Table Modules**, 2010
Philippe Malouin (Canada)
Aluminium tubes, stainless steel connectors, black MDF
© Photo: NextLevel

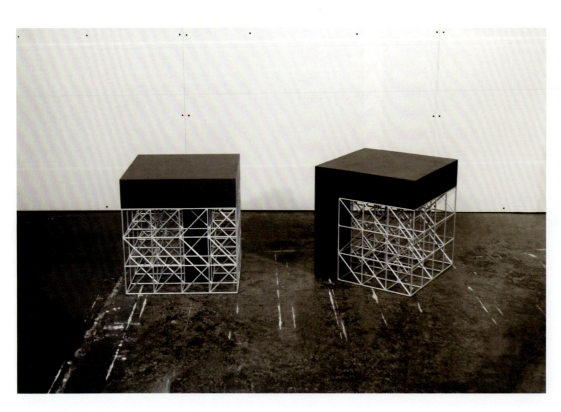

**Rad桌**，2010
菲利普·玛洛因（加拿大）
铝管，不锈钢接头，黑色中密度纤维板
© Photo: NextLevel

**Rad Table**, 2010
Philippe Malouin (Canada)
Aluminium tubes, stainless steel connectors, black MDF
© Photo: NextLevel

**d2网络存储服务终端**，2006
尼尔·浦尔顿（英国）
电子元件
© Photo: LaCie

**d2 network storage server**, 2006
Neil Poulton (UK)
Electronics
© Photo: LaCie

**Quadra硬盘**，2008
尼尔·浦尔顿（英国）
电子元件，黑漆，蓝色二极管
© Photo: LaCie

**Hard Disk Quadra**, 2008
Neil Poulton (UK)
Electronics, black lacquer and blue diode
© Photo: LaCie

**AC101凳子或边桌**，2004
皮埃尔·格纳隆斯（法国）
轻型混凝土
© Photo: Ascète

**Ascète: AC 101 stool or side table**, 2004
Pierre Gonalons (France)
Light concrete
© Photo: Ascète

**AC102凳子或边桌**，2004
皮埃尔·格纳隆斯（法国）
轻型混凝土
© Photo: Ascète

**Ascète: AC 102 stool or side table**, 2004
Pierre Gonalons (France)
Light concrete
© Photo: Ascète

阿诺德马戏凳，2006
马蒂诺·甘佩尔（意大利）
旋转模制塑料
© Photo: Anna Arca

**Arnold Circus stool**, 2006
**Martino Gamper** (Italy)
Rotation moulded plastic
© Photo: Anna Arca

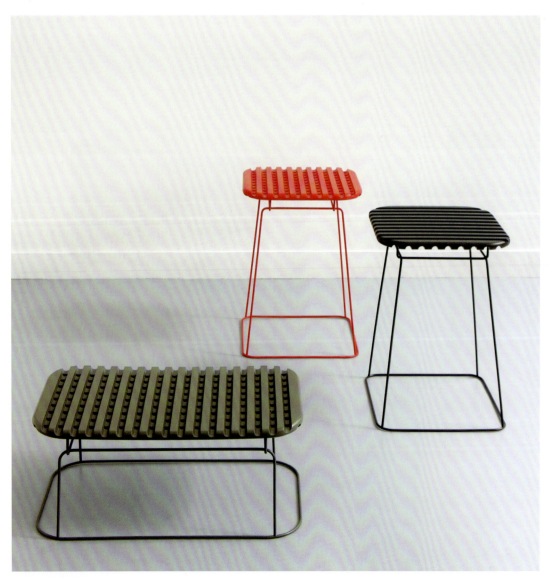

Ajours桌，2008
Normal工作室（法国）
木材，钢
© Photo: Normal studio

**Ajours Table**, 2008
**Normal Studio** (France)
Wood, steel
© Photo: Normal studio

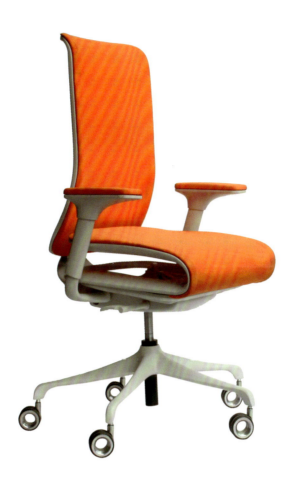

健康办公椅，2010
石振宇，艾万设计团队(中国)
尼龙玻纤，铝，碳纤
© Photo: A-ONE Innovative Design Research Center

**Health Office Chair**, 2010
Shi Zhenyu, A-ONE Design Group (China)
Nylon glass fiber, aluminum, carbon fiber
© Photo: A-ONE Innovative Design Research Center

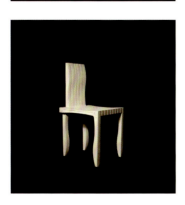
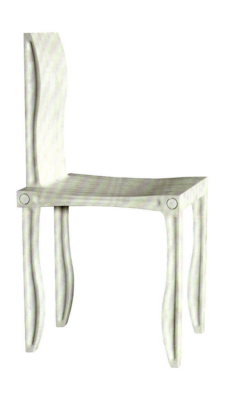

十构件组合椅，2009
阪茂(日本)
木-塑料复合
© Photo: Artek - Aino Huovio

**10-Unit System**, 2009
Shigeru Ban (Japan)
Wood-plastic composite
© Photo: Artek - Aino Huovio

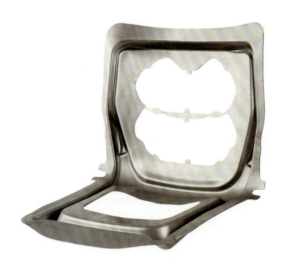

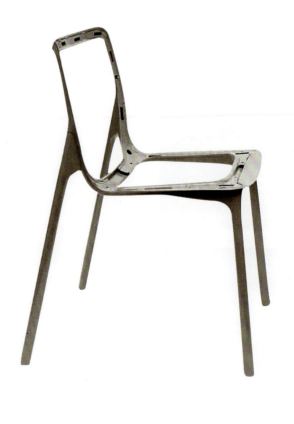

底盘椅（无椅面），2008
斯蒂芬·迪茨（德国）
铝
© Photo: Wilkhahn edition

**Chassis "naked"(without seatshell)**, 2008
**Stefan Diez** (Germany)
Aluminium
© Photo: Wilkhahn edition

底盘椅，2008
斯蒂芬·迪茨（德国）
扁平钢材，聚丙烯（椅面）
© Photo: Wilkhahn edition

**Chassis**, 2008
Stefan Diez (Germany)
Flat steel, polypropylene (seatshell)
© Photo: Wilkhahn edition

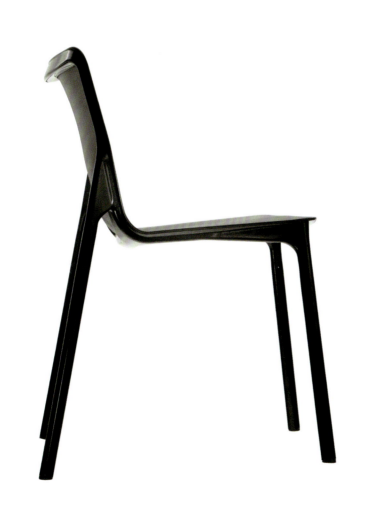

混凝土坐椅，2010
史蒂芬·科勒（奥地利）
混凝土
© Photo: Steffen Kehrle

**Concrete chair**, 2010
**Steffen Kehrle** (Austria)
Concrete
© Photo: Steffen Kehrle

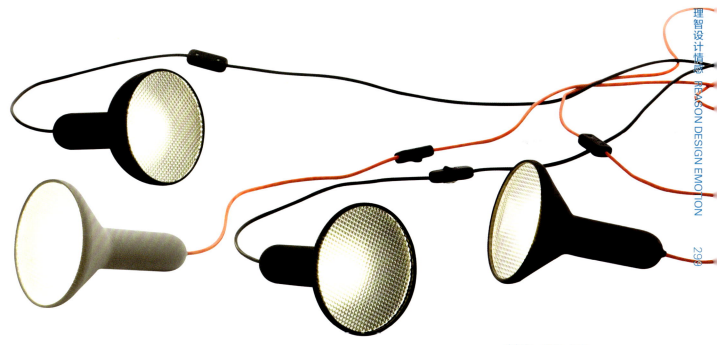

火炬灯，2008—2011
西尔万·威伦兹(比利时)
PVC聚合物，天花板固定件，钻石纹理聚碳酸酯散光罩
© Photo: Established and sons

**Torch light**, 2008-2011
Sylvain Willenz (Belgium)
PVC dipped polymer shade and ceiling fixing, clear diamond textured polycarbonate diffuser
© Photo: Established and sons

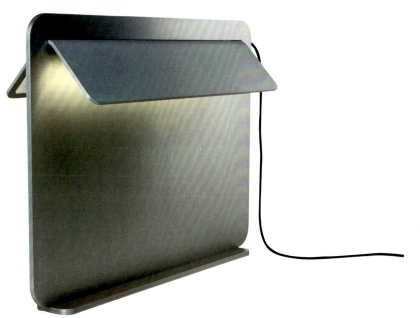

屏幕灯，2010
托马斯·克拉尔(捷克)
阳极氧化铝板，LED
© Photo: Julien Chavaillaz / ECAL

**Screen Lamp**, 2010
Tomas Kral (Czech)
Anodized aluminium sheets, LED
© Photo: Julien Chavaillaz / ECAL

理智情感——幽默，2011
弗雷德里克·塔舍尔(法国)
© Photo: Frederic Tacer

**Reasemotion-HUMOR**, 2011
**Frederic Tacer** (France)
© Photo: Frederic Tacer

# FOR SALE:

# SENSE OF HUMOR VERY LITTLE USE

PRICE
SUBJECT TO NEGOCIATION

HUMOR.SALE@GMAIL.COM HUMOR.SALE@GMAIL.COM HUMOR.SALE@GMAIL.COM HUMOR.SALE@GMAIL.COM HUMOR.SALE@GMAIL.COM HUMOR.SALE@GMAIL.COM HUMOR.SALE@GMAIL.COM HUMOR.SALE@GMAIL.COM HUMOR.SALE@GMAIL.COM HUMOR.SALE@GMAIL.COM HUMOR.SALE@GMAIL.COM HUMOR.SALE@GMAIL.COM HUMOR.SALE@GMAIL.COM HUMOR.SALE@GMAIL.COM HUMOR.SALE@GMAIL.COM HUMOR.SALE@GMAIL.COM HUMOR.SALE@GMAIL.COM HUMOR.SALE@GMAIL.COM HUMOR.SALE@GMAIL.COM HUMOR.SALE@GMAIL.COM

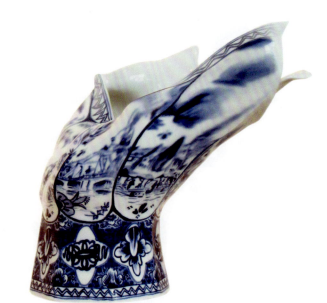

随风而逝的花瓶，2008
Front工作室／索菲娅·拉格维斯特，夏洛特·冯·德·兰肯，安娜·林格伦(瑞典)
代尔夫特皇家瓷
© Photo: Moooi

**Blow Away Vase**, 2008
Front / Sofia Lagerkvist, Charlotte von der Lancken, Anna Lindgren (Sweden)
Royal Delft porcelain
© Photo: Moooi

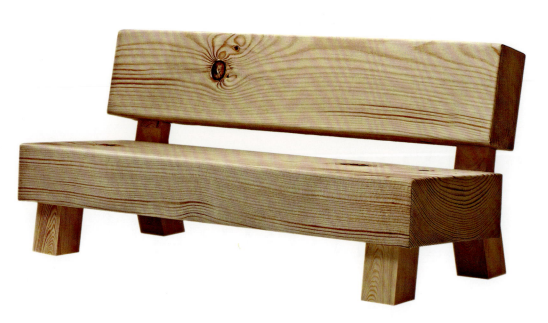

软木沙发，2010
Front工作室(瑞典)
抗压聚氨酯泡沫塑料，聚酯纤维，松木板
© Photo: Alessandro Padermi

**Soft Wood Sofa**, 2010
Front (Sweden)
Stress-resistant polyurethane foam with differentiated densities and polyester fiber on wood frame. Feet in natural laminated deal and with adjustable height glides
© Photo: Alessandro Padermi

Senza Fine坐椅，2010
盖塔诺·佩瑟（意大利）
聚氨酯
© Photo: Meritalia

**Senza Fine**, 2010
**Gaetano Pesce** (Italy)
Polyurethane
© Photo: Meritalia

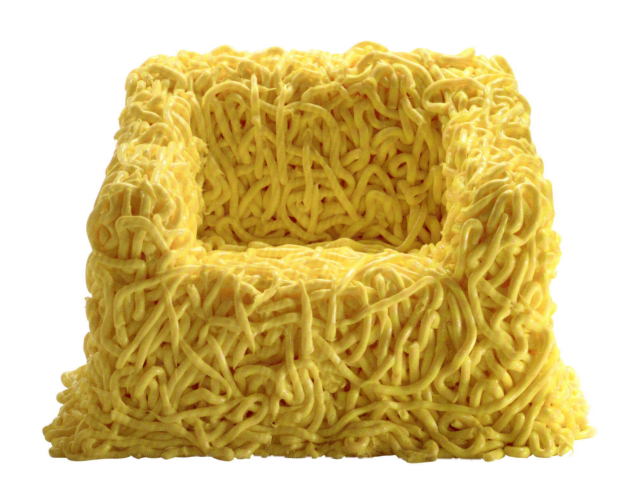

"蒸汽"灯，2009
尹佳·桑佩（法国）
高密度聚乙烯合成纸，上漆金属
© Photo: Moustache edition

**Vapeur**, 2009
**Inga Sempé** (France)
**Tyvek and lacquered metal**
© Photo: Moustache edition

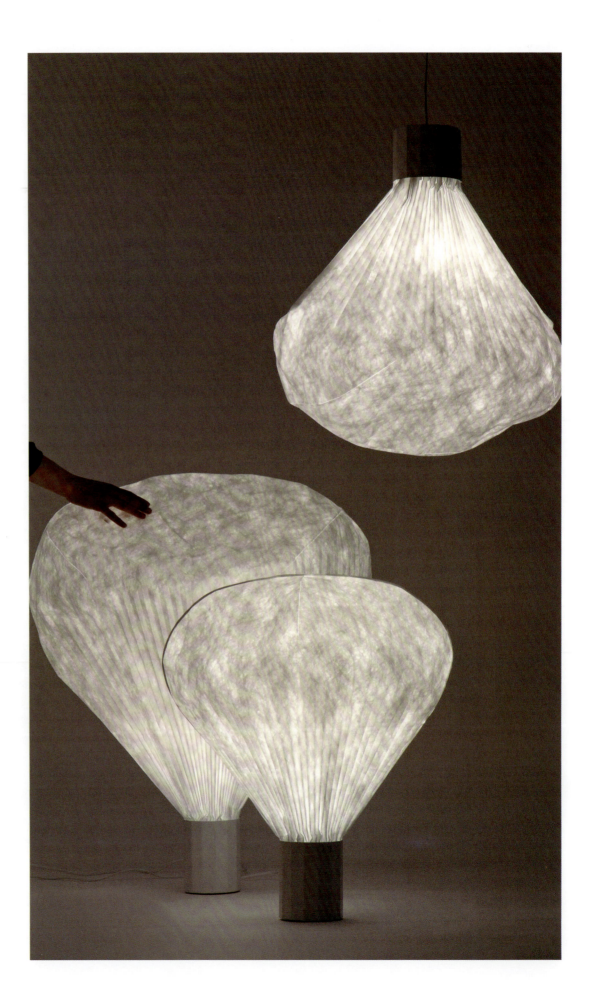

比尼克射灯，2010
艾奥娜·沃特林（法国）
ABS底座，聚碳酸酯射灯
© Photo: Foscarini edition

**Binic**, 2010
**Ionna Vautrin** (France)
ABS base and polycarbonate projector
© Photo: Foscarini edition

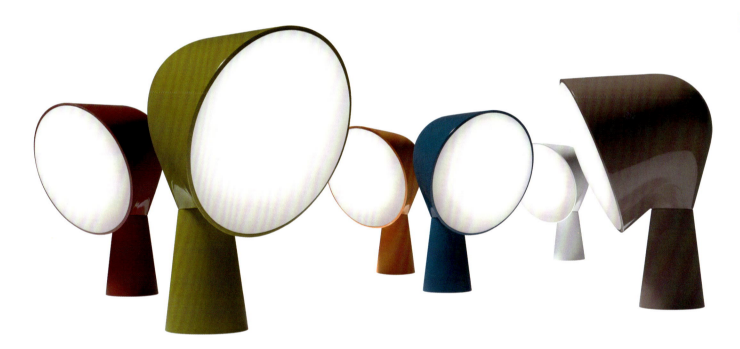

理智设计情感　REASON DESIGN EMOTION　306

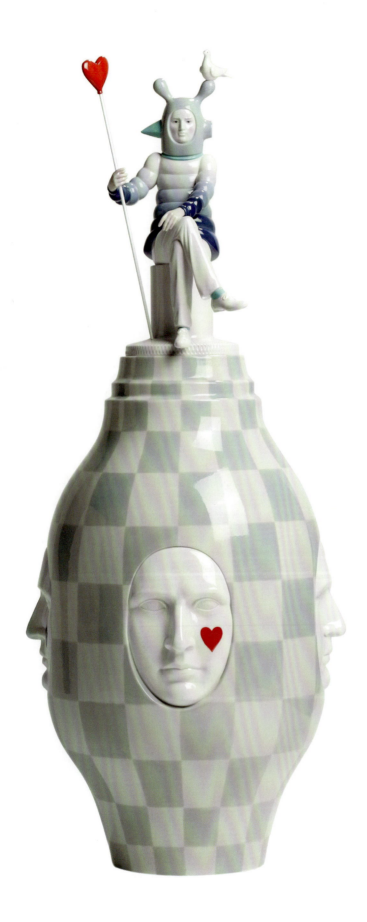

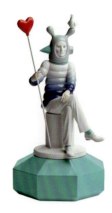

爱人1号，2008
亚米·海因（西班牙）
瓷
© Photo: Lladro

**The Lover I**, 2008
Jaime Hayon (Spain)
Porcelain
© Photo: Lladro

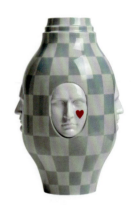

对话花瓶，2008
亚米·海因（西班牙）
瓷
© Photo: Lladro

**Conversation Vase**, 2008
Jaime Hayon (Spain)
Porcelain
© Photo: Lladro

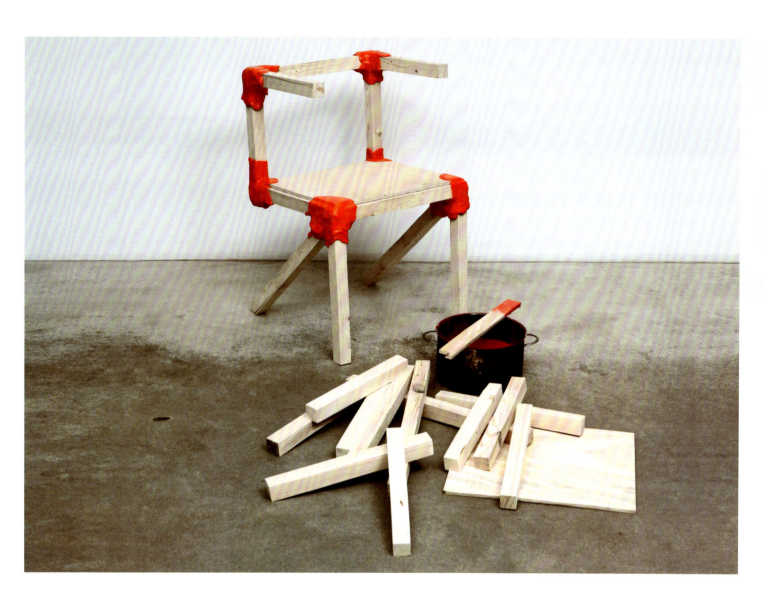

**工作室椅**，2009
泽西·西摩（加拿大）
木材，聚乙酸内脂蜡
© Photo: Markus Jahns

**Workshop Chair**, 2009
**Jerszy Seymour** (Canada)
Wood, polycaprolactone wax
© Photo: Markus Jahns

黏土带屉桌，2006
马丁·巴斯（荷兰）
喷漆合成黏土，金属架
© Photo: Maarten van Houten

**Clay table with drawer**, 2006
Maarten Baas (Netherlands)
Spry painted synthetic clay with metal skeleton
© Photo: Maarten van Houten

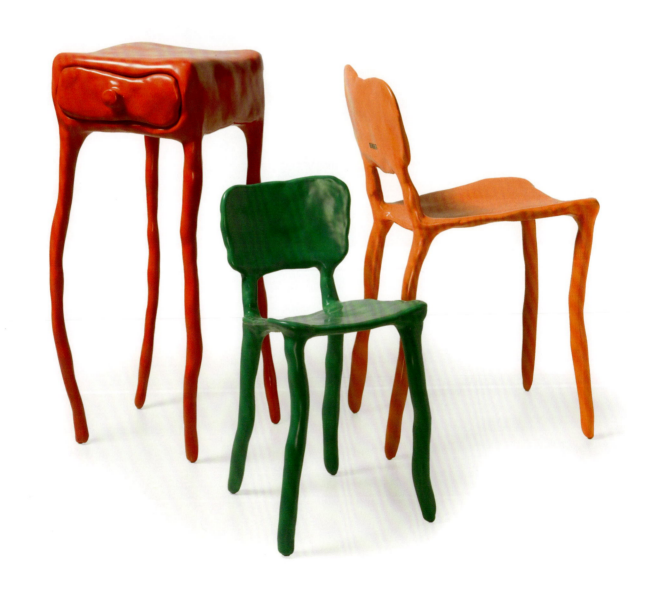

黏土餐椅，2006
马丁·巴斯（荷兰）
喷漆合成黏土，金属架
© Photo: Maarten van Houten

**Clay dining chair**, 2006
Maarten Baas (Netherlands)
Spry painted synthetic clay with metal skeleton
© Photo: Maarten van Houten

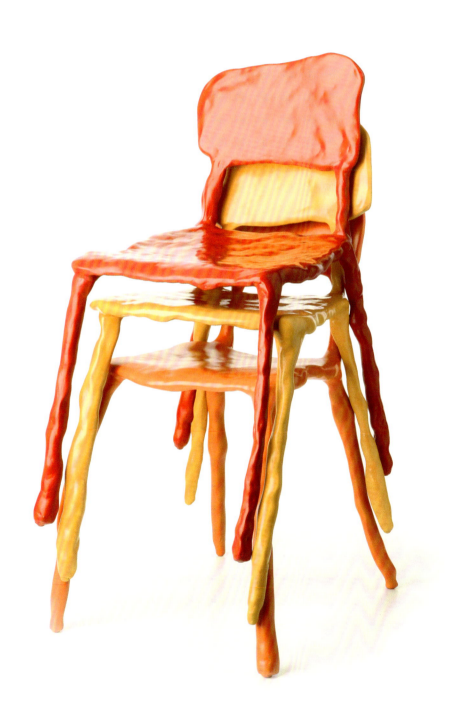

"米奇"丝带椅，2007
Nendo公司(日本)
金属板
© Photo: Cappellini Edition

**Mickey Ribbon**, 2007
Nendo (Japan)
Metal plate
© Photo: Cappellini Edition

泡泡椅，2009
马塞尔·万德斯(荷兰)
聚苯乙烯
© Photo: Magis Licence

**Sparkling Chair**, 2009
Marcel Wanders (Netherlands)
Polystyrene
© Photo: Magis Licence

卡姆衣架，2010
奥斯卡·齐塔（波兰）
钢
© Photo: Oscar Zieta prozessdesign

**Kamm hangers**, 2010
**Oskar Zieta** (Poland)
Steel
© Photo: Oscar Zieta prozessdesign

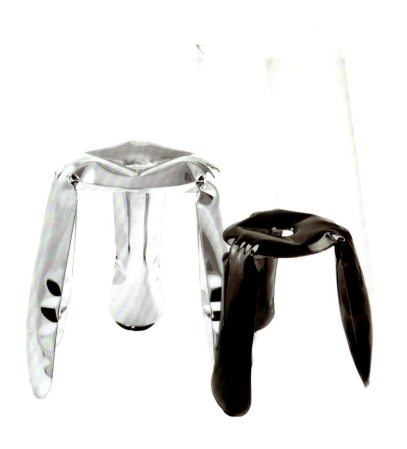

三足凳，2008
奥斯卡·齐塔（波兰）
钢
© Photo: Oscar Zieta prozessdesign

**Plopp Stools**, 2008
**Oskar Zieta** (Poland)
Steel
© Photo: Oscar Zieta prozessdesign

长发花瓶，2004
帕特里克·弗里德里克森，伊安·斯塔拉尔德（瑞典／英国）
瓷，马鬃毛
© Photo: Fredrikson Stallard

**Villosus Vase**, 2004
Patrik Fredrikson & Ian Stallard (Sweden / England)
Porcelain, horsehair
© Photo: Fredrikson Stallard

植物茶杯，2005
吉塔·盖斯温特娜（德国）
陶瓷
© Photo: Thorsten van Elten

**Plant Cup**, 2005
Gitta Gschwendtner (Germany)
Ceramic
© Photo: Thorsten van Elten

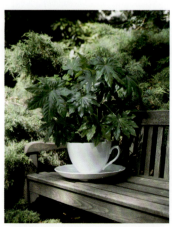

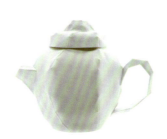

| | | |
|---|---|---|
| 茶壶，光渲染系列，2009<br>露丝·戈维奇（阿根廷）<br>白瓷<br>© Photo: Nymphenburg | 茶碗，光渲染系列，2009<br>露丝·戈维奇（阿根廷）<br>白瓷<br>© Photo: Nymphenburg | L花瓶，光渲染系列，2009<br>露丝·戈维奇（阿根廷）<br>白瓷<br>© Photo: Nymphenburg |
| **Teapot, Lightscape series**, 2009<br>Ruth Guvirch (Argentina)<br>Porcelain white biscuit<br>© Photo: Nymphenburg | **Teabowls, Lightscapes series**, 2009<br>Ruth Guvirch (Argentina)<br>Porcelain white biscuit<br>© Photo: Nymphenburg | **Vase L, Lightscape series**, 2009<br>Ruth Guvirch (Argentina)<br>Porcelain white biscuit<br>© Photo: Nymphenburg |

茶壶，光渲染系列，2009
露丝·戈维奇（阿根廷）
手绘瓷器
© Photo: Nymphenburg

茶碗，光渲染系列，2009
露丝·戈维奇（阿根廷）
手绘瓷器
© Photo: Nymphenburg

L花瓶，光渲染系列，2009
露丝·戈维奇（阿根廷）
手绘瓷器
© Photo: Nymphenburg

**Teapot, Lightscape series**, 2009
Ruth Guvirch (Argentina)
Porcelain hand-painted
© Photo: Nymphenburg

**Teabowls, Lightscapes series**, 2009
Ruth Guvirch (Argentina)
Porcelain hand painted
© Photo: Nymphenburg

**Vase L, Lightscape series**, 2009
Ruth Guvirch (Argentina)
Porcelain hand-painted
© Photo: Nymphenburg

无题——提梁方壶杯组，2008
石大宇（中国台湾）
瓷，不锈钢
© Photo: Dragonfly Design Center

**Untitled Twins Square Teapot Set**, 2008
**Jeff Dah-Yue Shi** (Taiwan, China)
Porcelain, stainless steel
© Photo: Dragonfly Design Center

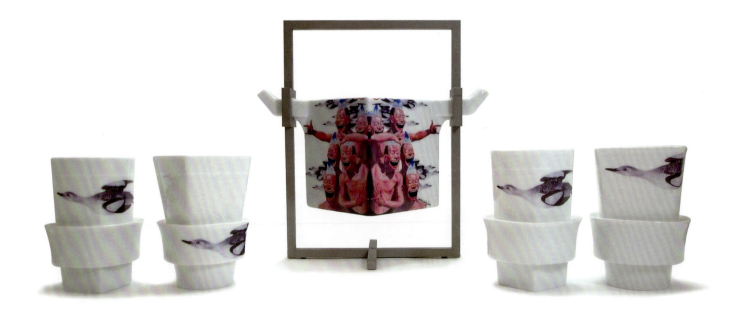

《灵魂出窍-1》烟灰缸，2008—2009

冯峰(中国)

瓷

© Photo: Feng Feng

Soul out 1 – Ashtray, 2008-2009

Feng Feng (China)

Porcelain

© Photo: Feng Feng

《灵魂出窍-2》熏香罩，2009

冯峰，卢麃麃(中国)

瓷

© Photo: Feng Feng

Soul out 2 – Censer, 2009

Feng Feng, Lu Biaobiao (China)

Porcelain

© Photo: Feng Feng

理智情感——庆典，2011
弗雷德里克·塔舍尔(法国)
© Photo: Frederic Tacer

**Reasemotion-CELEBRATION**, 2011
**Frederic Tacer** (France)
© Photo: Frederic Tacer

# PARTY TIME!

Omi.MGX灯，2005
阿萨·阿舒齐(以色列)
丙烯
© Photo: Assa Ashuach Studio

**Omi.MGX lights**, 2005
Assa Ashuach (Israel)
Polyamide
© Photo: Assa Ashuach Studio

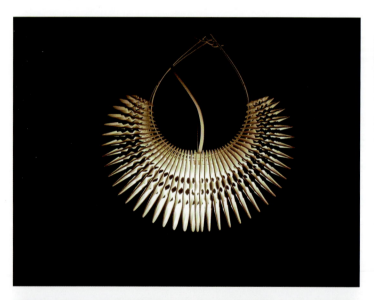
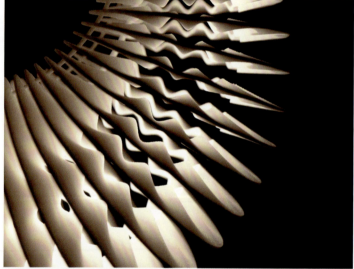
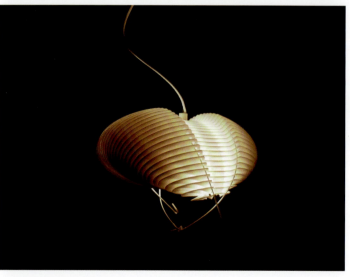
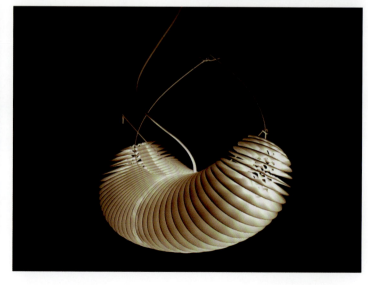

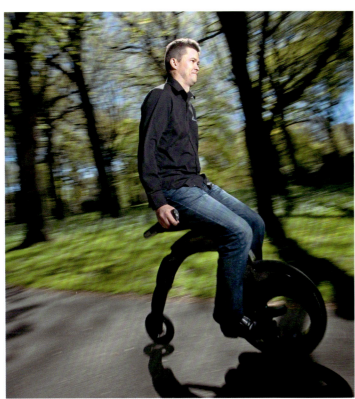
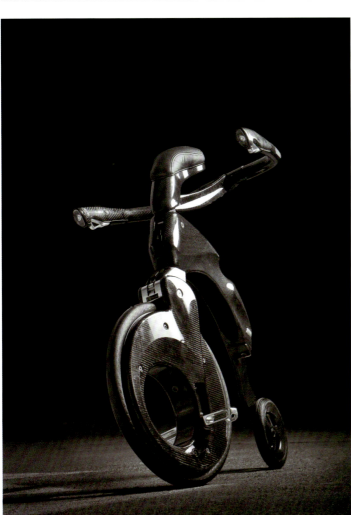
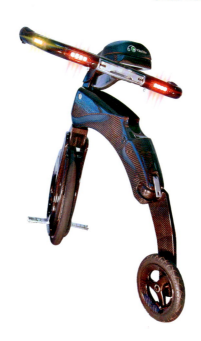
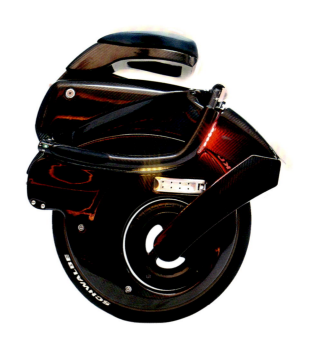

**YikeBike–电动自行车,** 2011
克莱布·史密斯,格兰特·赖安,彼得·希金斯,斯图尔特·贝拉吉欧,iDesign,保罗·宾纳（新西兰）
碳纤维
© Photo: YikeBike

**YikeBike-ElectricBike,** 2011
Caleb Smith, Grant Ryan, Peter Higgind, Stuart Belcher, iDesign, Paul Binner (New Zealand)
Carbon Fiber
© Photo: YikeBike

戴森无叶风扇，2009
詹姆斯·戴森（英国）
ABS，聚碳酸酯
© Photo: Dyson

**Dyson Air Multiplier**, 2009
James Dyson (UK)
ABS and polycarbonate
© Photo: Dyson

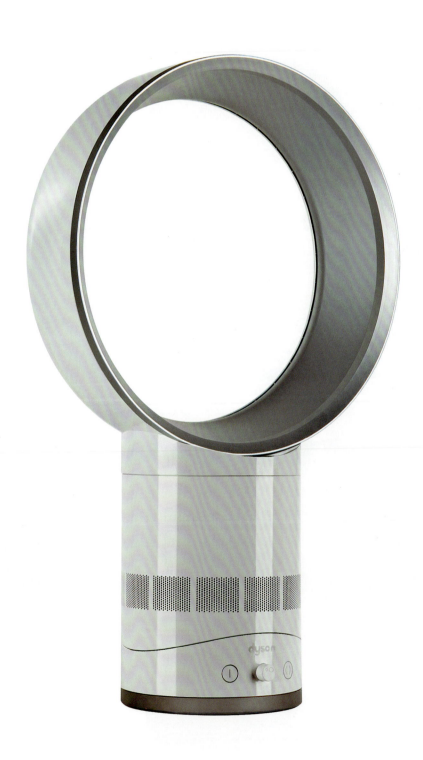

EADS "空中"自行车，2011
英国EADS创新工作室／安迪·霍金斯，克里斯·特纳（英国）
© Photo: EADS

**EADS Airbike**, 2011
EADS Innovation Works UK /Andy Hawkins, Chris Turner (UK)
© Photo: EADS

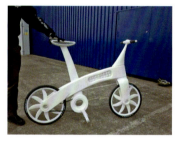

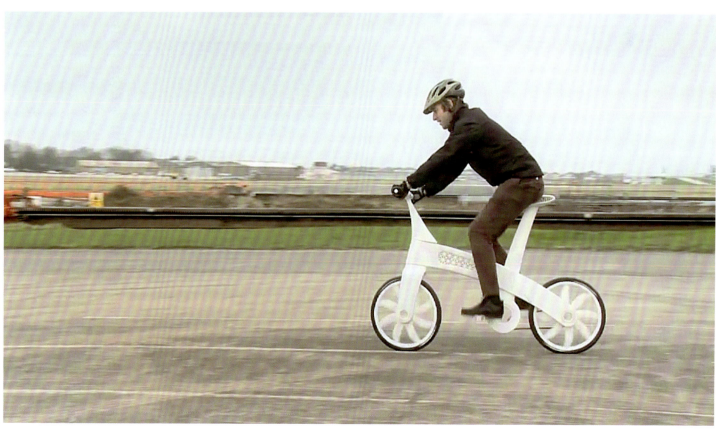

水果，2009
吉尔·百利（法国）
农业材料
© Photo: Felipe Ribon and Gilles Belley

**Fruit**, 2009
**Gilles Belley** (France)
**Agromaterial**
© Photo: Felipe Ribon and Gilles Belley

花簇，2009
吉尔·百利（法国）
农业材料
© Photo: Felipe Ribon and Gilles Belley

**Inflorescence**, 2009
**Gilles Belley** (France)
**Agromaterial**
© Photo: Felipe Ribon and Gilles Belley

树枝，2009
吉尔·百利（法国）
农业材料，大理石，玻璃
© Photo: Felipe Ribon and Gilles Belley

**Branch**, 2009
Gilles Belley (France)
Agromaterial, marble, glass
© Photo: Felipe Ribon and Gilles Belley

嫩枝，2009
吉尔·百利（法国）
农业材料，大理石
© Photo: Felipe Ribon and Gilles Belley

**Twig**, 2009
Gilles Belley (France)
Agromaterial, marble
© Photo: Felipe Ribon and Gilles Belley

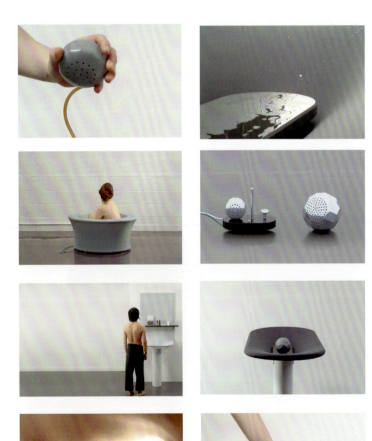

另类盥洗室，2008
菲利浦·里本（哥伦比亚）
© Photo: Felipe Ribon

**Another bathroom**, 2008
*Felipe Ribon* (Colombia)
© Photo: Felipe Ribon

银河旅馆太空度假村，2006
泽维尔·克拉拉蒙特(西班牙)
录像 4分48秒
© Photo: Xavier Claramunt

**Galactic Suite Space Resort**, 2006
Xavier Claramunt (Spain)
Video 4'48 minutes
© Photo: Xavier Claramunt

残障者自助移位器，2011
严扬，刘志国，张雷(中国)
铝合金，钢，塑料，橡胶

**The Self-help Shifter for Disabled**, 2011
Yan Yang, Liu Zhiguo, Zhang Lei (China)
Aluminium alloy, steel, plastic, ruber

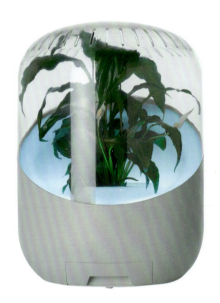
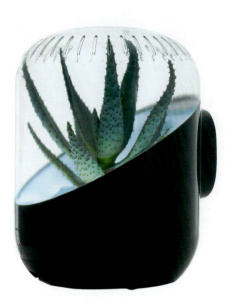

安德里亚空气清新器，2008
马修·雷汉尼尔，大卫·爱德华兹（法国/美国）
聚丙烯，PMMA（塑料）
© Photo: Véronique Huyghe

**Andrea**, 2008
Mathieu Lehanneur, David Edwards (France/USA)
Polypropylene, PMMA (plastic)
© Photo: Véronique Huyghe

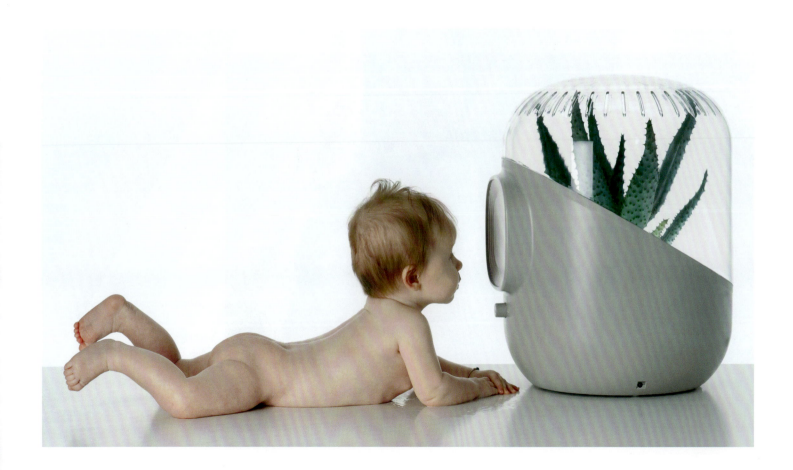

人体喷气机，2010
马克·纽森（澳大利亚）
印刷品
© Photo :Marc Newson Ldt – courtesy of Fabrice Gousset

**Body Jet**, 2010
Marc Newson (Australia)
Prints
© Photo :Marc Newson Ldt – courtesy of Fabrice Gousset

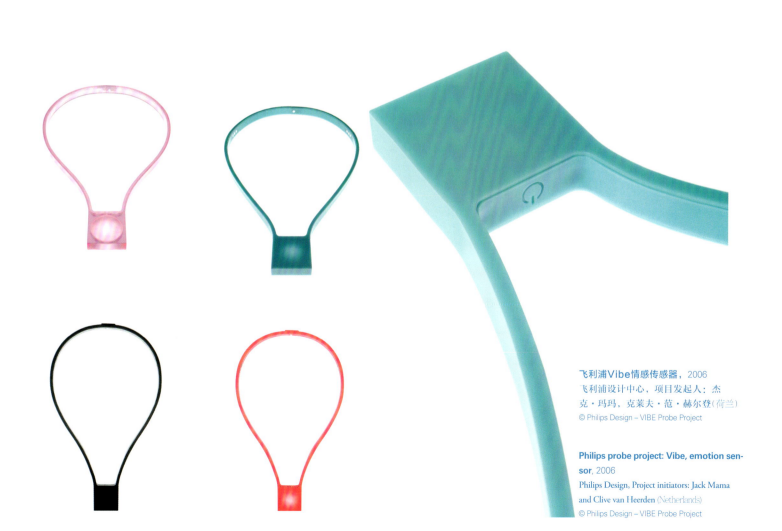

飞利浦Vibe情感传感器，2006
飞利浦设计中心，项目发起人：杰克·玛玛，克莱夫·范·赫尔登（荷兰）
© Philips Design – VIBE Probe Project

**Philips probe project: Vibe, emotion sensor**, 2006
Philips Design, Project initiators: Jack Mama and Clive van Heerden (Netherlands)
© Philips Design – VIBE Probe Project

**3D扫描仪**,2011
托马斯·勒博塞(法国)
桦木胶合板,人造石
© Photo: Thomas Lebécel

**3D scanner FabLab**, 2011
Thomas Lebécel (France)
Birch plywood and Corian
© Photo: Thomas Lebécel

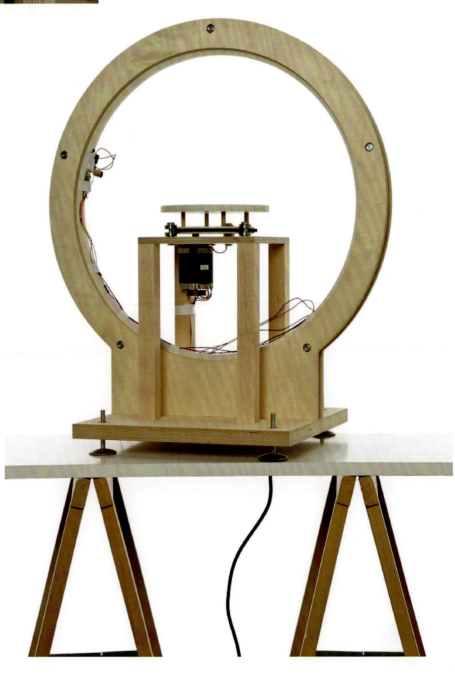

分形桌，2009
沃特尔·奥伯费尔（英国）
环氧树脂
© Photo: Platform

**Fractal Table**, 2009
Wertel Oberfell (UK)
Resin Expoxy
© Photo: Platform

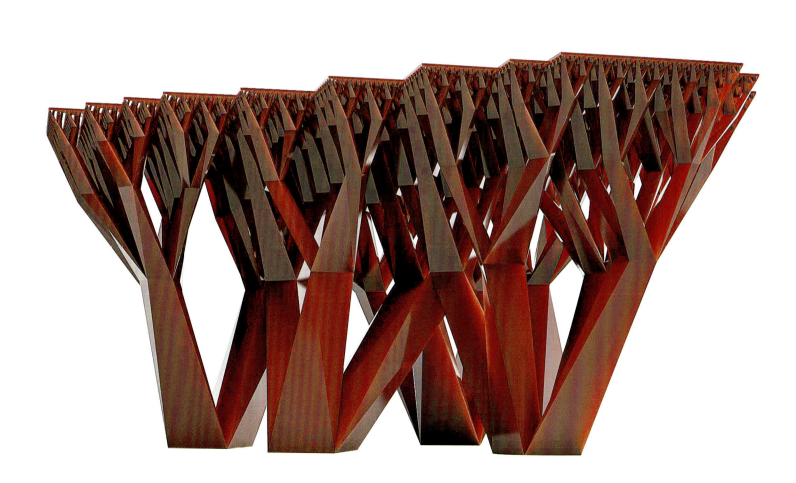

铝设计，2010
Brigantine公司(法国)
铝

**Nid d'abeille Aluminium**, 2010
Brigantine (France)
Aluminium

**Foaminal** 泡沫材料，2010
德国弗劳恩霍夫制造技术和应用材料研究院(德国)
铝

**Foaminal**, 2010
IFAM (Germany)
Aluminium

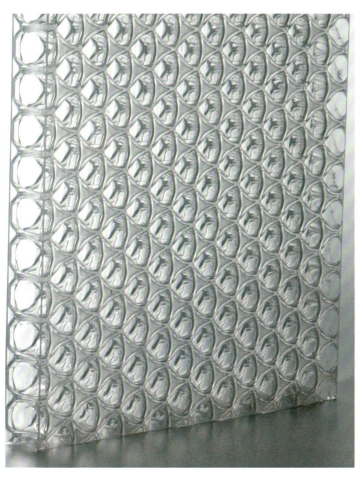

星光，2010
Bencore公司(意大利)
聚碳酸酯
© Photo: Bencore

**Starlight**, 2010
Bencore (Italy)
Acrylicore, polycarbonate Acrylicore
© Photo: Bencore

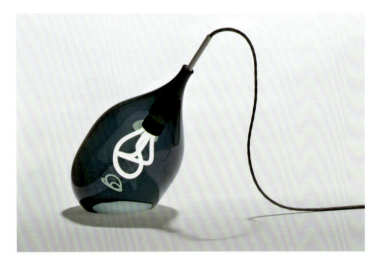
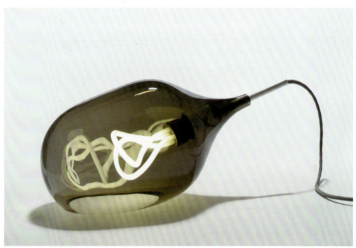

容器系列 01-03，2010
塞缪尔·威尔金森（英国）
吹制玻璃，铝制机器装配
© Photo: Decode

**Vessel Series 01-03**, 2010
Samuel Wilkinson (UK)
Mouth-blown glass, machined aluminium fitting
© Photo: Decode

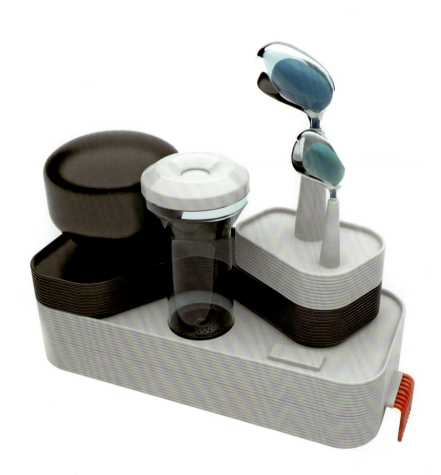

Hyné 再生能源存储系统，2010
皮埃尔·法夫雷斯，克里斯多夫·特平（法国）
塑料
© Photo: Pierre Favresse Studio

**Hyné**, 2010
Pierre Favresse, Christophe Turpin (France)
Plastic
© Photo: Pierre Favresse Studio

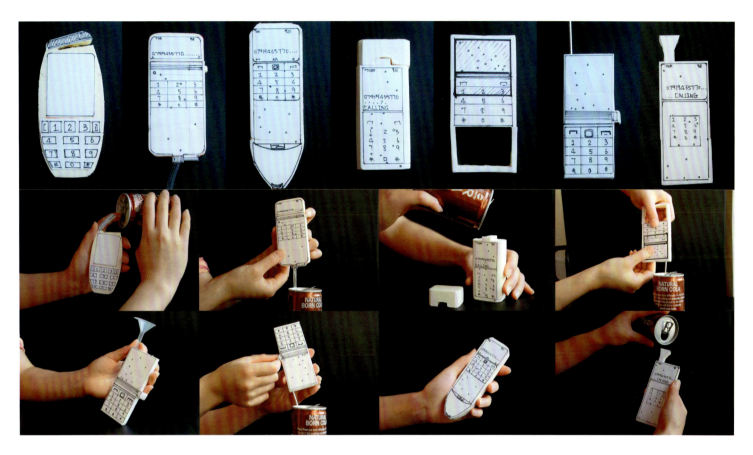

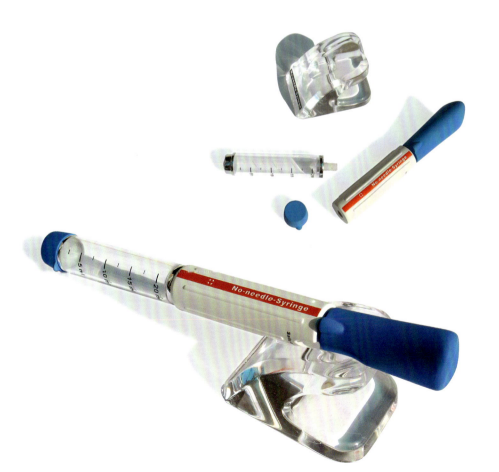

**诺基亚绿色手机**，2009
郑戴紫(中国)
电子和生物电池
© Photo: Daizy Zheng

**Nokia "Green" Phone**, 2009
Zheng Daizi (China)
Electronics and bio batteries
© Photo: Daizy Zheng

**无针注射器**，2011
罗丽弦(中国)
医用聚丙烯，金属，橡胶
© Photo: LuoLixian

**Needleless Injector**, 2011
Luo Lixian (China)
Medical polypropylene, metal, rubber
© Photo: LuoLixian

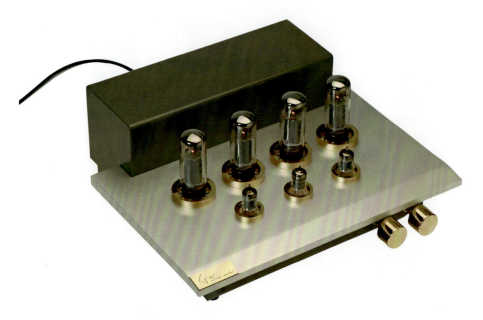

"沉浸"——音响设计，2006
刘志国，李楚晨 (中国)
铝合金
© Photo: Liu Zhiguo & Li Chuchen

**Immense HiFi Design**, 2006
Liu Zhiguo, Li Chuchen (China)
Aluminium
© Photo: Liu Zhiguo & Li Chuchen

我的阅读灯，2009
丁伟 (中国)
金属，亚克力
© Photo:Ding Wei

**Reading light**, 2009
Ding Wei (China)
Metal, acrylic
© Photo:Ding Wei

圆孔黑胶唱盘机，2006
石振宇（中国）
PVC，铝，石墨
© Photo: A-ONE Innovative Design Research Center

**Arcana Turntable LP1.2**, 2006
Shi Zhenyu (China)
PVC, aluminum, graphite
© Photo: A-ONE Innovative Design Research Center

生物芯片试验系列产品——个人点样仪，2006
赵超（中国）
ABS塑料板，金属等多种材料

**Bio Chip Instrument Design: Microarray Spotter**, 2006
Zhao Chao (China)
ABS Plastic, Metal, and Multi-material

理智情感——自由，2011
弗雷德里克·塔舍尔(法国)
© Photo: Frederic Tacer

**Reasemotion-FREEDOM**, 2011
**Frederic Tacer** (France)
© Photo: Frederic Tacer

蒙圣安杰洛地铁站，Traiano入口，那不勒斯，2014年完工
阿曼达·莱维特建筑事务所，安尼施·卡普尔（英国）
© © Photo : Amanda Levete Architect

**Monte St. Angelo Subway, Traiano Entrance, Naples**, Completion 2014
AL_A in collaboration with Anish Kappor (UK)
© © Photo : Amanda Levete Architect

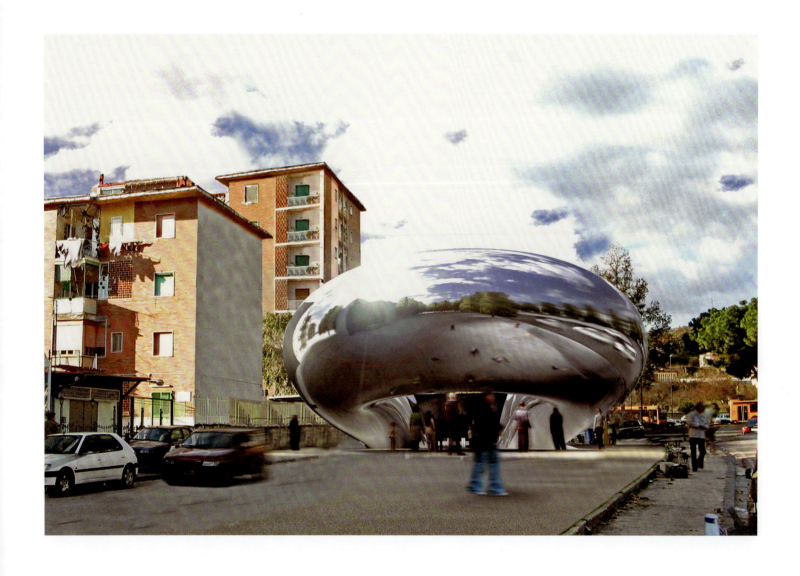

云屋，2011
安德列斯·安格利达克斯（希腊/挪威）
© Photo: Andreas Angelidakis

**Cloud House**, 2011
**Andreas Angelidakis** (Greece/ Norway)
© Photo: Andreas Angelidakis

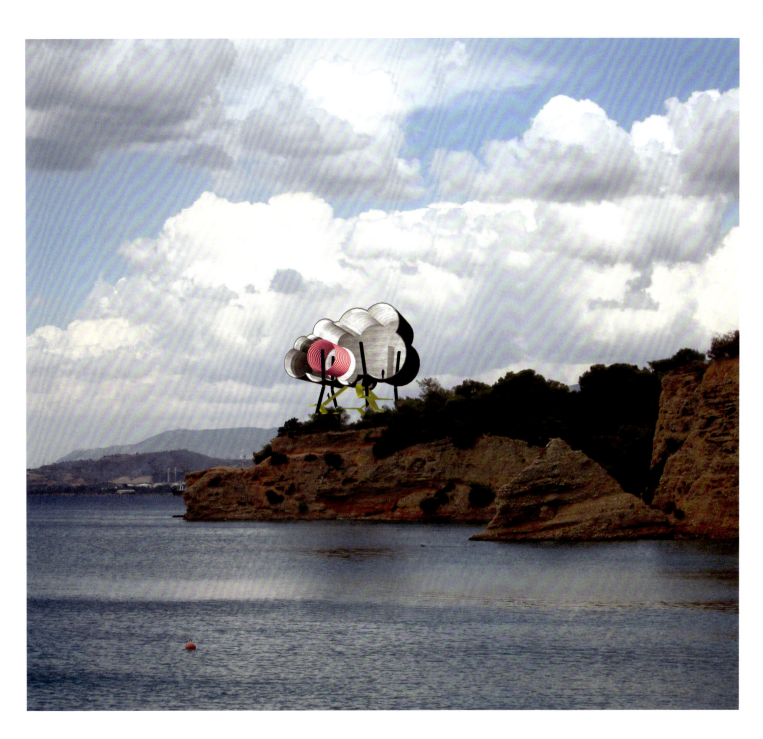

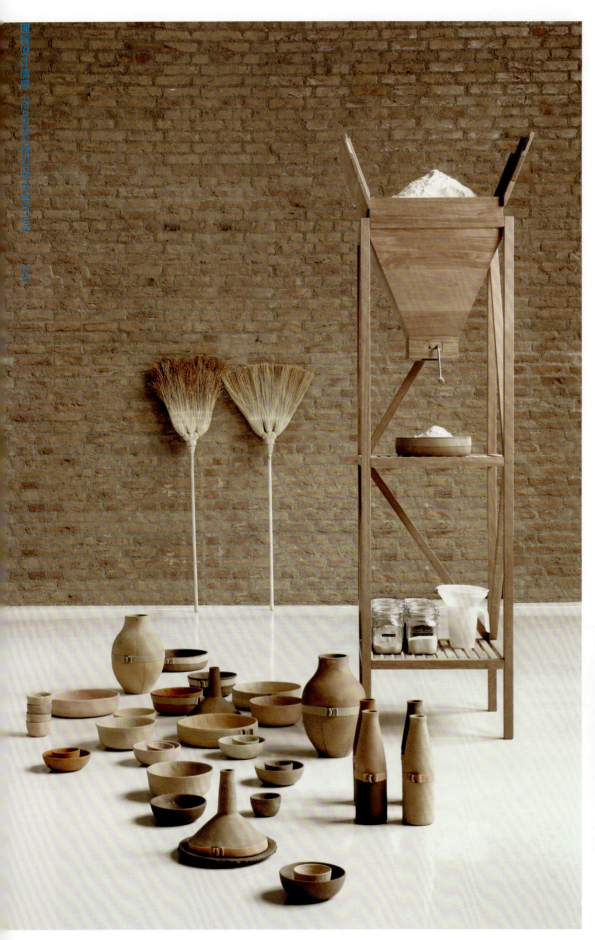

专制，2010
形式幻想工作室／安德里亚·奇玛齐，西蒙·法热西（意大利）
综合材料（面粉、农业废料、天然石灰石、纸巾、金属）
© Photo: Studio Formafantasma

**Autarchy**, 2010
Studio Formafantasma /Andrea Trimarchi and Simone Farresin (Italy)
Mixed media (flour, agricultural waste, natural limestone, tissue, metal)
© Photo: Studio Formafantasma

生活设施，1973—1975
克劳德·帕伦特（法国）
© Photo: Claude Parent

**Dispositif Living**, 1973-1975
Claude Parent (France)
© Photo: Claude Parent

用餐设施，1973—1975
克劳德·帕伦特（法国）
© Photo: Claude Parent

**Dsitif pour les repas**, 1973-1975
Claude Parent (France)
© Photo: Claude Parent

用餐设施，1973—1975
克劳德·帕伦特（法国）
© Photo: Claude Parent

**Dsitif pour les repas**, 1973-1975
Claude Parent (France)
© Photo: Claude Parent

城市移民的自由之路，2010
克劳德·帕伦特（法国）
© Photo: Claude Parent

**Inventer les chemins libres des migrants dans la ville d'aujourd'hui**, 2010
Claude Parent (France)
© Photo: Claude Parent

漫长的迁徙之途，2010
克劳德·帕伦特（法国）
© Photo: Claude Parent

**Un grand lieu de transit dans la migration**, 2010
Claude Parent (France)
© Photo: Claude Parent

大迁徙途中的临时落脚处，2010
克劳德·帕伦特（法国）
© Photo: Claude Parent

**Sur le chemin "de la Grande Migration"/ La Coupe Façade d'une "Halte transitoire"**, 2010
Claude Parent (France)
© Photo: Claude Parent

PLANT桌子，2008
大卫·德斯·穆迪（法国）
石料，枫木
© Photo: David des Moutis

**PLANT table**, 2008
David des Moutis (France)
Stone and Maple wood
© Photo: David des Moutis

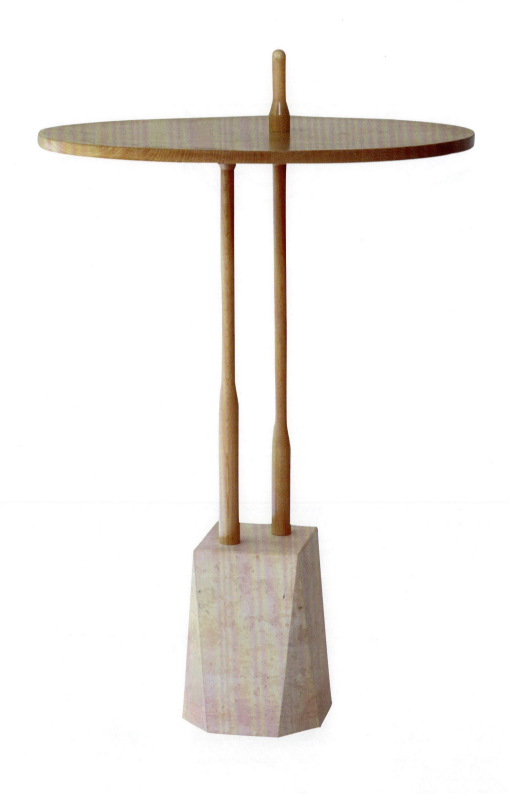

富盖旅馆的Barrière项目，2006
爱德华·弗朗索瓦（法国）
印刷品
© Photo: Edouard François Architecture

**Hotel Fouquet's Barrière project**, 2006
Edouard François (France)
Prints
© Photo: Edouard François Architecture

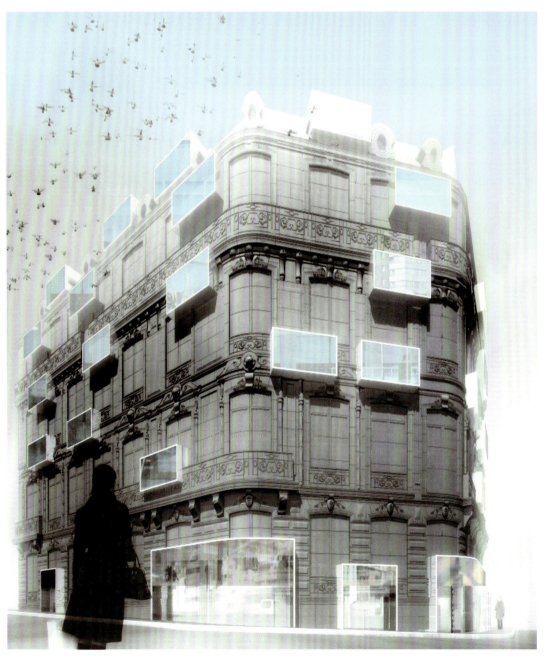

爱之桌，2008—2009
爱德华·弗朗索瓦（法国）
草图
© Photo: Edouard François Architecture

**Love Table**, 2008-2009
**Edouard François** (France)
Ink on paper
© Photo: Edouard François Architecture

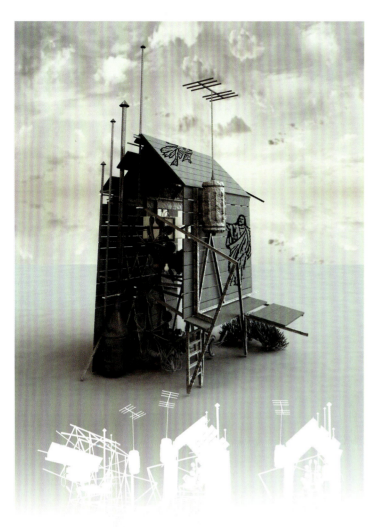
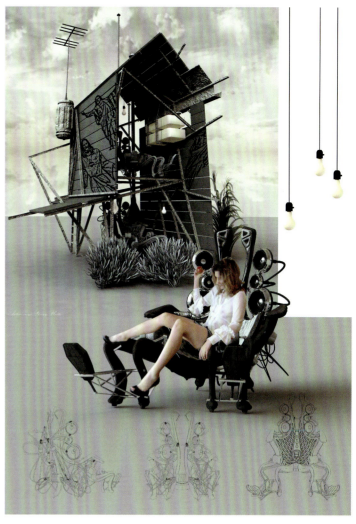
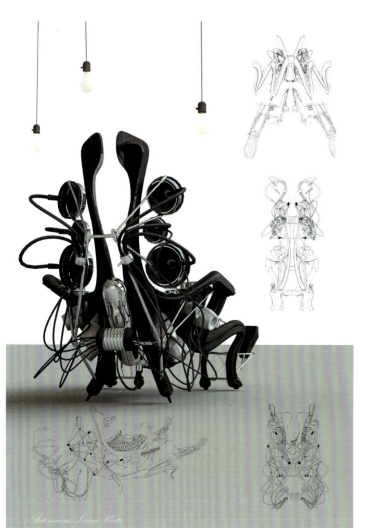

独立生存，2008
爱德华多·麦金托什（英国）
印刷品
© Photo: Eduardo McIntosh

**Autonomous Living**, 2008
Eduardo McIntosh (UK)
Prints
© Photo: Eduardo McIntosh

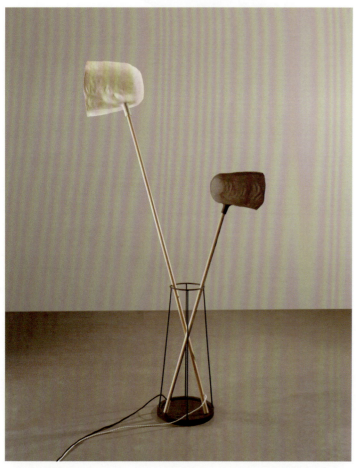

"Les Perchées" 灯束系列，2010
伊莉斯·嘉佰丽（法国）
纤维素，山毛榉，着色水泥，电子元件
© Photo: Eduardo McIntosh

**"Les Perchées" lamp**, 2010
Elise Gabriel (France)
Cellulose (Zelfo), beech, tinted cement, painted steel, electrical elemets
© Photo: Eduardo McIntosh

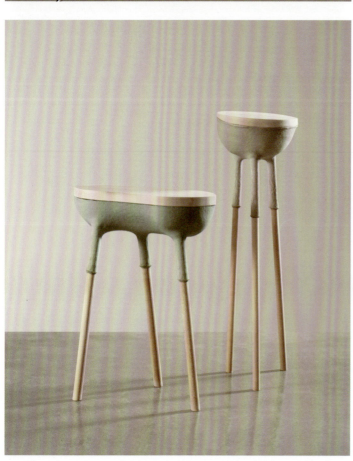
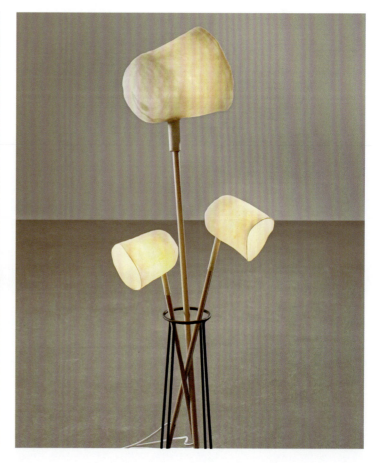

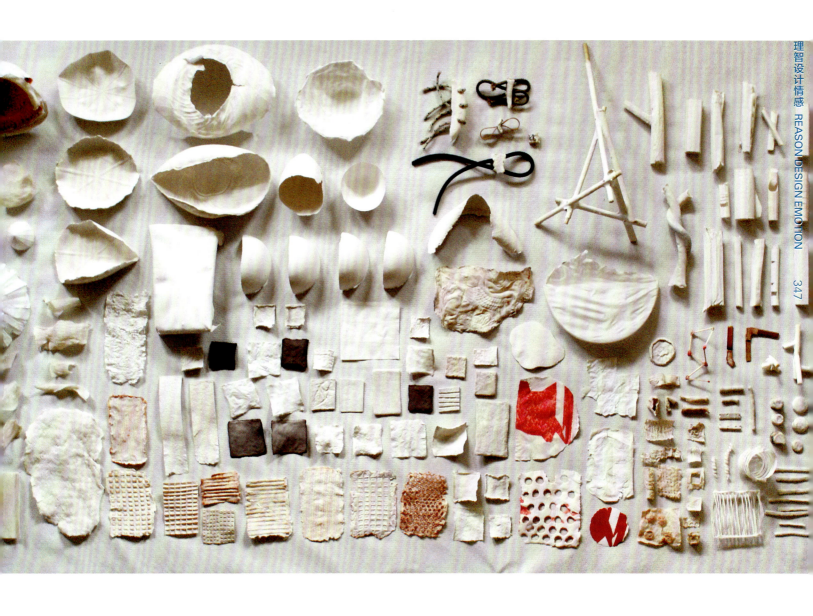

"Les Perchées" 灯束材料样本，2010
伊莉斯·嘉佰丽（法国）
© Photo: Eduardo McIntosh

"Les Perchées" lamp material samples,
2010
Elise Gabriel (France)
© Photo: Eduardo McIntosh

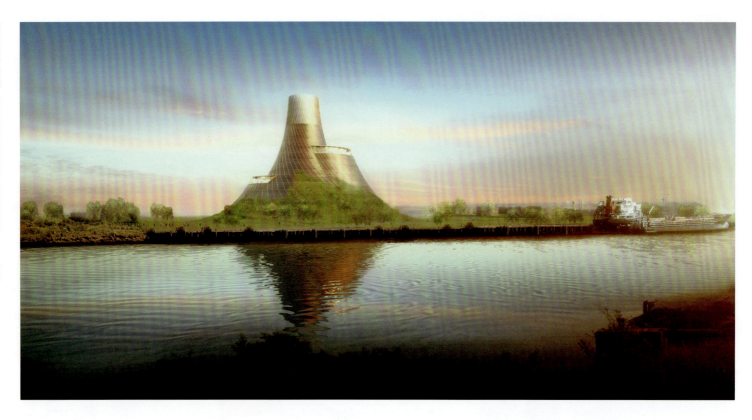

迪塞德电站，2010
赫斯维克工作室（英国）
印刷品
© Photo: Heatherwick Studio

**Teesside Power Station**, 2010
Heatherwick Studio (UK)
Prints
© Photo: Heatherwick Studio

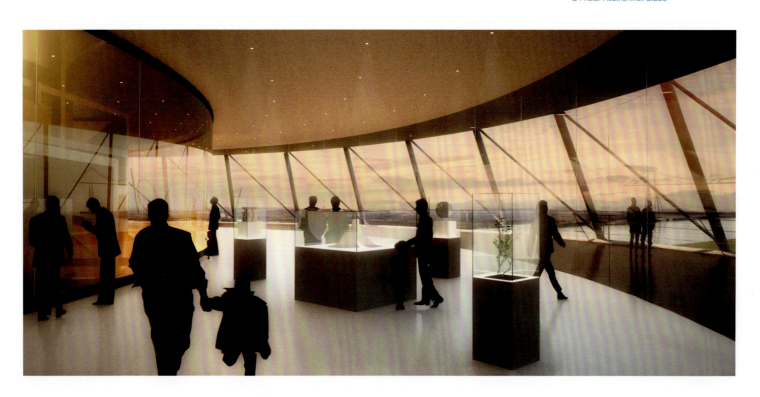

陀螺椅，2009
托马斯·赫斯维克（英国）
旋转模塑聚乙烯
© Photo: Magis

**Spun**, 2009
Thomas Heatherwick (UK)
Rotational moulded polyethylene
© Photo: Magis

上海世博会英国馆，2010
赫斯维克工作室（英国）
© Photo: Iwan Baan

**UK Pavilion, Shanghai Expo**, 2010
Heatherwick Studio (UK)
© Photo: Iwan Baan

香港西九龙文化区，2009 — 2011
福斯特建筑事务所（英国）
© Photo: Foster + Parners

**West Kowloon Cultural District**, 2009-2011
**Norman Foster + Partners** (UK)
© Photo: Foster + Parners

Mahanakhon,翠城新景,史各士大厦,槟榔屿热带城市
奥雷·舍人(德国)
中央电视台,电视文化中心,台北艺术中心,普拉达洛杉矶店,纽约店
雷姆·库哈斯,奥雷·舍人(荷兰、德国)
2001 — 2011
© Photo: OMA, Graphic: Buro Ole Scheeren

Mahanakhon, The Interlace, The Scotts Tower, Penang Tropical City
Ole Scheeren (Germany)
CCTV, TVCC, Taipei Performing Arts Center, Prada LA, Prada NY
Rem Koolhaas, Ole Scheeren (Netherlands, Germany)
2001 - 2011
© Photo: OMA, Graphic: Buro Ole Scheeren

**TWB凳子**，2010
Raw Edges设计工作室(以色列)
木
© Photo: Cappellini

**TWB Stool**, 2010
**Raw Edges Studio** (Israel)
Wood
© Photo: Cappellini

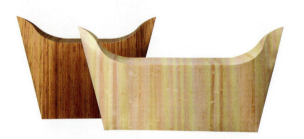

**裁剪的木材**，2008
Raw Edges设计工作室(以色列)
竹，木，聚亚安脂
© Photo: Raw Edges Studio

**Tailored Wood**, 2008
**Raw Edges Studio** (Israel)
Bamboo, wood, polyurethane moss
© Photo: Raw Edges Studio

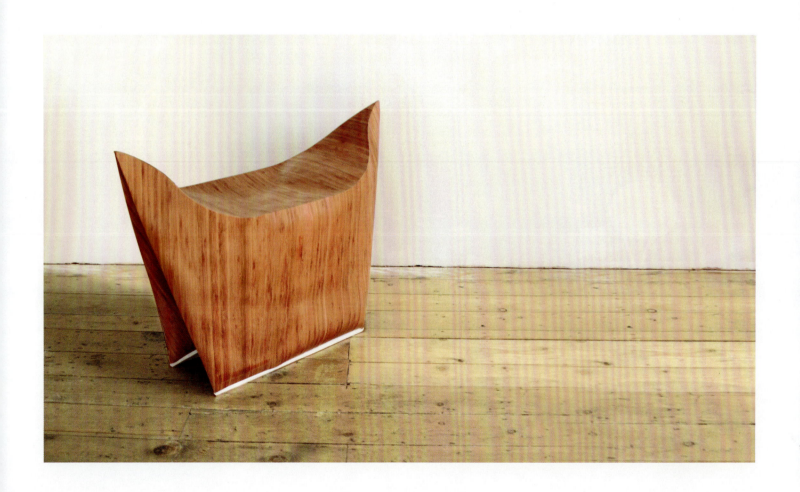

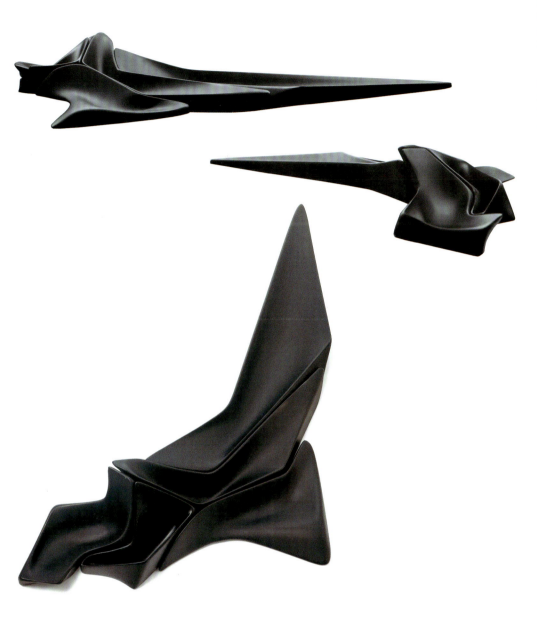

**Niche桌盘,** 2009
扎哈·哈迪德(英国)
黑色三聚氰胺
© Courtesy of Alessi, design Zaha Hadid Architects

**Niche Centrepiece**, 2009
Zaha Hadid (UK)
Black melamine
© Courtesy of Alessi, design Zaha Hadid Architects

**OS.08椅,** 2009
塞巴斯蒂安·维尔林克(比利时)
© Photo: Sebastien Wierinck

**OS.08**, 2009
Sébastien Wierinck (Belgium)
© Photo: Sebastien Wierinck

理智情感——空，2011
弗雷德里克·塔舍尔（法国）
© Photo: Frederic Tacer

**Reasemotion-EMPTINESS**, 2011
**Frederic Tacer** (France)
© Photo: Frederic Tacer

为雷丁村创作的6号立方体，2010
隈研吾（日本）
混凝土，钢座上的光导纤维
© Photo: Luccon Translucent Concrete/Juergen Frei

**Cube #6 for Raiding**, 2010
Kengo Kuma (Japan)
Concrete, light conducting fiber on steel base
© Photo: Luccon Translucent Concrete/Juergen Frei

材料样本装置，2010
隈研吾（日本）
混凝土材料样本
© Photo: Luccon Translucent Concrete/Juergen Frei

**Concrete Block Sample Installation**, 2010
Kengo Kuma (Japan)
Concrete samples
© Photo: Luccon Translucent Concrete/Juergen Frei

双泉提梁方壶杯组（刻瓷），2009
石大宇，马宪荣(中国台湾/中国)
瓷，不锈钢
© Photo: Dragonfly Design Center

**Twins Square Teapot Set- porcelain carving version**, 2009
Jeff Dah-Yue Shi, Ma Xianrong (Taiwan, China / China)
Porcelain, stainless steel
© Photo: Dragonfly Design Center

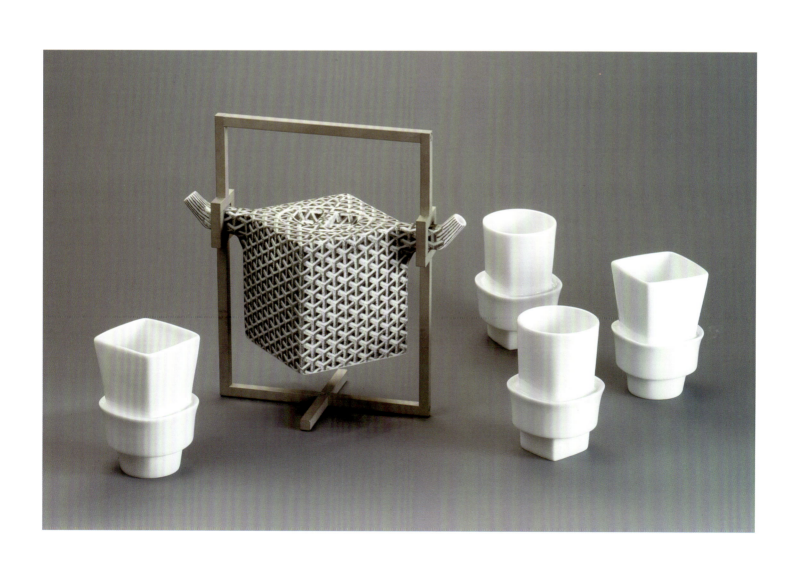

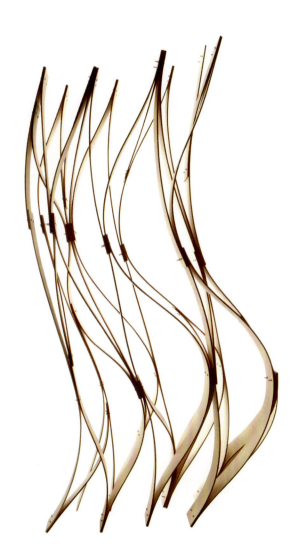

多向·异存，2011
克里斯朵夫·克莱蒙特，王欣（英国／中国）
胶合板
© Photo: Orproject

**Anisotropia**, 2011
Christoph Klemmt, Xin Wang (UK/China)
Flexible plywood
© Photo: Orproject

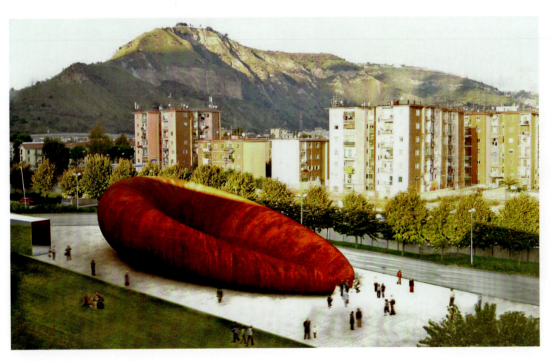

蒙圣安杰洛地铁站，Università入口，
那不勒斯，2014年完工
阿曼达·莱维特建筑事务所，安尼
施·卡普尔（英国）
© Photo : Amanda Levete Architect

**Monte St. Angelo Subway, Università Entrance, Naples**, Completion 2014
AL_A in collaboration with Anish Kappor (UK)
© Photo : Amanda Levete Architect

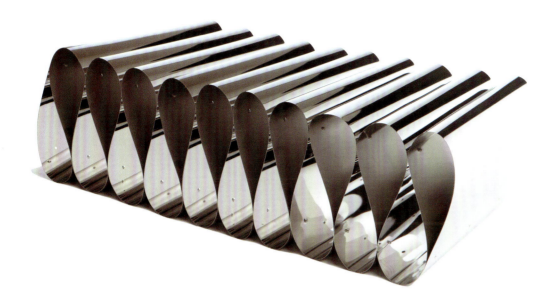

钢板凳，2011
多相工作室（中国）
不锈钢
© Photo: Duoxiang Studio

**Batting Bench**, 2011
Duoxiang Studio (China)
Stainless steel
© Photo: Duoxiang Studio

中药渣，2010 — 2011
冯峰，卢麃麃（中国）
中草药残渣
© Photo: Feng Feng

**Herb Residue Project**, 2010 - 2011
Feng Feng, Lu Biaobiao (China)
Chinese herb residue
© Photo: Feng Feng

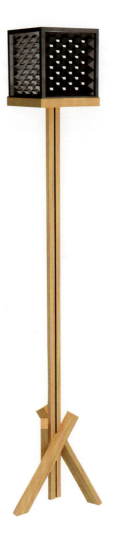

"藏地长城" LED立灯，2010
石大宇（中国台湾）
黑陶、松木、LED
© Photo: Dragonfly Design Center

**"Great Wall on Tibetan Land" LED Floor Lamp**, 2010
Jeff Dah-Yue Shi (Taiwan, China)
Black pottery, pinewood, LED
© Photo: Dragonfly Design Center

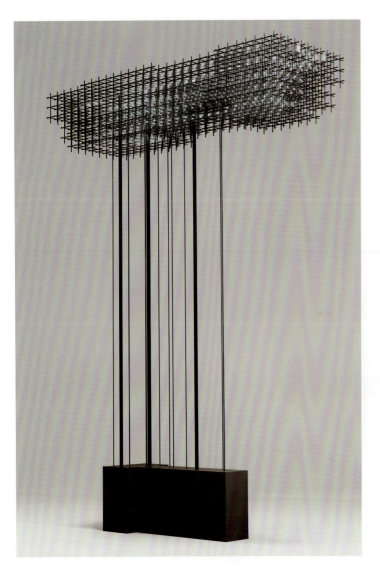

云灯，2011
杜异（中国）
LED，电路板，钢材

**Cloud of lights**, 2011
Du Yi (China)
LED, circuit boards, steel

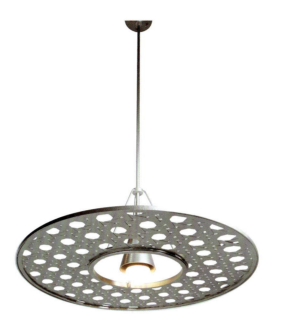

晒一灯，2011
王昀，章俊杰，胡丹丹，陈崇舜(中国)
不锈钢，弹簧钢
© Photo: Wang Yun

**Sun-lamp**, 2011
Wang Yun, Zhang Junjie, Hu Dandan, Chen Chongshun (China)
Stainless Steel, spring steel
© Photo: Wang Yun

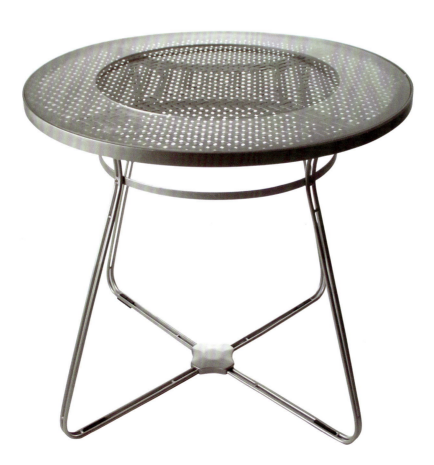

晒一桌，2011
王昀，章俊杰，胡丹丹，陈崇舜(中国)
不锈钢，弹簧钢
© Photo: Wang Yun

**Sun-table**, 2011
Wang Yun, Zhang Junjie, Hu Dandan, Chen Chongshun (China)
Stainless Steel, spring steel
© Photo: Wang Yun

玄关合，2010
朱大象，朱小杰(中国)
钢
© Photo: OPAL Studio

**Affection**, 2010
Zhu Daxiang, Zhu Xiaojie (China)
Steel
© Photo: OPAL Studio

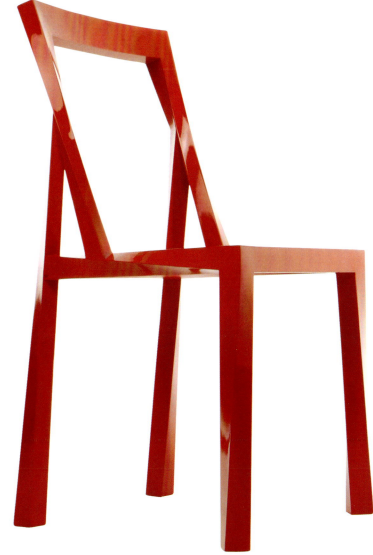

"漆"椅，2011
廖伟（中国）
漆木，中国漆
© Photo: Liao Wei

**Qi Chair**, 2011
Liao Wei (China)
Rhus vernicitera wood, lacquer
© Photo: Liao Wei

人造风景——境，2010
Hibanana Studio
苗晶，刘唱，李赞(中国)
录像 11分44秒
© Photo: Hibanana Studio

**Manufactured Landscapes**, 2010
Hibanana Studio
Miao Jing, Liu Chang, Li Zan (China)
Video 11'44 minutes
© Photo: Hibanana Studio

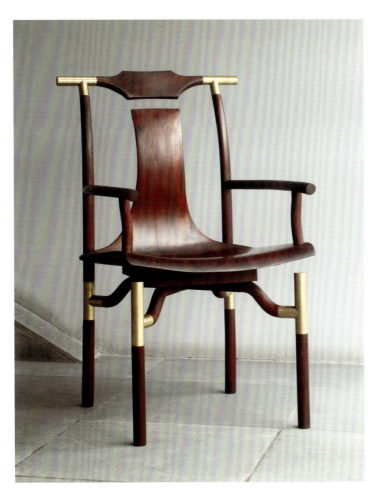

"武"北官帽椅，2010
陈旻，石振宇（中国）
红酸枝木，黄铜
© Photo: A-ONE Innovative Design Research Center

**"Wu" Office Hat Chair**, 2010
Chen Min, Shi Zhenyu （China）
Rosewood, Brass
© Photo: A-ONE Innovative Design Research Center

蓝白之间，2010
王雪青，杨帆（中国）
瓷
© Photo: Pierre bleue studio

**Between White & Blue**, 2010
Wang Xueqing, Yang Fan （China）
Porcelain
© Photo: Pierre bleue studio

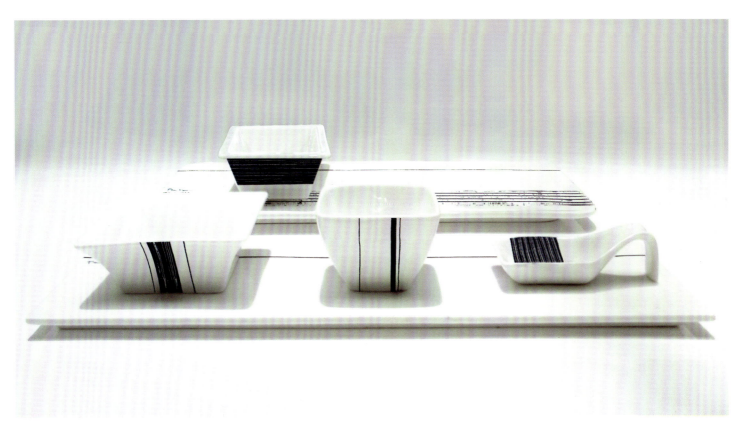

梦之石（方案），2011
Loya-b公司（法国）
香水：克里斯汀·奥斯特古威莱奥（创意总监）
香水师：安东尼·迈松迪尔（奇华顿公司）
声音装置：西尔万·雅克
光装置：本杰明·卢瓦约特
3D模型：蒂博·吉泰
感谢托马斯·勒伯歇和管汸嘉

**Dreamstone (Plan)**, 2011
**Agence Loya-b** (France)
Fragrance: Christian Astuguevieille (director of creation)
Perfumer: Antoine Maisondieu (Givaudan)
Sound project: Sylvain Jacques
Light installation: Benjamin Loyauté
3D project: Thibault Guittet
Thanks to Thomas Lebécel and Guan Yunjia

杂物框，2000  
克里斯汀·奥斯特古威莱奥（法国）  
编织篮，面料  
© Photo: Patrice Zamora

**Pocket Relief**, 2000  
**Christian Astuguevieille** (France)  
Fabric on a woven basket  
© Photo: Patrice Zamora

睡魔，2011  
西尔万·雅克（法国）  
循环声音播放 4分11秒  
© Sylvain Jacques

**Shuimo**, 2011  
**Sylvain Jacques** (France)  
Sound in loop 4'11min  
© Sylvain Jacques

理智+情感，2010 — 2011
本杰明·卢瓦约特（法国）
光设计，印刷品
© Photo: Benjamin Loyauté

**Reasemotion**, 2010-2011
**Benjamin Loyauté** (France)
Light project, Print on paper
© Photo: Benjamin Loyauté

# 4.

## 混合现实
## GOOD GUYS

| 策展人 | Curators |
|---|---|
| 特里斯坦·凯柏勒（瑞士） | **Tristan Kobler** (Switzerland) |
| 芭芭拉·霍泽尔（瑞士） | **Barbara Holzer** (Switzerland) |
| 李德庚（中国） | **Li Degeng** (China) |
| 马丁·海勒（瑞士，顾问） | **Martin Heller** (Switzerland, Consultant) |

特里斯坦·凯柏勒/芭芭拉·霍泽尔(瑞士)
李德庚(中国)

**Tristan Kobler / Barbara Holzer** (Switzerland)
**Li Degeng** (China)

## 单元主题阐释

社会发展的速度在加快，全球化也在不断深化。无论你喜欢与否，这是现实。今天，我们生活的环境充满了冲突、重叠与混搭，曾经的完整在继续碎裂，而新的力量正在把碎片重组出新的意义与价值——今天的现实是混合的现实。

本展览关注今天的设计师如何在看似困顿复杂的局面中发现新的方向，如何在表面的矛盾与冲突中找到内在的一致性——设计智慧会在我们拥有的事物中发掘出新的能量。我们将向公众呈现：地域化与国际化不是对立的两极，而是一种你中有我、我中有你的依存关系；发展现代生产也不一定以传统手工艺的逝去为代价，当手工艺中的多样性和人性部分融入工业生产之后，会让工业生产更符合人的需要；以未来为导向的潜台词不是遗忘历史。寻求可持续、公平贸易、再循环和个性化产品是设计师和消费者共同的责任。

本展览的展品涵盖了众多不同的设计门类，通过实物、模型或装置为公众打造一种全方位的视角，让他们了解世界一流设计师都在关心什么，以及他们对于生活的特殊态度源于何处——无论如何，没有好的设计师，没有这些好家伙们（Good Guys），好的设计也就无从谈起。

## Interpretation of the Sub-theme

Society is developing increasingly fast in parallel with the expansion of globalization. It is a real trend that overwhelms whatever one likes or dislikes. The intricacies of a chosen lifestyle are filled with conflicts, overlaps, mixes and hybrids. Forcefully as the current goes on, the old integrity is being shattered, and the pieces reorganized into shapes that frame new meanings and values. Indeed, the reality of today is in itself a hybridized one.

"Good Guys" foregrounds contemporary designers concerned with finding new ways to create objects that deal with ostensibly complex social issues filled with both compatibilities and contradictions. With these we make clear to the public that regionalization and globalization are not in a binary opposition; that modern manufacturing is not necessarily a replacement of traditional artisan craftsmanship; and that the unspoken words which underline the future do not leave out the past. It is the mutual responsibility of designers and consumers to seek sustainable, fair trade, recycled and individualized products.

The exhibition takes into account many design categories. The showpieces, in the form of objects, models and installations, create a comprehensive visualization for the public to see what sparks world-class design-minds and what leads to their special attitudes toward life. Anyway, without Good Designers, the so-called Good Guys, Good Design will not be achieved.

## 特里斯坦·凯柏勒

建筑师,策展人,洛桑艺术和设计学院教授,霍泽尔和凯柏勒建筑事务所合伙人

特里斯坦·凯柏勒,毕业于FIT。作为建筑师、策展人和设计师,先后参与过90多个文化和商业展览。1996年,他开始作为独立建筑师和策展人工作。1999年之后,经营和管理Morphing Systems,该事务所因承接数量众多的文化、展览项目而广受国内国际关注。1994年起,他在瑞士、法国和德国多所国际知名大学执教。2009年至今,担任洛桑艺术和设计学院教授。

2004年,特里斯坦·凯柏勒和芭芭拉·霍泽尔共同建立了霍泽尔和凯柏勒建筑事务所,成功参与了多个国际文化项目。2008年,特里斯坦·凯柏勒和芭芭拉·霍泽尔获得瑞士联邦设计大奖。

## 芭芭拉·霍泽尔

建筑师,策展人,彼得·贝伦斯建筑学院教授,霍泽尔和凯柏勒建筑事务所合伙人

芭芭拉·霍泽尔,毕业于FIT,SIA会员。以自由职业者身份从事建筑和展陈设计,直至1999年成立了自己的工作室d-case。1994年起,开始为丹尼尔·里伯斯金德(Daniel Libeskind)工作,作为项目主持人承接博物馆建筑和展陈设计国际项目。她在世界各地进行演讲,担任大奖赛评委,并在多所国际知名大学执教。目前,她以教授身份执教于杜塞尔多夫的彼得·贝伦斯建筑学院。

2004年,芭芭拉·霍泽尔和特里斯坦·凯柏勒共同建立了霍泽尔和凯柏勒建筑事务所,成功参与了多个国际文化项目。2008年,芭芭拉·霍泽尔和特里斯坦·凯柏勒获得瑞士联邦设计大奖。

## Tristan Kobler

Architect, Curator, Professor at University of art and design Lausanne, Partner of Holzer Kobler Architekturen

Tristan Kobler (graduate of FIT) has developed and successfully realised some 90 exhibitions as architect, curator and designer in the cultural and commercial fields. In 1996 he started working independently as an architect and curator. Since 1999 he has managed Morphing Systems, an office which has drawn attention to itself through numerous cultural and exhibition projects in Switzerland and abroad. Since 1994 he has taught at international universities in Switzerland, France and Germany. Since 2009 he has been a professor at ECAL, University of art and design Lausanne.

Tristan Kobler and Barbara Holzer have been jointly running the firm Holzer Kobler Architekturen since 2004, and have successfully realised international projects from the fields of culture and business. In 2008 Barbara Holzer and Tristan Kobler were awarded the Grand Prix Design of the Swiss Confederation for their international engagement in the field of scenography.

## Barbara Holzer

Architect, Curator, Professor at the Peter Behrens School of Architecture, Partner of Holzer Kobler Architekturen

Barbara Holzer (graduate of FIT, member of SIA) worked on a free-lance basis in architecture and exhibition design, until setting up her own office, d-case, in 1999. Since 1994 she has been working for Daniel Libeskind's practice as the project leader on international projects chiefly in the field of museum buildings and exhibitions. Barbara Holzer is a very active lecturer, serves on numerous competition juries and teaches at several international universities. Currently she is a professor at the Peter Behrens School of Architecture in Düsseldorf (PBSA).

Barbara Holzer and Tristan Kobler have been jointly running the firm Holzer Kobler Architekturen since 2004, and have successfully realised international projects from the fields of culture and business. In 2008 Barbara Holzer and Tristan Kobler were awarded the Grand Prix Design of the Swiss Confederation for their international engagement in the field of scenography.

## 李德庚

设计师,策展人,《设计管理》、《FRAME》和《MARK》中文版设计总监 今日美术馆设计馆学术总监,清华大学美术学院视觉传达系讲师

李德庚,1973年生于山西,现居北京。曾主编并设计《欧洲设计现在时》系列丛书与《今日交流设计》系列丛书。这两套丛书已经被证明是当代中国设计最具影响力的设计书籍,对当代中国青年设计师的成长起到了巨大的推动作用。学术论文与设计作品发表于国内外诸多刊物,如《Domus》、《装饰》、《艺术与设计》、《C_D》、《紫禁城》等,接受《Form》、《360》、《设计》、《三联生活周刊》、《青年周末》、《广州日报》、《外滩画报》、《晶报》等诸多设计及当代文化杂志报刊专访。

2009年起开始任教于清华大学美术学院。2010年起开始担任《设计管理》杂志、《FRAME》和《MARK》中文版的设计总监以及北京今日美术馆设计馆的学术总监。

## 马丁·海勒(顾问)

知名策展人,批评家,学者,苏黎世设计博物馆前馆长

马丁·海勒出生于瑞士。1972—1976年,于巴塞尔设计学院任教,1978—1985年在巴塞尔大学进行艺术史与社会人类学研究。1978—1986年,以艺术批评家、顾问、撰稿人及自由策展人身份工作。

1986—1999年,担任苏黎世设计博物馆的馆长,同时还在瑞士和世界不同地方从事出版、评审和教学工作,内容涉及摄影、设计、日常文化、策展以及博物馆学。

1999—2003年,马丁·海勒以创意总监身份成功参与了2002年的瑞士国家展览会,规模多达40余项展览,是一个囊括音乐、戏剧以及流行文化的盛大展会。

2003年,他成立了海勒公司,以独立策展人、作者以及文化企业家身份,参与瑞士、德国、奥地利等地的多个项目,并于同年被任命为德国布莱梅市申报2010年欧洲文化之都的创意总监。从2005年起,担任林茨申报2009年欧洲文化之都的艺术总监。此外,海勒还是威达股份有限公司的董事会成员。

## Li Degeng

Designer, Curator, Art Director of the magazines Design Management, FRAME and MARK Chinese version, Academic Director of Design House of Today Art Museum (Today Design Museum), Lecturer at the Visual Communication Department, Academy of Arts & Design, Tsinghua University

Li Degeng, born 1973 in Shanxi, now lives and works in Beijing. As an editor-in-chief, he has edited and designed two set of book series: "The European Design Now" and "Contemporary Communication Design from the Netherhlands", which have been proved to be the most influential contemporary design books in China and have also played a great role on designer of the contemporary Chinese youth's growth. His academic thesis has published in many publications such as "Domus", "Zhuangshi", "Art and Design", "C_D", "Forbidden City Magazine" and so on. He has been interviewed by many design and contemporary culture magazines and newspapers such as "Form", "Concept and Design Magazine", "Design", "Life Weekly", "Youth Weekend", "The Bund", "Guangzhou Daily", "Daily Sunshine" and so on.

Li Degeng has been a teacher at Tsinghua University since 2009. He is the Art Director of the magazines "Design Management", "FRAME" and "MARK" Chinese version since 2010 and he is the Academic Director of Design House of Today Art Museum (Today Design Museum) as well.

## Martin Heller (Consultant)

Curator, Critic, Former Director of the Zurich Design Museum

Born in Switzerland, Martin Heller obtained a teacher's certificate in art education at the Schule für Gestaltung Basel (1972-76), and proceeded to study art history and social anthropology at Basel University (1978-85, lic. phil.I 1985). Between 1978 and 1986, he worked as an art critic, consultant, essayist and freelance exhibition curator.

From 1986 to 1999, Heller served as director of the Zurich Design Museum (Museum für Gestaltung Zürich). At the same time, he was involved in various publications, juries and teaching assignments relating to photography, design, quotidian culture as well as curatorship and museology both in Switzerland and abroad (Hannover, Hamburg, Bonn, Vienna, Paris, Montreal, Chicago, New York, among others).

From 1999 to 2003, Martin Heller has served as creative director of the successful Swiss national exhibition Expo.02, an event with more than 40 exhibitions and a rich program in music, theatre and popular culture. In 2003 he founded Heller Enterprises and works now as an independent exhibition curator, author and cultural entrepreneur for several projects in Switzerland, Germany and Austria.

In 2003 he was appointed creative director for Bremen's application as Cultural Capital of Europe 2010. Since 2005 he is artistic director for Linz Cultural Capital of Europe 2009. Further¬more, Heller is a member of the Board of Directors of Vitta Holding Ltd.

# 混合现实

霍泽尔和凯柏勒建筑事务所／李德庚

## 设计

"我羞于获得设计奖这样愚蠢的东西。到底谁需要设计、生活风尚，以及所有这些破烂玩意儿呢？没有人需要！"

设计师菲利普·斯塔克（Philippe Starck）以上述激烈的言辞抨击自己从事的职业，这反映出一种广泛流行的观点，即设计是附属于奢侈品、生活风尚和消费主义的，因而也就是浅薄和多余的。

斯塔克这番言辞明显蕴含这样一个前提：设计仅与特定类型的产品相关联，这些产品仅是为满足部分消费者的美学需求而生产的，追逐所谓生活风尚产品所代表的短暂时尚而已。这类设计几乎可以肯定说是浅薄的。其背后的机制已为人们熟知，即少数时尚引领者或个人在公众面前展示产品，它们成为令人垂涎的对象，在经数周或数月的传播后突然成为最时尚的东西。这强化了这些产品的前卫形象，进而使之转化为设计业界的大生意。这种类型的设计也许可以达到最高的品质及美学吸引力方面的标准，当然并非一定就能，尽管那些在时尚变化后依然存留下来的设计作品可能会成为经典作品。

"美"和"好"这两个双生概念本身就暗示出设计需满足的相互冲突的需求，而在不同的文化、时间和地点，这两个概念又以很多种不同的方式被定义：一方面需要便利生活的功能性，另一方面又试图创造出美丽和具有吸引力的环境。虽然功能性和美学性并不是相互排斥的，但长久以来就设计在这两个概念之间如何定位自身所进行的争论一直在持续。在工业化时代到来之前，美学性是从手工艺方面定义的。随着规模化工业生产的发展，大众才有机会以可承受的价格购买产品。"好的设计"被解释为美学功能性，这已成为现代设计的教条。目前一些设计师依然认为在形式和功能间维持一种理想的平衡是很重要的，但维持这种平衡的文化关联性及其对设计师的吸引力都在下降。形式和功能的平衡已不足以满足我们对现代设计的要求。

功能和形式这两个问题在设计发展中也能见到：就前者而言，设计是一个"改进"的过程，侧重于功能、有效性或可用性等功能性要素；就后者而言，设计是一个美学意义上的"完善"过程，侧重于形式、外观设计或吸引力等美学性要素。以美学性要素衡量，这种设计让产品具有某种趋于神圣地位的特质。这种渲染装饰甚至赋予整个品牌一种美学功能，这样尽管品牌不生成任何实际内容，但却准确传达出我们前面提到的那个概念：设计如同代表生活风尚和社会地位的奢侈品，仅提供给一个排他的富裕群体，人们通过购买作为社会地位象征的奢侈品而成为这个排他的富裕群体的一员。

然而"设计"这个概念也可以代表一个可创造出事物的分类、差异性或秩序的创造性过程（设计这个词源于拉丁文的"designare"，指"指定、任命或安排"）。它将一些原本是平常的事物提升至高贵的地位，让人们刮目相看。一旦我们能将某物与其他物体明显地区分开来，我们和该物之间的一种关系就开始成形了。

这个物体成为某种个性化的东西。我们不仅仅是从其外观、形状、形式或颜色等方面认知该物体，还从其意味、整体性、气息甚至是其瑕疵等方面感知该物体。该物体成为"我们自己的"物体，一种通过它可以部分地定义我们自己的东西，成为我们自身的一部分。一旦我们与某物建立起这种关系，情绪就会发生作用。在我们与设计对象之间建立起了一种纽带，它与我们接近，如果失去它我们甚至会想念它。

从这一视角来看，设计极端重要。设计远不是仅与为少数富裕人群生产的奢侈品有关，而是渗入我们生活的每一个领域。设计的范围无所不包，从用户界面到创新的技术，从每季的日常服饰到可使用数十年的椅子，甚至还包括某种书写形式——如中国的汉字，它传承中国数千年来的文化遗产。

我们离不开设计。在我们的周围，遍布着那些其他人所创造的，塑造我们生活的物体。设计是视觉形式的文化，它反映经济和社会背景，并通过与这些经济和社会背景的对话而不断发展变化。

## 背景

"设计通过差异化创造意义。它是我们打开世界的媒介。"（诺伯特·波尔兹（Norbert Bolz），1999）

包含日常生活所有领域的这种"设计"概念，不能被简化为某一成型的产品。"设计"毋宁说是指一个创造性的过程，通过该过

程设计理念固化在产品中。这种"设计的无形现实"（该术语是瑞士社会学家布克哈特（Lucius Burckhardt）首创的），在设计的历史、政治、文化、哲学和美学背景中呈现出来。从这个意义上讲，设计是实用导向的，以多种不同的方式呈现和反映普遍的社会现实。仅是在某些时候，在这个创造性过程结束时可能会生成某个产品。

因此一个设计对象是一个创造性过程的快照，同样也始终是其时代的一面镜子。设计对象见证现时代的状况。鉴于设计是任何给定时间段全社会所关注的主要问题的反映和产物，对什么是"好的设计"的认知在不同的时代和社会就各有不同。即使不同设计师的兴趣和才能有很大差异，但他们所处时代的假定和偏好无疑会在其设计中留下痕迹。当然这并不一定就意味着功能性价值的废弃或丧失，但确实意味着作为当代设计师的我们将不会再以一样的方式去设计某个物品。消费者将不再能识别出这个物品，因而也就不会购买它。

根据这一逻辑，我们将始终选择生活在一个"好的"当代设计环境中。但是我们当中又有多少人能抛弃承载了如此多回忆的传家宝呢？其他产品，无论其设计得多么好，又怎能替代这些承载着个人回忆或物品本身历史的小物品呢？我们中有谁会仅以其当前的实用性去衡量那些曾改变了世界的物品，或是与那些改变了世界的人有关的物品呢？设计对象蕴含着历史和故事，既包括伟大的冒险，也包括那些不那么轰轰烈烈甚至是很平淡的私人历史。

虽然我们生活在一个所有时代的设计对象共存的世界中，但在处理这一现象时，我们通常并没有任何问题。我们对之习以为常，并通过诸如博物馆或纪念地等方式收藏它们。博物馆和我们生活的城镇等日常环境，是收藏暂时性记忆的地方，我们通过这种记忆来审视今天，而未来的规划者也必须回答当今的问题。设计，不论新旧，都构建出认同，并具有情感价值。

因此，设计师是热衷于改进世界的乐观主义者。他们始终致力于创造出具有新特点或填补空白的东西。意识到几乎所有事物都以多重形式存在，设计师必须识别出已改变的参数以及所造成的不足，并以新的内容和形式去弥补这种不足。设计师在一个过去、现在和未来相遇的环境中从事设计工作。他们必须不因此而退缩，因为这正是衡量他们工作的最终标尺。在某个产品或甚至某个创意，以及它们的全部历史在新的背景下被呈现、思考和解读时，一个新的创造性过程应运而生，而现在的理念中遗留着过去理念的痕迹。

**好的设计**

"举例来说，在19世纪开始时，如果你在一个不是很富裕的国家长大，冬天对你来说确实是很寒冷的冬天，那么你就需要穿上厚厚的大衣，这就是生活，这就是你需要的大衣，穿上它是为了御寒而非追逐时尚。大衣是如此美丽，因为你感到非常寒冷，不穿大衣就无法存活。它变得像你的朋友或家人。"
（三本耀司在维姆·文德斯的电影《衣食住行事件簿》中的独白）

好的设计必须被始终理解为一个涉及多种多样关系的系统的一部分。在今日这个全球化的世界中，设计对象和设计方法是极为多样化和杂糅的。此外，很明显并没有放诸四海皆准的品质标准。在每一个文化和时间段中，我们都必须重新定义什么是"好的设计"。不过与此同时，连续性、互联性和关系性也自然地存在。结果是构建出一个谈论设计及世界的差异性和相似性的网络。我们将之理解为一种大型家庭聚会。它是一种跨文化交流，通过这种交流并结合地方性知识，新事物不断地被创造出来。

那些推动当今的地方社会和全球社会变化的问题是什么呢？"好的设计"不再仅是20世纪50年代时人们普遍认为的功能物品的"好的形式"，"好的设计"的概念已变得更为复杂，包含"好的形式"之外的很多方面。

在一个全球化进程日益深化的社会里，设计被不断齐一化和复制，因此人们也越来越渴求独特的、不与其他产品雷同的产品，因此那些最好是在本地生产的个性化物品，其价值日益提高，也越来越趋向于成为独家产品。"旧片重制"*，即从现有对象中创造出一些新东西，正成为设计师的主旨之一。通过其制作品质以及其持久价值赢得使用者的喜爱和认可，"好的设计"历久弥新，而不是轰动一时随后即被遗忘。

旨在使用尽可能少资源的智能化生产制造方法，提倡小批量生产或手工生产。那些"美丽"的产品在全球不同的生产地流转三次才告制造完成，这被认为是不恰当的。相反，恰当的做法是在这些产品的产地进行推广，并充分利用创新潜力。即使是本地的设计也能获得国际认同，因为这种设计带有本地的文化特色。

所有从事设计的人都在思考有关设计品质的问题，以及"好的设计"在日常生活中的含义。这是正确的方向，其原因是相信设计对日常生活的影响正是设计最强的力量之一。因此，我们应当真心实意地欢迎就哪些因素和方面构成为"好的设计"而进行的广泛争论。这种智力交锋可以让人们更好地理解设计、制造和使用间的相互关系，对之具有更高的敏感性。

好的设计如何能为他人所用则是另一个问题。"好的设计"并不一定就是昂贵的或奢华的。"好的设计"完全取决于利用现有手段进行创造性工作，即拥有洞察事物并利用这种洞察力实现转

*旧片重制指一种电影类型（主要是实验电影），即电影制作人全部或部分地使用他人已拍摄的影像材料来制作自己的电影。制作人使用多种方式处理、整合、分解和重新解读这些影像材料。

变的能力。我们认为"循环利用"是"好的设计"的一个关键要素。我们应当分析我们周围已有的事物，通过再利用、改造、借用来实现改良的设计。在当前社会自我创造越来越受重视，而对大规模生产的依赖则日渐式微。设计师正在摆脱对"完美设计"的痴迷，并在探索以自我制作的方式创制独特的设计作品。社会参与是"好的设计"的主要目标之一。

但好的设计还做一些完全不同的事情：它创造出主体和客体之间的一种情感纽带。这种情感纽带让我们能以一种完全不同的方式从独特性这个角度来认知好的设计。设计对象变为历史的承载体——这里所说到的"历史"不仅仅是设计对象自身的创制史，也是其拥有者的历史，如前述三本耀司的那段话所指出的。事物和人们结合在一起，它们不仅仅被人们所拥有，也成为人们自身的一部分。正是这一点让事物变得独一无二，不可替代，在这个意义上讲也成为恒久的。

好的设计既悦人感官，又悦人心神，还刺激智力。它是件让人快乐的有趣工作！

## 我们的"好家伙"设计师

"没有什么比一个终于为世人所接受的理念而更强大的。"
（维克多·雨果）

"好的设计"需要好的设计师来完成。我们的"好家伙"设计师在处理可持续性、可循环利用性、公平贸易和社会责任等问题时所采用的方式是多种多样的。他们中的一些人重新解读传统工艺，或是使用新技术来制作传统产品。其他一些人则将大批量生产的货物转化为高价值的个性化物品，或是使用创新的材料来创制大规模生产的产品。我们的展览既包含设计原型，又包含实用性物品，还包含有艺术气息的物品。我们设计师的与众不同之处在于他们每天都通过其工作，以新眼光审视和思考我们生活的世界，在设计中注入新理念，从而为创造一个更加美好的未来世界做出贡献。

"好家伙"设计展邀请参观者去发现所展出的这些创造性设计解决方案，以及背后的设计师；去体验和感受体现这些意图、反思和创意的设计作品；去体味、赏析、触摸和观看这些设计作品。

"好家伙"设计展是一次视觉盛宴和美学之旅。我们有意不按来源、类型、主题或范畴等将物品分类。参展的设计师既有设计界的名人，也不乏一些尚未为人熟知的新锐设计师。对我们来说，设计首先是一种态度，即我们的"好家伙"设计师都拥有的那种态度。

展厅因此就成为了一个展示作品的中性空间。一个迂曲的龙形装置的框架，一个由20万双筷子缠绕而成的有机结构，贯穿于展厅，略为向上，却只是为了再次下降并将空间展开给参观者观看。这个装置将空间划分为相互间无缝融合的弹性区域，邀请参观者去探索和发现。展品放置在这个装置之内及其四周，看似随便摆放却又根据内容和空间相互联系在一起。参观者可触摸、轻叩、嗅闻、倾听其中一些展品，或就是观看它们。墙壁也被用作展览的元素。被文本、照片、图形和织物设计所装饰的墙壁，构成了展品展示的背景，作为空间背后的一幅全景画，将筷子装置纳入其中。

在展厅入口处悬挂着一个针织的钟。这是不同寻常的时钟。每隔半小时它就会编织一个单网孔——时间的象征，短暂和永恒的象征，而短暂和永恒对不同的设计对象、背景和类型来说会有完全不同的意义。举例来说，对于各种中国建筑物的插图，时间就具有特别的意义，这些建筑作品将其环境带入了遥远的未来。因此建筑作为构建和塑造环境的方式是非常重要的、居于中心地位的设计学科。时间漫长，潮流缓慢地不停变化，用途可以改变，而我们对建筑物的使用寿命有很高的期待。中国艺术家的参展作品均以可持续性地使用可用材料为特点，另一大特点则是都将位置、人和社会结构整合入了作品之中。

与建筑作品构成对位的则是另一种很受欢迎的设计类型：时装设计。这里时间段是短暂的，时尚潮流总在迅速地变化。中国设计师张达的时装设计作品涉及与瑞士设计师法比尼·埃瑞格尼（Fabienne Arrigoni）的对话，他曾说过："我希望人们对一件衣服的价值有新的感受。"一件衣服的价值部分是由公平制造的成本及所选择的上乘原料所界定的，同时也是部分由穿衣者和衣服之间的关系所界定的：儿童喜爱亮丽的衣服，这些衣服的式样有限但颜色则有很多种。织物设计同样也不仅仅是时尚。举例来说，我们就展出了瑞士一位富于创新精神的织物设计师克劳迪娅·卡维泽（Claudia Caviezel）的一件设计作品，克劳迪娅·卡维泽与著名时装设计师薇薇恩·韦斯特伍德（Vivienne Westwood）和瑞士纺织品制造商Jakob Schlaepfer都有合作。她专为北京国际设计三年展（BIDT）设计了一种墙纸，将我们带入了一个由绚丽多姿的形式和颜色构成的世界，其中有无数的故事当待观者去发现。这样一种墙纸与工业化大批量生产的墙纸截然不同，它由本地制造商根据订单生产，因而是独特的，且在使用多年后也不落伍。在展厅入口处我们还可以看到扬·凯斯（Jan Kath）的一件另一种风格的织物设计作品，鲜活地展示了现有产品可以如何被更新。凯斯选择经典的东方地毯，通过去除其上原来的染料而代之以当代的颜色，对经典的东方地毯进行了重新诠释。即使他做了这种改变，地毯上的旧图案依然熠熠生辉，让人回想起过往的时代。这件作品呈现的方式让人回想起东方的地摊市集——地毯被堆叠起来，部分展开。

紧挨着扬·凯斯作品的是另一种类型的设计，即工程设计。工程

设计主要涉及新技术和新材料的运用，所展出的法比安·穆勒（Fabian Müller）的作品就是工程设计的代表作。穆勒创制出一个可很容易就安装在自行车上的移动发电装置，任何人都可以用这个装置发电。该发电装置使用太阳能，并将所发的电储存在高性能电池中，这样每个人都可以自己为自己供电——电力生产的民主化。马丁·布拉莫（Markus Bangerter）的作品则是另一种类型的工程设计，横跨产品设计和工程设计这两个领域。他开发出一种使用热来硬化纺织纤维的工艺，这样这些经硬化处理的纺织纤维甚至能用于制造椅子。发现利用新材料和物质的方法，是以替代的方式使用原材料的重要组成部分，从这个意义上讲工程设计正在为塑造可持续发展的未来做出重大贡献。

开发新技术是处理可持续发展问题的方式之一，而另一种方式则是加工处理"旧"材料。例如年轻的荷兰设计师克拉斯·库肯（Klaas Kuiken），就使用吹瓶技术处理回收的旧玻璃瓶，将它们转化为具有独特风格的花瓶，其独特的形式一下子就能吸引住观者的眼球：大众产品成为高价值的个性化物品。来自柏林的年轻设计师蒂娜·罗德（Tina Roeder）则对被丢弃的消费品进行再利用，为它们赋予新的生命。她花了7年多时间收集白色的塑料座椅，然后通过穿孔和表面处理，创制出限量版的个性化物品。相比之下，设计师马蒂·古伊斯（Marti Guixe）则以实验性的方式探究产品的价值，他的设计作品"种植宠物"，是以塑料制成的可爱小宠物，宠物的眼睛则是植物种子。这是一种大众产品，但旨在创造出和物品主人之间的一种情感纽带。由于这些宠物在放入土中生长出食用植物前是没有实用性的，物品的主人必须在情感和功能间做出选择。这件作品是消费者通常都面临的两难处境的极好象征。

视觉传播是一种特别重要的设计类型，之所以重要是因为它对我们认知世界的方式有巨大影响。弗赖塔格（Freitag）工作室使用旧卡车篷布制造包包，这些环保包包将在本次展览中展出。仿效弗赖塔格公司，Raffinerie设计师公司创制了一个报刊阅览室，在阅览室中使用旧印刷机为弗赖塔格公司印制报纸。它使用传统技术并将之脱语境化，从而创造出一种新的独特的视觉语言。艺术家亚塔·博萨奇（Ata Bozaci）则探索另一种形式的视觉语言再解读，他的雕塑作品"黑色的MLS"将涂鸦从墙上引入室内，为室内视觉形象增添了一个新的维度。与此类似，约格－斯特劳斯（Joerger-Stauss）二人组（一个是摄影师，另一个是设计师）则探索空间和触觉，他们将三维空间带回入二维空间，即在空间中准确地捕捉到物质性，然后将之拍摄为照片，通过这种方式把三维空间定格在照片上。

不论这些作品有多大差异，它们都显示"好家伙"设计师是记录社会和政治发展变化的人，持续地与他们自己的生活环境和世界进行对话。他们擅长于对变化作出反应，学习吸收过去的经验，深入思考当前面临的问题，并构想出未来的愿景。他们认为自己有责任从美学、情感和社会维度来塑造我们生活的世界，并愿意承担创新的风险——创新意味着和现有结构的冲突。

设计是一种态度，一种共同的态度。这种态度将设计师、生产制作人、消费者和共同制造商联系在一起，跨越行业、文化、国家和年龄组的界限。设计是一种语言，一种就差异性和共通性所进行的持续的文化对话。

作为生活风尚的设计（如菲利普·斯塔克所说的），需要对世界进行深入的思考，绝非生活风尚产业的广告所宣示的那样简单。即使奢侈品业试图让我们成为沉溺于自恋的时尚产品消费者，我们还是必须重视"生活风尚产品"。

我们具有策展者和设计师双重身份，根本出发点是倡导一种智能化的和负责任的应对处理世界及其人力和自然资源的方式。这包括创新及专注地致力于以创造性的方式传达独特的文化和历史特征，这种文化和历史的独特性在当今这个全球化的世界里越来越重要。在这个过程中，我们最大的关注是确保我们当中的每个人都能做出自己的贡献和实现成功。

# GOOD GUYS

Holzer Kobler Architekturen / Li Degeng

**Design**

"I am ashamed to receive a prize for something as ridiculous as design. After all, who needs design, lifestyle and all that crap? Nobody!"

With that radical statement, designer Philippe Starck turns against his own profession – and reflects a widespread and popular view that design is luxury, lifestyle, consumption; that it is peripheral and superfluous.

The premise underlying his comment is clear: design relates to a specific class of products that are produced solely to meet an aesthetic need and respond to the ephemeral trends that govern lifestyle products. Such design is, almost inevitably, superficial. The mechanism is a familiar one: a small group of trendsetters or individuals who are in the public eye display the products; they become coveted objects and, a few weeks or months later, their appeal spreads and they are suddenly the height of fashion. This reinforces their avant-garde status which, in turn, translates into a flourishing business for the design industry. This kind of design may of course meet the highest standards in terms of quality and aesthetic appeal – but not necessarily. Those items that outlive the trend, though, may become classics.

The twin concepts of "beautiful" and "good" in themselves hint at the conflicting demands to which the idea of design is subject, and by which it is defined in various ways depending on culture, time and locality: the need and desire for a functionally simplified life on the one hand, and the striving to create an attractive environment for oneself, on the other. Functionality and aesthetics are not mutually exclusive; yet the debate over where design is to position itself between these two extremes has a long history. Before the age of industrialization, aesthetics were defined in terms of craftsmanship. It was not until the advent of industrial mass production that products were marketed to a broad public and became affordable for many. "Good design", interpreted as aesthetic functionality, became a dogma of the modern. To this day, some designers believe in the importance of an ideal balance between form and function; but the cultural relevance of doing so and its appeal for designers have declined. Honesty of form and function are no longer adequate to satisfy our modern-day conception of design.

These two issues – function and form – can also be seen in the development of design: first as a process of "improvement", conceived in a fairly functional sense in terms of parameters such as function, effectiveness or usability; second as a "perfection" in the aesthetic sense, relating to form, design or attractiveness. A development of this kind, measured as it is against aesthetic parameters, imbues a product with something approaching hallowed status. The hype even extends to conferring an aesthetic function on entire labels – brands that, although they no longer generate any actual content of their own, sell precisely that idea that we referred to earlier: design as a luxury product that promises lifestyle and social status, intended solely for an exclusive, wealthy community whose members secure admission to that community by acquiring those very same status symbols.

Yet the concept of "design" can also stand for a creative process that (reflecting its derivation from the Latin "designare" – to designate, appoint or arrange) results in the labelling, differentiation or ordering of things. It elevates certain unmistakeable things above the mass, making them identifiable and recognizable for human beings. And as soon as we are able to recognize an object, to separate it from the mass, a relationship between us and that object begins to take shape.

The object becomes something personal. We recognize it not merely from its appearance, shape, form or colour, but also from its feel, its consistency, its smell – even its shortcomings. It becomes "our" object, something through which we can partially define ourselves, which is a part of us. As soon as we enter into a relationship with an object, emotions come into play. A bond is created between us and the design object. It touches us – and if it is taken away from us, we miss it.

Viewed in this way, design is of the utmost importance. Far from being limited to a few products for an exclusive target audience, it pervades every area of our lives. It can be anything from a user interface to innovative technologies, seasonal everyday clothing to a chair that lasts for decades and even a form of writing which, as in China, enables communication across the millennia.

Design is inescapable. We are constantly surrounded by objects that others have created and that shape our lives. Design is culture in visual form; it infiltrates and reflects the economic and social context, and develops constantly through its dialogue with that context.

**Context**

"Design creates meaning through differentiation. It is the medium by which we open up the world." (Norbert Bolz, 1999)

A concept of design that encompasses all areas and fields of daily life cannot be reduced to a single product. Rather, it refers to a creative process in which the product is a crystallization of the developments that have preceded it. This "invisible reality of design", as the Swiss sociologist Lucius Burckhardt terms it, is informed by the entire context: the historical, political, cultural, philosophical and aesthetic conditions at the moment of creation. In this sense, design is practically oriented and engages with the prevailing conditions in many and varied ways; and some time, at the end of this process, there is – perhaps – a product.

A design object is thus a snapshot of an ongoing process and, equally, always the mirror of "its" time. Objects are contemporary witnesses. The perception of good design varies as a function of the issues preoccupying society at any given period. Even if designers differ widely in terms of their interests and abilities, the premises and preferences of a certain era invariably leave their mark. That, of course, does not necessarily imply obsolescence or a loss of functional value; but it does mean that we, as contemporary designers, would no longer design a given object in the same way. Buyers would no longer identify with it and, consequently, would no longer buy it.

By this logic, we will always choose to live in a "good", contemporary design environment. But how many of us can bring ourselves to discard a family heirloom to which so many memories, great and small, are attached? What other product – however well designed it may be – could replace those small, personal recollections or the dents and scratches that bear witness to an object's rich and varied history? Who among us would value objects that changed the world, or that were associated with people who changed the world, solely in terms of their present usefulness? Design objects embody history and stories – the great adventures but also the modest, quiet, personal ones.

Although we live in a world in which design objects from every possible era coexist, we do not normally have any problem dealing with this. We take them for granted and create special places such as museums or symbolic locations to house them. Both museums and the everyday built environments, such as the towns and cities in which we live, are a store of temporal memory against which the present day must measure itself and to whom the planners of the future must answer. Design, be it old or new, creates identity and, here too, has an emotional value.

As a consequence of this, designers are optimists keen to improve the world. They constantly strive to create something that has new qualities or fills a gap. Aware that almost everything already exists in multiple forms, they must identify the changed parameters and the resulting deficits, and fill them with new contents and forms. They operate in an environment where past, present and future meet. They must not allow this to hold them back, for it is the yardstick against which, ultimately, they are measured. At the moment when a product – or even simply an idea – and its entire history is placed, considered and interpreted in a new context, a new process comes into being and past ideas find their echo in those of the present day.

### Good Design

"For example at the beginning of the 19th century, if you grow up in a country that is not very rich, winter is really winter for you so it is very cold, so you need a thick coat on you, then this is life, this is a real coat for you, this is not for fashion. The coat is so beautiful because you feel so cold and then you cannot survive without this coat, for example. It becomes like your friend or your family."
(Yohji Yamamoto in the Wim Wenders film "Notebook on Cities and Clothes")

Good design must always be understood as part of a system involving a wide variety of relationships. Yet today, in a globalized world, this "family" of objects and design approaches is very multifaceted, and hybrid. Furthermore, it is clear that criteria of quality cannot be universally defined. The task of establishing what is good must be taken up anew in every culture and time period. Simultaneously, however, continuity, interconnection and relationships naturally exist. So the result is a network of differences and similarities that talk about design and about the world. We understand it as a kind of large family gathering. It's an intercultural exchange that, in combination with local knowledge, constantly gives rise to new things.

And what are the issues that move both local and global society today? The idea of "good design" no longer stands merely for the "good form" of a functional object in the way it did in the 1950s. The concept has become much more complex and comprises many other aspects.

In an increasingly globalized society where design is being constantly homogenized and reproduced, there is a growing desire for things that are unique and unmistakeable: one-offs, ideally from regional production, are becoming increasingly valued and ever more exclusive. Found footage – creating something new from existing objects – is becoming a leitmotif for designers. Good design is not short-lived – it "lasts" for a long time, in two respects: first through its production quality, and second through its lasting value as design.

Intelligent production methods that minimize the use of resources encourage the idea of small series or hand-made production. It is not considered right for "beautifu" things to travel three times round the world before they are finished; instead, they are expected to promote the place where they are produced and exploit its potential for innovation. Even locally produced design gains international recognition, because it "speaks" the language of cultural competence.

The question of quality in design and the meaning which "good design" has in everyday life occupies the thoughts of all those who are involved in it. Rightly so, because the belief in the impact on day-to-day life is one of the strongest forces in design. Therefore a broad debate about concepts and aspects of what is "good" in design should be

*Found footage refers to a specific genre of – chiefly experimental – films created wholly or partly using material not shot by the filmmakers themselves. There are various ways in which the material is handled, put together, assimilated and reinterpreted.

welcomed wholeheartedly. Such a condition makes it possible for people to read into higher sensibilities and better understand the interrelationship between design, production and use.

Another question is how good design can be made accessible to others. "Good design" need not necessarily be expensive or luxurious. It depends entirely on being creative with our current means – possessing the skill to see things and to use this quality to bring about transformation. We believe that recycling is a key element of "good design". We should analyse what is already around us – reuse, alter and appropriate to achieve an improved design. There is a lot more emphasis on self-creation now, rather than dependence on mass production. Designers are focusing less on "perfect design" and are exploring the aspect of self-making to create unique pieces. Social participation is a major aim of good design.

But good design also does something completely different: it creates an emotional bond between subject and object. This bond enables us to perceive good design in an entirely different way, in terms of uniqueness. Objects invariably also become bearers of history – not just the history of their own creation, but also the history of their owners, as Yohji Yamamoto's example describes. Things are brought together with people: they do not simply belong to them, but are also part of them.

It is this that makes things unique, irreplaceable and, in this sense, lasting.

Good design pleases the eyes, the body, the heart and stimulates the brain. It is fun and makes one happy!

**Our "Good Guys"**

"There is nothing more powerful than an idea whose time has come."
(Victor Hugo)

"Good design" needs good designers. The ways in which our "good guys" engage with issues such as sustainability, recycling, fair trade and social responsibility are as many and diverse as the people behind them. There are those who reinterpret old-established crafts or use new techniques to work with traditional products. Others convert mass-produced goods into valuable one-offs – or, conversely, use innovative materials to create mass-produced products. Our show contains both prototypes and utilitarian items, as well as pieces that have artistic aspirations. What distinguishes all our designers is that every day, through their work, they address our world anew, reflect on it and inject new ideas, thereby helping to shape the world of tomorrow.

The exhibition "Good Guys" is an invitation for visitors to discover for themselves these creative solutions and the people behind them; to experience and sense the results of their deliberations, reflections and engagements; to smell them, taste them, touch and see them.

"Good Guys" is an aesthetic tour guided by a purely sensual stagecraft. We have deliberately refrained from dividing the objects up by origin, type, topic or category; new and unfamiliar names rub shoulders with established design personalities. For us, design is first and foremost an attitude – one that all our "Good Guys" possess.

The museum thus becomes a neutral space for presenting the works, a framework for a meandering, dragon-shaped installation, an organic structure built out of 200,000 chopsticks winding its way through the room, rising gently upwards only to fall back again and open up the space to the eye. This installation divides the space into flexible areas that merge seamlessly into each other, inviting the visitor to explore and discover. The exhibits are distributed in and around the structure, seemingly at random yet linked together in terms of content and space; some of them can be touched, tapped, sniffed, heard or simply admired. The walls, too, are involved. Adorned with texts, photographs, graphics and textile design, they form the backdrop to the presentation, a kind of panorama behind the space-consuming chopstick installation.

Right at the start of the exhibition hangs a knitting clock. It is a quite remarkable timepiece. Every half an hour it knits a single mesh: a symbol of time, of brief periods and timelessness that can have entirely different meanings for different design objects, contexts and genres. In the exhibits that follow, for example – illustrations of various Chinese constructions – time has a very particular meaning, inasmuch as architectural works shape their environment far into the future. For that reason architecture as a way of creating and shaping the environment is a very central and important design discipline. The time periods are long, the trends come and go in slow procession, uses can change and the expectation in terms of longevity is high. The projects by Chinese artists that are on display are all distinguished by their sustainable use of the available materials, the location and the people and social structures involved.

Forming a counterpoint to architecture is another very popular category: fashion design. Here, the time periods are short, trends change rapidly.

Fashion from Chinese designer Zhang Da engages in a dialogue with pieces by the Swiss Fabienne Arrigoni, who says: "I want people to redevelop a feeling for the value of an item of clothing." The value of a piece of clothing is defined partly by the cost of fair manufacturing and the choice of high-quality materials, but also partly the relationship that its owner establishes with it: children love their bright clothes, with their limited number of cuts and large number of colours. Textile design, too, is more than just fashion. We show, for example, a work by Claudia Caviezel, an innovative Swiss textile designer who has worked with figures such as the fashion designer Vivienne Westwood and the Swiss textile producer Jakob Schlaepfer. Claudia Caviezel has designed a wall paper especially for BIDT that introduces us to a highly aesthetic world of forms and colours and on which there are countless stories to discover. A wall paper like this is the exact opposite of mass production: it is lovingly produced to order by a local manufacturer and is unique –

and remains in use for years. Right at the entrance to the exhibition we see yet another way of dealing with textiles: the work of Jan Kath, a prime example of how existing products can be understood anew. Kath takes classical Oriental carpets and reinterprets them by removing the existing dyes and replacing them with contemporary colours. Even once he has done so, however, the old pattern still shimmers through as a reminder of the past. The pieces are presented in a manner reminiscent of Oriental carpet bazaars: piled up and partially spread out.

Right next to Jan Kath is another type of design: engineering design. This discipline deals primarily with new technologies and materials, and is demonstrated here in the work of Fabian Müller. Müller has built a mobile power plant that can be transported easily on a bicycle and that anyone can use to produce their own electricity. The plant operates using solar power and stores the energy it generates in high-performance batteries, so everyone can take responsibility for their own power supply: power production is democratized. For another type of engineering design we turn to Markus Bangerter, whose work straddles the boundary between product design and engineering design. He has developed a process that uses heat to harden textile fibres so that they can even be used to make chairs. Finding ways to exploit new materials and substances is a key component of efforts to find an alternative approach to using our raw materials – so engineering design is making a vital contribution to our futures.

Developing new technologies is one way of addressing the issue of sustainability; another is processing "old" materials. The young Dutch designer Klaas Kuiken, for example, recycles old glass bottles, using blowing techniques to transform them into unique vases whose exceptional forms are immediately captivating: the mass product becomes a valuable one-off. Meanwhile Tina Roeder, a young product designer from Berlin, takes discarded consumer goods and gives them a new lease of life. She spent more than seven years collecting white, plastic monobloc chairs. Then, by means of perforations and surface treatment, she created one-off items as part of a limited series. Marti Guixe, by contrast, plays with the value of a product: his "Plant me pets" – cute little creatures made of plastic with seeds for eyes – are a mass product that nevertheless aims to create an emotional bond. Their owners must choose between emotion and function, because the pets are useless until they are embedded in the soil, at which point a food plant grows. It's a wonderful symbol of the dilemma that consumers so often face.

A particularly important design category is visual communication: important because of the enormous influence it has on the way we perceive the world. To accompany the opening of a reference shop for Freitag – the firm produces bags made from old truck tarpaulins that can also be seen in the exhibition – the agency Raffinerie created a newsroom in which newspapers were produced for Freitag on an old printing machine. It thus takes a traditional technique and decontextualizes it to create a new visual language that has an exclusivity all of its own. Ata Bozaci practises another form of reinterpretation: his sculpture "MLS black" moves graffiti off the wall and into the room, adding a new dimension to the typographical. The duo Joerger-Stauss – one a photographer, the other a designer – likewise play with the spatial and the haptic: they bring the third dimension back into the second, as it were, by experimenting in space until they have precisely captured the materiality, then photographing everything and, in so doing, transferring it back onto paper.

However different the examples may be, all of them show that "good guys" are designers who act as seismographers of social and political developments, engaged in a constant process of dialogue with their situation and with the circumstances of the world around them. They are real experts in reacting to changes, learning from the past, reflecting on the present and developing visions for the future. They see themselves as responsible for shaping our world aesthetically, emotionally and socially – and are willing to take the risk of being provocative and clashing with existing structures.

Design is an attitude: an attitude that is global. It unites designers, producers and consumers as co-producers, visitors and consumers, cutting right across sectors, cultures, nations and age groups. It is a language – one might almost say an idiom – that enables an ongoing cultural exchange on what differentiates and what constitutes.

Design as lifestyle, in the way Philippe Starck describes it, requires a far more considered view of the world than the advertising of the lifestyle industry suggests. Even as the luxury goods industry tries to reduce us to egomaniacal fashion victims, we must refocus attention on the "style of life".

From our dual perspective as curators and designers, we call first and foremost for an intelligent and respectful approach to dealing with the world and its human and natural resources. That includes both innovation and an enthusiastic, creative engagement with distinctive cultural and historical features, which are of growing importance in our globalized world. Throughout that process, our sole concern must be to ensure that every one of us is a winner.

大气球，2004
Topotek1设计工作室（马丁·雷卡农&洛伦茨·德克斯勒）(阿根廷/德国)
塑料
© Photo: Hanns Joosten

**Inflatable ball**, 2004
Topotek 1(Martin Rein-Cano & Lorenz Dexler)
(Argentinia/Germany)
Plastic
© Photo: Hanns Joosten

围巾，2010/2011
Ikou Tschüss设计工作室／古雅·玛尔尼，卡门·德·阿波罗尼奥（瑞士）
丝绸，包装绳
© Photo: Ikou Tschüss/Urs Fischer

**Scarf**, 2010/2011
Ikou Tschüss / Guya Marini & Carmen D'Apollonio (Switzerland)
Silk, packet string
© Photo: Ikou Tschüss/Urs Fischer

**3 雕塑**, 2011
亚塔·博萨奇（瑞士）
黑色中密度纤维板
© Photo: Ata Bozaci / Romy Rodiek

**3 sculptures**, 2011
**Ata Bozaci** (Switzerland)
**Black MDF**
© Photo: Ata Bozaci / Romy Rodiek

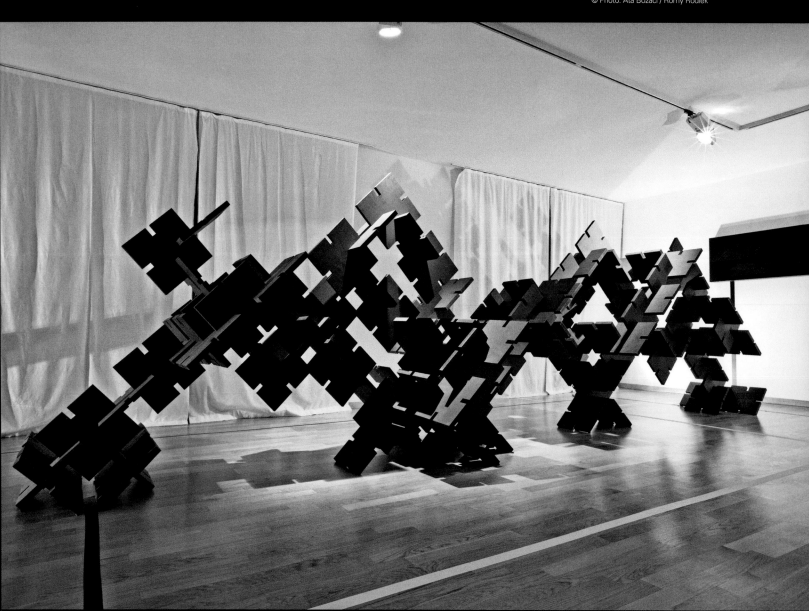

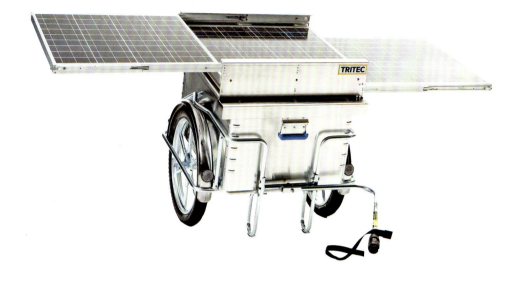

太阳能拖车，2009
法比安·穆勒(瑞士)
钢，铝，太阳能电池板
© Photo: Fabian Mueller

**Bicycle trailer**, 2009
Fabian Mueller (Switzerland)
Steel, aluminium, solar panels
© Photo: Fabian Mueller

电动自行车，2009
法比安·穆勒(瑞士)
钢，铝，太阳能电池板
© Fabian Mueller/Nomatark Photo: Mathias Stich

**Electric bicycle**, 2009
Fabian Mueller (Switzerland)
Steel, aluminium, solar panels
© Fabian Mueller/Nomatark Photo: Mathias Stich

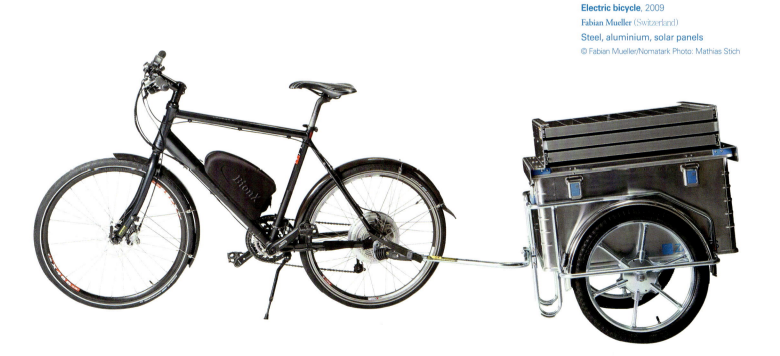

我在生活中学到的东西，2008
施德明（奥地利/美国）
印制在棉布上
© Photo: Sagmeister Inc.

**Things I have learned in my life so far**, 2008
Stefan Sagmeister (Austria/USA)
Print on cotton
© Photo: Sagmeister Inc.

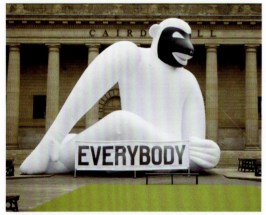

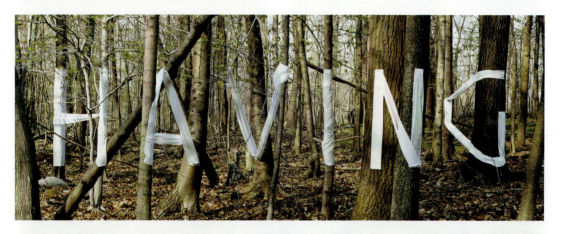
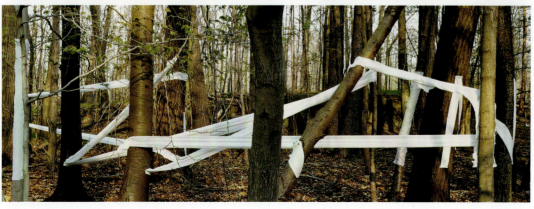

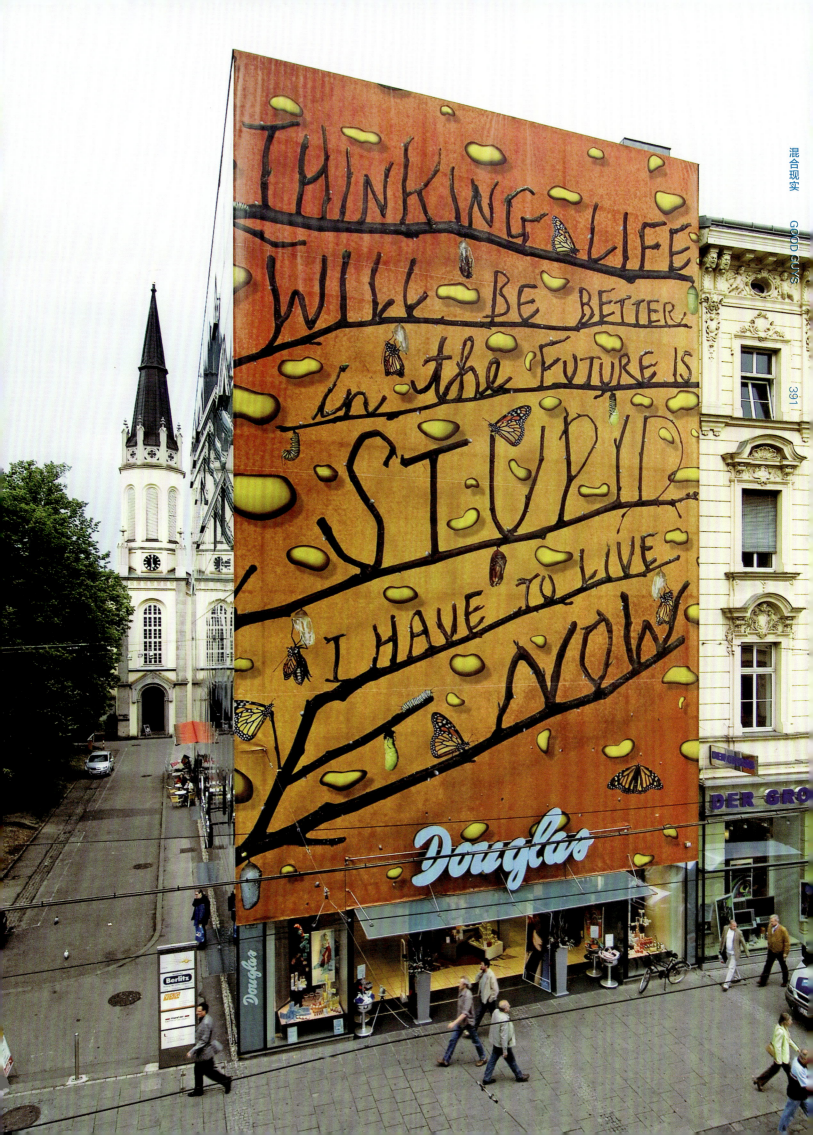

漂洗过的地毯，2010
扬·凯斯(德国)
羊毛
© Photo: Dimo Feldmann

**Pimp my rug**, 2010
Jan Kath (Germany)
Wool
© Photo: Dimo Feldmann

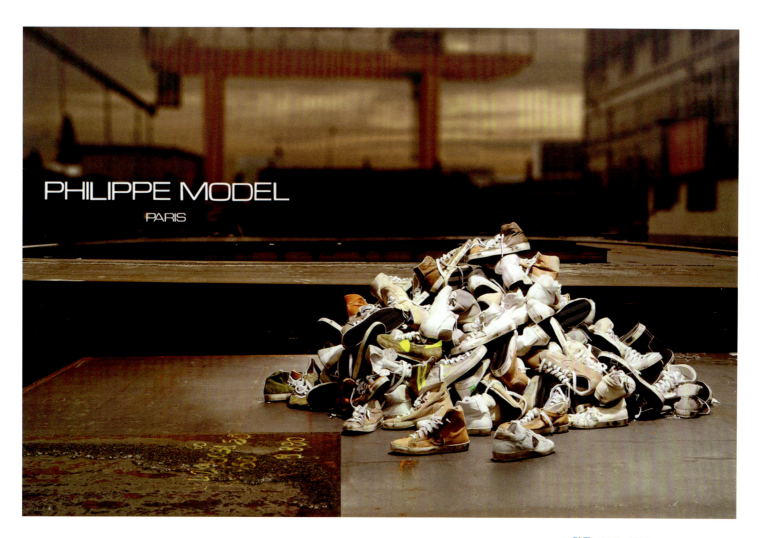

鞋子，2010—2011
菲利普·莫德尔（法国）
皮革，橡胶
© Photo: Paolo Gambato

**Shoes**, 2010–2011
Philippe Model (France)
Leather, rubber
© Photo: Paolo Gambato

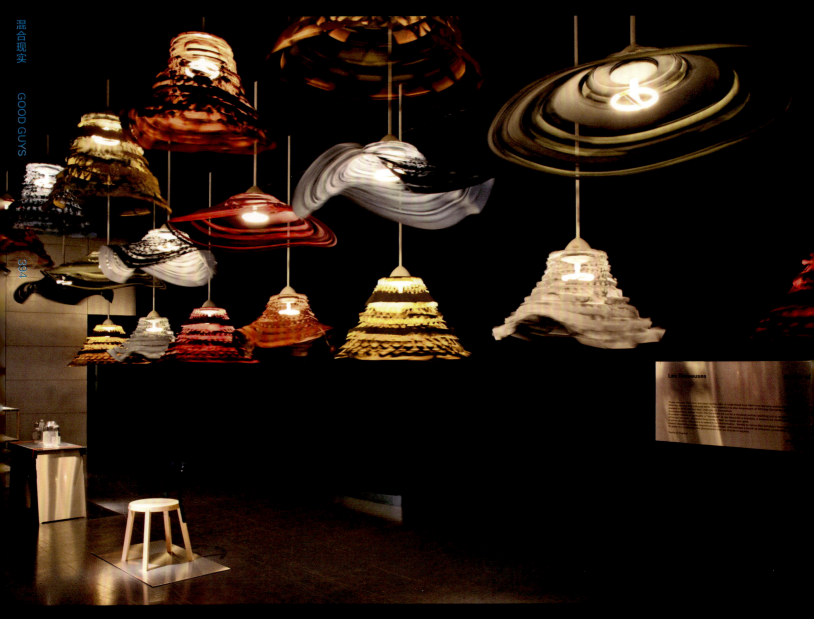

舞者,2010
油彩工作室(瑞士)
纺织品
© Photo: Atelier Oï

**Les danseuses**, 2010
Atelier Oï (Switzerland)
Textile
© Photo: Atelier Oï

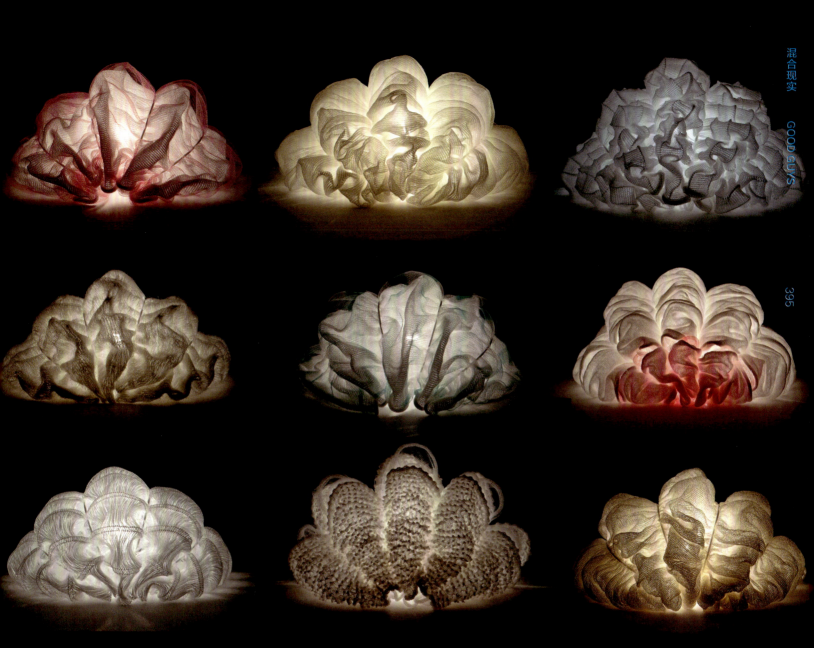

柔光，2010—2011
Luxluxlux设计工作室(瑞士/德国)
尼龙，金属丝，棉布
© Photo: Dunja Weber, Cecile Feilchenfeldt, Ezio Manciucca, Eliane Rutishauser

**Softlux**, 2010–2011
Luxluxlux (Switzerland/Germany)
Nylon, wire, cotton
© Photo: Dunja Weber, Cecile Feilchenfeldt, Ezio Manciucca, Eliane Rutishauser

聚丙烯座椅，2010
马库斯·班戈特（瑞士）
聚丙烯，热塑性塑料绳
© Photo: Magazin/Holger Wens

**Polyfine**, 2010
**Markus Bangerter** (Switzerland)
Polypropylene, thermoplastic string
© Photo: Magazin/Holger Wens

印刷报纸，2010
Raffinerie设计工作室（瑞士）
纸
© Photo: Raffinerie AG für Gestaltung

**Printed sheet newspaper**, 2010
Raffinerie (Switzerland)
Paper
© Photo: Raffinerie AG für Gestaltung

筷子歌，2011
莫里茨·加格恩（德国）
声音装置，无限循环
© Photo: René Löffler

**Chop suite**, 2011
**Moritz Gagern** (Germany)
Sound installation, infinite loop
© Photo: René Löffler

墙纸，2011
克劳迪娅·卡维泽（瑞士）
纸
© Photo: Claudia Caviezel

**Wallpaper**, 2011
**Claudia Caviezel** (Switzerland)
Paper
© Photo: Claudia Caviezel

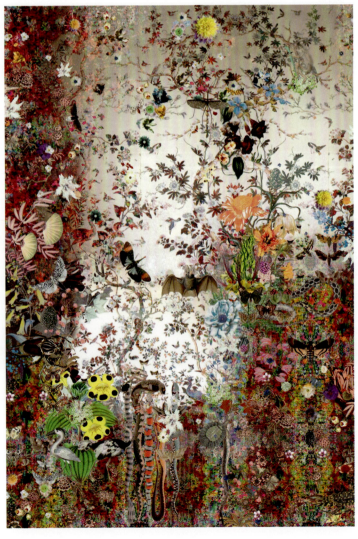

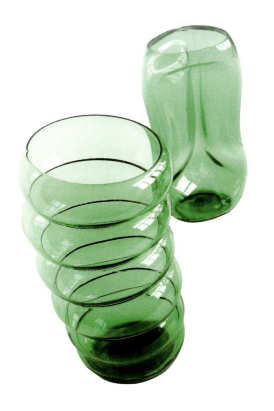
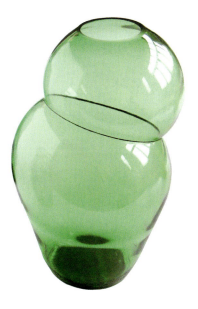

花瓶，瓶子，2010
克拉斯·库肯（瑞士）
玻璃
© Photo: Klaas Kuiken

**Vases&bottles**, 2010
Klaas Kuiken (Switzerland)
Glass
© Photo: Klaas Kuiken

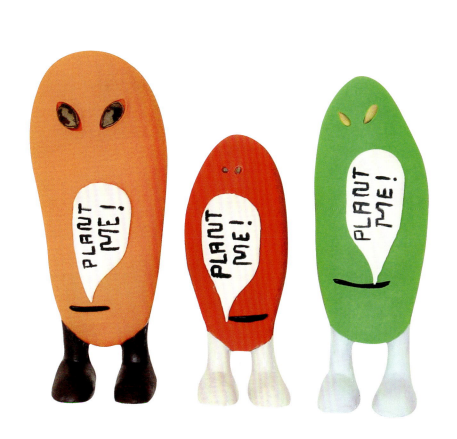

可种植的小宠物，2004
马蒂·古伊斯（西班牙）
塑料
© Photo: Imagecontainer/Knölke

**Plant me pets**, 2004
Marti Guixe (Spain)
Plastic
© Photo: Imagecontainer/Knölke

硬纸板服装，2009
萨拉·维达斯（瑞士）
木板喷绘
© Photo: Oliver Rust Photography

**Outfit cardboard cut-out**, 2009
Sara Vidas (Switzerland)
Print on wood
© Photo: Oliver Rust Photography

投弹手衬衣，2011
Junky时装工作室（英国）
纺织品
© Photo: Armando

**Bomber shirt**, 2011
Junky Styling (UK)
Textile
© Photo: Armando

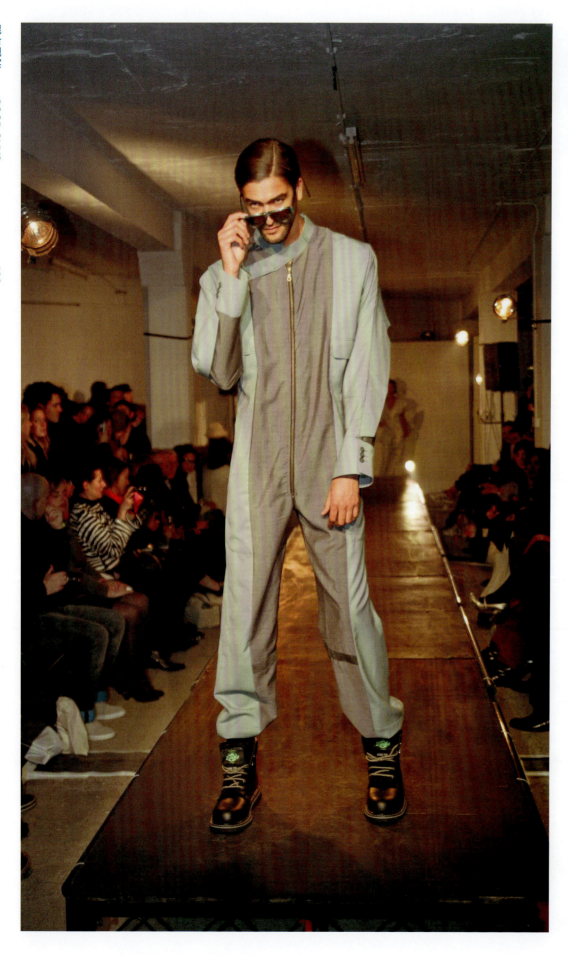

飞行套装，2011
Junky时装工作室（英国）
纺织品
© Photo: Ben James

**Flightsuit**, 2011
Junky Styling (UK)
Textile
© Photo: Ben James

儿童牛仔裤，2011
法比尼·埃瑞格尼（瑞士）
棉布
© Photo: Christoph Eser

**Kidjeans**, 2011
**Fabienne Arrigoni** (Switzerland)
Cotton
© Photo: Christoph Eser

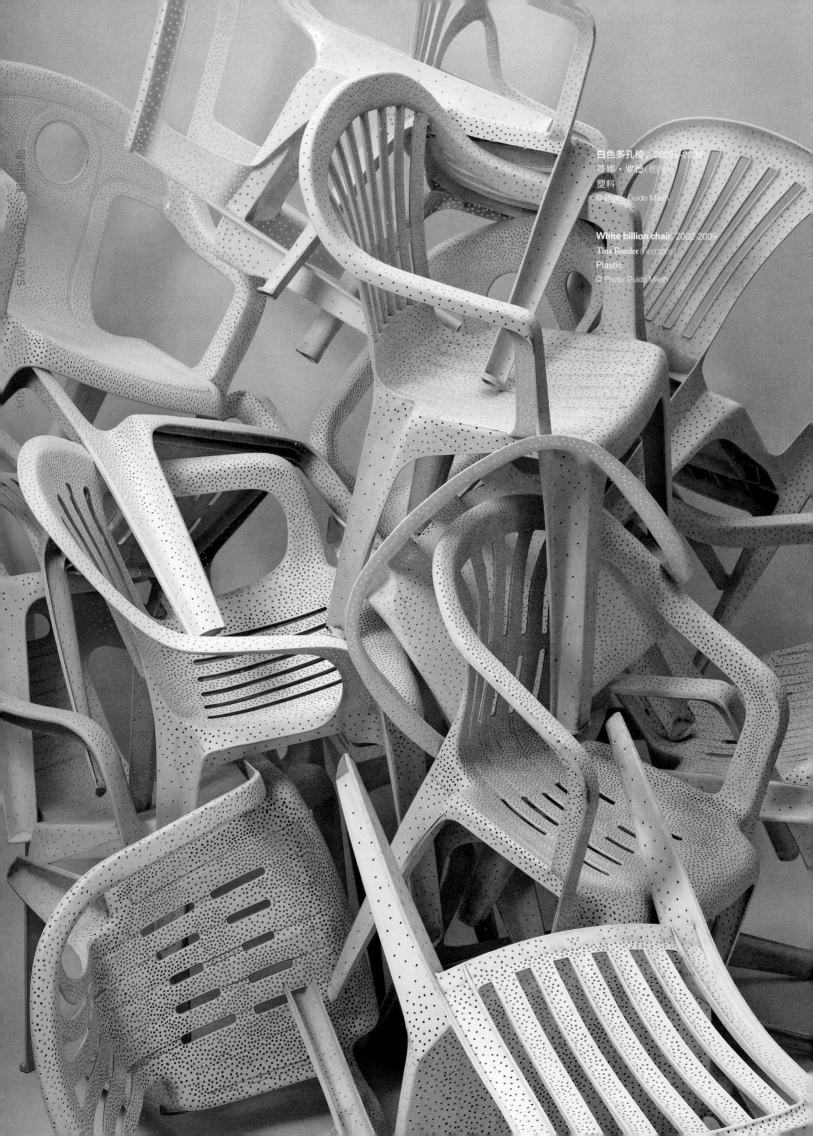

白色多孔椅，2002—2009
蒂娜·罗德(德国)
塑料
© Photo: Guido Mieth

**White billion chair** 2002-2009
Tina Roeder (Germany)
Plastic
© Photo: Guido Mieth

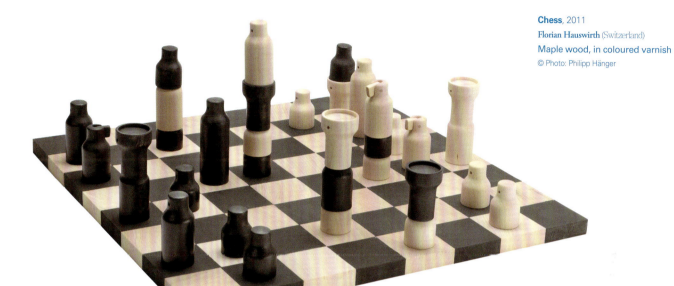

国际象棋，2011
弗洛连·豪斯维斯（瑞士）
枫木，彩色亮光漆
© Photo: Philipp Hänger

**Chess**, 2011
Florian Hauswirth (Switzerland)
Maple wood, in coloured varnish
© Photo: Philipp Hänger

托克托克，2010
马丁·布拉莫（德国）
木材，电子仪器
© Photo: Markus Bangerter

**Toktok**, 2010
Martin Bramer (Germany)
Wood, electronic device
© Photo: Markus Bangerter

**R105 多色仿蛇纹包**,2011
弗莱塔格工作室(瑞士)
卡车防水布
© Photo: Freitag/Bruno Alder

**R105 multcolor fakesnake**, 2011
Freitag (Switzerland)
Truck tarpaulin
© Photo: Freitag/Bruno Alder

**R108 米色摩根森包**,2011
弗莱塔格工作室(瑞士)
卡车防水布
© Photo: Freitag/Bruno Alder

**R108 Morgenson**, 2011
Freitag (Switzerland)
Truck tarpaulin
© Photo: Freitag/Bruno Alder

**R506 浅蓝绿色Hutchins包**，2011
弗莱塔格工作室（瑞士）
卡车防水布
© Photo: Freitag/Bruno Alder

**R506 Hutchins babyblue**, 2011
Freitag (Switzerland)
Truck tarpaulin
© Photo: Freitag/Bruno Alder

**R507 湖蓝色雷蒙德包**，2011
弗莱塔格工作室（瑞士）
卡车防水布
© Photo: Freitag/Bruno Alder

**R507 Raymond navyblue**, 2011
Freitag (Switzerland)
Truck tarpaulin
© Photo: Freitag/Bruno Alder

**R508 灰色Bonnier包**，2011
弗莱塔格工作室（瑞士）
卡车防水布
© Photo: Freitag/Bruno Alder

**R508 Bonnier grey**, 2011
Freitag (Switzerland)
Truck tarpaulin
© Photo: Freitag/Bruno Alder

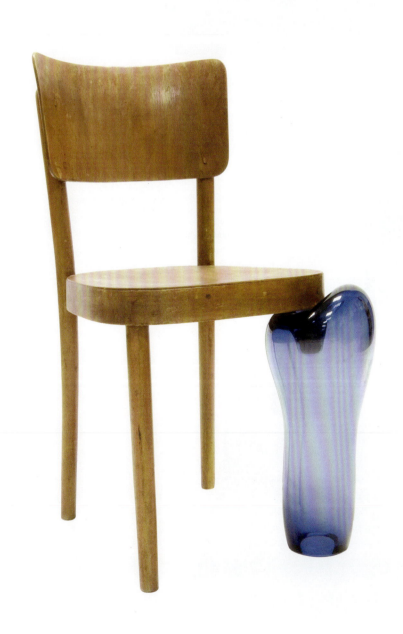

"灰姑娘"的椅子，2010
安娜·特哈尔（荷兰）
木，玻璃
© Photo: Studio Anna Ter Haar

**Cinderella's Chair**, 2010
**Anna Ter Haar** (Netherlands)
Wood, glass
© Photo: Studio Anna Ter Haar

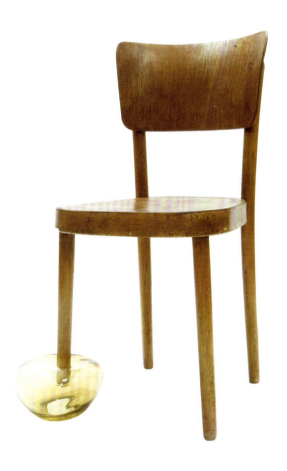

"灰姑娘"的椅子，2010
安娜·特哈尔(荷兰)
木，玻璃
© Photo: Studio Anna Ter Haar

**Cinderella's Chair**, 2010
**Anna Ter Haar** (Netherlands)
Wood, glass
© Photo: Studio Anna Ter Haar

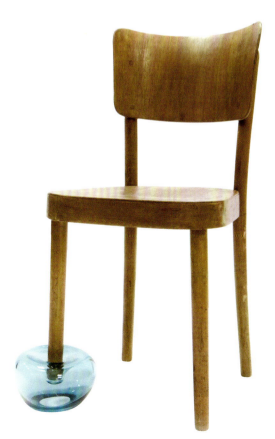

"灰姑娘"的椅子，2010
安娜·特哈尔(荷兰)
木，玻璃
© Photo: Studio Anna Ter Haar

**Cinderella's Chair**, 2010
**Anna Ter Haar** (Netherlands)
Wood, glass
© Photo: Studio Anna Ter Haar

麻布椅，2010
艾斯林格工作室（德国）
大麻纤维，树脂黏合剂
© Photo: Michel Bonvin for BASF & studio aisslinger

**Hemp chair**, 2010
**Studio Aisslinger** (Germany)
Hemp, acrodur
© Photo: Michel Bonvin for BASF & studio aisslinger

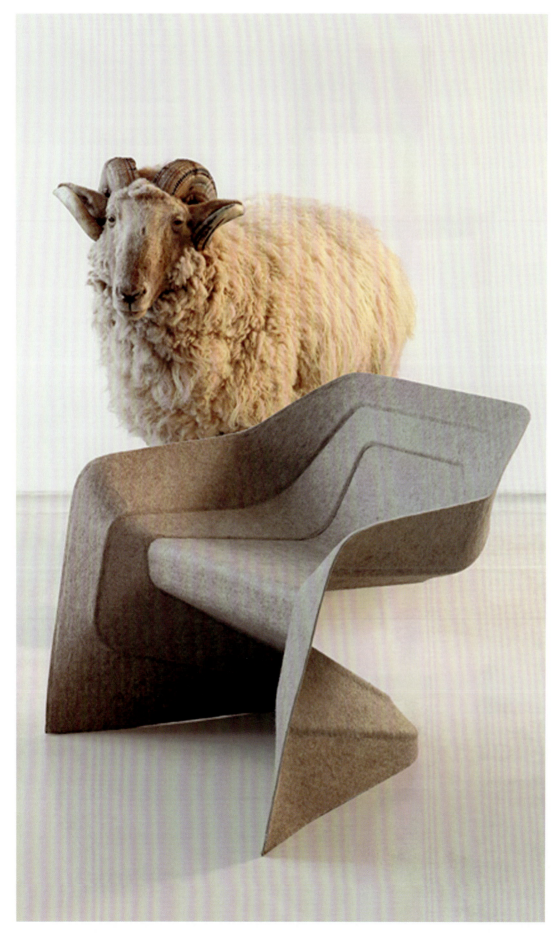

马特灯，2008
LLOT LLOV 艺术品商店（德国）
羊毛，电线，插座
© Photo: Llot Llov / Nicol®Æ Lanfranchi

**Matt**, 2008
LLOT LLOV artwork shop (Germany)
Wool, electric cord, socket
© Photo: Llot Llov / Nicol®Æ Lanfranchi

混合现实

GOOD GUYS

412

海报/明信片，2007/2009
约格·斯特劳斯工作室（瑞士/德国）
纸
© Photo: Susanne Stauss

**Poster/postcard**, 2007/2009
Joerger-Stauss (Switzerland/Germany)
Paper
© Photo: Susanne Stauss

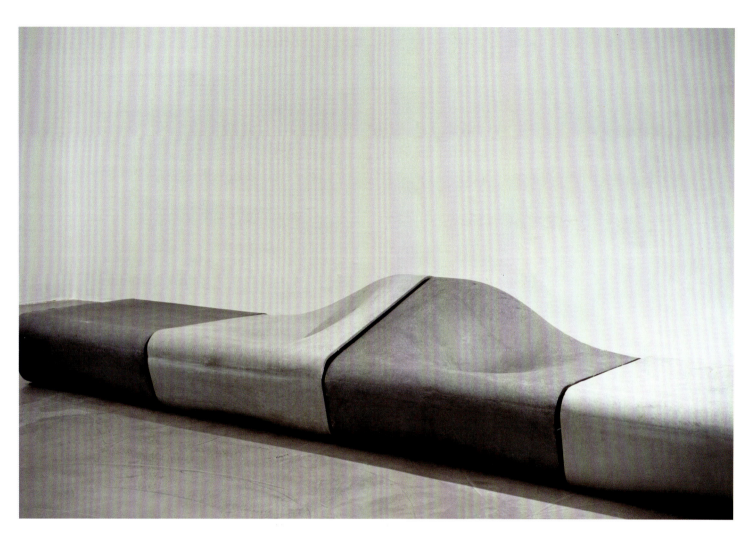

沙丘,2010
雷纳·穆奇(奥地利)
石棉水泥
© Photo: Raimund Appel

**Dune**, 2010
**Rainer Musch** (Austria)
Cement asbestos
© Photo: Raimund Appel

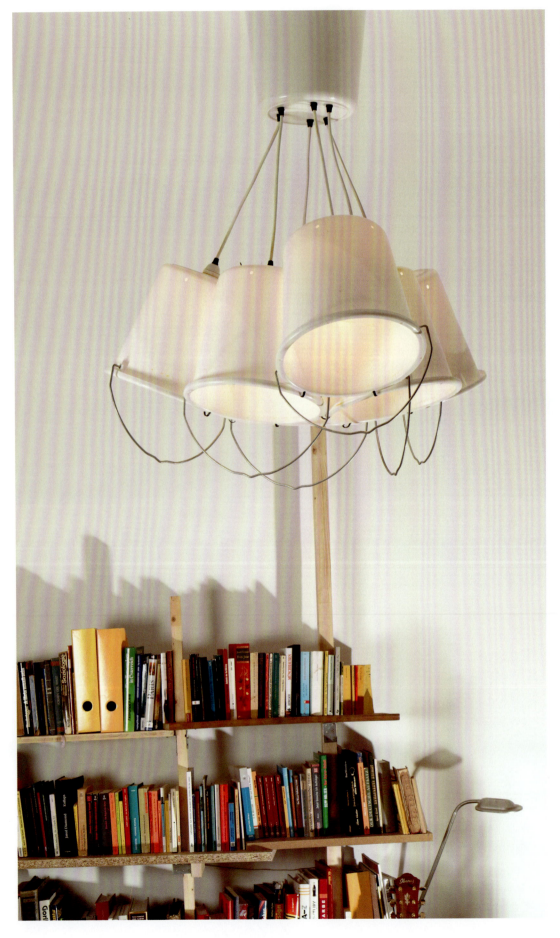

**Samsa塑料桶吊灯**，2010
Breaded Escalope工作室(奥地利)
塑料桶，线夹，灯泡，电线
© Photo: Breaded Escalope

**Samsa bucket chandelier**, 2010
**Breaded Escalope** (Austria)
Plastic buckets, cable clip, light bulb, electric cord
© Photo: Breaded Escalope

**Samsa**塑料桶储物架，2010
Breaded Escalope工作室(奥地利)
塑料桶，线夹
© Photo: Breaded Escalope

**Samsa bucket shelf**, 2010
Breaded Escalope (Austria)
Plastic buckets, cable clip
© Photo: Breaded Escalope

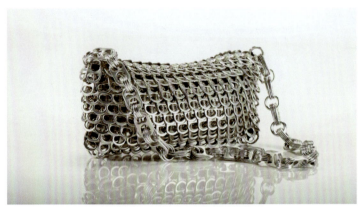

阿米莉亚包，2011
Escama工作室(美国)
铝制拉环，针织品
© Photo: Escama Studio/Deborah Ellen Jutz

**Amelia**, 2011
Escama (USA)
Aluminium pull tabs, crochet work
© Photo: Escama Studio/Deborah Ellen Jutz

雷尼达包，2011
Escama工作室(美国)
铝制拉环，针织品
© Photo: Escama Studio/Deborah Ellen Jutz

**Lenilda**, 2011
Escama (USA)
Aluminium pull tabs, crochet work
© Photo: Escama Studio/Deborah Ellen Jutz

丽达包，2011
Escama工作室(美国)
铝制拉环，针织品
© Photo: Escama Studio/Deborah Ellen Jutz

**Leda**, 2011
Escama (USA)
Aluminium pull tabs, crochet work
© Photo: Escama Studio/Deborah Ellen Jutz

普夫包，2011
Escama工作室(美国)
铝制拉环，针织品
© Photo: Escama Studio/Deborah Ellen Jutz

**Puff**, 2011
Escama (USA)
Aluminium pull tabs, crochet work
© Photo: Escama Studio/Deborah Ellen Jutz

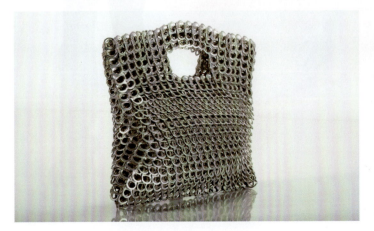
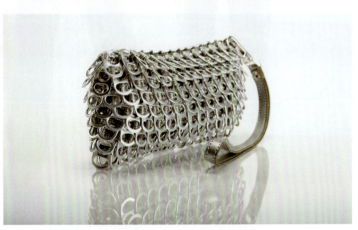

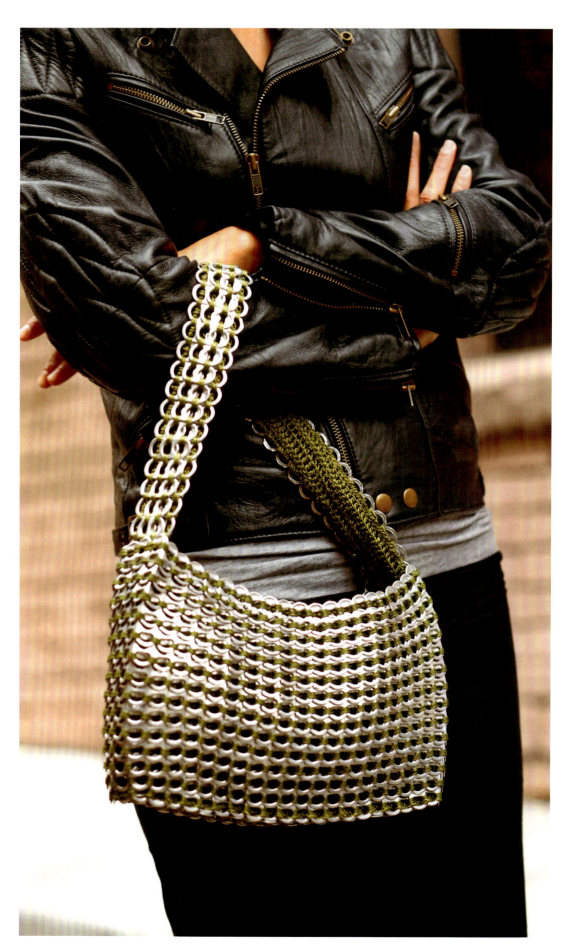

银色索科鲁包，2011
Escama工作室（美国）
铝制拉环，针织品
© Photo: Escama Studio/Deborah Ellen Jutz

**Socorro Silver**, 2011
Escama (USA)
Aluminium pull tabs, crochet work
© Photo: Escama Studio/Deborah Ellen Jutz

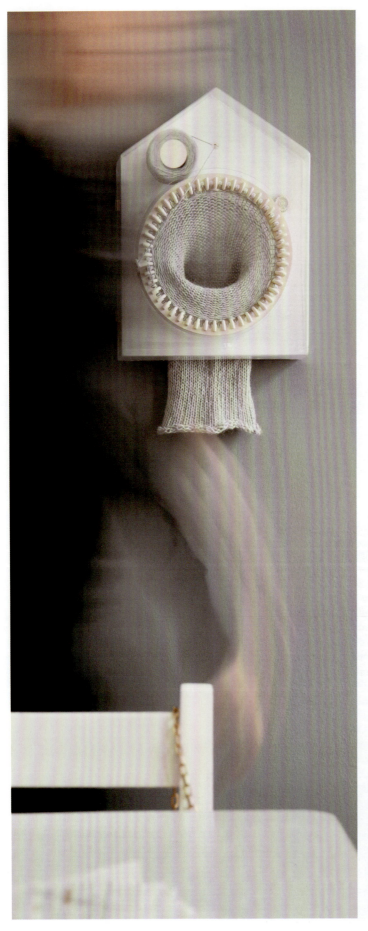

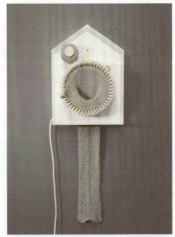

**365天针织时钟**，2010
塞壬·爱丽丝·威尔森（挪威）
塑料，机械钟表，纱线
© Photo: Mirian Lenhart

**365 knitting clock**, 2010
Siren Elise Willhelmsen (Norway)
Plastic, clockwork, yarn
© Photo: Mirian Lenhart

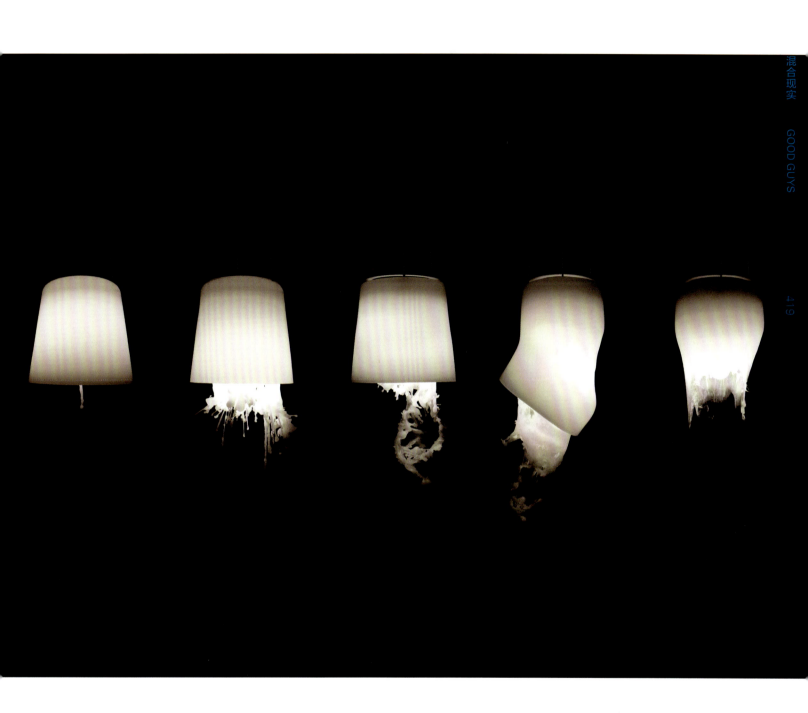

伊卡鲁斯，2007
艾琳·凯瑟尔，克里斯蒂安·梅茨纳
（德国）
蜡，不锈钢
© Photo: Christian Metzner

**Ikarus**, 2007
**Aylin Kayser & Christian Metzner** (Germany)
Wax, stainless steel
© Photo: Christian Metzner

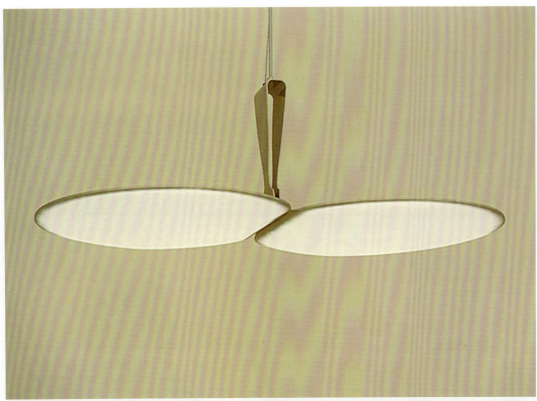

室内灯具，2010
蒋红斌(中国)
铝，塑料
© Photo: Jiang Hongbin

**Interior Lighting**, 2010
**Jiang Hongbin** (China)
Aluminum, Plastic
© Photo: Jiang Hongbin

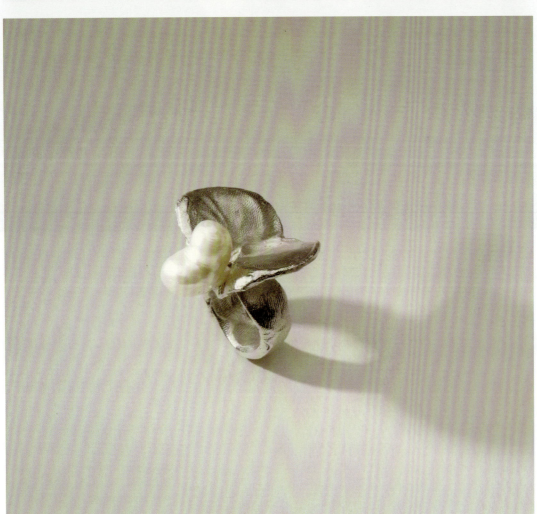

初潮，2009
滕菲(中国)
银，珍珠
© Photo: Teng Fei

**My First Period**, 2009
**Teng Fei** (China)
Silver & Pearls
© Photo: Teng Fei

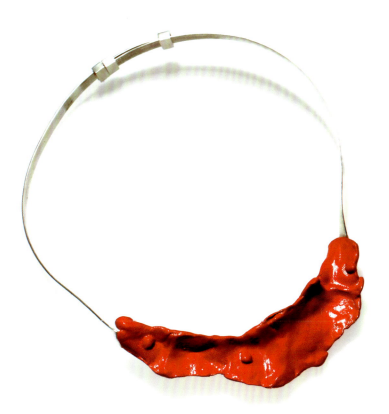

那个夏天，2007
滕菲(中国)
银，漆
© Photo: Teng Fei

**In That Summer**, 2007
**Teng Fei** (China)
Silver & Lacquer
© Photo: Teng Fei

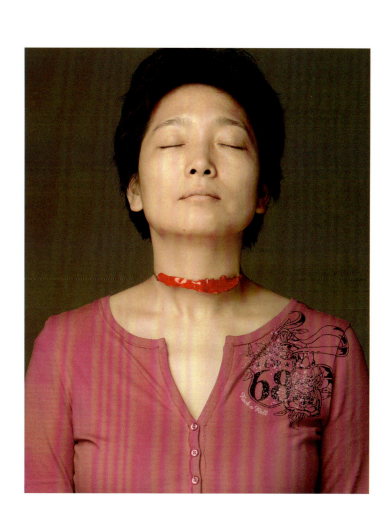

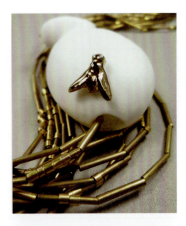

"飞行家", 2009
张小川(中国)
瓷,金,奥地利水晶,玻璃,925银
© Photo: Zhang Xiaochuan

**"Fly"**, 2009
Zhang Xiaochuan (China)
China, gold, Austrian crystals, glass, 925 silver
© Photo: Zhang Xiaochuan

"勺子"——项链, 2009
张小川(中国)
瓷,金,奥地利水晶,玻璃,925银
© Photo: Zhang Xiaochuan

**"Spoon"- necklace**, 2009
Zhang Xiaochuan (China)
China, gold, Austrian crystals, glass, 925 siver
© Photo: Zhang Xiaochuan

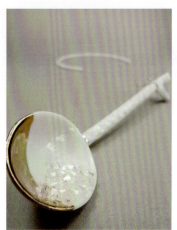

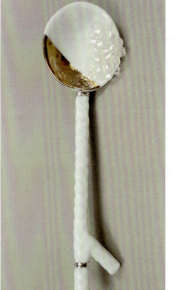

"勺子"——胸针, 2009
张小川(中国)
瓷,金,925银,奥地利水晶
© Photo: Zhang Xiaochuan

**"Spoon"- brooch**, 2009
Zhang Xiaochuan (China)
Porcelain, gold, 925 silver, Austria crystal
© Photo: Zhang Xiaochuan

"飞行家", 2009
张小川(中国)
瓷,金,奥地利水晶,玻璃,925银
© Photo: Zhang Xiaochuan

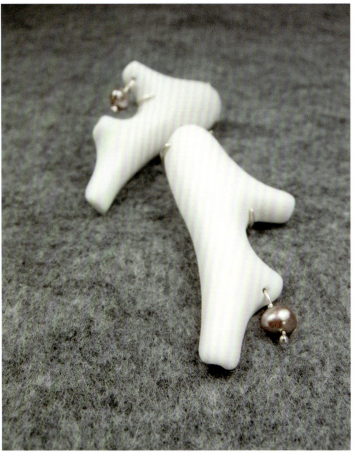

"白与珍珠"——耳环,2009
张小川(中国)
瓷,珍珠,925银
© Photo: Zhang Xiaochuan

**"White & Pearl"-earring**, 2009
Zhang Xiaochuan (China)
Porcelain, pearl, 925 silver
© Photo: Zhang Xiaochuan

"白与珍珠"——戒指,2009
张小川(中国)
瓷,聚乙烯
© Photo: Zhang Xiaochuan

**"White & Pearl"- ring**, 2009
Zhang Xiaochuan (China)
Porcelain, polyethylene
© Photo: Zhang Xiaochuan

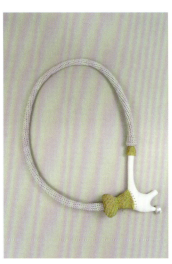 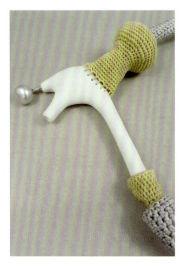 

"白与珍珠"——项链,2009
张小川(中国)
瓷,珍珠,锦纶线
© Photo: Zhang Xiaochuan

**"White & Pearl"-necklace**, 2009
Zhang Xiaochuan (China)
Porcelain, pearl, terylene
© Photo: Zhang Xiaochuan

《国家艺术·十二美人》，2010
陆智昌(中国)
纸
© Photo: Lu Zhichang

**12 Beauty**, 2010
Lu Zhichang (China)
Paper
© Photo: Lu Zhichang

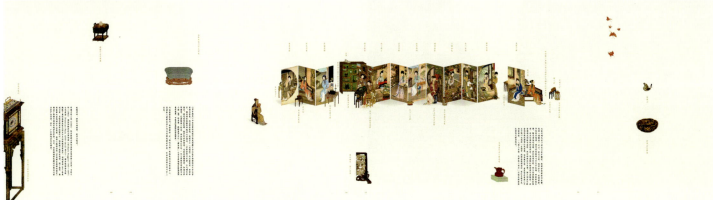
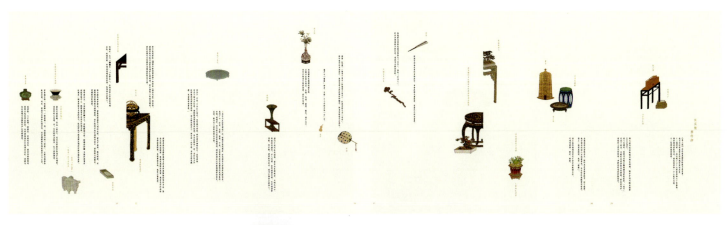
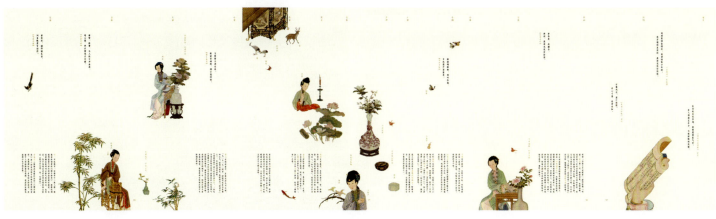

北京跑酷，2009
陆智昌（中国）
纸，塑料（盒）
© Photo: Lu Zhichang

**Beijing Parkour**, 2009
Lu Zhichang (China)
Paper, plastic (case)
© Photo: Lu Zhichang

《大紫禁城——王者的轴线》，2008
陆智昌(中国)
纸，塑料（盒）
© Photo: Lu Zhichang

**The Grand Forbidden City-The Imperial Axis**, 2008
Lu Zhichang (China)
Paper, plastic (case)
© Photo: Lu Zhichang

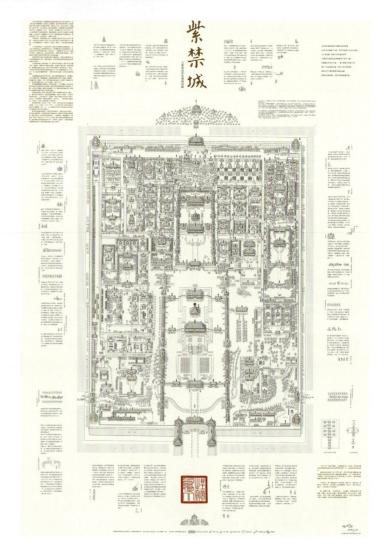

《紫禁城情调大地图》，2009
陆智昌(中国)
纸，塑料（盒）
© Photo: Lu Zhichang

**The Map of the Grand Forbidden City**, 2009
Lu Zhichang (China)
Paper, plastic (case)
© Photo: Lu Zhichang

服装，2011
张达 (中国)
拉链，棉布
© Photo: Zhang Da

**Clothing**, 2011
**Zhang Da** (China)
Zipper, cotton
© Photo: Zhang Da

**《漫游：建筑体验与文学想象》**, 2009
小马哥，橙子（中国）
纸
© Photo: Xiao Mage, Cheng Zi

**Odyssey: Architecture & Literature**, 2009
Xiao Mage, Cheng Zi (China)
Paper
© Photo: Xiao Mage, Cheng Zi

《物质／非物质》，2007
小马哥，橙子 (中国)
纸

© Photo: Xiao Mage, Cheng Zi

**Everything Material, Something Immaterial**, 2007
Xiao Mage, Cheng Zi (China)
Paper

© Photo: Xiao Mage, Cheng Zi

Seven Intellectuals
In Bamboo Forest
2003 Part 1

29 Mins.

Director: Yang Fudong
Music: Jin Wang
Design: Jianping He

Seven Intellectuals
In Bamboo Forest
2004 Part 2

35mm B&W Film 46 Mins
Yang Fudong (Director)
Jianping He (Design)

康戴里，2006
何见平(中国)
纸，塑料（盒）
© Photo: He Jianping

**Antalis**, 2006
He Jianping (China)
Paper, plastic (case)
© Photo: He Jianping

竹林七贤，2006
何见平(中国)
纸
© Photo: He Jianping

**Seven Intellectuals in Bamboo Forest**, 2006
He Jianping (China)
Paper
© Photo: He Jianping

他死了——本·拉登，2011
冯峰，卢麃麃(中国)
报纸
© Photo: Feng Feng, Lu Biaobiao

**He died--Osama Bin Laden**, 2011
Feng Feng, Lu Biaobiao (China)
Newspapers
© Photo: Feng Feng, Lu Biaobiao

他死了——迈克尔·杰克逊，2009
冯峰，卢麃麃(中国)
报纸
© Photo: Feng Feng, Lu Biaobiao

**He died--Michael Jackson**, 2009
Feng Feng, Lu Biaobiao (China)
Newspapers
© Photo: Feng Feng, Lu Biaobiao

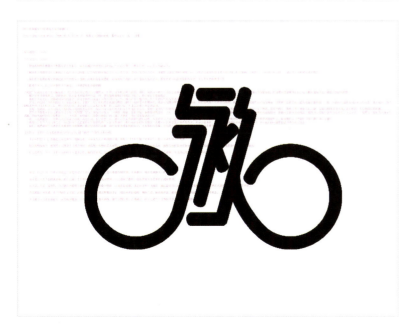

反印刷，2008
蒋华(中国)
纸
© Photo: Jiang Hua

**Anti-typography**, 2008
**Jiang Hua** (China)
Paper
© Photo: Jiang Hua

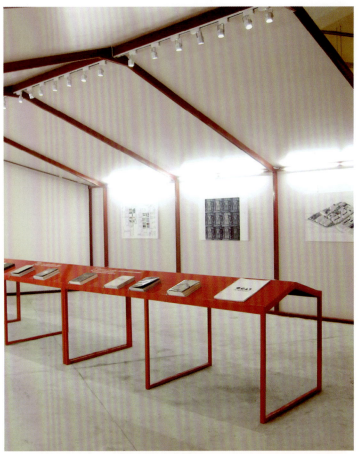

**OCT-LOFT文献展,** 2011
史建,王序,侯颖,陈海霞,张超,
丁凡,詹火德(中国)
综合材料
© Photo: Isreading Culture

**OCT-LOFT,** 2011
Shi Jian, Wang Xu, Hou Ying, Chen Haixia,
Zhang Chao, Ding Fan, Zhan Huode (China)
Mixed material
© Photo: Isreading Culture

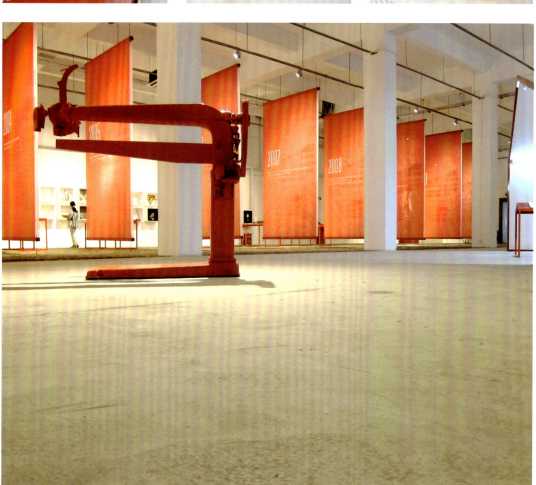

花棉被，2009
冯峰，卢彪彪(中国)
棉被，椅子
© Photo: Feng Feng, Lu Biaobiao

**Color cotton quilt**, 2009
Feng Feng, Lu Biaobiao (China)
Cotton quilt, chair
© Photo: Feng Feng, Lu Biaobiao

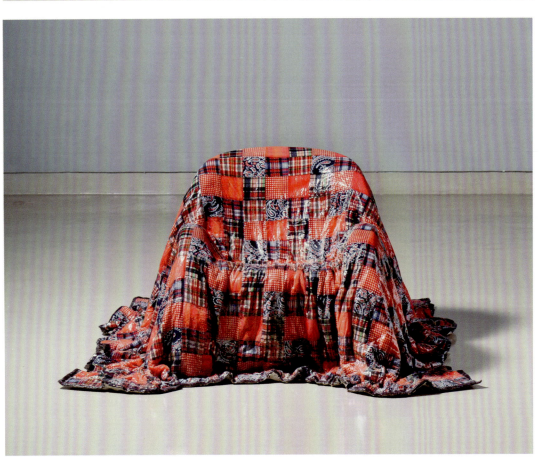

花棉被，2009
冯峰，卢彪彪(中国)
棉被，椅子

褶子，2009
冯峰，卢彪彪(中国)
PVC
© Photo: Feng Feng, Lu Biaobiao

**Pleat**, 2009
**Feng Feng, Lu Biaobiao** (China)
PVC
© Photo: Feng Feng, Lu Biaobiao

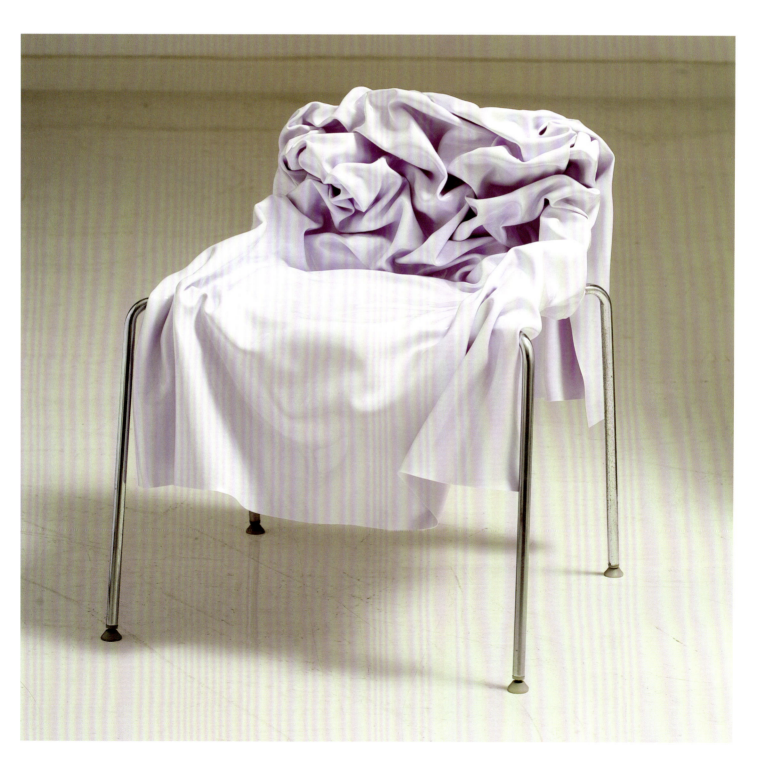

神马，2011
石川（中国）
木材，塑料瓶
© Photo: Tom Shi

**Shenma**, 2011
**Tom Shi** (China)
Wood, plastic bottle
© Photo: Tom Shi

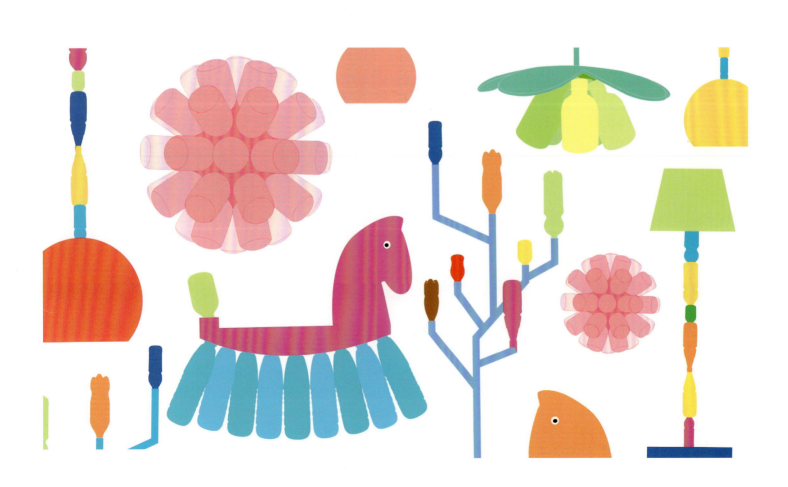

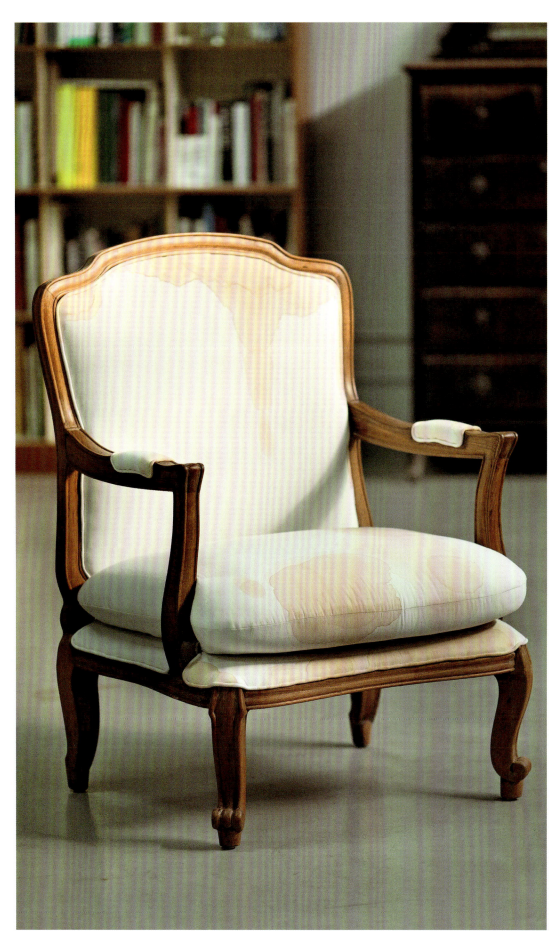

普洱茶洒在了沙发上，2009
冯峰，卢彪彪(中国)
普洱，沙发
© Photo: Feng Feng, Lu Biaobiao

**Pu'er tea spilled on the sofa**, 2009
**Feng Feng, Lu Biaobiao**(China)
Pu'er, Sofa
© Photo: Feng Feng, Lu Biaobiao

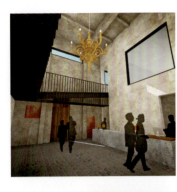
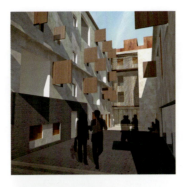

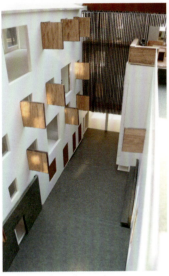

水舍，2008 — 2010
郭锡恩，胡如珊 (如恩设计研究室) (中国)
综合材料
© Photo: NERI & HU

**Water House**, 2008 - 2010
Lyndon Neri & Rossana Hu (NERI&HU) (China)
Mixed material
© Photo: NERI & HU

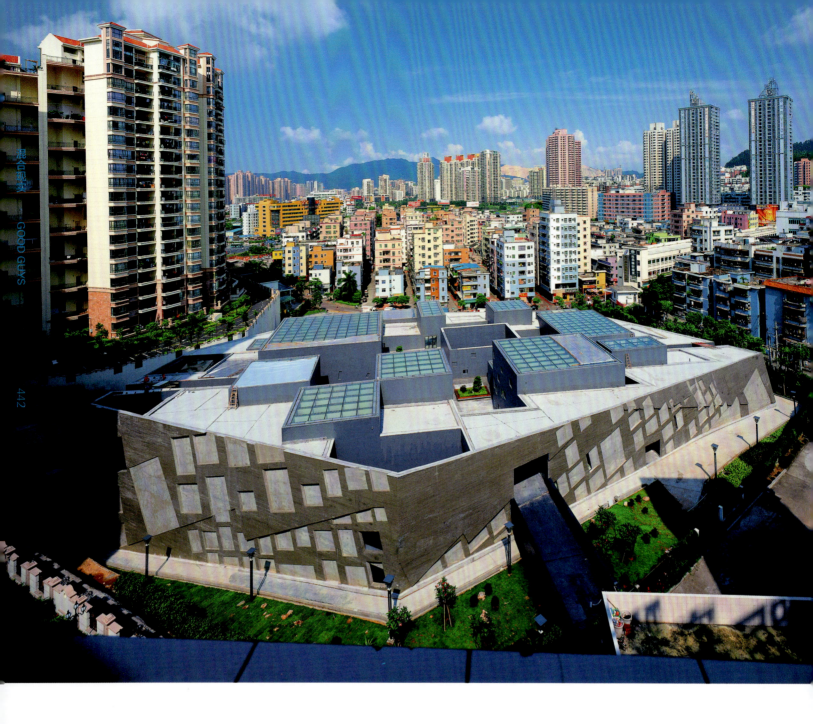

大芬美术馆,2005—2006
孟岩,刘晓都(都市实践)(中国)
综合材料
© Urbanus

**Dafen Art Museum**, 2005-2006
Meng Yan, Liu Xiaodu (Urbanus) (China)
**Mixed material**
© Urbanus

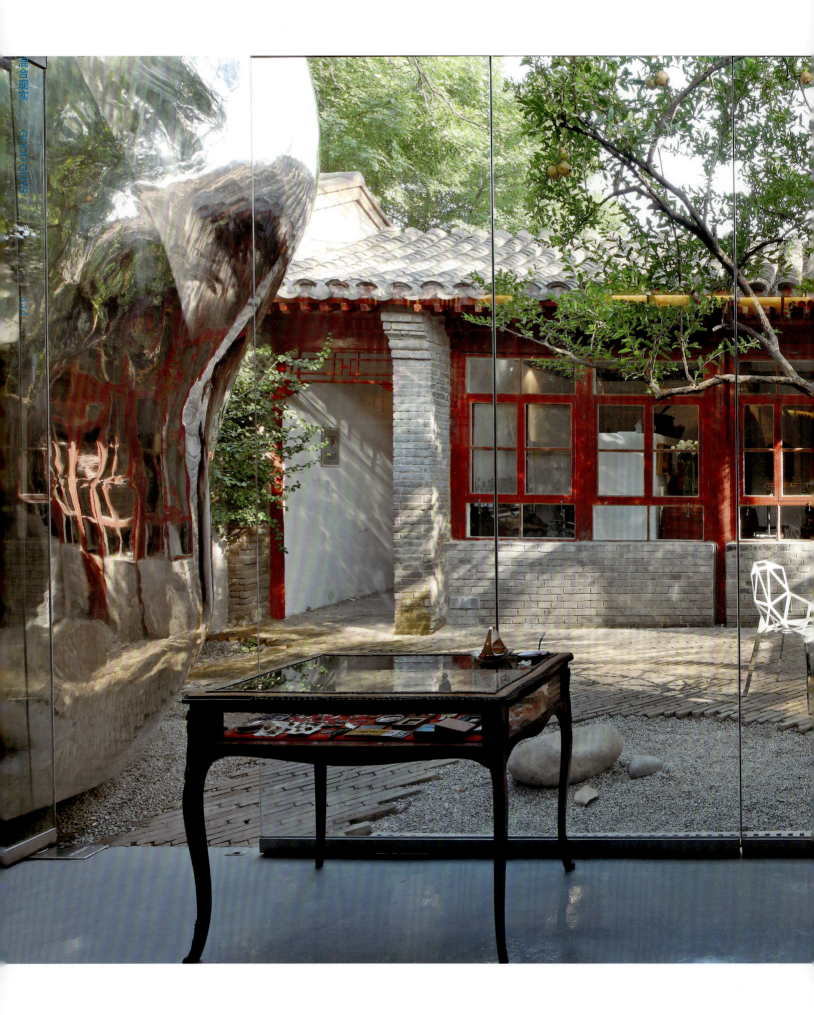

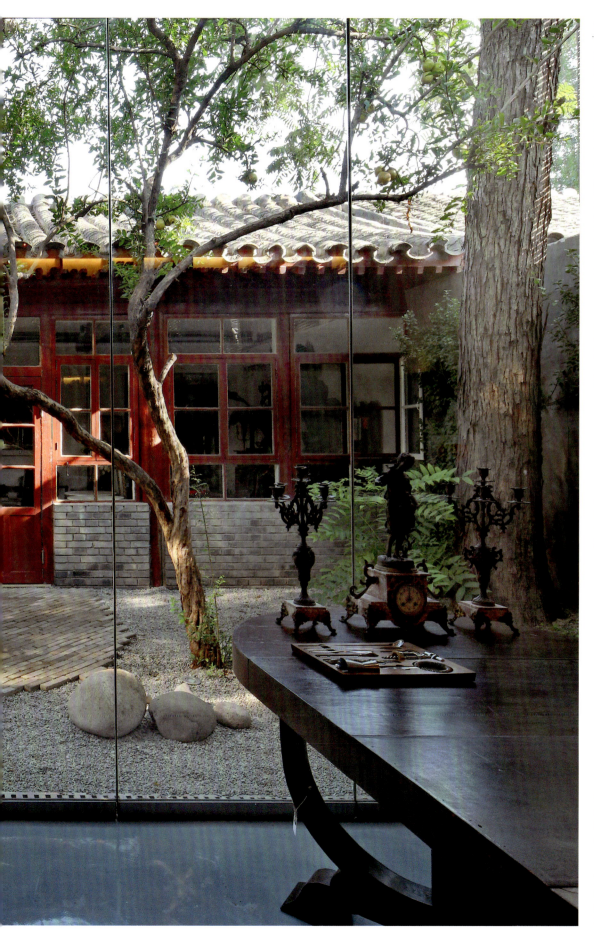

混合现实 GOOD GUYS

445

胡同泡泡，2006—2009
马岩松(MAD)，党群(中国)
综合材料
© Photo: MAD

**Hutong Bubble**, 2006-2009
Ma Yangsong (MAD)/Dang Qun (China)
Mixed material
© Photo: MAD

# 5.

## 可能的世界
## WHAT IF

| 策展人 | **Curators** |
|---|---|
| 菲奥娜·拉比（英国） | Fiona Raby (UK) |
| 安东尼·邓恩（英国） | Anthony Dunne (UK) |
| 金江波（中国） | Jin Jiangbo (China) |

菲奥娜·拉比(英国)
金江波(中国)

**Fiona Raby** (UK)
**Jin Jiangbo** (China)

## 单元主题阐释

我们是为当下世界而设计,还是为可能世界而设计?

本次的参展作品都提出了"假如……?",但不是为了预言未来,而是为了激发大家讨论未来科技对人类的正面和负面影响。

一段时间以来,我们对介于真实和虚幻之间的空间很感兴趣,那是一个汇集了梦想、希望和畏惧的空间。商业界对未来的预测,企业界所描述的设计图景,文学和电影界的乌托邦和反乌托邦,都在占据和抢夺这个空间——它是一个重要的空间,一个大家对尚未发生的事件进行思考并讨论的地方,所以,至少在理论上,我们可以努力获得我们最想得到的未来,并避免最糟糕的未来。

这里不存在既定的解决方案或答案,只存在无数问题、思考、想法和可能,并以设计的语言加以表述。它们检测我们的信仰和价值观,挑战我们假设的前提,鼓励我们大胆想象:平常人所谓的现实并非既定的,而是可以有另一番景象。它们帮助我们发现,现存的世界只是诸多可能世界中的一种,并且并不一定是最好的。如今,哺育了20世纪想象力的梦想已经开始褪色,我们必须学习如何去开始新的梦想。

## Interpretation of the Sub-theme

Do we design for how the world is now? ...or for how the world could be?

The projects in this exhibition ask 'what if…?' Their purpose is not to offer predictions but to inspire debate about th e human consequences of different technological futures — both positive and negative.

For a while now, we've been very interested in the space between reality and the impossible, a space of dreams, hopes, and fears. Usually this space is occupied by future forecasts (commercial world), design scenarios (corporate world) and utopias and dystopias (literary and cinematic worlds).—It's an important space, a place where the future can be debated and discussed before it happens, so that, at least in theory, the most desirable futures can be aimed for and the least desirable avoided .

There are no solutions here, or even answers, just lots of questions, thoughts, ideas and possibilities, all expressed through the language of design. They probe our beliefs and values, challenge our assumptions and encourage us to imagine how what we call 'reality' could be different. They help us see that the way things are now is just one possibility, and not necessarily the best one.—As the dreams that fed the 20th century imagination begin to fade, we need to learn how to dream new dreams.

## 菲奥娜·拉比

邓恩和拉比工作室合伙人,资深策展人
英国皇家艺术学院高级研究员

菲欧纳·拉比,生于1963年,伦敦皇家艺术学院交互设计研究课的资深导师,邓恩和拉比工作室合伙人。

邓恩和拉比工作室通过设计作为媒介,激发设计、企业和社会各界对新技术可能导致的社会、文化和伦理问题的讨论。其项目和作品在国际上造成了广泛影响,在纽约现代艺术博物馆、巴黎蓬皮杜中心、伦敦科学博物馆展出,同时被纽约现代艺术博物馆、维多利亚和阿尔伯特博物馆永久收藏。

出版物包括普林斯顿建筑出版社的《设计夜晚:电子物件的秘密生活》与MIT出版社的《赫兹的故事》。

## 安东尼·邓恩

邓恩和拉比工作室合伙人,资深策展人
英国皇家艺术学院教授,交互设计系主任

安东尼·邓恩,英国皇家艺术学院教授,交互设计系主任,计算机设计实验中心创始人之一。

他在英国皇家艺术学院学习工业设计,之后在东京的索尼设计中心工作。回到伦敦之后他在皇家艺术学院完成了交互设计的博士学位。他是CRD研究中心的创始成员,并作为高级研究员在那里工作。1998—2004年,他曾在皇家艺术学院产品设计系联合主持平台3课程。2009年,荣获Sir Misha Black奖,以表彰他对设计教育所做的创新贡献。他是邓恩和拉比工作室的创办人之一。邓恩和拉比工作室通过设计作为媒介,激发设计、企业和社会各界对新技术可能导致的社会、文化和伦理问题的讨论。其项目和作品在国际上造成了广泛影响,在纽约现代艺术博物馆、巴黎蓬皮杜中心、伦敦科学博物馆展出,同时被纽约现代艺术博物馆、维多利亚和阿尔伯特博物馆永久收藏。

目前正在主持BioLand项目。BioLand是一个虚拟的购物中心兼实验室,致力于满足人们在一个基因改良世界中所面临的生老病死需求。

## Fiona Raby

Partner of Dunne & Raby, Curator, Senior Research Tutor at the Royal College of Art, London

Fiona Raby, born 1963, is a partner in the design partnership Dunne & Raby and Senior Research Tutor on the Design Interactions Course at the Royal College of Art, London.

Dunne & Raby use design as a medium to stimulate discussion and debate amongst designers, industry and the public about the social, cultural and ethical implications of existing and emerging technologies.

Their work has been exhibited at MOMA, the Pompidou Centre, and the Science Museum in London and is in the permanent collections of MOMA, V&A, FRAC and FNAC. They have published Design Noir :The Secret Life of Electronic Objects (Princeton Architectural Press) and Hertzian Tales (MIT Press).

## Anthony Dunne

Partner of Dunne & Raby, Curator, Professor and Head of the Design Interactions Department at the Royal College of Art in London

Anthony Dunne is professor and head of the Design Interactions department at the Royal College of Art in London. He studied Industrial Design at the RCA before working at Sony Design in Tokyo. On returning to London he completed a PhD in Computer Related Design at the RCA. He was a founding member of the CRD Research Studio where he worked as a Senior Research Fellow leading EU and industry funded research projects. He also taught in Design Products where he jointly led Platform 3 between 1998 - 2004. He was awarded the Sir Misha Black Award for Innovation in Design Education in 2009.

Anthony Dunne is a partner in the design practice Dunne & Raby. His work with Fiona Raby uses design as a medium to stimulate discussion and debate amongst designers, industry and the public about the social, cultural and ethical implications of emerging technologies. Their projects have been exhibited and published internationally and is in the permanent collection of MoMA and the Victoria & Albert Museum. In 2005 they curated PopNoir at the Israel Museum in Jerusalem.

He is currently working on BioLand, a fictitious shopping centre and laboratory devoted to meeting birth, death and marriage needs in a genetically modified world.

# 金江波

新媒体艺术家，上海创意设计师协会理事
新西兰奥克兰大学访问学者

金江波，1972年生于浙江，1995年毕业于上海大学美术学院国画系，1997年—1998年在日本东京株式会社Celsys研修多媒体设计管理，2001年赴美国阿尔弗雷大学做访问学者。2002年，毕业于上海大学美术学院数码艺术专业，获硕士学位，同年留校任教，任数码艺术中心数码影像艺术工作室主任。

2007年毕业于清华大学美术学院信息艺术设计系，获得博士学位。2009年作为访问艺术家赴新西兰戈维布鲁斯特国立美术馆。2008年，获第四届连州国际摄影节年度杰出艺术家金奖。2009年获得ACC艺术中国年度十大艺术家（摄影类）。2010年，担任上海创意设计师协会理事、上海闸北区政协委员。2010年12月至今，为新西兰奥克兰大学访问学者。

金江波是国内最早从事新媒体艺术领域创作和研究的当代艺术家之一，曾参加过威尼斯双年展、上海双年展、南京三年展等国际大展，近年创作的大画幅摄影作品获得连州国际摄影节的金奖，并且被媒体称为："最早用艺术方式表述国际金融危机到来的艺术家。"

# Jin Jiangbo

New Media Artist, Director of the Shanghai Creative Designers Association
Visiting scholar of the University of Auckland, New Zealand

Jin Jiangbo, born in Zhejiang Province in 1972; graduated from the Traditional Chinese Painting Department, Shanghai University in 1995; 1997-1998 trained in Celsys Kabuskiki Kaisha in Tokyo, Japan, focusing on multi-media design and management; 2001, visiting scholar of Alfred University, U.S.A. In 2002, he graduated from the Academy of Fine Arts, Shanghai University with master degree. Because of his excellent performance, Jin Jiangbo was elected to teach in the university after graduation. In the same year, Jin Jiangbo was appointed as the director of the Digital Art Studio under the Digital Art Center.

In 2007, he got the PhD from Tsinghua University, focusing on information design. As a visiting artist, he worked for the Govett Brewster Art Gallery in New Zealand in 2009. In 2008, he won the Outstanding Artist Award of the 4th Lianzhou International Photography Festival. The next year, he was selected as ACC(Australia-China Council) Top Ten Artists Art in China(photography). In 2010, he became a member of Shanghai Creative Designers Association as well as Shanghai CPPCC member, Zhabei District. From December 2010 till now, Jin Jiangbo has been a visiting scholar of the University of Auckland, New Zealand.

Jin Jiangbo is one of the earliest contemporary Chinese artists focusing on the creation and research about new media art in mainland China. He participated many of international exhibitions including Venice Biennale, Shanghai Biennale and Nanjing Triennial etc. His recent works won the Gold Award of the Lianzhou International Photography Festival and got the following commend from media "The earliest artist to represent the arrival of the international financial crisis with art language."

# 可能的世界

安东尼·邓恩和菲奥娜·拉比

假如只有通过我们的喂养才可以使产品保持运作？假如机器可以读出我们的情绪变化？假如我们可以种植产品而不是批量的制作产品？假如人体组织可以被用来制作物品？这个展览邀请我们共同思考一系列富有想象力的创意，这是我们闻所未闻的。

上述项目作品被谨慎地置于现实与虚幻之间，虽然处于真实的语境和操作过程之中，却有着大胆的想象，促使我们勇敢地前行，大胆预测曾经被认为是不可能发生的事情。对怀疑的暂时悬隔为现实提供了一条实验性的线索：如果故事太离奇，可信度就降低，影响和改变日常世界的能力就被削减。但是同样，如果它和我们已知的太相近，那还能有激起我们行动的冲击力么？

三年展的主题是"好的设计"，但是"好"到底是什么意思却越来越难界定。一切都在变化中：政治局势，金融结构，生态政策。现在比以前要复杂得太多了，而且这个复杂性还在增长。科学亦是如此。科学前沿每天都在变化，我们的理解也越来越细节化，知识的密度在增强。解决方案不再是直接的，相反，我们有了更多的问题。

本次展览探索了设计角色转变过程中出现的新可能性：从习惯解决已知问题走向新问题的发现与提出。我们自以为知道的事情都在发生改变。

这个展览不是严格地以一个主题组织起来的，而是围绕不同问题各自聚集在一起。在一些组里，展出的项目会集体强化一个概念，另一些则有意互相抵触。展览的终极目的是给观者带来刺激、挑战和惊喜，甚至打破他们已有的认知；不确定性和不稳定性提供了一个丰富的、富有创造性的语境来审视潜在的改变。

我们为世界现在的样子设计？还是为世界的未来设计？

《云计划》位于展览的入口处。一个纳米冰激凌车被设计成任何一个纳米冰激凌车可能成为的样子，在车顶上有两个大炮筒。炮筒把纳米分子发射为下冰激凌的云朵：奇妙，迷人，从技术上来说，并非不可能。对于设计师Zoe Papadoupolou 和Cathrine Kramer来说，纳米技术的潜能是奇妙无比的，但是实际的纳米产品看起来都很中庸：防止脚臭的纳米银的袜子，或者是能够防污渍的上衣。但是，当产品被废弃之后那些纳米进入了生态系统之后会发生什么？把纳米技术用来改变环境的应用都有哪些？

就像设计师他们问自己的一样，他们应该设计更多的纳米产品吗？或者，设计一个能提出更多问题的过程是不是更好？

在最近的一次采访中，当被问到公众对这个项目的反应时，Carthrine提到这样一个人："他指责我迪士尼化（娱乐化）了地理工程学来取悦公众的品位。我觉得他是为数不多的具有足够批判性来看出这个项目的反乌托邦口吻的观众。他觉得观众没有能力用一个批判性的视角看这个项目，因为这其中的视觉语言使人们自然把它和消费主义潮流和被动娱乐联系起来。"

这个展览中的设计可能并不是人们预期的那样。

假如设计师不再解决问题而是提出问题时，那会是什么样？
设计师如何提问？
设计师应该问什么样的问题？

科学和设计有什么关系？
基因学、纳米技术、神经科学、量子力学、合成生物都是尖端、难懂、费脑筋的科学。科学家占领着这个纯净的领域。可以说，他们的想象力塑造着这些技术的未来。

科学想象力和设计想象力大相径庭。普通人的想象力又不一样。我们想用哪种想象力塑造未来？

假如我们能够培育出会发声的植物，那会是什么样？

一个开着小花样子古怪植物的大幅图片和其他一些植物以及花园提案并列放在一起。这组的项目是展示贯穿整个展览的我们与自然系统复杂而矛盾的关系的极好的例子：什么是"天然的"，人为操控自然系统程度的可接受度也在不断地被挑战。

自然通常都被描绘成一个浪漫的，宁静的，乌托邦式的，一个我们愿意强化的理想画面。想要去融入以及天衣无缝地与这些生物系统合为一体的欲望被《桃花源里》与《生生不息》很好地捕捉到。但是，似乎我们并不愿意承认我们使用了多少人为操控才达到这个理想。

园艺和农业有很长的历史。植物在科学家和基因工程出现之前就被高度的修改过——嫁接技术就是用来把不同的物种组合在一起改良

物种并极大地改变了农业的图景。

《听觉植物园》是David Benque的一个项目，它以植物实验的悠久栽培历史为基础。与植物科学家共同设计，植物能够发出优美而动听的声音。因为生物的有限性，它只有一个极小的花朵，因为所有的能量和养料都用来集中在发声这个功能上了。生物原则是很残酷的。但是，这个叫做"清脆地带"的发声花园周密而谨慎地利用和平衡了互相依存的多物种的生态体系，让一年四季都有不同的声音产生。

David关心的是科学资金越来越多的用于食物、医疗、能源与环境领域，他想质疑的就是在这场辩论当中栽培实验的位置在哪里？还是，栽培实验的任何一步都会被认为走得太远？

他质疑为什么只有科学家应该研究科学？……只有他们的想象力能被用来探索可能的新领域么？

**假如非专业的普通人也可以做科学实验，那会是什么样？**

科学被视为是普通人无法触及的，《爱猫俱乐部》是Nina Pope和Karen Guthie近期摄制的一部纪录片，揭示了"科学是可以被普通人所触及的。"这部影片提出一个很有趣的假设"业余科学能否有助于专业科学？"

"你的猫咪可以告诉你所需要的所有有关基因学的知识。"（Leslie Lyons博士，加利福尼亚大学戴维斯基因学实验室）

养猫者群体和各种各样的猫咪选美比赛从某种程度上揭示了这个业余人士的领域不仅富有活力，又是知识性极强的，这体现在挑剔的饲养学和基因系统学两方面。家养的猫咪各式各样，根据特征的不同，它们会被挑选参与到各种不同级别的比赛。猫咪爱好者的目的性极强，他们的猫咪并不是大街上常见的品种，很难在猫咪选美比赛的舞台外见到，它们被精心呵护与培养。

养猫爱好者通晓基因工程中的合成生物学，他们希望由此能使复杂的生物工程学标准化。具体是用一系列标准化的生化元素和单元按照类别分成几组序列，然后在网上成为开放的知识库。通过使更多人了解它，不仅在客观生活中被逐渐采用，作为知识系统的一部分，也会被迅速地传播到更加难以想象的多种领域。

在《拓粮者》项目中，业余人士组成的生态小组，利用已公开的人工生物学的知识改进他们的消化系统，吃到更多样的素食。这会是向维持这个星球生态多样化迈出的一大步。这个作品使我们意识到今天业余爱好者的假设和预测将会是未来创新的源泉，倘若给予一定的赞美和鼓励，他们将会在官方渠道所不能及的领域获得突破。

Tuur van Balen 是另一位希望把科学带出实验室的设计师。其作品《鸽群制药集团》将赛鸽与业余科学结合在一起，他认为鸽子就像是实验室的小白鼠，是科学爱好者探索这个领域的最好载体。鸽子的消化系统可以被认为是各种科学实验的孵化器。与设计师一同工作的生物合成学家James Chappell给Tuur编写出一系列在厨房中就可以进行的细菌实验的DNA代码。《人工免疫系统》的实验结果正是出自此。这种可以自助操作的装置用人工改良酵母去探测个人免疫系统中的各种异常状况。这个原理在《黑胆汁——情感调节盛宴》中被运用得更多，人的血液通过水蛭被全面修改后体内的羟色胺会被提取、管理、并获得平衡。吸出的血液经过烹饪后重新进入人的体内，整个过程人经历着准备、烹饪、享用三个愉快的步骤。对Tuur而言，医药学与科学程序的结合将成为每日生活中必不可少的一部分。

**我们是改变世界来适应自己？…还是改变自己来适应这个世界？**

假如我们让普通人掌握科学和技术，他们将会怎么做？他们将会改变什么？

在Susanna Soares看来，可持续发展是一个关乎人类义务的问题，而不仅仅只是与消耗自然资源有关，它需要强有力的行动。肉类的生产有着很显著的生态足迹，导致了大量的$CO_2$气体的排放。《素食主义者的牙齿》提出了一个问题：我们能跟随着我们的信仰走多远？比如，我们会愿意在生物学和基因方面改变和改造我们自己吗？

《拓粮者》热衷于进行生物学改造。如前面提到的，他们改造自己消化管道内的细菌，使得他们在通常能消化的植物之外，能够消化吸收更多的植物。每个人根据他们的个人承诺的程度来确定特定的实验装置。较保守的人将他们经过基因改良的外在胃置于小车上拖来拖去，一些人则将它置于自己真实胃的上方，尝试更紧密的联系。而更舒服的办法是将它挂在脖子上。最开明的人则会改造他们自己的胃，使得植物能直接进入他们的肠道。那些面具则表明他们全心致力于他们的目标。

Revital Cohen 认为直接的人体生物学改造是既实用而又符合道德的。《发电的阑尾》提议将一个多余的器官——阑尾，替换为来源于一种电鳗的经过改造的发电器官，用来为一群献身于数字系统和虚拟世界的人所使用的电子设备供电，以满足他们无穷尽的无害用电需求。

**假如人类的身体组织可以被制成物品，那会是什么样？**

当人的身体组织被转变成日常的人工制品，这将意味着什么？

作为婚姻的象征，Tobie Kerridge 和 Nikki Stott想要重新考虑在这一个生物技术年代的结婚戒指。贵重金属，例如黄金和白金，是否足够珍贵？痴迷于在聚合结构物上对生长的人类组织进行改造手

术和实验，Nikki和Tobie想到假如能够取得一对恋人的骨骼样本，将他们的生物材料永远融合起来并且培育成为一枚戒指，将会怎么样？技术上来说这很容易实现。而伦理上，就完全不是这么一回事了。他们与组织工程学专家Lan Thompson博士合作。后者经过多年的努力，跨越了各种伦理委员会的难题，终于完成了呈现在本展览中的这些骨骼戒指。而讨论、辩论和质疑的过程，与这些戒指本身一样重要。

这些人工制品可能非常简单，但是它们的意义和对人的价值是巨大的。在这个项目中，设计是一个强有力的工具，也是一个平台，聚集起不同领域的专家，面对复杂且情绪化的人类欲望，来探讨这一技术的后果。

对人体组织的应用，其心理和情感的后果还有待检验。

Revital Cohen最新的工作是思索新兴遗传学说在心理学上和情绪上的启示。《基因传家宝》探究了当我们完全知道了有害基因时我们应该承担的责任。遗传疾病给后代的可能性能够被预料，而不再是由无法抗拒的生育孩子的欲望所导致的冲动的赌博。她承认事实比想象的要复杂：例如，当一个孩子没有继承其他家庭成员所拥有的致命的基因时，他所感觉到的负疚。

在她的另一个项目《生命维持机》中，一条携带有特殊构造的泵的格雷伊猎犬取代了帮助某人呼吸的氧气罐。这种动物，是娱乐产业的一种"产物"，通常在3岁时，即他们的竞赛生涯结束时被宰杀。为了比赛要求而进行的极端饲养使得猎犬性情娇弱且匮乏，它需要人类恒久的伙伴情谊。这初看起来完全是剥削性质的，实际上透露出的却是一种真诚的共生关系。

无惧于艰辛复杂，Revital 进一步开拓更艰难的领域。她质疑并挑战了动物作为医用产品能够扮演的角色。在电影《后人类时代》中，人工肾看起来有着漂亮的"设计"并且能够"方便友好"地维持患者的生命，但是根据采访披露，病人与这些人工肾的关系是不愉快且情绪化的。我们现在拥有的最好器官是由生物和进化产生的，但是人类的血液能够被一只经过基因学改造的活羊净化是一个非常有挑战性的想法。

如果不考虑情感的话是不是会有不同？昆虫怎么样？蜜蜂有着不同寻常的嗅觉能力，并且很容易被训练而记住特定的气味。假如蜜蜂能够从我们的呼吸中，帮助我们嗅出并且识别疾病，会发生什么？当有生命的物体成为产品，这意味着什么？另外一些项目也在探索这个领域。它们提出了一个议题：当生物材料被用来定形和控制以得到产品，哪些是可以接受的，哪些是不能接受的。

**假如我们到其他星球播种生命，那会是什么样？**

现行的科学研究对我们本身的生物学有着更深入的了解，并且同时也深入了解了宇宙的产生和历史。一种来源于检测陨石中磷酸盐成分的学说使得科学家们推测地球上的生命来自于外太空的生物材料。Michael Burton说这改变了人们对宇宙的认知，使其由不利于生命转变为与生命融洽的，并且重新定义我们为太空生物学产物，以及确定了宇宙是孵化生命的场所。这种认知上的改变带来了新的梦想。

他的项目《身体宇宙》提出了一个非常不同的论点来阐述太空旅行的观念。他相信继续在宇宙中播种生命是人类的责任。

人体通过尿液进行磷酸盐的代谢。磷酸盐在人体内聚集形成结石，这种现象与宇宙的产生过程有可比之处。这是一个深刻的想法。磷酸盐才刚刚开始被认为是珍贵的，而澳大利亚是最先开采这种矿物而不是让它被冲刷走的国家之一。Micheal一直在从自己的尿液中提取磷酸盐以制造陨石。他打算把制造出来的陨石发射到太空使生命在宇宙中永存。他的目的地木星的卫星欧罗巴是在可及范围内的最有可能支持新生命的星球。

这可能是这个展览中最出色且具有哲学意味的。

**假如产品设计从动物行为获得启示，那会是什么样？**

科学的意识形态在向日常文化渗透，逐渐影响和改变我们，使我们思考自己是谁以及我们与宇宙、地球和其他物种的关系。接下来的展品探讨了这个问题。张苇苇的手提包中的皮革，不仅仅是一种制造出流行样式的材料。在生物学中，畸形个体是自然系统的一部分。在她的提包设计中，她表达的观点是清除有缺陷的个体不再是唯一的选择：现在可以说有机体是基因突变的胜利。

假如生命科学是数字系统发展过程中的一部分，又会怎么样？什么样子的产品会被生产出来？如果这些产品要"存活"的话，或许新的产品行为是必需的。在早期的电子电路中，灰尘是最大的敌人。"Attenborough 设计组"创造了一种能够打喷嚏去除内部灰尘的收音机，和一个长脚的光驱，当咖啡不小心泼出的时候，它能够用细小的腿举起自己以避免液体的危害。

这些可能看起来滑稽可爱，但是这些物体给这个由经济、实用和用后即弃所驱动的物质世界提出了一个挑战。它们展现了一种无生命的家用电器与他们的人类"主人"之间的更为复杂的关系，一种由于附属于人类而延长了产品寿命的关系。

当James Chamber的产品通过直接的拟人手法来触动人们的情感按钮时，王艾丽使用了更加微妙的人类行为的方式来获得情感连接，并且舍弃了日常产品中普遍的标准化。一种叫"完美睡眠"的闹钟只记录你想要睡眠的时间，而不管任何通用的时间结构。《嘀嗒！嘀嗒！》仅仅够在你入睡前，提供短时间的光照，阅读少数段落。另一种闹钟《暴君》与手机以及手机内的非常私人的号码名单相联系，当它的主

人不起床时，它会威胁要在大清早打电话给他朋友或者老板来使他难堪。最后，《帕维洛的产品》再次引入了生命元素的讨论。宠物狗是这个闹钟的"友好"部分，是"这个产品的扩充"，被细致地训练以通过舔你的脸来弄醒你。

假如为了让自己的物品工作，你必须给它喂食，那会是什么样？

Anab Jain和Alex Taylor朝着"有生命"的产品迈出了一大步。一个简单的收音机从微生物燃料电池那里获得能量。这种电池通过生物材料产生能量。它需要不断地用腐坏的食物、昆虫或者其他有机物进行"喂养"。这些相当难闻的废弃物是富有营养的微生物材料，能够被用来向植物提供营养，以将收音机与一个生态系统关联在一起。收音机巨大的尺寸表明需要足够多的食料，才能产生足够支持收音机工作的电量。收音机巨大的尺寸超越了我们的预期。杂乱、难闻和过大的尺寸与蔡江宇的小"漆"灯形成了鲜明的对比。后者会在有人在场时发出优美的光。在这种情况下的"有生命"显得流畅干净且有效。

James Auger和Jimmy Loizeau从以人为中心转向以机器为中心来诠释"活着"的概念。微生物燃料电池技术将这些机器从人类强加的高度功能性的暴虐下解放出来，给予它们真正的自主。捕蝇纸抓住的苍蝇给马达提供了足够的能量使得机轮转动，从而将下一个苍蝇从捕蝇纸上刮擦下来，使其进入微生物燃料电池，再次给马达提供能量。唯一多余的功能是表明机器吃了多少只苍蝇的计数器：它巧妙利用了人类的弱点，人到处都一样，它知道我们会控制不住地盯着它看。

假如机器能阅读我们的情绪，那会是什么样？

许多产品仅是保持和增强一个程序化、实用化和可操控的世界。他们对人类的缺点和错误的容忍性很低。我们有一种完美的思想，即自己是超级有用的存在，对自己的生命是完全掌控的。但是事实却复杂得多。我们能够允许这种思想规范我们的家和社会到什么程度？《信念系统》是一部在展览结束部分投影的一部大片，它戏谑地推测了假如机器能分析我们的情绪，并替我们做出判断，那会怎么样。在机器面前，我们的情绪比我们想象中的要透明得多。例如，我们本能和下意识地对一系列的人面部的微小表情做出反应。同时，显然我们自己微小的表情变化会泄露我们真实的感受。这些微小的信号能够被数字系统拣选出来并分析。Bernd想象了许多由于这些新技术的介入而使我们的私人感情变得公开化的场景：从重新训练我们的面部肌肉以保留我们的隐私，到解脱责任后的愉悦。在一个购买水壶的场景中，决定是自动化的。一个机器在屏幕上播放可选择的水壶的图片，同时监测顾客的面部。可能在顾客自己知道之前，它就已经知道顾客喜欢哪一个，并且将那一个递给他们。

王艾丽也认为机器缺少的正是这种"情商"。在另外一个项目中，她考虑了准确性和精密度，通常来说机器是以粗野，无情，以及缺乏细腻和精密而著称的。但是，她并不想替换掉机器决策这一步。她宁愿将人包括为整个进程的一个部分。王艾丽给出了三个非常不同的尺度. 一个超大的尺度，根据你离显示器的远近显示不同的体重。由人来决定他想精确到哪个程度。在第二种尺度中，读数器被放置在机器的前缘，在使用者所看不到的位置。它需要另外一个人来读出重量并且估计它有多准确。在第三种尺度中，根本就没有显示器，只有一根天线。体重以文本方式自动发送给另外一个人。王艾丽让我们想象我们可能会发送给谁：一个信任的朋友？一个健康专家？一个互助小组？第一眼看上去像什么，即使是一个简单的产品，也会成为引发多彩的辩论的催化剂。

假如产品设计能满足那些复杂的情感需求，那会是什么样？

在他的两部电影《孤独者用品》和《欲望管理》中，Noam Toran漂亮地抓住了人类需求的多样性和复杂性。他挑战了我们可能共同认为的"平常"的东西。离群索居的人通常被认为是悲伤，不快乐或者情感匮乏的。Noam改变了这种想法，创造了一个孤独的世界。在这个世界里，人完全在控制之中并且快乐地放纵着他们特殊的欲望。

人类的欲望复杂多样，下面这组项目展现了很多相互矛盾的欲望。Matt Hope的《法拉第套装》，以一套能够保护你远离已经成为日常生活的一部分的任何电磁波的套装，使得偏执狂也变得可以接受了。钟承达的《玩具枪》，想要提醒我们枪械给这个世界带来的真正痛苦。Bit Play的《砰！》，希望电视小说能具体化成为每日互动的好玩的部分。Matt Hope创造了一个不受控制的不妥协的设备，在日光的照射下，它会发出强烈的令人不适的声音；它没有开关，只有物理解除或者将它盖住才能使其缓和。柴春雷的《蒲公英灯》则希望我们所有与物体的互动能内在地促进和产生冷静和温和的行为。

假如重大问题的讨论出现创造性的进展，那会是什么样？

《核对话》是一件很有争议的作品。关于核能量的话题在英国极其少见，即使在未来能源枯竭是一个事实，官方机构也由于过于恐惧核能量的危害性而不愿正视它。所谓"核安全"，既包括反对恶意袭击，也涉及核泄漏责任承担等现实社会问题，"核安全"问题变得十分教条且不可动摇。

然而，Zoe Papadopoulou 提出了一个大胆的提议。她把铀元素称为"黄蛋糕"，它是核反应的主要元素之一。她的"黄蛋糕"实验室有6个曾在核工业机构工作过的科学家，探讨用盖格计数器测量香蕉和巴西坚果等原材料中的自然放射元素，然后制成蛋糕配方。英国10个核电厂附近的居民对话的茶话会上，他们用这种黄蛋糕来款待大家。一个安全的地方也是所有问题被公开提出的地方，既有希望也有失望；既有言而不信的毁约也有齐心协力的共勉。桌子上的食物告诉我们这个工作室的各种有趣提议。

设计被当做一种娱乐方式，一种借口，然而更根本的是，设计是解决复杂问题的有效框架。

《基因治安》也是通过娱乐的方式并置这些多样化的争论，因为不同兴趣者所关心的科学技术与开发方式也不同，这就导致了各种思想的迸发。Thomas Thwaites创造了一部看似很普通的纪录片，记录了警察对有关"警蜂"的一段访谈，他们用驯养的蜜蜂去侦察不合法的植物培植，它们会及时向警方汇报这些非法栽培的具体地址。整个过程并非如此简单，这种绝对意义上的基因重组植物的培植技术意味着极其复杂的草本药物可以在普通的种植园里培育，像马铃薯、太阳花、番茄的种植手法一样。但是这些植物的专利属于投资他们的大公司。养蜂人会对采集来的花粉进行分析，同时通过蜜蜂的"摇摆舞"也会获取某些线索，它们的舞蹈不仅向同伴传达出划分采集地的位置，也会向警署揭露违规者的位置。

表面上看起来普通的事，神奇般地被转化成另外一件不同的事，相信技术会慢慢渗透到我们的日常生活中。

钟承达认为科学技术的更新换代正在呈加速度进行，由此加深了代沟。他的作品《科技儿童》预测到，未来的青少年将会是高新技术的践行者，他们将是最超前的，他们的成长，不再受基本需求的限制，也不再依靠长辈的管理和监督。

**假如家用产品能实现我们的科技梦，那会是什么样？**

下一代是什么样的呢？面对像环境变化，过度污染，水、食物和能源短缺，很难想象理想主义仍大行其道。前一代人的科技之梦大多消逝了，以后的梦想将从何而来，它们又如何实现呢？

在这一组展品中，理想主义和现实主义相融合。对于这些设计师而言，体验比占有物品更有价值。单纯用电影来容纳逃避主义和空想是不够的。

Andrew Friend想要体现出一种孩童般的好奇心。他设计出一套能装在帆布背包中的装置——《幻想世界》来感受一些非同一般的东西。他花了一天的时间来到山脚下，又用一天时间走到了山中最偏远的地方。在照片里，我们可以看到他置身于壮丽的风景之中，他站在那里，用肩顶着高6米的装置，一个天线架，如果闪电来袭，他希望闪电会来，一个之字形的超级英雄的疤会烙在他的皮肤上，成为他这次经历的长久记忆。

这个旨在"体验不可见之物"的装置并没有留下不可磨灭的记号。它需要人们找到有增强的电波、超常的现象、或者电的存在的地方。又一次，他满怀希望地来到一个地方，脑袋上悬着一个展开的抛物线形的盘子，将所有的电磁能量集中于一点，希望体验不可见之物。另一种能在海上消失的装置将现实与想象紧密连接，给了他又一次非凡的体验。海上的一个洞能使他安全地消失，四周都是水，与陆地上的实验十分不同。

量子物理提供了另一个去想象并享受不可能和超想象的机会，因为量子物理表明一个与宇宙平行的世界的存在。钟承达创造出一些人工制品，我们可以在其中体会到这一点，而智恒的"水桌"，则可能被看做是普通条件下不可能存在的物品，但是在与我们世界平行的宇宙中它有自己的诗意的逻辑。

最后，Nelly Ben Hayoun奇迹般地创造出"大科学"和一些平常被认为不可能出现在日常家庭生活中的物品。《联盟号坐椅》，改编自家用扶手椅，精确地表现出火箭起飞时刻的体验，这一经历是仅仅极少数人能体验到的，专门为了纪念美国航空航天局在探索宇宙30年后最后一次发射火箭而造。

在另一个项目，《厨房水池中的暗物质》中，奈丽着迷于大型强子碰撞型加速装置——比一个城市还大的世界高能量粒子加速器，她想使每个人都能经历这种非同寻常的东西。这是个很普通的尝试，但却有着极大的野心，因为将大型强子对撞机缩小，并更适宜家庭使用，它的真空装置使你在自己的厨房水池就可以体会到"空"的感受。

《超级神冈音爆》，基于另一个同样宏大的科学实验，建造于日本一座山的内部，旨在弄清楚另一量子物理的现象——中微子。Nelly Ben Hayoun 仅用了很少的资金就创造了一次奇特的经历；用银制的气球和一艘浮船，她说服一些杰出的科学家去驾船，让人们在穿越空间时，听他们讲解物理原理及其意义。

在《另类火山》中，她将一座正在爆发的火山那行星一般的能量引入到起居室中。

不论我们喜欢与否，科学与科技正在塑造和改变着我们的世界，各种类型的创新思维在这些科学领域都有很大的发展空间。从这次展览我们发现，设计师起着像催化剂一般的关键作用。我们需要确定已经想象到了未来发展的各种可能性，而这些想象的影响可能最后会反馈到我们的日常生活中，所以，我们的未来是我们所想要的，并不是我们发现自己生活在其中的而已。

此次展览展出的展品完全不是对未来的预测，而是通过一系列"假如……"的设问，以及推测、思考、想象和梦想，去反思我们所希望生活于其中的技术世界。在这里，并没有解决方法或者答案，只有通过设计而表达的许多疑问、想法、观念和可能性。它们探查我们的信仰和价值观，挑战我们的假设，鼓励去想象怎样使我们所谓的"现实"变得不同。它们帮我们认识到，现实世界只是一种可能而且并不一定是最好的一种——20世纪的梦想已经开始褪色，我们需要学习如何拥有更新的梦想。

# WHAT IF

Anthony Dunne & Fiona Raby

What if ... we had to feed products to keep them alive? What if ...our emotions were read by machines? What if ...we could grow products without manufacturing them? What if ... human tissue could be used to make objects? "What if…?":Two very simple words that take us on an instant journey to another place. The exhibition space is an invitation to contemplate a series of imaginings and alternatives we may never have considered before.

The projects presented sit carefully poised between reality and fiction, although anchored in real contexts and real processes, imagination allow us to leap forward and speculate on ideas we may have previously considered impossible. Suspension of disbelief provides a tentative thread to reality : If the story is too fantastical, engagement is lost, the power to influence and shape the everyday world diminished. But equally, if it fits too neatly into what we already know, does it have any momentum to galvanize action?

"Good design" is the Triennial opening theme , but it's becoming harder to know what is good. The landscape is far more complex than it used to be. And the complexity continues to grow. Everything is shifting: Political situations, financial structures, ecological strategies. And then there is science. The edges move every day, our understanding becomes more detailed, the granularity of knowledge intensifies.

The solutions are no longer straightforward. Instead there are more questions. Many of the things we thought we knew are already transforming. The exhibition explores the potential of design to go beyond it's traditional role of providing solutions to one of asking questions.

The exhibition is not organised into strict themes, instead there are clusters around different issues. In some clusters, projects collectively reinforce an idea, in others, they purposely contradict. Ultimately the aim is to stimulate, challenge and surprise the viewer, even destabilise them; uncertainty and instability are rich and creative environments to speculate on potential change.

### Do we design for how the world is now? …or for how the world could be?

The Cloud Project, sits at the entrance to the exhibition. A nano-ice cream van. Designed like any nano-ice cream van should, with two large cloud seeding cannons on its roof. The cannons fire nano-particles into clouds to make them snow ice cream : Wondrous and enchanting, but technically not impossible. For Designers Zoe Papadoupolou and Cathrine Kramer, nanotechnology is amazing, yet actual nano-products seem so benign: Socks with nano-silver that stop your feet from smelling or stain proof trousers. But what happens to the nano-silver when it enters natural ecosystems after the product is discarded? What are the implications if nano technology is used to alter the climate?

As designers, should they design more nano-products? Or, is it better to design a process for asking more questions?

In a recent interview, when asked about public reaction to the project, Cathrine spoke about a man who
"…accused me of Disneyfying geo-engineering and making it palatable to the public. I felt like he was one of the few visitors critical enough to pick up on the underlying dystopian tone of the project. He believed that the visitors would be unable to apply a critical lens to this project as it uses a visual language that people inherently associate with consumerist tendencies and passive entertainment."

The Designs in this exhibition might not be what people expect them to be.

What happens when Design moves from solving problems to asking questions?
How do designers ask questions?  What kinds of questions should designers ask?

And Science. What has it got to do with Design?
Genetics, Nano-technology, Neuroscience, Quantum physics, Synthetic Biology. Super cutting edge; tough, brainy, difficult Science. The scientists occupy a rarified space. It could be said that their imaginations will shape the future of these technologies.

The scientific imagination and the design imagination are very different. The popular imagination is different again. What kinds of imagination do we want to shape the future?

### What if… we could design plants to make sounds?
A large image of an odd looking plant with tiny flowers sits in the exhibition next to a number of other plant and garden proposals. The collected group is a good representation of the complex and contradictory relationship we have with natural systems that we will see consistently throughout the exhibition.

Nature is portrayed as romantic, idyllic, utopia, an ideal we are happy to reinforce. The desire to connect to and be integrated with these biological systems is captured well by 'Xanadu' and 'Breathe Together' . But it seems we do not like to acknowledge how much manipulation we make to achieve our ideals.

There is a long and dedicated history of gardening and agriculture. Plants have been highly manipulated well before scientists and genetic engineering were involved — Grafting techniques were used

to hack different plant species together and selective breeding has radically transform landscapes.

'Acoustic Botany ' aims to build on the cultural history of experimentation. The plant in the image, designed together with plant scientists has been genetically engineered to make very beautiful and poetic sounds. Designed within biological limits, it can only manage to produce a tiny pathetic flower since its energy and resources are focused on the acoustic task. Biological principles are harsh. But, David's proposal, an acoustic garden called 'Silvery Acres' carefully and sensitively utilises and balances different ecologies of interdependent species.

David is concerned that science funding is increasingly being justified through vital applications such as food, healthcare, energy and the environment and he wants to know what part cultural experimentation plays in this debate? Or, is any kind of cultural human expression in science seen as a step too far?
He asks why should scientists be the only ones to think about science?... Should their imaginations be the only ones exploring the potential of this new knowledge?

**What if...science experimentation was done by amateurs?**
Science is seen as something well out of the reach of ordinary people. "The Fancy Cat Club", a documentary currently being filmed by Nina Pope and Karen Guthie, reveals that this is not always the case. The film asks if "community science" can have a meaningful relationship to "professional science"?

"Everything you need to know about genetics you can learn from your cat."
Leslie Lyons PhD, UC Davis Genetics Laboratory at the University of California

The community of amateur cat breeders and their regular pedigree cat shows and competitions are highly active and highly knowledgeable about selective breeding and genetic lines. In ordinary homes a very diverse range of extraordinary cats are bred. Their features carefully selected and pushed to the limits of each competition category. The amateur enthusiast is highly motivated. Not the average cat on the average street, these cats are very rarely seen outside of the cat show and are highly protected and invested in, both emotionally, and financially.

Amateurs already have access to probably one of the most cutting edge areas of genetic engineering called Synthetic Biology, that seeks to standardize the complexities of bio-engineering. It proposes a series of standard biological parts and components that can be catalogued and put together in known sequences as an open-source knowledge framework on the internet. By making this accessible to a broad range of people the objective is to build and expand on knowledge collectively, quickly and in multiple, diverse and unimaginable directions.

"The Foragers", use the open source knowledge of Synthetic Biology to pursue their own goals. The project recognises the dedication of today's enthusiasts and speculates that the amateurs of tomorrow will be a source of future innovation. Committed and emotionally driven, they will take risks and experiment far beyond official channels.

Tuur van Balen also wants to take Science out of the laboratory. In 'Pigeon D'or', pigeon racing and amateur science come together. He sees the pigeon as a perfect science resource for the amateur, an alternative laboratory mouse. The pigeon digestive system can be used as an experimental incubator unit for various bacterial experiments. He works with Synthetic Biologist James Chappell,who writes DNA sequences that Tuur can use in experiments in his own kitchen. 'Synthetic Immune System' we see laid out on the table is one of these experiments. The DIY home device helps to sense and diagnose anomalies in a personalized immune system. This is taken further in 'Cook Me Black Bile' where seretonin levels in the body are isolated, managed and balanced through synthetically modifying blood collected by a leech. The blood is then cooked and re-enters the body through the pleasurable process of preparing, cooking and eating a meal. For Tuur, medical and science processes come together and can become part of everyday living processes.

**Do we change the world to suit us?… or change ourselves to suit the world?**
If we put science and technology in the hands of citizens, what would we do? What would we change?

Susanna Soares see sustainability as an issue of human commitment rather than dwindling resources, requiring drastic action. Meat production has a large ecological footprint contributing substantial co2 emissions .The vegetarian human tooth raises the question how far would we go in our beliefs to willingly change and modify ourselves biologically and genetically?

A group called 'The Foragers' want to promote the biodiversity of plant species by broadening the range of vegetation that can be eaten by humans. They modify bacteria in their own digestive tracts to enable the absorption of a broader range of vegetation than is usually digestible; The range of devices each experiments with directly relates to their amount of personal commitment. The least committed pull their genetically modified external stomachs around on trolleys, some carry them on top of their realstomachs, attempting a closer connection, and those a little more comfortable wear them around their neck. The most committed have modified their own stomachs to allow the vegetation to enter directly into their gut. The masks signal a total focus on their goals.

Revital Cohen equally sees direct human biological manipulation as both practical and ethical. "Electrocyte Appendix" proposes replacing the appendix, a redundant organ, with a modified electrical organ from an eel for a group of people dedicated to digital systems, virtual worlds and endless guilt free electrical needs.

**What if… human tissue could be used to make objects?**
What does it mean when we start to shape our own biological material? When Human material is turned into an everyday artefact?

Tobie Kerridge and Jewellery Designer Nicki Stott wanted to question the wedding ring as the symbol of the ultimate union. Are precious metals such as gold and platinum precious enough? Fascinated with reconstructive surgery and experiments in growing human tissue on polymer structures, Nicki and Tobie asked what if you could take bone samples from two lovers and grow a ring that fused their biological material together, forever? Technically, it is easy to do. Ethically, it is

a different matter altogether. They worked with Tissue Engineering specialist Ian Thompson who, over a number of years, navigated various ethics committees to finally produce the bone rings you see here in the exhibition. The long process of discussion, debate and questioning are more important than the rings themselves.

The artefact may be very simple, but the meaning and human value are immense. Design becomes a powerful tool, a platform for gathering a diverse range of specialists together to debate the implications for such technologies along side complex and emotive human desires.

The psychological and emotional implications of manipulating human material are still unfolding.

Revital Cohen's latest work speculates on the psychological and emotional implications of emerging genetic knowledge. 'Genetic Heirloom' explores the responsibilities we may take on when we become fully aware of our faulty genes. The chance of passing diseases on to offspring could be seen as premeditated, rather than an emotional gamble from the overwhelming desire to have children. The imagined situations she constructs are complex.
This complexity expands to the relationships we have with animals. In 'Life Support' a greyhound, is used to help someone to breath. The animal a 'product' of the entertainment industries is usually killed at 3 years old when it's racing careers is over. The extreme breeding for its racing requirements has left the greyhound delicate and needy in temperament and it requires constant human companionship. What might initially seem exploitative is revealed to be a genuine symbiotic relationship.

Not afraid of complexity and contradiction Revital pushes further into difficult territory. In the film 'The Posthuman Condition' the kidney machines we see are beautifully "designed", user-friendly machines, keeping patients alive, but the relationship with these machines, revealed through the interviews is fraught and emotional. However the best machines of all are produced by biology and evolution, but its quite a challenging idea that human blood can be cleaned through the kidneys of a living sheep. Revital questions and challenges the role animals could play as medical products, made more complex by the emotional relationships we have with them.

But is it different if there is no emotional attachment? What about insects? Bees have remarkable abilities to smell and can be easily trained to target very specific smells. What if bees could smell for us? Help us identify illnesses that we are not aware of in our breath – What does it mean when living things become product? A number of projects continue to explore this area. They question what is and is not acceptable if biological material is to be shaped and manipulated as product.

What if… we continued to seed life on other planets?
Currently science is looking both deeper within our own biology, but also broader, back into history and the creation of the universe, challenging someundamental ideas. One particular theory from examining meteorites has caused scientists to speculate that life on earth was seeded from biological material and phosphate from outer space. Michael Burton says that this alters the perception of the universe, not as something hostile but bio-friendly, and redefines us all as astro-biological products, and the universe as a place to incubate life. It's a shift of perception. And with this shift brings new kinds of dreams.

His project, Astronomical Bodies , is a very different proposition to the mechanics of space travel. He thinks it is our human responsibility to continue the process of seeding life in the universe. The human body processes phosphate through urine. When it collects in the body as hard stones, they mirror the forces found in the creation of the universe. That's a profound thought. Phosphate is only beginning to be recognized as precious, and Australia is one of the first places to harvest the mineral rather than flush it away. Michael has been extracting phosphate from his urine to make a meteorite, which he intends to launch in to space to perpetuate life in the universe. The destination, Europa, is the next most likely planet within reach that could support new life.

Michael's proposition is probably the most wondrous and the most philosophical in the exhibition, But the influence of these big and fundamental ideas is evident in the imaginations of many more of the projects you'll see further on in the exhibition.

What if… animal behaviour influenced the design of products?
Slowly scientific ideologies are infiltrating everyday culture, incrementally readjusting who we think we are and our relationship to the universe, to the planet, to other species and we see this in the next cluster of objects. The leather in the Handbags by Wei Wei Chang, is not simply a material to make fashionable shapes. In biology anomalies are part of natural systems, wiping out imperfections is no longer an option: Organic is now a celebration of mutated forms.

What if evolutionary processes and the Life Sciences had been part of the development of digital systems, what kinds of products would have been produced? Perhaps new kinds of product behaviours would have been necessary if products were to survive. In the early days of electronic circuits, dust was the enemy. The Attenborough Design Group produced a radio that could sneeze the dust out and a 'Floppy legs' disc drive that could lift itself up with little legs, away from any harmful liquid, if coffee was accidentally spilt.

This may seem humorous and enchanting, but these objects provide a challenge for the product world driven by economy, utility and built-in obsolescence, They propose a more complex relationship between inanimate domestic objects and their human 'owners', one that promotes product longevity through human attachment.

James Chambers' objects have direct anthropomorphic references that directly press human emotional buttons. Alice Wang uses subtle human behavioural patterns to make that attachment and unpick the universal standardisation of the utilitarian product. One alarm clock only measures the amount of time you want to sleep, disregarding any universal time structures. "Tik Tik Tik" provides a short amount of light, just enough to read a few paragraphs before you drift off to sleep. 'Tyrant' another alarm clock is connected to a mobile phone, and its very personal list of contact numbers, it threatens to embarrass its owner if they don't wake up, by making early morning calls to their friends. And finally, 'Pavlov's Products' reintroduces into the discussion the biological element. The pet dog is trained to be the 'friendly' part of the alarm clock, the part that wakes you up in the

morning. The 'living' component, intrinsically linked to our emotional psychological and biological selves.

### What if... you had to feed your products to keep them alive?
Anab Jain & Alex Taylor take a more visceral approach to 'living' products. A simple radio receives power from a microbial fuel cell, which generates its energy from biological material. It needs to be continuously 'fed' with rotten food, insects and other organic matter, The rather smelly sludge which comes out as a waste product is a rich-micro material which can be then fed to plants, tying it into an ecosystem. The large size of the radio reveals the quantity required to make a sufficient charge to allow theradio to work, which feels disproportionately large for how we expect a radio to be. The messiness, smell and size is the exact opposite of Cai Jiangyu's small delicate 'Laquer' lights, which portray an unfettered magical ideal of 'living'. The lights respond to a persons presence gently illuminating. James Auger & Jimmy L'oizeau want to move from human-centric, to a machine-centric sense of 'living'. Microbial fuel cell technology releases these machines from the tyranny of human imposed hyper-functionality giving them true autonomy. The fly caught in the flypaper provides enough energy to power the motor to turn the wheel, which scrapes off the next fly, which falls into the microbial fuel cell, which then powers the motor again. The only superfluous action is the counter indicating the number of meals eaten: A scant acknowledgement of any kind of human existence, cleverly exploiting human weakness since it knows that we can't help but look at it.

### What if ...our emotions were read by machines?
Many products perpetuate and reinforce a world of function, utility and control. There is very little tolerance for human weaknesses and fallibility. We nurture the ideal of ourselves as super functional beings, in total control of our lives when the reality is much more complex. How far will we allow this ideal to shape our homes and societies? 'Belief Systems', the large film projected at the end of the space, is a playful speculation of finally letting go of our emotional responsibilities to electronic systems. Our emotions are much more transparent than we think. We instinctively and unconsciously react to a whole host of micro expressions in people's faces . And, of course our own micro expressions reveal our own true feelings. These tiny signals can be picked up and analyzed by digital systems. Bernd imagines a number of scenarios where these new technologies take over and our private feelings become public. The scenarios range from processes of retraining our facial muscles to retain our privacy, to the enjoyment of being released from responsibility; in a scenario about shopping for a kettle, the decision is automated, human reaction triggered by instinct is used as a selection mechanism.

It's the same 'emotional intelligence' part that Alice Wang thinks is missing from machines. She views accuracy and precision, which is usually celebrated, as crude and brutal, lacking subtlety and sophistication. But, she does not want to reproduce machine decision-making, she would rather include the human as part of the process. Alice proposes three very different sets of scales. An extra large scale, allows multiple weight readings depending how closely you stand to the display. The decision is left up to the person how accurate they want to be. In the second scale, the readout is placed on the front edge of the machine out of the person's view, it requires a second person to carefully evaluate how truthful to be, and provide an imaginative set of contexts to position that weight reading within, requiring good human emotional management skills. In the third scale there is no reading at all, just an antenna. The reading is automatically sent as a text to another person. Alice leaves it open for us to imagine who we might send it to: A trusted friend? a Heath Authority? a support group? a competition? When information becomes part of a larger network, a whole world of complexity emerges, and with it, a new set of questions. What may seem on first look, to be a simple product, can become a catalyst to trigger a very rich discussion.

### What if... products were designed for complex emotional needs?
The richness and complexity of human need is captured beautifully by Noam Toran in both his films, 'Objects for Lonely Men' and 'Desire Management'. He challenges what we collectively might think of as 'normal'. Men living alone are usually thought of as sad, unhappy, lacking, Noam turns this around to create a whole other world of isolation where men are totally in control and indulge their idiosyncratic desires, happily.

Human desire is a rich, complex and varied area of exploration, and this next group of projects express many conflicting desires: Matt Hope's 'Faraday Suit' emphasises paranoia protecting you from any electromagnetic waves that are now part of everyday places. Page Tsou wants toy guns for children to express more of the real pain that they bring into the world, to break the spell of cinema and TV. Bit Play wants the fiction of TV to be materialized as playful parts of everyday interactions. Matt Hope creates an uncompromising device that produces an intense uncomfortable sound, reacting only to sunlight, it has no controls; only physical removal or covering the units will control it. Cai Cunlei wants all our interactions with objects to inherently promote and produce calm and gentle behaviours.

Conflicting points of view provide energy and texture. Diversity is the ultimate goal, the human imagination expressed in all its multiple ideologies. If we take the biologist perspective, biodiversity is seen as a healthy condition in which the world can flourish and celebrate life. But it's not always so easy to manage.

### What if...creative processes were part of complex discussions?
The internet has enabled a very diverse range of opinions to be expressed, but in certain subjects it's difficult to find balanced dialogues, intense disagreements can produce deep divides.

 'Nuclear Dialogues' is a project that sits within one of these contentious spaces. In the United Kingdom, the subject of nuclear energy is tip-toed around, official agencies are terrified of activists and negative action, while future energy shortages are very real. Nuclear safety, through accident and malicious attack, as well as responsibilities for nuclear waste are very real and difficult issues. The subject is far too delicate for any kind of normal discussion, arguments have become dogmatic and engrained, it's impossible to imagine how a productive conversation might start.

Zoe, however, took a brazen approach. She used 'yellow cake' a term for uranium, which is one of the key constituents in nuclear energy production, to organize a cake baking workshop. Six young scientists, training to work in the nuclear industry discussed baking recipes for 'yellow cake' using a giga counter to measure small amounts of natural radiation given off by bananas and brazil nuts. These cakes

were then used in a 'tea party' to conduct a conversation with local residents living directly next to one of the UK's 10 nuclear plants. A safe space was created where all the main issues were raised. It was a space of hopes and fears, trade offs and compromises. The dishes on the table reveal some of the proposals generated in the workshop.

Design was used as a distraction, an excuse, but underpinning it was an effective framework for a complex discussion.
'Policing Genes' uses a similar distraction method to raise issues about the different ways science can be re-appropriated and exploited by different interests. Thomas Thwaites creates a very ordinary looking documentary, where a police officer, in a very straightforward interview talks about a new police unit which uses bees to reveal the location of illegal pharmaceuticals. But all is not what it seems. Cutting edge genetically modified plant technologies (plant-aceticals) mean that quite complex pharmaceutical products can be grown in familiar plants like potatoes, sunflowers and tomatoes, plants which are regularly grown in ordinary gardens. However, copyright of the plants are owned by large corporations, who want to benefit from their investment. The pollen collected by bees can be analyzed in specially designed apiaries and the location of the pollen is given by the bees 'waggle' dance. The dance tells the other bees the location of the plants: Useful information for the enforcers who can then prosecute the owners.

It all looks so normal on the surface; the ordinary is being transformed into the extra-ordinary. These technologies have the potential to quietly seep into the everyday fabric of everyday lives.

Shing Tat thinks these changes are developing at such an accelerated rate, the difference between generations will be pronounced. His 'Techno Children' shows a world where children will be so advanced, that out of pure necessity, they will end up supervising and managing the elderly.

### What if… domestic products allowed us to fulfill technological dreams?
So what of the next generation? In the face of such pressing issues as climate change, over population, water and energy shortages, it's hard to imagine being idealistic. The technological dreams of the previous generation are almost gone, where will the next dreams come from and what will nourish them?

In this group of projects idealism and realism come together. For these designers experiences are valued above the possession of things. Escapism and fantasy through cinematic effect are not enough. Andrew Friend wants to achieve a school child wonderment. Designed to fit in a rucksack, carried on the back, He has created a series of devices called "The Fantastics" for experiencing something extraordinary. It takes a day to arrive at the foot of the hill, another to walk into the remotest parts. You can just spot him in the photograph swallowed up in the magnificence of the landscape. He stands attached to his device which reaches 6 meters into the air, a zig-zag of metal pressed against his shoulder, if the lightening strikes and he hopes that it will, a zigzag super hero scar will be branded onto his skin as a lasting memory of his experience.

'The device for experiencing the invisible' leaves no indelible mark. It requires the person to seek out sites of increased radio, paranormal, or electrical activity. Again he is expectantly poised in the landscape, an unfolded parabolic dish held around the head, focusing all the electromagnetic energy onto one spot to 'experience the invisible'. The device for disappearing at sea provides another of these extra-ordinary moments, bringing reality and the imagination closer together. A hole in the sea allows for safe disappearance, a watery isolation, very different from the experience on land.

Another opportunity to imagine and enjoy the impossible and unimaginable is provided by quantum physics which suggests the existence of parallel universes. Shing Tat Chung imagines the kinds of artifacts we might find there. while Heng Zhi's water table, under ordinary circumstances might be seem as an impossible object becomes poetic.

And finally Nelly Ben Hayoun magically brings 'Big Science' and what ordinarily might be unachievable into our everyday domestic lives.

'The Soyuz Chair', an adapted domestic armchair, closely reproduces the first moments of take off on a space rocket, only experienced by a very small number of astronauts. She was fascinated by the Large Hadron Collider, the world's highest-energy particle accelerator, larger than a city and wanted to bring this into everyday experience. She designed 'Dark Matter in Your Kitchen Sink', a small modest experiment with the same lofty ambitions as the LHC. Shrunk down and domesticated. 'Sonic boom', another science experiment of equally enormous proportions is built inside a mountain in Japan to understand another phenomena in quantum physics, neutrinos. Here she creates an extraordinary experience with very little means, with silver balloons and a floating boat and convinces a number of eminent scientists to row people across the space while explaining the physics and its significance. And finally she brings the planetary power of an erupting volcano into the living room, by making a smaller version in ceramic for domestic contemplation.

What gathers these last projects in the exhibition together is a sense of the Impossible, and the wondrous scale of ambition they aim for. The human is revealed, finally, as tiny and insignificant in relation to the scale of the planet, humbling, no longer the dominant protagonist at the centre of the universe.

Science and technology are shaping and changing our world, whether we like it or not. And there is room for all types of creative minds in these technological spaces. As you can see from the exhibition Designers have a key role to play as a catalyst for a whole number of different engagements on many different levels. We need to make sure a rich and broad sets of possibilities are imagined, And that these imaginings influence and broaden the eventual outcomes that filter back into our everyday life experiences, so we have a future that we all want, rather than one that we find ourselves within.

The projects in this exhibition are absolutely not about prediction, but asking 'What if…' speculating, imagining, and even dreaming, to create and facilitate reflection on the kind of technologically mediated world we wish to live in. Ideally, one that reflects the complex, troubled people we are, rather than the easily satisfied consumers and users we are supposed to be.

## 假如云朵被人类控制降下冰淇淋，那会是什么样？

微观的纳米技术和以星球为尺度的宏观技术，为人类改造地球环境和气候提供了新的可能。这些进展是从一个梦想出发的。如果云彩可以降下冰激凌那该是什么样？这一想法促使科学家们进行了一系列实验，试图通过改变云的成分来制造新的美味的感官享受。

以冰激凌为引子，云计划的主旨是吸引人们走进纳米冰激凌贩卖车，体验并想象科技前沿成果——微观的纳米技术和以星球为尺度的宏观技术——被应用于现实的情形。

## What if... clouds were geo-engineered to snow cream?

Developments in nanotechnology and planetaryscale engineering point to new possibilities for us to conform the global environment to our needs. These advances combined with a dream to make clouds snow ice cream inspired a series of experiments that look at ways to alter the composition of clouds to make new and delicious sensory experiences.

Using ice-cream as a catalyst for dialogue, the project's focus is to welcome people into a nano-ice cream van and allow new audiences to experience and imagine emerging scientific developments and their consequences.

云计划，2009
佐伊·帕帕佐普洛卢（英国）
凯瑟琳·克莱默（英国）
© Zoe Papadopoulou

**The Cloud Project—Nano Ice cream van,**
2009
Zoe Papadopoulou (UK)
Cathrine Kramer (UK)
© Zoe Papadopoulou

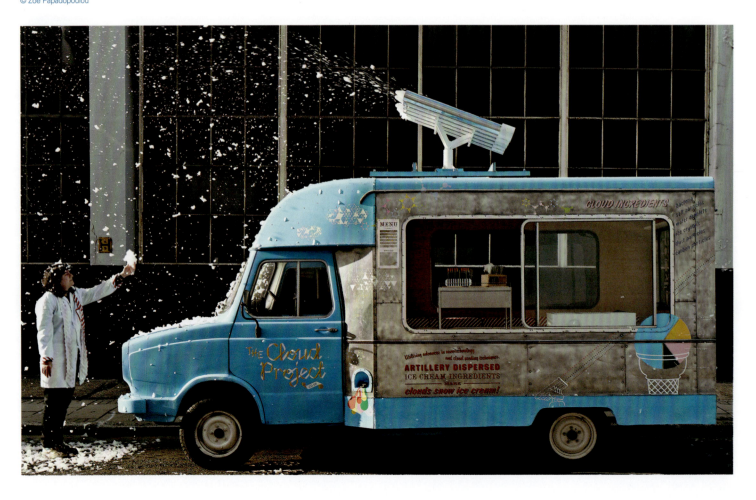

## 假如我们能够培植出会发声的植物，那会是什么样？

近期，有关基因工程的讨论主要集中在几个重要问题上，如食物、医疗和环境。然而，我们对自然的改造已经进行了几千年，目的不仅仅是为了满足基本的生存需求，也为了满足许多不合理的欲望。我们爱慕美丽的花朵，种植具有致幻效用的植物还会因武士蟹的纹路像人的脸而将其扔回海中。我们与自然的互动既是功能性的也是情感的、审美的及文化的。基因工程往往被看做是一个新兴的独立领域，于是我们可以选择是否深入其中。但如果将它视为人与自然复杂关系的延续时，其重要性使得科学家们更有兴趣投入这一领域。

我们希望自然生产那些能够带来审美享受的事物，无论它们是否符合自然规律。因此，我们的情感与信仰影响着周围的生态环境，并将道德意义赋予这些"自然的"事物。以获利十亿美元的园艺产业为例，大量的基建工程和资源被用于设计美丽的富有文化意味的产品。

这个项目展示给人们一座理想中的听觉花园，它是一个以娱乐为目的的受控的生态系统，并最终探究人与自然在文化和审美上的联系及其在人工生物时代的发展前景。

## What if... we could design plants to make sounds?

The debate around Genetic Engineering is currently centered around vital issues such as food, healthcare and the environment. However, we have been shaping nature for thousands of years, not only to suit our needs, but our most irrational desires.

We admire beautiful flowers, cultivate mind-altering weeds and put samurai crabs back into the ocean if their shell resembles a human face. Our interactions with nature are not only functional, but emotional, aesthetic and cultural.

Genetic engineering is often being presented as a new and separate space, which we can choose to enter or not, when it seems more relevant and interesting to consider it a continuation of our complex relationship with nature.

We encourage nature to produce the things we find aesthetically pleasing, wether they are in its best interest or not. Our emotions and beliefs therefore have consequences on the ecosystems around us, and on the moral value we put on 'natural' things. The billion dollar cut-flower industry for example, dedicates tremendous amounts of infrastructure and resources to designing and growing objects of beauty and cultural meaning.

By presenting a fantastical acoustic garden, a controlled ecosystem of entertainment, this project aims to explore our cultural and aesthetic relationship to nature, and to question its future in the age of Synthetic Biology.

1. 弦坚果和虫子被定制成能进行有韵律的咀嚼。
   String-Nut and bugs engineered to chew in rhythm.
2. 唱歌的花朵：因为寄生物为了自身的目的吸取植物的能量，只有很小的花才能生长起来。
   Singing Flower: Because the parasite diverts the plant's energy for its own purposes, only small flowers manage to grow.
3. 这个装置展示了一个在一年的时间中被基因工程定制的声音花园。
   An installation showing a genetically engineered sound-garden over the course of one year.

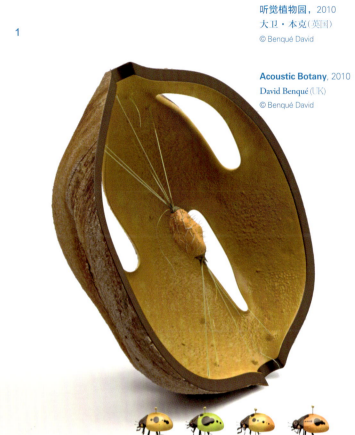

1  听觉植物园，2010
大卫·本克（英国）
© Benqué David

**Acoustic Botany**, 2010
David Benqué (UK)
© Benqué David

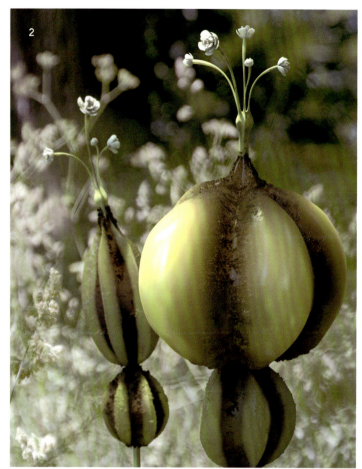

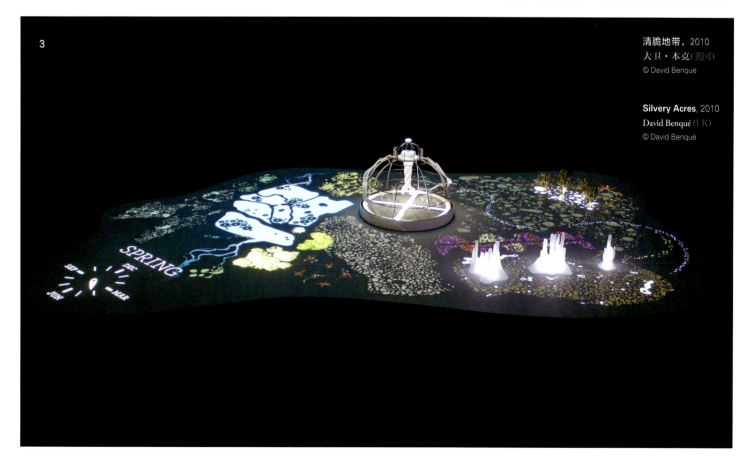

3  清脆地带，2010
大卫·本克（英国）
© David Benqué

**Silvery Acres**, 2010
David Benqué (UK)
© David Benqué

假如植物能造就我们的城市，那会是什么样？

该主题取"桃花源记"之意境，以长株潭城市群"两型"社会实验区为背景，演绎未来自然、生态新型城市的构想。以"师法自然"来实现"天人合一、返璞归真"的东方和谐自然城市生活的人文理想意境。用人类的智慧和理性来实现人与自然、与城市完美融合，以达到原生态和大都市和谐统一的梦想，推出自然生态"都市桃花源"的概念。

## What if... plants shaped our cities ?

Taking "Peach Blossom Spring" (the utopia in Chinese culture) as the conception, and ChangZhuTanCity Cluster "Two Types" social experiment as the background, the theme presents the natural interpretation of the future and the new eco-city concepts. Using "imitate nature" to achieve the ideal humanistic of the oriental harmony natural city life: " harmony between the heaven and human, back to nature."Using human intelligence and reason to achieve the perfect combination of human, nature, and the urban, so can reach the dream of ecological life and big cities as harmony and unity, and introduce the natural ecology "the Utopia GardenCity " concept.

桃花源里，2010
鲁晓波（中国）
© Lu Xiaobo

**Xanadu**, 2010
Lu Xiaobo (China)
© Lu Xiaobo

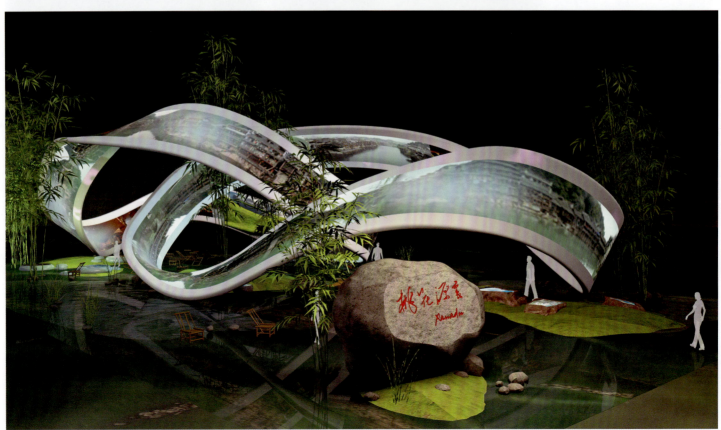

假如工业产品可以种植而不需制造，那会是什么样？

由于能源价格飙升导致全球原材料及包装产品运输成本高不可攀，只有富人能继续消费大批量生产的传统商品。现在，合成生物学使人们可以利用自然环境生产这些产品了。通过对植物的DNA编码，工业零部件能在植物结构的支撑系统中生长。当植物成熟，它们就会像剥核桃、掰玉米般被分离出来，等待组装。商店也转变为农业工厂，经审批的产品长出即可在原地出售。大部件生长慢且成本高，小的则廉价许多。邮递服务商会将重量轻的种子配送到国内各大制造商。

以生物学方式生产消费品，颠覆了标准化工业生产的观念，将多样性与弹性引入传统重工业的领地。

本项目展示在人们面前的是除草剂喷雾器，这种精致的园艺机器如今反过来从植物中生长出来。

**植物装配线**，2009
亚历桑德拉·黛西·吉恩斯伯格，
萨沙·奥弗里皮等（英国）
© Alexandra Daisy Ginsberg

## What if... we could grow products instead of manufacturing them?

After the cost of energy had made global shipping of raw materials and packaged goods unimaginable, only the rich could afford traditional, mass-produced commodities. Synthetic biology enabled us to harness our natural environment for the production of things. Coded into the DNA of a plant, product parts grow within the supporting system of the plant's structure. When fully developed, they are stripped like a walnut from its shell or corn from its husk, ready for assembly. Shops have evolved into factory farms as licensed products are grown where sold. Large items take time to grow and are more expensive while small ones are more affordable. The postal service delivers light-weight seed-packets for domestic manufacturers.

Using biology for the production of consumer goods has reversed the idea of industrial standards, introducing diversity and softness into a realm that once was dominated by heavy manufacturing.

The product shown here is the Herbicide Sprayer, an essential commodity to protect these delicate engineered horticultural machines from older nature.

**Growth Assembly**, 2009
Alexandra Daisy Ginsberg,
Sascha Pohflepp, ect. (UK)
© Alexandra Daisy Ginsberg

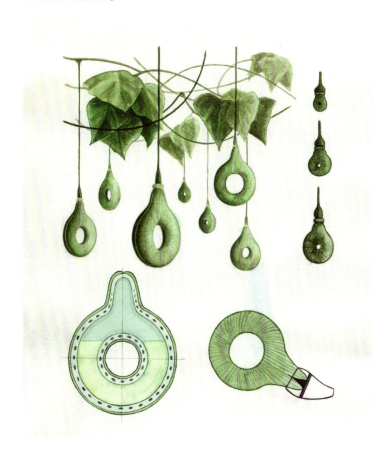

假如人们利用纳米技术能随心所欲地改变物体的形状和作用,那会是什么样?

这个项目更侧重发掘纳米技术的深层潜力和创造出更多的操控蓝本,如有机电子产品,而不是当前的纳米技术的发展,比如创造出更轻、更坚固的材料。有机计算会是怎样的呢?我们和这些产品的关系又会如何变化呢?带有生物传感器的有机电子产品会为感性和诗意的设计提供新的可能吗?种子包含着长成设备联网的有机体系和运算法则需要的材料和信息。使用这些种子作为智能微尘的模仿,这使得人们能很容易地看到新的互动,比如打破、共享、弃置、挖掘数据。这些新式的互动不仅产生新的行为,还重新定义了电子产品现有的思维定势。

## What if... nanotechnology allowed objects to change shape and function as needed?

Rather than focusing on the current development of nanotechnology, such as creating lighter and stronger materials, this project focuses on exploring its potential further, creating more manipulative prototypes such as organic electronics. What does organic computing look like and how will our relationship with these products change? Can organic electronics with biosensors open up new possibilities for sensual and poetic designs? Seeds contain material and information needed to grow organisms as well as algorithms for device networking. Using seeds as a simulation for smart dust, it allows one to easily visualize new interactions such as breaking, sharing, throwing away and mining data. These new interactions not only generate new behaviours but also redefine existing stereotypical electronic products.

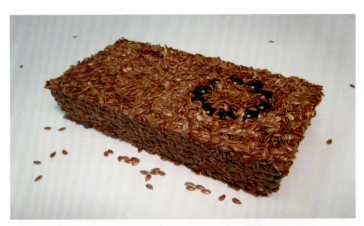

新感官联结,2007
克里斯·沃肯(美国)
© Chris Woebken

**New Sensual Interfaces**, 2007
**Chris Woebken** (USA)
© Chris Woebken

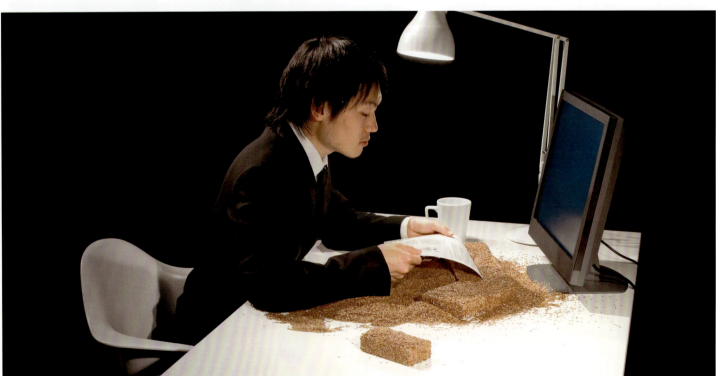

## 假如养猫的人被看做是科学家，那会是什么样？

本次展出的作品是艺术家妮娜·波普与卡伦·格思里"爱猫俱乐部"项目的一部分。三年多来，他们对养猫的人进行追踪，探究他们复杂的、创造性的通常又是科学的世界。

除在饲养者家中观察实用遗传学外，他们还联系遗传学实验室，寻找"草根科学"的猫咪饲养与"专业"科学有何相似之处。他们还采访对特种饲养发展有重要贡献的饲养者，以及美国顶尖猫科遗传学家莱斯利·里昂。里昂是遗传研究的积极倡导者，他与全世界的饲养人保持紧密的联系，借他们的观察与实验充实自己的研究。

波普－格思里设计组常与兴趣小组、专业——业余互助组合作，并对知识源自实际"制作"和观察这一现象颇为好奇。他们希望通过该项目表达一种观点，即遗传学是可以通过豢养宠物这样直接可及的方式与人们相关联。

## What if... cat breeders were seen as scientists?

The works exhibited have been developed as part of Cat Fancy Club an ongoing project by artists Nina Pope & Karen Guthrie. Over three years they have been following cat breeders exploring their complex, creative and often scientific world.

As well as exploring genetics at work in the breeders homes they have been making links to genetic laboratories to see how the 'citizen science' of cat breeding connects to 'professional' science. They have interviewed breeders key to the development of specific breeds, and top US feline geneticist Dr Leslie Lyons. A charismatic advocate for genetic research Leslie maintains close contact with breeders worldwide to fuel her research through their observations and experimentation.

Pope & Guthrie have a track record of working with hobby or 'pro-am' groups and are particularly interested in ways that knowledge can be generated by actual 'making and doing' combined with close observation. Through this project they hope to show that genetics can be approached in a very direct way through something as accessible as the family pet.

爱猫俱乐部，2010
妮娜·波普，卡伦·格思里(英国)
© Nina Pope Photo:Theo Cook

**Cat Fancy Club**, 2010
Nina Pope, Guthrie Karen (UK)
© Nina Pope Photo:Theo Cook

**假如市民科学能推动基因技术发展，那会是什么样？**

城市如同一个巨大的、极其复杂的新陈代谢体。与之相比，人类不过是沧海一粟，虽然渺小但本质上与这个未知的庞大有机体紧密相连。未来生物技术也会以这个复杂结构为终结。该项目旨在利用野生鸽群为合成生物学在城市环境下构建平台和连接点，最终成果则是具有去污功能的鸽子粪便。

通过改变鸽子的新陈代谢，尤其是改变它们体内的细菌，合成生物学或许能使我们赋予这些常被称作飞天老鼠的鸽子们一点新功能。设计师会给鸽子喂食特制的细菌，它们能使粪便变成去污剂。就像酸奶对人类无害一样，细菌对鸽子也是无害的。

在控制鸽子排泄物及设计适当的建筑连接口的过程中，该计划探究生物学设计的一系列影响，包括伦理的、政治的、实用的以及审美诸方面影响。

这个装置使鸽子成为你房子的一部分，建筑的一部分。鸽子笼镶在窗台上，这样人们可以（以特定的细菌）通过不同的出口喂养和选择分离鸽子，帮助准备城市消毒。

这个物件是鸽子和停车的合成界面。它可以捕捉并且喂养鸽子特定的细菌，鸽子的排泄物在这种细菌的作用下变为挡风玻璃的清洁剂。在这个物件中，特别设计的细菌产生的脂肪酶可以降低ph值，以此来清除挡风玻璃上的污渍和尘土。

**What if... Citizen Science contributed to genetic advances?**

The city is a vast and incredibly complex metabolism in which the human species is the tiniest of fractions; tiny and yet intrinsically linked into an organic embroidery beyond our understanding. It is within this complex fabric that (future) biotechnologies will end up. Pigeon d'Or proposes the use of feral pigeons as a platform and interface for synthetic biology in an urban environment by attempting to make a pigeon defecate soap.

By modifying the metabolism of pigeons - specifically the bacteria that live in their gut - synthetic biology might allow us to add new functionality to animals that are commonly condemned as being "flying rats", The pigeons would be fed a specially designed bacteria that turns faeces into detergent and is as harmless to pigeons as yoghurt is to humans.

Through the pursuit of manipulating pigeon excrement and designing appropriate architectural interfaces, the project explores the ethical, political, practical and aesthetic consequences of designing biology.

This object is an interface between pigeons and a parked automobile. The object traps the pigeons and allows to feed them bespoke bacteria that turn their faeces into windscreen soap.

This contraption allows pigeons to become part of your house, part of the architecture. The pigeon house is attached to the windowsill and allows one to feed pigeons (a selected bacteria), separate and select them and direct them through different exits, facilitating bespoke urban disinfection.

鸽群制药集团，2010
图尔·凡·巴伦（英国）
© Tuur Van Balen

**Pigeon d'Or**, 2010
**Tuur Van Balen** (UK)
© Tuur Van Balen

假如你能为自己诊病开方，那会是什么样？

合成生物学的巨大潜能使医疗保健变得更私人化、开放化，这或许能让我们为自己看病开药，并及时监控、调解自己的身体。通过将新陈代谢过程交付体外微生物处理，我们甚至能把免疫体统外部化、具象化。这些微生物，如酵母菌，可以感应并诊断身体异常，相应地合成、释放化学物质进行治疗。

人造免疫系统能根据一个人的基因情况、年龄、生活方式以及患病风险做出调整以适应使用者。

人造免疫系统是酵母菌制成的生物探测器系统。每个导管中放有不同的酵母，为特定的人探测特定的身体异常情况，它们还有助于分解乳糖、咖啡因或其他成分，检测维生素缺乏症或疾病，并生成相应的化学物质或药物。选择生物探测器要根据个人基因状况、生活方式及预期疾病等因素决定。

## What if... you could be your own doctor and pharmacist?

Synthetic Biology's potential to make healthcare more personal and participatory might turn us into our own doctors and pharmacists; constantly monitoring and tweaking our body. It might even allow us to externalize our immune system by outsourcing metabolic processes to external micro-organisms. These micro-organisms, for instance yeasts, sense and diagnose anomalies in our body to produce and deliver chemicals accordingly.

Such a Synthetic Immune System would be tailored to one's genetic predisposition, age, lifestyle and therefore risk.

This synthetic immune system is a network of biosensors, made of yeast. Each vessel contains a different yeast, designed to monitor a specific anomaly for a specific person; helping break down lactose, caffeine or other ingredients, detecting vitamin deficits or diseases and producing chemicals or drugs accordingly. The selection of biosensors is personal and relies on one's genetic predisposition, lifestyle and fears.

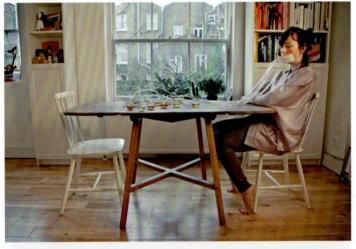

虚拟免疫系统，2010
图尔·凡·巴伦（英国）
© Tuur Van Balen

**Synthetic Immune System**, 2010
Tuur Van Balen (UK)
© Tuur Van Balen

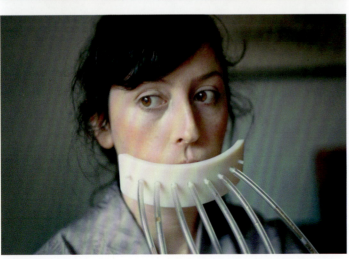
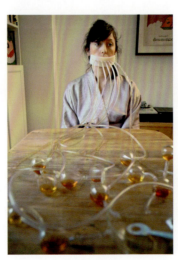
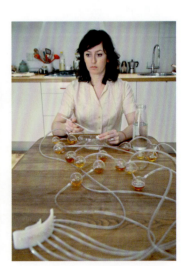

### 假如我们可以通过烹饪调节忧郁情绪，那会是什么样？

生物工程如合成生物学能为我们提供有关人体新陈代谢的详细信息，并建立起与身体的新联系。该项目将这种联系以烹饪的新形式展现出来，在特定时间为特定对象调节情绪。

"黑胆汁"项目为控制忧郁情绪提供了新配方。利用人工生物技术改造酵母菌，使其检测血液中的化学物质，相应地调节血清素浓度，最终降低或升高忧郁程度。为了达到这一目标，这场情感调节盛宴的菜肴将会是一条水蛭，只不过它要先吸饱用餐者的血。为了让水蛭生活在人的前臂上，设计师专门制作了一个装置。水蛭饱餐后会被烹制成鲜血慕斯，配以牡蛎蘑菇、红浆果酱及血酸模。

该食谱是受希波克拉底影响产生的，他的四体液学说认为人体由血液、黏液、黄胆和黑胆四种体液组成。这一理论催生了一种普遍的医疗手法即放血疗法，通过平衡四种体液来保持生理、心理的双重健康。每种体液对应一类气质，黑胆质是四种体液中最变幻无常的一个，能引起忧郁情绪。该项目旨在探索古代思想与未知世界、谬论与科学、厨房与药房之间的关系。

### What if... we could use cooking to adjust our feeling of melancholy?

Biotechnologies like synthetic biology can give detailed insight into our metabolic processes and introduce new interactions with our body. In this project, these interactions are proposed as a new form of cooking, to tailor an emotional experience for a specific person at a specific time.

Cook Me - Black Bile proposes a recipe for controlling the feeling of melancholy. Using synthetic biology, bespoke yeasts are designed that measure chemicals in the blood and alter levels of serotonin accordingly, making one feel less or more melancholic. To do so, the dish is cooked from a leech that has first fed itself on the body. An instrument specially designed for this recipe allows the leech to feed on the forearm and is then used to cook a blood mousse from the parasite's body. The blood mousse is accompanied by oyster mushroom, a redcurrant sauce and blood sorrel.

The recipe is inspired by Hippocrates, Ao Four Humours theory that sees the body as an entity comprised of four basic substances: yellow bile, blood, phlegm and black bile. This theory inspired bloodletting: a common medical practice aimed at restoring both physical and mental health by bringing these bodily fluids back into balance. Each substance is linked to a specific temperament, black bile, the fictional of these four fluids, evokes the humour of melancholy. This work examines the space between ancient beliefs and future unknowns, between nonsense and science, the kitchen and the pharmacy.

黑胆汁——情感调节盛宴，2011
图尔·凡·巴伦（英国）
© Tuur Van Balen

**Cook Me - Black Bile**, 2011
Tuur Van Balen (UK)
© Tuur Van Balen

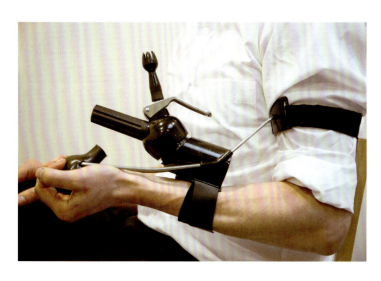

假如昆虫能帮助我们诊断病情，那会是什么样？

科学研究证明蜜蜂具有超凡的灵敏嗅觉。

在几分钟内，通过巴普洛夫的反射训练他们就可以给患者进行一次体检，主要方式是检测人呼吸中的某些特殊气味。

蜜蜂计划是替代性诊断系列中的一项，它利用蜜蜂对多种疾病进行精确的初期筛查。该计划旨在以当下的科技研究为基础，进一步发展，将其成果以设计的形式纳入实用系统，从而易于大众理解与使用，最终显著地改变我们的日常生活。

## What if... insects could help us diagnose illness?

Scientific research demonstrated that bees have an extraordinarily acute sense of smell.

They can be trained, within minutes, using Pavlov's reflex to perform a health check by detecting a specific odour in peoples' breath.

The "BEE'S" project consists in a series of alternative diagnostic tools that use bees to diagnose accurately at an early stage a vast variety of diseases.

The aim of this project is to develop upon current technological research by using design to translate the outcome into systems and objects that people can understand and use, engendering significant adjustments in their lives.

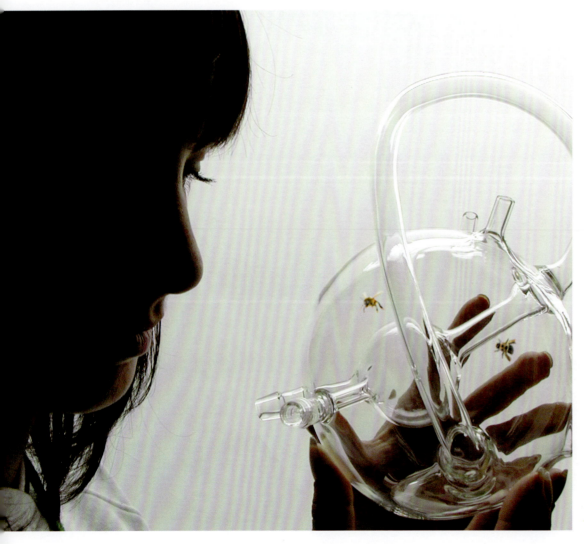

蜜蜂，2011
苏珊娜·索尔斯（英国）
© Susana Soares

**Bees**, 2011
*Susanna Soares* (UK)
© Susana Soares

假如消化系统被改造，从前不能吃的植物也能被消化，那会是什么样？

全球食品储备告急，据联合国通告，未来40年粮食生产必须增加70%才能缓解危机。但人口膨胀、资源枯竭的情况仍在继续，人们对警告漠不关心，继续着非可持续发展道路。

在该项目中，邓恩和拉比小组尝试以革命性方式和分子技术力挽狂澜。他们假设政府与工业无法解决这一难题，民众团体必须靠自己的知识主动建立个人应对方案。

目前，我们尚未获得改造自身的能力。但受其他哺乳动物、鸟类、鱼类及昆虫的消化系统启发，一些新型的消化装置已在研发。如果我们将这些装置与人工生物学结合，最终能从那些非人类食品中提取营养物质，粮食危机会有所好转吗？

因此，一些人决定将命运掌握在自己手中，他们开始自己组装设备。凭借合成生物学，他们制造出所谓"微生物式胃部细菌"，再辅以电子、机械设备，最大限度摄取城市环境能提供的营养成分，应对任何可能出现的渐进式食物短缺。这些人就是新的城市拓粮者。

## What if... we could alter our digestive system to eat plants we can't normally eat?

The world is running out of food – we need to produce 70% more food in the next 40 years according to the UN. Yet we continue to over-populate the planet, use up resources and ignore all the warning signs. It is completely unsustainable.

For this project Dunne & Raby look at evolutionary processes and molecular technologies and how we can take control. The assumption is that governments and industry together will not solve the problem and that groups of people will need to use available knowledge to build their own solutions, bottom-up.

So far we have not really embraced the power to modify ourselves. What if we could extract nutritional value from non-human foods using a combination of synthetic biology and new digestive devices inspired by digestive systems of other mammals, birds, fish and insects?

As such, a group of people take their fate into their own hands and start building DIY devices. They use synthetic biology to create "microbial stomach bacteria", along with electronic and mechanical devices, to maximize the nutritional value of the urban environment, making-up for any shortcomings in the commercially available but increasingly limited diet. These people are the new urban foragers.

拓粮者，2009
安东尼·邓恩，菲奥娜·拉比（英国）
© Anthony Dunne&Fiona Raby

Foragers, 2009
Anthony Dunne & Fiona Raby (UK)
© Anthony Dunne&Fiona Raby

假如我们能重新设计牙齿使其倾向于素食主义，那会是什么样？

牙齿是摄取营养的重要工具。它们的形状与一个人的饮食密切相关。

最近的研究显示食用肉类对全球变暖的影响，肉类生产的气体排放量约占总量的五分之一。联合国呼吁公众彻底地改变饮食习惯，称这对我们自身的健康及整个地球都将是有益的。

例如，食草动物的牙齿结构有助于咀嚼植物，这反映了它们的食物偏好。

我们的牙齿结构是否能进行类似的替换，以强化我们的饮食偏好？

**What if... we could redesign human teeth to encourage vegetarianism?**

Teeth are an essential tool for nutrition. Their shapes are related to each ones diet.

Current research point out the effects of eating meat for global warming, estimating that meat production accounts for nearly a fifth of gas emissions. Recently the UN appealed for a radical shift in diet, describing that couldn't only be good for our health but for our planet in general.

Herbivores animals, for example, have developed teeth structures that reflect their feeding preferences and facilitate in this case the consumption of plant material.

Can our teeth structure be replaced in order to reflect those dietary shifts, enhancing our dietary preferences?

素食主义牙齿，2008
苏珊娜·索尔斯(英国)
© Susana Soares

**Vegetarian tooth**, 2008
Susanna Soares (UK)
© Susana Soares

假如人类的身体组织可以被制成物品，那会是什么样？

体外培养的骨骼很快将被用于复原手术。随着应用过程的不断完善，对这一技术的展望刺激人们开发它的其他用途。生物饰品就是其中之一，它为情侣们提供了象征爱情的新饰物。

生物医学工程师、设计师以及临床医生为情侣们拔除智齿，并在伦敦Guys医院的实验室中培植其骨骼，最终将它们做成戒指。制作过程中，骨骼将镶嵌少量银。

生物饰品项目的目的在于引起人们对个人感情与科学研究之间关系的思考。

## What if... human tissue could be used to make objects?

Bone tissue cultivated outside a patient's body will soon be used in reconstructive surgery. As the process behind this application develops, the promise of the technology provokes curiosity and speculation about alternative uses. Biojewellery explores such an alternative, providing couples with a symbol of their love.

Biomedical engineers, designers and clinicians created rings for couples. Bone tissue was cultured in a laboratory at Guys Hospital in London, using cells from chips of bone donated by the couples during wisdom tooth extractions. The bone was combined with silver to create the rings. Biojewellery hopes to raise questions about the relationship between individual ambitions and scientific research.

生物饰品，2003—2007
托比·克利奇（英国）
© Tobie Kerridge

**Biojewellery**, 2003-2007
Tobie Kerridge (UK)
© Tobie Kerridge

假如人体能发电，那会是什么样？

发电阑尾是一个植入人体的人造器官，它使人成为能发电的有机体。设计师观察到电鳗利用发电细胞从腹部产生电流，由此受到启发，发电阑尾亦由人造细胞组成。这种细胞模仿并改进发电机制，将血糖转化为电能。

除替代人体自身退化的阑尾外，该人造器官还为人体带来新的功能，赋予人类靠自身发电并控制这种能量的能力。以新功能取代多余的生理结构残余，人体被重新设计以支持新的生活方式。

## What if... the human body could generate electricity?

The Electrocyte Appendix is an artificial organ that could be implanted into the body to allow people to become electric organisms. Inspired by the electric eel and the way it uses electrocyte cells to produce electrical current from its abdomens, the organ is constructed of artificial cells* that mimic and improve the electrocyte mechanism by converting blood sugar into electricity.

Replacing the vestigial appendix, the artificial organ brings a new functionality to the human anatomy, giving humans the ability to farm and produce electricity directly from their body. By discarding the remains of redundant anatomical functions in favor of new abilities, the body is redesigned in order to sustain its new way of living.

发电的阑尾，2009
莉微·科恩（英国）
© Revital Cohen

**Electrocyte appendix**, 2009
Revital Cohen (UK)
© Revital Cohen

假如我们可以通过气味找到人生的最佳伴侣，那会是什么样？

嗅觉直到最近才受到人们的重视。一直以来，嗅觉遭受学者们的轻视，这是受到18、19世纪科学家和哲学家对各种感觉进行评估的影响。当时，人们认为嗅觉是低等级、原始的、未完全进化的朴素感觉。这种认识导致针对嗅觉器官的研究远远落后于对视觉、听觉等更高级别感观的研究。近期，这种情况终于得到改善。研究显示，嗅觉对我们起着多方面的复杂影响。

这一项目探究人类嗅觉的经验性潜质，将当代科研成果应用到家庭和社会问题的研究中。其主要观点是，嗅觉这一复杂的感官在接受与释放过程中需要一定程度的控制。在诸多试验场景中，气味成为人们接受到的唯一信息，而嗅觉独特的影响力和巨大的潜力也由此凸显出来。

## What if... we could use smell to find the perfect partner?

Smell has been until recently a neglected sense.

The current low status of smell is a result of the revaluation of the senses by the philosophers and scientists of the 18th and 19th centuries. Smell was considered lower order, primitive, savage and bestial. This reputation led to a lack of research on the olfactory system as effort was concentrated on the 'higher' senses of vision and sound. Recently this has begun to change and it has been discovered that smell affects us in many complex ways.

This project explores the human experiential potential of the sense of smell, applying contemporary scientific research in a range of domestic and social contexts. The design concept acknowledges that smell is a complicated sense requiring a level of control for both input and output emissions. This control is then applied to several situations exploring the possibilities and potential of smell as raw information.

气味相投，2007
詹姆斯·奥格（英国）
© James Auger

**Smell +**, 2007
**James Auger** (UK)
© James Auger

假如基因知识能够改变我们的行为，那会是什么样？

随着基因信息技术的应用推广，身体与个性是基因的外在表现这一观点也愈发流行。这种自我认识不仅可以重建家庭关系，而且对责任、风险、自主等概念提出挑战。

如同癌症基因那样，金银财宝按惯例作为遗产代代相传。在药物中，特别是抗癌药中添加贵金属的新做法更是将实物遗传与基因遗传对应起来。

本项目中一系列探索性的"传家宝"，一方面基于微金颗粒在医疗领域的应用，另一方面也是对基于基因责任的新道德准则的回应。在此范围内，每件作品针对一个问题，主要集中在基因知识对情感及心理的潜在影响上。

对基因缺陷的理解如何改变我们的行为？新材料能否对我们的道德、社会结构产生影响？

干预治疗仪：此"传家宝"旨在将父母塑造为负责任的、对自然规律有完全掌控的个体。它包括在家庭内部遗传的液态金，可以测量、混合并管理富含微金颗粒的化疗设备以及一个旨在营造抗癌环境的界面。

愧疚调节仪：此"传家宝"是为那些未继承基因突变的孩子设计的，因为他们总感觉被排斥在家族叙事的主干之外。该仪器的功能类似治疗医疗焦虑的安慰剂，带给使用者一种循环：交替服用胶状金质毒物及其解药。这种循环可以根据愧疚的程度不断重复下去。

## What if... genetic knowledge changed our behavior?

With the increased availability of genetic information, the view of our body and identity as a sequence of genes is becoming prevalent. This perception of ourselves has the power to reconstruct our familial relationships and challenge our conception of responsibility, risk and autonomy.

Gold and silver, much like a number of genetic cancers, are traditionally passed down the generations as inheritance. The emerging use of precious metals in medicine and especially in cancer treatment draws parallels between material heirloom and genetic ancestry.

This series of speculative heirloom objects is based on the medical applications of nanogold particles and responds to the new moral codes of genetic responsibility. Each object address a certain issue within this context; focusing on the emotional and psychological implications of genetic knowledge.

How does the comprehension of genetic vulnerability change our behavior? Can new materials have an effect on our morals and social structures?

INTERVENTIONIST HEALER The intent of this heirloom is to portray the parent as a responsible individual who is in full control over natural law. It contains the dissolved family gold, the equipment needed to measure, mix and administer nanogold-enriched chemotherapy cycles and an interface which aims to make the surrounding environment counter-cancerous.

GUILT ADJUSTER This heirloom is given to the child who did not inherit the genetic mutation and feels excluded from a substantial part of the family's narrative. The object functions as a placebo for medical turmoil, presenting the user with a cycle: colloidal gold poison, alongside the antidote. To be repeated for as many cycles as the level of guilt demands.

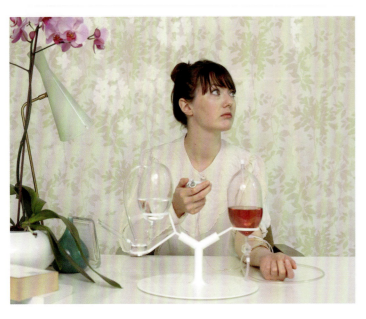
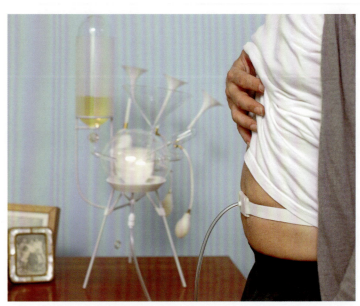

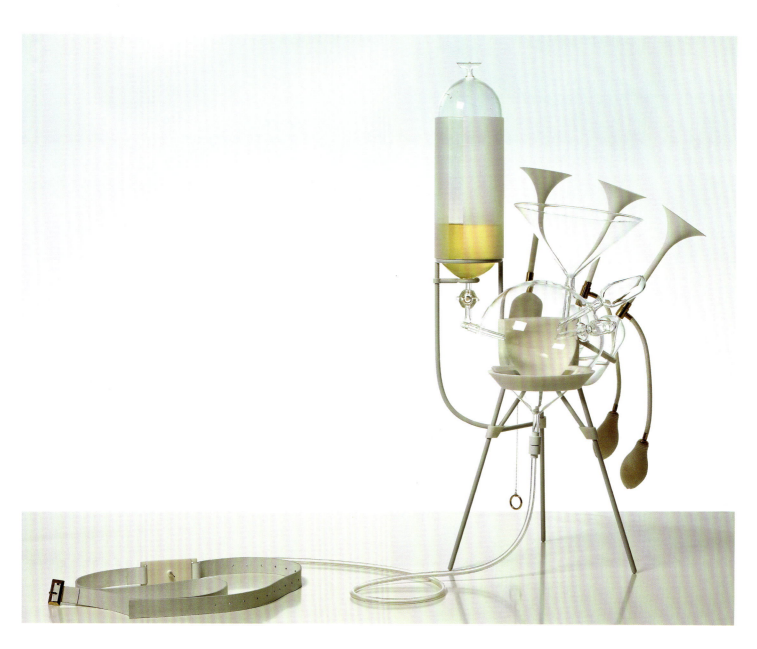

**基因传家宝**,2010
莉薇·科恩(英国)
© Revital Cohen

**Genetic Heirloom**, 2010
Revital Cohen (UK)
© Revital Cohen

假如动物被用作生命维持机,那会是什么样?

与电脑控制的机器不同,导盲犬及精神慰藉猫咪等小动物可以和它们援助的患者建立一种自然的互助关系。那么,这些动物能否转化为医疗设备呢?

这一项目计划将人类豢养的动物作为患者的同伴以及替代器官的提供者。这些动物或许是人们出于商业目的、食用目的或是娱乐意图而被饲养的。设计师将转基因农场中的动物或是退役的工作犬用作肾病和呼吸病患者的生命维持机,这实是在冰冷的医疗器械治疗外了增添了一个温情的选项。

但转基因动物能否像整套器械那样工作,而不是仅仅发挥局部的功能?人类又能否成为依靠其他生物生理功能生活的寄生者呢?

## What if... animals were used as life support machines?

Assistance animals - from guide dogs to psychiatric service cats - unlike computerised machines, can establish a natural symbiosis with the patients who rely on them. Could animals be transformed into medical devices?

This project proposes using animals bred commercially for consumption or entertainment as companions and providers of external organ replacement. The use of transgenic farm animals, or retired working dogs, as life support 'devices' for renal and respiratory patients offers an alternative to inhumane medical therapies.

Could a transgenic animal function as a whole mechanism and not simply supply the parts? Could humans become parasites and live off another organism's bodily functions?

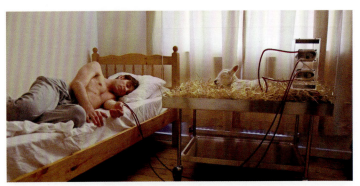

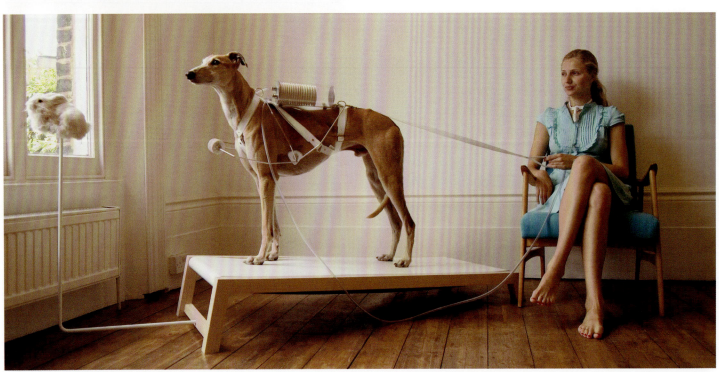

生命维持机,2008
莉薇·科恩(以色列)
© Revital Cohen

**Life support**, 2008
**Revital Cohen**(Isreal)
© Revital Cohen

假如头发与人体分离后仍然持续生长,那会是什么样?

你想在身后仍为人怀念的愿望有多强烈?

你的生活中是否有舍不得分离的人?

随着生物技术的飞速发展,我们现在终于有机会重新诠释自身与生死间的关系。"回光返照"展现了人类与死亡交汇的新场景,这种交汇使日常怀念仪式中追忆故去挚爱这一愿望成为现实。借用维多利亚时代结发的形式,脱离人体的头发继续生长与人们与日俱增的怀念之情两相契合。对逝者的回忆也因头发的情感质量(气息、质感、长度、颜色和风格)不断延续。

## What if... hair continued to grow separated from the person?

How would you like to be remembered after death? Is there anyone in your life you just can't live without?

With the burgeoning possibilities of biotechnology we have the opportunity to readdress our relationship with life and death. Memento Mori In Vitro presents a vision of a new association with death whereby a daily ritual and form of remembrance of a past loved one is imagined. With reference to the Victorian tradition of locks of hair worn in pendants, the act of sustaining disembodied hair growth of the dead presents a new encounter with remembrance. The memory of the person is further heightened by the emotive qualities of hair; it's smell, texture, length, colour and style.

回光返照,2006
迈克尔·伯顿(英国)
© Michael Burton

**Memento Mori In Vitro**, 2006
Michael Burton (UK)
© Michael Burton

**无所不能的物理,** 2009
奈丽·本·哈尤恩(英国/法国)
© Nelly Ben Hayoun

**The Physics of the Impossible**, 2009
Nelly Ben Hayoun (UK/France)
© Nelly Ben Hayoun

**假如科学能被改造并满足诗意的、创造性的需求,那会是什么样?**

该项目聚焦当代物理学,立足于科学与科幻的交汇处,考察我们对现实与科学潜能的认知。这一介于科学与科幻之间的空白领域不仅引人遐想,更能激发梦想,推动尖端实验。在这里,你会成为业余制造者,有权决定什么是可能的、什么是可信的,以及什么是另类的。你也可能是客厅中的宇航员,在厨房里从鸽子卵中生成暗能量或是在浴室里进行原子对撞。该项目试图讲述在家中制造未知事物的体验,尤其是这一体验在超现实层面的意义。

在荒谬和事实之间,我希望引发人们对科幻与"核心"科学之间界限的讨论,这也是一个平台,使业余爱好者的激进实验变"不可能"为可能。如同"想象力工具"那样,"无所不能的物理"中的三件手工制品毫无疑问是看得见摸得着的。同时,它们也被证实为事实上是正确的。这引导我进入关于科学真理的又一讨论,以及科学如何满足人类诗意的、创造性的需求。

**What if... science is adapted to fulfill poetic and creative needs?**

The Physics of The Impossible is about contemporary physics, at the crossroads between science and science fiction, testing our perceptions about reality and scientific potential. This interstitial space has the potential to engage our imagination, inspire dreams and extreme experimentations. Here, you are the hobbyist-amateur maker who decides the possible, the believable, and the alternative. You are the astronaut in the living room, generating dark energy from pigeons' eggs in the kitchen and colliding atoms in the bathroom. The project tries to deal with the surrealistic aspect of generating unknown experiences in your home.

Between something absurd and something factually right, I expect to engage in a discussion at the boundary between science fiction and 'hard-core' science - a platform where the extreme experiments of amateurs can make the physically 'impossible' happen. Like "Imaginary gadgets", the three pieces of The Physics of the Impossible have the unapologetic tangibility of hand made objects that work. They have also been approved as "factually right". This leads me to another debate on the truth within science and how science can be adapted to human poetic and creative needs.

假如我们接受与细菌、微生物、寄生虫协同进化是一种健康的选择，那会是什么样？

在你身上的每个细胞中都生长着10个非人类细胞，这些细胞来自细菌、病毒、真菌及其他微生物，它们对你的诸多生理功能异常重要。针对这一结论及宏基因组学研究，该计划将人类视作协同进化的生物体、重要细菌、微生物及寄生虫的混合体，并以此重新考虑卫生保健的方式方法。这一计划会仔细分析人类因"无心之失"而制造出的超级病菌，如滥用抗生素导致耐药性金黄色葡萄球菌诞生，并为使未来的生态系统更加平衡，更利于各生物互利共生而提供多种有益措施、新做法及新装置。

## What if... we accept co-evolution with bacteria, microbes and parasites as a healthy option?

For every one human cell in your body there are ten non-human cells living inside and on you belonging to bacteria, viruses, fungi and other microbes - they are vital to many of your daily functions. The Race responds to this outcome and human metagenomic research to reconsider our approach to healthcare as a co-evolved organism and conglomeration of vital bacteria, microbes and parasites. The project scrutinizes our inadvertent creation of superbugs like mRSA through the misuse of antibiotics to offer alternative enhancements, new behaviors and objects for a more symbiotic future as an extraordinary balanced ecosystem.

种族，2007
迈克尔·伯顿（英国）
© Michael Burton

**The Race**, 2007
Michael Burton (UK)
© Michael Burton

假如肉类能在实验室中培植而无需伤害动物,那会是什么样?

组织工程的近期成果使我们能够零成本培植肉类,而且避免了宰杀整头动物的残忍手法。现在,从一小块动物组织样本培植食用肉类已成为可能。这一项目检验我们如何控制这些新型肉类的形状、质感及风味从而提醒人们它们从何而来。

动物磁共振成像(MRI)小组在乡村中寻找最美的牛、猪、鸡以及其他牲畜样本。一旦找到,它会被从头到尾扫描一遍以期获得精确的内脏横断面图像。

解剖学中最有趣也最具审美享受的样本会被当做体外肉类的原型,我们不会选择常吃的那些无聊部位。最终成品会是令人满意地复杂但又逼真的食物形式。

**What if... meat could be grown in laboratories without harming animals?**

Recent advances in tissue engineering have enabled us to grow meat without the expense, cruelty and traditions of rearing the whole animal. It is now possible to grow edible meat from a small sample of animal tissue. This project examines how we might choose to give shape, texture and flavor to this new sort of food in order to better remind us where it came from.

The mobile animal MRI (Magnetic Resonance Imaging) unit scours the countryside looking for the most beautiful examples of cows, pigs, chickens and other livestock. Once located, the creature is scanned from head to toe, creating accurate cross-sectional images of its inner organs.

The most interesting and aesthetically pleasing examples of anatomy are used as templates to create moulds for the in-vitro meat (we wouldn't choose to eat the same old boring parts that we eat today). The result is a satisfyingly complicated and authentic form of food.

未来肉类食品,2006
詹姆斯·金(英国)
© James King

**The Meat of Tomorrow**, 2006
James King (UK)
© James King

假如日常用品受到仿生学影响，那会是什么样？

不像大多数的时装设计师，张苇苇将箱包设计当做一种话语形式，来讲述被这个社会认为是禁忌的故事。她十分感兴趣这样一个议题，箱包能否带给使用者新体验，使大家学会从新的角度欣赏事物。

受到连体婴儿的启发，张苇苇试图将连体特性用于箱包设计。人们会喜欢异型的箱包吗？箱包之间可以相互依赖吗？如果将两个同样的包粘合在一起，那会是什么样？使用者的行为会如何去适应这种新型包所带来的变化呢？

通过这些观念，并结合超现实主义表现手法和特殊材料，张苇苇试图创造出与普通包截然不同的、不可思议的效果。

## What if... biological anomalies inspired our everyday objects?

Unlike most fashion designers, Wei Wei Chang uses bags as a form of discourse, aiming to illustrate stories that our society considers taboo. She was interested in questioning whether bags can be used as a tool to trigger new experiences, allowing people to appreciate things from a different angle.

Inspired by conjoined twins, she wanted to experiment with bags that share such conjoined characters. Would people appreciate deformed bags? Could bags be dependent of each other? If duplications of the same bag were stuck together, what would that portray? How would people's behaviour change while using these bags?

By combining such concepts with surrealistic expressions and unusual materials, Chang wanted to create an uncanny effect not normally associated with bags.

双胞胎，2010
张苇苇（中国台湾）
© Zhang Wei Wei

**Twins**, 2010
**Zhang Wei Wei** (Taiwan, China)
© Zhang Wei Wei

## 假如陨石可以在地球播种,那会是什么样?

构成生命的所有化学物质在早期地球均已存在,除了一种特定形式的磷酸盐。由于缺少这种活性磷,科学家们无法继续研究,因为它是DNA、骨骼甚至肾结石的基本生物组成之一。

该计划是在利兹大学特伦斯·基博士研究的基础上进行的。特伦斯·基博士提出活性磷是由陨石带到早期地球的。他发现从太空来的磷更具活性,更适合激发早期生物复杂变化的化学反应。

与博士的研究逆向进行,身体宇宙项目从身体中寻找磷,用肾结石、尿液培植人造陨石。在其他关键促生化学物的补充下,这一项目将人造陨石送至其他适宜生命诞生的地点,如木星的卫星欧罗巴,最终播种生命。

## What if... meteorites seeded life on earth?

All chemicals required to start life existed on early Earth except a suitable form of phosphate. The lack of a reactive form of phosphorus has baffled scientists especially as it is an essential biological component found in DNA, bones and even kidney stones.

Astronomical Bodies is based on the work of Dr Terence Kee at Leeds University who proposes a reactive form of phosphorus arrived on early Earth in meteorites. Dr Kee found the phosphorus from space to be more reactive and suitable to start the chemical reactions, which gathered complexity into early life.

Astronomical Bodies, reverses this process to recover phosphorus from the body, in the form of struvite kidney stones and urine, to grow man-made meteorites. With a complement of other key life promoting chemicals - the work proposes to send this man-made meteorite to sites in space suitable for Life, like Jupiter's moon Europa, to seed life.

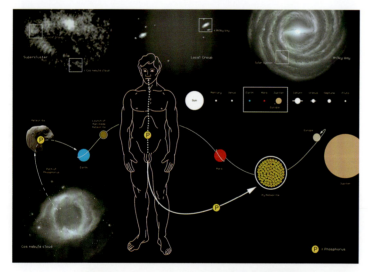

**身体宇宙**,2010
迈克尔·伯顿(英国)
© Michael Burton Photo:Theo Cook

**Astronomical Bodies**, 2010
Michael Burton (UK)
© Michael Burton Photo:Theo Cook

## 假如产品设计从动物行为获得启示，那会是什么样？

### 健康收音机

为了防止尤其对早期处理器有害的灰尘，健康收音机每六个月就会打一次喷嚏排出内部的有害物质。一个风箱系统会借助正面的两个鼻孔排出机体内的灰尘。

健康收音机底部有一个写有SNZ的喷嚏开关，主人可以根据需要开启它的喷嚏机制。收音机正面的两个鼻孔为排尘所用。

### 软腿

可移动磁盘驱动器在液体面前很脆弱。软腿驱动器是一个保护3.5寸磁盘免受损坏的可移动磁盘驱动器。如果在机体周围有液体洒出，可收缩的腿就会把磁盘驱动器从表面升起来，既保护了磁盘驱动器，也给主人争取了清理洒出的液体的时间。

这个磁盘驱动器探测到了洒出的咖啡，然后激活了可伸缩的腿。磁盘被洒出的咖啡激活，然后被主人从危险中移走。

## What if… animal behaviour influenced the design of products?

### GESUNDHEIT RADIO

Developed as a protection against dust which was particularly threatening to early microprocessors, the Gesundheit Radio sneezes every six months to expel potentially damaging material from its interior. A bellows system extracts the dust from inside the unit, blowing waste from two nostrils located on the front.

The Gesundheit Radio features a button marked SNZ to enable the owner to active the sneeze mechanism at will. Two nostrils located on the front of the radio allow dust to leave the unit.

### FLOPPY LEGS

Portable disk drives are very vulnerable to liquids. The Floppy Legs disk drive is a portable disk drive designed to protect the 3.5 disk format from damage. If liquid is spilled near the unit retractable legs raise it from the surface, both preserving the unit and allowing the owner time to clean up the spill.

The hard drive has detected a coffee spill which has activated its integrated legs. The hard drive is activated by a coffee spill, then moved out of harm's way by its owner.

**阿滕伯格设计组，** 2010
詹姆斯·钱伯斯（英国）
© James Chambers

**Attenborough Design Group**, 2010
James Chambers (UK)
© James Chambers

假如闹钟会反映不同的睡眠习惯，那会是什么样？

如果我们仔细的观察周围的事物，就会发现它们隶属于统一的系统，是由销售公司制定的一套系统。我们的行为和习惯大多是在这些系统影响下形成的，因为我们没有第二种选择。

像闹钟这样的日用品是这些统一系统的最好代表。当下的市场有上千种不同的闹钟，但是它们的装配方式是一样的。我们的社会在改变，日用品扮演着与人们生活息息相关的角色，难道不应该改变吗？或许这些日用品的功能仍然保持，但是我们与它们交互的方式可能需要改变。

我们是否应该根据不同人的生活和睡眠习惯设计不同的闹钟呢？或许那些早起的人的闹钟应该不同于失眠病人的闹钟。闹钟上反映出的各种不同睡眠和饮食习惯从根本上迎合了各类人的身体和心理上的双重需求。

高质量的睡眠——越来越多人的生活习惯趋于弹性化，同时在开展每日工作之前要保证充足的睡眠。与其设置起床的时间，这个闹钟规定了你的睡眠时间。

**What if... alarm clocks reflected different sleep habits?**

If we look closely at objects that surround us, they often belong to a unified system, a system created by big commercial cooperations. Our habits and behaviors are often sculpted to adapt these systems because there usually isn't a second choice.

Everyday objects such as alarm clocks are a good example of these unified systems. There are over thousands of alarm clocks on the market today, but they are all set the same way. The society we live in is changing, shouldn't the interactive side of these daily objects change with us? Perhaps the function of the objects stay, but it is the process of how we interact with them that must change.

Should there be different clocks designed for people with different lifestyle; with different sleeping habits? Maybe those who has to get up at a set time in the morning should own a different clock to those who suffer from insomnia. Perfect Sleep and Tyrant are all examples of possible variations on alarms that caters different people's physical and emotional needs.

Perfect Sleep ---More people have flexible lifestyles and can therefore have the perfect amount of sleep before they start their day. So, instead of setting when you want to wake up, this clock allows you to set how long you want to sleep for.

闹钟，2008
王艾丽（中国台湾）
© Alice Wang

**Alarm Clocks**, 2008
**Alice Wang** (Taiwan, China)
© Alice Wang

假如产品如动物般可以被驯化，那会是什么样？

巴甫洛夫用食物作为条件反射刺激物，节拍器作为刺激传输媒介。这些狗一听到节拍器的声音就会立刻获得食物。十几次尝试之后，巴甫洛夫发现狗在听到节拍器之后会立刻分泌唾液。把巴甫洛夫发现的这种经常在动物身上发生的条件反射用到我们的产品上会如何？使得我们的产品像动物一样可以被驯化。

**What if… animal behavior was part of a product?**

Ivan Pavlov used food as the unconditioned stimulus, and the sound of a metronome was chosen to be the neutral stimulus. The dogs would first be exposed to the sound of the ticking metronome, and then the food was immediately presented. After several conditioning trials, Pavlov noted that the dogs began to salivate after hearing the metronome. Applying Pavlov's classic conditioning theory to products, the user must first train their dogs to familiarize to the stimuli for the product to work properly.

**巴甫洛夫的产品，** 2011
王艾丽（中国台湾）
© Alice Wang

**Pavlov's Products**, 2011
**Alice Wang** (Taiwan, China)
© Alice Wang

## 假如信息可以通过牙齿接受，那会是什么样？

收音牙齿植入技术是有关个人信息沟通的一种激进的新观念。在普通的牙科手术中，医生可以将一个微型的收音和播音芯片植入牙齿。近距离磁效应会激活接收装置上休眠的芯片，传感器将这种声音信号转化为微振动，通过下颌骨传到内耳。

收音牙齿植入技术原意在制造一件实体产品，但在实际操作中它只是一个观念或主张，旨在激发关于移植技术的可能性的讨论及其对社会、文化的影响。该项目采取大众传播的宣传策略，将这种讨论从展厅引入公共领域。

目前，尚未计划将该项目开发投产。

## What if... you could receive messages through your teeth?

The Audio Tooth Implant is a radical new concept in personal communication. A miniature audio output device and receiver are implanted into the tooth during routine dental surgery. Near field magnetic effects energize the dormant chip on the receipt of a call, a transducer then converts this sound information into micro-vibrations that travel along the jawbone and into the inner ear through the process of transduction.

Initially proposed as a real product, the Audio Tooth Implant in reality is a conceptual proposition intended to encourage discourse and comment on the possibilities of implantable technology and their potential impact on society and culture. The project used the popular media as a dissemination strategy to take the debate out of the gallery and into the public domain.

There are no plans to put the Audio Tooth Implant into production.

听觉牙齿植入技术，2001
詹姆斯·奥格（英国）
© Auger-Loizeau

**Audio Tooth Implant**, 2001
James Auger (UK)
© Auger-Loizeau

假如日常用品中含有人工制造的活性成分，那会是什么样？

当生命处于原初状态时，我们如何区分自然与非自然？合成生物学以生物为材料库，再不需要什么石化制品，取而代之的是，从活体中提取某一特征，定位其DNA，并将它插入生物体内。这种设计出的生命体会估算并产生能量，清理污染，杀菌甚至做家务。同时，我们会为生命之树增添一个新的分枝。人工合成王国是新自然的一部分，生物技术使我们能够控制自然，但生物机器需要人类操控。可持续性与健康的魅力是否足以让人类接受这样的妥协呢？

**What if... everyday products contained synthetically produced living components?**

How will we classify what is natural or unnatural when life is built from scratch? Synthetic Biology is turning to the living kingdoms for its materials library. No more petrochemicals: instead, pick a feature from an existing organism, locate its DNA and insert into a biological chassis. Engineered life will compute, produce energy, clean up pollution, kill pathogens and even do the housework. Meanwhile, we'll have to add an extra branch to the Tree of Life. The Synthetic Kingdom is part of our new nature. Biotech promises us control over nature, but living machines need controlling. Are promises of sustainability and healthiness seductive enough to accept such compromise?

虚拟王国，2009
亚历山大·黛西·吉恩斯伯格（英国）
© Alexandra Daisy Ginsberg

**Synthetic Kingdom**, 2009
Alexandra Daisy Ginsberg (UK)
© Alexandra Daisy Ginsberg

## 假如我们能用细菌为世界重新着色,那会是什么样?

细菌颜料是设计师与科学家在合成生物学领域的合作项目。2009年,剑桥大学的7名本科生利用暑假进行细菌基因改造,使细菌分泌出多种肉眼可识别的色素。他们将设计出的标准系列DNA命名为生物砖,并植入大肠杆菌细胞。生物砖的每部分都是由精选基因组成的,这些基因来自生物界现存的有机体,它们能使细菌产生色素:红、黄、绿、蓝、棕或紫。再通过与其他生物砖混合,细菌就会变得大有用处,例如标示饮用水是否安全,如果水中有毒素,细菌就会变红。该项目已经获得了2009年国际基因工程器械大赛的大奖。

该技术尚在研发阶段,设计者们已经开始发掘它的应用潜力了。他们制定了时间表并提出细菌颜料在下个世纪可能的发展路径。这些预见性应用包括食品添加剂、专利技术、个人药品、恐怖主义及新型侵蚀技术。他们探究不同的动机会为该技术在日常生活中的利用带来何种影响,当然这些影响未必都是积极的。细菌颜料是一项在基因学、人类学双学科范畴下研发的技术。

## What if... bacteria recoloured our world?

E. chromi is a collaboration between designers and scientists in the new field of synthetic biology. In 2009, seven Cambridge University undergraduates spent the summer genetically engineering bacteria to secrete a variety of colored pigments, visible to the naked eye. They designed standardized sequences of DNA, known as BioBricks, and inserted them into E. coli bacteria. Each BioBrick part contains genes selected from existing organisms spanning the living kingdoms, enabling the bacteria to produce a color: red, yellow, green, blue, brown or violet. By combining these with other BioBricks, bacteria could be programmed to do useful things, such as indicate whether drinking water is safe by turning red if they sense a toxin. E. chromi won the Grand Prize at the 2009 International Genetically Engineered Machine Competition (iGEM).

They explore the potential of this new technology, while it was being developed in the lab. They designed a timeline proposing ways that E. chromi could develop over the next century. These scenarios include food additives, patenting issues, personalized medicine, terrorism and new types of weather. Not necessarily desirable, they explore the different agendas that could shape the use of E. chromi and in our everyday lives. E. chromi is a technology that has been designed at both the genetic and the human scale.

E-chromi, 2009
亚历山大·黛西·吉恩斯伯格(英国)
© Alexandra Daisy Ginsberg & James King

E-chromi, 2009
**Alexandra Daisy Ginsberg** (UK)
© Alexandra Daisy Ginsberg & James King

*1. Drink*
Synthetic E.chromi bacteria are ingested as a probiotic yoghurt.

*2. Colonise*
Colonising the gut, the E.chromi keep watch for the chemical markers of disease.

*3. Monitor*
If a disease is detected, the bacteria secrete an easily-read colour signal, visible in faeces.

E.chromi - cheap, personalised disease monitoring from the inside out.

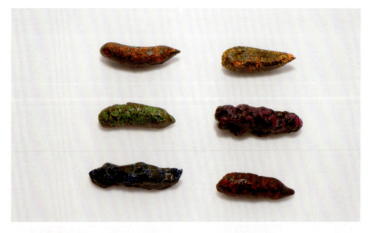

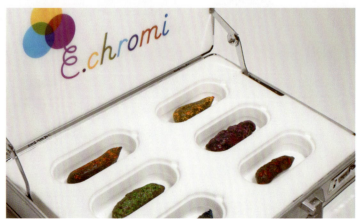

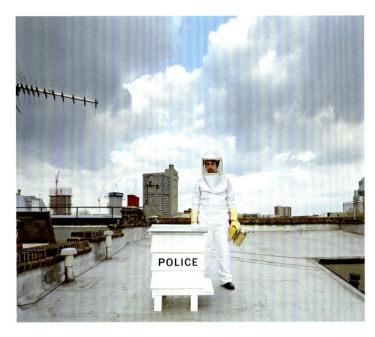

基因治安，2010
托马斯·特威士（英国）
© Thomas Thwaites

**Policing genes**, 2010
Thomas Thwaites (UK)
© Thomas Thwaites

### 假如我们的花园由蜜蜂管理，那会是什么样？

制药公司正在进行转基因制药实验——改变植物的基因以生产有用的、珍贵的药物。最近，番茄已进入种植实验阶段，这是为了生产预防老年痴呆症的疫苗。此外，马铃薯也能使人对乙肝产生免疫。同时，更多的草本药物在全球的实验室中被人们研制。

但是，将基因输入植物组织的技术也能被业余人士和犯罪分子利用。该项目假设，如同其他技术那样，基因工程也有可能被非法使用，比如，在看似普通的花园中，改良植物以生产麻醉药物及非法药品。

因此，在人们的花园或菜地中，转基因植物或许会成为一个治安问题……

### What if... our gardens were policed by bees?

Pharmaceutical companies are experimenting with Pharming - genetically engineering plants to produce useful and valuable drugs. Tomato plants are currently undergoing field trials, that produce a vaccine for Alzheimer's disease, and potatoes that immunize against Hepatitis B. Many more Plant-Made-Pharmaceuticals are being developed in laboratories around the world.

However, the techniques to insert genes into plants are within reach of the amateur, and the criminal. Policing Genes speculates that, like other technologies, genetic engineering will also find a use outside the law, with innocent-looking garden plants modified to produce narcotics and unlicensed pharmaceuticals.

The genetics of the plants in your garden or allotment could become a police matter...

假如为了让自己的物品工作，你必须给它喂食，那会是什么样？

这一项目提出了人类与具备生物特性的机器间的关系问题，这些机器必须依赖生物能量才能运行。展出的作品是一台收音机，它可以依靠自己的新陈代谢系统吸收能量，因此你必须定时为它提供家中的残羹冷炙、废料或是易于粉碎消化的材料，否则它就会罢工。为保持它的身体健康，使用者最好为它制定一套食谱，在现有条件下为其选择最佳的食物。如果维护得当，收音机会一直运行良好。

这台大号收音机是一件概念作品，内部装有许多微生物燃料电池为其提供能量。只要它的主人记得喂给它有机废料，它就能自动合成能量并工作，而且很可能达到"永生"的状态。

## What if... you had to feed your products to keep them alive?

Living Radio raises questions about the relationships people might build with machines that rely on organic matter to operate. The object on exhibit is a 'radio' that incorporates its own metabolic system for digestion and that must be regularly supplied with household leftovers, compost and other materials that can be easily broken down and digested. To maintain the radio and have it function, optimally, the user fine tunes its diet, determining the best food stuffs for the given environmental conditions. Cared for correctly, the radio will operate and last indefinitely.

This large-scale radio is a design for a conceptual appliance which contains several living microbial fuel cells producing energy. As long as its owners remember to feed the radio with organic waste, it could power itself, and potentially 'live forever'.

活体收音机，2008
阿耐普·杰恩，阿列克斯·泰勒（英国）
© Anab Jain

**The Living radio**, 2008
**Anab Jain, Alex Taylor** (UK)
© Anab Jain

假如家用机器人能够自给自足，那会是什么样？

该项目为家用机器人提供了一种另类的前景，使它们无论在审美上还是功能上都更惹人喜爱。

为了更好地反映家庭环境，我们有意回避了有关机器人的未来主义的陈词滥调，转而采用当代家用产品的美学准则。

机器人可以从微生物电池中产生能量。这种电池利用电化学反应从有机组织中自动发电。有机组织可以是飞虫也可能是啮齿类动物。这使它们成为能量自给自足的机器人，不需人类干预，但这也意味着它们事实上会因饥饿而死亡。这种做法催生出新式的人工家庭生态系统，在新生态系统中，苍蝇不再只是害虫，它还与这场人造生命游戏息息相关。机器人生命的不可预知性旨在引申出一种更有意义的关系，即那些通常被作为娱乐消遣而生产的机器人与人类自身的关系。

## What if... domestic robots could be self-sufficient?

This project offers an alternative perspective on domestic robots, exploring a more sympathetic approach to both their aesthetics and functionality.

To better reflect the home environment, we have avoided the stereotypical futuristic look normally associated with robots and adopted a contemporary domestic product aesthetic.

The robots generate their own energy from a microbial fuel cell: a device that uses an electrochemical reaction to generate electricity from organic matter, this organic matter comprises flying insects and rodents. This allows them to become energy autonomous: existing without need for human intervention, however, it also means that they can effectively die should the fuel cell run out of food. This behavior creates an artificial new domestic ecosystem: flies are no longer just a nuisance but become linked to an artificial game of life. The unpredictability of their existence aims to elicit a more meaningful relationship that those usually generated by entertainment or companion robots.

家用娱乐机器人，2008
詹姆斯·奥格（英国）
© James Auger

**Carnivorous Domestic Entertainment Robots**, 2008
James Auger (UK)
© James Auger

假如产品可以感知出我们的焦虑,那会是什么样?

"机器人不会伤害人类"——阿西莫夫第一定律。人工智能被传媒广泛讨论,但是我们与这项技术的差距究竟有多远?我们对人工智能发展的担心究竟是必要的还是多余的?究竟是什么使得我们恐惧不已?有没有哪种家用产品打破了这一定律?电子秤,即使不对人体造成伤害也会对心理造成细微的伤害。这种物品是否应该存在于这个情感日益脆弱的复杂社会中?

善良的谎言——这种电子秤允许使用者自我欺骗。你越往后站就会越轻。使用者会逐渐地得到真实体重。

一半的真实——这种电子秤可能具备伤害性,因为它的智能不够判断什么时候才是向使用者公布事实的时机。它把你的同伴放在裁决者的位置,由他决定是向你隐瞒还是揭露事实。这个简单的机器就这样具备了一定的智能性。

公开的秘密——这个秤会把你每次称得的体重通过短信的方式通知你提供的号码。获得该短信的人会在你们俩会面时告知你这条短信的内容。

## What if... products reflected our anxieties?

"A robot may not harm a human being." — the first law of robotics by Isaac Asimov. Artificial intelligence is a topic widely used in the media, however, exactly how far are we from such technology? Are these fears towards robotic developments necessary or purely irrational? What is it about these currently fictional characters that scare us? Are there existing domestic objects that already break this law? Weighing scales, although don't perform physical harm, have been subtly damaging us psychologically. Should objects like these exist in a complex society like ours where people are more emotionally fragile?

White Lies—This weighing scale allows one to lie to him/ herself. The further back you stand, the lighter you become. The user can gradually move closer and closer to reality

Half-Truth—Weighing scales can be harmful cause they don't have intelligence to judge when's the right moment to hit you with the truth. This weighing scale puts your partner responsible for deciding whether to lie or hit you with the truth, adding a little bit of human intelligence back into these simple machines.

Open Secrets—This weighing scale reveals your weight every time you weigh yourself by sending a text message to the desired mobile phone. The receiver is then responsible to reveal the answer immediately or the next time you two meet.

阿西莫夫第一定律,2008
王艾丽(中国台湾)
© Alice Wang

**Asimov's First Law**, 2008
**Alice Wang** (Taiwan, China)
© Alice Wang

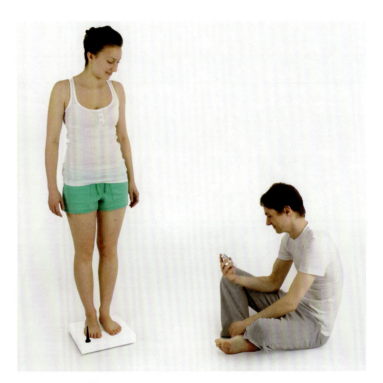

假如我们的情绪能够被机器读懂，那会是什么样？

面部转瞬即逝的微小表情几乎是无法控制的，但它们与大脑中的感情活动密切相关，这些感情活动是很容易被某些特殊科技装置捕捉的。科学研究揭露了人们的决策过程其实是感性的而非理性的，这使得所谓的自由意志遭到质疑。科技具备了识别情感的能力，它让整个社会着迷于人类的情感反应。曾经深藏心中的情绪、信念以及信仰如今都已无所遁形。

"认知系统"正是这样一部短片，讲述人类社会如何应对现代神经科学的挑战，如何利用这一先进科技所带来的各种可能性，去解读、评估和改变人类的行为和情感。

## What if... our emotions were read by machines?

Facial micro expressions last less than a second and are almost impossible to control. They are hard wired to the emotional activity in the brain which can be easily captured using specially developed technological devices. Free will is now in question as the science exposes decision-making as an emotional process rather than a rational one.

This ability to read emotions technologically result in a society obsessed with their emotional reactions. Emotions, convictions and beliefs which usually remain hidden, now become a public matter. "Belief systems" is a video scenario about a society that responds to the challenges of modern neuroscience by embracing these technological possibilities to read, evaluate and alter peoples behaviours and emotions.

认知系统，2010
伯恩哈德·霍普夫加特纳（德国）
© Bernhard Hopfengärtner

**Belief systems**, 2010
Bernhard Hopfengärtner (Germany)
© Bernhard Hopfengärtner

可能的世界　WHAT IF

假如产品能揭示出隐藏的故事，那会是什么样？

这件作品强调了人们对社会功能障碍的漠视与麻木不仁。其手法是标新立异的。故事的叙述没有任何的逻辑和秩序，给观者留下了大量的想象空间，故事的主线是多角度构成的，与传统的线性方式相比，它更像是一部影片。

《玩具枪》的主旨是压缩现实，将所有内容混入玩具枪爆炸所释放出的灰色烟尘中去。隐藏其中的暴力因素逐渐浮现，我们曾经漠视的东西因此被展现出来。但当所见的景象全部展开时，我们才意识到所有这些暴力都源于玩具枪的爆炸。原来，我们所谓存在于这个世界中的暴力只是一把无辜的玩具枪而已。

**What if…products revealed hidden stories?**

This piece stresses humanity's disregard and numbness towards social dysfunction. The approach is unconventional. There is no logic or order to the storytelling, leaving a greater imaginative role for the viewer. The storyline is expressed multi-directionally, as in a movie, rather than in a more traditional linear fashion.

The idea is to compress reality, mixing all that can be said into one scene exploding all the grays from a toy gun. The violence that was hidden within is brought forward, showing what we previously missed. But then it is when the view is pan out, where we will realize that all these violence in this world happens on a toy gun. The transitions explained that what we portray as violence in this world is simply regarded as an innocence toy gun.

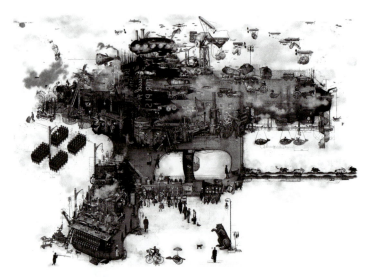

玩具枪，2010
邹骏昇（中国台湾）
© Page Tsou

**Toy Gun**, 2010
**Page Tsou** (Taiwan, China)
© Page Tsou

**假如工业产品同时是好玩的，那会是什么样？**

《砰！》是一盏有一把手机形遥控器的台灯。使用者一开枪，灯就会关上。当灯光熄灭时，灯罩会偏向一侧，像是被击中一样。

要想让它恢复至原状，只需再次击中它。灯罩会缓慢扶正，灯光同时也会恢复初始状态。

**What if… products were playful?**

Bang! is a desk lamp with a gun-shaped remote controller. User can fire the "gun" to turn the light off. The light goes out and the lampshade knocks to the side, showing that it's been hit.

To turn it back on, simply shot it again, and the lampshade will raise up slowly and turn the light back on at the same time.

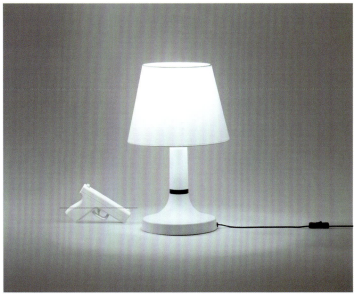

砰！，2010
玩点互动公司（中国台湾）
©Bit Play inc

**Bang!**, 2010
**Bit Play INC**(Taiwan, China)
©Bit Play inc

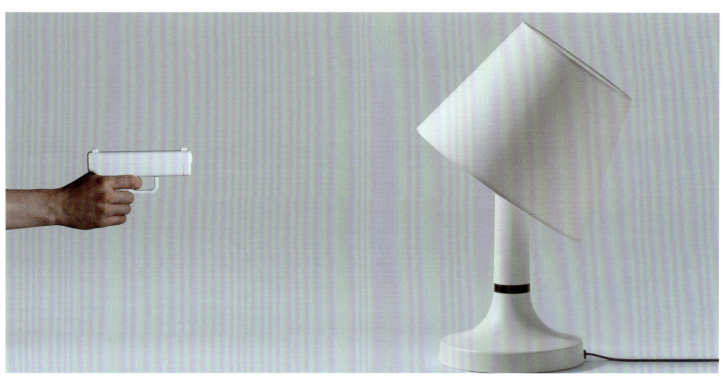

## 假如地球能量可以进入客厅，那会是什么样？

萨特说："为了出人头地，我必须将生死置之度外。"另类火山正是假想了这样一种爱恨交织的感情。你家角落中潜伏着一位"沉睡的巨人"，它拥有令人振奋的，甚至令人恐惧的能量。虽然它的苏醒与爆发不会危害性命，但很可能威胁到你那干净整洁、装修精美的客厅。这个项目试图将自然界最激烈的能量释放过程引入家庭，重新解读多种自然现象的本质，同时质疑那些以消遣为目的的改造自然的活动。

## What if... planetary energy entered the living room?

"In order to make myself recognized by the Other, I must risk my own life" said Sartre. The Other Volcano imagines a love-hate relationship, a 'sleeping giant' in the corner of your domestic environment, with the power to provoke excitement with its rumblings, and also perhaps fear, if not for one's life in this case, then at least for the soft furnishings of one's clean and neat 'living' room. It is a project that domesticates the most violent of natural processes, addressing and reinterpreting different natures.

另类火山，2010
奈丽·本·哈尤恩（英国/法国）
© Nelly Ben Hayoun

**The Other Volcano**, 2010
Nelly Ben Hayoun (UK/France)
© Nelly Ben Hayoun

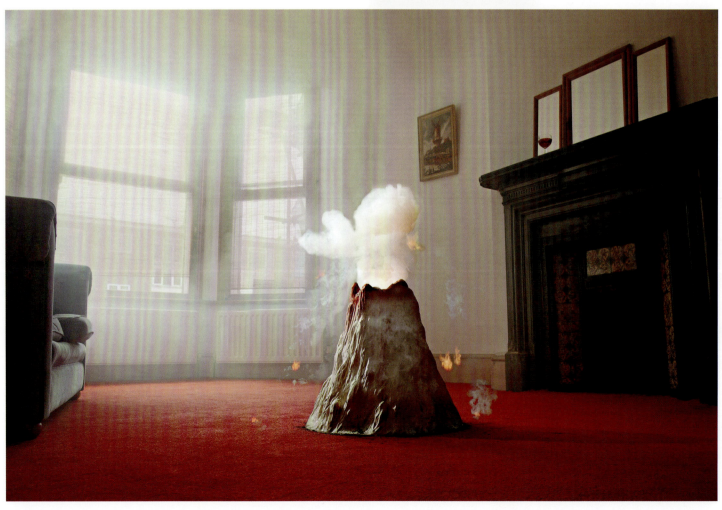

假如物理学令人颤栗，那会是什么样？

该项目再现了日本超级神冈中微子观测站的一次音爆实验。

这个巨大的装置实际上是一条23米长的"河"，水沿着隧道流淌，隧道则由成千上万的银色气球（光电倍增管）包围着。体验者登上一艘小船，沿"河"而下，掌舵的是位粒子物理专家。乘客会听到巨大的轰鸣声，看到明亮的蓝色闪光，这就是切伦科夫辐射，复制真实的超级神冈音爆，纯水的中微子及原子的相互作用。

旅途中，乘客将了解中微子的基本知识，如它们在宇宙中的地位以及科学家如何探测它们。在隧道入口，全体船员首先必须穿上特卫强质地的衣服、长靴、帽子等等防护用具，将身体严密包裹起来，任何暴露在安全长官奈丽眼前的部位都会招来她的盛怒。

这一装置意在带给人们震撼的物理体验，引导观众踏上探索宇宙奥秘之旅。

## What if... physics could be thrilling?

Super K Sonic BOOOOum recreates the experience of a sonic boom at Japan's Super-Kamio-kande neutrino observatory.

This large installation consists of a twenty tree meter long 'river' of water running through a tunnel lined with thousands of silver balloons (photomultiplier tubes). Members of the public embark on a boat, pulled through the tunnel, with an expert particle physicist navigator as a guide. Passengers hear loud booms and see bright flashes of blue light – Cherenkov Radiation –replicating the real Super-K interactions between neutrinos and atoms of extremely pure water.

On the journey they learn of neutrinos, their role in the Universe and how scientists detect. All crew members must first don white Tyvek suits, wellies and hard hats or else face the wrath of Nelly the security chief, at the entrance of the tunnel.

This installation is designed to deliver physically thrilling experiences; emersing the audience on a journey through the mysteries of the Universe.

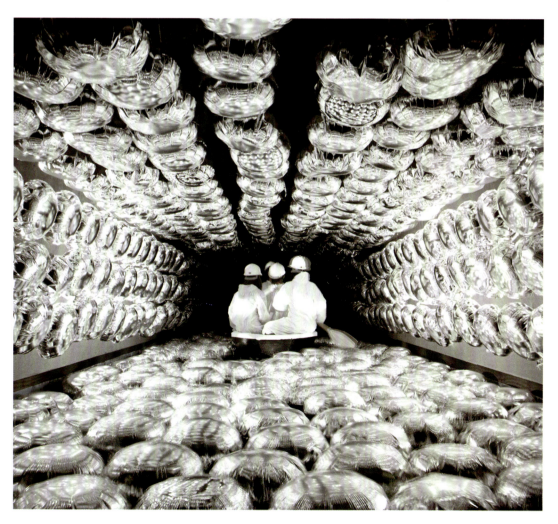

超级神冈音爆，2009
奈丽·本·哈尤恩（英国/法国）
© Nelly Ben Hayoun Photo: Nick Ballon

**Sonic BOOOOum**, 2009
*Nelly Ben Hayoun* (UK/France)
© Nelly Ben Hayoun Photo: Nick Ballon

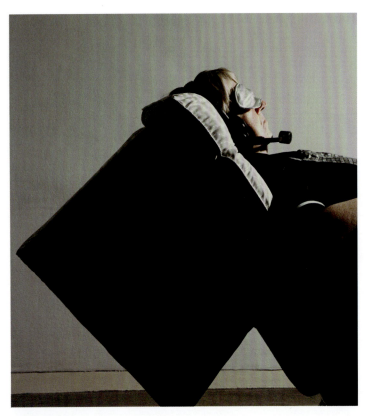
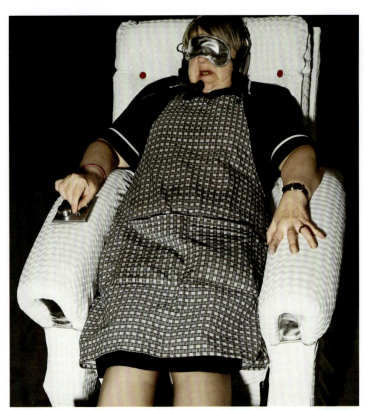
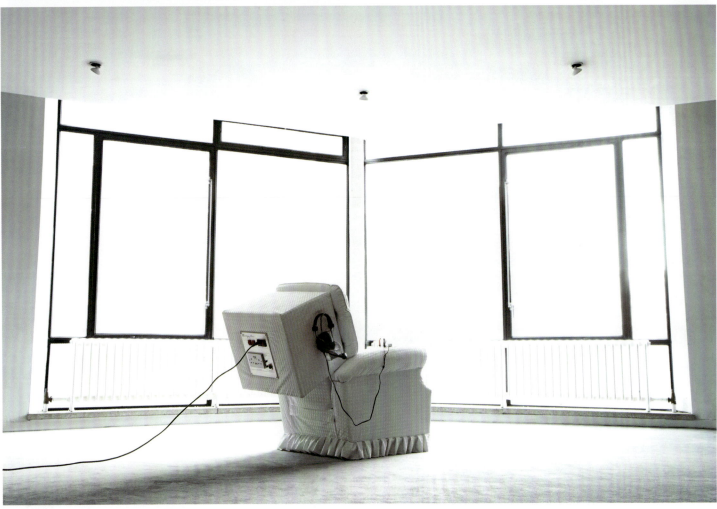

假如家用产品能实现我们的科技梦，那会是什么样？

进行太空旅行，感受失重状态绝对会是人生一大成就。现在，从发射瞬间的兴奋到最终进入未知宇宙等一系列体验不再是遥不可及的幻想。

但太空旅行仍是少数人的娱乐项目。

联盟号坐椅项目精确再现联盟号火箭发射的三阶段。首先坐椅倾斜到发射角度，面对天空，戴上通话器，在控制板上选择你想体验的状态，可以是单独的阶段，也可是发射升空的全过程，从倒计时5、4、3、2、1开始。

你想在哪个星球着陆？

**What if... Domestic products allowed us to fulfill technological dreams?**

Space tourism is a great success; the possibilities of weightlessness. To feel the thrill of lift-off and to finally meet the unknown doesn't have to be a fantasy anymore.

But space tourism is still just for the few.

The Soyuz chair accurately reproduces the three stages of the Soyuz rocket launch. Reclining into launch position, you face the sky, put on your headset, and use the control panel to select your mode; just a single stage, or the full lift-off experience. 5... 4... 3... 2... 1...,

Which planet will you land on?

联盟号坐椅，2009
奈丽·本·哈尤恩（英国/法国）
© Nelly Ben Hayoun

**Soyuz Chair**, 2009
**Nelly Ben Hyoun** (UK/France)
© Nelly Ben Hayoun

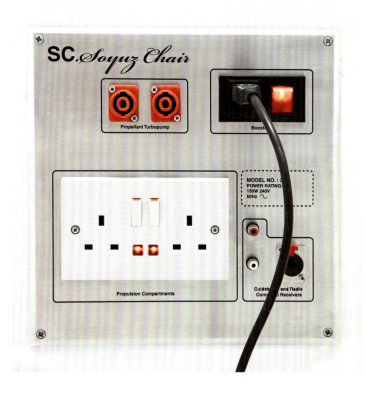

**假如量子物理学能创造平行的宇宙,那会是什么样?**

这是一套由15件小装置构成的一个系列,代表15种不同的可互换的现状。这些装置扮演一个可叙述的生成器,生成的结果都是以往改变所导致的。15件装置都有一段简单的描述,给它们存在的前因后果提供一定线索。

试想我们在现实间穿梭,最终回到一间不同的房子,它在不停地变化:时而大,时而小;时而旧,时而新;有时甚至会消失。它所揭示的并非日常世界中的那种大尺度的变化,而是与我们最邻近的微观世界的变化。我们如何在自己的家中感受到这一变化呢?我们的吹风机、杯子等日用品会因此产生变化吗?

**What if… quantum physics created parallel universes?**

A series of objects, fifteen in total, representing fifteen different and alternate presents. The rapid prototyped objects act as narrative generators, each a result or effect from a change in the past. The objects are supplied with a short description to give a hint in what the cause in the past could have been.

Imagine traveling back and forth arriving back in a different house. The house itself and the contents keep changing, growing larger or smaller or nice or poorer or even disappears. Rather than revealing changes on a grand scale in terms of the world around us, what happens to our most immediate surroundings. How do the consequences, the effects reveal themselves in the context of our home, how would this cause, ripple and effect banal objects such as a hairdryer or a cup?

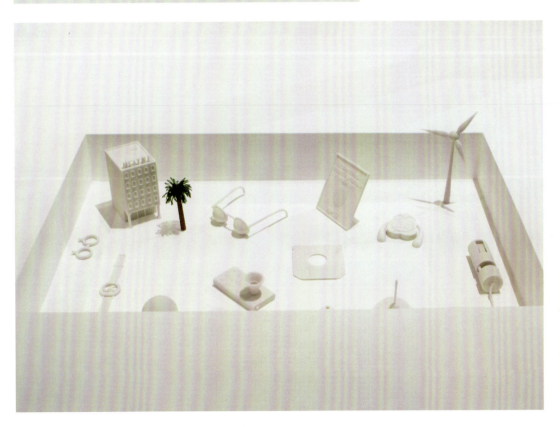

被改变的现状,2010
钟承达(中国香港)
© Shingtat Chung

**Altered Presents**, 2010
Shingtat Chung (Hong Kong, China)
© Shingtat Chung

## 假如产品设计能够满足那些复杂的情感需求，那会是什么样？

电影《欲望管理》由五个独立的部分组成，片中物品被设计为异见行为的载体。影片将家庭空间视为隐私的最后战线，在那里不合群的人定做设备享受非常规体验。例如，女乘务员与涡流发生了某种特别的关系；一个男人时不时向自己的神秘盒子中看去；一位老人乐于享受真空吸尘器的服务；一对夫妻因棒球浮想联翩；男人在同伴强迫下对着奇怪的装置哭泣。

影片中的道具是依据切身经历和新闻报道而特制的，意在展现情感与身份构建寻求统一的内在需求。

### What if... products were designed for complex emotional needs?

Desire Management is a film comprising five sequences in which objects are used as vehicles for dissident behavior. In the film, the domestic space is defined as the last private frontier, a place where bespoke appliances provide unorthodox experiences for alienated people: An airline hostess with a unique relationship to turbulence, the owner of a mysterious box which men ritually visit to look inside, an elderly man who enjoys being vacuumed, a couple who engage in baseball driven fantasies, a man who is forced by his partner to cry into a strange device.

Based on real testimonials and news reports, the objects specifically created for the film attempt to reveal the inherent need for expression and identity formation in the face of conformity.

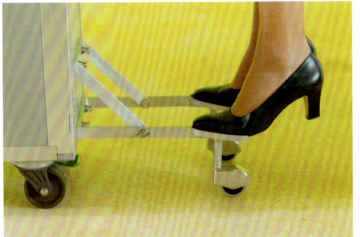

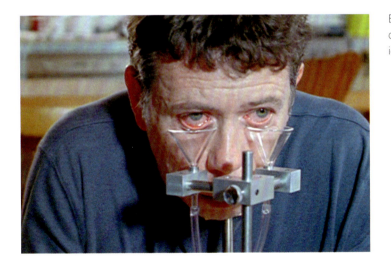

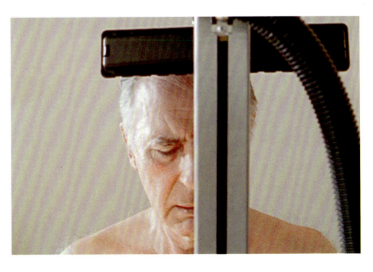

欲望管理，2005
诺曼·道朗（英国）
© Noam Toran

**Desire Managemeant**, 2005
Noam Toran (UK)
© Noam Toran

## 假如产品设计能够满足不为人知的需求，那会是什么样？

孤独者用品讲述了一个男人的故事，他因着迷于戈达尔的电影《筋疲力尽》，于是设计了一款托盘来模拟电影的物理语言。这个托盘是由一块真空成型的塑料做的，其上压出许多凹槽，用来摆放男人所需的物品。这些物品包括一个人体模型的头部（制作成女主演简·瑟伯格的样子）、一把枪、帽子、电话、国际先驱论坛报、墨镜、烟灰缸、方向盘、反光镜和一包吉坦尼斯无滤嘴香烟。这个托盘是男人欲望的释放，使他在电影影响下产生的幻想可以直接付诸实际行动。

## What if... products were designed for unacknowledged needs?

Object for Lonely Men tells the story of a man so obsessed with Godard's Breathless that he designs and builds a tray which reflects the physical language of the film. The tray is made from a single sheet of vacuum formed plastic and has recesses which house the objects that the man interacts with. The objects include a mannequin head which resembles Jean Seberg (the female lead), a gun, hat, telephone, Herald Tribune newspaper, sunglasses, ashtray, steering wheel, rear view mirror and a pack of Gitanes non-filtered cigarettes. The tray serves as an outlet for the man's desires; it allows him to directly channel the influence of the movie on his fantasies into physical action.

孤独者用品，2001
诺曼·道朗（英国）
© Noam Toran

**Objects for lonely men**, 2001
**Noam Toran** (UK)
© Noam Toran

**假如幻想可以被设计，那会是什么样？**

假如你处于正确的时间和正确的地点，就有可能经历一些所谓异想天开的事情。

雷击体验装置：这一装置可以增加体验者遭受雷击的可能性。雷击的能量会被转化为热能，在体验者身上留下一道疤痕，作为这一可怖体验的回忆。该装置旨在颠覆人们对遭受雷击这件事的刻板印象，质疑那种把致命一击变作小事一桩、把神奇化为平凡的观念。

**What if... we could design the fantastic?**

If you are in the right place, at the right time, you (may) experience something fantastic. Device for Experiencing Lightning strike-
This device increases the user's likelihood of getting struck by lightning. Energy from the strike is transferred to heat, used to brand the user, who following the experience is left scarred as a memory of the event. The device questions the dissemination of this experience, from the life threatening, to simple story, the transition from the fantastic to the banal.

**幻想世界，** 2010
安德鲁·福蓝德（英国）
© Andrew Friend

**The Fantastics,** 2010
Andrew Friend (UK)
© Andrew Friend

假如诗意的装置可以使不可能成为可能，那会是什么样？

"为什么我们需要一把叉子？为什么不文明的野蛮人直接用手从你的盘子里抓取食物？因为在公共场所用餐时，满手油渍会显得很尴尬。"——诺尔伯特·埃利亚斯

你知道吗？我们所使用的汤匙手柄是17世纪才有的，绅士们可以吃得很优雅并不弄脏他们的领子。我们所使用的叉子有四个尖齿而不是两个，这并不是出于卫生或功能的考虑，而是考虑到这种设计就会使我们免于从叉子上咬下食物的尴尬。所熟知的餐桌通过诗意的诠释令我们意识到正规的餐饮礼节在每日生活中是必不可少的。这张水桌看起来柔美至极，使得坐在旁边的人自然而然地关注自己的举止。像往常一样看着用餐各个环节的进行，我们开始质疑：为什么某些行为举止和日用品竟会在各个社会圈子里建立起完全不同的关系？诗意情调产生的同时某种程度上损耗了日常用品原有的功能。

事实上，情调产生于我们每日的生活，但是情调不具备实效。

**What if… the impossible could be captured by poetic objects?**

"Why do we need a fork? Why is it 'barbarian' and 'uncivilized' to eat with hands from your own plate? Because it feels embarrassing to be seen with dirty and oily finger in company."
Norbert Elias

Did you know that the handle of the spoon was extended to its length today only in 17th Century, so the aristocrats could eat more elegantly without dirtying their collars? Or that forks got four prongs instead of two, not out of hygienic or functional reasons, but because this way one doesn't have to "bite" the food off the fork? Poetic interpretation of the familiar shape of a dining table brings to mind the formalities of dining that are taken for granted in the everyday life. Poetry happens during the process of serving the table, by force of the fragility of the whole setting. Watching the downfall of the eating implements that we are used to, we start to question why certain patterns of behaviour and certain everyday objects make up the relationships within social groups. Poetry takes place here by turning an everyday object useless.

Indeed, the poetry is often rooted in the everyday, but has never been there for practical purposes.

水桌，2011
智恒（中国）
© Zhi Heng

**Water Table**, 2011
**Heng Zhi** (China)
© Zhi Heng

水桌，2011
智恒（中国）
© Zhi Heng

假如重大问题的讨论出现创造性的进展，那会是什么样？

该项目旨在通过挑选开放性的、非决断性的对话环境解决核裂变这一极具争议的问题。

茶话会的诱人陈设无疑是探讨核技术及其主要副产品高温废气、废水问题的好场合。这类讨论不求拿出解决方案，只是鼓励人们思考如何变废为宝，造福反应堆附近的社区。

设计者邀请试验者参与其中，品尝"黄饼"——核反应燃料U3O8的俗称。设计师与Nuclear FiRST的科学家们共同为可食用的黄饼制定配方，原料采用放射性同位素，挑战人们根深蒂固的观念及对危险的误解。

本次展览中，层层递进的黄饼配方是由Nuclear FiRST的科学家和设计师佐伊·帕帕佐普洛卢提供的，再搭配上英国兰卡斯特郡希舍姆的黄饼品尝会录像节选。品尝会上，当地居民应主办者号召，探讨附近核反应堆的排放物对白家小区有何潜在的影响。

核对话，2010
佐伊·帕帕佐普洛卢（英国）
© Zoe Papadopoulou photo: Theo Cook

## What if... creative processes where part of complex discussions?

This project aims to deal with the contentious area of nuclear fission by choosing an open, non-judgmental environment, designed for dialogue rather than dispute.

The inviting setting of a tea party allows for engaging discussion about the technology and its by-products, predominantly excess heat and hot water. Rather than imposing solutions, the discussion encourages suggestions on how by-products can benefit communities living in close proximity to the reactors.

Participation is encouraged through a tasting of 'yellowcake' – a colloquialism for uranium oxide U3O8, an essential ingredient in the preparation of uranium fuel for nuclear reactors. The designer along with scientists from Nuclear FiRST devised a recipe for an edible yellowcake using ingredients that contain radioactive isotopes challenging entrenched viewpoints and misunderstandings of risk.

A Step-by-step recipe for yellowcake is presented by scientists from Nuclear FiRST and Zoe Papadopoulou. This is followed by video extracts from a yellowcake tasting in Heysham, Lancashire. Local residents were encouraged to think of the by-products produced by the nearby nuclear reactor and the potential impact they could have on the local community.

**Nuclear Dialogues**, 2010
Zoe Papadopoulou (UK)
© Zoe Papadopoulou photo: Theo Cook

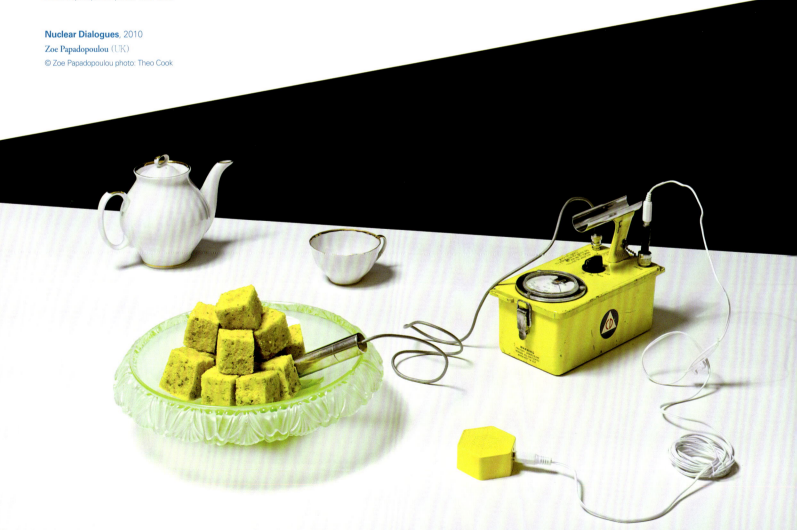

假如人类善变的一面可以与机器的精细化特性产生互补，那会是什么样？

现代资本工业化社会中，人们借购买、装扮各种机械大量生产、制造之物品而彰显个人品位与能力。再以此些物品而组装出每人期望表现于众人之前的自我人格形象。如同工厂作业员一般，组装各种文化、格调零件而产生出最终产品——自我形象绘图机。本为大量制造之物品，自此被赋予超脱机能之使命，而负担起虚幻不可触的品牌认同、阶级文化潜意识。人们在机械化物质社会中，操作机器、被机械生产之物操纵、协同机械而生产更多物品，再以劳力所得换取更多欲求物品。身处此巨大复杂交错的社会机器、如螺丝般存在的个人如何求取自我存在之意义与平衡？便成为各人仅能独自解题的终生实验。

自画像机计划尝试微缩复杂交错的人机关系。借人与机械的合作而求取各人期望表现形象。借由自画像的过程，浓缩体现真实生活中，人们为求人前美好表现而如何交易了自我意志与自由。计划目标借由公开展示及开放众人亲身体验，期望能各自质疑此一大问题并能寻求每人自我之解答。

## What if... man's inconsistencies complemented the precision of machines?

The human relationship with machines is one were we are locked into a spiral of ever increasing production, possibilities for future products, and new machines to produce them. We now find ourselves in a situation where nearly everything that surrounds us has been created by machines. Within this human/machine spiral, we create individual identities represented by the products of the human / machine relationship, further binding the two together. How do we recognize our place and the meaning of perpetuating the spiral?

The Self Portrait Machine is a human / machine relationship miniature; by cooperating with the machine, a self-portrait is generated. It is self-drawn but from an external viewpoint through controlled movement and limited possibility. Our choice of how we are represented is limited to what the machine will allow, and we adapt to create our ideal outcome.

自画像机，2009
廖人晖（中国台湾）
© Jen-Hui Liao

**Drawing Machine**, 2009
**Jen-Hui Liao** (Taiwan, China)
© Jen-Hui Liao

假如工厂搬进城市，那会是什么样？

工厂要进城了！它们正从看不见的偏远地带转移到我们的城市中。微观技术的进步导致全球性变革，临时搭建的小工厂就在我们家门口生产高科技产品。这种新生产方式会给我们的城市景观带来何种变化？从车库式作坊到马戏团式的临时厂棚，从街头贩卖亭到露营地式生产，在收回生产资料所有权这种令人激动的前景下，该项目探究未来工厂的可能形式及其与社会的关系。

## What if... factories were in cities?

The factories are coming to town! They are moving away from the unseen fringes, and into our cities. Advances in micro-scale engineering point to a global scale revolution where local, disposable factories produce hi tech goods at our very doorstep. What shapes might this new way of "making things" take within our urban landscape? From garage-workshops to circus-like temporary structures, from street vendor stalls to vagabond encampments, this project explores the factories of the future and what our relationship to them might be, with the exciting prospect of taking back ownership over our production tools.

奇妙新工厂，2010
大卫·本克（英国）
© David Benqué

**Fabulous Fabbers**, 2010
David Benqué (UK)
© David Benqué

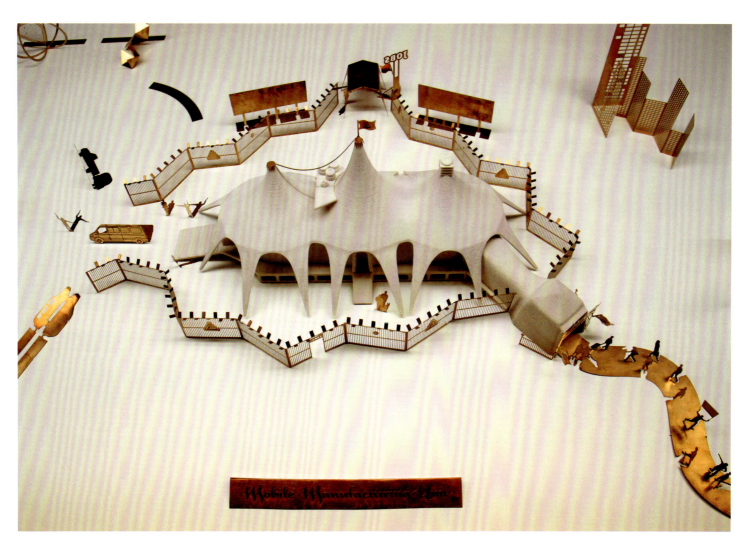

可能的世界　WHAT IF

假如我们能够与大自然系统相连接，那会是什么样？

这个三维动画短片试图探索生命运行的秘密。作为个体的我或者你，都会老去，躯体消亡，就像树上的一片叶子会凋落，但是新的叶子会长出来，那就是我们的后代，以及他们的后代，将生命不断延续。

片中所呈现的生命体同时代表了自然个体和人类，将各种不同物体联系起来的是生命。各个自然物体好像是各个器官，共同组成一个大的生命体；或者从另一方面看，人体内的循环犹如自然界的循环。

原来，我们与自然同呼吸。

## What if ... we connected with natural systerms?

This Stereo 3D animation showing is seeking for the secret of life.

If only the clock of our life would never stop,,if only our aged body could be reborn, like a new embryo in Spring, and growing youthful again! Isn't this the most dreamed dream we have been dreaming for? Yet this dream could really be fulfilled, when we understand the key of the grand circulation and connection between lives.

The living things showed in this animation represent both nature and human. Like different organs, nature lives, such as plants, flowers, etc. build up a big life body. From the other side, the circulation in human body is the same as the cycle of a natural world. Sure as each individual, we will all grow old in time and we will all disappear someday, like a leaf on a tree. But the new leaves will keep growing out from the tree of life, season after season, generation after generation.

So, we breathe with the nature together.

生生不息，2010-2011
祝卉（中国）
© Zhu Hui

**Breathe Together**, 2010-2011
**Zhu Hui** (China)
© Zhu Hui

假如工业产品中包含着对人的关怀，那会是什么样？

蒲公英灯是一个关注情感的人机交互智能台灯：它的灯头设计成蒲公英的硬装，每一个"小种子"内部有一个LED灯，用户以吹散蒲公英种子的动作来关闭灯源，灯光就会逐渐熄灭，好像蒲公英种子逐渐飞走的感觉。这个设计极富有情趣性，同时又节能环保，为用户带来一种充满童趣的独特体验。

### What if... products encouraged gentleness?

The SECRET OF LIGHT is a Lighting system, That mimicksthe popular real-life action of blowing onto the dandelion flower. The ways of blowing to turn off and shanking to turn on remain us of the natural emotion, as well as new fresh use experience.

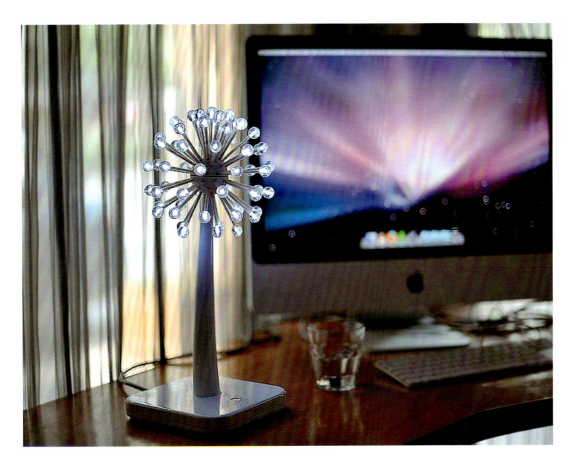

蒲公英灯，2010
柴春雷，邱懿武(中国)
© Chai Chunlei

**Secret of light**, 2010
Chai Chunlei,
Qiu Yi wu (China)
© Chai Chunlei

假如人可以被复杂的网络所代表，那会是什么样？

人和传播的信息组成了社交网络。每人都是参与者，而传播的信息所反映的是不可见的行为与效果。当社交网络来到实体世界的时候，每一个人成为了一个立方体。当我们从其中的一个用户变为一个全局的统揽者的时候，社交网络中的发展与变化，就从这些或聚或散的立方体群的相互影响情况而体现出来。起伏变换的立方体演绎了社交网络一天天的活动状况。每一个观众本是立方体方阵中的一个立方体。

立方体长10cm，宽6.5cm，高4.5cm，外壳是塑料的。每一个立方体内部都有一个独立的嵌入式系统。因此从某种程度上讲，每一个立方体就是一台小计算机。通过内置的wifi功能模块立方体可以跟其他的立方体和服务器进行通信。在会展现场，参观的人同样可以通过wifi访问到为立方体的展出特别搭建的服务器，通过验证后就可以和立方体进行互动，这样观众就不需要触碰立方体。

那些没有被访问的立方体还可以通过声音传感器对展会现场的声响做出响应，参观者也可以通过喊话，或者播放声音来引起立方体的注意，与它们进行互动。

立方体的情绪和状态将通过面部表情和身体的颜色来表达。面部表情的变化是通过对一块用于展示表情LED阵列的控制来实现的；而立方体体内有各种颜色的LED灯，可以作为改变身体颜色的实现。

## What if... people were represented in complex networks?

Social network formed by users and information. Every user is a participant and the information represents invisible communicating behavior and result. Our work is to demonstrate the social network in real life. We have used to be one of the participants in social network. However, in this project, we could overview the whole picture. Variation of the cubes illustrates the activity in daily social network. From the interaction between each cube, one can easily find out the development of social network. The audience themselves are one of the cubes in the cube matrix.

Cube looks like a 100mm long, 65mm wide and 45mm height box, its shell is made of plastic. Inside Cube there will be a PCB and some electronic devices.

All of the 20 Cubes will be placed on table (Size can be flexible, for example, one meter wide and two meters long). Each Cube has an embedded system, which means every Cube is minicomputer. Cubes employ WIFI module to communicate with each other and the Server. The visitors could interact with Cubes by visiting the Server's Web sites. On the sites, visitor could choose the Cube they want to visit and have some operations like sending a message. Then the Cube will start to spread their responds and feelings to each other. So the visitors do not need to touch them.

Cubes' emotions and feelings will express by their well designed smiley and the colors of their body. There is a led matrix used to show Cubes smiley and several colorful LED used to illustrate the body color.

社会立方，2011
付志勇，李轲，田力，李鑫(中国)
© Fu Zhiyong

**Social Cubes: MATRIX**, 2011
Fu Zhiyong, Li Ke, Tian Li, Li Xin(China)
© Fu Zhiyong

**假如产品能感知你的存在，那会是什么样？**

选用中国千年传统大漆工艺与现代新科技环保节能LED灯结合设计，造型简约，富质感，品质高尚。灯具具有红外线人体感应装置，使用者进入1m内灯具会自动开关，1m内光线最足，人离开后，光线随时间递减，节约电能，这是一款具亲和力的人机交互设计产品。

**What if… products acknowledged our presence?**

I've selected the China's millennium traditional lacquer technic and modern new technology environmental protection and energy saving leds combine design, modelling is contracted, rich simple sense, of good character. The lamps and lanterns has infrared sensors, users 100cm at present human body within automatically switch, lamps and lanterns, the most sufficient light in 100cm at present who left, light decrease with time, managing electric energy, as a paragraph of the human-computer interaction design provide affinity products.

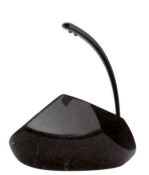

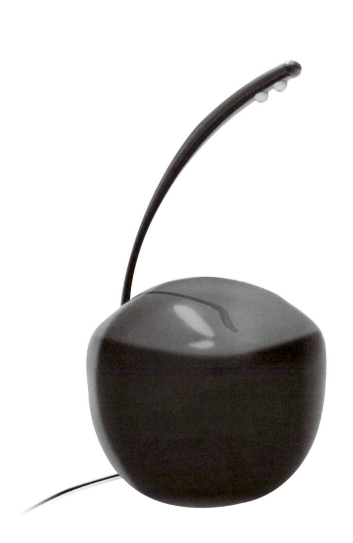

漆，2011
蔡江宇(中国)
© Cai Jiangyu

**Lacquer**, 2011
**Cai Jiangyu**(China)
© Cai Jiangyu

## 假如科技可以丰富我们的学识,那会是什么样?

科学儿童是针对未来一代青少年的专属名词,他们更加成熟、更加先进。这个项目专门研究快速成长的儿童,以及他们与老一辈人的关系。这件制服和儿童工具实际上就是为这个问题而设置的,即两代人的互动空间和关系。青少年将是最近新科学技术的掌握者,他们如何操作、使用这些技术呢?与其用今天的方法测试,他们更期待获得未来的科技测试手段。

这套儿童制服上有一个小标志,代表了这名儿童所属的机构。这枚印章是管理工具,判断所选定的主题——老年人研究,是否适用于此项技术。

## What if... technologies accelerated our knowledge?

Techno Children is a term attributed to a future generation of young and more mature/ advanced children of the future. The project investigates and deals with the result of rapidly maturing children, the relationships between them and the increasing older population. The arrangement of the uniform and the child's tools question this space and relationship between the two generations. Will children in the future hold the upper hand with technology, and if so, how do they control and supply this. Maybe instead of the driving test of today, children will hold the technology test of tomorrow.

The uniform for the child, with an attached logo represents an institution or cooperation that the child belongs to. The stamps are administrative tools, which determine if the chosen subject, the elderly, are fit to use the specified technology.

科技儿童,2010
钟承达(中国香港)
© Shingtat Chung

**Techno Children**, 2010
**Shing Tat Chung** (Hong Kong, China)
© Shingtat Chung

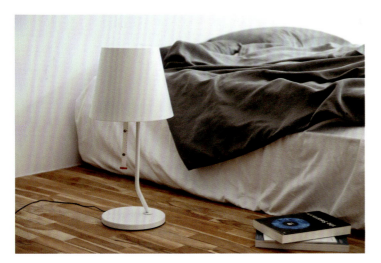

### 假如台灯可以反映不同人的睡眠习惯，那会是什么样？

《嘀嗒！嘀嗒！》是睡前阅读者的良伴，是专门为那些经常忘记关灯的人设计的。 在每一个灯罩下都有一根可以反映时间长度的拉线，拉得越长，台灯就会更长时间的保持亮度。"嘀嗒！嘀嗒！"灯在指定时间内缓缓变暗，最终完全熄灭。

### What if… lamps reflected different sleep habits?

"TikTikTIk" is the perfect light for reading or even just cuddling a bit before bed—or for people who otherwise forget to turn off the light! Pulling down on "TikTikTIk" is pull chain sets the length of time the light is on. The further you pull the chain, the longer the lamp stays on. The lamp pull retracts silently until a few minutes before the timer runs out. The light dims and then turns off.

嘀嗒！嘀嗒！，2010
玩点互动公司(中国台湾)
© Bitplay INC

**TikTikTik**, 2010
Bit Play INC (Taiwan, China)
© Bitplay INC

## 假如产品能"呼吸",那会是什么样?

如果我们的产品能"呼吸"会怎样?任何生命体都在呼吸,通过呼吸来生长。那么产品是不是也可以会"呼吸",有"生命"?

城市中严重的汽车尾气污染,不仅夺走了昔日的蓝天,威胁到人体的健康,也使人们对未来的生活感到沮丧。"会呼吸的灯-1"正是基于这一问题而提出的解决方案。该设计源于植物的"呼吸作用"和"光合作用"。它以太阳能和风能为动力,一方面将城市中的"尾气"吸入"体内",经"空气净化装置"转变成清洁空气后排出"体外";另一方面通过顶端的LED照明装置为城市提供高效的照明。"会呼吸的灯-2"是一个延展方案,其特点在于它的扇叶具有显像功能。扇叶中心的"摄像头"可以捕捉到附近人的动态,然后通过体内的微处理器处理后,再将相应的图像动态地显示在扇叶上,实现人和物的"交互感应"。

## What if ... product could breath?

What if our product could breath? Any live breaths to live and grow. What if our product could breathe and has a life?

The serious automobile exhaust in the city is not only destroying the air harming the human, but also makes people dispirited for their future. Breath & Light-1 is a real solution based on this problem. The original design comes from the respiration and photosynthesis of plant. It is powered by the energy solar and wind. On one hand, it breaths with exchanging the automobile exhaust to clean air through Air Purifier. On the other hand, it provides efficient lighting with LED light on the top. Breath & Light-2 extends Breath & Light -1 by the feature its fan has the function of raster display. The camera on center of the fan can seize the figure nearby, and then process to show the acquired image on the fan by inside microprocessor. It can realize a telepathy between objects and people!

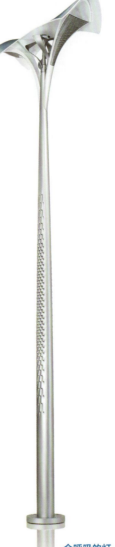

会呼吸的灯-1,2011
邱松设计工作室
© Qiu Song Design Studio

会呼吸的灯-2,2011
邱松设计工作室
© Qiu Song Design Studio

**BREATH & LIGHT-1**, 2011
Qiu Song Design Studio
© Qiu Song Design Studio

**BREATH & LIGHT -2**, 2011
Qiu Song Design Studio
© Qiu Song Design Studio

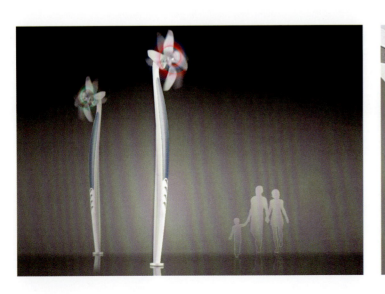

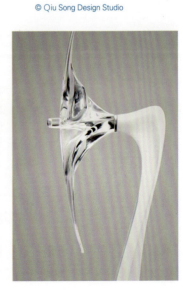
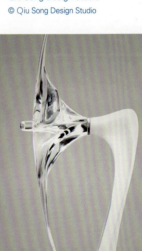

**假如机器能够代替人体器官，那会是什么样？**

医疗技术已经达到了新的水平，生理退化不再意味着生命的终结。当数字技术进入人体并与之融合，它们会重新定义人体的物质和功能属性。而当人体具备了技术的效能时，身体与机器的分界线又在哪里呢？

**What if... machines replaced our organs?**

Medical technologies have reached the stage in which biological deterioration no longer means the end of a human life. When digital technologies enter and merge with the body, they redefine its material and functional properties. As the human anatomy gains technological capabilities, where does the body end and the machine begin?

后人类时代，2008
莉薇·科恩（英国）
© Revital Cohen

**The Posthuman Condition**, 2008
Revital Cohen (UK)
© Revital Cohen

# 首届北京国际设计三年展 大事记

2009年7月15日，首届北京国际设计三年展筹备动员会在清华大学美术学院召开，清华大学美术学院名誉院长冯远主持会议，三年展项目正式启动。

2009年12月，三年展筹备组拟定北京国际设计三年展策划案草案，确定首届北京国际设计三年展的展览主题为"仁：设计的善意"。

2010年3月至5月，教育部、文化部、中国文联相继正式批复，同意成为首届北京国际设计三年展联合主办单位。

2010年4月下旬，三年展筹备组赴意大利、法国和瑞士考察联络，与米兰设计周外围展主策划人吉达·博亚迪及其他国外著名策展人和相关人士会谈接洽。

2010年7月，北京市人民政府正式批复，同意成为首届北京国际设计三年展联合主办单位，并建议首届北京国际设计三年展与2011北京国际设计周联合举办，以整合各方资源，为北京申办设计之都助力。

2010年11月，清华大学与北京歌华文化发展集团、北京工业设计促进中心达成紧密合作关系，决定三方共同承办"2011北京国际设计周暨首届北京国际设计三年展"。

2010年11月下旬，三年展筹备组赴意大利、法国考察威尼斯建筑双年展及2010圣泰田设计双年展，并与圣泰田设计双年展组委会相关负责人进行深入交流。同月，三年展筹备办公室正式成立。此后，工作人员陆续到位，并全面展开筹备工作。三年展筹备办公室主要成员包括：三年展秘书长：杨冬江；策展人协调项目部：李敏、周艳阳、李诗雯、王晨雅、汪芸、谢欣、刘雅曦；网络推广与文案编撰项目部：陈岸瑛、谢欣、安丛；展陈设计与现场协调项目部：管沄嘉、马赛、周艳阳、乔忠林、刘一；视觉与礼品设计项目部：王鹏、谢欣；综合办公与事务协调项目部：郭秋惠、贺秦岭；物流运输与场馆协调项目部：孟凡顺、乔忠林；媒体推广与公关合作项目部：汪芸、郭秋惠；开幕式与活动策划项目部：千哲、王之纲；视频与展场资料项目部：郭秋惠、李敏敏、王晨雅、李诗雯、汪芸、刘雅曦；人员接待与展场服务项目部：任茜、赵丽俐、张金荣、周艳阳。

2010年12月，三年展策展委员会副主任杭间赴香港考察2010设计营商周，与香港设计中心董事会副主席、香港当代文化中心董事刘小康商谈合作事宜。

2010年12月中旬，三年展筹备办公室与多位国际知名策展人就策展事宜展开沟通，并发出邀请。

2011年1月20日—1月26日，三年展候选策展人工作会议在清华大学美术学院召开。参加本次会议的有来自意大利、法国、瑞士、英国、美国和中国香港的共8组（10名）境外策展人，他们分别就各自的展览主题和策展方案向三年展策展委员会进行了汇报。

2011年2月下旬，经三年展策展委员会反复研究，并与中外策展人就合作协议进行深入磋商，最终确定首届三年展五个分展览主题及中外策展人阵容。其中，"创意联结"单元策展人为吉达·博亚迪（意大利）、杨冬江（中国）；"知'竹'"单元策展人为刘小康（中国香港）、杭间（中国）；"理智设计情感"单元策展人为本杰明·卢瓦约特（法国）、方晓风（中国）；"混合现实"单元策展人为特里斯坦·凯柏勒（瑞士）、芭芭拉·霍泽尔（瑞士）、马丁·海勒（瑞士）、李德庚（中国）；"可能的世界"单元策展人为菲奥娜·拉比（英国）、安东尼·邓恩（英国）、金江波（中国）。

2011年3月初，五组境外策展人来京参加策展人工作会议，正式签署协议，与中方策展人见面并确定合作关系。与此同时，国内20余家设计专业媒体与三年展筹备办公室达成战略合作关系。

2011年3月3日，首届北京国际设计三年展首次新闻发布会在清华大学主楼接待厅隆重召开，活动主、承办方及新闻媒体界代表近200余人参加了本次活动。作为本次发布会的重点，三年展策展委员会副主任杭间对展览筹备进度及各展览单元进行了介绍，来自意大利、英国、法国、瑞士、中国及中国香港的五组策展团队集体亮相，接受媒体专访。在新闻发布会召开的同时，三年展官方网站（www.bidt.org）正式上线。

2011年4月25日，2011北京国际设计周暨首届北京国际设计三年展组委会工作会议召开，清华大学、北京歌华发展集团及北京工业促进中心三方相关人员参会，通报设计周筹备工作进展情况、三年展筹备工作进展情况，讨论组委会汇报的内容与方案，讨论确定logo设计方案及现阶段工作中急需解决的问题。

2011年4月27日，北京国际设计三年展工作汇报会在清华大学美术学院召开。会议由清华大学美术学院常务副院长郑曙旸主持，筹备办公室向清华大学美术学院名誉院长冯远汇报三年展工作进展，冯远对

筹备工作给予肯定，并就下一步工作提出建议。

2011年5月12日，首届北京国际设计三年展第三次策展人工作会议在清华大学美术学院举行，各主题单元国际策展人先后汇报展陈方案、参展作品及设计师。汇报后，与会策展人及专家进行了集体讨论，杭间代表三年展策展委员会对策展工作表示肯定，并逐一对分主题展提出建设性意见，希望各主题展深化展陈方案，充分展现当代国际设计的风采。

2011年5月19日，北京国际设计三年展承办方清华大学、北京歌华发展集团，在歌华大厦就三年展的海外展品运输及展览场地租借事宜进行深入讨论，并达成一致意见。

2011年6月3日，北京国际设计三年展海外展品运输项目竞争性谈判在清华大学美术学院举行，三家国内外一流物流运输企业入围。经评审，最终选择中国远洋物流有限公司作为承运单位。三年展海外展品将于6月15日起陆续从法国巴黎、瑞士苏黎世、英国伦敦、意大利米兰及中国台湾、中国香港等地运往北京。

2011年6月14日，2011北京国际设计周暨首届北京国际设计三年展组委会第一次会议于在北京市政府北楼第一会议室召开。北京市委常委、宣传部长、副市长鲁炜，中国文联副主席冯远，教育部国际合作与交流司司长张秀琴，清华大学副校长谢维和，市委宣传部副部长张淼出席会议，国家部委相关机构、北京市属相关单位负责同志参加会议。会议由市政府副秘书长侯玉兰主持。张淼代表组委会办公室介绍了2011设计周暨三年展活动方案和筹备情况。鲁炜、冯远和教育部、文化部以及各成员单位负责人，对组委会办公室前一阶段筹备工作给予了肯定，对活动方案和下一步工作提出了建议和意见。

2011年6月29日，2011北京国际设计周暨首届北京国际设计三年展组委会办公室第一次主任会议在北京市委306会议室召开。会议议定了组委会办公室组织机构和领导分工，听取了活动方案汇报并对下一步筹备工作提出要求。办公室副主任曾辉、杨冬江、孙群和王果儿在会上分别汇报了开幕式、北京设计论坛、主题展览、主宾城市、年度设计奖和设计之旅六项活动方案，沟通了根据组委会第一次会议精神调整细化的相关活动内容。

2011年7月4日至8月4日，北京国际设计三年展"理智设计情感"单元、"创意联结"单元、"混合现实"单元、"知竹"单元、"可能的世界"单元外方策展团队陆续来京，与三年展筹备办公室协调展陈施工及其他相关工作细节。

2011年7月10日，首届北京国际设计三年展展示与陈设工程招标评审会在清华大学美术学院A327会议室举行。四家具有相关资质的企业递交了投标文件。经综合评审，北京清尚建筑装饰工程有限公司成为首届北京国际设计三年展展示与陈设工程第一标段中标企业，北京永一格展览展示有限公司成为第二标段中标企业。

2011年7月21日，2011北京国际设计周暨首届北京国际设计三年展组委会副主席、执行主席、市委常委、宣传部部长、副市长鲁炜在北京市委听取了"2011北京国际设计周暨首届北京国际设计三年展"筹备工作情况汇报。组委会副秘书长、办公室主任、市委宣传部副部长张淼主持会议并做了活动筹备情况的汇报。鲁炜对组委会办公室近期工作和整体活动方案给予了充分肯定，并针对方案的策划内容和下一阶段的工作提出要求。组委会办公室副主任杭间、清华大学美术学院副院长赵萌及三年展工作人员，参加会议并汇报三年展相关筹备情况。

2011年8月16日，《首届北京国际设计三年展作品集》完成编辑、设计工作，中国建筑工业出版社开始进行校对、印刷、出版工作。

2011年8月26日，从英国、法国、瑞士、意大利及其他相关国家启运的首届北京国际设计三年展海外展品相继到达天津口岸。

2011年8月30日，由清华大学美术学院师生近百人组成的首届北京国际设计三年展志愿者团队正式组建，志愿者团队不仅参加展览的筹备和接待工作，还将在展览期间为公众义务讲解展览，并提供相关志愿服务。

2011年9月10日，北京国际设计三年展"创意联结"、"知'竹'"、"理智设计情感"、"混合现实"、"可能的世界"五个单元的中外策展人齐聚北京，完成三年展开幕前的系列准备工作，并将参加"2011北京国际设计周暨首届北京国际设计三年展"开幕式、论坛等相关活动。

# CHRONICLE OF EVENTS OF THE FIRST BEIJING INTERNATIONAL DESIGN TRIENNIAL

The preparatory and mobilization meeting for the first Beijing International Design Triennial (BIDT) was held in the Academy of Arts and Design, Tsinghua University on July 15, 2009, which was chaired by Feng Yuan, honorary president of the aforesaid academy, and the BIDT project was formally launched since then.

The preparatory group of the triennial finished the draft plan for BIDT in December 2009, and determined the exhibition theme: "REN: Good Design".

The Ministry of Education, the Ministry of Culture and China Federation of Literary and Art Circles gave official written replies in sequence from March to May 2010, and granted approval to become the joint hosts of the first Beijing International Design Triennial

The preparatory group of the BIDT went to Italy, France and Switzerland on a tour of investigation and liaison late in April 2010, during which they met and contacted Gilda Bojardi, the chief planner of the Milan design week, and other renowned foreign curators and relevant personnel.

People's Government of Beijing Municipal gave an official written reply and approval to become the joint sponsor of the first Beijing International Design Triennial in July 2010, and proposed to hold the BIDT with the 2011 Beijing Design Week to integrate resources of various parties, and contribute to making Beijing successfully apply for the Capital of Design.

Tsinghua University reached close partnership with Beijing Gehua Cultural Development Group and Beijing Industrial Design Center in November 2010, and the three parties decided to jointly undertake the "2011 Beijing Design Week & the First Beijing International Design Triennial".

The preparatory group of the BIDT went to Italy and France late in November 2010 to investigate Venice Architectural Biennale and 2010 Saint-Etienne International Design Biennial, and carried out in-depth exchanges with the relevant personnel in charge of the organizing committee of Saint-Etienne International Design Biennial. The Preparatory Office of the BIDT was formally established in the same month. Then the staffs were ready for work in sequence, and carried out preparatory work in an all-round way. The main members of the preparatory office includes Yang Dongjiang, secretary general of the BIDT; Curator Coordination Department: Li Minmin, Zhou Yanyang, Li Shiwen, Wang Chenya, Wang Yun, Xie Xin, Liu Yaxi; Internet Promotion & Content Compilation Department: Chen Anying, Xie Xin, An Cong; Scenograph and Site Organization Department: Guan Yunjia, Ma Sai, Zhou Yanyang, Qiao Zhonglin, Liu Yi; Visual and Gift Design Department: Wang Peng, Xie Xin; Comprehensive Office & Business Coordination Department: Guo Qiuhui, He Qinling; Logistics Transportation & Venue Coordination Department: Meng Fanshun, Qiao Zhonglin; Media Promotion & Public Relations Department: Wang Yun, Guo Qiuhui; Opening Ceremony& Events Planning Department: Qian Zhe, Wang Zhigang; Video & Exhibition Visual Material Department: Guo Qiuhui, Li Minmin, Wang Chenya, Li Shiwen, Wang Yun, Liu Yaxi; Reception & Exhibition Venue Service Department: Ren Qian, Zhao Lili, Zhang Jinrong, Zhou Yanyang.

Hang Jian, vice director of the BIDT Committee, went to Hong Kong to investigate 2010 Business of Design Week in December 2010, and carried out negotiation on cooperation with Freeman Lau, vice chairman of the Board of Directors of Hong Kong Design Centre, director of Hong Kong Institute of Contemporary Culture.

The BIDT Preparatory Office carried out communications on exhibition planning with several international renowned curators and sent out the invitation in the middle of December 2010.

The working conference for the candidate curator of the BIDT was held in the Academy of Arts and Design, Tsinghua University from January 20 to26, 2011. Totally 8 groups(10 people) of the overseas curators from Italy, France, Switzerland, UK, USA and China Hong Kong attended the meeting. The curators gave reports on respective exhibition themes and exhibition planning programs to the BIDT Curatorial Committee.

The themes of the five sub-theme exhibitions of the first Beijing International Design Triennial and the lineup of the Chinese and foreign curators were finally determined on late February 2011 through a lot of research done by the BIDT Curatorial Committee after in-depth negotiation on cooperation agreement with the Chinese and foreign curators. The curators of the sub-theme exhibition "Creative Junctions" are Gilda Bojardi (Italy) and Yang Dongjiang (China); The curators of the sub-theme exhibition "Rethinking Bamboo" are Freeman Lau(China Hong Kong) and Hang Jian (China) ; The curators of the sub-theme exhibition "Reason Design Emotion" are Benjamin Loyauté (France) and Fang Xiaofeng (China); The curators of the sub-theme exhibition "Good Guys" are Tristan Kobler (Switzerland), Barbara Holzer (Switzerland), Martin Heller (Switzerland, Consultant) and Li Degeng (China);The curators of the sub-theme exhibition "What If " are Fiona Raby(UK), Anthony Dunne(UK) and Jin Jiangbo(China).

Five groups of international curators came to Beijing for the curator working conference on early March 2011, and they formally signed agreements, met Chinese curators and determined cooperative relationship. Meanwhile, over 20 domestic professional design media reached strategic partnership with the BIDT preparatory office.

The press conference of the first Beijing International Design Triennial was held in the reception hall of the main building of Tsinghua University on March 3, 2011. Over 200 people attended the press conference including the hosts and organizers of the event, and the media. As the focus of the press conference, Hang Jian, vice director of the BIDT Curatorial Committee introduced the progress of the preparation work of the exhibition, and each sub-theme exhibition. Five groups of curators from Italy, England, France, Switzerland, China and China Hong Kong showed up collectively and received exclusive interviews. The official website of BIDT (www.bidt.org) was officially launched online when the press conference was held.

The working conference of the organizing committee of Beijing Design Week & the First Beijing International Design Triennial was held on April 25, 2011, and relevant personnel from Tsinghua University, Gehua Group and Beijing Industrial Design Center attended the conference and reported the progress of the preparatory work of the Design Week, and the Triennial, discussed the content and the programs reported by the organizing committee, discussed and determined the logo of the event and the problems need to be solved urgently in the current work.

The work report meeting of Beijing International Design Triennial was held in the Academy of Arts and Design, Tsinghua University on April 27, 2011, which was chaired by Zheng Shuyang the standing deputy dean of the Academy of Arts and Design of Tsinghua University, and the preparatory office reported work progress of the BIDT to Feng Yuan,

honorary dean of the academy. Feng Yuan affirmed the preparatory work, and put forth proposals on the following work.

The third working conference of the curators of the first Beijing International Design Triennial was held in the Academy of Arts and Design, Tsinghua University on May 12, 2011, and the international curators of each sub-theme exhibition reported the exhibition scenograph, exhibits and designers in sequence. The curatos and experts at the conference carried out collective discussion, and Hang Jian gave affirmation to the exhibition planning work on behalf of the BIDT Curatorial Committee, and put forth constructive opinions on the various sub-theme exhibitions one by one,expecting each sub-theme curator to deepen exhibition scenography and fully express the excellence of the international contemporary design.

The organizers of BIDT such as Tsinghua University and Gehua Group carried out in-depth discussion on the transportation of overseas exhibits and renting of exhibition venues in Gehua Building and reached consensus on May 19, 2011.

Competitive negotiation on the transportation of the overseas exhibits of Beijing International Design Triennial was held in the Academy of Arts and Design, Tsinghua University on June 3, 2011, and three domestic and foreign top logistics companies were enlisted. And China Ocean Shipping Logistics Co., Ltd. was finally determined to be the carrier through review. The overseas exhibits of the BIDT will be transported from Paris of France, Zurich of Switzerland, London of England, Milan of Italy, China Taiwan and China Hong Kong to Beijing in sequence since June 15.

The first meeting of the organizing committee of the 2011 Beijing Design Week & the First Beijing International Design Triennial was held in the No.1 conference room in north building of Beijing Municipal Government on June 14, 2011. Lu Wei, standing committee member of Beijing municipal party committee, director of Publicity Department and vice mayor, Feng Yuan, vice chairman of China Federation of Literary and Art Circles, Zhang Xiuqin, director of International Cooperation and Exchanges Department of the Ministry of Education, Xie Weihe, vice president of Tsinghua University, and Zhang Miao, vice director of Publicity Department of municipal party committee attended the meeting. Comrades in charge of the relevant organizations of the state ministries and relevant institutes in Beijing also participated in the meeting. The meeting was chaired by Hou Yulan, vice secretary general of the municipal government, and Zhang Miao introduced the program and preparation work of 2011 Beijing Design Week and the First Beijing International Design Triennial on behalf of the office of the Organizing Committee. Lu Wei. Feng Yuan, the Ministry of Education, Ministry of Culture and the personnel in charge of various organization gave affirmation to the first preparatory work of the office of the organizing committee, and put forth proposals and opinions on the programs and the following work.

The first director's conference of the office of the Organizing Committee of 2011 Beijing Design Week & the First Beijing International Design Triennial was held in Room 306 of Beijing municipal party committee on June 29, 2011, which determined the organizing institute of the Organizing Committee office, and the division of work among leaders. The members participated in the meeting listened to the reports on the programs and put forth requirements for the following preparatory work. Zeng Hui, vice director of the office, Yang Dongjiang, Sun Qun and Wang Guoer reported the programs of six events such as the opening ceremony, Beijing Design Forum, Featured Exhibitions, Guest City Program, Design Hop and the Annual Design Awards respectively at the meeting, and also communicated the content of relevant events adjusted and refined according to the spirit of the first meeting of the organizing committee.

The bidding conference of the first Beijing International Design Triennial was held in Room 327, Building A, the Academy of Arts and Design, Tsinghua University on July 10, 2011. Four enterprises with qualifications submitted bids at the meeting. Beijing Qingshang Architectural Decoration Co., Ltd. became the bid winner of the scenography constructiondesign (first phase) for BIDT and the Beijing Unique Exhibition Co., Ltd. became the bid winner of the scenography constructiondesign (second phase) for BIDT after comprehensive evaluation .

The BIDT international curatorial team of each sub-theme exhibition "Reason Design Emotion", "Creative Junctions", " Good Guys", "Rethinking Bamboo", and " What If" came to Beijing in sequence from July 4 to August 4, 2011, and coordinated scenography and the details of the other relevant work with BIDT preparatory office.

Lu Wei, vice chairman, executive chairman of the Organizing Committee of the 2011 Beijing Design Week & the First Beijing International Design Triennial, member of municipal standing party committee, director of the Publicity Department and vice mayor listened to the report on the preparatory work of 2011 Beijing Design Week & the First Beijing International Design Triennial in Beijing municipal party committee on July 21, 2011. Zhang Miao, vice secretary general of the Organizing Committee, office director, and vice director of the Publicity Department of Municipal Committee chaired the meeting, and reported the preparation work of the events. Lu Wei gave full affirmation to the recent work and overall event program of the office of the Organizing Committee, and put forth the requirements for the planning content of the programs and the following work. Hang Jian, vice office director of the Organizing Committee, Zhao Meng, vice dean of the Academy of Arts and Design, Tsinghua University and the staffs from the BIDT office attended the meeting and reported relevant preparation work.

Collection of the Works of the First Beijing International Design Triennial was compiled and designed before August 16, 2011, and China Architectural Industrial Press started proofreading, printing and publishing.

The overseas exhibits for the first Beijing International Design Triennial transported from England, France, Switzerland, Italy and other relevant countries arrived at Tianjin port in sequence on August 26, 2011.

The volunteer team for the first Beijing International Design Triennial composed of nearly 60 teachers and students from the Academy of Arts and Design, Tsinghua University was formally established on August 30, 2011. The volunteers have not only taken part in the preparation and reception work of the exhibition, but also will give voluntary interpretation to the public and provide relevant volunteer service during the exhibition.

The Chinese and overseas curators of the five sub-theme exhibitions "Creative Junctions", "Rethinking Bamboo", "Reason Design Emotion", "Good Guys" and "What If" gathered together in Beijing on September 10, 2011, completed series preparatory work before the opening of the Beijing International Design Triennial, and will attend the relevant events such as the opening ceremony and forum etc. of the "2011 Beijing Design Week & the First Beijing International Design Triennial".

# 索引 INDEX

---

**0-9**

5.5 designers  5.5设计工作室  *p258, 274*
5+1 AA  5+1 AA工作室  *p64*

---

**A**

Aisslinger,Werner  维尔纳·艾斯林格  *p410*
Aalto,Alvar  阿尔瓦·阿尔托  *p34*
Adami,Massimiliano  马西米里奥诺·阿达米  *p78, 97*
Agence Loya-b  Loya-b公司  *p366, 367*
Agotob,Karta  卡塔·艾高塔  *p214*
AL_A in collaboration with Anish Kapoor  阿曼达·莱维特建筑事务所，安尼施·卡普尔  *p338, 358*
Alexandra Daisy Ginsberg & Sascha Pohflepp,ect.  亚历山大·黛西·吉恩斯伯格，萨沙·奥弗里皮  *p469, 495, 496*
Anab Jain, Alex Taylor  阿耐普·杰恩, 阿列克斯·泰勒  *p498*
Ando,Tadao  安藤忠雄  *p174*
Angeletti & Ruzza  安杰莱蒂, 鲁扎  *p161*
Angelidakis,Andreas  安德列斯·安格利达克斯  *p339*
Antalis (Shanghai) Trading Co.,Ltd  康戴里贸易（上海）有限公司  *p211*
A-ONE Design Group  艾万设计团队  *p295*
Arad,Ron  让·阿瑞得  *p42, 72, 95*
Aromdee,Korakot  可拉寇特·阿旺迪  *p220*
Arrigoni,Fabienne  法比尼·埃瑞格尼  *p403*
Ashizawa,Ryuichi  芦泽龙一  *p238, 239*
Ashuach,Assa  阿萨·阿舒齐  *p318*
Astuguevieille,Christian  克里斯汀·奥斯特古威莱奥  *p368*
Atelier Oï  油彩工作室  *p394*
Auger,James  詹姆斯·奥格  *p481, 494, 499*
Aulenti,Gae & Castiglioni,Piergiacomo  加埃·奥兰迪, 皮耶贾科莫·卡斯提利奥尼  *p167*
Azambourg,Francois  弗朗索瓦·阿臧宝  *p71*

---

**B**

Baas,Maarten  马丁·巴斯  *p308, 309*
Bangerter,Markus  马库斯·班戈特  *p396*
Baptist,Maarten  马腾·巴普蒂斯特  *p218*
Barber,Edward & Osgerby,Jay  爱德华·巴伯, 杰·奥斯格毕  *p288*
Baron,Sam & Cabelli,Fabrica Ben  山姆·巴让, 法布里卡·本·卡贝利  *p77*
Bauchet,Francois  弗朗索瓦·班查德  *p289*
BBKen & Corri  易春友, 谭雪娇  *p143*
Béhar,Yves  伊夫斯·贝哈  *p283*
Belley,Gilles  吉尔·百利  *p322, 323*
Bellini,Mario  马里奥·贝里尼  *p84, 94*
Ben Hayoun,Nelly  奈丽·本·哈尤恩  *p486, 504, 505, 506, 507*
Bencore  Bencore公司  *p331*
Benedini Associati  贝纳蒂尼公司  *p59*
Benjamin Loyauté  本杰明·卢瓦约特  *p369*
Benqué,David  大卫·本克  *p466, 467, 515*
Benshetrit,Dror  德罗尔·本舍齐特  *p73*
Binfaré,Francesco  弗兰切斯科·宾法莱  *p83*
Biomega Philosophy (Ross Lovegrove)  Biomega Philosophy公司（洛斯·拉古路夫）  *p214*
Bit Play INC  玩点互动公司  *p503, 521*
Bluebell HK Ltd(Campana Fratelli)  蓝钟香港有限公司（坎帕纳兄弟）  *p216*
Boeri,Cini  契尼·波里  *p133*
Boontje,Tord  托德·布谢尔  *p63, 101, 164*
Bozaci,Ata  亚塔·博萨奇  *p388*
Bramer,Martin  马丁·布拉莫  *p405*
Branzi,Andrea  安德里亚·布兰兹  *p90, 96, 135, 161, 258*

Breaded Escalope  Breaded Escalope设计工作室  *p414, 415*
Brelli/Zonsius Pamelan  布莱利公司/宋·巴米兰  *p215*
Brigantine  Brigantine公司  *p330*
Brilliant Bamboo Craft Co.,Ltd./Lin Chun Han  竹采艺品有限公司/林群涵  *p204, 210, 211, 217*
Burton,Michael  迈克尔·伯顿  *p485, 487, 490*

---

**C**

Cai,Jiangyu  蔡江宇  *p519*
Caleb Smith, Grant Ryan, Peter Higgind, Stuart Belcher, iDesign, Paul Binner  克莱布·史密斯, 格兰特·赖安, 彼得·希金斯, 斯图尔特·贝拉吉欧, iDesign, 保罗·宾纳"  *p319*
Cappellini,Giulio  朱利奥·卡佩里尼  *p69, 72*
Casalgrande Padana SPA  卡萨格兰德·帕达纳公司  *p63*
Castiglioni,Achille & Piergiacomo  阿切莱·卡斯蒂里奥尼, 皮埃尔贾科莫·卡斯蒂里奥尼  *p127, 157*
Cathrine,Kramer  克莱默·凯瑟琳  *p464*
Caviezel,Claudia  克劳迪娅·卡维泽  *p398*
Centro Stile Marazzi  玛拉兹中心  *p64*
Ceretti,Giorgio/Derossi,Pietro/Rosso,Riccardo  乔治·切里提, 皮埃特罗·德罗西, 里卡多·罗索  *p139*
Chai,Chunlei  柴春雷  *p517*
Chambers,James  詹姆斯·钱柏斯  *p491*
Chan,Eric  陈秉鹏  *p207*
Chan,Soo  曾士生  *p172*
Charles & Eames,Ray  查尔斯和蕾·伊姆斯夫妇  *p154*
Chen Kao-Ming  陈考明  *p261*
Chen,Min & Shi,Zhenyu  陈旻, 石振宇  *p365*
Chen,Nan  陈楠:  *p148*
Chipperfield,David  大卫·奇普菲尔德  *p58*
Chiu,Chin Tuan  邱锦缎  *p215*
Chun zai Furniture Design ( Shanghai)/Jerry,J.I. Chen  春在（上海）家具贸易有限公司/陈仁毅  *p200, 201*
Citterio,Antonio  安东尼·奇特里奥  *p106, 122, 126, 147*
CL3 Architects Limited/Lim,William  思联建筑设计有限公司/林伟而  *p226, 227*
Claramunt,Xavier  泽维尔·克拉拉蒙特  *p325*
Club House Italia  意大利俱乐部之屋  *p106*
Cohen,Revital  莉微·科恩  *p480, 482, 483, 484, 523*
Colombo,Carlo  卡洛·科伦坡  *p88, 114, 159*
Colombo,Joe  乔·科伦坡  *p135*

---

**D**

De Coster,Quentin  昆汀·德·考斯特  *p283*
De Leon & Primmer Architecture Workshop  德里昂及普利莫建筑工作室（罗伯特·德里昂，罗斯·普利莫）  *p232, 233*
De Lucchi,Michele  米歇尔·德·卢基  *p107, 112, 113*
De Pas,Jonathan/D'Urbino,Donato/Lomazzi,Paolo  纳森·德·巴斯, 多纳托·德·乌日比诺/保罗·洛马齐  *p133, 154*
Decq,Odile  欧迪勒·德克  *p115*
Deganello,Paolo  保罗·德加尼罗  *p135*
Denis,Santachiara  桑塔其阿莱·丹尼斯  *p155*
Derossi,Pietro  皮埃特罗·德罗西  *p171*
Diez,Stefan  斯蒂芬·迪茨  *p111, 296, 297*
Ding,Wei  丁伟  *p334*
Dixon,Tom  汤姆·迪克森  *p105*
Dordoni,Rodolfo  鲁道夫·多多尼  *p86, 89, 133, 147*
Doshi,Nipa & Levien,Jonathan  尼帕·多施, 乔纳森·莱维  *p56*
Du,Yi  杜异  *p360*
Duoxiang Studio  多相工作室  *p359*
Dyson,James  詹姆斯·戴森  *p320*

## E

EADS Innovation Works UK/Hawkins,Andy & Turner,Chris  英国EADS创新工作室/安迪·霍金斯，克里斯·特纳  p321
Elkann,Lapo & Meritalia  拉普·埃尔康，梅里塔里亚  p93
Emeco  Emeco公司  p100
Enjoy Bamboo Home  赏竹雅舍商贸有限公司  p223
Enrico,Baleri & Denis,Santachiara  巴莱里·安利柯，桑塔其阿莱·丹尼斯  p155
Ergonomidesign/Puranen,Jan  人机工程设计工作室 Ergonomidesign/杨·普拉恩  p276
Escama  Escama设计工作室  p416, 417

## F

Faux  Faux（路易斯·帕帕克里斯顿）  p223
Favresse,Pierre & Dupont,Emmanuelle  皮埃尔·法夫雷斯，艾玛纽勒·杜蓬特  p269
Favresse,Pierre & Turpin,Christophe  皮埃尔·法夫雷斯，克里斯多夫·特平  p332
Feichtner,Thomas  托马斯·费希特纳  p268
Feng,Feng  冯峰  p315, 359, 432
Fernando & Campana,Humberto  费尔南多·坎帕纳，翁贝托·坎帕纳  p71, 83, 164, 167
Fioravanti,Odoardo  奥多尔多·费奥拉万提  p44, 78, 84
FLORA  互若亚股份有限公司  p211
Fornasetti,Barnaba  巴拿巴·弗纳赛蒂  p63
Foster+Partners  福斯特建筑事务所  p40, 350
Francois,Edouard  爱德华·弗朗索瓦  p343, 344
Fredrikson,Patrik & Stallard,Ian  帕特里克·弗里德里克森，伊安·斯塔拉尔德  p312
Freitag  弗莱塔格工作室  p406, 407
Friend,Andrew  安德鲁·福蓝德  p511
Front / Lindgren,Anna/ Lagerkvist,Sofia / Von Der Lancken,Charlotte  Front工作室 / 安娜·林格伦，索菲娅·拉格维斯特，夏洛特·凡·德·兰肯  p51, 102, 302
Fu Zhiyong, Li Ke, Tian Li, Li Xin  付志勇，李轲，田力，李鑫  p518
Fukasawa,Naoto  深泽直人  p53, 162, 263
Fuksas,Massimiliano & Mandrelli,Doriana  马西米拉诺·福克萨斯，多里安娜·奥·曼德莱利  p58

## G

Gabriel,Elise  伊莉斯·嘉佰丽  p346, 347
Gagern,Moritz  莫里茨·加格恩  p398
Galante,Maurizio  马乌里齐奥·加兰特  p70, 74
Galiotto,Raffaello  拉斐罗·加里奥托  p134
Gamper,Martino  马蒂诺·甘佩尔  p294
Gao,Qiang  高一强  p170
Gatti,Piero/Paolini,Cesare/Teodoro,Franco  皮耶罗·加蒂，切萨里·帕奥里尼，弗朗哥·狄奥多罗  p127
Gilad,Ron  让·杰拉德  p82
Giovannoni,Stefano  斯蒂凡诺·乔凡诺尼  p59, 60, 66
Gomez Paz,Francisco  弗朗西斯科·戈麦斯·帕斯  p162
Gonalons,Pierre  皮埃尔·格纳隆思  p293
Gözetlik,Mehmet  默罕默德·格采特里克  p277, 278
Graindorge,Benjamin  本杰明·格兰多戈；  p259
Grandi,Diego  迭戈·格兰迪  p63
Grcic,Konstantin  康斯坦丁·格里克  p40, 50, 81, 260, 261, 290, 291
Green Village, Bali  巴厘岛绿色村庄  p230, 231
Gschwendtner,Gitta  吉塔·盖斯温特娜  p312
Guixé,Martí  马蒂·古伊斯  p159, 399
Guvirch, Ruth  露丝·戈维奇  p313

## H

Hadid,Zaha  扎哈·哈迪德  p51, 61, 75, 104, 353
Hangzhou Hotry Bamboo Culture & Creativity Co., Ltd  杭州合骏竹文化创意有限公司  p211
Hauswirth,Florian  弗洛连·豪斯维斯  p405
Hayon,Jaime  亚米·海因  p143, 167, 306
Hazebroek,Adri  阿德里·哈斯布罗克  p67
He,Jianping  何见平  p430, 431
He,Jie  何洁  p130
Heatherwick Studio  赫斯维克工作室  p348, 349
Heatherwick,Thomas  托马斯·赫斯维克  p349
Hecht,Sam  山姆·赫奇特  p264, 281
Herzog & De Meuron  赫尔佐格，德梅隆  p75
Hibanana Studio/Miao, Jing/Liu, Chang/Li, Zan  Hibanana Studio/苗晶，刘唱，李赞  p364
Holzer,Jenny  珍妮·霍尔泽  p162
Hopfengärtner,Bernhard  伯恩哈德·霍普夫加特纳  p501
Huke,Jared  杰瑞德·胡克  p199
Hutten,Richard  理查德·胡腾  p165

## I

IFAM  德国弗劳恩霍夫制造技术和应用材料研究院  p330
Ikou Tschüss  Ikou Tschüss设计工作室  p387
Iosa Ghini,Massimo  马西莫·约乔·基尼  p95

## J

Jacob & MacFarlane  贾柯柏，麦克法兰建筑事务所  p46
Jensen,Ole  奥利·詹森  p107
Jia,David  贾伟  p158
Jia,Li  贾立  p123
Jiang,Hongbin  蒋红斌  p420
Jiang,Hua  蒋华  p433
Jörger-Stauss  约格-斯特劳斯工作室  p412
Junky Styling  Junky时装工作室  p401, 402
Junya,Ishigami  石上纯也  p166

## K

Kadid,Léonard  莱奥纳尔·卡迪德  p262
Kath,Jan  扬·凯斯  p392
Kawayan Tech/Cadiz,Eric&Chan,Englebert  Kawayantech公司/埃里克·卡迪兹，陈·英格尔伯特  p214
Kayser,Aylin & Metzner,Christian  艾琳·凯瑟尔，克里斯蒂安·梅茨纳  p419
Kehrle,Steffen & Rüf,Robert  史蒂芬·科勒，罗伯特·吕夫  p282, 298
Kerridge,Tobie  托比·克利奇  p479
King,James  詹姆斯·金  p488
Kita,Toshiyuki  喜多俊之  p132, 142, 148, 170, 171, 000
Kral,Tomas  托马斯·克拉尔  p299
Kuiken,Klaas  克拉斯·库肯  p399
Kuma,Kengo  隈研吾  p356
Kyoto University,VBL(Venture Business Laboratory) / Matsushige Kazumi  京都大学，VBL车业实验室/松重和美  p212

## L

La viola,Claudio  克劳迪·拉·维奥拉  p107
Laarman,Joris  乔瑞斯·拉曼  p156
Lancman,Tal  塔尔·兰克曼  p74
Laviani,Ferruccio  费鲁齐奥·拉维阿尼  p165
Lebécel,Thomas  托马斯·勒博塞  p328
Lehanneur,Mathieu & Edwards,David  马修·雷汉尼尔，大卫·爱德华兹  p326
Levy,Arik  艾瑞克·莱维  p91, 114
Li,Hong & Liu Wenwei  李泓，刘文伟  p124, 139
Li,Wei  李薇  p123
Liao,Renhui  廖人晖  p514
Liao,Wei  廖伟  p363

索引 INDEX

Lissoni,Piero  皮耶罗·里梭尼  p54, 67, 92, 93, 97, 102
Liu,Carl  刘传凯  p108, 109, 111
Liu,Kaiwei  刘凯威  p168
Liu,Nathan  刘峰  p119
Liu,Tiejun  刘铁军  p118
Liu,Zhiguo & Li,Chuchen  刘志国，李楚晨  p334
Liu,Zi  刘孜  p123
llot llov artwork shop  llot llov艺术品商店  p411
Longoni,Paola & Marras Gianluca  葆拉·朗格尼，马拉斯·吉安卢卡  p138
Lovegrove,Ross  洛斯·拉古路夫  p53, 74, 214, 267
Lu,Biaobiao  卢麃麃  p432
Lu,Xiaobo  鲁晓波  p468
Lu,Yongqing  陆永庆  p110
Ludovica + Roberto Palomba  罗伯托·帕罗姆巴，卢多维卡·帕罗姆巴  p69, 126
Luk,Chi Cheong  陆智昌  p424, 425, 426
Luo,Lixian  罗丽弦  p333
Luxluxlux  Luxluxlux设计工作室  p395

M

Ma,Xianrong  马宪荣  p357
Ma,Yansong  马岩松  p116, 444, 445
Machet,Christophe  克里斯多佛·马歇  p275
Magistretti,Vico  维克·玛吉斯特莱蒂  p36, 132
Magistretti,Vico  维克·玛吉斯特来提  p36
Malouln,Phllippe  菲利浦·玛洛因  p292
Mangiarotti,Angelo  安杰洛·曼加洛蒂  p125
Marchand,Christophe  克里斯多夫·马尚  p289
Mariscal,Javier  哈维尔·马里斯卡尔  p91, 100
Massaud,Jean-Marie  让-马里·马索德  p102, 103
Maurer,Ingo  因格·毛赫尔  p38, 39, 74
McIntosh,Eduardo  爱德华多·麦金托什  p345
Mendini,Alessandro  亚历山德罗·门迪尼  p37, 46, 68, 69, 104, 117
Mike Mak/Mike  Mike Mak公司/麦隽永  p80
Mimótica Micola S.L.  米莫提卡·米可拉公司  p215
Missoni Home Studio  米索尼家庭工作室  p116
Model,Philippe  菲利普·莫德尔  p393
Morandini,Marcello  马切洛·莫兰蒂尼  p146
Morgante,Andrea  安德里亚·摩根特  p69
Morrison,Jasper  贾斯珀·莫里森  p59, 72, 263
Moutis,David Des  大卫·德斯·穆迪  p342
Mueller,Fabian  法比安·穆勒  p389
Munari,Bruno  布鲁诺·穆纳里  p143
Mutsch,Rainer  雷纳·穆奇  p413

N

Nanni,Mario  马里奥·纳尼  p86, 152, 153
Navone,Paola  葆拉·娜万  p105, 114, 134
Nendo (Oki Sato)  Nendo公司（佐藤大）  p81, 120, 172, 264, 265, 310
Neri,Lyndon & Hu,Rossana  郭锡恩，胡如珊  p141, 173, 440, 441
New Deal Design  New Deal Design公司  p224
Newson,Marc  马克·纽森  p327
Nichetto,Luca  卢卡·尼切托  p71, 161
Nicolas,Gwenael  格温内尔·尼古拉斯  p52
Norguet,Patrick  帕特里克·诺尔盖  p62
Normal Studio  Normal工作室  p294
Nouvel,Jean  让·努维尔  p58, 92, 101
Novembre,Fabio  法比奥·诺文布雷  p73, 78, 80, 131

O

Oberfell,Wertel  沃特尔·奥伯费尔  p329

Ora-Ito  欧若·伊图  p160
Oval Partnership Ltd.(Dr. Lin Hao, Chris Law)  奥华尔顾问有限公司（郝琳博士，罗健中）  p234

P

Palomba,Ludovica & Roberto  卢多维卡·帕洛姆巴，罗伯特·帕罗姆巴  p85
Papadopoulou,Zoe  佐伊·帕帕佐普洛  p464, 465, 513
Parent,Claude  克劳德·帕伦特  p341
Paster,Eva & Michael Geldmacher  爱娃·帕斯特，迈克尔·哥德马赫  p90
Pegatron Corporation/Lee Alain-de Lee, Chan Andrew, Wang Kiwi, Yang Ming ,Liu David  和硕联合科技股份有限公司/李政宜，陈效正，王翬元，杨宇民，刘大维  p220
Pesce,Gaetano  盖塔诺·佩瑟  p91,93,94, 111, 303
Philips Design/Mama,Jack/Van Heerden,Clive  飞利浦设计中心/杰克·玛玛，克莱夫·范·赫尔登  p327
Pillet,Christophe  克里斯托弗·皮耶  p92
Poli,Franco  弗兰克·波利  p98
Ponti,Gio  吉奥·庞蒂  p35, 163
Pope,Nina & Karen,Guthrie  妮娜·波普，卡伦·格思里  p471
Pot,Bertjan  贝特扬·波特  p103
Poulton, Neil  尼尔·浦尔顿  p293

Q

Qian,Yiran  钱轶冉  p174
Qiu,Song  邱松  p522
Quitllet,Eugeni  欧金尼·凯特莱特  p266

R

Raby, Fiona&Dunne,Antony  菲奥娜·拉比，安东尼·邓恩  p477
Raffinerie AG für Gestaltung  Raffinerie设计公司  p397
Rasulo,Prospero  普洛斯贝罗·拉苏洛  p60
Raw Edges Studio  Raw Edges设计工作室  p76, 352
Rebello Lima,Vinicius  维尼休斯·里贝罗·利马  p206
Ribon,Felipe  飞利浦·里本  p324
Rinspeed Inc(Frank M.Rinderknecht)  林斯比得公司（弗兰克·M·林德克奈希特）  p213
Rizzatto,Paolo  保罗·里扎托  p126, 162
Rocco Design Architects Ltd. / Yim Rocco  许李严建筑师事务所有限公司 / 严迅奇  p228, 229
Roeder,Tina  蒂娜·罗德  p404
Ronan & Bouroullec,Erwan  罗南·布鲁莱克，尔旺·布鲁莱克  p41, 49, 164, 269
Rüf,Robert  罗伯特·吕夫  p282
Rybakken,Daniel  丹尼尔·瑞巴克  p260

S

Sadler,Marc  马克·萨德勒  p81, 85
Sambonet,Roberto  罗贝托·桑博奈  p154
Sandeep,Sangaru  桑迪普·桑伽如  p192, 193, 194, 195, 196
Santachiara,Denis  丹尼斯·桑塔奇阿莱  p155
Sawaya,William  威廉·萨瓦亚  p47, 67
Scheeren,Ole  奥雷·舍人  p351
Sempé,Inga  尹佳·桑佩  p304
Sérrano,Hector  赫克托·赛拉诺  p163
Seymour,Jerszy  泽西·西摩  p307
Shao,Fan  邵帆  p149
Shi,Chuan  石川  p438
Shi,Jeff Dah-Yue  石大宇  p204, 205, 235, 314, 357, 360
Shi,Jian/Wang,Xu/Hou, Ying/Chen, Haixia/Zhang,Chao/Ding,Fan/Zhan,Huode  史建，王序，侯颖，陈海霞，张超，丁凡，詹火德  p434, 435
Shi,Zhenyu  石振宇  p280, 295, 335
Shigeru Ban  坂茂  p295
Shingtat Chung  钟承达  p508, 520

Shinichiro Ogata / Wasara　绪方慎一郎/ Wasara　p284
Silvestrin,Claudio　克劳迪奥·西尔伟斯特林　p79
Sipek,Borek　波列克·斯伯克　p91, 128
Soares,Susanna　苏珊娜·索尔斯　p476, 478
Sottsass,Ettore　埃托·索特萨斯　p144
Starck,Philippe　菲利浦·斯塔克　p43, 76, 129, 137, 162, 266, 279
Stefan,Sagmeister　施德明　p390, 391
Studio 65　65工作室　p127
Studio FormaFantasma/Trimarchi,Andrea/Farresin,Simone　形式幻想工作室/安德里亚·奇马卡奇，西蒙·法热辛　p340
Suardi,Silvia & Sezgin,Aksu　西维亚·苏阿尔迪，阿克苏·赛斯格　p157
Sun,Jiaying　孙嘉英　p110
Sun,Yun　孙云　p172, 175
Sylvain Jacques　西尔万·雅克　p368

## T

Tacer,Frederic　弗雷德里克·塔舍尔　p256, 257, 272, 273, 286, 287, 300, 301, 316, 317, 336, 337, 354, 355
Talocci,Giovanna　乔瓦娜·塔洛奇　p56
Targetti R & D Dept　Targetti公司研发部　p75
Tek-siā design studio/Wang,Wen-Hsiung/Lin,Wun-Bing/Lin,Camo　Tek-siā 设计工作室/王文雄，林文柄，林桓民　p208, 209
Teng,Fei　滕菲　p420, 421
Ter Haar,Anna　安娜·特哈尔　p408, 409
Tessarollo,Mario　马里奥·德萨罗洛　p54
Thun,Matteo / Rodriguez,Antonio　玛寰·图恩，安东尼奥·罗德里贵兹　p55, 57, 67
Thwaites,Thomas　托马斯·特威士　p497
Toan Nguyen　全阮　p106
Tono,Attilio　阿提里奥·托诺　p150
TOPOTEK 1　TOPOTEK 1设计工作室　p386
Torafu architects　Torafu建筑事务所　p271
Toran,Noam　诺曼·道朗　p509, 510
Tsou,Page　邹骏昇　p502
Tuur Van Balen　图尔·凡·巴伦　p472, 473, 474, 475

## U

Uchino Co., Ltd.　日本内野公司　p225
Urbanus Architecture & Design Inc.　都市实践建筑师事务所　p442, 443
Urquiola,Patricia　帕特里夏·乌古拉　p45, 80, 87, 98, 99, 122, 125, 160

## V

Van Duysen,Vincent　文森特·凡·杜森　p62, 96
Van Engelen,Ed　艾德·范·恩格仑　p219
Van Lattum,Lotte　洛特·凡·拉顿　p198
Van Woerkom,Stijn　斯蒂恩·凡·韦科姆　p197
Vautrin,Ionna　艾奥娜·沃特林　p305
Vidas,Sara　萨拉·维达斯　p400
Vietnam Museum of Ethnology　越南民族博物馆　p222, 223
Vola Research & Development Studio　Vola设计研发工作室　p69

## W

Wanders,Marcel　马塞尔·万德斯　p54, 63, 103, 121, 129, 158, 160, 310
Wang Yun, Zhang Junjie, Hu Dandan, Chen Chongshun　王昀，章俊杰，胡丹丹，陈崇舜　p361
Wang,Alice　王艾丽　p492, 493, 500
Wang,Peng & Ren,Rui　王鹏，任蕊　p140
Wang,Xin & Klemmt,Christoph　王欣，克利斯朵夫·克勒姆特　p358

Wang,Xueqing & Yang Fan　王雪青，杨帆　p365
Wangen,Norbert　诺伯特·万根　p54, 58
WASARA / Ogata,Shinichiro　WASARA公司/绪方慎一郎　p284
Wierinck,Sébastien　塞巴斯蒂安·维尔林克　p353
Wilhelmsen,Siren Elise　塞壬·爱丽丝·威尔森　p418
Wilkinson,Samuel　塞缪尔·威尔金森　p332
Willenz,Sylvain　西尔万·威伦兹　p299
Woebken,Chris　克里斯·沃肯　p470
Wu,Qihua & Liu Yinan　吴其华，刘轶楠　p138
Wu,Vivian　吴凌之　p142

## X

Xiao Mage & Chengzi　小马哥，橙子　p428, 429
Xiao,Yong　肖勇　p157
Xie,Dong　谢东　p174
Xie,Zaru　谢一鸣　p171

## Y

Yamanaka,Yasuhiro　山中康广　p207
Yan,Yang/Liu,Zhiguo/Zhang,Lei　严扬，刘志国，张雷　p325
Yang,Jamy　杨明洁　p284
Yeh,Yu-Hsuan　叶宇轩　p140, 285
Yksi Design / Leonne Cuppen,Kees Heurkens,Eduard Sweep　Yksi团队/莱昂内·库佩，爱德华·斯韦普，谢斯·霍尔肯斯　p202, 203
Yoshioka,Tokujin　吉冈德仁　p166, 169, 267
Young,Michael　迈克尔·扬　p79
Yu,Lizhan　于历战　p121

## Z

Zeisser,Boris & Lammers,Maartje　鲍里斯·蔡瑟，马蒂尔·拉姆斯　p236, 237
Zhang,Da　张达　p427
Zhang,Lei　张雷　p168
Zhang,Weiwei　张苇苇　p489
Zhang,Xiaochuan　张小川　p422, 423
Zhang,Yung Ho　张永和　p136, 151
Zhao,Chao　赵超　p170, 335
Zhejiang YoYu Bamboo Joint-Stock Co.,Ltd　浙江永裕竹业股份有限公司　p225
Zheng,Daizi　郑戴紫　p333
Zheng,Shuyang & Tian,Qing　郑曙旸，田青　p145
Zhi,Heng　智恒　p512
Zhou,Hongtao　周洪涛　p124
Zhou,Shangyi　周尚仪　p151
Zhou,Yi　周佚　p270
Zhu,Daxiang　朱大象　p362
Zhu,Hui　祝卉　p516
Zhu,Pei & Wu,Tong　朱锫，吴桐　p170
Zhu,Xiaojie　朱小杰　p147, 217, 362
Zieta,Oskar　奥斯卡·齐塔　p311

# 后记

当我们编成本书的时刻，首届北京国际设计三年展的揭幕已是迫在眉睫。回想整个筹备期的艰辛，只有身临其境才能真正体味。这次展览对于"中国设计"乃至社会发展的意义，也许在今天还不为决策层和大众所理解，至于它能否成为社会所能品尝的佳酿，可能还要经过相当长的一段发酵期。然而，射向目标的"中国设计"之箭已不可能回头，它终将命中成就创新型国家的靶心。

2008年7月清华大学聘请中国文联副主席冯远就任美术学院教授及名誉院长。2009年初冯远教授倡议，由清华大学发轫，在中国举办"北京国际设计三年展"。其目标的高度是与国际同类展览齐名。显然这只能是国家层面的兴办格局。最初的一轮斡旋，争取到中国文联、文化部、教育部的支持。接下来又与北京市申办设计之都和2009年开始举办设计周的目的不谋而合，最终成为由中华人民共和国文化部、中华人民共和国教育部、中国文学艺术界联合会和北京市人民政府共同主办，清华大学、北京歌华文化发展集团和北京工业设计促进中心共同承办的"2011北京国际设计周暨首届北京国际设计三年展"。

2011北京国际设计三年展，以"仁：设计的善意"作为展览主题，按照人类社会和谐发展的核心理念，构建一个开放的交流平台，以期汇聚国际设计资源，推动中国创意产业发展，通过科技转化为生产力，促进中国设计产业的发展。作为首届的展览内容，以"创意联结"、"知'竹'"、"理智设计情感"、"混合现实"和"可能的世界"五个单元，将现代设计的过去、现在与将来充分展现在观者的面前，相信观者能够从中体验到设计的无限魅力。

采用国际通行的三年展模式和策展人制度，由海内外策展人组成5组联合策展团队，成为这次展览举办的一个特点。正因为此，作为协调整个展览运行的"首届北京国际设计三年展办公室"就成为活动成败的关键点。该机构是一个由清华大学美术学院青年教师和研究生组成的团队（17人平均年龄31岁），"办公室"在环境艺术设计系杨冬江副教授（北京国际设计三年展秘书长）的领导下，以策展人协调、展陈设计及现场组织、网站维护及文案撰写、视觉设计及礼品开发、视频及展场图像资料、物流运输及场馆协调、媒体推广及公关合作、开幕式及活动策划、人员接待及展场服务、综合办公与事务协调10个项目部的高效工作，保证了活动的顺利进行。值得一提的是，这17人中的绝大部分，还要完成平日的正常教学与行政管理工作。从他们身上可以看到中国设计光明的未来。

摆在面前的这本图册，只是"首届北京国际设计三年展"全部工作的缩影，虽然只有文字和平面的图形，与真正在展厅中看到的实物相比，所传达的信息也极其有限，然而在展览结束后，它却能够以文献的形式将其流传于后世。出版的意义就在于此，是为后记。

郑曙旸
清华大学美术学院常务副院长
2011年8月30日

# EPILOGUE

The moment we've compiled this book is just the time when the first Beijing International Design Triennial is about to begin. Only those who have personally participated in the preparation for this triennial could tell the true feelings after experiencing all the hardships occurred during the whole process. The significance of this exhibition to "China Design" or even social development may not be perfectly understood by the policy-making authorities or the general public for now; and there will be a long fermentation period before it finally becomes a cup of vintage wine for the whole society to taste. However, the arrow of "China Design" which has already been shot towards its destination can never turn back; it is determined to right hit the bull's-eye of this innovative-type country.

In July 2008, Tsinghua University employed Fe Yuan, the vice chairman of China Federation of Literary and Art Circles (CFLAC), as a professor and honorary principal of Academy of Art & Design. At the beginning of 2009, Prof. Feng Yuan advocated that Tsinghua University should organize Beijing International Design Triennial, hoping this exhibition will one day enjoy the equal popularity with other international exhibitions of this kind. Obviously, it should be organized by organs on the state level. After the first round of negotiation, supports have been obtained from CFLAC, the Ministry of Culture, and the Ministry of Education. Besides, the idea coincidently agrees with Beijing government's application for a UNESCO City of Design and organization of the Design Week as of 2009. Finally, 2011 Beijing International Design Week and the First Beijing International Design Triennial has been finalized, which is to be hosted by the Ministry of Education, Ministry of Culture, CFLAC, and People's Government of Beijing Municipality, and organized by Tsinghua University, Beijing Gehua Cultural Development Group, and Beijing Industrial Design Group.

In 2011 Beijing International Design Triennial takes "Ren: Good Design" as its theme, building up an open platform based on the core philosophy of harmonious development of human society. The exhibition will collect international design resources and promote the development of creative industries; furthermore, it will also stimulate the development of the Chinese design industry by transferring science and technology into productivity. The exhibition has 5 units, characterized by their respective sub-themes, including Creative Junctions, Rethinking Bamboo, Reason Design Emotion, Good Guys and What If, which fully exhibits the past, present and future of modern design in front of visitors. Visitors will surely experience the infinite charms of design this time.

The exhibition is triennial in line with international practice. The exhibition planning team is made up of 5 domestic and overseas curators, which is also another feature of the activity. It is right for this reason that the Office of the First Beijing International Design Triennial has become the key to success in coordination and operation of the whole exhibition. The Office, under the leadership of Yang Dongjiang, associate professor of Department of Environmental Art Design (secretary-general of Beijing International Design Triennial), comprises 17 young teachers and graduates from the Academy of Arts & Design, with the average age of 31. The office is responsible for coordination of curators, scenograph and site organization, website, editing and writing, visual design and gift design, video and exhibition visual material, logistic transportation and venue arrangement, media promotion and public relations, opening ceremony and events planning, reception and site service, general affairs and coordination, and highly efficient coordination with these 10 project departments, so as to ensure the smooth operation of this activity.

What's worth mentioning is that most of these 17 members also have to complete their routine teaching task and administrative management work at the same time. We can see a brilliant future of the design in China from them.

This book in front of you is just a miniature of all the jobs we've done for this exhibition. In comparison with substantial showpieces, the Catalogue only delivers limited information in terms of words and plane patterns; however, it can be handed down as a document for future generations as well. And this is, indeed, the very meaning for us to publish it.

Zheng Shuyang
Standing Deputy Dean of Academy of Arts & Design, Tsinghua University
August 30, 2011

图书在版编目(CIP)数据

仁：设计的善意　首届北京国际设计三年展／首届北京国际设计三年展筹备办公室编.-北京：中国建筑工业出版社，2011.9

ISBN 978-7-112-13562-2

Ⅰ.①仁…　Ⅱ.①首…　Ⅲ.①艺术品—作品综合集—世界　Ⅳ..①J111

中国版本图书馆CIP数据核字(2011)第185083号

---

总 策 划：郑曙旸　杭　间
策　　划：杨冬江
统　　筹：李敏敏
审　　校：陈岸瑛　李敏敏
编　　辑：李诗雯　王晨雅　谢　欣　刘雅曦　汪　芸
装帧设计：王　鹏
排版制作：陈桂莲　谢　欣
责任编辑：唐　旭　张　华
责任校对：关　健　姜小莲

---

仁：设计的善意
首届北京国际设计三年展
REN:GOOD DESIGN
THE FIRST BEIJING INTERNATIONAL DESIGN TRIENNIAL
首届北京国际设计三年展筹备办公室　编
\*
中国建筑工业出版社出版、发行(北京西郊百万庄)
各地新华书店、建筑书店经销
北京图文天地制版印刷有限公司制版印刷
\*
开本：965×1270毫米　1/16　印张：33 1/2　字数：1337千字
2011年9月第一版　2011年9月第一次印刷
定价：380.00元
ISBN 978-7-112-13562-2
　　　　(21325)

**版权所有　翻印必究**
如有印装质量问题，可寄本社退换
(邮政编码 100037)